Spurgeon on PRAYER & SPIRITUAL WARFARE

CHARLES SPURGEON

 Whitaker House

Unless otherwise indicated, all Scripture quotations are from the *King James Version* (KJV) of the Bible.

Scripture quotations marked (RV) are taken from the *Revised Version* of the Holy Bible.

SPURGEON ON PRAYER AND SPIRITUAL WARFARE

ISBN: 0-88368-527-2
Printed in the United States of America
Copyright © 1998 by Whitaker House

Whitaker House
30 Hunt Valley Circle
New Kensington, PA 15068

Library of Congress Cataloging-in-Publication Data

Spurgeon, C. H. (Charles Haddon), 1834–1892.
 Spurgeon on prayer and spiritual warfare / by Charles Haddon Spurgeon.
 p. cm.
 ISBN 0-88368-527-2 (alk. paper)
 1. Prayer—Christianity. 2. Spiritual warfare. I. Title.
 BV210.2.S667 1998
 248.3'2—dc21 98-28296

3 4 5 6 7 8 9 10 11 12 / 08 07 06 05 04 03 02 01 00

deliberately think on these
things upon rising: 6/11/23
Phil 4:8
 1 true
 2 honest
 3 just
 4 pure
 5 lovely
 6 good report
 7 virtu(ous)
 8 praise (worthy)

Spurgeon
on
PRAYER
&
SPIRITUAL
WARFARE

Contents

Introduction

Charles Haddon Spurgeon was born on June 19, 1834, at Kelvedon, Essex, England, the firstborn of eight surviving children. His parents were committed Christians, and his father was a preacher. Spurgeon was converted in 1850 at the age of fifteen. He began to help the poor and to hand out tracts; he was known as "The Boy Preacher."

His next six years were eventful. He preached his first sermon at the age of sixteen. At age eighteen, he became the pastor of Waterbeach Baptist Chapel, preaching in a barn. Spurgeon preached over six hundred times before he reached the age of twenty. By 1854, he was well-known and was asked to become the pastor of New Park Street Chapel in London. In 1856, Spurgeon married Susannah Thompson; they had twin sons, both of whom later entered the ministry.

Spurgeon's compelling sermons and lively preaching style drew multitudes of people, and many came to Christ. Soon, the crowds had grown so large that they blocked the narrow streets near the church. Services eventually had to be held in rented halls, and he often preached to congregations of more than ten thousand. The Metropolitan Tabernacle was built in 1861 to accommodate the large numbers of people.

Spurgeon published over thirty-five hundred sermons, which were so popular that they sold by the ton. At one point, his sermons sold twenty-five thousand copies every week. The prime minister of England, members of the royal family, and Florence Nightingale, among others, went to hear him preach. Spurgeon preached to an estimated ten million people throughout his life. Not surprisingly, he is called the "Prince of Preachers."

In addition to his powerful preaching, Spurgeon founded and supported charitable outreaches, including educational institutions. His pastors' college, which is still in existence today, taught nearly nine hundred students in Spurgeon's time. He also founded the famous Stockwell Orphanage.

Charles Spurgeon died in 1892, and his death was mourned by many.

Book One

The Power in Prayer

1

Guaranteed to Succeed

And I say unto you, Ask, and it shall be given you;
seek, and ye shall find; knock, and it shall be opened unto you.
For every one that asketh receiveth; and he that seeketh findeth;
and to him that knocketh it shall be opened.
—Luke 11:9–10

To seek aid from a supernatural being in time of distress is an instinct of human nature. I do not mean that human nature unrenewed ever offers truly spiritual prayer or ever exercises saving faith in the living God. But still, like a child crying in the dark, with painful longing for help from somewhere or other, the soul in deep sorrow almost always cries to some supernatural being for help. None have been more ready to pray in time of trouble than those who have ridiculed prayer in their prosperity. In fact, probably no prayers have been truer to the feelings of the hour than those that atheists have offered when in fear of death.

In one of his papers in the *Tattler,* Addison describes a man who, on board ship, loudly boasted of his atheism. A brisk gale springing up, he fell on his knees and confessed to the chaplain that he had been an atheist. The common seamen, who had never heard the word before, thought it was some strange fish. They were more surprised when they saw it was a man and learned out of his own mouth that he never believed until that day that there was a God. One of the old sailors whispered to an officer that it would be a good deed to heave him overboard, but this was a cruel suggestion, for the poor creature was already in misery enough. His atheism had evaporated, and in mortal terror he cried to God to have mercy on him.

Similar incidents have occurred more than once or twice. Indeed, so frequently does boastful skepticism tumble down at the end that we always expect it to do so. Take away unnatural restraint from the mind, and it may be said of all men that, like the comrades of Jonah, they cry *"every man unto his god"* (Jonah 1:5) in their trouble. As birds to their nests and as deer to their hiding places, so men in agony fly to a superior being for help in the hour of need.

By instinct man turned to his God in Paradise. Now, though he is to a sad degree a dethroned monarch, there lingers in his memory shadows of what he was and remembrances of where his strength must still be found. Therefore, no matter where you find a man, you will meet one who will ask for supernatural help in his distress.

I believe in the truthfulness of this instinct, and I believe that man prays because there is something in prayer. When the Creator gives His creature the power of thirst, it is because water exists to meet its thirst. When He creates hunger, there is food to correspond to the appetite. Even so, when He inclines men to pray, it is because prayer has a corresponding blessing connected with it.

We find a powerful reason for expecting prayer to be effective in the fact that it is an institution of God. In God's Word we are over and over again commanded to pray. God's institutions are not folly. Can I believe that the infinitely wise God has ordained for me an exercise that is ineffective and is no more than child's play? Does He tell me to pray, and yet does prayer have no more of a result than if I whistled to the wind or sang to a grove of trees? If there is no answer to prayer, prayer is a monstrous absurdity, and God is the author of it, which it is blasphemy to assert. Only a fool will continue to pray when you have once proved to him that prayer has no effect with God and never receives an answer. If it is indeed true that its effects end with the man who prays, prayer is a work for idiots and madmen, not for sane people!

I will not enter into any arguments upon the matter. Rather, I am coming to my text, which to me, at least, and to you who are followers of Christ, is the end of all controversy. Our Savior knew quite well that many difficulties would arise in connection with prayer that might tend to stagger His disciples, and therefore He has balanced every opposition by an overwhelming assurance. Read those words, *"I say unto you."* *"I"*—your Teacher, your Master, your Lord, your Savior, your God—*"I say unto you, Ask, and it*

shall be given you; seek, and ye shall find; knock, and it shall be opened unto you." Luke 11:9

In the text our Lord meets all difficulties first by giving us the weight of His own authority: *"I say unto you."* Next, He presents us with a promise: *"Ask, and it shall be given you"* and so on. Then He reminds us of an indisputable fact: *"Every one that asketh receiveth."* Here are three mortal wounds for a Christian's doubts about prayer.

HIS AUTHORITY

First, then, our Savior gives to us the weight of His own authority: *"I say unto you."* The first mark of a follower of Christ is that he believes his Lord. We do not follow the Lord at all if we raise any questions on points about which He speaks explicitly. Even if a doctrine is surrounded by ten thousand difficulties, the fact that the Lord Jesus said it sweeps them all away, so far as true Christians are concerned. Our Master's declaration is all the argument we need. *"I say unto you"* is our logic. Reason, we see you at your best in Jesus, for He is made wisdom to us by God (1 Cor. 1:30). He cannot err; He cannot lie; if He says, *"I say unto you,"* there is an end of all debate.

However, there are certain reasons that should lead us to rest all the more confidently in our Master's word upon this point. There is power in every word of the Lord Jesus, but there is special force in the utterance before us. It has been objected about prayer that it is not possible for prayer to be answered because the laws of nature are unalterable, and they must and will go on whether men pray or not. To us it does not seem necessary to prove that the laws of nature are disturbed. God can work miracles, and He may work them yet again as He has done in times long past. However, it is no part of the Christian faith that God must work miracles in order to answer the prayers of His servants. When a man has to disarrange all his affairs and, so to speak, stop all his machinery in order to fulfill a promise, it proves that he is but a man and that his wisdom and power are limited. But He is God indeed who, without reversing the engine or removing a single cog from a wheel, fulfills the desires of His people as they come up before Him. The Lord is so omnipotent that He can work results tantamount to miracles without in the slightest degree suspending any one of His laws. In olden

13

times He did, as it were, stop the machinery of the universe to answer a prayer (see Joshua 10:12–13), but now, with equally Godlike glory, He orders events so as to answer believing prayers and yet suspends no natural law.

But this is far from being our only or our main comfort. Our main comfort is that we hear the voice of One who is competent to speak on the matter, and He says, *"I say unto you, Ask, and it shall be given you."* Whether the laws of nature are reversible or irreversible, *"Ask, and it shall be given you; seek, and ye shall find."* Now, who is He that speaks this way? It is He who made all things, without whom *"was not any thing made that was made"* (John 1:3). Can He not speak on this point? Eternal Word, who *"was in the beginning with God"* (v. 2), balancing the clouds and fastening the foundations of the earth, You know what the laws and the unalterable constitutions of nature may be. If You say, *"Ask, and it shall be given you,"* then assuredly it will be so, be the laws of nature what they may.

Besides, our Lord is the sustainer of all things. Seeing that all the laws of nature operate only through His power and are sustained by His might, He must be aware of the motion of all the forces in the world. Therefore, if He says, *"Ask, and it shall be given you,"* He does not speak in ignorance, but He knows what He affirms. We may be assured that there are no forces that can prevent the fulfillment of the Lord's own word. From the Creator and the Sustainer, the words *"I say unto you"* settle all controversy forever.

Another objection has been raised that is very ancient indeed, and it has a great appearance of force. It is raised not so much by skeptics as by those who hold a part of the truth. It is this: prayer can certainly produce no results because the decrees of God have settled everything and those decrees are immutable. Now, we have no desire to deny the assertion that the decrees of God have settled all events. Certainly, it is our full belief that God has foreknown and predestinated everything that happens in heaven above or in the earth beneath. I fully believe that the foreknown station of a reed by the river is as fixed as the station of a king, and the chaff from the hand of the winnower is steered like the stars in their courses. Predestination embraces the great and the little; it reaches to all things. The question is, Why pray? Might it not as logically be asked, Why breathe, eat, move, or do anything? We have an answer that satisfies us; namely, our prayers are in the predestination, and God has as much ordained His people's

prayers as anything else. So, when we pray, we are producing links in the chain of ordained facts. Destiny decrees that I should pray—I pray. Destiny decrees that I will be answered—the answer comes to me.

But we have a better answer than all this. Our Lord Jesus Christ comes forward, and He says to us, "My dear children, the decrees of God need not trouble you; there is nothing in them inconsistent with your prayers being heard. *'I say unto you, Ask, and it shall be given you.'*"

Now, who is the One who says this? Why, it is He who has been with the Father from the beginning: *"The same was in the beginning with God"* (John 1:2). He knows what the purposes of the Father are and what the heart of the Father is, for He has told us in another place, *"The Father himself loveth you"* (John 16:27). Now, since He knows the decrees of the Father and the heart of the Father, He can tell us with the absolute certainty of an eyewitness that there is nothing in the eternal purposes in conflict with this truth, that he who asks receives and he who seeks finds. He has read the decrees from beginning to end. Has He not taken the book, loosed the seven seals thereof (Rev. 5:5), and declared the ordinances of heaven? He tells you there is nothing there inconsistent with your bended knee and streaming eye and with the Father's opening the windows of heaven to shower upon you the blessings that you seek.

Moreover, the One who promises to answer prayer is God Himself. The purposes of heaven are His own purposes. He who ordained the purpose here gives the assurance that there is nothing in it to prevent the efficacy of prayer. *"I say unto you."* You who believe in Him, your doubts are scattered to the winds; you know that He hears prayer.

But sometimes there arises in our minds another difficulty, which is associated with our own judgment of ourselves and our estimate of God. We feel that God is very great, and we tremble in the presence of His majesty. We feel that we are very little and that we are also vile. It does seem an incredible thing that such guilty nothings should have power to move the arm that moves the world. I am not surprised if that fear often hampers us in prayer. But Jesus answers it so sweetly. He says, *"I say unto you, Ask, and it shall be given you."*

I ask again, Who is it that says, *"I say unto you"*? Why, it is He who knows both the greatness of God and the weakness of man. He

15

is God, and out of His excellent majesty I think I hear Him say, *"I say unto you, Ask, and it shall be given you."* But He is also man like ourselves, and He says, "Do not dread your littleness, for I, bone of your bone and flesh of your flesh, assure you that God hears man's prayer."

Again, if the dread of sin should haunt us and our own sorrow depress us, I would remind you that Jesus Christ, when He says, *"I say unto you,"* gives us the authority, not only of His person, but of His experience. Jesus prayed. Never did any pray as He did. Nights were spent in prayer by Him and whole days in earnest intercession, and He says to us, *"I say unto you, Ask, and it shall be given you."* I think I see Him coming fresh from the heather of the hills, among which He had knelt all night to pray, and He says, "My disciples, *'Ask, and it shall be given you';* for I have prayed, and it has been given to me." He *"was heard in that he feared"* (Heb. 5:7), and therefore He says to us, *"I say unto you...knock, and it shall be opened unto you."* I think I hear Him speak thus from the cross, His face bright with the first beam of sunlight after He had borne *"our sins in his own body on the tree"* (1 Pet. 2:24) and had suffered all our griefs to the last pang. He had cried, *"My God, my God, why hast thou forsaken me?"* (Matt. 27:46); now, having received an answer, He cries in triumph, *"It is finished"* (John 19:30). In so doing, He bids us also to *"ask, and it shall be given* [us]." Jesus has proved the power of prayer.

Remember, too, that if Jesus our Lord could speak so positively here, there is an even greater reason for believing Him now: He has gone within the veil, and He sits at the right hand of God, even the Father. (See Hebrews 6:19–20; 10:12.) The voice does not come to us from the man of poverty, wearing a garment without seam, but from the enthroned priest with the golden girdle about His loins. It is He who now says from the right hand of God, *"I say unto you, Ask, and it shall be given you."*

Do you not believe in His name? How then can a prayer that is sincerely offered in that name fall to the ground? When you present your petition in Jesus' name (John 15:16; 16:23), a part of His authority clothes your prayers. If your prayer is rejected, Christ is dishonored; you cannot believe that. You have trusted Him; then believe that prayer offered through Him must and will win the day.

We cannot stay any longer on this point, but I trust the Holy Spirit will impress it upon your heart.

16

HIS PROMISE

We will now remember that our Lord presents us with a promise. Note that the promise applies to several varieties of prayer. *"I say unto you, Ask, and it shall be given you; seek, and ye shall find; knock, and it shall be opened unto you."* The text clearly asserts that all forms of true prayer will be heard, provided they are presented through Jesus Christ and are for promised blessings. Some are vocal prayers: men ask aloud. Never should we fail to offer up every day continually the prayer that is uttered by the tongue, for the promise is that the asker will be heard. But there are others who, not neglecting vocal prayer, are far more abundant in active prayer. By humble and diligent use of the means, they seek for the blessings that they need. Their hearts speak to God by their longings, strivings, emotions, and labors. Let them not cease seeking, for they will surely find. There are others who, in their earnestness, combine the most eager forms, both acting and speaking, for knocking is a loud kind of asking and a vehement form of seeking.

So the prayers grow from asking, which is the statement, to seeking, which is the pleading, and then to knocking, which is the urgent requesting. To each of these stages of prayer, there is a distinct promise. He who asks will have; what more did he ask for? But he who seeks will go further; he will find, will enjoy, will grasp, and will know that he has obtained. He who knocks will go further still, for he will understand, and to him will the precious thing be opened. He will not merely have the blessing and enjoy it, but he will comprehend it. He will *"comprehend with all saints what is the ...depth, and height"* (Eph. 3:18).

I want you, however, to notice this fact, which covers all: whatever form your prayer may assume, it will succeed. If you only ask, you will receive. If you seek, you will find. If you knock, it will be opened. In each case, *"according to your faith* [will it be] *unto you"* (Matt. 9:29). The clauses of the promise before us are not put, as we say in law, jointly: he who asks and seeks and knocks will receive. They are put separately: he who asks will have; he who seeks will find; he who knocks will have it opened. It is not when we combine all three that we get the blessing, though, doubtless, if we did combine them, we would get the combined reply. But if we exercise only one of these three forms of prayer, we will still get what our souls seek.

These three methods of prayer exercise a variety of our graces. Commenting on this passage, our forefathers in the faith noted that faith asks, hope seeks, and love knocks; that comment is worth repeating. Faith asks because it believes God will give. Hope, having asked, expects and therefore seeks for the blessing. Love comes nearer still; it will not take a denial from God but desires to enter into His house and to dine with Him. Therefore, love knocks at His door until He opens.

But, again, let us come back to the old point. It does not matter which grace is exercised; a blessing comes to each one. If faith asks, it will receive; if hope seeks, it will find; and if love knocks, the door will be opened to it.

These three modes of prayer suit us in different stages of distress. There I am, a poor beggar at mercy's door; I ask, and I will receive. But suppose I lose my way so that I cannot find Him of whom I once asked so successfully. Well, then I may seek with the certainty that I will find. And if I am in the last stage of all, not merely poor and bewildered, but so defiled that I feel shut out from God, like a leper shut out of the camp, then I may knock and the door will open to me.

Each one of these different descriptions of prayer is exceedingly simple. If anybody said, "I cannot ask," my reply would be, "You do not understand the word." Surely everybody can ask. A little child can ask. Long before an infant can speak, he can ask; he does not need to use words in order to ask for what he wants. Not one among us is incapacitated from asking. Prayers need not be fancy. I believe God abhors fancy prayers. When we pray, the simpler our prayers are, the better. The plainest, humblest language that expresses our meaning is the best.

The next word is *seek*, and surely there is no difficulty about seeking. In finding there might be, but in seeking there is none. When the woman in the parable lost her money, she lit a candle and sought for it (Luke 15:8–9). I do not suppose that she had ever been to a university, that she qualified as a lady physician, or that she could have sat on a school board as a woman of superior intellect, but she could seek. Anybody who desires to do so can seek, whether man, woman, or child. For their encouragement, the promise is not given to some particular philosophical form of seeking, but *"he that seeketh findeth."*

Then there is knocking. Well, that is a thing of no great difficulty. We used to do it when we were boys, sometimes too much for

the neighbors' comfort. And at home, if the knocker was a little too high, we had ways and means of knocking at the door even then. A stone would do it, or the heel of a boot would do it. Anything would make a knock. It was not beyond our capacity by any means. Therefore, it is put in this fashion by Christ Himself, as much as to tell us, "You do not need to have scholarship, training, talent, or wit for prayer. Ask, seek, knock—that is all. And the promise is to every one of these ways of praying."

Will you believe the promise? It is Christ who gives it. No lie ever fell from His lips. Oh, do not doubt Him. Pray on if you have prayed, and if you have never prayed before, may God help you to begin today!

HIS TESTIMONY

Our third point is that Jesus testifies to the fact that prayer is heard. Having given a promise, He then adds, in effect: "You may be quite sure that this promise will be fulfilled, not only because I say it, but because it is and always has been so." When a man says the sun will rise tomorrow morning, we believe it because it always has risen. Our Lord tells us an indisputable fact: all through the ages, true asking has been followed by receiving. Remember that He who stated this fact knew it. If you state a fact, you may say, "Yes, as far as my observation goes, it is true." But the observation of Christ was unbounded. There was never a true prayer offered unknown to Him. Prayers acceptable with the Most High come to Him by the way of the wounds of Christ. Therefore, the Lord Jesus Christ can speak by personal knowledge, and His declaration is that prayer is successful. *"Every one that asketh receiveth; and he that seeketh findeth."*

Now, here we must, of course, accept the limitations that would be made by ordinary common sense and that are made by Scripture. Not everyone who frivolously or wickedly asks or pretends to ask of God gets what he asks for. It is not every silly, idle, unconsidered request of unregenerate hearts that God will answer. By no means. Common sense limits the statement this far. Besides, Scripture limits it again. *"Ye have not, because ye ask not...*[or] *because ye ask amiss"* (James 4:2–3). There is an asking amiss that will never obtain. But those things being remembered, the statement of our Lord has no other qualification: *"Every one that asketh receiveth."*

Let it be remembered that frequently even when the ungodly and the wicked have asked of God, they have received. Often in times of distress, they have called upon God, and He has answered them. "Do you really say so?" asks one. No, I do not say so, but the Scripture says so. Ahab's prayer was answered, and the Lord said,

Seest thou how Ahab humbleth himself before me? because he humbleth himself before me, I will not bring the evil in his days: but in his son's days will I bring the evil upon his house. *(1 Kings 21:29)*

So, also, the Lord heard the prayer of Jehoahaz, the son of Jehu, who did evil in the sight of the Lord. (See 2 Kings 13:1–4.) When the Israelites were given over to their foes because of their sins, they cried to God for deliverance, and they were answered. Yet the Lord Himself testified concerning them that they only flattered with their mouths (Ps. 78:34–36).

Does this surprise you? Does He not hear the young ravens when they cry? Do you think He will not hear man, who is formed in His own image? Do you doubt it? Remember Nineveh. (See Jonah 3:1–10.) The prayers offered at Nineveh, were they spiritual prayers? Did you ever hear of a church of God in Nineveh? I have not; nor do I believe the Ninevites were ever visited by converting grace. They were, however, convinced by the preaching of Jonah that they were in danger from the great Jehovah. They proclaimed a fast and humbled themselves, God heard their prayer, and Nineveh for a while was preserved.

Many times in the hour of sickness and in the time of woe, God has heard the prayers of the unthankful and the evil. Do you think God gives nothing except to the good? Have you dwelt at the foot of Sinai and learned to judge according to the law of merit? What were you when you began to pray? Were you good and righteous? Has not God commanded you to do good to the evil? (See Matthew 5:44.) Will He command you to do what He will not do Himself? Has He not said that He *"sendeth rain on the just and on the unjust"* (Matt. 5:45), and is it not so? Is He not daily blessing those who curse Him and doing good to those who despitefully use Him? This is one of the glories of God's grace. When there is nothing else good in the man, yet if there is a cry lifted up from his heart, the Lord graciously reaches down to send relief from trouble. Now, if God has heard the prayers even of men who have not sought Him

in the highest manner and has given them temporary deliverances in answer to their cries, will He not much more hear you when you are humbling yourself in His sight and desiring to be reconciled to Him? Surely you can use this as an argument that God will answer your prayers.

But to come more fully to the point with regard to real and spiritual prayers, *"Every one that asketh receiveth"* without any limit whatsoever. There has never been an instance yet of a man really seeking spiritual blessings from God without his receiving them. The tax collector stood afar off, and so broken was his heart that he dared not look up to heaven, yet God looked down on him. (See Luke 18:13–14.) Manasseh lay in the low dungeon. He had been a cruel persecutor of the saints. Nothing in him could commend him to God. But God heard him out of the dungeon and brought him forth to liberty of soul. (See 2 Chronicles 33:1–13.) By his own sin, Jonah had brought himself into the whale's belly, and he was an irritable servant of God at best. But out of the belly of hell he cried, and God heard him. (See Jonah 1:17–2:2.) *"Every one that asketh receiveth; and he that seeketh findeth; and to him that knocketh it shall be opened."* Everyone. If I needed evidence, I should be able to find it among believers. I would ask any follower of Christ to bear witness that God heard his prayer. I do not believe that among the damned in hell there is one who would dare say, "I sought the Lord, and He rejected me."

There will not be found at the last day of account one single soul who can say, "I knocked at mercy's door, but God refused to open it." There will not stand before the Great White Throne a single soul who can plead, "O Christ, I would have been saved by You, but You would not save me. I gave myself up into Your hands, but You rejected me. I penitently asked You for mercy, but You did not give it." *"Every one that asketh receiveth."* It has been so until this day; it will be so until Christ Himself will come. If you doubt it, try it; if you have tried it, try it again.

Are you in rags? That does not matter—*"Every one that asketh receiveth."* Are you foul with sin? That means nothing—*"He that seeketh findeth."* Do you feel as if you were shut out from God altogether? That does not matter either—*"Knock, and it shall be opened unto you. For every one that asketh receiveth."*

Is there no election there? Doubtless there is, but that does not alter this truth that has no limit to it whatsoever—*"every one."* What a rich text it is! *"Every one that asketh receiveth."*

When our Lord spoke this, He could have pointed to His own life as evidence. At any rate, we can refer to it now and show that there is no one who asked of Christ who did not receive. The Syrophenician woman was at first repulsed when the Lord called her a dog, but when she had the courage to say, *"Yet the dogs eat of the crumbs which fall from their masters' table"* (Matt. 15:27), she soon discovered that *"every one that asketh receiveth."* She, also, who came behind Him in the crowd and touched the hem of His garment was no asker, but she was a seeker, and she found. (See Matthew 9:20–22.)

I think I hear, in answer to all this, the lamentable wail of one who says, "I have been crying to God a long time for salvation. I have asked, I have sought, and I have knocked, but it has not come yet." Well, dear friend, if I am asked who is true, God or you, I know whom I will stand by, and I would advise you to believe God before you believe yourself. God will hear prayer, but do you know there is one thing before prayer? What is it? Why, the Gospel is not "he who prays will be saved." That is not the Gospel. I believe he will be saved, but that is not the Gospel that I am told to preach to you. *"Go ye into all the world, and preach the gospel to every creature. He"*—what?—*"He that believeth and is baptized shall be saved"* (Mark 16:15–16).

Now, you have been asking God to save you. Do you expect Him to save you without your believing and being baptized? Surely you have not had the impudence to ask God to make void His own word! Might He not say to you, "Do as I tell you; believe My Son. He who believes on Him has everlasting life"? (See John 3:16.) Let me ask you, Do you believe Jesus Christ? Will you trust Him? "Oh, I trust Him," says one. "I trust Him wholly." Soul, do not ask for salvation anymore. You have it already; you are saved. If you trust Jesus with all your soul, your sins are forgiven, and you are saved. The next time you approach the Lord, go with praise as well as with prayer, and sing and bless His name.

"But how do I know that I am saved?" asks one. God says, *"He that believeth and is baptized shall be saved."* Have you believed? Have you been baptized? If so, you are saved. How do I know that? On the best evidence in all the world: God says you are. Do you want any evidence besides that? "I want to feel it." Feel! Are your feelings better than God's witness? Will you make God a liar by asking more signs and tokens than His sure word of testimony? I have no evidence this day that I dare trust in concerning

my salvation but this, that I rest on Christ alone with all my heart and soul and strength. Other refuge have I none. If you have that evidence, it is all the evidence that you need to seek for this day. Other witnesses of grace in your heart will come by and by and cluster around you and adorn the doctrine you profess, but now your first business is to believe in Jesus.

"I have asked for faith," says one. Well, what do you mean by that? To believe in Jesus Christ is the gift of God, but it must be your own act as well. Do you think God will believe for you or that the Holy Spirit believes instead of you? What does the Holy Spirit have to believe? You must believe for yourself or be lost. He cannot lie; will you not believe in Him? He deserves to be believed. Trust in Him, and you are saved, and your prayer is answered.

I think I hear another say, "I trust that I am already saved, but I have been looking for the salvation of others in answer to my prayers." Dear friend, you will get it. *"Every one that asketh receiveth; and he that seeketh findeth; and to him that knocketh it shall be opened."* "But I have sought the conversion of a certain person for years with many prayers." You will have it, or you will know one day why you do not have it and will be made content not to have it.

Pray on in hope. Many a one has had his prayers for others answered after he has died. There was a father who had prayed for many years for his sons and daughters, and yet they were not converted but became exceedingly worldly. His time came to die. He gathered his children around his bed, hoping to bear such a witness for Christ at the end that it might be blessed to their conversion. But, unhappily for him, he was in deep distress of soul; he had doubts about his own interest in Christ. He was one of God's children who are put to bed in the dark. This was, above all, the worst fear of his mind, that his dear children would see his distress and be prejudiced against religion. The good man was buried, his sons came to the funeral, and God heard the man's prayer that very day. For as they went away from the grave, one of them said to the other, "Brother, our father died a most unhappy death."

"He did, brother. I was very astonished at it, for I never knew a better man than our father."

"Ah," said the first brother, "if a holy man such as our father found it a hard thing to die, it will be a dreadful thing for us who have no faith when our time comes." That same thought had

struck them all and drove them to the Cross, and so the good man's prayer was heard in a mysterious way.

"Heaven and earth shall pass away" (Matt. 24:35), but while God lives, prayer must be heard. While God remains true to His word, supplication is not in vain. May the Lord give you grace to exercise it continually. Amen.

2

The Raven's Cry

He giveth to the beast his food,
and to the young ravens which cry.
—Psalm 147:9

I will open this chapter with a quotation. I must give you one commentator's note on ravens, which I have selected because it will surely give us a deeper trust in God's care for us.

Naturalists tell us that when the raven has fed his young in the nest until they are well fledged and able to fly abroad, then he thrusts them out of the nest, and will not let them abide there, but makes them get their own living. Now when these young ones are upon their first flight from their nest, and are little acquainted with means how to help themselves with food, then the Lord provides food for them.

It is said by credible authorities that the raven is marvelously strict and severe in this; for as soon as his young ones are able to provide for themselves, he will not fetch any more food for them; yes, some affirm that the old ones will not allow them to stay in the same country where they were bred; and if so, then they must wander.

We say proverbially, "Need makes the old wife trot"; we may say, "And the young ones, too." It has been, and possibly is, the practice of some parents toward their children, to, as soon as they can shift for themselves and are competent to get their own bread, turn them out of doors, as the raven does his young ones out of the nest.

Now, says the Lord in the text, when the young ones of the raven are at this pinch, that they are turned out and wander for lack of meat, who then provides for them? Do not

I, the Lord? Do not I, who provide for the old raven, provide for his young ones, both while they abide in the nest and when they wander for lack of meat?

Solomon sent the sluggard to the ant, and he himself learned lessons from badgers, greyhounds, and spiders. Let us be willing to be instructed by any of God's creatures. Let us go to the raven's nest now to learn as in a school.

Our blessed Lord once derived a very powerful argument from ravens, an argument intended to comfort and cheer those of His servants who were oppressed with needless anxieties about their temporal circumstances. To such He said,

> *Consider the ravens: for they neither sow nor reap; which neither have storehouse nor barn; and God feedeth them: how much more are ye better than the fowls?* (Luke 12:24)

Following the Master's logic, I will argue here in this manner: Consider the ravens as they cry. With harsh, inarticulate, croaking notes they make known their wants, and your heavenly Father answers their prayer and sends them food. You, too, have begun to pray and to seek His favor. Are you not much better than they? Does God care for ravens, and will He not care for you? Does He listen to the cries of the unfledged ravens in their nests when they cry to Him in their hunger and watch to be fed? Does He, I say, supply them in answer to their cries, and will He not answer you, poor, trembling children of men who are seeking His face and favor through Jesus Christ?

The whole business of this chapter will simply be to work out that one thought. Under the guidance of the Holy Spirit, I will aim to write something to those who have been praying for mercy but as yet have not received it; who have gone on their knees, perhaps for months, with one exceeding great and bitter cry but as yet know not the way of peace. Their sin still hangs like a millstone around their necks; they sit in the valley of the shadow of death; no light has dawned upon them; and they are wringing their hands and moaning, "Has God forgotten to be gracious? Has He shut His ears against the prayers of seeking souls? Will He be mindful of sinners' piteous cries no more? Will penitents' tears drop upon the earth and no longer move His compassion?"

Satan, too, is telling you, dear friends who are now in this state of mind, that God will never hear you, that He will let you cry

until you die, that you will pant out your life in sighs and tears, and that at the end you will be cast into the lake of fire.

I long to give you some comfort and encouragement. I want to urge you to cry yet more vehemently, to come to the Cross and lay hold of it and vow that you will never leave its shadow until you find the blessing that your soul covets. I want to move you, if God the Holy Spirit will help me, so that you will say within yourselves, like Queen Esther, *"I* [will] *go in unto the king...and if I perish, I perish"* (Est. 4:16). May you add to that the vow of Jacob: *"I will not let thee go, except thou bless me!"* (Gen. 32:26).

MORE VALUABLE THAN A RAVEN

Here, then, is the question at hand: Since God hears the young ravens, will He not hear you? First, I argue that He will when I remember that it is only a raven that cries and that you, in some senses, are much better than a raven. The raven is only a poor, unclean bird, whose instant death would make no grievous gap in creation. If thousands of ravens had their necks wrung tomorrow, I do not think that there would be any vehement grief and sorrow in the universe about them. There would simply be a number of poor dead birds, and that would be all.

You, however, are an immortal soul. The raven is gone when life is over; there is no raven any longer. But when your present life is past, you have not ceased to be. You are launched upon the sea of life; you have begun to live forever. You will see earth's ancient mountains crumble to nothingness before your immortal spirit will expire. The moon will have paled her feeble light, and the sun's more mighty fires will have been quenched in perpetual darkness. Yet, your spirit will still be marching on in its everlasting course—an everlasting course of misery unless God hears your cry.

> Oh, that truth immense,
> This mortal, immortality shall wear!
> The pulse of mind shall never cease to play;
> By God awakened, it forever throbs,
> Eternal as His own eternity!
> Above the angels, or below the fields:
> To mount in glory, or in shame descend—
> Mankind are destined by resistless doom.

Do you think that God will hear the poor bird that exists and then exists not, that is here a moment and then blotted out of existence, and will He not hear you, an immortal soul, whose duration is to be coequal with His own? I think it surely must strike you that if He hears the dying raven, He will also hear an undying man.

Moreover, I have never heard that ravens were made in the image of God; but I do find that as defiled, deformed, and debased as our race is, originally God said, *"Let us make man in our* [own] *image"* (Gen. 1:26). There is something about man that is not to be found in the lower creatures, the best and noblest of whom are immeasurably beneath the humblest child of Adam. There is a dignity about the fact of personhood that is not to be found in any of the beasts of the field. Behemoth and leviathan are put in subjection beneath the foot of man. The eagle cannot soar as high as man's soul mounts, nor the lion feed on such royal meat as man's spirit hungers after. Do you think that God will hear so low and so humble a creature as a raven and yet not hear you, when you are one of the race that was formed in His own image? Oh, do not think so harshly and so foolishly of Him whose ways are always just!

I will ask you this. Does not nature itself teach that man is to be cared for above the fowls of the air? If you heard the cries of young ravens, you might feel compassion enough for those birds to give them food if you knew how to feed them. But I cannot believe that any of you would help the birds and yet would not fly upon the wings of compassion to rescue a perishing infant, whose cries you might hear from the place where he was cast by cruel neglect. If, in the stillness of the night, you heard the plaintive cry of a man expiring in sickness, unpitied in the streets, would you not arise and help him? I am sure you would if you are one who would help a raven. If you have any compassion for a raven, you would have much more pity on a man. Then, do you not think that God, the all-wise One, when He cares for these unfledged birds in the nest, would be sure also to care for you? Your heart says, "Yes." Therefore, answer the unbelief of your heart by turning its own just reasoning against it.

But I hear you say, "Ah, but the raven is not sinful as I am. It may be an unclean bird, but it cannot be so unclean as I am morally. It may be black in hue, but I am black with sin. A raven cannot break the Sabbath, cannot swear, cannot commit adultery. A

raven cannot be a drunkard. It cannot defile itself with vices such as those with which I am polluted."

I know all that, friend, and it may seem to you to make your case more hopeless, but I do not think it really does. Just think of it for a minute. What does this prove? Why, that you are a creature capable of sinning and, consequently, that you are an intelligent spirit living in a sense in which a raven does not live. You are a creature moving in the spirit world; you belong to the world of souls, in which the raven has no portion. The raven cannot sin because it has no spirit, no soul; but you are an intelligent agent, of which the better part is your soul.

Oh, if you will only think of it, you must see that it is not possible for a raven's cry to gain an audience of the ear of Divine Benevolence and yet for your prayer to be despised and disregarded by the Most High.

> The insect that with puny wing,
> Just shoots along one summer's ray;
> The flow'ret, which the breath of Spring
> Wakes into life for half a day;
> The smallest mote, the tenderest hair,
> All feel our heavenly Father's care.

Surely, then, He will have respect to the cry of the humble, and He will not refuse their prayers.

I can hardly leave this point without remarking that the mention of a raven should encourage a sinner. As an old author has written,

> Among fowls He does not mention the hawk or falcon, which are highly prized and fed by princes; nor the sweetly singing nightingale, or similar musical, pretty birds, which men much delight in; but He chooses that hateful and malicious bird, the croaking raven, which no man values except when she eats up the carrion, which might annoy him.
>
> Behold, then, and wonder at the providence and kindness of God, that He should provide food for the raven, a creature of so dismal a hue and of so untunable a tone, a creature that is so odious to most men, and ominous to some.
>
> There is a great providence of God seen in providing for the ant, who gathers her meat in summer; but a greater in the raven, who, though he forgets, or is careless to provide for

himself, yet God provides and lays up for him. One would think the Lord should say of ravens, Let them shift for themselves or perish; no, the Lord God does not despise any work of His hands; the raven has his being from God, and therefore the raven will be provided for by Him; not only the fair, innocent dove, but the ugly raven has his meat from God. This clearly shows that the lack of excellence in you, you black, raven-like sinner, will not prevent your cry from being heard in heaven. Unworthiness the blood of Jesus will remove, and defilement He will utterly cleanse away. Only believe on Jesus, and you will find peace.

A BETTER CRY

Then, in the next place, there is a great deal of difference between your cry and the cry of a raven. When the young ravens cry, I suppose they scarcely know what they want. They have a natural instinct that makes them cry for food, but their cry does not in itself express their need. You would soon find out, I suppose, that they meant food, but they have no articulate speech. They do not utter even a single word. It is just a constant, croaking, craving cry, and that is all.

But you know what you want, and few as your words are, your heart knows its own bitterness (Prov. 14:10) and dire distress. Your sighs and groans have an obvious meaning; your understanding is at the right hand of your needy heart. You know that you want peace and pardon; you know that you need Jesus, His precious blood, His perfect righteousness.

Now, if God hears such a strange, chattering, indistinct cry as that of a raven, do you not think that He will also hear the rational and expressive prayer of a poor, needy, guilty soul who is crying to Him, *"God be merciful to me a sinner"* (Luke 18:13)? Surely your reason tells you that!

Moreover, the young ravens cannot use arguments, for they have no understanding. They cannot say as you can,

> He knows what arguments I'd take
> To wrestle with my God,
> I'd plead for His own mercy's sake,
> And for a Savior's blood.

They have one argument, namely, their dire necessity, which forces their cry from them, but beyond this they cannot go; and even this they cannot set forth in order or describe in language. But you have a multitude of arguments ready at hand, and you have an understanding with which to set them in array and marshal them to besiege the throne of grace. Surely, if the mere plea of the unuttered desire of the raven prevails with God, much more will you prevail with the Most High if you can argue your case before Him and come to Him with arguments in your mouth.

Come, you despairing one, and try my Lord! I do implore you now to let that doleful ditty ascend into the ears of mercy! Open that bursting heart, and let it out in tears if words are beyond your power.

I fear, however, that a raven sometimes has a great advantage over some sinners who seek God in prayer, namely in this: young ravens are more in earnest about their food than some are about their souls. This, however, should not discourage you, but rather it should make you more earnest than you have been so far. When ravens want food, they do not cease crying until they have got it. There is no quieting a hungry, young raven until his mouth is full, and there is no quieting a sinner, when he is really in earnest, until he gets his heart full of divine mercy.

I desire that some of you would pray more vehemently! *"The kingdom of heaven suffereth violence, and the violent take it by force"* (Matt. 11:12). An old Puritan said, "Prayer is a cannon set at the gate of heaven to burst open its gates." You must take the city by storm if you would have it. You will not ride to heaven on a featherbed; you must go on a pilgrimage. There is no going to the land of glory while you are sound asleep; dreamy sluggards will have to wake up in hell. If God has made you feel in your soul the need of salvation, cry like one who is awake and alive. Be in earnest; cry aloud; spare not. Then I think you will find that if He hears such a cry as the raven's, it is much more certain that He will hear yours.

A MORE NOBLE REQUEST

Remember that the matter of your prayer is more congenial to the ear of God than the raven's cry for meat. All that the young ravens cry for is food; give them a little carrion, and they are done.

31

Your cry must be much more pleasing to God's ear, for you pray for forgiveness through the blood of His dear Son. It is a nobler occupation for the Most High to bestow spiritual rather than natural gifts. The streams of grace flow from the upper springs. I know He is so gracious that He does not dishonor Himself even when He drops food into the young raven's mouth; but still, there is more dignity about the work of giving peace and pardon and reconciliation to the sons of men. Eternal love appointed a way of mercy from before the foundation of the world, and infinite wisdom is engaged with boundless power to carry out the divine design. Surely the Lord must take much pleasure in saving the sons of men.

If God is pleased to supply the beasts of the field, do you not think that He delights much more to supply His own children? I think you would find more congenial employment in teaching your own children than you would in merely foddering your oxen or scattering barley among the fowls at the barn door, because there would be in the first work something nobler, which would more fully call up all your powers and bring out your inward self. I am not left here to conjecture. It is written, *"He delighteth in mercy"* (Mic. 7:18). When God uses His power, He cannot be sad, for He is a happy God. But if there is such a thing possible as the Infinite Deity being more happy at one time than at another, it is when He is forgiving sinners through the precious blood of Jesus.

Ah, sinner, when you cry to God, you give Him an opportunity to do what He loves most to do; for He delights to forgive, to press His Ephraim to His chest, to say of His prodigal son, *"This my son was dead, and is alive again; he was lost, and is found"* (Luke 15:24). This is more comfortable to the Father's heart than feeding the fatted calf or tending the cattle of a thousand hills.

Since, dear friends, you are asking for something that will honor God far more to give than the mere gift of food to ravens, I think there comes a very forcible blow of my argumentative hammer to break your unbelief in pieces. May God the Holy Spirit, the true Comforter, work in you mightily! Surely the God who gives food to ravens will not deny peace and pardon to seeking sinners. Try Him! Try Him at this moment! No, do not run away! Try Him now.

A DIVINE WARRANT

We must not pause on any one point when the whole subject is so prolific. There is another source of comfort for you, namely, that

the ravens are nowhere commanded to cry. When they cry, their petition is unwarranted by any specific exhortation from the divine mouth, while you have a warrant derived from divine exhortations to approach the throne of God in prayer. If a rich man would open his house to those who were not invited, he would surely receive those who were invited. Ravens come without being invited, yet they are not sent away empty. You come as an invited guest; how can you be denied?

Do you think you are not invited? Listen to this: *"Whoever shall call on the name of the Lord shall be saved"* (Acts 2:21). *"Call upon me in the day of trouble: I will deliver thee, and thou shalt glorify me"* (Ps. 50:15). *"Go ye into all the world, and preach the gospel to every creature. He that believeth and is baptized shall be saved; but he that believeth not shall be damned"* (Mark 16:15–16). *"Believe on the Lord Jesus Christ, and thou shalt be saved"* (Acts 16:31). *"Repent, and be baptized every one of you in the name of Jesus Christ for the remission of sins"* (Acts 2:38).

These are exhortations given without any limitation as to character. They freely invite you; no, they implore you to come. Oh, after this can you think that God will spurn you? The window is open, the raven flies in, and the God of mercy does not chase it out. The door is open, and the promise invites you to come; do not think that He will give you a denial. Rather, believe that He will receive you graciously and love you freely, and then you will *"render* [to him] *the calves of* [your] *lips"* (Hos. 14:2). At any rate, try Him! Try Him even now!

A WORK OF GRACE

Again, there is yet another, far mightier argument. The cry of a young raven is nothing but the natural cry of a creature, but your cry, if it is sincere, is the result of a work of grace in your heart. When the raven cries to heaven, it is nothing but the raven's own self that cries. But when you cry, *"God be merciful to me a sinner"* (Luke 18:13), it is God the Holy Spirit crying in you. It is the new life that God has given you crying to the Source from where it came to have further communion and communication in sincerity and in truth.

We can, if we think it right, teach our children to "say their prayers," but we cannot teach them to pray. You may make a

prayer book, but you cannot put a grain of prayer into a book, for it is too spiritual a matter to be put on pages. Some of you, perhaps, may read prayers in the family. I will not denounce the practice, but I will say this much about it: you may read those prayers for seventy years, and yet you may never once pray, for prayer is quite a different thing from mere words.

True prayer is the trading of the heart with God, and the heart never comes into spiritual commerce with the ports of heaven until God the Holy Spirit puts wind into the sails and speeds the ship into its haven. *"Ye must be born again"* (John 3:7). If there is any real prayer in your heart, though you may not know the secret, God the Holy Spirit is there.

Now, if He hears cries that do not come from Himself, how much more will He hear those that do! Perhaps you have been puzzling yourself to know whether your cry is a natural or a spiritual one. This may seem very important, and doubtless it is; but whether your cry is either the one or the other, still continue to seek the Lord. Possibly you doubt whether natural cries are heard by God; let me assure you that they are.

I remember saying something on this subject on one occasion in a certain ultra-Calvinistic place of worship. At that time I was preaching to children, and I was exhorting them to pray. I happened to say that, long before any actual conversion, I had prayed for common mercies and that God had heard my prayers.

This did not suit my good friends of that superfine school. Afterward they all came around me professedly to know what I meant but really to quibble and nag according to their nature and habit. *"They compassed me about like bees"* (Ps. 118:12); yes, like bees they compassed me about! To say that God hears the prayers of natural men was something worse than Arminianism, if indeed anything could be worse to them. "How could it be that God could hear a natural prayer?" And while I paused for a moment, an old woman in a red cloak pushed her way into the little circle around me and said to them in a very forcible way, like *"a mother in Israel"* (Judg. 5:7), as she was, "Why do you raise this question, forgetting what God Himself has said? What is this you say, that God does not hear natural prayer? Why, does He not hear the young ravens when they cry unto Him, and do you think they offer spiritual prayers?" Immediately, the men of war took to their heels; no defeat was more thorough. For once in their lives they must have felt that they might possibly err.

Surely, friends, this may encourage and comfort you. I am not going to give you just now the task of finding out whether your prayers are natural or spiritual, whether they come from God's Spirit or whether they do not, because that might, perhaps, perplex you. If the prayer proceeds from your very heart, I know how it got there, though you may not. God hears the ravens, and I do believe He will hear you. I believe, moreover, though I do not want to raise questions in your heart, that God hears your prayer because— though you may not know it—there is a secret work of the Spirit of God going on within you that is teaching you to pray.

A MIGHTY PRAYER PARTNER

But I have mightier arguments, and nearer the mark. When the young ravens cry, they cry alone; but when you pray, you have a mightier One than you praying with you. Hear that sinner crying, *"God be merciful to me a sinner"* (Luke 18:13). Listen! Do you hear that other cry that goes up with his? No, you do not hear it because your ears are dull and heavy, but God hears it. There is another voice, far louder and sweeter than the first and far more powerful, mounting up at the same moment and pleading, "Father, forgive them through My precious blood." The echo to the sinner's whisper is as majestic as the thunder's peal. Never does a sinner truly pray without Christ praying at the same time. You cannot see or hear Him, but never does Jesus stir the depths of your soul by His Spirit without His soul being stirred, too. Oh, sinner! Your prayer, when it comes before God, is a very different thing from what it is when it issues forth from you.

Sometimes poor people come to us with requests that they wish to send to some company or important person. They bring the request and ask us to have it presented for them. It is very badly spelled, very strangely written, and we can barely make out what they mean; but still there is enough to let us know what they want. First of all, we make out a good copy for them, and then, having stated their case, we put our own name at the bottom. If we have any influence, of course they get what they desire through the power of the name signed at the foot of the petition.

This is just what the Lord Jesus Christ does with our poor prayers. He makes a good copy of them, stamps them with the seal of His own atoning blood, puts His own name at the foot, and thus they go

up to God's throne. It is your prayer, but, oh, it is His prayer, too. It is the fact of its being His prayer that makes it prevail.

Now, this is a sledgehammer argument: If the ravens prevail when they cry all alone, if just their poor chattering brings them what they want, how much more will the plaintive petitions of the poor, trembling sinner prevail. For the sinner can say, "For Jesus' sake" and can clench all his own arguments with the blessed plea, "The Lord Jesus Christ deserves it; O Lord, give it to me for His sake."

I have been writing this to seeking ones, who have been crying so long and yet are afraid that they will never be heard. I do trust that they may not have to wait much longer but may soon have a gracious answer of peace. And if they do not get the desires of their hearts just yet, I hope that they may be encouraged to persevere until the day of grace dawns. You have a promise that the ravens have not, and that might make another argument, if space permitted us to dwell upon it. Trembler, having a promise to plead, never fear, but speed to the throne of grace!

ENCOURAGEMENT FOR SINNERS

And now, let me say to the sinner, in closing, that if you have cried unsuccessfully, still cry on. *"Go again seven times"* (1 Kings 18:43), yes, and *"seventy times seven"* (Matt. 18:22). Remember that the mercy of God in Christ Jesus is your only hope; cling to it, then, as a drowning man clings to the only rope within reach. If you perish praying for mercy through the precious blood, you will be the first that ever perished that way. Cry on; just cry on. But, believe, too, for believing brings the morning star and the day dawn.

When John Ryland's wife Betty lay dying, she was in great distress of mind, though she had been a Christian for many years. Her husband said to her in his quaint but wise way, "Well, Betty, what ails you?"

"Oh, John, I am dying, and I have no hope, John!"

"But, my dear, where are you going then?"

"I am going to hell!" was the answer.

"Well," said he, covering up his deep anguish with his usual humor and meaning to strike a blow that would be sure to hit the nail on the head and put her doubts to speedy flight, "what do you

intend to do when you get there, Betty?" The good woman could give no answer, and Mr. Ryland continued, "Do you think you will pray when you get there?"

"Oh, John," she said, "I would pray anywhere; I cannot help praying!"

"Well, then," said he, "they will say, 'Here is Betty Ryland praying here; throw her out. We won't have anybody praying here; throw her out!'"

This strange way of putting it brought light to her soul. She saw at once the absurdity of the idea of a soul really seeking Christ and yet being cast away forever from His presence.

Cry on, soul; cry on! While the child can cry, he lives; and while you can besiege the throne of mercy, there is hope for you. But hear as well as cry, and believe what you hear, for it is by believing that peace is obtained.

What is it you are looking for? Some of you are expecting to see bright visions, but I hope you may never be gratified, for they are not worth a penny a thousand. All the visions in the world since the days of miracles, put together, are but mere dreams after all, and dreams are nothing but vanity. People eat too much supper and then dream; it is indigestion or a morbid activity of the brain, and that is all. If that is all the evidence you have of conversion, you will do well to doubt it. I pray you will never rest satisfied with it; it is wretched rubbish to build your eternal hopes upon.

Perhaps you are looking for very strange feelings—not quite an electric shock, but something very singular and peculiar. Believe me, you need never feel the strange emotions that you prize so highly. All those strange feelings that some people speak of in connection with conversion may or may not be of any good to them, but I am certain that they really have nothing to do with conversion so as to be at all necessary to it.

I will put a question or two to you. Do you believe yourself to be a sinner? "Yes," you say. But, supposing I put that word *sinner* away, do you mean that you believe you have broken God's law, that you are a good-for-nothing offender against God's government? Do you believe that you have in your heart, at any rate, broken all the commandments and that you deserve punishment accordingly? "Yes," you say, "I not only believe that, but I feel it; it is a burden that I carry around with me daily." Now, something more, do you believe that the Lord Jesus Christ can put all this sin

of yours away? "Yes, I do believe that." Then, can you trust Him to save you? You want saving; you cannot save yourself; can you trust Him to save you? "Yes," you say, "I already do that." Well, my dear friend, if you really trust Jesus, it is certain that you are saved, for you have the only evidence of salvation that is continual with any of us. There are other evidences that follow afterward, such as holiness and the graces of the Spirit, but the only evidence that is continual with the best of men living is this:

> Nothing in my hands I bring,
> Simply to Thy cross I cling.

Can you use Jack the huckster's verse?

> I'm a poor sinner and nothing at all,
> But Jesus Christ is my all in all.

I hope you will go a great deal further in experience on some points than this by and by, but I do not want you to advance an inch further as to the ground of your evidence and the reason for your hope. Just stop there. If now you look away from everything that is within you or without you to Jesus Christ, if now you trust His sufferings on Calvary and His whole atoning work as the ground of your acceptance before God, you are saved. You do not need anything more; you have *"passed from death unto life"* (John 5:24). *"He that believeth on him is not condemned"* (John 3:18). *"He that believeth on the Son hath everlasting life"* (v. 36).

If I were to meet an angel in the aisle of the church and he should say, "Charles Spurgeon, I have come from heaven to tell you that you are pardoned," I would say to him, "I know that I am pardoned without your telling me so; I know it on a much greater authority than yours." If he asked me how I knew it, I would reply, "The Word of God is better to me than the word of any angel, and God has said it: *'He that believeth on him is not condemned.'* I do believe on Him, and therefore I am not condemned, and I know it without an angel telling me so."

You troubled ones, do not look for angels and tokens and evidences and signs. If you rest on the finished work of Jesus, you already have the best evidence of your salvation in the world. You have God's word for it; what more is needed? Can you not accept God's word? You can accept your father's word; you can accept

38

your mother's word; why can you not accept God's word? Oh, what bad hearts we must have to distrust God Himself! Perhaps you say you would not do such a thing. Oh, but you do doubt God if you do not trust Christ, for *"he that believeth not God hath made him a liar"* (1 John 5:10). If you do not trust Christ, you do in effect say that God is a liar. You do not want to say that, do you?

Oh, believe the truthfulness of God! May the Spirit of God constrain you to believe the Father's mercy, the power of the Son's blood, the willingness of the Holy Spirit to bring sinners to Himself! Come, my dear friends, and join with me in prayer that you may be led by grace to see in Jesus all that you need.

> Prayer is a creature's strength, his very breath
> and being;
> Prayer is the golden key that can open the wicket
> of mercy;
> Prayer is the magic sound that saith to fate, so
> be it;
> Prayer is the slender nerve that moveth the
> muscles of Omnipotence.
> Wherefore, pray, O creature, for many and great
> are thy wants;
> Thy mind, thy conscience, and thy being, thy
> needs commend thee unto prayer,
> The cure of all cares, the grand panacea for all
> pains,
> Doubt's destroyer, ruin's remedy, the antidote to
> all anxieties.

3

Order and Argument in Prayer

Oh that I knew where I might find him!
that I might come even to his seat! I would
order my cause before him, and fill my
mouth with arguments.
—Job 23:3–4

I n Job's uttermost extremity he cried after the Lord. The long-
ing desire of an afflicted child of God is to see his Father's face
once more. His first prayer is not, "Oh, that I might be healed
of the disease which now festers in every part of my body!" Nor is
it even, "Oh, that I might see my children restored from the jaws of
the grave and my property once more brought from the hand of the
spoiler!" But the first and uppermost cry is, "Oh, that I knew
where to find Him who is my God! Oh, that I might come even to
His seat!" God's children run home when the storm comes on.

It is the heaven-born instinct of a gracious soul to seek shelter
from all problems beneath the wings of Jehovah. "He who has made
God his refuge" might serve as the title of a true believer. A hypo-
crite, when he feels that he has been afflicted by God, resents the
infliction and, like a slave, would run from the Master who has
scourged him. The true heir of heaven does not do so. He kisses the
hand that struck him, and he seeks shelter from the rod in the arms
of that very God who frowned upon him.

You will observe that the desire to commune with God is inten-
sified by the failure of all other sources of consolation. When Job first
saw his friends at a distance, he may have entertained a hope that

their kind counsel and compassionate tenderness would blunt the edge of his grief. However, they had not spoken long before he cried out in bitterness, *"Miserable comforters are ye all"* (Job 16:2). They put salt into his wounds, they heaped fuel upon the flame of his sorrow, and they added the gall of their reproaches to the wormwood of his griefs. In the sunshine of his smile they once had longed to sun themselves, and now they dared to cast shadows upon his reputation, most ungenerous and undeserved.

Alas for the poor man when his wine cup mocks him with vinegar and his pillow pricks him with thorns! The patriarch turned away from his sorry friends and looked up to the celestial throne, just as a traveler turns from his empty skin bottle and runs full speed to the well. He bade farewell to earthborn hopes and cried, *"Oh that I knew where I might find* [my God]!"

My friends, nothing teaches us so much the preciousness of the Creator as when we learn the emptiness of all besides. When you have been pierced through and through with the sentence, *"Cursed be the man that trusteth in man, and maketh flesh his arm"* (Jer. 17:5), then you will find unutterable sweetness in the divine assurance, *"Blessed is the man that trusteth in the LORD, and whose hope the LORD is"* (v. 7). Turning away with bitter scorn from earth's hives, where you found no honey but many sharp stings, you will rejoice in Him whose faithful word is sweeter than honey or the honeycomb (Ps. 19:10).

It is further observable that although a good man hastens to God in his trouble, although he runs with all the more speed because of the unkindness of his fellowmen, sometimes the gracious soul is left without the comfortable presence of God. This is the worst of all griefs. The text of this chapter is one of Job's deep groans, far deeper than any that came from him on account of the loss of his children and his property: *"Oh that I knew where I might find him!"* The worst of all losses is to lose the smile of God. He now had a foretaste of the bitterness of his Redeemer's cry, *"My God, my God, why hast thou forsaken me?"* (Matt. 27:46). God's presence is always with His people in one sense, as far as secretly sustaining them is concerned, but His manifest presence they do not always enjoy. You may be beloved of God and yet have no consciousness of that love in your soul. You may be as dear to His heart as Jesus Christ Himself; yet for a small moment He may forsake you, and in a little wrath He may hide Himself from you (Isa. 54:7–8).

41

But, dear friends, at such times the desire of the believing soul gathers yet greater intensity from the fact of God's light being withheld. The gracious soul addresses itself with a double zeal to find God, and it sends up its groans, its entreaties, its sobs, and its sighs to heaven more frequently and fervently. *"Oh that I knew where I might find him!"* Distance or labor are as nothing; if the soul only knew where to go, it would soon leap over the distance. That seems to me to be the state of mind in which Job pronounced the words of our text.

We cannot stop on this point, for the object of this chapter beckons us onward. It appears that Job's end in desiring the presence of God was that he might pray to Him. He had prayed, but he wanted to pray as in God's presence. He desired to plead as before one whom he knew would hear and help him. He longed to state his own case before the seat of the impartial Judge, before the very face of the all-wise God. He would appeal from the lower courts, where his friends judged unrighteous judgment, to the Court of King's Bench—the high court of heaven. "There," he says, *"I would order my cause before him, and fill my mouth with arguments."*

In this verse Job teaches us how he meant to plead and intercede with God. He does, as it were, reveal the secrets of his prayer closet and unveil the art of prayer. We are here admitted into the guild of suppliants; we are shown the art and mystery of pleading; we have here taught to us the blessed handicraft and science of prayer. If we can be bound apprentice to Job for the next chapter and can have a lesson from Job's Master, we may acquire great skill in interceding with God.

There are two things here set forth as necessary in prayer: ordering our cause and filling our mouths with arguments. We will speak of those two things, and then if we have rightly learned the lesson, a blessed result will follow.

ORDERING OUR CAUSE

First, it is necessary that our suit be ordered before God. There is a vulgar notion that prayer is a very easy thing, a kind of common business that may be done in any way, without care or effort. Some think that you just have to get a book from the shelf and get through a certain number of very excellent words and you

have prayed and may put the book back. Others suppose that to use a book is superstitious and that you ought rather to repeat extemporaneous sentences, sentences that come to your mind with a rush, like a herd of swine or a pack of hounds. They think that when you have uttered them with a little attention to what you have said, you have prayed.

Now, neither of these modes of prayer were adopted by ancient saints. They appear to have thought a great deal more seriously about prayer than many do nowadays. The ancient saints were accustomed, with Job, to ordering their cause before God. For example, a petitioner coming into court does not come there to state his case on the spur of the moment. Certainly not. He enters into the audience chamber with his suit well prepared. Moreover, he has learned how he ought to behave himself in the presence of the great one to whom he is appealing. In times of peril and distress we may fly to God just as we are, as the dove enters the cleft of the rock even though her plumes are ruffled; however, in ordinary times we should not come with an unprepared spirit, even as a child does not come to his father in the morning until he has washed his face.

See yonder priest. He has a sacrifice to offer, but he does not rush into the court of the priests and hack at the bull with the first ax he can find. He first washes his feet at the brazen basin; he puts on his garments and adorns himself with his priestly clothing. Then he comes to the altar with his victim properly divided according to the law. He is careful to do according to the command. He takes the blood in a bowl and pours it in an appropriate place at the foot of the altar, not throwing it just as it may occur to him; and he kindles the fire with the sacred fire from off the altar, not with common flame.

Now this ritual is all set aside, but the truth that it taught remains the same: our spiritual sacrifices should be offered with holy carefulness. God forbid that our prayer should be a mere leaping out of one's bed and kneeling down and saying anything that comes first to mind; on the contrary, may we wait upon the Lord with holy fear and sacred awe.

See how David prayed when God had blessed him. He went in before the Lord—understand that. He did not stand outside at a distance, but he went in before the Lord and sat down. (Sitting is not a bad posture for prayer, even if some do speak against it.) Sitting down quietly and calmly before the Lord, he then began to

43

pray, but not until he had first thought over the divine goodness and so attained to the spirit of prayer. By the assistance of the Holy Spirit, he opened his mouth. Oh, that we more often sought the Lord in this style!

Abraham may serve as an example. He rose up early—here was his willingness. He went three days' journey—here was his zeal. He left his servants at the foot of the hill—here was his privacy. He carried the wood and the fire with him—here was his preparation. Lastly, he built the altar and laid the wood in order and then took the knife—here was the devout carefulness of his worship.

David put it this way: *"In the morning will I direct my prayer unto thee, and will look up"* (Ps. 5:3). This Scripture means that he marshaled his thoughts like men of war or that he aimed his prayers like arrows. He did not take the arrow and put it on the bowstring and just shoot anywhere. After he had taken out the chosen shaft and fitted it to the string, he took deliberate aim. He looked—looked well—at the center of the target. He kept his eye fixed on it, directing his prayer, and then drew his bow with all his strength and let the arrow fly. Then, when the shaft had left his hand, what did he say? "[I] *will look up.*" He looked up to see where the arrow went, to see what effect it had, for he expected an answer to his prayers; he was not like many who scarcely think of their prayers after they have uttered them. David knew that he had an engagement before him that required all his mental powers. He marshaled his faculties and went about the work in a workmanlike manner, as one who believed in it and meant to succeed.

We should plow carefully and pray carefully. The better the work, the more attention it deserves. To be anxious in the shop and thoughtless in the prayer closet is little less than blasphemy, for it is an insinuation that anything will do for God, but the world must have our best.

If any ask what order should be observed in prayer, I am not about to give you a scheme such as many have drawn up, in which adoration, confession, petition, intercession, and ascription are arranged in succession. I am not persuaded that any such order is of divine authority. It is no mere mechanical order I have been referring to, for our prayers will be equally acceptable, and possibly equally proper, in any form. There are examples of prayers in all shapes in the Old and New Testaments.

The true spiritual order of prayer seems to me to consist of something more than mere arrangement. It is most fitting for us first to feel that we are now doing something that is real. We are about to address ourselves to God, whom we cannot see but who is really present. We can neither touch nor hear nor by our senses comprehend Him, but, nevertheless, He is as truly with us as though we were speaking to a friend of flesh and blood like ourselves. Feeling the reality of God's presence, our minds will be led by divine grace into a humble state. We will feel like Abraham when he said, *"I have taken upon me to speak unto the Lord, which am but dust and ashes"* (Gen. 18:27). Consequently, we will not deliver ourselves of our prayers as boys repeating their lessons, as a mere matter of rote. Much less will we speak as if we were rabbis instructing our pupils or, as I have heard some do, with the coarseness of a robber stopping a person on the road and demanding his money. No, we will be humble yet bold petitioners, humbly asking mercy through the Savior's blood.

When I feel that I am in the presence of God and I take my rightful position in His presence, the next thing I will want to recognize will be that I have no right to what I am seeking and cannot expect to obtain it except as a gift of grace. I must recollect that God limits the channel through which He will give me mercy: He will give it to me through His dear Son. Let me put myself then under the patronage of the Great Redeemer. Let me feel that now it is no longer I who speak but Christ who speaks with me. While I plead, I plead His wounds, His life, His death, His blood, Himself. This is truly getting into order.

The next thing is to consider what I am going to ask for. It is most proper in prayer to aim at great distinctness of supplication. It is good not to beat around the bush in prayer, but to come directly to the point. I like that prayer of Abraham's: *"O that Ishmael might live before thee!"* (Gen. 17:18). There is the name of the person prayed for and the blessing desired, all put in a few words: *"that Ishmael might live before thee."* Many people would have used a roundabout expression of this kind: "Oh, that our beloved offspring might be regarded with the favor that You so graciously bear to those who..." Say "Ishmael" if you mean Ishmael. Put it in plain words before the Lord.

Some people cannot even pray for the minister without using such indirect descriptions that one might think it were the church usher or somebody who should not be mentioned too particularly.

Why not be distinct and say what we mean as well as mean what we say? Ordering our cause would bring us to greater distinctness of mind.

In the prayer closet, it is not necessary, my dear friends, to ask for every supposable good thing. It is not necessary to rehearse the catalog of every want that you may have, have had, can have, or will have. Ask for what you need now, and, as a rule, keep to present need. Ask for your daily bread—what you want now—ask for that. Ask for it plainly, as before God, who does not regard your fine expressions. To Him your eloquence and oratory will be less than nothing and vanity. You are before the Lord; let your words be few, but let your heart be fervent.

You have not quite completed the ordering when you have asked for what you want through Jesus Christ. You should look at the blessing that you desire, to see whether it is assuredly a fitting thing to ask. Some prayers would never be offered if people would only think. A little reflection would show us that some things that we desire were better left alone. We may, moreover, have a motive at the bottom of our desires that is not Christlike, a selfish motive that forgets God's glory and caters only to our own ease and comfort. Now, although we may ask for things that are for our profit, still we must never let our profit interfere in any way with the glory of God. There must be mingled with acceptable prayer the holy salt of submission to the divine will.

I like Martin Luther's saying: "Lord, I *will* have my will of Thee at this time." "What!" you gasp. "You like such an expression as that?" I do, because of the next sentence, which was, "I will have my will, for I know that my will is Thy will." That is well spoken, Luther, but without the last words it would have been wicked presumption.

When we are sure that what we ask for is for God's glory, then, if we have power in prayer, we may say, *"I will not let thee go, except thou bless me"* (Gen. 32:26). We may come to close dealings with God, and, like Jacob with the angel, we may even put it to the wrestle and seek to give the angel the fall sooner than be sent away without the blessing. However, we must be quite clear before we come to those terms that what we are seeking is really for the Master's honor.

Put these three things together: deep spirituality, which recognizes prayer as being real conversation with the invisible God; much distinctness, which is the reality of prayer, asking for what

we want with much fervency, believing the thing to be necessary and therefore resolving to obtain it if it can be had by prayer; and above all these, complete submission, leaving it still with the Master's will. Commingle all these, and you have a clear idea of what it means to order your cause before the Lord.

Still, prayer itself is an art that only the Holy Spirit can teach us. He is the giver of all prayer. Pray for prayer. Pray until you can pray. Pray to be helped to pray, and do not give up praying because you cannot pray. It is when you think you cannot pray that you are most praying. Sometimes, when you have no sort of comfort in your supplications, it is then that your heart, all broken and cast down, is really wrestling and truly prevailing with the Most High.

FILLING THE MOUTH WITH ARGUMENTS

The second part of prayer is filling the mouth with arguments—not filling the mouth with words or good phrases or pretty expressions, but filling the mouth with arguments. The ancient saints were known to argue in prayer. When we come to the gate of mercy, forcible arguments are the knocks of the rapper by which the gate is opened.

"Why are arguments to be used at all?" one may inquire. The reply is, Certainly not because God is slow to give, not because we can change the divine purpose, not because God needs to be informed of any circumstance with regard to ourselves or of anything in connection with the mercy asked; the arguments to be used are for our own benefit, not for His. He requires us to plead with Him and to *"bring forth* [our] *strong reasons"* (Isa. 41:21) because this will show that we feel the value of the mercy. When a man searches for arguments for a thing, it is because he attaches importance to what he is seeking.

The best prayers I have ever heard in our prayer meetings have been those that have been most full of argument. Sometimes my soul has been melted down, so to speak, when I have listened to friends who have come before God feeling that the mercy is really needed and that they must have it. They first pleaded with God to give it for this reason, then for a second, then for a third, and then for a fourth and a fifth, until they awakened the fervency of the entire assembly.

My friends, there is no need for prayer at all as far as God is concerned, but what a need there is for it on our own account! If we

were not constrained to pray, I question whether we could even live as Christians. If God's mercies were to come to us unasked, they would not be half as useful as they now are, when they have to be sought for. Now we get a double blessing, a blessing in the obtaining and a blessing in the seeking.

The very act of prayer is a blessing. To pray is, as it were, to bathe in a cool, swirling stream and so to escape from the heat of earth's summer sun. To pray is to mount on eagle's wings above the clouds and get into the clear heaven where God dwells. To pray is to enter the treasure-house of God and to gather riches out of an inexhaustible storehouse. To pray is to grasp heaven in one's arms, to embrace the Deity within one's soul, and to feel one's body made a temple of the Holy Spirit.

Apart from the answer, prayer in itself is a blessing. To pray, my friends, is to cast off your burdens. It is to tear away your rags; it is to shake off your diseases; it is to be filled with spiritual vigor; it is to reach the highest point of Christian health. May God grant us to be frequently engaged in the holy art of arguing with God in prayer.

A CATALOG OF ARGUMENTS

The most interesting part of our subject remains. It is a very rapid summary and catalog of a few of the arguments that have been used with great success with God.

God's Attributes

In prayer, it is good to plead with Jehovah His attributes. Abraham did so when he laid hold upon God's justice. Sodom was to be pleaded for, and Abraham began,

> *Peradventure there be fifty righteous within the city: wilt thou also destroy and not spare the place for the fifty righteous that are therein? That be far from thee to do after this manner, to slay the righteous with the wicked: and that the righteous should be as the wicked, that be far from thee: Shall not the Judge of all the earth do right?* (Gen. 18:24–25)

Here the wrestling began. It was a powerful argument by which the patriarch grasped the Lord's left hand and arrested it just when the thunderbolt was about to fall. But there came a reply

to it. It was hinted to him that this would not spare the city. Then you notice how the good man, when sorely pressed, retreated by inches. At last, when he could no longer lay hold upon justice, he grasped God's right hand of mercy—that gave him a wondrous hold—when he asked that the city might be spared if there were only ten righteous.

So you and I may take hold at any time upon the justice, the mercy, the faithfulness, the wisdom, the long-suffering, the tenderness of God; and we will find every attribute of the Most High to be, as it were, a great battering ram with which we may open the gates of heaven.

God's Promise

Another mighty piece of weaponry in the battle of prayer is God's promise. When Jacob was on the other side of the brook Jabbok and his brother Esau was coming with armed men, he pleaded with God not to allow Esau to destroy the mother and the children. As a master reason he pleaded, *"And thou saidst, I will surely do thee good"* (Gen. 32:12). Oh, the force of that plea! He was holding God to His word: *"Thou saidst."* The attribute is a splendid horn of the altar to lay hold upon; but the promise, which has in it the attribute and something more, is an even mightier holdfast. *"Thou saidst."*

Remember how David put it. After Nathan had spoken the promise, David said at the close of his prayer, *"Do as thou hast said"* (2 Sam. 7:25). *"Do as thou hast said."* That is a legitimate argument with every honest man. *"God is not a man, that he should lie;...hath he said, and shall he not do it? or hath he spoken, and shall he not make it good?"* (Num. 23:19). *"Let God be true, but every man a liar"* (Rom. 3:4). Will He not be true? Will He not keep His word? Will not every word that comes out of His lips stand fast and be fulfilled?

Solomon, at the opening of the temple, used this same mighty plea. He pleaded with God to remember the word that He had spoken to his father David and to bless that place (1 Kings 8:25–26).

When a man gives a promissory note, his honor is engaged. He signs it with his signature, and he must discharge it when the due time comes, or else he loses credit. It will never be said that God dishonors His bills. The credit of the Most High never was impeached

49

and never will be. He is punctual to the moment; He is never before His time, but He is never behind it. You can search the Bible through and compare it with the experiences of God's people, and the two match from the first to the last. Many an aged patriarch has said with Joshua in his old age, *"There failed not ought of any good thing which the LORD had spoken...all came to pass"* (Josh. 21:45).

My friend, if you have a divine promise, you need not plead it with an "if" in it; you may plead with a certainty. If, for the mercy that you are now asking, you have God's solemnly pledged word, there will scarcely be any room for caution about submission to His will. You know His will. That will is in the promise. Plead it. Do not give Him rest until He fulfills it. He meant to fulfill it, or else He would not have given it.

The Great Name of God

A third argument to be used is that employed by Moses: the great name of God. How mightily he argued with God on one occasion upon this ground! "What will You do for Your great name? The Egyptians will say, 'Because the Lord could not bring them into the land, therefore He slew them in the wilderness.'" (See Exodus 32:12; Numbers 14:13–16.)

There are some occasions when the name of God is very closely tied up with the history of His people. Sometimes in reliance upon a divine promise, a believer will be led to take a certain course of action. Now, if the Lord should not be as good as His promise, not only is the believer deceived, but the wicked world looking on would say, "Aha! Aha! Where is your God?"

Take the case of our respected brother, Mr. Müller, of Bristol. These many years he has declared that God hears prayer, and firm in that conviction, he has gone on to build house after house for the support of orphans. Now, I can very well conceive that, if he were driven to a point of need for the care of those one or two thousand children, he might very well use the plea, "What will You do for Your great name?"

And you, in some severe trouble, when you have received the promise, may say, "Lord, You have said, 'In six troubles I will be with you, and in seven I will not forsake you.' (See Job 5:19.) I have told my friends and neighbors that I put my trust in You, and if

You do not deliver me now, where is Your name? Arise, O God, and do this thing, lest Your honor be cast into the dust."

The Sorrows of His People

We may also plead the sorrows of His people. This is frequently done. Jeremiah was the great master of this art. He said,

Her Nazarites were purer than snow, they were whiter than milk, they were more ruddy in body than rubies, their polishing was of sapphire: their visage is blacker than a coal.
(Lam. 4:7–8)

The precious sons of Zion, comparable to fine gold, how are they esteemed as earthen pitchers, the work of the hands of the potter! *(Lam. 4:2)*

He talks of all their griefs and distresses in the siege. He calls upon the Lord to look upon His suffering Zion, and before long his plaintive cries are heard.

Nothing is so eloquent with a father as his child's cry. Yes, there is one thing more mighty still, and that is a moan—when the child is so sick that he is past crying and lies moaning with the kind of moan that indicates extreme suffering and intense weakness. Who can resist that moan? Ah, and when God's Israel is brought very low so that they can scarcely cry but only their moans are heard, then comes the Lord's time of deliverance, and He is sure to show that He loves His people.

Dear friends, whenever you also are brought into the same condition, you may plead your moanings; and when you see a church brought very low, you may use her griefs as an argument as to why God should return and save the remnant of His people.

The Past

Friends, it is good to plead the past with God. Ah, you experienced people of God, you know how to do this. Here is David's example of it: *"Thou hast been my help; leave me not, neither forsake me"* (Ps. 27:9). He pleaded God's mercy to him from his youth up. He spoke of being cast upon his God from his very birth, and then he pleaded, *"Now also when I am old and greyheaded, O God, forsake*

me not" (Ps. 71:18). Moses also, speaking with God, said, "You brought this people up out of Egypt." (See Numbers 14:13.) As if he would say, "Do not leave Your work unfinished. You have begun to build; complete it. You have fought the first battle; Lord, end the campaign! Go on until You get a complete victory."

How often have we cried in our trouble, "Lord, You delivered me in such and such a sharp trial, when it seemed as if no help were near; You have never forsaken me yet. I have set up my *"Ebenezer"* (1 Sam. 7:12) in Your name. If You had intended to leave me, why have You showed me such things? Have You brought Your servant to this place to put him to shame?"

Friends, we deal with an unchanging God, who will do in the future what He has done in the past because He never turns from His purpose and cannot be thwarted in His design. The past thus becomes a very mighty means of winning blessings from Him.

The Only True God

There was once an occasion when the very existence and true deity of Jehovah became a triumphant plea for the prophet Elijah. On that august occasion, when he had bidden his adversaries to see whether their god could answer them by fire, you can little guess the excitement there must have been that day in the prophet's mind. With what stern sarcasm did he say, *"Cry aloud: for he is a god; either he is talking, or he is pursuing, or he is in a journey, or peradventure he sleepeth, and must be awakened"* (1 Kings 18:27). And as they cut themselves with knives and leaped upon the altar, oh, the scorn with which that man of God must have looked down upon their impotent exertions and their earnest but useless cries!

But think of how his heart might have palpitated if it had not been for the strength of his faith, when he repaired the altar of God that was broken down, laid the wood in order, and killed the bull. Hear him cry, "Pour water on it. You will not suspect me of concealing fire. Pour water on the victim." When they had done so, he told them, "Do it a second time," and they did it a second time. Then he said, "Do it a third time." And when it was all covered with water, soaked and saturated through, then he stood up and cried to God, *"Let it be known this day that thou art God in Israel"* (v. 36).

Here everything was put to the test. Jehovah's own existence was now put, as it were, at stake before the eyes of men by this bold prophet. But how well the prophet was heard! Down came the fire and devoured not only the sacrifice, but the wood, the stones, and even the very water that was in the trenches, for Jehovah God had answered his servant's prayer.

We sometimes may do the same and say to Him, "Oh, by Your deity, by Your existence, if indeed You are God, now show Yourself for the help of Your people!"

The Sufferings of Jesus

Lastly, the grand Christian argument is the sufferings, the death, the merit, the intercession of Christ Jesus. Friends, I am afraid we do not understand what we have at our command when we are allowed to plead with God for Christ's sake. I met with this thought the other day; it was somewhat new to me, but I believe it should not have been. When we ask God to hear us, pleading Christ's name, we usually mean, "O Lord, Your dear Son deserves this of You; do this for me because of what He merits." But if we knew it, we might go further. Suppose you should say to me, you who keep a warehouse in the city, "Sir, call at my office, and use my name, and say that they are to give you such a thing." I would go in and use your name, and I would obtain my request as a matter of right and a matter of necessity.

This is virtually what Jesus Christ says to us. "If you need anything from God, all that the Father has belongs to Me; go and use My name." Suppose that you give a man your checkbook signed with your own name and left blank, to be filled in as he chooses. That would be very close to what Jesus has done in these words: *"If ye shall ask any thing in my name, I will do it"* (John 14:14). If I had a good name at the bottom of the check, I would be sure that it would be cashed when I went to the bank with it. So when you have got Christ's name—to whom the very justice of God has become a debtor and whose merits have claims with the Most High—when you have Christ's name, there is no need to speak with fear and trembling and bated breath. Oh, waver not, and let not faith stagger! When you plead the name of Christ, you plead that which shakes the gates of hell and that which the hosts of heaven obey, and God Himself feels the sacred power of that divine plea.

Friends, you would do better if you sometimes thought more in your prayers of Christ's griefs and groans. Bring before the Lord His wounds; tell the Lord of His cries; make the groans of Jesus cry again from Gethsemane; and make His blood speak again from that frozen Calvary. Speak out and tell the Lord that with such griefs and cries and groans to plead, you cannot take a denial. Such arguments as these will aid you.

A MOUTH FILLED WITH PRAISES

If the Holy Spirit will teach us how to order our cause and how to fill our mouths with arguments, the result will be that we will have our mouths filled with praises. The man who has his mouth full of arguments in prayer will soon have his mouth full of benedictions in answer to prayer.

Dear friend, do you have your mouth full right now? What of? Full of complaining? Pray to the Lord to rinse that black stuff out of your mouth, for it will little help you, and it will be bitter in your bowels one of these days.

Oh, have your mouth full of prayer, full of it, full of arguments, so that there is room for nothing else. Then come with this blessed mouthful, and you will soon go away with whatever you have asked of God. Only *"delight thyself also in the LORD; and he shall give thee the desires of thine heart"* (Ps. 37:4).

It is said—I do not know how true it is—that the explanation of the text, *"Open thy mouth wide, and I will fill it"* (Ps. 81:10), may be found in an Oriental custom. It is said that several years ago the King of Persia ordered the chief of his nobility, who had done something or other that had greatly gratified him, to open his mouth. When he had done so, he began to put into his mouth pearls, diamonds, rubies, and emeralds, until he had filled it with as much as it could hold, and then he bade him go his way. This is said to have been occasionally done in Oriental courts toward great favorites.

Now, certainly whether that is an explanation of the text or not, it is an illustration of it. God says, "Open your mouth with arguments," and then He will fill it with priceless mercies, gems unspeakably valuable. Would a man not open his mouth wide when he could have it filled in such a way? Surely the most simpleminded among you would be wise enough for that. Oh, let us then open

wide our mouths when we plead with God. Since our needs are great, let our askings be great, and the supply will be great, too. *"Ye are not straitened in* [Him], *but ye are straitened in your own bowels"* (2 Cor. 6:12). May the Lord give you large-mouthedness in prayer and great power, not in the use of language, but in employing arguments.

What I have been speaking to the Christian is applicable in great measure to the unconverted man. May God grant you to see the force of it and to fly in humble prayer to the Lord Jesus Christ and to find eternal life in Him.

4

Pleading

But I am poor and needy: make haste unto me,
O God: thou art my help and my deliverer;
O LORD, make no tarrying.
—Psalm 70:5

Young painters were eager in the olden times to study under the great masters. They concluded that they would more easily attain excellence if they entered the schools of eminent men. Men paid large premiums so that their sons could be apprenticed to those who best understood their trades or professions.

Now, if any of us would learn the sacred art and mystery of prayer, it is good for us to study the productions of the greatest masters of that science. I am unable to point out one who understood it better than the psalmist David. So well did he know how to praise that his psalms have become the language of good men in all ages. So well did he understand how to pray that if we catch his spirit and follow his mode of prayer, we will have learned to plead with God after the most powerful sort. Place before you, first of all, David's Son and David's Lord, that most mighty of all intercessors, and, next to Him, you will find David to be one of the most admirable models for your imitation.

We will consider our text, then, as one of the productions of a great master in spiritual matters. We will study it, praying all the while that God will help us to pray in the same fashion.

In our text we find four aspects of the soul of a successful pleader. First, we view the soul confessing, for he said, *"I am poor and needy."* Next, you have the soul pleading, for he made a plea

out of his poor condition and added, *"Make haste unto me, O God!"* Third, you see a soul in its urgency, for he cried, *"Make haste,"* and he varied the expression but kept the same idea: *"Make no tarrying."* And you have, in the fourth and last view, a soul grasping God, for the psalmist put it this way: *"Thou art my help and my deliverer."* With both hands he laid hold upon His God, so as not to let Him go until a blessing was obtained.

A SOUL CONFESSING

To begin with, then, we see in this model of supplication a soul confessing. The wrestler strips of all but the most minimal clothing before he enters the contest, and confession does the same for the man who is about to plead with God. A racer on the plains of prayer cannot hope to win unless, by confession, repentance, and faith, he lays aside every weight of sin. (See Hebrews 12:1.)

Now, let it ever be remembered that confession is absolutely necessary to the sinner when he first seeks a Savior. It is not possible for you, seeker, to obtain peace for your troubled heart until you have acknowledged your transgression and your iniquity before the Lord. You may do what you will, yes, even attempt to believe in Jesus, but you will find that the faith of God's elect is not in you unless you are willing to make a full confession of your transgression and lay bare your heart before God.

Usually, we do not give charity to those who do not acknowledge that they need it: the physician does not send his medicine to those who are not sick. The blind man in the Gospels had to feel his blindness and to sit by the wayside begging; if he had entertained a doubt as to whether he were blind or not, the Lord would have passed him by. He opens the eyes of those who confess their blindness, but of others He says, "[Because] *ye say, We see; therefore your sin remaineth"* (John 9:41). He asks of those who are brought to Him, *"What wilt thou that I should do unto thee?"* (Mark 10:51) in order that their need may be publicly avowed. It must be so with all of us; we must offer the confession, or we cannot gain the blessing.

Let me speak especially to you who desire to find peace with God and salvation through the precious blood: you will do well to make your confession before God very frank, very sincere, very explicit. Surely you have nothing to hide, for there is nothing that

you can hide. He knows your guilt already, but He would have you know it; therefore, He tells you to confess it. Go into the details of your sin in your secret acknowledgments before God. Strip yourself of all excuses. Say,

> *Against thee, thee only, have I sinned, and done this evil in thy sight: that thou mightest be justified when thou speakest, and be clear when thou judgest.* (Ps. 51:4)

Acknowledge the evil of sin; ask God to make you feel it. Do not treat it as a trifle, for it is not. To redeem the sinner from the effects of sin, Christ Himself had to die; and unless you are delivered from sin, you must die eternally. Therefore, do not play with sin. Do not confess it as though it were some venial fault that would not have been noticed unless God had been too severe; but labor to see sin as God sees it, as an offense against all that is good, a rebellion against all that is kind. See it to be treason, to be ingratitude, to be a low and base thing.

Never expect that the King of heaven will pardon a traitor if he will not confess and forsake his treason. Even the tenderest father expects the child to humble himself when he has offended, and he will not withdraw his frown from him until with tears the child has said, "Father, I have sinned."

Do you dare expect God to humble Himself to you, and would it not be so if He did not constrain you to humble yourself to Him? Would you have Him ignore your faults and wink at your transgressions? He will have mercy, but He must be holy. He is ready to forgive but not to tolerate sin. Therefore, He cannot let you be forgiven if you hug your sins or if you presume to say, "I have not sinned." Hasten, then, seeker; hasten, I pray you, to the mercy seat with this upon your lips: "'I am poor and needy,' I am sinful, and I am lost; have pity on me." With such an acknowledgment, you begin your prayer well, and through Jesus you will prosper in it.

Beloved friends, the same principle applies to the church of God. If you are praying for a display of the Holy Spirit's power in your church, in order to have successful pleading in this matter, it is necessary that you unanimously make the confession of our text, *"I am poor and needy."* We must admit that we are powerless in this business. Salvation is of the Lord, and we cannot save a single soul. The Spirit of God is treasured up in Christ, and we must seek the Spirit of the great Head of the church. We cannot command the

Spirit, and yet we can do nothing without Him. He *"bloweth where [He] listeth"* (John 3:8). We must deeply feel and honestly acknowledge this. Before God blesses His church, He will make it know that the blessing is altogether from Himself. *"Not by might, nor by power, but by my spirit, saith the LORD of hosts"* (Zech. 4:6).

The career of Gideon was a very remarkable one, and it commenced with two most instructive signs. (See Judges 6:36–40.) I think our heavenly Father would have all of us learn the very same lesson that He taught to Gideon, and when we have mastered that lesson, He will use us for His own purposes. You remember Gideon laid a fleece on the barn floor; and in the morning all around was dry, and the fleece alone was wet. God alone had saturated the fleece so that he could wring it out; and its moisture was not due to its being placed in a favorable situation, for all around was dry.

He would have us learn that if the dew of His grace fills any one of us with its heavenly moisture, it is not because we lie on the barn floor of a ministry that God usually blesses or because we are in a church that the Lord graciously visits. Rather, the visitations of His Spirit are fruits of the Lord's sovereign grace and gifts of His infinite love, not of the will of man nor by man.

But then the miracle was reversed, for, as old Thomas Fuller said, "God's miracles will bear to be turned inside out and will look as glorious one way as another." The next night the fleece was dry and all around was wet, for skeptics might have said, "Yes, but a fleece would naturally attract moisture, and if there were any in the air, it would likely be absorbed by the wool." But, lo, on this occasion, the dew is not where it might be expected to be, even though it lies thickly all around. Damp is the stone, and dry is the fleece.

So God will have us know that He does not give us His grace because of any natural adaptation in us to receive it. Even where He has given a preparedness of heart to receive, He will have us understand that His grace and His Spirit are free in action and sovereign in operation; He is not bound to work after any rule of our making. If the fleece is wet, He makes it wet, and not because it is a fleece, but because He chooses to do so. He will have all the glory of all His grace from first to last.

Come then, my friends, and become disciples of this truth. Consider that from the great Father of lights every good and perfect gift must come (James 1:17). *"We are his workmanship"* (Eph. 2:10); He must work all our works in us. Grace is not to be commanded by our position or condition: *"the wind bloweth where it listeth"* (John 3:8).

The Lord works, and no man can hinder. But if He works not, the mightiest and the most zealous will labor in vain (Ps. 127:1).

It is very significant that before Christ fed the thousands, He made the disciples assess all their provisions. It was good to let them see how low the food supply had become, for then when the crowds were fed, they could not say that the basket fed them or that the lad had done it. God will make us feel that our barley loaves are very little and our fishes are very small, and He will compel us to ask, *"What are they among so many?"* (John 6:9).

When the Savior told His disciples to cast the net on the right side of the ship and they dragged such a mighty catch to land, He did not work the miracle until they had confessed that they had toiled all night and had caught nothing. They were thus taught that the success of their fishery was dependent on the Lord and that it was neither their nets nor the way of dragging them nor their skill and art in handling their vessels, but that altogether and entirely their success came from their Lord. We must get down to this, and the sooner we come to it the better.

Immediately preceding the ancient Jews' keeping of the yearly Passover, observe what they did. The unleavened bread was to be brought in, and the paschal lamb to be eaten; but there was to be no unleavened bread and no paschal lamb until they had purged out the old leaven. If you have any old strength and self-confidence, if you have anything that is your own and is, therefore, leavened, it must be swept right out. There must be a bare cupboard before there can come in the heavenly provision upon which the spiritual passover can be kept.

I thank God when He cleans us out. I bless His name when He brings us to feel our soul poverty as a church, for then the blessing will be sure to come.

One other illustration will show this, perhaps, more distinctly still. Behold Elijah with the priests of Baal at Carmel. The test appointed to decide Israel's choice was this: *"The God that answereth by fire, let him be God"* (1 Kings 18:24). Baal's priests invoked the heavenly flame in vain. Elijah was confident that it would come upon his sacrifice, but he was sternly resolved that the false priests and the fickle people would not imagine that he himself had produced the fire. He determined to make it clear that there was no human contrivance, trickery, or maneuver about the matter. The flame should be seen to be of the Lord, and of the Lord alone. Remember the stern prophet's commands:

*Fill four barrels with water, and pour it on the burnt sacrifice,
and on the wood. And he said, Do it the second time. And they
did it the second time. And he said, Do it the third time. And
they did it the third time. And the water ran round about the
altar; and he filled the trench also with water.*

(1 Kings 18:33–35)

There could be no latent fires there. If there had been any
combustibles or chemicals calculated to produce fire after the man-
ner of the cheats of the time, they would all have been dampened and
spoiled.

When no one could imagine that man could burn the sacrifice,
the prophet lifted up his eyes to heaven and began to plead, and
down came the fire of the Lord. It consumed the burnt sacrifice and
the wood, as well as the altar stones and the dust, and even licked up
the water that was in the trench. Then when all the people saw it,
they fell on their faces, and they said, "Jehovah is the God; Jehovah
is the God."

The Lord, if He means to bless us greatly, may send us the trial
of pouring on the water once, twice, and three times. He may dis-
courage us, grieve us, try us, and bring us low, until all will see that
it is not of the preacher, it is not of the organization, it is not of man,
but altogether of God, the Alpha and the Omega, *"who worketh all
things after the counsel of his own will"* (Eph. 1:11).

Thus I have shown you that for a successful season of prayer,
the best beginning is a confession that we are poor and needy.

A SOUL PLEADING

Second, after the soul has unburdened itself of all weights of merit
and self-sufficiency, it proceeds to prayer, and we have before us a
soul pleading. *"I am poor and needy: make haste unto me, O God:
thou art my help and my deliverer; O LORD, make no tarrying."* The
careful reader will perceive four pleas in this single verse.

Upon this topic I would remark that it is the habit of faith,
when it is praying, to use pleas. Mere prayer sayers, who do not
pray at all, forget to argue with God; however, those who would
prevail bring forth their reasons and their strong arguments, and
they debate the question with the Lord. Those who play at wres-
tling catch here and there at random, but those who are really
wrestling have a certain way of grasping the opponent—a certain

mode of throwing and the like. They work according to order and rule. Faith's art of wrestling is to plead with God and say with boldness, "Let it be thus and thus, for these reasons."

Hosea tells us of Jacob at Jabbok that *"there he spake with us"* (Hos. 12:4); from this I understand that Jacob instructed us by his example. Now, the two pleas that Jacob used were God's precept and God's promise. First, he said, "[Thou] *saidst unto me, Return unto thy country, and to thy kindred"* (Gen. 32:9). He as much as put it this way: "Lord, I am in difficulty, but I have come here through obedience to You. You told me to do this. Now, since You commanded me to come here into the very teeth of my brother Esau, who comes to meet me like a lion, Lord, You cannot be so unfaithful as to bring me into danger and then leave me in it." This was sound reasoning, and it prevailed with God.

Then Jacob also urged a promise: *"Thou saidst, I will surely do thee good"* (v. 12). Among men, it is a masterly way of reasoning when you can challenge your opponent with his own words. You may quote other authorities, and he may say, "I deny their force"; but when you quote a man against himself, you foil him completely. When you bring a man's promise to his mind, he must either confess himself to be unfaithful and changeable, or, if he holds to being the same and being true to his word, you have him, and you have won your will of him.

Oh, friends, let us learn to plead the precepts, the promises, and whatever else may serve our case; but let us always have something to plead. Do not think that you have prayed unless you have pleaded, for pleading is the very marrow of prayer. He who pleads well knows the secret of prevailing with God, especially if he pleads the blood of Jesus, for that unlocks the treasury of heaven. Many keys fit many locks, but the master key is the blood and the name of Him who died but rose again and ever lives in heaven to save to the uttermost.

Faith's pleas are plentiful, and this is well, for faith is placed in various positions and needs them all. Faith will boldly plead all God's gracious relationships. It will say to Him, "Are You not the Creator? Will You forsake the work of Your own hands? Are You not the Redeemer? You have redeemed Your servant; will You cast him away?" Faith usually delights to lay hold upon the fatherhood of God. This is generally one of its master points; when it brings this into the field, it wins the day. "You are a Father, and would You chasten us as though You would kill us? A Father, and will

You not provide? A Father, and have You no sympathy and no heart of compassion? A Father, and can You deny what Your own child asks of You?" Whenever I am impressed with the divine majesty and so, perhaps, a little dispirited in prayer, I find that the short and sweet remedy is to remember that although He is a great King and infinitely glorious, I am His child; and no matter who the father is, the child may always be bold with his father. Yes, faith can plead any and all of the relationships in which God stands to His chosen.

Faith, too, can ply heaven with the divine promises. Suppose you went to a bank and saw a man go in and lay a piece of paper on the table and pick it up again and nothing more. If he did that several times a day, I think there would soon be orders issued to the guard to keep the man out because he was merely wasting the clerk's time and doing nothing purposeful. Those who come to the bank in earnest present their checks, wait until they receive their money, and then leave, but not without having transacted real business. They do not put the paper down, speak about the excellent signature, and discuss the correctness of the document; they want their money for it, and they are not content without it. These are the people who are always welcome at the bank and not the triflers.

Alas, a great many people play at praying; it is nothing better. I say they play at praying; they do not expect God to give them an answer, and thus they are mere triflers who mock the Lord. He who prays in a businesslike way, meaning what he says, honors the Lord. The Lord does not play at promising; Jesus did not sport at confirming the Word by His blood; and we must not make a jest of prayer by going about it in a listless, unexpecting spirit.

The Holy Spirit is in earnest, and we must also be in earnest. We must go for a blessing and not be satisfied until we have it, like the hunter who is not satisfied because he has run so many miles but is never content until he takes his prey.

Faith, moreover, pleads the performances of God; it looks back on the past and says, "Lord, You delivered me on such and such an occasion; will You fail me now?" It, moreover, takes its life as a whole and pleads this way:

> After so much mercy past,
> Wilt Thou let me sink at last?

"Have you brought me this far so that I may be put to shame at the end?" Faith knows how to bring out the ancient mercies of God, and it makes them arguments for present favors. But your time would all be gone if I tried to exhibit even a thousandth part of faith's pleas.

Sometimes, however, faith's pleas are very singular, as in this text. It is by no means according to the proud rule of human nature to plead, *"I am poor and needy: make haste unto me, O God."* It is like another prayer of David: *"Pardon mine iniquity; for it is great"* (Ps. 25:11). It is not the manner of men to plead this way; they say, "Lord, have mercy on me, for I am not so bad a sinner as some." But faith reads things in a truer light and bases its pleas on truth. "Lord, because my sin is great and You are a great God, let Your great mercy be magnified in me."

You know the story of the Syrophenician woman; that is a grand instance of the ingenuity of faith's reasoning. (See Matthew 15:22–28.) She came to Christ about her daughter, and He answered her not a word. What do you think her heart said? Why, she said in herself, "It is well, for He has not denied me. Since He has not spoken at all, He has not refused me." With this for an encouragement, she began to plead again. Soon Christ spoke to her sharply, and then her brave heart said, "I have gained words from Him at last; I will have deeds from Him by and by." That also cheered her. Then, when He called her a dog, "Ah," she reasoned, "but a dog is a part of the family; it has some connection with the master of the house. Though it does not eat meat from the table, it gets the crumbs under it, and so I have You now, great Master, dog as I am. The great mercy that I ask of You, great as it is to me, is only a crumb to You. Grant it then, I implore You." Could she fail to have her request? Impossible! When faith has a will, it always finds a way, and it will win the day when all things forebode defeat.

Faith's pleas are singular, but, let me add, faith's pleas are always sound. After all, it is a very telling plea to urge that we are poor and needy. Is that not the main argument with mercy? Necessity is the very best plea with benevolence, either human or divine. Is not our need the best reason we can urge? If we would have a physician come quickly to a sick man, "Sir," we say, "it is no common case; he is on the point of death. Come to him; come quickly!" If we wanted our firemen to rush to a fire, we would not say to them, "Make haste, for it is only a small fire." On the contrary, we

would urge that it is an old house, full of combustible materials, and there are rumors of petroleum and gunpowder on the premises. Besides, it is near a timber yard, hosts of wooden cottages are close by, and before long we will have half the city in a blaze. We put the case in as bad a light as we can. Oh, for wisdom to be equally wise in pleading with God, to find arguments everywhere but especially to find them in our necessities!

It was said two centuries ago that the trade of beggary was the easiest one to carry on but that it paid the worst. I am not sure about the latter at this time, but certainly the trade of begging with God is a hard one, and undoubtedly it pays the best of anything in the world. It is very noteworthy that beggars with men usually have plenty of pleas on hand. When a man is driven hard and starving, he can usually find a reason why he should ask aid of every likely person. Suppose it is a person to whom he is already under many obligations; then the poor creature reasons, "I may safely ask of him again, for he knows me and has always been very kind." If he never asked of the person before, then he says, "I have never worried him before; he cannot say he has already done all he can for me. I will be bold to begin with him." If it is one of his own kin, then he says, "Surely you will help me in my distress, for you are a relative." And if it is a stranger, he says, "I have often found strangers kinder than my own blood; help me, I entreat you." If he asks of the rich, he pleads that they will never miss what they give. If he begs of the poor, he urges that they know what want means, and he is sure they will sympathize with him in his great distress.

Oh, that we were half as much on the alert to fill our mouths with arguments when we are before the Lord! How is it that we are not half awake and do not seem to have any spiritual senses aroused? May God grant that we may learn the art of pleading with the eternal God, for by that we will prevail with Him through the merit of Jesus Christ.

AN URGENT SOUL

I must be brief on the next point, which is having an urgency in our souls: *"Make haste unto me, O God....O LORD, make no tarrying."* We may well be urgent with God if we are not yet saved, for our need is urgent. We are in constant peril, and the peril is of the

most tremendous kind. O sinner, within an hour, within a minute, you may be where hope can never visit you; therefore, cry, "Make haste, O God, to deliver me; make haste to help me, O Lord!" Yours is not a case that can bear lingering; you do not have time to procrastinate. Therefore, be urgent, for your need is so.

Remember, if you really are under a sense of need and the Spirit of God is at work within you, you will and must be urgent. An ordinary sinner may be content to wait, but a quickened sinner wants mercy now. A dead sinner will lie quiet, but a living sinner cannot rest until pardon is sealed home to his soul. If you are urgent, I am glad of it, because your urgency, I trust, arises from the possession of spiritual life. When you can live no longer without a Savior, the Savior will come to you, and you will rejoice in Him.

Believer, the same truth holds true with you. God will come to bless you, and come speedily, when your sense of need becomes deep and urgent. Oh, how great is the church's need! We will grow cold, unholy, and worldly; there will be no conversions; there will be no additions to our numbers; there will be subtractions; there will be divisions; there will be mischief of all kinds; Satan will rejoice; and Christ will be dishonored, unless we obtain a larger measure of the Holy Spirit. Our need is urgent, and when we feel that need thoroughly, then we will get the blessing that we lack.

For my part, brothers and sisters, I desire to feel a spirit of urgency within my soul as I plead with God for the dew of His grace to descend upon the church. I am not bashful in this matter, for I have a license to pray. Begging is forbidden in the streets, but before the Lord I am a licensed beggar. The Bible says, *"Men ought always to pray, and not to faint"* (Luke 18:1). You land on the shores of a foreign country with the greatest confidence when you carry a passport with you, and God has issued passports to His children by which they come boldly to His mercy seat. He has invited you, He has encouraged you, He has bidden you to come to Him, and He has promised that *"whatsoever ye shall ask in prayer, believing, ye shall receive"* (Matt. 21:22). Come, then; come urgently; come persistently; come with this plea: *"I am poor and needy....O LORD, make no tarrying."* Then a blessing will surely come; it will not tarry. May God grant that we may see it and give Him the glory of it.

THE SOUL GRASPING GOD

I am sorry to have been so brief where I needed to enlarge, but I must close with the fourth point. Here is another part of the art and mystery of prayer—the soul grasping God. It has pleaded, and it has been urgent, but now it comes to close quarters. It grasps the covenant angel with one hand, *"Thou art my help,"* and with the other, *"Thou art...my deliverer."* Oh, those blessed *my*'s, those potent *my*'s. The sweetness of the Bible lies in the possessive pronouns, and he who is taught to use them as the psalmist did will be a conqueror with the eternal God.

Now, sinner, I pray that you may be helped to say to the blessed Christ of God, *"Thou art my help and my deliverer."* Perhaps you mourn that you cannot get that far, but, poor soul, have you any other help? If you have, then you cannot hold two helpers with the same hand. "Oh, no," you say, "I have no help anywhere. I have no hope except in Christ." Well, then, poor soul, since your hand is empty, that empty hand was made on purpose to grasp your Lord with. Lay hold of Him! Say to Him this day, "Lord, I will hold onto You as poor, lame Jacob did. Now I cannot help myself; I will cleave to You. *'I will not let thee go, except thou bless me'* (Gen. 32:26)."

"Ah, it would be too bold," says one. But the Lord loves holy boldness in poor sinners; He would have you be bolder than you think of being. It is an unhallowed bashfulness that dares not trust a crucified Savior. He died on purpose to save such as you are; let Him have His way with you, and do trust Him.

"Oh," says one, "but I am so unworthy." He came to seek and save the unworthy. He is not the Savior of the self-righteous; he is the sinners' Savior. *"Friend of...sinners"* (Matt. 11:19) is His name. Unworthy one, lay hold of Him!

"Oh," says one, "but I have no right." Well, since you have no right, your need will be your claim; it is all the claim you need.

I think I hear someone say, "It is too late for me to plead for grace." It cannot be; it is impossible. While you live and desire mercy, it is not too late to seek it. Notice the parable of the man who wanted three loaves. (See Luke 11:5–8.) I will tell you what crossed my mind when I read it. The man went to his friend at midnight. It could not have been later. If it had been a little later than midnight, it would have been early the next morning, and so

not late at all. It was midnight, and it could not have been later. So, if it is downright midnight with your soul, yet, be of good cheer. Jesus is an out-of-season Savior. Many of His servants are *"born out of due time"* (1 Cor. 15:8).

Any season is the right season to call upon the name of Jesus; therefore, do not let the Devil tempt you with the thought that it can be too late. Go to Jesus now—go at once—and lay hold of the horns of the altar by a venturesome faith. Say, "Sacrifice for sinners, You are a sacrifice for me. Intercessor for the graceless, You are an intercessor for me. You who distributes gifts to the rebellious, distribute gifts to me, for a rebel I have been. *'When we were yet without strength, in due time Christ died for the ungodly'* (Rom. 5:6). Such am I, Master; let the power of Your death be seen in me to save my soul."

Oh, you who are saved and therefore love Christ, I want you, dear friends, as the saints of God, to practice this last part of my subject and be sure to lay hold upon God in prayer. *"Thou art my help and my deliverer."* As a church we throw ourselves upon the strength of God, and we can do nothing without Him. But we do not mean to be without Him; we will hold Him fast. *"Thou art my help and my deliverer."*

There was a boy in Athens, according to the old story, who used to boast that he ruled all of Athens. When they asked him how, he said, "Why, I rule my mother, my mother rules my father, and my father rules the city."

He who knows how to be master of prayer will rule the heart of Christ, and Christ can and will do all things for His people, for the Father has *"given all things into his hands"* (John 13:3). You can be omnipotent if you know how to pray, omnipotent in all things that glorify God. What does the Word itself say? *"Let him take hold of my strength"* (Isa. 27:5). Prayer moves the arm that moves the world. Oh, for grace to grasp almighty love in this fashion.

We want more holdfast prayer, more tugging and gripping and wrestling that says, *"I will not let thee go"* (Gen. 32:26). That picture of Jacob at Jabbok will suffice for us to close with. The covenant angel is there, and Jacob wants a blessing from him. He seems to put him off, but no put-offs will do for Jacob. Then the angel endeavors to escape from him, and he tugs and strives; this he may do, but no efforts will make Jacob relax his grasp. At last, the angel falls from ordinary wrestling to wounding him in the very

seat of his strength. Jacob will let his thigh go, and all his limbs go, but he will not let the angel go. The poor man's strength shrivels under the withering touch, but in his weakness he is still strong. He throws his arms around the mysterious man, and he holds him as in a death grip.

Then the other says, *"Let me go, for the day breaketh"* (Gen. 32:26). Note, he did not shake him off; he only said, *"Let me go."* The angel will do nothing to force him to relax his hold; he leaves that to his voluntary will.

The valiant Jacob cries, "No, I am set on it. I am resolved to win an answer to my prayer. *'I will not let thee go, except thou bless me'* (v. 26)."

Now, when the church begins to pray, it may be at first that the Lord will act as though He would go further (see Luke 24:28), and we may fear that no answer will be given. Hold on, dear friends. *"Be ye stedfast, unmoveable"* (1 Cor. 15:58), despite all. By and by, it may be, there will come discouragements where we looked for a flowing success. We will find friends hindering; some will be slumbering and others sinning. Backsliders and impenitent souls will abound. But let us not be turned aside. Let us be all the more eager.

And if it should so happen that we ourselves become distressed and dispirited and we feel we never were so weak as we are now, never mind, friends; still hold on. For when the sinew is shrunk, the victory is near. Grasp with a tighter grip than ever. Let this be our resolution: *"I will not let thee go, except thou bless me."* Remember, the longer the blessing is in coming, the richer it will be when it arrives. That which is gained speedily by a single prayer is sometimes only a second-rate blessing; but that which is gained after many a desperate tug, and many an awful struggle, is a full-weighted and precious blessing.

The children of persistence are always fair to look upon. The blessing that costs us the most prayer will be worth the most. Only let us be persevering in supplication, and we will gain a broad, far-reaching blessing for ourselves, the churches, and the world. I wish it were in my power to stir you all to fervent prayer, but I must leave it with the great Author of all true supplication, namely, the Holy Spirit. May He work in us mightily for Jesus' sake. Amen.

5

The Throne of Grace

The throne of grace.
—Hebrews 4:16

These words are found embedded in that gracious verse, *"Let us therefore come boldly unto the throne of grace, that we may obtain mercy, and find grace to help in time of need"* (Heb. 4:16). They are a gem in a golden setting. True prayer is an approach of the soul by the Spirit of God to the throne of God. It is not the utterance of words; it is not alone the feeling of desires; but it is the advance of the desires to God, the spiritual approach of our nature toward the Lord our God. True prayer is neither a mere mental exercise nor a vocal performance. It is far deeper than that. It is spiritual commerce with the Creator of heaven and earth.

God is a Spirit, unseen by mortal eye and only to be perceived by the inner man. Our spirits within us, begotten by the Holy Spirit at our regeneration, discern the Great Spirit, commune with Him, set before Him their requests, and receive from Him answers of peace. It is a spiritual business from beginning to end. Its aim and objective end not with man, but they reach to God Himself.

In order to offer such prayer, the work of the Holy Spirit Himself is needed. If prayer were of the lips alone, we would only need breath in our nostrils to pray. If prayer were of the desires alone, many excellent desires are easily felt, even by natural men. But when it is the spiritual desire and the spiritual fellowship of the human spirit with the Great Spirit, then the Holy Spirit Himself must be present all through it. He helps infirmity and gives life and power. Without the Holy Spirit, true prayer will never be presented; the thing offered to God will wear the name and have the form, but the inner life of prayer will be far from it.

Moreover, it is clear from the connection of our text that the interposition of the Lord Jesus Christ is essential to acceptable prayer. As prayer will not be truly prayer without the Spirit of God, so it will not be prevailing prayer without the Son of God. He, the Great High Priest, must go within the veil for us; no, through His crucified person the veil must be entirely taken away. Until then, we are shut out from the living God. The man who, despite the teaching of Scripture, tries to pray without our Savior, insults the Deity. If a person imagines that his own natural desires, coming up before God, unsprinkled with the precious blood, will be an acceptable sacrifice before God, he makes a mistake; he has not brought an offering that God can accept, any more than if he had struck off a dog's head or offered an unclean sacrifice. Worked in us by the Spirit, presented for us by the Christ of God, prayer becomes power before the Most High, but not by any other way.

In trying to write about the text, I will outline it this way: First, here is a throne. Second, here is grace. Then we will put the two together, and we will see grace on a throne. And putting them together in another order, we will see sovereignty manifesting itself, resplendent in grace.

A THRONE

Our text speaks of a throne, *"the throne of grace."* God is to be viewed in prayer as our Father; that is the aspect that is dearest to us. However, we are not to regard Him as though He were such as we are. Our Savior has qualified the expression *"our Father"* with the words *"which art in heaven"* (Matt. 6:9) close at the heels of that gracious name. He wanted to remind us that our Father is still infinitely greater than we are. He has told us to say, *"Hallowed be thy name. Thy kingdom come"* (vv. 9–10), for our Father is still to be regarded as King. In prayer we come not only to our Father's feet, but also to the throne of the Great Monarch of the universe. The mercy seat is a throne, and we must not forget this.

Lowly Reverence

If prayer should always be regarded by us as an entrance into the courts of the Royalty of heaven, if we are to behave ourselves as courtiers should in the presence of an illustrious majesty, then we

are not at a loss to know the right spirit in which to pray. If in prayer we come to a throne, it is clear that we should, in the first place, approach in a spirit of lowly reverence. It is expected that the subject in approaching the king should pay him homage and honor. The pride that will not acknowledge the king, the treason that rebels against the sovereign will, should, if it is wise, avoid any near approach to the throne. Let pride stand on the curb at a distance, let treason lurk in corners, for only lowly reverence may come before the King Himself when He sits clothed in His robes of majesty.

In our case, the King before whom we come is the highest of all monarchs, the King of Kings, the Lord of Lords. Emperors are but the shadows of His imperial power. They call themselves kings by right divine, but what divine right do they have? Common sense laughs their pretensions to scorn. The Lord alone has divine right, and to Him only does the kingdom belong. He is *"the blessed and only Potentate"* (1 Tim. 6:15). They are but nominal kings, to be set up and put down at the will of men or the decree of providence; but He is Lord alone, the Prince of the kings of the earth.

> He sits on no precarious throne
> Nor borrows leave to be.

My heart, be sure that you prostrate yourself in such a presence. Since He is so great, place your mouth in the dust before Him, for He is the most powerful of all kings. His throne has sway in all worlds. Heaven obeys Him cheerfully, hell trembles at His frown, and earth is constrained to yield Him homage willingly or unwillingly. His power can make or can destroy. To create or to crush, either is easy enough to Him. My soul, be sure that when you draw nigh to the Omnipotent God, who is as *"a consuming fire"* (Deut. 4:24), you take your shoes off your feet and worship Him with lowliest humility.

Besides, He is the most holy of all kings. His throne is a great, white throne, unspotted and clear as crystal. *"The heavens are not clean in his sight"* (Job 15:15), and *"his angels he charged with folly"* (Job 4:18). And you, a sinful creature, should draw near to Him with lowliness. Familiarity there may be, but let it not be unhallowed. Boldness there should be, but let it not be impertinent. Still, you are on earth and He in heaven. Still, you are a worm of the dust, a creature *"crushed before the moth"* (v. 19), and He is the Everlasting. *"Before the mountains were brought forth...thou art God"* (Ps. 90:2). If all created things should pass away again,

still He would be the same. My friends, I am afraid we do not bow as we should before the Eternal Majesty; but from now on, let us ask the Spirit of God to put us in a right attitude, so that every one of our prayers may be a reverential approach to the Infinite Majesty above.

Devout Joyfulness

A throne is, in the second place, to be approached with devout joyfulness. If I find myself favored by divine grace to stand among those favored ones who frequent His courts, should I not feel glad? I could have been in His prison, but I am before His throne. I could have been driven from His presence forever, but I am permitted to come near to Him, even into His royal palace, into His secret chamber of gracious audience. Should I not then be thankful? Should not my thankfulness ascend into joy, and should I not feel that I am honored, that I am made the recipient of great favors, when I am permitted to pray?

Why is your countenance sad, oh, suppliant, when you stand before the throne of grace? If you were before the throne of justice to be condemned for your iniquities, you might well be sad. But now you are favored to come before the King in His silken robes of love; let your face shine with sacred delight. If your sorrows are heavy, tell them to Him, for He can comfort you. If your sins are multiplied, confess them, for He can forgive them. Oh, courtiers in the halls of such a Monarch, be exceedingly glad, and mingle praises with your prayers.

Complete Submission

It is a throne, and therefore, in the third place, whenever it is approached, it should be with complete submission. We do not pray to God to instruct Him as to what He ought to do; neither for a moment must we presume to dictate the line of the divine procedure. We are permitted to say to God, "Thus and thus we would like to have," but we must evermore add, "But seeing that we are ignorant and may be mistaken—seeing that we are still in the flesh and, therefore, may be actuated by carnal motives—not as we will, but as You will."

Who would dictate to the throne? No loyal child of God will for a moment imagine that he is to occupy the place of the King, but he

bows before Him who has a right to be Lord of all. Though he utters his desire earnestly, vehemently, persistently, and pleads and pleads again, yet it is evermore with this necessary reservation: "Your will be done, my Lord; and if I ask anything that is not in accordance with Your will, my inmost will is that You would be good enough to deny Your servant. I will take it as a true answer if You refuse me if I ask what does not seem good in Your sight." If we constantly remembered this, I think we would be less inclined to push certain suits before the throne, for we would feel, "I am here in seeking my own ease, my own comfort, my own advantage, and, perhaps, I may be asking for that which would dishonor God. Therefore, I will speak with the deepest submission to the divine decrees."

Enlarged Expectations

Friends, in the fourth place, if it is a throne, it ought to be approached with enlarged expectations. Well does our hymn put it:

> Thou art coming to a King:
> Large petitions with thee bring.

We do not come in prayer, as it were, only to God's poorhouse where He dispenses His favors to the poor, nor do we come to the back door of the house of mercy to receive the leftover scraps, though that would be more than we deserve; to eat the crumbs that fall from the Master's table is more than we could claim. But when we pray, we are standing in the palace on the glittering floor of the Great King's own reception room, and thus we are placed upon a vantage ground. In prayer we stand where angels bow with veiled faces. There, even there, the cherubim and seraphim adore before that selfsame throne to which our prayers ascend. And should we come there with stunted requests and narrow and contracted faith? No, it does not become a King to be giving away pennies and nickels; He distributes pieces of gold. He scatters not, as poor men must, scraps of bread and leftover meat, but He makes a feast of fat things, of fat things full of marrow, of wines well refined.

When Alexander's soldier was told to ask what he would, he did not ask sparingly after the nature of his own merits, but he made such a heavy demand that the royal treasurer refused to pay it and brought the case to the king. Alexander, in right kingly sort,

replied, "He knows how great Alexander is, and he has asked as from a king. Let him have what he requests." Take heed of imagining that God's thoughts are like your thoughts and His ways like your ways (Isa. 55:8). Do not bring before God small petitions and narrow desires and say, "Lord, do according to these." Remember, as high as the heavens are above the earth, so high are His ways above your ways, and His thoughts above your thoughts (v. 9). Ask, therefore, after a Godlike sort. Ask for great things, for you are before a great throne. Oh, that we always felt this when we come before the throne of grace, for then He would do for us *"exceeding abundantly above all that we ask or* [even] *think"* (Eph. 3:20).

Unstaggering Confidence

And, beloved, I may add, in the fifth place, that the right spirit in which to approach the throne of grace is that of unstaggering confidence. Who would doubt the King? Who dares impugn the Imperial word? It was well said that if integrity were banished from the hearts of all mankind besides, it still ought to dwell in the hearts of kings. Shame on a king if he can lie. The beggar in the streets is dishonored by a broken promise, but what can we say of a king if his word cannot be depended on?

Oh, shame on us if we are unbelieving before the throne of the King of heaven and earth. With our God before us in all His glory, sitting on the throne of grace, will our hearts dare to say we mistrust Him? Will we imagine either that He cannot or will not keep His promise? There, surely, is the place for the child to trust his Father, for the loyal subject to trust his Monarch; therefore, all wavering or suspicion should be far from the throne. Unstaggering faith should be predominant before the mercy seat.

Deepest Sincerity

I have only one more remark to make on this point: if prayer is a coming before the throne of God, it ought to always be conducted with the deepest sincerity and in the spirit that makes everything *real*. If you are disloyal enough to despise the King, at least, for your own sake, do not mock Him to His face and when He is upon His throne. If anywhere you dare repeat holy words without heart,

let it not be in Jehovah's palace. If I am called upon to pray in public, I must not dare use words that are intended to please the ears of my fellow worshipers, but I must realize that I am speaking to God Himself and that I have business to transact with the great Lord. And, in my private prayer, if I rise from my bed in the morning and bow my knee and repeat certain words, or if go through the same regular form when I retire to rest at night, I rather sin than do anything that is good, unless my very soul speaks unto the Most High. Do you think that the King of heaven is delighted to hear you pronounce words with a frivolous tongue and a thoughtless mind? You know Him not. *"God is a Spirit: and they that worship him must worship him in spirit and in truth"* (John 4:24).

Beloved, the summary of all my remarks is just this: prayer is no trifle. It is an eminent and elevated act. It is a high and wondrous privilege. Under the old Persian Empire, a few of the nobility were permitted at any time to come in to the king, and this was thought to be the highest privilege possessed by mortals. You and I, the people of God, have a permit, a passport, to come before the throne of heaven at any time we will, and we are encouraged to come there with great boldness. Still, let us not forget that it is no light thing to be a courtier in the courts of heaven and earth, to worship Him who made us and sustains us in being. Truly, when we attempt to pray, we may hear the voice saying out of the excellent glory, "Bow the knee." From all the spirits that behold the face of our Father who is in heaven, even now, I hear a voice that says,

> *O come, let us worship and bow down: let us kneel before the* LORD *our maker. For he is our God; and we are the people of his pasture, and the sheep of his hand.* (Ps. 95:6–7)

The voice also says, *"Worship the* LORD *in the beauty of holiness. Fear before him, all the earth"* (1 Chron. 16:29–30).

GRACE

Lest the glow and brilliance of the word *throne* should be too much for mortal vision, our text now presents us with the soft, gentle radiance of that delightful word *grace*. We are called to the throne of grace, not to the throne of law. Rocky Sinai once was the

throne of law when God came to Paran with ten thousand of His holy ones (Deut. 33:2). Who desired to draw near to that throne? Even Israel did not. Boundaries were set around the mount, and if even a beast touched the mount, it was stoned or thrust through with a dart. Oh, self-righteous ones who hope that you can obey the law and think that you can be saved by it, look to the flames that Moses saw, and shrink, and tremble, and despair. To that throne we do not come now, for through Jesus the case is changed. To a conscience purged by the precious blood, there is no anger upon the divine throne, though to our troubled minds

> Once 'twas a seat of burning wrath,
> And shot devouring flame;
> Our God appeared consuming fire,
> And *Jealous* was His name.

And, blessed be God, I am not now going to write about the throne of ultimate justice. Before that we will all come, and those of us who have believed will find it to be a throne of grace as well as of justice; for He who sits upon that throne will pronounce no sentence of condemnation against the man who is justified by faith. It is a throne set up on purpose for the dispensation of grace, a throne from which every utterance is an utterance of grace. The scepter that is stretched out from it is the silver scepter of grace. The decrees proclaimed from it are purposes of grace. The gifts that are scattered down its golden steps are gifts of grace. He who sits upon the throne is grace itself. It is *"the throne of grace"* to which we approach when we pray; let us think this over for a moment or two, by way of consolatory encouragement to those who are beginning to pray—indeed, to all of us who are praying men and women.

Faults Overlooked

If in prayer I come before a throne of grace, then the many faults of my prayer will be overlooked. In beginning to pray, dear friends, you feel as if you did not pray. The groanings of your spirit, when you rise from your knees, are such that you think there is nothing in them. What a blotted, blurred, smeared prayer it is. Never mind. You have not come to the throne of justice, or else when God perceived the fault in the prayer, He would spurn it.

Your broken words, your gaspings, your stammerings, are before a throne of grace.

When any one of us has presented his best prayer before God, if he saw it as God sees it, there is no doubt he would make great lamentation over it. There is enough sin in the best prayer that was ever prayed to secure its being cast away from God. But it is not a throne of justice, I say again, and here is the hope for our lame, limping supplications. Our gracious King does not maintain a stately etiquette in His court like that which has been observed by princes among men, where a little mistake or a flaw would secure the petitioner's being dismissed with disgrace. Oh, no. The faulty cries of His children are not severely criticized by Him. The Lord High Chamberlain of the palace above, our Lord Jesus Christ, takes care to alter and amend every prayer before He presents it, and He makes the prayer perfect with His perfection and prevailing with His own merits. God looks upon the prayer as presented through Christ, and He forgives all of its own inherent faultiness.

How this ought to encourage any of us who feel ourselves to be feeble, wandering, and unskillful in prayer! If you cannot plead with God as sometimes you did in years gone by, if you feel as if somehow or other you have grown rusty in the work of supplication, never give up, but come still; yes, and come more often. For it is not a throne of severe criticism; it is a throne of grace to which you come.

Then, further, inasmuch as it is a throne of grace, the faults of the petitioner himself will not prevent the success of his prayer. Oh, what faults there are in us! To come before a throne, how unfit we are—we, who are all defiled with sin within and without! Ah, I could not say to you, "Pray," not even to you saints, unless it were a throne of grace.

Much less could I talk of prayer to you sinners. But now I will say this to every sinner, though he thinks himself to be the worst sinner that ever lived: Cry to the Lord, and *"seek ye the LORD while he may be found"* (Isa. 55:6). A throne of grace is a place fitted for you; go to your knees. By simple faith go to the Savior, for He, He it is who is the throne of grace. It is in Him that God is able to dispense grace to the most guilty of mankind. Blessed be God, neither the faults of the prayer nor those of the suppliant will shut out our petitions from the God who delights in broken and contrite hearts.

Desires Interpreted

If it is a throne of grace, then the desires of the pleader will be interpreted. If I cannot find words in which to utter my desires, God in His grace will read my desires without the words. He takes the meaning of His saints, the meaning of their groans. A throne that was not gracious would not trouble itself to make out our petitions. But God, the infinitely gracious One, will dive into the soul of our desires, and He will read there what we cannot speak with the tongue.

Have you ever seen a parent, when his child is trying to say something to him and he knows very well what it is the little one has got to say, help him over the words and utter the syllables for him? If the little one has half-forgotten what he wants to say, you have seen the father suggest the word. Likewise, the ever blessed Spirit, from the throne of grace, will help us and teach us words, no, write in our hearts the desires themselves. We have in Scripture instances where God puts words into sinners' mouths. "Take with you words," says He, "and say unto Him, 'Receive us graciously and love us freely.'" (See Hosea 14:2.)

He will put the desires and will put the expression of those desires into your spirit by His grace. He will direct your desires to the things for which you ought to seek. He will teach you your wants, though as yet you do not know them. He will suggest to you His promises so that you may be able to plead them. He will, in fact, be Alpha and Omega to your prayer just as He is to your salvation; for as salvation is from first to last of grace, so the sinner's approach to the throne of grace is of grace from first to last. What comfort this is. Will we not, my dear friends, with greater boldness draw near to this throne as we draw out the sweet meaning of these precious words, *"the throne of grace"*?

Needs Supplied

If it is a throne of grace, then all the needs of those who come to it will be supplied. The King on such a throne will not say, "You must bring to Me gifts; you must offer to Me sacrifices." It is not a throne for receiving tribute; it is a throne for dispensing gifts. Come, then, you who are as poor as poverty itself. Come, you who have no merits and are destitute of virtues. Come, you who are reduced to a

beggarly bankruptcy by Adam's fall and by your own transgressions. This is not the throne of majesty that supports itself by the taxation of its subjects, but it is a throne that glorifies itself by streaming forth like a fountain with floods of good things. Come, now, and receive the wine and milk that are freely given. *"Yea, come, buy wine and milk without money and without price"* (Isa. 55:1). All the petitioner's needs will be supplied because it is a throne of grace.

"The throne of grace." The phrase grows as I turn it over in my mind. To me it is a most delightful reflection that if I come to the throne of God in prayer, I may see a thousand defects within me, but yet there is hope. I usually feel more dissatisfied with my prayers than with anything else I do. I do not believe that it is an easy thing to pray in public so as to conduct the devotions of a large congregation properly. We sometimes hear people commended for preaching well, but if any will be enabled to pray well, there will be an equal gift and a higher grace in it.

But, friends, suppose in our prayers there are defects of knowledge; it is a throne of grace, and our Father knows that we have need of these things. Suppose there are defects of faith; He sees our little faith and still does not reject it, small as it is. He does not in every case measure out His gifts by the degree of our faith, but by the sincerity and trueness of faith. If there are grave defects in our spirits even, and failures in the fervency or in the humility of the prayer, still, though these should not be there and are much to be deplored, grace overlooks all this and forgives all this. Still, its merciful hand is stretched out to enrich us according to our needs. Surely this ought to induce many to pray who have not prayed, and this should make us who have long been accustomed to using the consecrated art of prayer, to draw near with greater boldness than ever to the throne of grace.

GRACE ENTHRONED

Now, regarding our text as a whole, it conveys to us the idea of grace enthroned. It is a throne, and who sits on it? It is Grace personified that is here installed in dignity. Truly, today, Grace is on a throne. In the Gospel of Jesus Christ, grace is the most predominant attribute of God.

How does it come to be so exalted? Well, grace has a throne by conquest. Grace came down to earth in the form of the Well

Beloved, and it met with sin. Long and sharp was the struggle, and grace appeared to be trampled underfoot by sin. But grace at last seized sin, threw it on its own shoulders, and, though all but crushed beneath the burden, grace carried sin up to the cross and nailed it there, slew it there, and put it to death forever. Grace triumphed gloriously. For this reason, grace sits on a throne at this hour because it has conquered human sin, has borne the penalty of human guilt, and has overthrown all its enemies.

Grace, moreover, sits on the throne because it has established itself there by right. There is no injustice in the grace of God. God is as just when He forgives a believer as when He casts a sinner into hell. I believe in my own soul that there is as much and as pure a justice in the acceptance of a soul who believes in Christ as there will be in the rejection of those souls who die impenitent and are banished from Jehovah's presence. The sacrifice of Christ has enabled God to *"be just, and* [also] *the justifier of him which believeth in Jesus"* (Rom. 3:26). He who knows the word *substitution* and can give its right meaning will see that there is nothing due to punitive justice from any believer, seeing that Jesus Christ has paid all the believer's debts. Now, God would be unjust if He did not save those for whom Christ vicariously suffered, for whom His righteousness was provided, and to whom it is imputed. Grace is on the throne by conquest, and it sits there by right.

Grace is enthroned this day, friends, because Christ has finished His work and has gone into the heavens. It is enthroned in power. When we speak of its throne, we mean that it has unlimited might. Grace sits not on the footstool of God, grace stands not in the courts of God, but it sits on the throne. It is the reigning attribute; it is the king today. This is the dispensation of grace, the year of grace; grace reigns through righteousness to eternal life. We live in the era of reigning grace. *"Seeing he ever liveth to make intercession"* for the sons of men, Jesus *"is able also to save them to the uttermost that come unto God by him"* (Heb. 7:25).

Sinner, if you were to meet grace on the road, like a traveler on his journey, I would bid you to make its acquaintance and ask its influence. If you were to meet grace as a merchant on the exchange, with treasure in his hand, I would bid you to court its friendship; it would enrich you in the hour of poverty. If you were to see grace as one of the peers of heaven, highly exalted, I would bid you to seek to get its ear. But, oh, when grace sits on the throne, I implore you, close in with it at once. It can be no higher;

it can be no greater; for it is written, *"God is love"* (1 John 4:8), which is an alias for grace. Oh, come and bow before it; come and adore the infinite mercy and grace of God. Doubt not; halt not; hesitate not. Grace is reigning; grace is God; God is love. There is *"a rainbow round about the throne...like unto an emerald"* (Rev. 4:3), the emerald of His compassion and His love. Oh, happy are the souls who can believe this and, believing it, can come at once and glorify grace by becoming instances of its power.

THE GLORY OF GRACE

Lastly, our text, if rightly read, has in it sovereignty resplendent in glory—the glory of grace. The mercy seat is a throne; though grace is there, it is still a throne. Grace does not displace sovereignty. Now, the attribute of sovereignty is very high and terrible. Its light is like a jasper stone, most precious (Rev. 21:11), and like a sapphire stone, or, as Ezekiel calls it, *"the terrible crystal"* (Ezek. 1:22). Thus says the King, the Lord of Hosts, *"I will have mercy on whom I will have mercy, and I will have compassion on whom I will have compassion"* (Rom. 9:15).

> *Man, who art thou that repliest against God? Shall the thing formed say to him that formed it, Why hast thou made me thus? Hath not the potter power over the clay, of the same lump to make one vessel unto honour, and another unto dishonour?*
> *(Rom. 9:20–21)*

But, ah, lest any of you should be downcast by the thought of His sovereignty, I invite you to the text. It is a throne—there is sovereignty—but to every soul who knows how to pray, to every soul who by faith comes to Jesus, the true mercy seat, divine sovereignty wears no dark and terrible aspect but is full of love. It is a throne of grace. From this I gather that the sovereignty of God to a believer, to a pleader, to one who comes to God in Christ, is always exercised in pure grace. To you, to you who come to God in prayer, the sovereignty always goes like this: "I will have mercy on that sinner, though he does not deserve it, though in him there is no merit; yet because I can do as I will with My own, I will bless him, I will make him My child, and I will accept him. He will be Mine in the day when I make up My jewels."

There are yet two or three things to be discussed, and I will be done with this subject. On the throne of grace, sovereignty has placed itself under bonds of love. God will do as He wills; but on the mercy seat, He is under bonds—bonds of His own making—for He has entered into covenant with Christ and so into covenant with His chosen. Though God is and ever must be a sovereign, He will never break His covenant, nor will He alter the word that is gone out of His mouth. He cannot be false to a covenant of His own making. When I come to God in Christ, to God on the mercy seat, I need not imagine that by any act of sovereignty God will set aside His covenant. That cannot be; it is impossible.

Moreover, on the throne of grace, God is again bound to us by His promises. The covenant contains in it many gracious promises, exceedingly great and precious. *"Ask, and it shall be given you; seek, and ye shall find; knock, and it shall be opened unto you"* (Matt. 7:7). Until God had said that word or a word to that effect, it was at His own option to hear prayer or not, but it is not so now. For now, if it is true prayer offered through Jesus Christ, His truth binds Him to hear it. A man may be perfectly free, but the moment he makes a promise, he is not free to break it; and the everlasting God does not want to break His promise. He delights to fulfill it. He has declared that all His promises are *"yea"* and *"amen"* (2 Cor. 1:20) in Christ Jesus. For our consolation, when we survey God under the high and awesome aspect of His sovereignty, we have this to reflect on: He is under covenant bonds of promise to be faithful to the souls who seek Him. His throne must be a throne of grace to His people.

The sweetest thought of all is that every covenant promise has been endorsed and sealed with blood, and far be it from the everlasting God to pour scorn upon the blood of His dear Son. When a king has given a charter to a city, he may have been absolute before, and there may have been nothing to check his prerogatives; however, when the city has its charter, then it pleads its rights before the king.

Even thus, God has given to His people a charter of untold blessings, bestowing upon them the sure mercies of David. Very much of the validity of a charter depends on the signature and the seal, and, my friends, how sure is the charter of covenant grace! The signature is the handwriting of God Himself, and the seal is the blood of the Only Begotten. The covenant is ratified with blood, the blood of His own dear Son. It is not possible that we can plead

in vain with God when we plead the blood-sealed covenant, *"ordered in all things, and sure"* (2 Sam. 23:5). *"Heaven and earth shall pass away"* (Matt. 24:35), but the power of the blood of Jesus can never fail with God. It speaks when we are silent, and it prevails when we are defeated. *"Better things than that of Abel"* (Heb. 12:24) does it ask for, and its cry is heard. Let us come boldly, for we bear the promise in our hearts. When we feel alarmed because of the sovereignty of God, let us cheerfully sing:

> The Gospel bears my spirit up;
> A faithful and unchanging God
> Lays the foundation for my hope
> In oaths, and promises, and blood.

May God the Holy Spirit help us to use rightly from this time forward *"the throne of grace."* Amen.

6

Exclamatory Prayer

So I prayed to the God of heaven.
—Nehemiah 2:4

As we see in the reading of the Scripture, Nehemiah had made inquiry as to the state of the city of Jerusalem, and the tidings he heard caused him bitter grief. *"Why should not my countenance be sad,"* he said, *"when the city, the place of my fathers' sepulchres, lieth waste, and the gates thereof are consumed with fire?"* (Neh. 2:3). He could not endure that it should be a mere ruinous heap—the city that was once *"beautiful for situation, the joy of the whole earth"* (Ps. 48:2).

Laying the matter to heart, he did not begin to speak to other people about what they would do, nor did he draw up a wonderful scheme about what might be done if so many thousand people joined in the enterprise. It occurred to him that he would do something himself. This is just the way that practical men start a matter. The unpractical will plan, arrange, and speculate about what may be done, but the genuine lover of Zion puts this question to himself: "What can you do? Nehemiah, what can you yourself do? Come, it has to be done, and you are the man to do it—at least, to do your share. What can you do?"

Coming so far, he resolved to set apart a time for prayer. He never had it out of his mind for nearly four months. Day and night Jerusalem seemed written on his heart, as if the name were painted on his eyeballs. He could only see Jerusalem. When he slept, he dreamed about Jerusalem. When he woke, the first thought was, "Poor Jerusalem!" And before he fell asleep again, his evening prayer was for the ruined walls of Jerusalem. The man of

one thing, you know, is a formidable man; and when one single passion has absorbed the whole of his manhood, something will be sure to come of it. Depend on that. The desire of his heart will develop into some open demonstration, especially if he talks the matter over before God in prayer. Something did come of this. Before long, Nehemiah had an opportunity.

Men of God, if you want to serve God and cannot find the favorable occasion, wait awhile in prayer, and your opportunity will break on your path like a sunbeam. There was never a true and valiant heart that failed to find a fitting sphere somewhere or other in His service. Every diligent laborer is needed in some part of His vineyard. You may have to linger; you may seem as if you stood in the market idle because the Master would not engage you; but wait there in prayer and with your heart boiling over with a warm purpose, and your chance will come. The hour will need its man, and if you are ready, you, as a man, will not be without your hour.

God sent Nehemiah an opportunity. That opportunity came, it is true, in a way that he could not have expected. It came through his own sadness of heart. This matter preyed upon his mind until he began to look exceedingly unhappy. I cannot tell whether others saw it, but the king whom he served, when he went into court with the royal goblet, noticed the distress on the cupbearer's countenance. He said to him, *"Why is thy countenance sad, seeing thou art not sick? this is nothing else but sorrow of heart"* (Neh. 2:2). Nehemiah little knew that his prayer was making the occasion for him. The prayer was registering itself upon his face. His fasting was making its marks upon his visage, and although he did not know it, he was in that way preparing the opportunity for himself when he went in before the king.

But, you see, when the opportunity did come, there was trouble with it, for he said, *"I was very sore afraid"* (v. 2). Thereupon the king asked him what he really wished; by the manner of the question he seemed to imply an assurance that he meant to help him. And here, we are somewhat surprised to find that instead of promptly answering the king (the answer is not given immediately), an incident occurs, a fact is related. Though he was a man who had lately given himself up to prayer and fasting, this little parenthetical remark was made: *"So I prayed to the God of heaven."*

My preamble leads up to this parenthetical remark. This prayer I propose to expound. Three thoughts occur to me here, on

each of which I intend to enlarge: the fact that Nehemiah did pray just then, the manner of his prayer, and the excellent kind of prayer he used.

THE FACT THAT NEHEMIAH PRAYED

The fact that Nehemiah prayed challenges attention. He had been asked a question by his sovereign. The proper thing you would suppose was to answer it. Not so. Before he answered, he *"prayed to the God of heaven."* I do not suppose the king noticed the pause. Probably the interval was not long enough to be noticed, but it was long enough for God to notice it, long enough for Nehemiah to have sought and obtained guidance from God as to how to frame his answer to the king. Are you not surprised to find a man of God having time to pray to God between a question and an answer? Yet Nehemiah found that time.

We are the more astonished at his praying because he was so evidently perturbed in mind, for according to the second verse, he was *"very sore afraid."* When you are flustered and dismayed, you may forget to pray. Do you not, some of you, account it a valid excuse for omitting your ordinary devotion? Nehemiah, however, felt that if he were alarmed, it was a reason for praying, not for forgetting to pray. So habitually was he in communion with God that as soon as he found himself in a dilemma, he flew away to God, just as the dove would fly to hide herself in the clefts of the rock.

His prayer was the more remarkable on this occasion because he must have felt very eager about his object. The king asked him what he wanted, and his whole heart was set upon building up Jerusalem. Are you not surprised that he did not at once say, "O king, live forever. I long to build up Jerusalem's walls. Give me all the help you can"? But no, eager as he was to pounce upon the desired object, he withdrew his hand until it is said, *"So I prayed to the God of heaven."*

I confess I admire him. I desire also to imitate him. I desire that every Christian's heart might have just that holy caution that did not permit Nehemiah to be too hasty. Prayer and provisions hinder no man's journey. Certainly, when the desire of our hearts is close before us, we are eager to seize it; but we will be all the surer of getting the bird we spy in the bush into our hands if we quietly pause, lift up our hearts, and pray to the God of heaven.

It is all the more surprising that he should have deliberately prayed just then because he had already been praying for the past three or four months concerning the identical matter. Some of us would have said, "That is the thing I have been praying for; now all I have got to do is take it and use it. Why pray any more? After all my midnight tears and daily cries, after setting myself apart by fasting to cry to the God of heaven, after such an anxious conference, surely at last the answer has come. What is to be done except to take the good that God provides me with and rejoice in it?" But no, you will always find that the man who has prayed much is the man to pray more. *"For unto every one that hath shall be given, and he shall have abundance"* (Matt. 25:29). If only you know the sweet art of prayer, you are the one who will be often engaged in it. If you are familiar with the mercy seat, you will constantly visit it.

> For who that knows the power of prayer
> But wishes to be often there?

Thus, although Nehemiah had been praying all this while, he nevertheless offered another petition. *"So I prayed to the God of heaven."*

One thing more is worth recollecting, namely, that he was in a king's palace, and in the palace of a heathen king, too, and he was in the very act of handing up to the king the goblet of wine. He was fulfilling his part in the state festival, I doubt not, among the glare of lamps and the glitter of gold and silver, in the midst of princes and peers of the realm. Or even if it were a private festival with the king and queen only, yet still men generally feel so impressed with the responsibility of their high position on such occasions that they are apt to forget prayer. But this devout Israelite, at such a time and in such a place, when he stood at the king's foot to hold up to him the golden goblet, refrained from answering the king's question until he had first prayed to the God of heaven.

THE MANNER OF THIS PRAYER

The fact that Nehemiah offered this prayer prompts us to observe the manner of his prayer. Very briefly, it was what we call exclamatory prayer, prayer which, as it were, hurls a dart and then is done. It was not the type of prayer that stands knocking at

mercy's door—knock, knock, knock—but it was the concentration of many knocks into one. It was begun and completed, as it were, with one stroke. This exclamatory prayer I desire to commend to you as among the very best forms of prayer.

Notice how very short it must have been. It was introduced—slipped in, sandwiched in—between the king's question and Nehemiah's answer. As I have already said, I do not suppose it took up any time at all that was appreciable, scarcely a second. Most likely the king never observed any kind of pause or hesitation, for Nehemiah was in such a state of alarm at the question that I am persuaded he did not allow any delay or vacillation to appear, but the prayer must have been offered like an electric flash, very rapidly indeed.

In certain states of strong excitement, it is wonderful how much the mind gets through in a short time. Drowning men, when rescued and recovered, have said that while they were sinking, they saw the whole panorama of their lives pass before them in a few seconds. So the mind must be capable of accomplishing much in a brief space of time. Thus, the prayer was presented like the winking of an eye. It was done intuitively, yet done it was, and it proved to be a prayer that prevailed with God.

It was a prayer of a remarkable kind. I know it was so, because Nehemiah never forgot that he did pray it. I have prayed hundreds and thousands of times and not recollected any minute detail afterward, either as to the occasion that prompted me or the emotions that excited me. But there are one or two prayers in my life that I never can forget. I have not jotted them down in a diary, but I remember when I prayed because the time was so special, the prayer was so intense, and the answer to it was so remarkable. Now, Nehemiah's prayer was never, never erased from his memory; and when these words of history were written down, he recorded this: *"So I prayed to the God of heaven."*

THIS EXCELLENT STYLE OF PRAYING

Now, beloved friends, I want, in the third place, to recommend to you this excellent style of praying. I will speak to the children of God mainly, to you who have faith in God. I beg you often—no, I would ask you always—to use this method of exclamatory prayer. And I pray to God, also, that some who have never prayed before

would offer an exclamation to the God of heaven. I desire that a short but fervent petition, something like that of the tax collector in the temple, might go up from you: *"God be merciful to me a sinner"* (Luke 18:13).

To deal with this matter practically, then, it is the duty and privilege of every Christian to have set times of prayer. I cannot understand a man's keeping up the vitality of godliness unless he regularly retires for prayer, morning and evening, at the very least. Daniel prayed three times a day, and David said, *"Seven times a day do I praise thee"* (Ps. 119:164). It is good for your hearts, good for your memory, good for your moral consistency, that you hedge about certain portions of time and say, "These belong to God. I will do business with God at such and such a time and will try to be as punctual to my hours with Him as I would be if I made an engagement to meet a friend."

When Sir Thomas Abney was Lord Mayor of London, a banquet somewhat troubled him, for Sir Thomas always had prayer with his family at a certain time. The difficulty was how to leave the banquet to keep up family devotions. So important did he consider it that he vacated the chair, saying to a person nearby that he had a special engagement with a dear friend that he must keep. And he did keep it, and he returned again to his place, none of the company being the wiser, but he himself being all the better for observing his usual habit of worship.

Mrs. Rowe used to say that when her time came for prayer, she would not give it up if the apostle Paul were preaching. No, she said, if all the twelve apostles were there and could be heard at no other time, she would not absent herself from her prayer closet when the set time came around.

But now, having urged the importance of such habitual piety, I want to impress on you the value of another sort of prayer, namely, the short, brief, quick, frequent exclamations of which Nehemiah gives us an example. And I recommend this because it hinders no engagement and occupies no time. You may be buying your groceries or adding up an account, and between the items you may say, "Lord, help me." You may breathe a prayer to heaven and say, "Lord, keep me." It will take no time.

Exclamatory prayers are of great advantage to people who are hard-pressed in business, because such prayers will not, in the slightest degree, incapacitate them from attending to the business at hand. Such prayers do not require you to go to a particular place.

You can stand where you are, ride in a cab, walk along the streets, be a sawyer in a sawmill, and yet pray just as well such prayers as these. No altar, no church, no so-called sacred place is needed; but wherever you are, just such a little prayer as that will reach the ear of God and win a blessing.

Such a prayer as that can be offered anywhere, under any circumstances. On the land or on the sea, in sickness or in health, amid losses or gains, great reverses or good returns, still might a man breathe his soul in short, quick sentences to God. The advantage of such a way of praying is that you can pray often and pray always. The habit of prayer is blessed, but the spirit of prayer is better. It is the spirit of prayer that is the mother of these exclamations; therefore I like them because she is a plentiful mother. Many times in a day, we may speak with the Lord our God.

Such prayer may be suggested by all sorts of surroundings. I recollect a poor man once paying me a compliment that I highly valued at the time. He was lying in a hospital, and when I went to see him, he said, "I heard you for some years, and now whatever I look at seems to remind me of something or other that you said, and it comes back to me as fresh as when I first heard it."

Well, now, he who knows how to pray exclamatory prayers will find everything around him helping him to the sacred habit. Is it a beautiful landscape? Say, "Blessed be God, who has strewn these treasures of form and color throughout the world to cheer my sight and gladden my heart." Are you in doleful darkness, and is it a foggy day? Say, "Lighten my darkness, O Lord." Are you in the midst of company? You will be reminded to pray, "Lord, *'keep the door of my lips'* (Ps. 141:3)." Are you quite alone? Then you can say, "Let me not be alone, but be with me, Father." Putting on your clothes, sitting at the breakfast table, getting into a vehicle, walking down the street, opening your ledger, closing your window, everything may suggest such prayer as that which I am trying to describe, if you are only in the right frame of mind for offering it.

These prayers are commendable because they are truly spiritual. Wordy prayers may also be windy prayers. There is much of praying from books that has nothing whatsoever to recommend it. How much benefit would a manual of French conversation be to anyone traveling in France without a knowledge of the language? That is how much good a manual of prayers is to a poor soul who does not know how to ask our heavenly Father for a blessing or

benefit that he needs. A manual, a handbook, indeed! Pray with your heart, not with your hands. Or, if you would lift hands in prayer, let them be your own hands, not another man's. The prayers that come leaping out of the soul—the gust of strong emotion, fervent desire, lively faith—these are the truly spiritual prayers.

This kind of prayer is free from any suspicion that it is prompted by the corrupt motive of being offered to please men. Others cannot say that the secret exclamations of our souls are presented with any view to our own praise, for no man knows that we are praying at all; therefore, I recommend such prayers to you and hope that you may abound in them.

There have been hypocrites who have prayed by the hour. I do not doubt that there are hypocrites as regular at their devotions as the angels are before the throne of God, and yet there is no life, no spirit, and no acceptance in their pretentious homage. But he who exclaims—whose heart talks with God—he is no hypocrite. There is a reality and force and life in his prayers. If I see sparks come out of a chimney, I know there is a fire inside somewhere, and exclamatory prayers are like the sparks that fly from a soul that is filled with burning coals of love to Jesus Christ.

Short, exclamatory prayers are of great use to us, dear friends. Oftentimes they check us. Bad-tempered people, if you would always pray just a little before you let angry expressions fly from your lips, why, many times you would not say those naughty words at all. A good woman was advised to take a glass of water and hold some of it in her mouth five minutes before she scolded her husband. I dare say it was not a bad recipe; but if, instead of practicing that little eccentricity, she would just breathe a short prayer to God, it would certainly be more effective and far more scriptural. I can recommend it as a valuable prescription for the hasty and the irritable, for all who are quick to take offense and slow to forgive insult or injury. When you are about to close a business deal, about the propriety of which you have a little doubt or a positive scruple, such a prayer as "Guide me, good Lord" would often keep you back from doing what you would afterward regret.

The habit of offering these brief prayers would also check your confidence in yourself. It would show your dependence on God. It would keep you from getting worldly. It would be like sweet perfume burnt in the chamber of your soul to keep away the fever of the world from your heart. I can strongly recommend these short, sweet, blessed prayers. May the Holy Spirit give them to you!

Besides, they actually bring us blessings from heaven. Take the case of Eliezer, the servant of Abraham. (See Genesis 24:12–14.) Look at the case of Jacob when he said, even in dying, *"I have waited for thy salvation, O LORD"* (Gen. 49:18). Moses offered prayers on occasions when we do not read that he prayed at all at the time, yet God said to him, *"Wherefore criest thou unto me?"* (Exod. 14:15). David frequently presented exclamations. These prayers were all successful with the Most High. Therefore abound in them, for God loves to encourage and to answer them.

I could thus keep on recommending exclamatory prayer, but I will say one more thing in its favor. I believe it is very suitable to some people of a special temperament who could not pray for a long time to save their lives. Their minds are rapid and quick. Well, dear friends, time is not an element in the business. God does not hear us because of the length of our prayer, but because of the sincerity of it. Prayer is not to be measured by the yard or weighed by the pound. It is the might and force of it, the truth and reality of it, the energy and the intensity of it. You who are either of so little a mind or of so quick a mind that you cannot use many words or continue long to think of one thing, it should be to your comfort that exclamatory prayers are acceptable.

And it may be, dear friend, that you are in a condition of body in which you cannot pray any other way. A headache such as some people are frequently affected with for the major part of their lives—a state of body that the physician can explain to you—might prevent the mind from concentrating itself long on one subject. Then, it is refreshing to be able again and again and again—fifty or a hundred times a day—to address one's self to God in short, quick sentences, the soul being all on fire. This is a blessed style of praying.

Now, I will conclude by just mentioning a few of the times when I think we ought to resort to this practice of exclamatory prayer. Rowland Hill was a remarkable man for the depth of his piety; but when I asked at Wotton-under-Edge for his study, though I rather pressed the question, I did not obtain a satisfactory reply. At length the good minister said, "The fact is, we never found any. Mr. Hill used to study in the garden, in the parlor, in the bedroom, in the streets, in the woods, anywhere." I asked where he retired for prayer. They said that they supposed it was in his chamber but that he was always praying, that it did not matter where he was, the good old man was always praying. It seemed as if

his whole life, though he spent it in the midst of his fellowmen do-
ing good, was passed in perpetual prayer. He had been known to
stand on Black Friars' Road, with his hands under his coattails,
looking in a shop window, and if you listened, you might soon per-
ceive that he was breathing out his soul before God. He was in a
constant state of prayer. I believe it is the best condition in which a
man can be—praying always, praying without ceasing, always
drawing near to God with these exclamations.

But if I must give you a selection of suitable times, I will men-
tion such as these. Whenever you have a great joy, cry, "Lord,
make this a real blessing to me." Do not exclaim with others, "Am I
not lucky?" but say, "Lord, give me more grace and more gratitude,
now that You multiply Your favors." When you have got any ardu-
ous undertaking at hand or a heavy piece of business, do not touch
it until you have breathed your soul out in a short prayer. When
you have a difficulty before you and you are seriously perplexed,
when business has got into a tangle or a confusion that you cannot
unravel or arrange, breathe a prayer. It need not occupy a minute,
but it is wonderful how many snarls come loose after just a word of
prayer.

Are the children particularly troublesome to you, good woman?
Does it seem as if your patience is almost worn-out with worry?
Now is the time for an exclamatory prayer. You will manage them
all the better, and you will bear with their naughty tempers all the
more quietly. At any rate, your own mind will be less ruffled.

Do you think that there is a temptation before you? Do you
begin to suspect that somebody is plotting against you? Now offer a
prayer: *"Lead me in a plain path, because of mine enemies"* (Ps.
27:11).

Are you at work at the bench or in a shop or in a warehouse
where lewd conversation and shameful blasphemies assail your
ears? Now lift up a short prayer. Have you noticed some sin that
grieves you? Let it move you to prayer. These things ought to re-
mind you to pray. I believe the Devil would not let people swear so
much if Christian people always prayed every time they heard an
oath. He would then see it did not pay. Their blasphemies might
somewhat be hushed if they provoked us to supplication.

Do you feel your own heart going off track? Does sin begin to
fascinate you? Now utter a prayer—a warm, earnest, passionate
cry—"Lord, *'hold thou me up'*" (Ps. 119:117). Did you see
something with your eye, and did that eye infect your heart? Do

you feel as if your *"feet were almost gone;* [and your] *steps had well nigh slipped"* (Ps. 73:2)? Now offer a prayer: "Hold me, Lord, by my right hand." Has something quite unlooked-for happened? Has a friend treated you badly? Then, like David say, *"LORD, I pray thee, turn the counsel of Ahithophel into foolishness"* (2 Sam. 15:31). Breathe a prayer now.

Are you eager to do some good? Be sure to have a prayer over it. Do you mean to speak to that young man as he goes out of the church tonight about his soul? Pray first, Christian. Do you mean to address yourself to the members of your class and write them a letter this week about their spiritual welfare? Pray over every line, Christian. It is always good to have praying going on while you are talking about Christ. I always find I can preach better if I can pray while I am preaching.

The mind is very remarkable in its activities. It can be praying while it is studying. It can be looking up to God while it is talking to man. There can be one hand held up to receive supplies from God while the other hand is dealing out the same supplies that He is pleased to give.

Pray as long as you live. Pray when you are in great pain; the sharper the pang, the more urgent and persistent should your cry to God be. And when the shadow of death gathers around you and when strange feelings flush or chill you and plainly tell that you near the journey's end, then pray. Oh, that is a time for exclamation! Short and pithy prayers like this: *"O LORD…hide not thy face from me"* (Ps. 143:7), or this: "O God, *'Be not far from me'"* (Ps. 22:11) will doubtless suit you. *"Lord Jesus, receive my spirit"* (Acts 7:59) were the thrilling words of Stephen in his extremity. *"Father, into thy hands I commend my spirit"* were the words that your Master Himself uttered just before He bowed His head and *"gave up the ghost"* (Luke 23:46). You may well take up the same strain and imitate Him.

These thoughts and counsels are so exclusively directed to the saints and faithful friends in Christ that you will be prone to ask, "Is there not anything to be addressed to the unconverted?" Well, whatever has been expressed here may be used by them for their own benefit. But let me address myself to you, my dear friends, as pointedly as I can. Though you are not saved, you must not say, "I cannot pray." Why, if prayer is simply thus, what excuse can you have for neglecting it? It needs no measurable space of time. Such prayers as these God will hear; and you have, all of you, the ability

and opportunity to think and to express them. All you need to pray these prayers is that elementary faith in God that believes *"that he is, and that he is a rewarder of them that diligently seek him"* (Heb. 11:6). Cornelius had, I suppose, gone about as far as this when he was admonished by the angel to send for Peter, who preached to him peace by Jesus Christ to the conversion of his soul.

Is there such a strange being as a man or woman who never prays? How should I reason with you? May I steal a passage from a poet who, though he has contributed nothing to our hymnbooks, hums a note so suited to my purpose and so pleasant to my ear that I like to quote it?

> More things are wrought by prayer
> Than this world dreams of. Wherefore let thy voice
> Rise like a fountain, flowing night and day:
> For what are men better than sheep or goats,
> That nourish a blind life within the brain,
> If, knowing God, they lift not hands of prayer,
> Both for themselves and those who call them friend?
> For so the whole round world is every way
> Bound by gold chains about the feet of God.

I do not suspect there is a creature who never prays, because people generally pray to somebody or other. The man who never prays to God such prayers as he ought, prays to God such prayers as he ought not. It is an awful thing when a man asks God to damn him, and yet there are people who do that. Suppose He were to hear you; He is a prayer-hearing God.

If I address one profane swearer, I would like to put this matter clearly before him. Were the Almighty to hear you—if your eyes were blinded and your tongue were struck dumb while you were uttering a wild curse—how would you bear the sudden judgment on your impious speech? If some of those prayers of yours were answered for yourself, and if some that you have offered in your passion for your wife and for your children were fulfilled to their hurt and your distress, what an awful thing it would be.

Well, God does answer prayer, and one of these days He may answer your prayers to your shame and everlasting confusion. Would it not be well to pray now, "Lord, have mercy on me. Lord, save me. Lord, change my heart. Lord, give me faith to believe in Christ. Lord, give me now an interest in the precious blood of Jesus.

Lord, save me now"? Will not each one of you breathe such a prayer as that? May the Holy Spirit lead you to do so.

If you once begin to pray rightly, I am not afraid that you will ever cease, for there is something that holds the soul fast in real prayer. Sham prayers—what is the good of them? But real heart pleading—the soul talking with God—when it once begins, will never cease. You will have to pray until you exchange prayer for praise and until you go from the mercy seat below to the throne of God above.

May God bless you all. All of you, I say—all who are my kindred in Christ and all for whose salvation I yearn. God bless you all and every one, for our dear Redeemer's sake. Amen.

Book
Two

Praying Successfully

1

David's Prayer in the Cave

A prayer when he was in the cave.
—Psalm 142:1

I like the title given to Psalm 142: *"A prayer when he was in the cave."* David did pray when he was in the cave. If he had prayed half as much when he was in the palace as he did when he was in the cave, things would have been better for him. But, alas, when he was king, we find him rising from his bed in the evening, looking from the roof of his house, and falling into temptation. If he had been looking up to heaven, if his heart had been in communion with God, he might never have committed that great crime that has so deeply stained his whole character.

"A prayer when he was in the cave." God will hear prayer on the land, on the sea, and even under the sea. I remember someone at a prayer meeting saying so. Somebody else at the prayer meeting was rather astonished and asked, "How would God hear prayer under the sea?" The man said that he was a diver, and he often went down to the bottom of the sea after shipwrecks. He said that he had held communion with God while he had been at work in the depths of the ocean.

Our God is not only the God of the hills, but also of the valleys. He is the God of both land and sea. He heard Jonah when the disobedient prophet was at the roots of the mountains and when *"the earth with her bars"* (Jonah 2:6) seemed to be around him forever. Wherever you work, you can pray. Wherever you lie sick, you can pray. There is no place to which you can be banished that God is not near, and there is no time of day or night that His throne is inaccessible.

"*A prayer when he was in the cave.*" The caves have heard the best prayers. Some birds sing best in cages. Likewise, some of God's people shine brightest in the dark. Many an heir of heaven never prays so well as when he is driven by necessity to pray. Some will sing aloud upon their beds of sickness who hardly ever sang when they were well. Some will sing God's high praises in the fire who did not praise Him as they should have before the trial came. In the furnace of affliction, the saints are often seen at their best. If you are in a dark and gloomy situation, if your soul is bowed down, may this become a special time of powerful communion and intercession. May the prayer of the cave be the very best of your prayers!

In this chapter, I will use David's prayer in the cave as a picture of a soul under a deep sense of sin. Second, I will use it to represent the condition of a persecuted believer. Third, I will write about how it reveals the condition of a believer who is being prepared for greater honor and wider service.

THE PERSON CONVICTED OF SIN

First, let me try to use this psalm as a picture of the condition of a soul under a deep sense of sin.

A little while ago, perhaps, you were out in the open field of the world, sinning nonchalantly, plucking the flowers that grow in those poisoned valleys and enjoying their deadly perfume. You were as happy as your sinful heart could be, for you were giddy and careless and thoughtless. However, it has pleased God to capture you. You have been arrested by Christ and have been put in prison. You are behind bars. You feel like one who has come out of the bright sunshine and balmy air into a dark, musty cavern, where you can see very little, where there is no comfort, and where there appears to be no hope of escape.

Cry to God

Well now, according to the psalm before us, which is meant for you as well as for David, your first business is to make an appeal to God. I know the doubts you may have. I know the fears you may have of God. I know how frightened you may be at the very mention of His name. But if you want to come out of your present gloom, I charge you to go to God at once. See, the psalm begins, "*I cried unto*

the LORD *with my voice; with my voice unto the* LORD *did I make my supplication"* (Ps. 142:1). Cry to God with your voice. If you have no place where you can use your voice, cry to God in silence, but do cry to Him. Look Godward. If you look in any other direction, all is darkness. Look Godward. There, and only there, is hope.

"I have sinned against God," you say. Be assured that God is ready to pardon. He has provided the great Atonement through which He can justly forgive the greatest offenses. Look Godward, and begin to pray. I have known people to do this who hardly believed in God. Having a faint desire to pray, they cried to God. Even though it was a poor prayer, God heard it. I have known some to cry to God in utter despair. When they hardly believed that there could be any use in praying, still it was that or nothing. They knew that it could not hurt them to pray, and so they got down on their knees and cried. It is wonderful to see what poor prayers God will hear and answer—prayers that have no legs to run with, no hands to grasp with, and very little heart. Still, God has heard them and has accepted them.

Get on your knees, you who feel guilty. Get on your knees if your heart is sighing on account of sin. If the dark gloom of your iniquities is gathering around you, cry to God. He will hear you.

Make a Full Confession

The next thing to do is to pour out your heart. David said, *"I poured out my complaint before him; I showed before him my trouble"* (v. 2). The human heart longs to express itself. An unuttered grief will lie and smolder in the soul until its black smoke blinds the very eyes of the spirit.

Sometimes it is not a bad thing to speak to a Christian friend about the anguish of your heart. I would not encourage you to make it a priority—far from it—but it may be helpful to some. However, I do encourage you to make a full confession unto the Lord. Tell Him how you have sinned. Tell Him how you have tried to save yourself and have failed. Tell Him what a wretch you are, how fickle, how proud, how unruly. Tell Him how your ambition carries you away like an unbridled horse. Tell Him all your faults, as far as you can remember them. Do not attempt to hide anything from God. You cannot do so, for He knows all. Therefore, do not hesitate to tell Him everything—the darkest secret, the sin you would not even wish to whisper to the evening's breeze. Tell it all.

Confession to God is good for the soul. *"Whoso confesseth and for-saketh* [his sins] *shall have mercy"* (Prov. 28:13).

I urge you who are now in a gloomy cave to seek a secret, quiet place and, alone with God, to pour out your heart before Him. David said, *"I showed before him my trouble"* (Ps. 142:2). Do not think that the use of pious words can be of any help. It is not merely words that you have to utter; you have to lay all your trouble before God. As a child tells his mother his griefs, tell the Lord all your griefs, your complaints, your miseries, your fears. Get them all out, and great relief will come to your spirit.

Acknowledge That God Is Your Only Hope

So, first, appeal to God. Second, make confession to Him. Third, acknowledge to God that there is no hope for you but in His mercy. Put it as David did: *"I looked on my right hand, and beheld, but there was no man that would know me"* (v. 4). There is only one hope for you; acknowledge that. Perhaps you have been trying to be saved by your good works. They are altogether worthless, even if you heap them together. Possibly you expect to be saved by your religiousness. But half of it is hypocrisy, and how can a person hope to be saved by his hypocrisy? Do you hope to be saved by your feelings? What are your feelings? They are as changeable as the weather. A puff of wind will change all your fine feelings into murmuring and rebellion against God.

Friend, you cannot keep the law of God! Keeping it perfectly is the only other way to heaven besides Christ. The perfect keeping of God's commandments would save you if you had never committed a sin. But since you have sinned, even that will not save you now, for future obedience will not wipe out past disobedience.

Here, in Christ Jesus, who is the atoning sacrifice for sin, is the only hope for you. Lay hold of it. In the cave of your doubts and fears, where you are chilled and numbed by the clinging dampness of your despair around you and by the dread of the wrath to come, make God in Christ your sole confidence, and you will yet have perfect peace.

Plead with God

Furthermore, if you are still in the cave of doubt and sin, plead with God to set you free. You cannot present a better prayer than

the prayer of David in the cave: *"Bring my soul out of prison, that I may praise thy name"* (Ps. 142:7).

If you are in prison, you cannot get out by yourself. You may grab the bars and try to shake them, but they are unmovable. You cannot break them with your hands. You may meditate, think, invent, and devise, but you cannot get through those bars. However, there is a hand that can cut bars of iron. Oh, prisoner in the iron cage, there is a hand that can open your cage and set you free! You do not have to be a prisoner. You do not have to be confined. You may walk in freedom through Jesus Christ, the Savior. Only trust Him, and believingly pray David's prayer right now: *"Bring my soul out of prison, that I may praise thy name"* (v. 7). He will set you free!

How sinners do praise God's name when they get out of the prison of sin! I remember how, when I was set free, I felt like singing all the time. I understood very well the words of Charles Wesley:

> Oh, for a thousand tongues to sing
> My great Redeemer's praise!

I recall a story that my old friend, Dr. Alexander Fletcher, told some children one time. He said that he was going down the street one day and saw a boy standing on his head, turning cartwheels, and jumping up and down. He said to him, "What are you doing? You seem to be tremendously happy." The boy replied, "Oh, mister, if you had been locked up for six months and had just gotten out, you would be happy, too!"

I have no doubt that this is very true. When a person gets out of the prison of sin—a far worse prison than any earthly prison— he must praise God's free grace and dying love. He must sing and make his whole life musical with the praise of the emancipating Christ.

Now, that is my advice to you who are in a cave because of conviction of sin. May God make that cave a blessing to you! If you are under a sense of sin, heed what I have already said; you do not need to notice anything else that I am going to write in this chapter. If you are not in the cave of conviction, the rest of this chapter belongs to you.

THE PERSECUTED BELIEVER

I will go on to my second subject. This psalm sets forth the condition of a persecuted believer.

A persecuted believer! Are there any in our country? Yes, dear friends, there are many! When a person becomes a Christian, he immediately becomes different from the people around him.

I was standing at my window one day, meditating on possible subjects for my next sermon. I could not decide on a text, when all of a sudden, I saw a flock of birds. A canary had escaped from its cage and was flying over the roofs of the houses opposite mine. It was being chased by about twenty sparrows, along with other rough birds. Then I thought of that text, *"Mine heritage is unto me as a speckled bird, the birds round about are against her"* (Jer. 12:9). Why, the birds in pursuit seemed to say to one another, "Here is a yellow fellow. We have not seen a bird like him in our city. He has no business here. Let us pull off his bright coat. Let us kill him, or let us make him as dark and dull as we are."

That is just what people of the world try to do to Christians. Here is a godly man who works in a factory, or a Christian woman who is employed in an office building. Such Christians will have a sad tale to tell of how they have been hunted down, ridiculed, and scoffed at by ungodly coworkers.

You Do Not Know What to Do

It may be that you are in the condition just described. You hardly know what to do. You are as David described himself in Psalm 142, for he said, *"My spirit was overwhelmed within me"* (v. 3). Perhaps you are a new believer, and your coworkers have turned against you and become your persecutors. It is a new thing to you as a young believer. You are quite perplexed and completely unsure of what you should do. They are severe, ferocious, and incessant. They find out your tender spots and know just how to touch you on those raw places. You are like a lamb in the midst of wolves; you do not know which way to turn.

Well then, say to the Lord what David said: *"When my spirit was overwhelmed within me, then thou knewest my path"* (v. 3). God knows exactly where you are and what you have to bear. Have confidence that, when you do not know what to do, He can and will direct your way if you trust Him.

You Are Tempted

In addition, it may be that you are greatly tempted. David said, *"They privily laid a snare for me"* (Ps. 142:3). This is often the case with a young man. His coworkers find out that he has become a Christian, and they try to trip him up. If they can, they will devise a scheme by which they can make him appear to be guilty, even if he is not. Ah, if you are in this situation, you will need much wisdom! I pray that you may never yield to temptation but may hold your ground by divine grace. Young Christian soldiers often have a very rough time of it in the barracks. But I hope that you will prove yourself a true soldier and not yield an inch to those who would lead you astray.

It will be very painful if, in addition to that, your family turns against you. David said, *"There was no man that would know me"* (v. 4). Is it the same with you? Are your father and mother against you? Is your wife or your husband against you? Do your brothers and sisters call you a hypocrite? Do they point the finger of scorn at you when you get home? And often, when you go home after church, where you have been so happy, do you have to hear profanity the moment you enter the house?

Christians should pray for young people who are newly converted, for their worst enemies are often those in their own household. "I would not mind so much," a new believer said, "if I had a Christian friend to go to. I spoke to a Christian the other day, and he did not seem to care about my situation at all."

Such a nonchalant attitude really hurts a young convert. Take John as an example. He has truly, lovingly, given his heart to Christ. The manager where he works is a Christian. John is ridiculed by his coworkers, and he tries to talk to this Christian man about it. John's boss squelches him in a moment and has no sympathy for him. Well, there is another Christian working near John's desk. As the young convert begins to tell him a little about his trouble, this man, too, is very grumpy and cross.

I have noticed that some Christians appear to keep to themselves, and they do not seem to notice the troubles of beginners in the Christian life. Do not let this be the case with you. My dear brothers and sisters, cultivate great love to those who, having come into the army of Christ, are harassed by adversaries. Like David, they are in the cave. Do not disown them. They are trying to do their best. Stand side by side with them. Say to the persecutors of

your young Christian friend, "I, too, am a Christian. If you are honoring that young man with your ridicule, let me have my portion of it. If you are pouring contempt on him, give me a share of it, for I also believe as he believes."

Will you do that? Some of my readers will, I am sure. Will you stand by the man of God who upholds the Lord's revealed truth? Some of you will. But there are plenty of people who want to save their skin. If they can sneak away from a fight, they are glad to get home, go to bed, and slumber until the battle is over. May God help us to have more of the lion in us and not so much of the chicken! May God grant us grace to stand by those who are out-and-out for God and for His Christ, so that we may be remembered with them in the day of His appearing!

You Are Weak

It may be that your worst point is that you feel very feeble. You say, "I would not mind the persecution if I felt strong, but I am so weak." Well now, always distinguish between feeling strong and being strong. The person who feels strong is weak; the person who feels weak is strong. Paul said, *"When I am weak, then am I strong"* (2 Cor. 12:10). David prayed, *"Deliver me from my persecutors; for they are stronger than I"* (Ps. 142:6).

Just hide yourself away in the strength of God. Pray much. Take God for your refuge and your portion. Have faith in Him. Then you will be stronger than your adversaries. They may seem to pull you down, but you will soon be up again. They may set before you puzzles that you cannot solve. They may come up with their scientific knowledge, and you may be at a disadvantage. But never mind that. The God who has led you into the cave will turn the tables for you one of these days. Only hold on, and hold out, even to the end.

I am glad that there is some trouble in being a Christian, for it has become a very common thing to profess to be one. If I am right, it is going to become a much less common thing for a person to say, "I am a Christian." There will come times when sharp lines will be drawn. Some of us will help to draw them if we can. The problem is that people bear the Christian name but act like worldlings and love the amusements and the follies of the world. It is time for a division in the house of the Lord in which those for Christ go into

one camp and those against Christ go into the other camp. We have been mixed together too long.

I, for one, say, "May the day soon come when every Christian will have to run the gauntlet!" It will be a good thing for genuine believers. It will just blow some of the chaff away from the wheat. We will have all the purer gold when the fire gets hot and the crucible is put into it, for then the dross will be separated from the precious metal.

Be courageous, my fellow believer. If you are now in the cave, the Lord will bring you out of it in His own good time.

THE BELIEVER IN TRAINING

Now, to close this chapter, I want to write a little about the condition of a believer who is being prepared for greater honor and wider service.

Is it not a curious thing that whenever God means to make a man great, He always breaks him into pieces first? There was a man whom the Lord meant to make into a prince. How did He do it? Why, He met him one night and wrestled with him! We always hear about Jacob's wrestling. Well, I dare say Jacob did wrestle, but it was not Jacob who was the principal wrestler: *"There wrestled a man with him until the breaking of the day"* (Gen. 32:24). God wrestled with him. He touched the hollow of Jacob's thigh and put it out of joint before He called him Israel, which means "a prince of God." The purpose of the wrestling was to take all of Jacob's strength out of him. When his strength was gone, then God called him a prince.

Now, David was to be king over all of Israel. What was the way to Jerusalem for David? What was the way to the throne? Well, he went by way of the cave of Adullam. He had to go there first and be an outcast, for that was the way by which he would be made king.

Have you ever noticed that whenever God is about to give you a promotion, elevating you to a larger sphere of service or a higher platform of spiritual life, you always get thrown down? That is His usual method of working. He makes you hungry before He feeds you. He strips you before He clothes you. He makes you nothing before He makes you something. This was the case with David. He was to be king in Jerusalem, but he had to go to the throne by way of the cave.

Now, are you about to go to heaven or to a more heavenly state of sanctification or to a greater sphere of usefulness? Do not be surprised if you go by way of the cave. Why is this? God wants to teach you several things.

Pray

First, in order for God to make you greatly useful, He must teach you how to pray. The man who is a great preacher and yet cannot pray will come to a bad end. A woman who is noted for her Bible teaching and yet cannot pray will also come to a bad end. If you can be great without prayer, your greatness will be your ruin. If God means to bless you greatly, He will make you pray greatly, as He did with David, who said while in the cave, *"I cried unto the LORD with my voice; with my voice unto the LORD did I make my supplication"* (Ps. 142:1).

Always Believe in God

The person whom God will greatly honor must always believe in God, even when he is at his wits' end. *"When my spirit was overwhelmed within me, then thou knewest my path"* (v. 3). Are you never at your wits' end? Then God has not sent you to do business in great waters. If He has, before long you will be in a great storm, staggering to and fro and at your wits' end. Oh, it is easy to trust when you can trust yourself. But when you cannot trust yourself, when your spirit sinks below zero in the chill of utter despair, then it is time to trust in God. If that is your case, you have the marks of a believer who can lead God's people and be a comforter to others.

Stand Alone

Next, on the way to greater usefulness, many a man or woman of God must be taught to stand alone. *"I looked on my right hand, and beheld, but there was no man that would know me"* (Ps. 142:4). If you want others to help you, you will make a decent follower. But if you look to no man and can stand alone, God being your Helper, you will make a good leader.

It was an impressive thing when Martin Luther stepped out of the ranks of Rome. There were many good men around him who

said, "Be quiet, Martin. You will be burned at the stake if you do not hold your tongue. Let us stay where we are, in the Church of Rome, even if we have to hear false teaching. We can believe the Gospel and still remain where we are." But Luther knew that he had to defy antichrists and declare the pure Gospel of the blessed God. He knew he had to stand alone for the truth, even if there were as many devils against him as there were tiles on the house-tops in his hometown of Worms, Germany.

That is the kind of man whom God blesses. I fervently desire that many young people reading this book will have the courage to say, "I can stand alone if need be. I would be glad to have my co-workers and friends and family stand with me, but if nobody will go to heaven with me, I will say good-bye to them and go to heaven alone through the grace of God's dear Son."

Delight in God

The person whom God will bless will be the person who delights in God alone. David said, *"I cried unto thee, O LORD: I said, Thou art my refuge and my portion in the land of the living"* (Ps. 142:5).

Oh, to have God as our refuge and to make God our portion! You may lose your job. You may lose your income. You may lose the approval of others. "But," says the believer, "I will not lose my portion, for God is my portion. He is my job, my income, my everything. I will hold onto Him, come what may."

If you have learned to *"delight thyself also in the LORD,"* then *"he shall give thee the desires of thine heart"* (Ps. 37:4). Then you are in a state in which God can use you and make much of you. But until you make much of God, He will never make much of you. May God deliver us from having our portion in this life, for if we do, we are not among His people at all!

Sympathize

The person whom God will use must be taught to sympathize with hurting Christians. David said, *"I am brought very low"* (Ps. 142:6).

If the Lord means to bless you, believer, and to make you useful in His church, you can be sure that He will try you. Half, perhaps up

to ninety percent, of a minister's trials are not sent to him for his own welfare; they are sent for the good of other people. Many children of God who go very smoothly to heaven do very little for others. But others of the Lord's children, who have experienced all the ups and downs and changes of mature believers' lives, have done so in order that they may be better equipped to help others. They are able to weep with those who weep or rejoice with those who rejoice.

Therefore, you, my brother who has entered the cave, and you, my sister who has deep spiritual challenges, I want to comfort you by showing you that this is God's way of making something out of you. He is digging you out. You are like an old ditch that cannot hold any more, and God is digging you out to make room for more grace. His shovel will cut sharply as it digs up clump after clump and throws them aside. The very thing you would like to keep will be thrown away, and you will be hollowed out and dug out so that the word of Elisha may be fulfilled: *"Make this valley full of ditches. For thus saith the* LORD, *Ye shall not see wind, neither shall ye see rain; yet that valley shall be filled with water"* (2 Kings 3:16–17). You are to be tried, my friend, so that God may be glorified in you.

Praise

Lastly, if God means to use you, you must be full of praise. Listen to what David said: *"Bring my soul out of prison, that I may praise thy name: the righteous shall compass me about; for thou shalt deal bountifully with me"* (Ps. 142:7).

If God is trying you in order to benefit you and afflicting you in order to promote you, may He give you grace to begin to praise Him! The singers are the ones who go before the others; those who can praise the best will be fit to lead others in the work. Do not ask me to follow a gloomy leader. Do not ask me to march to a sad tune. No, no, give me a joyous song. Sing unto the Lord who has triumphed gloriously (Exod. 15:1). Praise His great name again and again.

If you have a cheerful spirit, if you are glad in the Lord and joyful after all your trials and afflictions, and if you rejoice all the more because you have been brought low, then God is making something out of you. He will yet use you to lead His people to greater works of grace.

ENCOURAGEMENT

What I have written in this chapter I have written to three kinds of people: those convicted of sin, persecuted believers, and disciples in training. May God grant to each of you the grace to know which you are and to take what belongs to you!

If you know anyone who is in a cave, stop and comfort him. Even if you feel that you are too busy, put yourself second. Just paddle your own canoe alongside someone else's little ship, and see whether you cannot communicate with the poor troubled one on board. Say a word to cheer a sad heart. Always do this. If you are in prison yourself, the way out of it is to help another out. God restored the riches of Job when he prayed for his friends. When we begin to look after others and seek to help others, God will bless us. May it be so for His name's sake!

2

Ask and Have

*Ye lust, and have not: ye kill, and desire to have,
and cannot obtain: ye fight and war, yet ye have not, because ye
ask not. Ye ask, and receive not, because ye ask amiss,
that ye may consume it upon your lusts.*
—James 4:2–3

M an is a creature abounding in wants. He is ever restless. His heart is full of desires. I can hardly imagine a person who does not have many desires of some kind or another. Man is like a sea anemone with its multitude of tentacles, which are always hunting in the water for food. Man is like certain plants that send out tendrils, seeking to climb higher. Man steers for what he thinks to be his port, but as yet, he is tossed about upon the waves. One of these days he hopes to find his heart's delight, and so he continues to desire with more or less expectancy.

This fact applies to both the worst of people and the best of people, but there is a difference between the desires of sinners and the desires of saints. Sinners' desires become lusts; their longings are selfish, sensual, and consequently evil. The current of their desires runs forcefully in a wrong direction. These lusts, in many cases, become extremely intense. They make the man their slave and domineer over his judgment; they stir him up to violence. He fights and wars; perhaps he literally kills. In God's sight, who considers anger to be the same as murder (Matt. 5:21–22), he kills quite often. His desires are so strong that they are commonly referred to as passions. When these passions are fully excited, the man himself struggles vehemently. Like the kingdom of heaven, the kingdom of the Devil suffers violence, and the violent take it by force. (See Matthew 11:12.)

At the same time, there are desires in Christians also. To rob the saints of their desires would be to injure them greatly, for by their desires they rise out of their lower selves. Believers desire the best things: things that are pure and peaceful, admirable and elevating. They desire God's glory; therefore, their motives are higher than the motives that inflame the unrenewed mind. Such desires in Christians are frequently very fervent and forceful. Indeed, they should always be so. Desires from the Spirit of God stir the renewed nature, exciting and stimulating it. They make the believer groan in anguish until he can attain the things that God has taught him to long for.

The lusts of the wicked and the holy desires of the righteous have their own ways of seeking gratification. The wicked seek to satisfy their lusts through contention. They kill and desire to have; they fight and war. On the other hand, the desires of the righteous, when properly guided, take a far better course to achieve their purposes. They express themselves in fervent and persistent prayer. The godly man, when full of desire, asks and receives from the hand of God.

At this time I will, by God's help, try to explain our text, James 4:2–3. First, I will explain the poverty of lusting, expressed in the words, *"Ye lust, and have not."* Next, I will show the poverty that many professing Christians have in spiritual things. They also long for things and do not have them. In the third place, I will write on the wealth with which holy desires are rewarded if we simply use the right means. If we ask, we will receive.

THE POVERTY OF LUSTING

First, consider the poverty of lusting. *"Ye lust, and have not."* Carnal lusts, however strong they may be, often do not obtain what they seek. The text says, *"Ye...desire to have, and cannot obtain."* The carnal person longs to be happy, but he is not. He yearns to be great, but he grows more contemptible every day. He aspires after this and after that, whatever he thinks will content him, but he is still not satisfied. He is like the troubled sea that cannot rest. One way or another, his life is a disappointment. His labors are vexatious and in vain; they are only fuel for the fire. How can it be otherwise? If we sow the wind, must we not reap the whirlwind, and nothing else (Hos. 8:7)?

115

Even if the strong lusts of an active, talented, persevering person do give him what he seeks, how soon he loses it. He has it, then he does not have it. The pursuit is toilsome, but the possession is a dream. He sits down to eat, and, behold, the feast is snatched away; the cup vanishes when it is at his lips. He wins to lose. He builds, but the sandy foundation slips from under his tower, and it lies in ruins. Take Napoleon as an example. He conquered kingdoms but died discontented on a lonely island in the middle of the ocean. As Jonah's protecting plant withered in a night (see Jonah 4:6–11), so empires have fallen suddenly, and their lords have died in exile. What people obtain by warring and fighting is an estate with a short lease. The possession is so temporary that it still stands true, "[They] *lust, and have not.*"

Even if such a person has enough talent and power to retain what he has won, in another sense he does not have it even while he has it, for the pleasure that he looked for in it is not there. He plucks the apple, and it turns out to be one of those Dead Sea apples that crumble to pieces in the hand. Such a person may be rich, but God takes from him the power to enjoy his wealth. By his lusts and his wars, the lustful person at last obtains the object of his cravings. However, after a moment's gratification, he loathes what he so passionately lusted for. He longs for the tempting pleasure, seizes it, and crushes it by his eager grasp.

See the boy hunting the butterfly, which flits from flower to flower while he pursues it eagerly. At last it is within reach, and with his cap he knocks it down. But when he picks up the poor remains, he finds the painted butterfly spoiled by the act that won it. Likewise, it may be said of multitudes of people, *"Ye lust, and have not."*

James set forth their threefold poverty: *"Ye kill, and desire to have, and cannot obtain"*; *"Ye have not, because ye ask not"*; and, *"Ye ask, and receive not, because ye ask amiss."*

Fighting to Get Ahead

The lustful *"kill, and desire to have, and cannot obtain."* If they fail, it is not because they did not work to gain what they wanted. For, according to their nature, they used the most practical means within their reach, and used them eagerly, too. According to the mind of the flesh, the only way to obtain a thing is to

fight for it. In fact, James set this down as the reason for all fighting: *"From whence come wars and fightings among you? come they not hence, even of your lusts that war in your members?"* (James 4:1). But their fighting is unsuccessful, for James said in the next verse, *"Ye fight and war, yet ye have not."* Yet people cling to this method from age to age.

We are told that if a person is to get along in this world, he must contend with his neighbors and push them from their place of advantage. He must not be concerned about his neighbor's success, but he must mind his own opportunities. He must be sure to rise, no matter how many he may trample on. He cannot expect to get ahead if he loves his neighbor as himself. It is a fair fight, and every man must look out for himself. Do you think I am being sarcastic? I am, but I have heard this sort of talk from people who truly meant it. So they take to fighting, and their fighting is often victorious, for according to the text they *"kill"*—that is, they overthrow their adversaries and make an end of them.

Multitudes of people are living for themselves, competing here and warring there, fighting for their own welfare with the utmost perseverance. Conscience is not allowed to interfere in their transactions. The old advice rings in their ears, "Get money; get money honestly if you can, but by any means get money." It does not matter that body and soul are ruined and that others are deluged with misery. They must fight on, for there is no discharge in this war. James wisely said, *"Ye kill, and desire to have, and cannot obtain: ye fight and war, yet ye have not."*

Refusing to Ask

When people who have their hearts set on their selfish desires do not succeed, they may possibly hear that the reason of their failure is *"because* [they] *ask not."* Is success to be achieved by asking then? The text seems to hint this, and the righteous find that it is so.

Why does the person with intense desires not try asking? The reason is, first, that it is unnatural to the natural man to pray. He would just as naturally sprout wings and fly. He despises the idea of supplication. "Pray?" he asks. "No, I want to work. I cannot waste time on devotions. Prayers are not practical; I want to fight my way. While you are praying, I will have beaten my opponent. I go to my office and leave you to your Bibles and your prayers."

The carnal person has no intention of asking God for anything. He is so proud that he considers himself to be his own providence. He thinks that his own strong arm will get him the victory. When he is very liberal in his views, he admits that though he does not pray, there may be some good in it, for it quiets people's minds and makes them more comfortable. But as far as any prayer ever being answered, he scoffs at the idea. He talks philosophically and theologically about the absurdity of supposing that God alters His conduct to answer prayers. "Ridiculous," he says, "utterly ridiculous!" Therefore, in his own great wisdom, he returns to his fighting and his warring, for by such means he hopes to achieve his goal. Yet he does not obtain it. The whole history of mankind shows that evil lusts fail to obtain their object.

Futile Asking

For a while the carnal person goes on fighting and warring, but eventually he changes his mind, for he is ill or frightened. His purpose is the same, but if it cannot be achieved one way, he will try another. If he must ask, well, he will ask. He will become religious and do good to himself in that way. He finds that some religious people prosper in the world and that even sincere Christians are by no means fools in business. Therefore, he will try their plan.

Now he comes under the third reprimand of our text: *"Ye ask, and receive not."* Why does the lustful person not obtain his desire, even when he resorts to asking? The reason is that his asking is a mere matter of form; his heart is not in his worship. He buys a book containing what are called forms of prayer, and he repeats these. He has discovered that repeating is easier than praying, and it demands no thought.

I have no objection to your using a model of prayer if you pray with it; but I know a great many who do not pray with it, but only repeat the words. Imagine what our families would be like if instead of our children speaking to us frankly when they need something, they always went to the library to hunt up a prayer to read to us. Surely there would be an end of all family feelings and love. Life would be shackled in its movements. Our households would become a kind of boarding school or barracks. All would be ritual and formality, instead of happy eyes looking up with loving trust into fond eyes that delight to respond. Many spiritual people use a

model, but carnal people are almost sure to do so, for they are only interested in the form, not in true prayer.

If your desires are the longings of fallen nature, if your desires begin and end with your own self, and if the primary purpose for which you live is not to glorify God but to glorify yourself, then you may fight, but you will not have. You may get up early and stay up late, but nothing worth gaining will come of it. Remember how the Lord has spoken in the book of Psalms:

> *Cease from anger, and forsake wrath: fret not thyself in any wise to do evil....For yet a little while, and the wicked shall not be: yea, thou shalt diligently consider his place, and it shall not be. But the meek shall inherit the earth; and shall delight themselves in the abundance of peace. (Ps. 37:8, 10–11)*

I believe I have written enough to prove the poverty of lusting.

SPIRITUAL POVERTY

Second, I have before me a serious business, and that is to show how Christian churches may suffer spiritual poverty. They, too, may desire to have and not be able to obtain. Of course, the Christian seeks higher things than the worldly person, or else he would not be worthy of the name "Christian." Outwardly, at least, his objective is to obtain the true riches and to glorify God in spirit and in truth. But look, dear believers—all churches do not get what they desire. Not here and there, but in many places, churches are nearly asleep and are gradually declining.

They find excuses, of course. They say that the population is dwindling or that another place of worship is attracting the people. There is always an excuse handy when a person needs one. However, we must face the facts: public worship is almost deserted in some places, the ministry has no rallying power, members who put in an appearance are discontented or indifferent, and in such churches there are no conversions. What is the reason for these things?

Christian Competition

First, even professed Christians may pursue desirable things by a wrong method. *"Ye fight and war, yet ye have not."* Have not

churches tried to prosper by competing with other churches? We foolishly say, "At such and such a place of worship, they have a very clever minister; we must get a clever minister, too. In fact, he must be a little cleverer than the other church's hero. That is just what we need—a clever minister!" How awful that we should live in an age in which we talk about clever ministers preaching the Gospel of Jesus Christ! How sad that this holy service should be thought to depend on human cleverness!

Churches have competed with each other in architecture, music, apparel, and social status. In some cases, there is a measure of bitterness in the rivalry. It is not pleasant to small minds to see other churches prospering more than their own. Other congregations may be more earnest than we are, they may be doing God's work better, but we are too apt to turn a jealous eye toward them. We would rather they did not get along quite so well. *"Do ye think that the scripture saith in vain, The spirit that dwelleth in us lusteth to envy?"* (James 4:5). If there were a disturbance among them that caused the church to break up and die, we would not rejoice. Of course not. But nor would we suffer any real sorrow.

In some churches an evil spirit lingers. God will never bless such means and such a spirit. Those who give way to them will desire to have but will never obtain.

Failure to Ask

Meanwhile, what is the reason that these churches do not have a blessing? The text says, *"Because ye ask not."* I am afraid there are churches that do not ask. Prayer in all forms is too much neglected. Private prayer is allowed to decay. I will put it to the conscience of every reader to determine how much he attends to secret prayer and how much time he spends with God in secret fellowship. Certainly the healthy existence of secret prayer is vital to church prosperity. Family prayer is easier to judge, for we can see it. I fear that in these days many have quite given up family devotions. I pray that you do not imitate such people.

I hope you have the same attitude as a certain Scottish laborer. He obtained employment in the house of a wealthy farmer who was known to pay well, and all his friends envied him because he had gone to live in such a place. However, in a short time he returned to his native village. When they asked him why he had left

his job, he replied, "I cannot live in a house that has no roof." The rich man's house had a physical roof, of course; but the laborer was speaking of a covering of prayer. A house without prayer is a house without a roof. We cannot expect blessings on our churches if we have none on our families.

As for the attendance at what we call our prayer meetings, is there not a decline? In many cases the prayer meeting is despised. It is looked down on as a sort of second-rate gathering. Some church members are never present, and it does not even prick their consciences that they do not attend. Some congregations combine the prayer meeting with a Bible study so that they can hold only one service during the week.

The other day I read an excuse for all this: people are better at home, attending to family concerns. This is foolish talk. None of us wishes to see people neglect their domestic concerns. However, the people who take care of their own concerns best are the people who are diligent to get everything in order so that they may go to church. Negligence of the house of God is often an indication of negligence of one's own house. If a person does not bring his children to church services, I am persuaded that he is not bringing them to Christ.

Anyhow, the prayers of the church measure its prosperity. If we restrain prayer, we restrain the blessing. Our true success as churches can only be had by asking the Lord for it. Are we not prepared to reform and improve in this matter? Oh, for Zion's travailing hour to come, when an agony of prayer will move the whole body of the faithful!

Praying Improperly

Some may reply, "We have prayer meetings, and we do ask for the blessing, yet it does not come." Is not the explanation to be found in the next verse of the text: *"Ye ask, and receive not, because ye ask amiss"*? When prayer meetings become a mere formality, when believers stand up and waste time with their long orations instead of speaking to God in earnest and burning words, when there is no expectation of a blessing, when the prayer is cold and icy, then nothing is accomplished. He who prays without fervency does not pray at all. We cannot commune with God, who is *"a consuming fire"* (Deut. 4:24), if there is no fire in our prayers.

Many prayers fail to achieve their purpose because there is no faith behind them. Prayers that are filled with doubt are requests for refusal. Imagine that you wrote to a friend and said, "Dear friend, I am in great trouble. I am telling you this, and I am asking for your help, because it seems right to do so. But though I am writing to you, I do not believe you will send me any help. Indeed, I would be shocked if you did, and I would speak of it as a great wonder."

Do you think you would get any help? I should say that your friend would be sensible enough to observe how little confidence you had in him. He would reply that, since you did not expect anything, he would not astonish you. Your opinion of his generosity is so low that he does not feel inclined to go out of his way on your account. When our prayers are like that letter, we must not be surprised if we *"receive not,"* for we *"ask amiss."*

Moreover, if our praying is a mere asking that our church may prosper because we want to glory in its prosperity, if we want to see our own denomination largely increased and its respectability improved so that we may share in the honors, then our desires are nothing but lusts after all. How can it be that the children of God manifest the same jealousies and ambitions as people of the world? Should religious work be a matter of rivalry and contest? No. The prayers that seek selfish success will have no acceptance at the mercy seat, no matter how earnest and believing they may be. God will not listen to us but will tell us to leave, for He does not care for petitions in which self is the object. *"Ye have not, because ye ask not...*[or] *because ye ask amiss."*

YOUR AVAILABLE WEALTH

Now, I have much more pleasant work to do, which is to hint at the wealth that awaits the use of the right means, namely, proper praying.

I invite your most earnest attention to this matter, for it is vitally important. Upon first observation, we find how very small this demand is that God makes of us. Ask? Why, it is the least thing He can possibly expect of us. And it is no more than we ordinarily require of those who need help from us. We expect a poor person to ask. If he does not, we lay the blame for his lack on him.

If God will give for the asking but we remain poor, who is to blame? Is not our blame most grievous? Does it not look as if we

are out of touch with God when we will not even ask a favor of Him? Surely there must be in our hearts a lurking enmity toward Him. Otherwise, instead of prayer being an unwelcome necessity, it would be a great delight.

My fellow believers, whether we like it or not, asking is the rule of the kingdom. *"Ask, and ye shall receive"* (John 16:24). It is a rule that never will be altered in anybody's case. Our Lord Jesus Christ is the elder brother of the family, but God did not relax the rule even for Him. Jehovah said to His own Son, *"Ask of me, and I shall give thee the heathen for thine inheritance, and the uttermost parts of the earth for thy possession"* (Ps. 2:8). If the royal, divine Son of God was not exempt from the rule of asking, you and I cannot expect the rule to be relaxed for us.

God blessed Elijah and sent rain on Israel, but Elijah had to pray for it. If the chosen nation was to prosper, Samuel had to plead for it. If the Jews were to be delivered, Daniel had to intercede. God blessed Paul, and the nations were converted through him, but Paul had to pray. Pray he did, *"without ceasing"* (1 Thess. 5:17). His epistles show that he expected nothing except by asking for it.

Moreover, even the most shallow thinker knows that there are some things necessary for the church of God that we cannot get any other way than by prayer. You can get that clever minister I wrote about earlier, and that new church, and that new organ and choir. You can even get them without prayer. However, you cannot get the heavenly anointing without prayer. The gift of God is not to be purchased with money.

Some of the members of a small village church thought that they would build their congregation by hanging a very handsome chandelier in the meetinghouse. Indeed, the villagers talked about this chandelier, and some went to see it, but the light of it soon grew dim.

You can buy all sorts of fancy furniture; you can purchase any kind of paint, brass, and fine linen, together with flutes, organs, and all kinds of instruments. You can get these without prayer. In fact, it would be disrespectful to pray about such rubbish. But you cannot get the Holy Spirit without prayer. Like the wind, He goes where He wishes. He will not be brought near by any process or method apart from asking. Furthermore, there are no mechanical means that will make up for His absence. Prayer is the great door of spiritual blessing, and if you close it, you shut out His favor.

The Privilege of Prayer

Beloved believers, do you not think that this asking that God requires is a very great privilege? Suppose there were a law passed that you must not pray. That would be a hardship indeed. If prayer were to interrupt rather than increase the stream of blessing, it would be a sad calamity.

Have you ever seen a mute person very excited or suffering great pain and, therefore, wanting desperately to speak? It is a terrible sight to see. The face is distorted; the body is fearfully agitated. The mute writhes in dire distress. Every limb is contorted with a desire to help the tongue, but it cannot break its bonds. Hollow sounds come from the breast, and ineffective stutterings awaken some attention, although they cannot reach as far as articulated words. The poor creature is in unspeakable pain.

Suppose our spiritual nature were full of strong desires, yet we were unable to pray. I think it would be one of the worst afflictions that could possibly befall us. We would be terribly maimed and dismembered, and our agony would be overwhelming. Blessed be His name; the Lord ordains a way of expression, and He bids our hearts to speak to Him.

Beloved, we must pray. It seems to me that it ought to be the first thing we ever think of doing when in need. If people were right with God and loved Him truly, they would pray as naturally as they breathe. I hope some of us are right with God and do not need to be driven to prayer. I hope prayer has become an instinct for some of us.

Recently I was told a story about a little German boy. The dear little child believed his God, and he delighted in prayer. His schoolteacher had urged the students to be at school on time, and this child always tried to be. But his parents were leisurely people. One morning, through their fault alone, he had just left the door as the clock struck the hour for school to open. A friend standing nearby heard the little one cry, "Dear God, please help me to be on time for school." It struck the friend that for once prayer could not be heard, for the child had quite a walk ahead of him, and the hour had already come. He was curious to see the result.

Now, it so happened that on this particular morning, the teacher, in trying to open the classroom door, turned the key the wrong way. The lock was stuck, and they had to send for a locksmith to open the door. It was the needed delay! Just as the door

opened, our little friend entered with the rest of the children, all in good time.

God has many ways of granting right desires. It was most natural that, instead of crying and whining, a child who really loved God should speak to Him about his trouble. Should it not be natural to us to spontaneously and immediately tell the Lord our sorrows and ask for help? Should this not be the first resort, instead of the last?

Alas, according to Scripture and observation, and I grieve to add, according to my own experience, prayer is often the last resort. Look at the sick man in Psalm 107. Friends bring him various foods, but his soul *"abhorreth all manner of meat"* (v. 18). The physicians do what they can to heal him, but he grows worse and worse. He draws *"near unto the gates of death"* (v. 18). Finally, he cries to the Lord in his trouble (v. 19). He puts last what he should put first.

"Send for the doctor. Prepare him nourishment. Wrap him in blankets!" All very well, but when will you pray to God? God will be called on when the case grows desperate.

Look at the sailors described in the same psalm. Their ship is very close to being wrecked. *"They mount up to the heaven, they go down again to the depths: their soul is melted because of trouble"* (v. 26). Still they do all they can to ride out the storm. But when *"they reel to and fro, and stagger like a drunken man, and are at their wit's end,"* then *"they cry unto the LORD in their trouble"* (vv. 27–28).

Oh yes, we seek God when we are driven into a corner and are ready to perish. What a mercy that He hears such delayed prayers and delivers the suppliants out of their troubles! But should it be this way with you and with me and with churches of Christ? Should not the first impulse of a declining church be to say, "Let us pray day and night until the Lord blesses us. Let us meet together *'with one accord in one place'* (Acts 2:1) and never separate until the blessing descends on us"?

Prayers Abundantly Answered

Do you know, believers, what great things are to be had for the asking? Have you ever thought about it? Does it not motivate you to pray fervently? All of heaven lies within the grasp of the asking

individual. All the promises of God are rich and inexhaustible, and their fulfillment is to be had by prayer. Jesus said, *"All things are delivered unto me of my Father"* (Matt. 11:27), and Paul said, *"All things are yours...and ye are Christ's"* (1 Cor. 3:21, 23). Who would not pray when all things are handed over to us like this? Promises that were first made to specific individuals are also made to us if we know how to plead them in prayer. For example, only Jacob was present at Peniel, yet Hosea used the word *us* in referring to the experience: *"There he spake with us"* (Hos. 12:4). Israel went through the Red Sea ages ago, yet the word *we* is used in the sixty-sixth Psalm: *"There did we rejoice in him"* (v. 6).

When Paul wanted to give us a great promise for times of need, he used these words: *"For he hath said, I will never leave thee, nor forsake thee"* (Heb. 13:5). Where did Paul get that verse? It was the assurance that the Lord gave to Joshua: *"I will not fail thee, nor forsake thee"* (Josh. 1:5). You may think, "Surely the promise was for Joshua only." No, it is for us. *"No prophecy of the scripture is of any private interpretation"* (2 Pet. 1:20). All Scripture is ours.

See how God appeared to Solomon at night and said, *"Ask what I shall give thee"* (1 Kings 3:5). Solomon asked for wisdom. "Oh, that is Solomon," you say. Read this: *"If any of you lack wisdom, let him ask of God"* (James 1:5). In addition, God gave Solomon wealth and fame in the bargain. Is that unique to Solomon? No, for it is said of true wisdom, *"Length of days is in her right hand; and in her left hand riches and honour"* (Prov. 3:16). This is very similar to our Savior's promise: *"Seek ye first the kingdom of God, and his righteousness; and all these things shall be added unto you"* (Matt. 6:33).

Do you see that the Lord's promises have many fulfillments? They are waiting now to pour their treasures into the lap of those who pray. God is willing to repeat the biographies of His saints in us. He is waiting to be gracious and to load us with His benefits (Ps. 68:19). Does this not lift prayer up to a high level?

Here is another truth that ought to make us pray: If we ask, God will give us much more than we ask. When God promised Abraham that He would give him a child through Sarah, Abraham asked God to bless Ishmael: *"O that Ishmael might live before thee!"* (Gen. 17:18). Abraham thought, "Surely this is the promised child. I cannot expect that Sarah will bear a child in her old age. God has promised me a child, and surely it must be this child of

Hagar. *'O that Ishmael might live before thee.'"* God granted him that, but He gave him Isaac as well, and all the blessings of the covenant.

Then there was Jacob. When he knelt down at Bethel to pray, he asked the Lord to give him food to eat and clothes to put on as he continued on his journey. But what did his God give him? When he came back to Bethel several years later, his family and possessions were divided into two large groups. He had thousands of sheep and camels, as well as much wealth. God had heard him and had done immeasurably more than he had asked.

David said of himself, "[The king] *asked life of thee, and thou gavest it him, even length of days for ever and ever"* (Ps. 21:4). Yes, God gave him not only length of days himself, but a throne for his sons throughout all generations. When God told David that his throne would be established forever, he went and sat before the Lord, overpowered with the Lord's goodness.

"Well," you may be saying, "did this concept of getting more than we ask work for New Testament believers?" Yes, it also worked for New Testament suppliants, whether saints or sinners. When a paralytic was brought to Jesus for Him to heal, Jesus said, *"Son...thy sins be forgiven thee"* (Matt. 9:2). The man had not asked for forgiveness, had he? No, but God gives greater things than we ask for!

Hear that poor dying thief's humble prayer, *"Lord, remember me when thou comest into thy kingdom"* (Luke 23:42). Jesus replied, *"To day shalt thou be with me in paradise"* (v. 43). He had not dreamed of such an honor.

Even the story of the Prodigal Son teaches us about God's abundant giving. The Prodigal Son had resolved to say, "I *'am no more worthy to be called thy son; make me as one of thy hired servants'* (Luke 15:19)." What was his father's answer?

> *Bring forth the best robe, and put it on him; and put a ring on his hand, and shoes on his feet...for this my son was dead, and is alive again.* (Luke 15:22, 24)

Get into the position of a petitioner, and you will have what you never asked for and never thought of. People often misquote Ephesians 3:20. They say, "God *'is able to do exceeding abundantly above all that we* [can] *ask or think.'"* The truth is that we *could* ask for the very greatest of things, if we were only more alert and had more

127

faith. Ephesians 3:20 really says that God *"is able to do exceeding abundantly above all that we* [do] *ask or think."* God is willing to give us infinitely more than we actually do ask.

John's Picture of Prayer

I believe that God's church could have inconceivable blessings at this moment if she were only ready to pray. Did you ever notice that wonderful portrayal of prayer in the eighth chapter of the book of Revelation? It is worthy of careful notice.

As John was receiving the remarkable vision of the last times, God gave him this special picture of prayer. It begins in this way: *"When* [the Lord] *had opened the seventh seal, there was silence in heaven about the space of half an hour"* (Rev. 8:1). There was silence in heaven. There were no anthems, no hallelujahs; not an angel stirred a wing. Silence in heaven! Can you imagine it? Then seven angels stood before God, and to them were given seven trumpets. There they waited, trumpet in hand, but there was not a sound. Not a single note of cheer or warning during an interval that was long enough to provoke lively emotion, but short enough to prevent impatience. Silence unbroken, profound, awe-inspiring, reigned in heaven. Action was suspended in heaven, the center of all activity.

"And another angel came and stood at the altar, having a golden censer" (v. 3). There he stood, but no offering was presented. Everything had come to a standstill. What could possibly set it in motion? Prayer could. Prayer was presented together with the merit of the Lord Jesus:

> *And there was given unto him much incense, that he should offer it with the prayers of all saints upon the golden altar which was before the throne.* (Rev. 8:3)

Now, notice what happened. *"And the smoke of the incense, which came with the prayers of the saints, ascended up before God out of the angel's hand"* (v. 4). Prayer was the key to the whole matter. Now the angel began to work.

> *And the angel took the censer, and filled it with fire of the altar, and cast it into the earth; and there were voices, and thunderings, and lightnings, and an earthquake. And the*

seven angels which had the seven trumpets prepared them-
selves to sound. (Rev. 8:5–6)

Everything was now moving. As soon as the prayers of the saints were mixed with the incense of Christ's eternal merit and began to ascend from the altar, then prayer became effective. Down fell the living coals among the people on earth. The angels of divine providence, who had stood still before, blew their trumpets. The will of the Lord was done.

Such is the scene in heaven, to a certain degree, even today. Bring the incense! Bring the prayers of the saints! Set them on fire with Christ's merits. On the golden altar let them smoke before the Most High. Then we will see the Lord at work. The will of the Lord will *"be done in earth, as it is in heaven"* (Matt. 6:10).

May God send His blessing with these words for Christ's sake.

3

Real Prayer

*Call upon me in the day of trouble: I will
deliver thee, and thou shalt glorify me.*
—*Psalm 50:15*

One book charmed me when I was a boy. *Robinson Crusoe* was a wealth of wonders to me. I could have read it twenty times and never grown tired of it. I am not ashamed to confess that I can read it even now with ever fresh delight.

Robinson and his trusted aide Friday, though mere inventions of fiction, are wonderfully real to me, and to many who have read their story. But why am I going on and on about a work of fiction? Is this subject altogether out of place? I hope not. A passage in that book comes vividly to my mind as I contemplate our text, and in it I find more than an excuse to write on this subject.

Robinson Crusoe had been shipwrecked. All alone on a desert island, he was in a very miserable condition. He went to bed and was afflicted with a fever. This fever lasted a long time, and he had no one to help him—no one even to bring him a drink of cold water. He was ready to die.

He was accustomed to sin and had all the vices of an evil sailor, but his hard case caused him to think. Opening a Bible that he had found in his sea chest, he stumbled upon this passage: *"Call upon me in the day of trouble: I will deliver thee, and thou shalt glorify me."* That night he prayed for the first time in his life, and ever after that, he had a hope in God.

Daniel Defoe, the author of the book, was a Presbyterian minister. Though not overly spiritual, he knew enough of faith to be able to describe very vividly the experience of a person who is in

despair but finds peace by casting himself upon God. As a novelist, he had a keen eye for the probable, and he could think of no passage more likely to impress a poor broken spirit than this. Instinctively, he perceived the wealth of comfort that lies within the words of Psalm 50:15.

Now I know I have your attention, and that is one reason that I began the chapter this way. But I have a further purpose. Although Robinson Crusoe was not a real person, nor was Friday, there may be some reader very much like him, a person who has suffered shipwreck in life and has now become a drifting, solitary creature. He remembers better days, but by his sins, he has become a castaway for whom no one seeks. He is reading this book, washed up on shore without a friend, suffering in body and crushed in spirit. In a city full of people, he does not have a friend. There is no one who would wish to admit that he has ever known him. He has come to the bare bones of existence now. Nothing lies before him but poverty, misery, and death.

The Lord says to you, my friend, *"Call upon me in the day of trouble: I will deliver thee, and thou shalt glorify me."* I have the feeling that I am writing directly, God helping me, to some poor burdened spirit. Of what use is comfort to those who are not in distress? The words of this chapter will be of no help and may have little interest to those who have no distress of heart. But however poorly I may write, those hearts that need the cheering assurance of a gracious God will dance for joy. Sad hearts will be enabled to receive assurance as it shines forth in this golden text: *"Call upon me in the day of trouble: I will deliver thee, and thou shalt glorify me."*

It is a text that I want to write in stars across the sky or proclaim with the blowing of a trumpet from the top of every tower. It should be known and read by all mankind.

Four important concepts suggest themselves to me. May the Holy Spirit bless what I am able to write about them!

BEING REAL BEFORE GOD

My first observation is not so much in my text alone as it is in the context. The observation is this: God prefers realism to ritualism. If you will carefully read the entire psalm, you will see that the Lord is speaking of the rituals and ceremonies of Israel. He is

showing that He cares little about formalities of worship when the heart is absent from them. Here are several key verses that illustrate this:

> *I will not reprove thee for thy sacrifices or thy burnt offerings, to have been continually before me. I will take no bullock out of thy house, nor he goats out of thy folds. For every beast of the forest is mine, and the cattle upon a thousand hills. I know all the fowls of the mountains: and the wild beasts of the field are mine. If I were hungry, I would not tell thee: for the world is mine, and the fulness thereof. Will I eat the flesh of bulls, or drink the blood of goats? Offer unto God thanksgiving; and pay thy vows unto the most High: and call upon me in the day of trouble: I will deliver thee, and thou shalt glorify me.* (Ps. 50:8–15)

Thus, praise and prayer are accepted in preference to every form of offering that the Jew could possibly present before the Lord. Why is this?

Real Prayer Has Meaning

First of all, real prayer is far better than mere ritual because there is meaning in it. When grace is absent, there is no meaning in ritual. It is as senseless as a fool's game.

Did you ever stand in a Roman Catholic cathedral and watch the daily service, especially if it happened to be on a holiday? There are those who carry candlesticks, those who carry crosses, those who carry cushions and books, those who ring bells, those who sprinkle water, those who bob their heads, and those who bow their knees. The whole scene is very strange to look at—very amazing, very childish. One wonders, when he sees it, what it is all about, and what kind of people are really made better by it. One wonders also what idea Roman Catholics must have of God if they imagine that He is pleased with such performances. What must His glorious mind think of it all?

The glorious God cares nothing for pomp and show. But when you call upon Him in the day of trouble and ask Him to deliver you, there is meaning in your groan of anguish. This is no empty formality. There is heart in it, is there not? There is meaning in the sorrowful appeal. Therefore, God prefers the prayer of a broken

heart to the finest service that was ever performed by priests and choirs.

Real Prayer Has Spiritual Life

Why does God prefer realism to ritualism? It is for this reason also: There is something spiritual in the cry of a troubled heart. *"God is a Spirit: and they that worship him must worship him in spirit and in truth"* (John 4:24). Suppose I were to repeat the finest creed that was ever composed by learned and orthodox men. Yet if I had no faith in it, and you had none, what would be the use of repeating the words? There is nothing spiritual in mere orthodox statements if we have no real belief in them. We might as well repeat the alphabet and call it devotion. If I were to burst forth in the grandest hallelujah that was ever uttered by mortal lips, but I did not mean it, there would be nothing spiritual in it, and it would mean nothing to God.

However, when a poor soul gets away into his bedroom and bows his knee and cries, "God be merciful to me! God save me! God help me in this day of trouble!" there is spiritual life in such a cry. Therefore, God approves it and answers it. Spiritual worship is what He wants, and He will have it or have nothing. John 4:24 uses the word *must*: *"They that worship him must worship him in spirit and in truth."* He has abolished the ceremonial law, destroyed the one altar at Jerusalem, burned the temple, abolished the Aaronic priesthood, and ended forever all ritualistic performance. He seeks only true worshipers, who worship Him in spirit and in truth.

Real Prayer Recognizes God

Furthermore, the Lord loves the cry of the broken heart because it distinctly recognizes Him as the living God, truly sought after in prayer. From much of outward devotion God is absent. But how we mock God when we do not discern Him as present and do not come near to the Lord Himself! When the heart or the mind or the soul breaks through itself to get to its God, then God is glorified. But He is not glorified when we merely perform ritualistic exercises and forget about Him. Oh, how real God is to a person who is perishing and feels that only God can save him! He truly believes

that God exists, or else he would not make so passionate a prayer to Him. When he said his prayers before, he cared little whether God heard or not. But he genuinely prays now, and God's hearing is his chief concern.

Real Prayer Has Sincerity

In addition, dear friends, God takes great delight in our crying to Him in the day of trouble because there is sincerity in it. I am afraid that in the hour of our mirth and in the day of our prosperity, many of our prayers and our thanksgivings are hypocrisy. Too many of us are like spinning tops—we do not move into action unless we are whipped. Certainly we pray with deep intensity when we get into deep trouble.

Take, for instance, a man who is very poor. He has lost his job. He has worn out his shoes in trying to find work. He does not know where the next meal is coming from for his children. If he prays in this situation, it is likely to be a very sincere prayer. He would be in real earnest because of real trouble.

I have sometimes wished that very comfortable Christians, who seem to treat religion as if it were a bed of roses, could have just a little time of "roughing it" and really come into actual difficulties. A life of ease breeds hosts of falsehoods and pretenses, which would soon vanish in the presence of matter-of-fact trials.

Many a man has been converted to God by hunger, weariness, and loneliness, who, when he was a wealthy man, surrounded by frivolous flatterers, never thought of God at all. Many a man on board a ship out on the ocean has learned to pray in the cold chill of an iceberg, or in the horrors of a tidal wave out of which the ship could not rise. When the mast has gone by the board and every timber has been strained and the ship has seemed doomed, then hearts have begun to pray in sincerity.

God loves sincerity. When we mean it; when the soul melts in prayer; when we say, "I must have it or be lost"; when it is no sham, no vain performance, but a real heartbreaking, agonizing cry; then God accepts it. That is why He says, *"Call upon me in the day of trouble."* Such a cry is the kind of worship that He cares for, because there is sincerity in it, and this is acceptable with the God of truth.

Real Prayer Has Humility

Furthermore, in the cry of the troubled one, there is humility. We may go through a highly brilliant performance of religion, following the rites of some showy church—or we may go through our own rites, which may be as simple as they can be—and we may all the while be saying to ourselves, "This is very nicely done." The preacher may be thinking, "Am I not preaching well?" The believer at the prayer meeting may think within himself, "How delightfully fluent I am!" Whenever there is that attitude in us, God cannot accept our worship. Worship is not acceptable if it is devoid of humility.

On the other hand, when a person goes to God in the day of trouble and says, "Lord, help me! I cannot help myself, but do intervene for me," there is humility in that confession and cry. Therefore, the Lord takes delight in that prayer.

Real Prayer Has Faith

The Lord loves such pleadings because there is a measure of faith in them. When the person in trouble cries, "Lord, deliver me!" he is looking away from himself. You see, he is driven out of himself because of the despair in his life. He cannot find hope or help on earth; therefore, he looks toward heaven.

God loves to discover even a shadow of faith in an unbelieving person. God can spy out even a small trace of faith, and He can and will accept prayer for the sake of that little faith.

Oh, dear heart, what is your condition? Are you torn with anguish? Are you sorely distressed? Are you lonely? Are you pushed aside? Then cry to God. No one else can help you. He is your only hope. Wonderful hope! Cry to Him, for He can help you. I tell you, in that cry of yours will be the pure and true worship that God desires. He desires a sincere cry far more than the slaughter of ten thousand rams or the pouring out of rivers of oil (Mic. 6:7). We undoubtedly find in Scripture that the groan of a burdened spirit is among the sweetest sounds that are ever heard by the ear of the Most High. Woeful cries are anthems with Him, to whom all mere arrangements of sound must be like child's play.

See then, poor, weeping, and distracted ones, that it is not ritualism, it is not the performance of pompous ceremonies, it is not

135

bowing and struggling, it is not using sacred words, but it is crying to God in the hour of trouble that is the most acceptable sacrifice your spirit can bring before the throne of God.

HOW TO TAKE ADVANTAGE OF ADVERSITY

I now come to my second observation. In our text, *"Call upon me in the day of trouble: I will deliver thee,"* we have adversity turned into advantage. What a wonderful truth! May God impress it on us all!

I write this with all reverence: God Himself cannot deliver a person who is not in trouble. Therefore, it is to some advantage to be in distress, because God can then deliver you. Even Jesus Christ, the Healer of men, cannot heal a person who is not sick. Therefore, sickness is not an adversity for us, but rather an advantageous opportunity for Christ to heal us.

The point is, my reader, your adversity may prove your advantage by offering occasion for the display of divine grace. It is wise to learn the art of making lemonade out of lemons, and the text teaches us how to do that. It shows how trouble can become gain. When you are in adversity, then call upon God, and you will experience a deliverance that will be a richer and sweeter experience for your soul than if you had never known trouble. It is an art and a science to make gains out of losses, and advantages out of adversities.

Now, let me suppose that there is someone among my readers who is in trouble—perhaps another deserted Robinson Crusoe. I am not idly supposing that there is a tried individual among my readership; I know there is.

Well now, when you pray—and, oh, I wish you would pray now—do you not see what a basis for prayer you have? First, you have a basis in the very time you are in: *"the day of trouble."* You can plead, "Lord, this is a day of trouble! I am in great affliction, and my case is urgent!" Then state what your trouble is—a sick wife, a dying child, a bankrupt business, your failing health, or poverty staring you in the face. Say unto the Lord of mercy, "My Lord, if ever a person was in a day of trouble, I am. Therefore, I take the liberty and license to pray to You now because You have said, *'Call upon me in the day of trouble.'* This is the hour that You have appointed for appealing to You: this dark, stormy day. If ever

there was a person who had a right to pray according to Your own Word, I do, for I am in trouble. Therefore, I will make use of the very time I am in as a plea with You. Do, I entreat You, hear Your servant's cry in this midnight hour."

Furthermore, turn your adversity into advantage by pleading God's command. You can go to the Lord now, at this precise instant, and say, "Lord, do hear me, for You have commanded me to pray! I, though I am evil, would not tell someone to ask me for something if I intended to deny him. I would not urge him to ask for help if I meant to refuse it."

Do you not know, friends, that we often impute to the Lord conduct that we would be ashamed of in ourselves? This must not be. Suppose you said to a poor person, "You are in very sad circumstances. Write to me tomorrow, and I will help you." If he did write to you, you would not treat his letter with contempt. You would be bound to consider his case. When you told him to write, you meant that you would help him if you could. And when God tells you to call upon Him, He does not mock you. He means that He will deal kindly with you.

I do not know who you are, but you may call upon the Lord, for He bids you to call. If you do call upon Him, you can put this argument into your prayer:

> Lord, Thou hast bid me seek Thy face,
> And shall I seek in vain?
> And shall the ear of sovereign grace
> Be deaf when I complain?

So plead the time, plead the trouble, and plead the command. Then, plead God's own character. Speak with Him reverently, but believingly, in this fashion: "Lord, it is You Yourself to whom I appeal. You have said, *'Call upon me.'* If my neighbor would tell me to do so, I might fear that perhaps he would change his mind and not hear me. But You are too great and too good to change. Lord, by Your truth and by Your faithfulness, by Your immutability and by Your love, I, a poor sinner, heartbroken and crushed, call upon You in the day of trouble! Oh, help me, and help me soon, or else I will die!"

Surely you who are in trouble have many, mighty pleas. You are on firm ground with the God of the covenant, and you may bravely seize the blessing. I do not feel as if the text is encouraging

me half as much as it will encourage those of my readers who are in trouble. Although I thank God that I am full of joy and rest right now, I am half inclined to see if I can dig up a little bit of trouble for myself. Surely if I were in trouble, I would open my mouth and drink in this text. I would pray like David or Elijah or Daniel with the power of this promise: *"Call upon me in the day of trouble: I will deliver thee, and thou shalt glorify me."*

Oh, you troubled ones, leap up at the sound of this promise! Believe it. Let it go down into your souls. *"The LORD looseth the prisoners"* (Ps. 146:7). He has come to loose you.

I can see my Master arrayed in His silk garments. His countenance is as joyous as heaven, His face is as bright as a morning without clouds, and in His hand He holds a silver key. "Where are you going, my Master, with that silver key of Yours?" I ask. "I go," He says, "to open the door of the captive and to loosen everyone who is bound."

Blessed Master, fulfill Your errand, but do not pass by the prisoners of hope! We will not hinder You for a moment, but do not forget these mourners! Go to the heart of every reader, and set free the prisoners of despair. Make their hearts sing for joy by delivering them in the day of trouble after they have called upon You. Because of Your merciful deliverance, they will glorify You!

GOD PROMISES GRACE

My third topic, God's vow, is clearly found in our text, Psalm 50:15. Here we have free grace vowed to us.

Nothing in heaven or earth can be freer than grace. In our wonderful text, God's grace is promised by a vow or covenant. Listen to God's definite promise to deliver us: *"Call upon me in the day of trouble: I will deliver thee."*

If a person once says to you, "I will," you hold him to his promise. He has placed himself at the command of his own declaration. If he is a true man and has plainly said, "I will," you have him in your hand. He was free before giving the promise, but he is not free after giving it. He has put himself in a certain position, and he must act according to what he has promised. Is this not true?

With the deepest reverence, I say the same things about my Lord and Master. He has bound Himself in the text with cords that He will not break. He must now hear and help those who call upon

Him *"in the day of trouble."* He has solemnly promised, and He will fully perform His vow.

Notice that our text is unconditional in that it applies to everyone. It contains the gist of another promise that we will discuss in the next chapter: *"Whosoever shall call upon the name of the Lord shall be saved"* (Rom. 10:13).

Remarkably, Psalm 50:15 was originally written to those who had mocked God. They had presented their sacrifices without a true heart. Yet the Lord said to each of them, *"Call upon me in the day of trouble: I will deliver thee."*

I gather from this that God excludes none from the promise. You atheist, you blasphemer, you immoral and impure one, if you call upon the Lord now, in the day of your trouble, He will deliver you! Come and try Him.

Do you say, "If there is a God"? I declare that there is a God. Come, put Him to the test and see. He says, *"Call upon me in the day of trouble: I will deliver thee."* Will you not test Him now and find Him true? Come here, you enslaved ones, and see if He does not free you! Come to Christ, all of you who labor and are burdened down, and He will give you rest (Matt. 11:28)! In both temporal and spiritual things, but especially in spiritual things, call upon Him in the day of trouble, and He will deliver you.

Moreover, notice that this *"I will"* includes all the power that may be required for deliverance. *"Call upon me in the day of trouble: I will deliver thee."* "But how can this be?" one cries. Ah, that I cannot tell you, and I do not feel bound to tell you. It rests with the Lord to find suitable ways and means. God says, *"I will."* Let Him do it in His own way. If He says, *"I will,"* you can be sure that He will keep His word. If it is necessary to shake heaven and earth, He will do it. He cannot lack power, and He certainly does not lack honesty. An honest man will keep his word at all costs, and so will our faithful God. Hear Him say, *"I will deliver thee,"* and ask no more questions.

I do not suppose that Daniel knew how God would deliver him out of the den of lions. I do not suppose that Joseph knew how he would be delivered out of prison when his master's wife had slandered his character so shamefully. I do not suppose that these ancient believers even dreamed of the way of the Lord's deliverance. They just left themselves in God's hands. They rested on God, and He delivered them in the best possible manner. He will do the same

for you. Simply call upon Him, and then *"stand still, and see the salvation of the LORD"* (Exod. 14:13).

Notice, the text does not say exactly when God will bring deliverance. *"I will deliver thee"* is plain enough, but whether it will be tomorrow or next week or next year is not so clear. You are in a great hurry, but the Lord is not. Your trial may not have yet worked all the good for you that it was sent to do, and therefore it must last longer. When the gold is cast into the refiner's fire, it might cry to the goldsmith, "Let me out." "No," he says, "you have not yet lost your dross. You must wait in the fire until I have purified you."

God may likewise subject us to many trials. Yet if He says, *"I will deliver thee,"* you can be sure that He will keep His word. When you get God's *"I will,"* you may always cash it by faith. God's promise for the future is a bona fide offer for the present, if you simply have faith to use it. *"Call upon me in the day of trouble: I will deliver thee"* is tantamount to deliverance already received. It means, "If I do not deliver you now, I will deliver you at a time that is better than now. You would prefer to be delivered at this future time rather than now if you were as wise as I am."

Promptness is implied in God's promise of deliverance, for a late deliverance is not truly deliverance. "Ah," someone says, "I am in such trouble that if I do not get deliverance soon I will die of grief." Rest assured that you will not die of despair. You will be delivered before you die that way. God will deliver you at the best possible time.

The Lord is always punctual. You never were kept waiting by Him. You have kept Him waiting many times, but He is prompt to the instant. He never keeps His servants waiting one single tick of the clock beyond His own appointed, fitting, wise, and proper moment. *"I will deliver thee"* implies that His delays will not be too long, lest the spirit of man should fail because of hope deferred. The Lord rides on the wings of the wind when He comes to the rescue of those who seek Him. Therefore, be courageous!

Oh, this is a blessed text! But, unfortunately, I cannot carry it to those of you who need it most. Spirit of the living God, come, and apply these rich consolations to those hearts that are bleeding and ready to die!

As I repeat our text, take special note of the words *I* and *thee*: *"Call upon me in the day of trouble: I will deliver thee."* Those two words are threaded together: *"I will deliver thee."* Men would not,

angels could not, but God will. God Himself will rescue the person who calls upon Him. Your part is to call; God's part is to answer. Poor trembler, do you begin to try to answer your own prayers? Why did you pray to God then? When you have prayed, leave it to God to fulfill His own promise. He says, "Do call upon Me, and I will deliver you."

Especially ponder that word *thee*: *"I will deliver thee."* I know what you are thinking, reader. You murmur, "God will deliver everybody, I believe, but *not me*." But the text says, *"I will deliver thee."* It is the person who calls who will get the answer. If you call upon God, He will answer *you*. To *you* He will give the blessing, even to your own heart and spirit, in your own experience. Oh, for grace to take that personal pronoun and apply it personally to our own souls! Oh, to make sure of the promise as though we could see it with our own eyes!

The apostle wrote, *"Through faith we understand that the worlds were framed by the word of God"* (Heb. 11:3). I know beyond the shadow of a doubt that the worlds were made by God. I am sure of it. Yet I did not see Him making them. I did not see the light appear when He said, *"Let there be light"* (Gen. 1:3). I did not see Him divide the light from the darkness (v. 4) and gather the waters together so that the dry land appeared (v. 9). Yet I am quite sure that He did all this. Even though I was not there to see God make even a bird or a flower, all the evolutionists in the world cannot shake my conviction that God created the world.

Why should I not have the same kind of faith about God's answer to my prayer in my time of trouble? If I cannot see how He will deliver me, why should I wish to see it? He created the world well enough without my being there and knowing how He would do it, and He will deliver me without my having a finger in it. It is no business of mine to see how He works. My business is to trust in my God and to glorify Him by believing that what He has promised, He is able to perform (Rom. 4:21).

TAKING TURNS WITH GOD

We have had three sweet things to remember, and I will close this chapter with a fourth. It is this: both God and the praying person have parts to play in this process.

That is an odd idea to close with, but I want you to notice it. First, here is your part: *"Call upon me in the day of trouble."* Next is God's part: *"I will deliver thee."* Again, you take another part in that you are delivered and in that you praise Him for it: *"Thou shalt glorify me."* Then, the Lord takes the last part in that He receives the glory. Here is an agreement, a covenant that God enters into with those who pray to Him and are helped by Him. He says, "You will have the deliverance, but I must have the glory. You will pray, I will bless, and then you will honor My holy name." Here is a delightful partnership: we obtain what we so greatly need, and all that God asks is the glory that is due unto His name.

Poor troubled heart! I am sure you do not object to these terms. "Sinners," says the Lord, "I will give you pardon, but you must give Me the honor for it." Our only answer is, "Yes, Lord, that we will, forever and ever."

> Who is a pardoning God like Thee?
> Or who has grace so rich and free?

"Come, souls," He says, "I will justify you, but I must have the glory for it." And our answer is, *"Where is boasting then? It is excluded. By what law? of works? Nay: but by the law of faith"* (Rom. 3:27). God must have the glory if we are justified by Christ.

"Come," He says, "I will put you into My family, but My grace must have all the glory." And we say, "Yes, that it will, good Lord! *'Behold, what manner of love the Father hath bestowed upon us, that we should be called the sons of God'* (1 John 3:1)."

"Now," He says, "I will sanctify you and make you holy, but I must have the glory for it." And our answer is, "Yes, we will sing this song forever: 'We have washed our robes and made them white in the blood of the Lamb (Rev. 7:14). Therefore, we will serve Him day and night in His temple (v. 15), giving Him all praise.'"

"I will take you home to heaven," God says. "I will deliver you from sin and death and hell, but I must have the glory for it." "Truly," we say, "You will be magnified. Forever and forever we will sing, *'Blessing, and honour, and glory, and power, be unto him that sitteth upon the throne, and unto the Lamb for ever and ever'* (Rev. 5:13)."

Stop, you thief! Where are you going? Running away with a portion of God's glory? A person who would steal God's glory must be quite a villain! Take, for example, a man who was recently an

alcoholic. God has loved him and made him sober, but he takes the credit and is extremely proud of his sobriety. What foolishness! Stop it, mister! Stop it! Give God the glory for your deliverance from the degrading vice, or else you are still degraded by ingratitude.

Take another man as an example. He used to swear, but he has been praying now. He even delivered a sermon the other night, or at least a personal testimony. He has been as proud as a peacock about this. Oh, bird of pride, when you look at your fine feathers, remember your black feet and your hideous voice! Oh, reclaimed sinner, remember your former character, and be ashamed! Give God the glory if you have ceased to use profane language. Give God the glory for every part of your salvation.

"I will deliver thee"—that is your share to receive. But *"Thou shalt glorify me"*—that is God's share, and His only. He must have all the honor from first to last.

Go out, you saved ones, and proclaim what the Lord has done for you. An aged woman once said that if the Lord Jesus Christ really would save her, He would never hear the last of her praise. Join with her in that resolution. Truly, my soul vows that my delivering Lord will never hear the last of my praise.

> I'll praise Him in life, and praise Him in death,
>> And praise Him as long as He lendeth me breath;
> And say when the death-dew lies cold on my brow,
>> "If ever I loved Thee, my Jesus, 'tis now."

Come, poor soul, you who are in the deepest of trouble—God means to glorify Himself by you! The day will yet come when you will comfort other mourners by telling your happy experience. The day will yet come when you who were outcasts will preach the Gospel to outcasts. The day will yet come, poor fallen woman, when you will lead other sinners to the Savior's feet where you now stand weeping! You who have been abandoned by the Devil, whom even Satan is tired of, whom the world rejects because you are worn-out and stale—the day will yet come when, renewed in heart and washed in the blood of the Lamb, you will shine like a star in the sky, to the praise of the glory of the grace of God, who has made you to be accepted in the Beloved (Eph. 1:6)!

Oh, desponding sinner, come to Jesus! Do call upon Him, I entreat you! Be persuaded to call upon your God and Father. If you

can do no more than groan, groan unto God. Drop a tear, heave a sigh, and let your heart say to the Lord, "O God, deliver me for Christ's sake! Save me from my sin and the consequences of it." As surely as you pray this way, He will hear you and say, "Your sins are forgiven. Go in peace." May it be so for you today, my friend.

4

Grace Guaranteed

*And it shall come to pass, that whosoever shall call on
the name of the LORD shall be delivered.
—Joel 2:32*

*And it shall come to pass, that whosoever shall call on
the name of the Lord shall be saved.
—Acts 2:21*

If we want to understand the full meaning of Joel 2:32, let us first examine the circumstances at the time when Joel was writing. Vengeance was coming toward Judah at full speed. The armies of divine justice had been called forth for war. They ran like mighty men; they climbed the wall like men of war (Joel 2:7). They invaded and devastated the land, and they turned the land from being like the Garden of Eden into a desolate wilderness. All faces grew pale; the people were *"much pained"* (v. 6). The sun itself was dim, the moon was dark, and the stars withdrew themselves; furthermore, the earth quaked, and the heavens trembled (v. 10).

At such a dreadful time, when we might have least expected it, between the peals of thunder and the flashes of lightning was heard this gentle word: *"It shall come to pass, that whosoever shall call on the name of the LORD shall be delivered."*

Let us carefully read the verse in context:

*And I will show wonders in the heavens and in the earth,
blood, and fire, and pillars of smoke. The sun shall be turned
into darkness, and the moon into blood, before the great and
the terrible day of the LORD come. And it shall come to pass,*

145

> *that whosoever shall call on the name of the LORD shall be delivered.* *(Joel 2:30–32)*

In the worst times that can ever happen, salvation is still available. When day turns to night and life becomes death, when famine rules the land and the hope of man has fled, there still remains in God, in the person of His dear Son, deliverance to all who will call upon the name of the Lord.

We do not know what is going to happen. Looking into the future, I prophesy dark things. Even so, this light will always shine between the clouds: *"Whosoever shall call on the name of the LORD shall be delivered."*

At Pentecost, Peter set this passage in its place as a sort of morning star of gospel times. When the Spirit was poured out upon God's servants, and sons and daughters began to prophesy (Acts 2:16–17), it was clear that the wondrous time had come that had been foretold so long before (Joel 2:28). Then Peter, as he preached his memorable sermon, told the people, *"Whosoever shall call on the name of the Lord shall be saved,"* thus giving a fuller and more evangelical meaning to the word *"delivered."*

"Whosoever shall call on the name of the LORD shall be delivered"—from sin, death, and hell. He will, in fact, be so delivered as to be, in divine language, *"saved"*—saved from guilt, saved from the penalty and the power of sin, saved from the wrath to come.

These present gospel times are still the happy days in which *"whosoever shall call on the name of the Lord shall be saved."* In the year of grace, we have reached a day and an hour in which *"whosoever shall call on the name of the Lord shall be saved."* To you, at this moment, is this salvation sent. A dispensation of immediate acceptance was proclaimed at Pentecost, and it has never ceased. Its fullness of blessing has grown rather than dwindled. The sacred promise stands in all its certainty, fullness, and freeness; it has lost none of its breadth or length. *"Whosoever shall call on the name of the Lord shall be saved."*

I have nothing to write about in this chapter except the old, old story of infinite mercy meeting infinite sin; of free grace leading free will into better things; of God Himself appearing to undo man's ruin that he brought on himself; of God lifting man up by a great deliverance. May the Holy Spirit graciously aid me while I write of these things in simple terms.

The Need of All Mankind

First, there is something that every person needs. That something is deliverance, or salvation. It is the requisite of man wherever man is found. As long as there are people on the face of the earth, there will always be a need of salvation.

If we were to go into a large city, into its alleys and slums, we would think very differently of human need than we do when we simply come from our own quiet homes, step into our pews, and hear a sermon. The world is still sick and dying; it is still corrupted and rotting. The world is a ship in which the water is rising fast, and the vessel is sinking down into the deep of destruction. God's salvation is needed as much today as when it was preached in the days of Noah. God must step in and bring deliverance, or there remains no hope.

In Present Trouble

I have no doubt that many readers need deliverance from present trouble. If you are in much trouble and are very distressed, I invite you to take my text as your guide and believe that *"whosoever shall call on the name of the LORD shall be delivered."* You can be sure that in any form of distress—physical, mental, or whatever it may be—prayer is wonderfully available. As we saw in the previous chapter, God says, *"Call upon me in the day of trouble: I will deliver thee, and thou shalt glorify me"* (Ps. 50:15).

This promise will prove true whenever you come into a position of deep personal distress, whether of a physical kind, a financial kind, or any kind. When you do not know how to act, when you are bewildered and at your wits' end, when wave of trouble has followed wave of trouble until you are like a sailor in a storm who staggers to and fro, if you cannot help yourself because your spirit sinks and your mind fails, call upon God, call upon God, call upon God! Lost child in the woods, with the night fog thickening around you, ready to lie down and die, call upon your Father! Call upon God, troubled one, for *"whosoever shall call on the name of the LORD shall be delivered."*

In the last great Day, when all secrets are known, it will seem unnecessary that people ever spent their time in writing fictional stories, for the real stories of what God has done for those who

have cried to Him are infinitely more spectacular. If men and women could just tell in simple, natural language how God has come to their rescue in the hour of imminent distress, they would set the harps of heaven singing with new melodies. They would cause the hearts of saints on earth to glow with new love for God for His wonderful kindness to the children of men. *"Oh that men would praise the LORD for his goodness"* (Ps. 107:8)! Oh, that we could repeatedly remind ourselves of His great goodness during the night of our weeping!

In Future Trouble

Joel 2:32 also promises deliverance from future troubles. What is to happen in the future we do not know. We do know from the Word of God that *"the sun shall be turned into darkness, and the moon into blood"* (v. 31). God will show great wonders in the heavens and in the earth: blood, fire, and pillars of smoke. You will certainly need deliverance then. Fortunately, deliverance will still be near at hand.

God put this encouraging verse in the same chapter as some startling and tragic events in order to advise us that when the worst and most terrible convulsions occur, *"whosoever shall call on the name of the LORD shall be delivered."* The star Wormwood may fall (Rev. 8:11), but we will be saved if we call upon the name of the Lord. Plagues may be poured out, trumpets may sound, and judgments may follow one another as quickly as the plagues of Egypt, but *"whosoever shall call on the name of the LORD shall be delivered."*

While the need for deliverance will notably increase, the abundance of salvation will increase with it. You do not need to fear the direst of all wars, the bitterest of all famines, the deadliest of all plagues, because the Lord has pledged to deliver us if we call upon Him. This word of promise meets the most terrible of possibilities with a sure salvation.

In the Dreaded Last Hour

Yes, when your time comes to die, when to you the sun has turned into darkness, this text ensures deliverance in the dreaded last hour. Call upon the name of the Lord, and you will be saved.

Amid the pains of death and the gloom of departure, you will enjoy a glorious visitation, which will turn darkness into light and sorrow into joy. When you wake up amid the realities of eternity, you will not need to dread the Resurrection or the Judgment Day or the yawning mouth of hell. If you have called upon the name of the Lord, you will still be delivered. Though the unpardoned are thrust down to the depths of woe and the righteous are scarcely saved, you who have called upon the name of the Lord must be delivered. The promise stands firm, no matter what may be hidden in the great book of the future. God cannot deny or contradict Himself. He will deliver those who call upon His name.

A Sure Foundation

What is needed, then, is salvation. I do think, beloved believers, that those who preach the Word and long to save souls need to repeat very often this grand old truth about salvation for the guilty. We need to speak often about deliverance for all who call upon the name of the Lord. Sometimes we talk to friends about the higher life or about attaining high degrees of sanctity. All this is very proper and very good, but still the great fundamental truth is, *"Whosoever shall call on the name of the Lord shall be saved."*

We urge our friends to be sound in doctrine, to be certain about what they believe, and to understand the revealed will of God. This is also very proper. Even so, first and foremost is this elementary, all-important truth: *"Whosoever shall call on the name of the Lord shall be saved."* To this old foundational truth, we come back for comfort.

Sometimes I rejoice in the God of my salvation and spread my wings to mount up into communion with the heavenlies. However, there are other seasons when I hide my head in darkness. Then I am very glad for such a broad, gracious promise as this: *"Whosoever shall call on the name of the Lord shall be saved."*

I find that my sweetest, happiest, safest state is that of a poor, guilty, helpless sinner calling upon the name of the Lord and taking mercy from His hands, although I deserve nothing but His wrath. I am happy when I dare to hang the weight of my soul on such a sure promise as this: *"Whosoever shall call on the name of the Lord shall be saved."* No matter who you are, however high your experience, however great your usefulness, you will always

need to come back to the same ground on which the poorest and weakest of hearts must stand—the ground of salvation by almighty grace through simply calling upon the name of the Lord.

PRAYER: THE MEANS OF DELIVERANCE

Now, second, let us attentively observe the way in which this deliverance is to be obtained. Help us, blessed Spirit, in this meditation. Deliverance is to be realized, according to Joel 2:32, by calling upon the name of the Lord.

The most obvious meaning of this verse is that we are to pray. Are we not brought to the Lord by a trustful prayer, a prayer that asks God to give the needed deliverance and expects to receive it from Him as a gift of grace?

The words of Joel 2:32 amount to much the same thing as saying, "Believe and live." How can a person call upon God if he has not heard of Him (Rom. 10:14)? And if the person has heard, his calling will be in vain if he does not believe as well as hear.

To *"call on the name of the LORD"* is to pray a believing prayer—to cry to God for His help and to leave yourself in His hands. This is very simple, is it not? There is no cumbersome process here, nothing complex and mysterious. No priestly help is needed, except the help of our Great High Priest, who always intercedes for us (Heb. 7:25). A poor, broken heart pours its distress into the ear of God and calls upon Him to fulfill His promise to help in the time of need—that is all. I thank God that nothing more is mentioned in our texts. The promise is *"whosoever shall call on the name of the Lord shall be saved."*

To the One True God

Although obtaining deliverance is as simple as calling on the name of the Lord, Acts 2:21 contains within it a measure of specific instruction. First, the prayer must be to the true God. Whoever calls on the name of Jehovah will be saved. There is something distinctive here. Suppose one calls on Baal, another on Ashtoreth, and a third on Molech; none of these people would be saved. The promise is specific: *"Whosoever shall call on the name of the Lord [Jehovah] shall be saved."*

You know that triune name, "Father, Son, and Holy Spirit." Call upon it. You know how the name of Jehovah is set forth most conspicuously in the person of the Lord Jesus. Call upon Him. Call upon the true God. Call upon no idol, call upon no Virgin Mary, call upon no saint, living or dead. Call upon no impression of your mind! Call upon the living God, upon Him who reveals Himself in the Bible, upon Him who manifests Himself in the person of His dear Son. For whoever calls upon this God will be saved.

You may call upon the idols, but these will not hear you. *"Eyes have they, but they see not: they have ears, but they hear not"* (Ps. 115:5–6). You may call upon mere men to deliver you, but they are all sinners like you. Many call upon priests, but they cannot deliver their most zealous parishioners. But *"whosoever shall call on the name of the Lord* [Jehovah] *shall be saved."*

Notice that the key is not the mere repetition of a prayer as a sort of charm or a kind of religious witchcraft. You must make a direct address to God, an appeal to the Most High to help you in your time of need. In presenting true prayer to the true God, you will be delivered.

With Intelligence

Moreover, the prayer should be intelligently presented. Let us take a closer look at the words *the name* in the verse, *"Whosoever shall call on the name of the Lord."* Now, by the word *name* is meant the person, the character of the Lord. Therefore, the more you know about the Lord, and the better you know His name, the more intelligently you will call upon that name. If you know His power, you will call upon that power to help you. If you know His mercy, you will call upon that mercy to save you. If you know His wisdom, you will feel that He knows your difficulties and can help you through them. If you understand His immutability, you will call upon the same God who has saved other sinners to come and save you.

It would be wise, therefore, for you to study the Scriptures faithfully and to ask the Lord to manifest Himself to you so that you may know Him. To the degree that you are acquainted with Him, you will be able to call with confidence upon His name.

Little as you may know, call upon Him according to the little that you do know. Cast yourself upon Him, whether your trouble is external or internal, but especially if it is internal. If it is the trouble

of sin, if it is the burden of guilt, if it is a load of horror and fear because of wrath to come, call upon the name of the Lord, for you will be delivered.

Your deliverance is promised by God. The promise is not, "He may be delivered," but, "He '*shall be.*'" Note well the everlasting "*shall*" of God—irrevocable, unalterable, unquestionable, irresistible. His promise stands eternally the same. "*Hath he said, and shall he not do it?*" (Num. 23:19). Yes, He will do what He has said. "*Whosoever shall call on the name of the Lord shall be saved.*"

For God's Glory

This way of salvation—calling upon the name of the Lord—glorifies God. He asks nothing of you but that you ask everything of Him. You are the beggar, and He is the Benefactor. You are in trouble, and He is the Deliverer. All you have to do is to trust Him and ask Him. This is easy enough. This takes the matter out of your hands and puts it into the Lord's hands. Do you not like the plan? Put it into practice immediately! It will prove itself gloriously effective.

Dear friends, I am sure I write to some who are under severe trial. You are beginning to lose hope. Perhaps you have given up, or, at any rate, have given yourself up. Yet, I ask you, call upon the name of the Lord. You cannot perish praying; no one has ever done so. If you could perish praying, you would be a new wonder in the universe. A praying soul in hell is an utter impossibility. A man calling on God and rejected by God—the supposition is not to be endured! "*Whosoever shall call on the name of the Lord shall be saved.*"

God Himself would have to lie, deny His nature of love, forfeit His claim to mercy, and destroy the integrity of His character if He were to let a poor sinner call upon His name and yet refuse to hear him. There will come a day in the next state when He will say, "I called, but you refused," but that day is not now. While there is life, there is hope. "*To day if ye will hear his voice, harden not your heart*" (Ps. 95:7–8). Call upon God at once, for this guarantee of grace runs through all the regions of mortality. "*Whosoever shall call on the name of the Lord shall be saved.*"

I recollect a time when if I had heard a simple sermon on this subject, I would have leaped into comfort and light in a single

moment. Is it such a time with you? I used to think that I must *do* something, that I must *be* something, that I must in some way prepare myself for the mercy of God. I did not know that simply calling upon God, simply trusting myself to His hand, simply petitioning His sacred name, would bring me to Christ the Savior.

However, this is the case, and I was indeed happy when I found it out. Heaven is given away. Salvation may be had for the asking. I hope that many a captive heart will at once leap to loose his own chains and cry, "It is even so. If God has said it, it must be true. There it is in His own Word. I have called upon Him, and I must be delivered."

To Whom Is the Promise Given?

Notice the people to whom this promise and this deliverance are given: *"Whosoever shall call on the name of the LORD shall be delivered."*

To Those Afflicted by Troubles or Sin

In the book of Joel, the people had been greatly afflicted—afflicted beyond all precedent, afflicted to the very brink of despair. But the Lord had said, *"Whosoever shall call on the name of the LORD shall be delivered."*

Go down to the hospital. You may select, if you wish, a hospital for recovering alcoholics or drug users. In that house of misery, you may stand at each bed and say, *"Whosoever shall call on the name of the Lord shall be saved."* You may then hasten to the jail. You may stop at every door of every cell, yes, even at the bars of the cells on death row, and you may safely say to each one, *"Whosoever shall call on the name of the LORD shall be delivered."*

I know what the Pharisees will say: "If you preach this, people will go on in sin." It has always been true that the great mercy of God has been turned by some into a reason for continuing in sin, but God—and this is the wonder of it—has never restricted His mercy because of that. It must be a terrible provocation of almighty grace when people pervert God's mercy into an excuse for sin, but the Lord has never even taken the edges off His mercy because people have misused it. He has still made His mercy stand out

153

bright and clear: *"Whosoever shall call on the name of the Lord shall be saved."*

Still the Lord cries, "Turn and live." In Isaiah, He puts it this way:

> *Let the wicked forsake his way, and the unrighteous man his thoughts: and let him return unto the LORD, and he will have mercy upon him; and to our God, for he will abundantly pardon.*
> (Isa. 55:7)

Undimmed is that brave sun that shines on the foulest trash heaps of evil. Trust Christ and live! Call upon the name of the Lord, and you will be pardoned. Yes, you will be rescued from the bondage of your sin and will be made a new person, a child of God, a member of the family of His grace. Those most afflicted by troubles and those most afflicted by sin are met by this gracious promise: *"Whosoever shall call on the name of the Lord shall be saved."*

To Both Small and Great

Yes, but there were some, according to Joel, who had the Spirit of God poured out upon them. What about them? Were they saved by that? Oh, no! Even those whom God's Spirit enabled to dream dreams and to see visions had to come to the palace of mercy by this same gate of believing prayer: *"Whosoever shall call on the name of the LORD shall be delivered."*

Ah, poor soul! You say to yourself, "If I were a deacon of a church, if I were a pastor, oh, then I would be saved!" You do not understand anything about this matter. Church officers are no more saved by their office than you are by being without office. We owe nothing to our official positions in this matter of salvation. In fact, we may owe our damnation to our official standings unless we carefully watch our ways. Preachers have no advantage over common people. I assure you, I am quite happy to go to Christ on the same footing as any one of my readers, regardless of who he may be.

> Nothing in my hand I bring,
> Simply to Thy cross I cling.

Often, when I have been cheering up a poor sinner and urging him to believe in Christ, I have thought, "Well, if he will not drink

this cup of comfort, I will drink it myself." I assure you, I need it as much as those to whom I offer it. I have been as great a sinner as any of you, my readers, and therefore I take the promise for myself. The divine cup of comfort will not be lost; I will accept it.

I came to Jesus as I was, weary, worn, faint, sick, and full of sin. I trusted Him for myself and found peace—peace on the same ground that my texts set before us. If I could drink this consolation, you may drink it, too. The miracle of this cup is that millions may drink from it, yet it is just as full as ever. There is no restriction in the word *"whosoever."*

You young women who have the Spirit of God upon you, and you old men who dream, it is neither having the Spirit of God nor the dreaming that will save you, but your calling on the sacred name. For *"whosoever shall call on the name of the Lord shall be saved."* There are some upon whom the Spirit of God has not fallen. They do not speak with tongues or prophesy the future or work miracles, but though they do none of these marvels, it remains true for them that *"whosoever shall call on the name of the Lord shall be saved."* Though no supernatural gift is bestowed upon them, though they see no vision and cannot speak with tongues, if they have called upon the name of the Lord, they are saved. The way of salvation is the same for the little as well as for the great, for the poorest and most obscure as well as for the strong in faith who lead the army of God to battle.

To Those without Devout Feelings

"Ah," someone else says, "but I am worse than that. I have no devout feelings. I would give all that I own to have a broken heart. I wish I could feel despair, but I am as hard as a stone."

I have been told that sorrowful story many times, and it is almost always true that those who most mourn their lack of feeling are those who feel most acutely. They say that their hearts are like hardened steel, but it is not true. Even if it were true, *"whosoever shall call on the name of the Lord shall be saved."*

Do you think that the Lord wants you to give yourself a new heart first and that then He will save you? My dear soul, if you had a new heart, you would be saved already and would not need Him to save you. "Oh, but I must have devout feelings!" You must? Where will you go to get them? Are you going to search the trash heap of your depraved nature to find devout feelings there?

Come to God without any devout feelings. Come just as you are. Come, you who are like a frozen iceberg, who have nothing in you whatsoever but that which chills and repels. Come, call upon the name of the Lord, and you will be saved. As someone once wrote, "Wonders of grace to God belong." It is not a small gospel message for small sinners that He has sent us to preach, but ours is a great gospel message for great sinners. *"Whosoever shall call on the name of the Lord shall be saved."*

To Nobodies

"Ah, well," someone says, "I cannot believe that salvation is meant for me; I am a nobody." A nobody, are you? I have a great love for nobodies. I am tired of somebodies, and the worst somebody in the world is my own somebody. How I wish I could always throw my own somebody out and keep company with none but nobodies!

Nobody, where are you? You are the very person that I am sent to look after. If there is nothing in you, there will be all the more of Christ. If you are not only empty, but cracked and broken; if you are done for, destroyed, ruined, and utterly crushed; to you is this word of salvation sent: *"Whosoever shall call on the name of the Lord shall be saved."*

I have opened the gate wide. If the entrance led to the wrong track, all the sheep would go through. But since it is the right road, I can leave the gate open as long as I wish, yet the sheep will evade it unless You, Great Shepherd, go around the field and lead them in. Take up in Your own arms a lost lamb whom You purchased long ago with Your dear heart's blood. Take him upon Your gracious shoulders, rejoicing as You do it, and place him within the field where the good pasture grows.

A Bountiful Blessing

I want you to dwell for a minute on the blessing itself. *"Whosoever shall call on the name of the LORD shall be delivered."* I will not write much more about it because I have explained a good deal about it already.

When a person gives you a promise, it is a very good rule to understand it in the narrowest sense. This is being fair to the person

who gives the promise. Let him interpret it liberally if he wishes, but he is actually bound to give you no more than the bare terms of his promise.

Now, this is a rule that all God's people may safely practice: We may always understand God's promises in the largest possible sense. If the words could possibly mean more than you thought at first glance, you may certainly believe the broader meaning. He *"is able to do exceeding abundantly above all that we ask or* [even] *think"* (Eph. 3:20). God never draws a line in His promise so that He may barely go up to it. No, it is with the great God as it was with His dear Son, who, although He was sent *"unto the lost sheep of the house of Israel"* (Matt. 15:24), spent a great part of His time in Galilee, which was called, "Galilee of the Gentiles." Furthermore, as we will see in the next chapter, He went to the very edge of Canaan to find a Canaanite woman so that He could give her a blessing.

Therefore, you may believe the broadest and most generous implications of our text, Joel 2:32, just as Peter did. The New Testament is known for giving a broader meaning to Old Testament words. It does so most properly, for God loves us to treat His words with the breadth of faith.

If you are the object of the wrath of God, if you believe that God's hand has visited you on account of sin, come to God. Call upon Him, and He will deliver you both from judgment and from the guilt that brought judgment—both from the sin and from what follows the sin. He will help you to escape. Go to Him now.

Perhaps you are a child of God who is in trouble. Perhaps that trouble eats away at your spirit and daily causes your heart to weep. Call upon the Lord. He can take away the vexation and also the trouble. *"Whosoever shall call on the name of the LORD shall be delivered."* On the other hand, you may still have to bear the trouble, but it will be so transformed that it will be a blessing rather than an evil. When the nature of your cross has been changed, you will fall in love with it.

If sin is the cause of your present trouble, if sin has brought you into bondage to evil habits, if you have been a drunkard and do not know how to learn sobriety, if you have been immoral and have become entangled in evil relationships, call upon God. He can break you away from the sin and set you free from all its entanglements. He can cut you loose right now with the great sword of His grace and make you free. Although you feel like a poor sheep between the jaws

of a lion, ready to be devoured immediately, God can come and pluck you out of the lion's jaws. The prey will be taken from the mighty, and the captive will be delivered (Isa. 49:24). Only call upon the name of the Lord, and you will be delivered!

THE CONSEQUENCES OF REFUSING THE BLESSING

As I conclude this chapter, I must explain one unhappy thought. I want to warn you about the common neglect of this blessing. You would think that everybody would call upon the name of the Lord, but read the second part of Joel 2:32: *"For in mount Zion and in Jerusalem shall be deliverance, as the LORD hath said."* It will be there, as the Lord has said. But will those in mount Zion and Jerusalem receive God's deliverance then? Unfortunately, not all of them will, for notice the last part of the verse: *"And in the remnant whom the LORD shall call."* It seems to leave me altogether speechless, that word *"remnant."* What! Will all not come? No, only a remnant. And even that remnant will not call upon the name of the Lord until God first calls them by His grace. This is almost as great a wonder as the love that so graciously invites them. Will all not call upon His blessed name? No, only a remnant? Are they madmen? Could even devils behave worse? If they were invited to call upon God and be saved, would they refuse?

Unhappy business! The way is plain, but *"few there be that find it"* (Matt. 7:14). After all the preaching and all the invitations and all the breadth of the promise, yet all who are saved are contained *"in the remnant whom the LORD shall call."* Is our text not a generous invitation, the setting open of the door, yes, the lifting of the door off its hinges so that it might never be shut? Yet *"wide is the gate, and broad is the way, that leadeth to destruction, and many there be which go in thereat"* (v. 13).

There they go, streams of them, hurrying impatiently, rushing down to death and hell—yes, eagerly panting, hurrying, running into one another to descend to that awful gulf from which there is no return! No missionaries or ministers are needed to plead with people to go to hell. No persuasive books are needed to urge them to rush onward to eternal ruin.

The Master never spoke a word that is more clearly proved by observation than this: *"Ye will not come to me, that ye might have*

life" (John 5:40). People will attend church, but they will not call upon the Lord. Jesus cries, *"Search the scriptures; for in them ye think ye have eternal life: and they are they which testify of me. And ye will not come to me, that ye might have life"* (vv. 39–40). People will do anything rather than come to Jesus. They stop short of calling upon Him.

Oh, my dear readers, do not let it be so with you! Many of you are saved. I earnestly ask you to intercede for those who are not saved. Oh, that my unconverted readers may be moved to pray! Before you lay down this book, breathe an earnest prayer to God, saying,

> *"God be merciful to me a sinner"* (Luke 18:13). Lord, I need to be saved. Save me. I call upon Your name. Lord, I am guilty. I deserve Your wrath. I cannot save myself. Lord, I need a new heart and a right spirit, but what can I do? I can do nothing. Come and give me both the desire and the ability to do what You want.
>
> Now, from my very soul, I call upon Your name. Trembling, yet believing, I cast myself entirely upon You, O Lord. I trust the blood and righteousness of Your dear Son. I trust Your mercy, Your love, and Your power, as they are revealed in Jesus. I dare to claim this promise of Yours, that *"whosoever shall call on the name of the Lord shall be saved."* Lord, save me now, for Jesus' sake. Amen.

Pray this moment, I entreat you, and you will be saved.

5

Pleading, Not Contradiction

She said, Truth, Lord: yet...
—Matthew 15:27

In the narrative about the Syrophenician woman, have you ever stopped to think about the following two verses: *"Then Jesus went thence, and departed into the coasts of Tyre and Sidon. And, behold, a woman of Canaan came out of the same coasts"* (Matt. 15:21–22)? Notice that as Jesus went toward the coast of Sidon, the woman of Canaan came from the seashore to meet Him. In this way, they came to the same town.

Notice how the grace of God arranges things. Jesus and the seeker had a common attraction. He came, and she came. Her coming from the seacoast of Tyre and Sidon would have been of no use if the Lord Jesus had not also come down to the Israelite border of Phoenicia to meet her. His coming made her coming a success. What a happy circumstance when Christ meets sinners and sinners meet their Lord!

Our Lord Jesus, as the Good Shepherd, was drawn to that area by the instincts of His heart. He was seeking for lost ones, and He seemed to feel that there was one to be found on the borders of Tyre and Sidon. Therefore, He had to go that way to find that one. It does not appear that He preached or did anything special on the way there. He left the ninety-nine by the sea of Galilee to seek that one lost sheep by the Mediterranean shore. When He had dealt with her, He went back again to His old places of ministry in Galilee.

Our Lord was drawn toward this woman, but she was driven toward Him. What made her seek Him? Strange to say, the Devil

had a hand in it, but I do not give him any of the praise. The truth is that a gracious God used the Devil himself to drive this woman to Jesus, for her daughter was *"grievously vexed with a devil"* (Matt. 15:22). She could not bear to stay at home and see her child in such misery.

Oh, so often a great sorrow drives men and women to Christ, even as a fierce wind compels the sailor to hasten to the harbor! I have seen a daughter's great affliction influence the heart of a mother to seek the Savior. No doubt, many a father, broken in spirit by the likelihood of losing a darling child, has turned his face toward the Lord Jesus in his distress. Ah, my Lord, You have many ways of bringing Your wandering sheep back. You even send the black dog of sorrow and of sickness after them. This dog comes after the sheep, and his growling and barking are so dreadful that the poor lost sheep runs to the Shepherd for shelter.

May God make it so with any reader who has a great trouble at home! If your son is sick, may his sickness be the means of your spiritual health. If your daughter has died, may her death bring about your spiritual life. Oh, that your soul and Jesus may meet today. Your Savior, drawn by love, and your poor heart, driven by anguish—may you in this way be brought together!

Now, you would suppose that since Jesus and the Canaanite woman were seeking each other, the happy meeting and the gracious blessing would easily be brought about. But as the old saying goes, "The course of true love never did run smooth." For certain, the course of true faith is seldom without trials.

Here was genuine love in the heart of Jesus toward this woman; here, too, was genuine faith in her heart toward Christ. But difficulties sprang up that we never would have expected. It is for the good of us all that they occurred, but we could not have anticipated them. Perhaps there were more difficulties in the way of this woman than of anybody else who ever came to Jesus in the days of His earthly ministry. I have never read any other passage in which the Savior spoke such apparently rough words as He spoke to this woman of great faith. Did such a hard sentence as the following ever fall from His lips at any other time: *"It is not meet to take the children's bread, and cast it to dogs"* (v. 26)?

Jesus knew her well, and He knew that she could stand the trial and would be greatly benefited by it. He knew that He would be glorified by her faith throughout all future ages. Therefore, with good reason He put her through the exercises that train a vigorous

161

faith. Doubtless it was for our sakes that He put her through this test. He never would have exposed her to it had she been a weakling unable to sustain it. She was trained and developed by His rebuffs. While His wisdom tried her, His grace sustained her.

Now, notice how the incident began. The Savior came to the town, but He was not there in public. On the contrary, He sought seclusion. Mark wrote in his gospel,

From thence he arose, and went into the borders of Tyre and Sidon, and entered into an house, and would have no man know it: but he could not be hid. For a certain woman, whose young daughter had an unclean spirit, heard of him, and came and fell at his feet. (Mark 7:24–25)

Why was He hiding from her? He did not usually avoid the quest of the seeking soul. "Where is He?" she asked His disciples. They gave her no information; they had their Master's orders to let Him remain in hiding. He sought quiet and needed it, so they discreetly held their tongues. Yet, she found Him and fell at His feet. Somewhere half a hint had been dropped; she had heard it and followed it until she had discovered the house where the Lord was staying.

That was the beginning of her trial: the Savior was in hiding. But He could not be hidden from her eager search. She was all ears and eyes for Him. Nothing can be hidden from an anxious mother who is eager to bless her child.

Disturbed by her, the Blessed One went out into the street, and His disciples surrounded Him. But she was determined to be heard over their heads. Therefore, she began to cry aloud, *"Have mercy on me, O Lord, thou son of David"* (Matt. 15:22). As He walked along, she still cried out with mighty cries and pleadings until the streets rang with her voice. His whereabouts, which He *"would have no man know,"* were proclaimed loudly in the marketplace.

Peter did not like it; he preferred a quiet following. John was very disturbed by the noise; he lost a sentence, a very precious sentence, that the Lord had just uttered. The woman's noise was very distracting to everybody, and so the disciples came to Jesus and said, *"'Send her away'* (v. 23). Do something for her, or tell her to be gone. She cries after us. We have no peace because of her clamor. We cannot hear You speak because of her pitiful cries."

Meanwhile, she, perceiving that they were speaking to Jesus, came nearer, broke into the inner circle, fell down before Him, worshiped Him, and uttered this plaintive prayer: *"Lord, help me"* (Matt. 15:25). There is more power in worship than in noise; she had advanced a step. Our Lord had not yet answered her a single word. He had heard what she had said, no doubt, but He had not said a word to her yet. All that He had done was to say to His disciples, *"I am not sent but unto the lost sheep of the house of Israel"* (v. 24).

That did not prevent her nearer approach or stop her prayer, for then she pleaded, *"Lord, help me."* At length, the Blessed One did speak to her. Greatly to our surprise, it was a rebuff. What a cold answer it was! How cutting—or so it seemed! The Lord answered, *"It is not meet to take the children's bread, and cast it to dogs"* (v. 26).

Now, what would the woman do? She was near the Savior; she had an audience with Him, such as it was. She was on her knees before Him, and He appeared to drive her away! How would she act now?

Here is the point that I wish to make. She would not be driven away. She persevered, she advanced nearer, she actually turned the rebuff into a plea. She had come for a blessing, and she believed that she would have a blessing. She meant to plead for it until she won it. Therefore, she dealt with the Savior in a very heroic manner and in the wisest possible style. She answered Him, *"Truth, Lord: yet the dogs eat of the crumbs which fall from their masters' table"* (v. 27).

I want every reader to learn a lesson from her behavior: you, like this woman, may win with Christ and hear the Master say to you, *"Great is thy faith: be it unto thee even as thou wilt"* (v. 28).

I have gathered three pieces of advice from this woman's example. First, agree with the Lord, whatever He says. Say, *"Truth, Lord."* Say yes to all His words. Second, plead with the Lord. *"Truth, Lord: yet..."* Think of another truth, and mention it to Him as a plea. Say, "Lord, I will not let You go; I must plead with You yet." And third, have faith in the Lord, no matter what He says. However He tries you, still believe in Him with unstaggering faith. Know for certain that He deserves your utmost confidence in His love and power.

AGREE WITH THE LORD

My first advice to every heart seeking the Savior is this: agree with the Lord. In the Revised Version we read that she said, *"Yea, Lord"* (Matt. 15:27), or, "Yes, Lord." Regardless of what Jesus said, she did not contradict Him in the least. I like the King James translation, for it is very expressive: *"Truth, Lord."* She did not say, "It is hard," or, "It is unkind," but, "It is true." She said, in essence, "It is true that it is not good to take the children's bread and throw it to dogs. It is true that, compared with Israel, I am a dog. For me to gain this blessing would be like dogs feeding on the children's bread. *'Truth, Lord.'"*

Now, dear friend, if you are dealing with the Lord for life and death, never contradict His Word. You will never come into perfect peace if you are in a contradicting mood, for that is a proud and unacceptable condition of mind. He who reads the Bible to find fault with it will soon discover that the Bible finds fault with him. The same may be said of the Book of God as it is said of its Author: *"If ye...walk contrary unto me; then will I also walk contrary unto you"* (Lev. 26:23–24). I may truthfully say of this Holy Book, *"With the froward* [perverse] *thou wilt show thyself froward"* (Ps. 18:26).

Remember, dear friend, that if the Lord reminds you of your unworthiness and your unfitness, He only tells you what is true. It would be wise to say, *"Truth, Lord."* When Scripture describes you as having a depraved nature, say, *"Truth, Lord."* The Bible describes you as going astray like a lost sheep (Isa. 53:6), and the charge is true. It describes you as having a deceitful heart, and you have such a heart. Therefore, say, *"Truth, Lord."* The Bible says you have no strength and no hope. Let your answer be, *"Truth, Lord."*

The Bible never gives unrenewed human nature a good description, nor does it deserve one. The Bible exposes our corruptions and lays bare our falseness, pride, and unbelief. Do not quibble with God's faithful Word. Take the lowest place, and acknowledge that you are a lost and ruined sinner. If the Scriptures seem to degrade you, do not take offense, but admit that they deal honestly with you. Never let proud nature contradict the Lord, for this will only increase your sin.

This woman took the lowest possible place. She not only admitted that she was like one of the little dogs, but she put herself under the table. She said, *"The dogs eat of the crumbs which fall from their masters' table"* (Matt. 15:27).

Yet she went even lower than that. You have probably supposed that she referred to the crumbs that fell from the table of the Master Himself. If you will kindly look at the passage, you will see that it is not so. *"Their masters'"* refers to several masters. The word is plural, and it refers to the children who were the little masters of the little dogs. She, in fact, put herself under the children's table, rather than under the Master's table.

Thus, she humbled herself to be not only like a dog to the Lord, but like a dog to the house of Israel—to the Jews. This was going very far indeed, for a Tyrian woman of proud Sidonian blood to admit that the Jews were to her like masters, that these disciples who had just said, *"Send her away"* (Matt. 15:23), stood in the same relation to her as the children stand toward the little dogs under the table. Great faith is always the sister of great humility. It does not matter how low Christ put her, she sat there. *"Truth, Lord."*

I earnestly advise every reader of mine to consent to the Lord's verdict. Never argue with the sinner's Friend. When your heart is heavy, when you think you are the greatest of sinners, remember that you are a greater sinner than you think. Though your conscience has rated you very low, you may go even lower and still be in the right place. For, to tell you the truth, you are as bad as bad can be. You are worse than your darkest thoughts have ever painted you. You are a wretch most undeserving and hell-deserving. Apart from sovereign grace, your case is hopeless. If you were now in hell, you would have no cause to complain against the justice of God, for you deserve to be there. If you have not yet found mercy, I fervently desire that you would agree with the severest declarations of God's Word. They are all true, and they all apply to you. Oh, that you would say, "Yes, Lord. I do not have a syllable to say in self-defense!"

Furthermore, if it should appear to your humbled heart to be a very strange thing for you to be saved, do not fight against that belief. A proper sense of divine justice may suggest to you the following thoughts: "What! Me saved? Then I would be the greatest wonder on earth! Surely, God would have to go beyond all former mercy to pardon someone like me. He would be taking the children's bread and throwing it to a dog. I am so unworthy, so insignificant and useless, that even if I were saved, I would be good for nothing in God's service. How can I expect the blessing?"

Do not attempt to argue to the contrary. Do not seek to magnify yourself. Rather, cry, "Lord, I agree with Your evaluation of

me. I freely admit that if I am forgiven, if I am made Your child, and if I enter heaven, I will be the greatest marvel of immeasurable love and boundless grace that ever lived in earth or heaven."

We should be all the more ready to agree with every syllable of the divine Word because Jesus knows us better than we know ourselves. The Word of God knows more about us than we can ever discover about ourselves. We are partial to ourselves, and so we are half blind. Our judgment always fails to hold the balance evenly when our own case is being weighed. What person is not on good terms with himself? Your faults, of course, are always excusable. And if you do a little good, why, it deserves to be talked of and to be valued like diamonds. Each one of us is a very superior person—so our proud hearts tell us.

However, our Lord Jesus does not flatter us. He lets us see our cases as they are. His searching eye perceives the bare truth of things. He is *"the faithful and true witness"* (Rev. 3:14) who deals with us according to the rule of uprightness. Oh, seeking soul, Jesus loves you too much to flatter you. Therefore, I ask you to have such confidence in Him that, however much He may rebuke, reprove, and even condemn you by His Word and Spirit, you may without hesitation reply, *"Truth, Lord."*

Nothing can be gained by contradicting the Savior. Imagine a beggar standing at your door and asking for charity. He goes about it the wrong way if he begins a discussion with you and contradicts your statements. If beggars must not be choosy, certainly they must not be controversial. If a beggar wants to dispute, let him dispute, but let him give up begging. If he quibbles about how he will receive your gift, or how or what you will give to him, you will probably send him on his way. A critical sinner disputing with his Savior is certainly a fool.

As for me, my mind is made up that I will quarrel with anyone else sooner than with my Savior. I will especially contend with myself and pick a desperate quarrel with my own pride rather than have a shade of strife with my Lord. To contend with one's benefactor is foolish indeed! For the justly condemned to quibble with the Lawgiver, who has the prerogative to pardon, would be folly. Instead of that, with heart and soul I cry, "Lord, whatever I read in the Holy Scriptures, which are the revelation of Your mind, I do believe it; I will believe it; I must believe it. Therefore, I say, *'Truth, Lord.'* It is all true, even if it were to condemn me forever."

Now, notice this: if you find your heart agreeing with what Jesus says, even when He answers you roughly, you may depend on it that this is a work of grace. Human nature is very proud and stands very much upon its silly dignity; therefore, it contradicts the Lord when He deals truthfully with it and humbles it. Human nature, if you want to know its true condition, is that naked thing that so proudly tries to cover itself with apparel of its own devising. See, it sews fig leaves together to make itself clothes! What a destitute object! Clothed with withered leaves, it seems worse than naked! Yet this wretched human nature proudly rebels against salvation by Christ. It will not hear of imputed righteousness; it believes that its own righteousness is far dearer. Woe to the obstinate pride that rivals the Lord Jesus Christ!

If, my reader, you are of the proper thinking and are willing to acknowledge that you are a sinner, lost, ruined, and condemned, it is well with you. If you are of this attitude—that whatever humbling truth the Spirit of God may teach you in the Word or teach you by the conviction of your conscience, you will agree with it at once and confess, "It is true"—then the Spirit of God has brought you to this humble and truthful and obedient condition. You are going in the right direction.

PLEAD WITH THE LORD

Our second lesson from the account of the Syrophenician woman is this: although you must not quibble with Christ, you may plead with Him. She said, *"Truth, Lord,"* but she added, *"yet...."*

Setting One Truth next to Another

When you plead with Christ, do what the Syrophenician woman did: set one truth next to another. Do not contradict a sad truth, but bring up a happy one to meet it.

Do you remember how the Jews were saved out of the hands of their enemies in the book of Esther? Allow me to tell the story. The king had issued a decree that, on a certain day, the people of his kingdom could rise up against the Jews, slay them, and take their possessions as plunder. Now, according to the laws of the Medes and Persians, this decree could not be altered; it stood firm. What

could be done? How was it to be turned around? Why, by meeting that ordinance with another. Another decree was issued stating that although the people might rise against the Jews, the Jews could defend themselves. If anybody dared to hurt the Jews, they could slay him and take his property. One decree thus counteracted another.

How often we may use the holy art of looking from one doctrine to another! If a truth looks dark, it is not wise for me to dwell on it all the time. It is wise to examine the whole range of truth and see if there is not some other doctrine that will give me hope. David practiced this when he said of himself, *"So foolish was I, and ignorant: I was as a beast before thee"* (Ps. 73:22), for he confidently added, *"Nevertheless I am continually with thee: thou hast holden me by my right hand"* (v. 23). He did not contradict himself, yet the second verse removes the bitter taste left by the first. The two sentences together set forth the supreme grace of God, who enabled a poor beastlike being to commune with Him. I beg you to learn this holy art of setting one truth side by side with another so that you may have a fair view of the whole situation and not despair.

For instance, I meet with people who say, "Oh, pastor, sin is an awful thing; it condemns me. I feel that I can never answer the Lord for my iniquities, nor stand in His holy presence." This is certainly true, but remember another truth: *"The LORD hath laid on him the iniquity of us all"* (Isa. 53:6). Also, *"He hath made him to be sin for us, who knew no sin"* (2 Cor. 5:21). Furthermore, *"There is therefore now no condemnation to them which are in Christ Jesus"* (Rom. 8:1). Set the truth of the sin-bearing, substitutionary death of our Lord next to the guilt and curse of sin due to you.

"The Lord has an elect people," someone may be saying, "and this discourages me." Why should it? Do not contradict that truth; believe it as you read it in God's Word. But hear how Jesus put it:

> *I thank thee, O Father, Lord of heaven and earth, because thou hast hid these things from the wise and prudent, and hast revealed them unto babes.*　　　　　*(Matt. 11:25)*

To you who are as weak, simple, and trustful as a baby, the doctrine is full of comfort. If the Lord will save a multitude that no person can number, why should He not save me? It is true that it is written, *"All that the Father giveth me shall come to me"* (John 6:37), but that

Fain our pity would reclaim,
And snatch the firebrands from the flame.

There are those who are utterly careless about divine things. Will You impress them? May some stray shot reach their consciences! Oh, that they may be led to solemnly consider their position and their latter end! May thoughts of death and of eternity dash irresistibly against their souls like some mighty waves! May heaven's light shine into their consciences! May they begin to ask themselves where and what they are, and may they be turned to the Lord with full purpose of heart.

There are others who are concerned, but they are wavering between two opinions. There are some whom we love in the flesh who have not yet decided for God. Behold, they tremble in the balance! Cast in Your cross, O Jesus, and turn the scale! Love irresistible, come forth, and carry by blessed storm the hearts that have not yet yielded to all the attacks of the law! May some who never could be melted, even by the furnace of Sinai, be dissolved by the beams of love from the tearful eyes of Jesus!

Lord, if there is a heart that is saying, "Now, behold, I yield. At Your feet, rebellion's weapons I lay down and cease to be Your foe, O King of Kings"—if there is one who is saying, "I am willing to be espoused unto Christ, to be washed in His blood, to be called in His righteousness"—bring that willing sinner in now! May there be no more delay, but may this be the time when, once for all, the great transaction will be done, and they will be their Lord's, and He theirs.

Oh, that we could pour out our souls in prayer for the unconverted! You know where they will all be in a few years! Oh, by Your wrath, we pray, let them not endure it! By the flames of hell, be pleased to ransom them from going down into the pit! By everything that is dreadful in the wrath to come, we urge You to have mercy on these sons of men, even on those who have no mercy on themselves. Father, have You not promised Your Son to see His soul's travail? We point You to the ransom paid; we point You once again to the groans of Your Son, to His agony and bloody sweat! Turn, turn Your glorious eyes there. Look on these sinners, speak the word, and bid them live.

Righteous Father, refresh every corner of the vineyard, and on every branch of the vine, let the dew of heaven rest. Oh, that You would bless Your church throughout the world! Let visible union be

established, or if not that, yet let the invisible union that has always existed be better recognized by believers. Will You repair our schisms? Will You repair the breaches that have been made in the walls of Zion? Oh, that You would purge us of everything unscriptural, until all Christians come to the law and to the testimony and still keep the ordinances and the doctrines as they were committed to the apostles by Christ!

Remember our land in this time of need. Be pleased by some means to relieve the prevalent distress. Quicken the wheels of commerce so that the many who are out of employment may no longer be crying for work and bread. Oh, that You would cause wars to cease to the ends of the earth, or when they break out, use them to break the slave's fetters. Though desperate be the evil, yet grant that Satan may cast out Satan, and may his kingdom be divided and so fall.

Above all, You long-expected Messiah, do come! Your ancient people who despised You once are waiting for You in Your second coming, and we, the Gentiles, who did not know You or regard You, we, too, are watching for Your advent. Do not wait, O Jesus! May Your feet soon stand again on Olivet! This time, You will not have to sweat great drops of blood there, but You will come to proclaim the year of vengeance for Your foes, and the year of acceptance for Your people.

> When wilt Thou the heavens rend,
> In majesty come down?

Earth travails for Your coming. The whole creation groans in pain together until now. Your own expect You. We are longing until we are weary for Your coming. Come quickly, Lord Jesus, come quickly.

5

To the King Eternal

Our God and Father, draw us to Yourself by Your Spirit, and may the few minutes that we spend in prayer be full of the true spirit of supplication. Grant that none of us with closed eyes may yet be looking abroad over the fields of vanity, but may our eyes be really shut to everything else but what is spiritual and divine. May we have communion with God in the secret places of our hearts and find Him to be a sanctuary.

O Lord, we do not find it easy to get rid of distracting thoughts, but we pray that You would help us to draw the sword against them and drive them away. As Abraham drove away the birds that came down upon his sacrifice (Gen. 15:11), so may we chase away all cares, all thoughts of pleasure, everything else, whether pleasing or painful, that would keep us away from real fellowship with the Father and with His Son, Jesus Christ.

We want to begin with adoration. We worship from our hearts the Three in One, the infinitely glorious Jehovah, the only living and true God. We adore the Father, the Son, and the Holy Spirit, the God of Abraham, of Isaac, and of Jacob. We have not yet ascended to the place where pure spirits behold the face of God, but we will soon be there, perhaps much sooner than we think. We desire to be there in spirit now, casting our crowns upon the glassy sea before the throne of the Infinite Majesty, and ascribing glory and honor, and power and praise, and dominion and might to Him who sits on the throne, and unto the Lamb forever and ever.

All the church worships You, O God. Every heart renewed by grace takes a delight in adoring You. We, among the rest, though least and lowest of them all, would yet bow as heartily as any, worshiping, loving, praising in our souls, being silent before God because our joy in Him is altogether inexpressible.

Lord, help us to worship You in life as well as by our lips. May our whole being be taken up with You. As the fire fell down on Elijah's sacrifice of old and licked up even the water that was in the trenches (1 Kings 18:30–39), so may the consuming fire of the divine Spirit use up all our nature. Even the thing that might seem to hinder, even out of that may God get glory by the removal of it. Thus would we adore You.

But, dear Savior, we come to You, and we remember what our state is. The condition we are in encourages us to come to You now as beggars, depending on Your heavenly charity. You are a Savior, and as such, You are looking for those who need saving, and here we are; here we come. We are the men and women You are looking for, needing a Savior.

Great Physician, we bring You our wounds and bruises and putrefying sores. The more diseased we are and the more conscious we are today of the depravity of our nature, of the deep-seated corruption of our hearts, the more we feel that we are the sort of beings that You are seeking, for the well and whole have no need of a physician, but those who are sick (Mark 2:17).

Glorious Benefactor, we can meet You on good terms, for we are full of poverty. We are just as empty as we can be. We could not be more abjectly dependent than we are. Since You want to display Your mercy, here is our sin. Since You want to show Your strength, here is our weakness. Since You want to manifest Your lovingkindness, here are our needs. Since You want to glorify Your grace, here we are, people who can never have a shadow of a hope except through Your grace, for we are undeserving, ill-deserving, hell-deserving. If You do not magnify Your grace in us, we must perish.

Somehow we feel that it is sweet to come to You in this way. If we had to tell You that we had some good thing in us that You required of us, we would have to question whether we were not flattering ourselves and presumptuously thinking that we were better than we are. Lord Jesus, we come just as we are. This is how we came at first, and this is how we come still—with all our failures, with all our transgressions, with all and everything that is what it ought not to be—we come to You. We do bless You that You receive us and our wounds, and by Your stripes we are healed (Isa. 53:5). You receive us and our sins, and by Your sin-bearing we are set clear and free from sin. You receive us and our death, even our death, for You are He who lives, and was dead, and are alive forevermore (Rev. 1:18).

We simply come and lie at Your feet, obedient to that call of Yours, *"Come unto me, all ye that labour and are heavy laden, and I will give you rest"* (Matt. 11:28). Let us feel sweet rest, since we do come at Your call. May some come that have never come until this day, and may others who have been coming these many years consciously come again, coming unto You *"as unto a living stone...chosen of God, and precious"* (1 Pet. 2:4), to build our ever-lasting hopes upon.

But, Lord, now that we have come so near to You and are on right terms with You, we venture to ask You this, that we who love You may love You much, much more. Oh, since You have been precious, Your very name has music in it to our ears, and there are times when Your love is so inexpressibly strong upon us that we are carried away with it. We have felt that we would gladly die to increase Your honor. We have been willing to lose our name and our reputation if You might be glorified through that. Truly, we often feel that if the crushing of us would lift You one inch higher, we would gladly suffer it.

For You, blessed King, we would set the crown on Your head, even if the sword would smite our arm off at the shoulder blade. You must be King, You must be glorified, no matter what becomes of us.

Yet we have to mourn because we do not always feel this rapture and ardor of love as we should. Oh, at times You manifest Yourself to us so charmingly that heaven itself could scarcely be happier than our world becomes when You are with us in it. But when You are gone and we are in the dark, give us the love that loves in the dark, that loves when there is no comforting sense of Your presence. Do not let us depend on feelings; may we always love You. If You were to turn Your back on us for a whole year, may we still think no less of You, for You are to be unspeakably loved whatever You do. If You give us rough words, may we still cling to You. And if the rod is used until we tingle, may we still love You, for You are to be infinitely loved by all men and angels. As Your Father loves You, make our hearts love You always the same. With all the capacity for love that there is in us, and with all the more that You can give us, may we love our Lord in spirit and in truth.

Help us, Lord, to conquer sin out of love for You. Help some dear strugglers who have been mastered by sin sometimes, but who are struggling against it. Give them the victory, Lord. When the battle gets very sharp and they are tempted to give way a little,

help them to be very firm and very strong, never giving up hope in the Lord Jesus, and resolving that if they perish, they will perish at His feet and nowhere else but there.

Lord, raise up in our churches many men and women who are all on fire with love for Christ and His divine Gospel. Oh, give us again men like Antipas, Your faithful martyr, and men like Paul, Your earnest servant who proclaimed Your truth so boldly. Give us Johns, men to whom the Spirit speaks, who will have us hear what the Spirit says to the churches. Lord, revive us! Revive Your work in the midst of the years in all the churches. Return to the church of God in this country. Return to her. Your adversaries think that they will have it all their own way, but they will not, for the Lord lives, and blessed be our Rock (Ps. 18:46).

Because of truth and righteousness, we implore You, lay bare Your arm in these last days. O Shepherd of Israel, deal a heavy blow at the wolves, and keep Your sheep in their own true pastures, free from the poisonous pastures of error. O God, we want to stir You up. We know You do not sleep, and yet sometimes it seems as if You nap awhile and allow things to go on in their own way.

We entreat You, awake. Plead Your own cause. We know Your answer: *"Awake, awake; put on thy strength, O Zion"* (Isa. 52:1). This we want to do, Lord, but we cannot do it unless You put forth Your strength to turn our weakness into might.

Great God, save this nation! O God of heaven and earth, stop the floods of infidelity and filthiness that roll over this land. O God, may we see better days! Men seem entirely indifferent now. They will not come to hear the Word as they once did. God of our fathers, let Your Spirit work again among the masses. Turn the hearts of the people to the hearing of the Word, and convert them when they hear it. May it be preached with the Holy Spirit sent down from heaven.

Our hearts are weary for You, O King, You King forgotten in Your own land, You King despised among Your own people. When will You yet be glorious before the eyes of all mankind? Come, we implore You, come quickly, or if You do not come personally, send forth the Holy Spirit with a greater power than ever so that our hearts may leap within us as they see miracles of mercy repeated in our midst.

Father, glorify Your Son. Somehow our prayer always comes to this before we finish. *"Father...glorify thy Son, that thy Son also may glorify thee"* (John 17:1). Let the days come when He will see

the travail of His soul and will be satisfied (Isa. 53:11). Bless all work done for You, whether it is in the barn or in the cathedral, silently and quietly in the street, or in the Sunday school or in the classroom. O Lord, bless Your work. Hear also prayers that have been offered up by wives for their husbands, children for their parents, parents for their children. Let the holy service of prayer never cease, and let the intercession be accepted by God, for Jesus Christ's sake.

6

The Wonders of Calvary

G reat God Almighty, there was a time when we dreaded the thought of coming near to You, for we were guilty, and You were angry with us. But now we will praise You because Your anger is turned away, and You comfort us. Now the very throne that was once a place of dread has now become the place of shelter. We flee to You to hide us.

We long to get away from the world, even from the remembrance of it, and have fellowship with the world to come by speaking with Him who *"was, and is, and is to come"* (Rev. 4:8), the Almighty. Lord, we have often been worried and wearied with care, but with You, care comes to an end. All things are with You, and when we live in You, we live in wealth, in sure repose, in constant joy.

We battle with the sons of men against a thousand errors and unrighteousnesses, but when we flee to You, all is truth and purity and holiness, and our hearts find peace. Above all, we have to battle with ourselves, and we are very much ashamed of ourselves. After many years of great mercy, after tasting the powers of the world to come, we still are so weak, so foolish. But when we get away from self to God, there we find truth and purity and holiness, and our hearts rest in peace, wisdom, completeness, delight, joy, and victory.

Oh, bring us now, we pray, near to Yourself. Let us bathe ourselves in communion with our God. Blessed be the love that chose us before the world began. We can never sufficiently adore You for Your sovereignty, the sovereignty of love that saw us in the ruins of the Fall, yet loved us notwithstanding all.

We praise the God of the eternal council chamber and the everlasting covenant. Yet we struggle to find sufficiently worthy

words with which to praise Him who gave us grace in Christ His Son, before He spread the starry sky.

We also bless You, O God, as the God of our redemption, for You have loved us so much that You even gave Your dear Son for us. He gave Himself, His very life for us, so that He might redeem us from all iniquity and sanctify us for Himself to be His special people, zealous for good works (Titus 2:14).

We can never sufficiently adore free grace and dying love. The wonders of Calvary never cease to be wonders. They grow marvelous in our eyes as we think of Him who washed us from our sins in His own blood. Nor can we cease to praise the God of our regeneration, who found us dead and made us live, found us at enmity and reconciled us, found us loving the things of this world and lifted us out of the morass and mire of selfishness and worldliness into the love of divine, everlasting things.

O Spirit of God, we love You this day, especially for dwelling in us. How can You abide in so crude a habitation? How can You make these bodies Your temples? And yet You did so. For that, let Your name be held in reverence as long as we live.

O Lord, we want to delight ourselves in You this day. Give us faith and love and hope so that, with these three graces, we may draw very near to the triune God. You will keep us, You will preserve us, You will feed us, You will lead us, and You will bring us to the mind of God. There You will show us Your love, and in the glory everlasting and boundless, there You will make us know and taste and feel the joys that cannot be expressed.

But a little longer waiting and we will come to the golden shore. But a little longer fighting and we will receive the crown of life that does not fade away.

Lord, get us up above the world. Come, Holy Spirit, heavenly Dove, mount and bear us on Your wings, far from these inferior sorrows and inferior joys, up where eternal ages roll. May we ascend in joyful contemplation, and may our spirits come back again, strong for all service, armed for all battles, armored for all dangers, and made ready to live heaven on earth, until by and by we will live heaven in heaven. Great Father, be with Your waiting people. Any in great trouble, may You greatly help. Any who are despondent, may You sweetly comfort and cheer. Any who have erred and are suffering under their own sin, may You bring them back and heal their wounds. Any who this day are panting after holiness, may

You give them the desire of their hearts. Any who are longing for usefulness, may You lead them into ways of usefulness.

Lord, we want to live while we live. We do pray that we may not merely groan out an existence here below, or live as earthworms crawling back into our holes and dragging now and then a dry leaf with us. Rather, give us the ability to live as we ought to live, with a new life that You have put into us, with the divine awakening that has lifted us as much above common men as men are lifted above the beasts that perish.

Do not let us always be hampered like poor half-hatched birds within the eggshell. May we chip the shell today and get out into the glorious liberty of the children of God. Grant us this, we pray.

Lord, visit our churches. We have heard Your message to the churches at Ephesus; it is a message to us also. Do not let any of us lose our first love. Do not let our churches grow cold and dead. We are not, we fear, what we once were. Lord, revive us! All our help must come from You. Give back to the church its love, its confidence, its holy daring, its consecration, its liberality, its holiness. Give back all that it ever had, and give it much more. Take every member and wash his feet most tenderly. Sweet Lord, set us with clean feet in a clean road, with clean hearts to guide us. May You bless us, as You are disposed to do, in a divine way.

Bless us, our Father, and let all the churches of Jesus Christ partake of the same care and tenderness. Walking among the golden candlesticks, Lord, trim every lamp and make every light, even though it burns but feebly now, to shine out gloriously through Your care.

Now bless the sinners. Lord, convert them. O God, save men. Save this great city, this wicked city, this slumbering, dead city. Lord, arouse it, arouse it by any means, so that it may turn to its God. Lord, save sinners all the world over.

Let Your precious Word be fulfilled: *"Behold, he cometh with clouds"* (Rev. 1:7). Why do You wait? Do not wait, O Lord. And now unto the Father, Son, and Holy Spirit be glory forever and ever.

7

"Let All the People Praise Thee"

Our Father, when we read Your description of human nature, we are sure it is true, for You have seen man ever since his fall, and You have been grieved at heart concerning him. Moreover, You have such a love toward him that You did not judge him harshly. Every word that You have spoken must be according to truth. You have measured and computed the iniquity of man, for You have laid it on the Well Beloved, and we know You have not laid on Him more than is just.

O God, we are distressed and greatly bowed down when we see the condition to which we and all our race have fallen. *"Where is boasting then?"* (Rom. 3:27). And yet we grieve to say that we do boast, have boasted, and that our fellowmen are great at boasting. Instead, we ought to lay our hands upon our mouths before You.

It is a wonder to us that You should look upon man at all. The most hateful object in creation must be a man, because he killed Your Son, because he has multiplied rebellions against Your holy law. Yet truly there is no sight that gives You more pleasure than man, for Jesus became a man. The brightness of His glory covers all our shame, and the pureness and perfection of His obedience shines like the sun in the midst of the darkness. For His sake, You are well pleased, and You dwell with us.

Lord, we once thought that those descriptions of our hearts were somewhat exaggerated, but we do not think so now. Truly we perceive that had it not been for restraint that held us like chains, we, in our unregenerate state, were capable of anything. Even now, when we are regenerate, the old sin that remains in us is capable of reaching a high degree of infamy. If the new life did not restrain the old death, we do not know what we might yet become.

We once thought we were humble, but we soon found that our pride will feed on any current flattery that is laid at our door. We thought we were believers, but sometimes we are so doubting, so unbelieving, so vexed with skepticism, that we would not certainly choose to follow. That is Your work in us. By nature we are such liars that we think You are a liar, too—the surest token of our untruthfulness is that we think that You could be untrue.

Oh, these wicked hearts of ours! Do they not have enough kindling in them to set on fire the course of nature? If only a spark were to fall into them, any one of our members left to itself would dishonor Christ, deny the Lord who bought us, and turn back into perdition.

We are altogether ashamed. Truly in us is fulfilled Your own Word: *"That thou...never open thy mouth any more because of thy shame"* (Ezek. 16:63). Your love to us has silenced us. That great love has hidden boasting away from us—Your great love, with which You loved us even when we *"were dead in trespasses and sins"* (Eph. 2:1); Your great love with which You have loved us still, despite our poor manners, our wanderings, our shortcomings, and our excesses.

Oh, the matchless love of God! Truly if there is any glory, it must all be the Lord's. If there is any virtue, it is the result of grace. If there is anything whatsoever that lifts us above the Devil himself, it is the work of the divine Spirit, to whom be glory!

At the remembrance of all this, and being in Your presence, we rejoice that our unrighteousness is covered, that we are free from condemnation, and that we are the favored of the Lord. You have allowed us, O Lord, to taste of the love that is not merely laid up for us, for we have enjoyed it and do enjoy it still.

Our hearts know the Father's love, for we *"have received the Spirit of adoption, whereby we cry, Abba, Father"* (Rom. 8:15). We joy and rejoice in the redemption of our spirits, and we expect the redemption of our bodies, when at the coming of the Lord, they, too, *"shall be raised incorruptible, and we shall be changed"* (1 Cor. 15:52).

O Jesus, You will bring Israel out of Egypt, and not a hoof will be left behind—no, not a bone or any piece of Your elect will be left in the hands of the Adversary. We will come out clean, delivered by Him who does nothing by halves, but who on the cross said, *"It is finished"* (John 19:30), and who much more will say it on His throne. Glory be unto the Father, Son, and Holy Spirit, who lifted us up from

our ruin and condemnation, made us new creatures, justified us, and guaranteed us eternal life that will be manifested at the coming of the Lord. All glory be unto His blessed name forever and ever!

Now, Lord, during the few days that remain to us here below, let it be all our business to cry, *"Behold the Lamb"* (John 1:29)! Oh, teach these hearts to be always conscious of Your love; and then teach these lips that they may express as best they can with Your divine help the matchless story of the Cross. Oh, give us the privilege of winning many to Jesus. Do not let us be barren, but may we be able to cry that we are the beloved of the Lord, and our offspring is with us. May we have many spiritual offspring who will go with us to the throne, so that we may say before Him, *"I and the children whom the LORD hath given me"* (Isa. 8:18).

Lord, bless the work of the churches and all their branches. Let Your kingdom come into the hearts of multitudes through the churches. Remember all churches that are really at work for Jesus, and all private individuals, workers alone, workers by themselves. Let the Lord's own name be made known by tens of thousands. Give the Word, and may the company of those who publish it be great. Let our beloved country know Christ and come to His feet. Let the dark places of our cities be enlightened with the sweet name of Jesus. And then let the heathen know You, and the ends of the earth hear of You.

Oh, from the tree declare Your salvation, and from the throne let it be published in the proclamations of a king. *"Let the people praise thee, O God; let all the people praise thee"* (Ps. 67:3).

Our hearts seem as if they have nothing else to ask for when they reach this point. Yet we want to go back a moment and say, "Lord, forgive our sins; Lord, sanctify our persons; Lord, guide us in difficulty; Lord, supply our needs. May He teach us, perfect us, comfort us, and prepare us for the appearing of His Son from heaven!"

And now we come back to a theme that still seems to engross our desires. Oh, that Christ would come! Oh, that His Word would be made known to the ends of the earth! Lord, they die, they perish, they pass away by multitudes! Every time the sun rises and sets, they pass away! Do not wait, we entreat You. Give wings to the feet of Your messengers and fire to their mouths, so that they may proclaim the Word with Pentecostal swiftness and might. Oh, that Your kingdom would come, and Your will be done on earth as it is in heaven, *"for thine is the kingdom, and the power, and the glory, for ever. Amen"* (Matt. 6:13).

8

A Prayer for Holiness

Our Father, we worship and love You. It is one point of our worship that You are holy. There was a time when we loved You for Your mercy, for we knew no more. But now You have changed our hearts and made us in love with goodness, purity, justice, true holiness. We understand now why the cherubim and seraphim continually cry, *"Holy, holy, holy, Lord God Almighty"* (Rev. 4:8).

We adore You because You are holy, and we love You for Your infinite perfection. Now we sigh and cry after holiness ourselves. Sanctify us wholly, spirit, soul, and body. Lord, we mourn over the sins of our pasts and our present shortcomings. We bless You, for You have forgiven us. We are reconciled to You by the death of Your Son. There are many who know that they have been washed, and that He who bears away sin has borne their sin away. These are they who cry to You to be delivered from the power of sin, to be delivered from the power of temptation without, but especially from indwelling sin within.

Lord, purify us in head, heart, and hand. If it is necessary that we should be put into the fire to be refined as silver is refined, we would even welcome the fire, if we may be rid of the dross. Lord, save us from constitutional sin, from sins of temperament, from sins of our surroundings. Save us from ourselves in every shape, and grant us especially to have the light of love strong within us.

May we love You, God. May we love You, O Savior. May we love the people of God as being members of one body in connection with You. May we love the guilty world with the love that desires its salvation and conversion. May we love not in word only, but in deed and in truth (1 John 3:18). May we help the helpless, comfort the mourner, sympathize with the widow and fatherless, and may

206

we always be ready to put up with wrong, to be long-suffering, to be very patient, full of forgiveness, counting it a small thing that we should forgive our fellowmen since we have been forgiven by God. Lord, tune our hearts to love, and then give us an inward peace, a restfulness about everything.

May we have no burden to carry because, though we have a burden, we have rolled it upon the Lord. May we take up our cross, and because Christ has once died on the cross, may our cross become a comfort to us. May we count it all joy when we fall into various trials, knowing that in all this God will be glorified, His image will be stamped on us, and the eternal purpose will be fulfilled, in which He has predestined us *"to be conformed to the image of his Son"* (Rom. 8:29).

Lord, look upon Your people. We could pray about our troubles, but we will not do so right now. We will only pray against our sins. We could come to You about our weariness, about our sickness, about our disappointment, about our poverty, but we will leave all that for now. We will only come about sin. Lord, make us holy, and then do what You will with us.

We ask You, help us to adorn the doctrine of God our Savior in all things. If we are fighting against sin—*"the sin which doth so easily beset us"* (Heb. 12:1)—Lord, lend us heavenly weapons and heavenly strength so that we may cut the giants down, these men of Anak that come against us. (See Numbers 13:33.) We feel very feeble. Oh, make us *"strong in the Lord, and in the power of his might"* (Eph. 6:10). May we never let sin have any rest in us. May we chase it, drive it out, slay it, hang it on a tree, abhor it, and may we *"cleave to that which is good"* (Rom. 12:9).

Some of us are trying, striving after some excellent virtue. Lord, help strugglers. Enable those who contend against great difficulties to see greater grace, have more faith, and be nearer to God. Lord, we will be holy, and by Your grace we will never rest until we are. You have begun a good work in us, and You will carry it on (Phil. 1:6). You will work in us to will and to do of Your own good pleasure (Phil. 2:13).

Lord, help the converted child to be correct in his relationship to his parents. Help the Christian father and mother to be right in dealing with their children. May they not *"provoke...*[their] *children to anger, lest they be discouraged"* (Col. 3:21). Take away willfulness from the young. Take away impatience from the old. Lord, help Christian men of business to act uprightly. May Christian

masters never be harsh with their servants, with their workers. May Christian workers give to their masters what is just and equal in the way of work in return for wages. May we as Christians always stand on our rights, but also be willing to minister to the needs of others.

Oh, that as Christians we might be humble! Lord, take away that stiff-necked, proud look. Take away from us the spirit of "stand away, for I am holier than thou." Make us reach out to men of low social standing, yes, and even to men of low morals, low character. May we seek them out, seek their good. Oh, give to the church of Christ an intense love for the souls of men. May it make our hearts break to think that they will perish in their sin. May we grieve every day because of the sin of our cities. Put a mark on our foreheads, and let us be known to You as men who sigh and cry for all the abominations that are done in the midst of our cities (Ezek. 9:4).

O God, save us from a hard heart, an unkind spirit, that is insensible to the woes of others. Lord, preserve Your people also from worldliness, from rioting, from drunkenness, from clamoring and lewdness, from strife and envy, from everything that would dishonor the name of Christ that we bear. Lord, make us holy. Our prayer comes back to this: make us holy. Cleanse the inside and let the outside be clean, too. Make us holy, O God. Do this for Christ's sake. It is not that we hope to be saved by our own holiness, but holiness is salvation. When we are holy, we are saved from sin.

Lord, help Your poor children to be holy. Oh, keep us so if we are so. Keep us even from stumbling, and present us faultless before Your presence at last (Jude 24). We pray for friends who are ill, for many who are troubled because of the illness of others. We bring before You every case of trouble and trial known to us and ask for Your gracious intervention. We pray for Your ministers everywhere. For Your missionary servants, we ask You to remember those who are making great sacrifice out in the hot sun or in the cold and frozen North. Everywhere preserve those who for Christ's sake carry their lives in their hands.

Our brothers and sisters, in poverty many of them, working for Christ, Lord accept them and help us to help them. Do remember the Sunday school teachers, the city missionaries, along with those who visit and hand out tracts door-to-door, and all who in any way endeavor to bring Christ to the notice of men. Oh, help them all.

We will offer but one more prayer, and it is this. Lord, look in pity on any who are not in Christ. May they be converted. May they pass from death to life and never forget it. May they see the eternal light for the first time, and may they remember it even in eternity. Father, help us. Bless us now for Jesus' sake.

9

Glorious Liberty

Our Father, we bless Your name that we can say from the bottom of our hearts, *"Abba, Father"* (Rom. 8:15). It is the chief joy of our lives that we have become the children of God by faith that is in Christ Jesus, and we can in the deep calm of our spirits say, *"Our Father which art in heaven, Hallowed be thy name. Thy kingdom come. Thy will be done in earth, as it is in heaven"* (Matt. 6:9–10).

Lord, we thank You for the liberty that comes to our emancipated spirits through the adoption that You have made us to enjoy. When we were in servitude, the chains were heavy, for we could not keep Your law. There was an inward spirit of rebellion. When the commandment came, it irritated our corrupt nature, sin revived, and we died.

Even when we had some inner striving for better things, the power that was in us lusted to evil, and the spirit of Hagar's Ishmael was upon us. We wanted to get away from the Father's house. We were wild men, men of the wilderness, and we did not love living in the Father's house.

O God, we thank You that we have not been cast out. Indeed, if You had cast out the child of the bondwoman, You would have cast us all out, but now through sovereign grace all is altered with us. Blessed be Your name. It is a work of divine power and love over human nature, for now we are the children of the promise, certainly not born according to the strength of the human will, or of blood, or of birth, but born by the Holy Spirit through the power of the Word, *"begotten...again unto a lively hope by the resurrection of Jesus Christ from the dead"* (1 Pet. 1:3), children of the Great Father who is in heaven, having His life within us. Now, like Isaac, we are heirs according to promise and heirs of the promise. We

dwell at home in the Father's house, and our souls are satisfied as with marrow and fatness, and our mouths will praise You as with joyful lips (Ps. 63:5).

O God, we would not trade places with angels, much less with kings of the earth. To be indeed Your sons and daughters—the thought of it brings to our souls a present heaven, and the fruition of it will be our heaven, to dwell forever in the house of the Lord, and leave it no more, but to be His sons and His heirs forever and ever.

Our prayer is for others who are still in bondage. We thank You, Lord, that You have given them the spirit of bondage and made them to fear. We are glad that they are brought to feel the evil of sin, to feel the perfection of Your law, to know something of the fiery nature of Your justice, and so to be shut up unto salvation by grace through faith. But, Lord, do not let them remain long under the harsh teacher, but may the schoolmaster with his rod bring them to Christ. (See Galatians 3:24.)

Lord, cure any of Your chosen of self-righteousness. Deliver them from any hope in their own abilities, but keep them low. Bring them out of any hope of salvation by their own prayers or their own repentance. Bring them to cast themselves upon Your grace to be saved by trusting in Christ. Emancipate them from all observance of days, weeks, months, years, and things of human institution. Bring them into the glorious liberty of the children of God so that Your law may become their delight, so that You may become their strength and their all, and so that Your Son may become their joy and their crown. We do pray this with all our hearts.

Lord, deliver any of Your children from quarreling with You. Help us to be always at one with our God. *"It is the LORD: let him do what seemeth him good"* (1 Sam. 3:18), and blessed be His name forever and ever.

God bless our country, and the sister country across the ocean, and all lands where Your name is known and reverenced, and heathen lands where it is unknown. Everywhere may the Lord's kingdom come and His name be glorified. Glory be to the Father, and to the Son, and to the Holy Spirit, as it was in the beginning, is now, and ever will be, world without end.

10

The Music of Praise

O blessed God, we must be helped by Your Spirit or we cannot worship You fittingly. Behold, the holy angels adore You, and the hosts redeemed by blood bring everlasting hallelujahs to Your feet. What are we, the creatures of a day, polluted with sin, that we should think that we can praise You? And yet the music of praise would not be complete if Your children did not join in it, even those of them who are still in this world below. Help us, then. Enable us to tune our harps and to bring forth music from our spirits.

Truly, Lord, if there are any creatures in the world that can praise You, we ought to do so. Each one among us feels that he has some special reason for gratitude. Lord, it is an unspeakable mercy to know You—to know You as our reconciled God, to know You as our Father in Christ Jesus, who has forgiven us all our trespasses. Oh, it is unspeakably sweet to come and rest in You, and to know that there is now no cause of quarrel between us and You. On the contrary, we realize that we are bound to one another by a covenant that in infinite tenderness and mercy You have made, so that Your people might have strong consolation and might boldly take hold of You.

Oh, the joy of knowing that we are Yours forever, Yours in the trials of life, and Yours in the last dread trial of death, and then Yours in resurrection, Yours throughout eternity! We do therefore worship You, O God, not under coercion, nor under terror or pressure, but cheerfully and gladly, ascribing unto You praise, power, dominion, glory, and honor, world without end.

We wish we knew how to do something for You. We pray that we may be helped to do so before we die. May every fleeting hour confess that we have brought Your Gospel some renown. May we

so live as to extend the Redeemer's kingdom at least in some little measure. May ours not be fruitless, wasted lives. May no faculty of ours lay by and rust, but to the utmost of our capacity, may we be helped by the divine Spirit to spend the whole of our lives in real adoration.

We know that he who serves is actually praying, he who gives is actually praising, and he who obeys is actually adoring. The life is the best music. Oh, set it to good music, we pray, and help us throughout all our lives to keep to the right notes. May there be no false pitch in all the singing of our lives, but let all be according to that sacred score that is written out so fully in the life music of our Lord.

We implore You to look down upon Your children and cheer us. Lord, lift us up. Come, Holy Spirit, like a fresh, invigorating wind. Let our spirits, through Your Spirit, rise upward toward God.

With much shamefacedness we acknowledge our transgressions and sins. However, there are some who have never felt the burden of sin at all. Lord, lay it on them; press them with it. Almighty God, vex their souls. Let them find no rest until they find rest in You. May they never be content to live and die in sin, but in Your infinite mercy, come to them and make them sorry for their sin.

As for Your people, we are grieved to think that we do not live better than we do. Blessed be Your name for every fruit of holiness, for every work of faith, but oh, for more. You have changed the tree; it is no longer a bramble. It can bring forth figs, but now we want to bring forth more of these sweet fruits.

Lord, make us to love Christ intensely, to love the souls of men most heartily, to love Your truth with earnestness, to love the name of Jesus above everything. May we be ravished with the sound of it. May the Lord give us every grace, not only love, but faith, hope, holy gentleness, meekness, patience, and brotherly love. Build us up, we pray, Lord, in all knowledge and in all experience. Give us, along with submission to Your will, holy resignation, great watchfulness, much carefulness in our speech, so that we may rule the tongue and so rule the whole body.

Lord, may You pour out Your Spirit upon us so that every chamber of our nature may be sweetened and perfumed with the indwelling of God, until our imaginations only delight in things chaste and pure; until our memories cast out the vile stuff from the dark chambers; until we expect and long for heavenly things; until

our treasure all is in heaven, and our hearts are there. Take our highest manhood, Lord, and saturate it in Your love, until, like Gideon's fleece, it is filled with dew, every lock and every single fleck of it, not a single portion of it left unmoistened by the dew from heaven.

How we bless You for many who are striving to walk as Christ walked, and who are also trying to bring others to Christ. O Lord, help us in this struggle after holiness and usefulness. As You have given to many the desire of their hearts in this respect up to a certain measure, now enlarge their hearts, and give them more both of holiness and usefulness. May we be like trees *"planted by the rivers of water"* (Ps. 1:3), so that we ourselves may be vigorous. Give us the ability to bring forth abundant fruit according to our season (v. 3), to the everlasting praise and glory of God.

Our desire is that we may be quickened in our progress toward the celestial life. Visit us with Your salvation. Lord, let us not only have life, but let us have it more abundantly (John 10:10). May we every one of us quicken his pace, and may we run more earnestly than ever toward the mark that is set before us.

Remember all Your church throughout the whole world. Prosper missionary operations. Be with any ministers or missionaries who are depressed for lack of success. Be with any who are rejoicing because of success. May each heart be kept in a right state, so that You may use Your servants to the utmost of possibility.

O God, send us better days than these, we pray. We thank You for all the light there is, but send us more light. We thank You for what life there is among Christians, but send more of it.

Bind the churches together in unity, and then give them such speed, such force, such power, that they will break into the ranks of the Adversary and the victory be unto Christ and to His people.

Remember our dear country. Bless the head of our nation. Remember all those who lead our legislature. Be gracious to all ranks and conditions of men. Have mercy on all who are poor and needy, on all who are sick and sorrowing, and who are tossed upon the sea. Remember the prisoners and those who have no helper. Be gracious to those who are in the summons of death. Finally, let the day come when the Son will shine forth in all His brightness, even Christ Jesus will be manifested, to be admired in them who believe and to make glad the whole creation. Do not wait, O Son of Righteousness, but come forth speedily. We ask it for Your name's sake.

11

Under the Blood

Jehovah, our God, we thank You for leaving on record the story of Your ancient people. It is full of instruction to us. Help us to take its warning to avoid the faults into which they fell! You are a covenant God, and You keep Your promises. Your Word never fails. We have proved this to be so:

> Thus far we find that promise good,
> Which Jesus ratified with blood.

But as for ourselves, we are like Israel of old, a fickle people. We confess with great shame that although there are days when we take the tambourine and sing with Miriam *"unto the LORD, for he hath triumphed gloriously"* (Exod. 15:1), yet, not many hours later, we are thirsty, and we cry for water, and we murmur in our tents. Bitter Marah turns our hearts (vv. 22–25), and we are grieved with You, our God. When we behold Your Sinai covered in smoke, we bow before You with reverence and awe, but there have been times when we have set up the golden calf and have said of some earthly things, *"These be thy gods, O Israel"* (Exod. 32:4). We believe with intensity of faith and then doubt with a horribleness of doubt.

Lord, You have been very patient with us. Many have been our provocations, many have been Your chastisements, but

> Your strokes are fewer than our crimes,
> And lighter than our guilt.

You *"hath not dealt with us after our sins; nor rewarded us according to our iniquities"* (Ps. 103:10). Blessed be Your name!

And now fulfill that part of the covenant wherein You have said, *"A new heart also will I give you, and a new spirit will I put*

within you" (Ezek. 36:26). *"I will put my fear in their hearts, that they shall not depart from me"* (Jer. 32:40). Hold us fast, and then we will hold fast to You. Turn us, and we will be turned. Keep us, and we will keep Your statutes.

We cry to You that we may no longer provoke You. We beg You to send the serpents among us rather than to let sin come among us. Oh, that we might have our eyes always on the bronze serpent that heals all the bites of evil (Num. 21:9), but may we not look to sin or love it. Do not let the devices of Balaam and of Balak prevail against us, to lead Your people away from their purity. Do not let us be defiled with false doctrine or with unholy living, but may we walk as the separated people of God and keep ourselves unspotted from the world. Lord, we do not want to grieve Your Spirit. May we never vex You so as to lead You in Your wrath to say, *"They shall not enter into my rest"* (Heb. 3:11). Bear with us still for the dear sake of Him whose blood is upon us. Bear with us still. Do not send the destroying angel as You did to Egypt, but again fulfill that promise of Yours: *"When I see the blood, I will pass over you"* (Exod. 12:13).

Just now may we be consciously passed over by the Spirit of condemnation. May we know in our hearts that *"there is therefore now no condemnation to them which are in Christ Jesus"* (Rom. 8:1). May we feel the peace-giving power of divine absolution. May we come into Your holy presence with our feet washed in the bronze laver, hearing our Great High Priest say to us, "[You are] *clean every whit"* (John 13:10). Thus made clean, may we draw near to God through Jesus Christ our Lord.

Further, our heavenly Father, we come before You now washed in the blood, wearing the snowy-white robe of Christ's righteousness, and we ask You to remember Your people. Some are sorely burdened. Lighten the burden or strengthen the shoulder. Some are bowed down with fear, and perhaps they mistrust You. Forgive the mistrust, and give a great increase of faith so that they may trust You where they cannot trace You. Lord, remember any who bear the burdens of others. Some cry to You day and night about the sins of the times, about the wanderings of Your church. Lord, hear our prayers! We want to bear this yoke for You, but help us to bear it without the fear that causes us to distrust You. May we know that You will take care of Your own case and preserve Your own truth, and may we thus be restful about it all.

Some are crying to You for the conversion of relatives and friends. They have taken up this burden to follow after Jesus in the

Fain our pity would reclaim,
And snatch the firebrands from the flame.

There are those who are utterly careless about divine things. Will You impress them? May some stray shot reach their consciences! Oh, that they may be led to solemnly consider their position and their latter end! May thoughts of death and of eternity dash irresistibly against their souls like some mighty waves! May heaven's light shine into their consciences! May they begin to ask themselves where and what they are, and may they be turned to the Lord with full purpose of heart.

There are others who are concerned, but they are wavering between two opinions. There are some whom we love in the flesh who have not yet decided for God. Behold, they tremble in the balance! Cast in Your cross, O Jesus, and turn the scale! Love irresistible, come forth, and carry by blessed storm the hearts that have not yet yielded to all the attacks of the law! May some who never could be melted, even by the furnace of Sinai, be dissolved by the beams of love from the tearful eyes of Jesus!

Lord, if there is a heart that is saying, "Now, behold, I yield. At Your feet, rebellion's weapons I lay down and cease to be Your foe, O King of Kings"—if there is one who is saying, "I am willing to be espoused unto Christ, to be washed in His blood, to be called in His righteousness"—bring that willing sinner in now! May there be no more delay, but may this be the time when, once for all, the great transaction will be done, and they will be their Lord's, and He theirs.

Oh, that we could pour out our souls in prayer for the unconverted! You know where they will all be in a few years! Oh, by Your wrath, we pray, let them not endure it! By the flames of hell, be pleased to ransom them from going down into the pit! By everything that is dreadful in the wrath to come, we urge You to have mercy on these sons of men, even on those who have no mercy on themselves. Father, have You not promised Your Son to see His soul's travail? We point You to the ransom paid; we point You once again to the groans of Your Son, to His agony and bloody sweat! Turn, turn Your glorious eyes there. Look on these sinners, speak the word, and bid them live.

Righteous Father, refresh every corner of the vineyard, and on every branch of the vine, let the dew of heaven rest. Oh, that You would bless Your church throughout the world! Let visible union be

established, or if not that, yet let the invisible union that has always existed be better recognized by believers. Will You repair our schisms? Will You repair the breaches that have been made in the walls of Zion? Oh, that You would purge us of everything unscriptural, until all Christians come to the law and to the testimony and still keep the ordinances and the doctrines as they were committed to the apostles by Christ!

Remember our land in this time of need. Be pleased by some means to relieve the prevalent distress. Quicken the wheels of commerce so that the many who are out of employment may no longer be crying for work and bread. Oh, that You would cause wars to cease to the ends of the earth, or when they break out, use them to break the slave's fetters. Though desperate be the evil, yet grant that Satan may cast out Satan, and may his kingdom be divided and so fall.

Above all, You long-expected Messiah, do come! Your ancient people who despised You once are waiting for You in Your second coming, and we, the Gentiles, who did not know You or regard You, we, too, are watching for Your advent. Do not wait, O Jesus! May Your feet soon stand again on Olivet! This time, You will not have to sweat great drops of blood there, but You will come to proclaim the year of vengeance for Your foes, and the year of acceptance for Your people.

> When wilt Thou the heavens rend,
> In majesty come down?

Earth travails for Your coming. The whole creation groans in pain together until now. Your own expect You. We are longing until we are weary for Your coming. Come quickly, Lord Jesus, come quickly.

5

To the King Eternal

Our God and Father, draw us to Yourself by Your Spirit, and may the few minutes that we spend in prayer be full of the true spirit of supplication. Grant that none of us with closed eyes may yet be looking abroad over the fields of vanity, but may our eyes be really shut to everything else but what is spiritual and divine. May we have communion with God in the secret places of our hearts and find Him to be a sanctuary.

O Lord, we do not find it easy to get rid of distracting thoughts, but we pray that You would help us to draw the sword against them and drive them away. As Abraham drove away the birds that came down upon his sacrifice (Gen. 15:11), so may we chase away all cares, all thoughts of pleasure, everything else, whether pleasing or painful, that would keep us away from real fellowship with the Father and with His Son, Jesus Christ.

We want to begin with adoration. We worship from our hearts the Three in One, the infinitely glorious Jehovah, the only living and true God. We adore the Father, the Son, and the Holy Spirit, the God of Abraham, of Isaac, and of Jacob. We have not yet ascended to the place where pure spirits behold the face of God, but we will soon be there, perhaps much sooner than we think. We desire to be there in spirit now, casting our crowns upon the glassy sea before the throne of the Infinite Majesty, and ascribing glory and honor, and power and praise, and dominion and might to Him who sits on the throne, and unto the Lamb forever and ever.

All the church worships You, O God. Every heart renewed by grace takes a delight in adoring You. We, among the rest, though least and lowest of them all, would yet bow as heartily as any, worshiping, loving, praising in our souls, being silent before God because our joy in Him is altogether inexpressible.

Lord, help us to worship You in life as well as by our lips. May our whole being be taken up with You. As the fire fell down on Elijah's sacrifice of old and licked up even the water that was in the trenches (1 Kings 18:30–39), so may the consuming fire of the divine Spirit use up all our nature. Even the thing that might seem to hinder, even out of that may God get glory by the removal of it. Thus would we adore You.

But, dear Savior, we come to You, and we remember what our state is. The condition we are in encourages us to come to You now as beggars, depending on Your heavenly charity. You are a Savior, and as such, You are looking for those who need saving, and here we are; here we come. We are the men and women You are looking for, needing a Savior.

Great Physician, we bring You our wounds and bruises and putrefying sores. The more diseased we are and the more conscious we are today of the depravity of our nature, of the deep-seated corruption of our hearts, the more we feel that we are the sort of beings that You are seeking, for the well and whole have no need of a physician, but those who are sick (Mark 2:17).

Glorious Benefactor, we can meet You on good terms, for we are full of poverty. We are just as empty as we can be. We could not be more abjectly dependent than we are. Since You want to display Your mercy, here is our sin. Since You want to show Your strength, here is our weakness. Since You want to manifest Your lovingkindness, here are our needs. Since You want to glorify Your grace, here we are, people who can never have a shadow of a hope except through Your grace, for we are undeserving, ill-deserving, hell-deserving. If You do not magnify Your grace in us, we must perish.

Somehow we feel that it is sweet to come to You in this way. If we had to tell You that we had some good thing in us that You required of us, we would have to question whether we were not flattering ourselves and presumptuously thinking that we were better than we are. Lord Jesus, we come just as we are. This is how we came at first, and this is how we come still—with all our failures, with all our transgressions, with all and everything that is what it ought not to be—we come to You. We do bless You that You receive us and our wounds, and by Your stripes we are healed (Isa. 53:5). You receive us and our sins, and by Your sin-bearing we are set clear and free from sin. You receive us and our death, even our death, for You are He who lives, and was dead, and are alive forevermore (Rev. 1:18).

We simply come and lie at Your feet, obedient to that call of Yours, *"Come unto me, all ye that labour and are heavy laden, and I will give you rest"* (Matt. 11:28). Let us feel sweet rest, since we do come at Your call. May some come that have never come until this day, and may others who have been coming these many years consciously come again, coming unto You *"as unto a living stone...chosen of God, and precious"* (1 Pet. 2:4), to build our everlasting hopes upon.

But, Lord, now that we have come so near to You and are on right terms with You, we venture to ask You this, that we who love You may love You much, much more. Oh, since You have been precious, Your very name has music in it to our ears, and there are times when Your love is so inexpressibly strong upon us that we are carried away with it. We have felt that we would gladly die to increase Your honor. We have been willing to lose our name and our reputation if You might be glorified through that. Truly, we often feel that if the crushing of us would lift You one inch higher, we would gladly suffer it.

For You, blessed King, we would set the crown on Your head, even if the sword would smite our arm off at the shoulder blade. You must be King, You must be glorified, no matter what becomes of us.

Yet we have to mourn because we do not always feel this rapture and ardor of love as we should. Oh, at times You manifest Yourself to us so charmingly that heaven itself could scarcely be happier than our world becomes when You are with us in it. But when You are gone and we are in the dark, give us the love that loves in the dark, that loves when there is no comforting sense of Your presence. Do not let us depend on feelings; may we always love You. If You were to turn Your back on us for a whole year, may we still think no less of You, for You are to be unspeakably loved whatever You do. If You give us rough words, may we still cling to You. And if the rod is used until we tingle, may we still love You, for You are to be infinitely loved by all men and angels. As Your Father loves You, make our hearts love You always the same. With all the capacity for love that there is in us, and with all the more that You can give us, may we love our Lord in spirit and in truth.

Help us, Lord, to conquer sin out of love for You. Help some dear strugglers who have been mastered by sin sometimes, but who are struggling against it. Give them the victory, Lord. When the battle gets very sharp and they are tempted to give way a little,

help them to be very firm and very strong, never giving up hope in the Lord Jesus, and resolving that if they perish, they will perish at His feet and nowhere else but there.

Lord, raise up in our churches many men and women who are all on fire with love for Christ and His divine Gospel. Oh, give us again men like Antipas, Your faithful martyr, and men like Paul, Your earnest servant who proclaimed Your truth so boldly. Give us Johns, men to whom the Spirit speaks, who will have us hear what the Spirit says to the churches. Lord, revive us! Revive Your work in the midst of the years in all the churches. Return to the church of God in this country. Return to her. Your adversaries think that they will have it all their own way, but they will not, for the Lord lives, and blessed be our Rock (Ps. 18:46).

Because of truth and righteousness, we implore You, lay bare Your arm in these last days. O Shepherd of Israel, deal a heavy blow at the wolves, and keep Your sheep in their own true pastures, free from the poisonous pastures of error. O God, we want to stir You up. We know You do not sleep, and yet sometimes it seems as if You nap awhile and allow things to go on in their own way.

We entreat You, awake. Plead Your own cause. We know Your answer: *"Awake, awake; put on thy strength, O Zion"* (Isa. 52:1). This we want to do, Lord, but we cannot do it unless You put forth Your strength to turn our weakness into might.

Great God, save this nation! O God of heaven and earth, stop the floods of infidelity and filthiness that roll over this land. O God, may we see better days! Men seem entirely indifferent now. They will not come to hear the Word as they once did. God of our fathers, let Your Spirit work again among the masses. Turn the hearts of the people to the hearing of the Word, and convert them when they hear it. May it be preached with the Holy Spirit sent down from heaven.

Our hearts are weary for You, O King, You King forgotten in Your own land, You King despised among Your own people. When will You yet be glorious before the eyes of all mankind? Come, we implore You, come quickly, or if You do not come personally, send forth the Holy Spirit with a greater power than ever so that our hearts may leap within us as they see miracles of mercy repeated in our midst.

Father, glorify Your Son. Somehow our prayer always comes to this before we finish. *"Father...glorify thy Son, that thy Son also may glorify thee"* (John 17:1). Let the days come when He will see

the travail of His soul and will be satisfied (Isa. 53:11). Bless all work done for You, whether it is in the barn or in the cathedral, silently and quietly in the street, or in the Sunday school or in the classroom. O Lord, bless Your work. Hear also prayers that have been offered up by wives for their husbands, children for their parents, parents for their children. Let the holy service of prayer never cease, and let the intercession be accepted by God, for Jesus Christ's sake.

6

The Wonders of Calvary

Great God Almighty, there was a time when we dreaded the thought of coming near to You, for we were guilty, and You were angry with us. But now we will praise You because Your anger is turned away, and You comfort us. Now the very throne that was once a place of dread has now become the place of shelter. We flee to You to hide us.

We long to get away from the world, even from the remembrance of it, and have fellowship with the world to come by speaking with Him who *"was, and is, and is to come"* (Rev. 4:8), the Almighty. Lord, we have often been worried and wearied with care, but with You, care comes to an end. All things are with You, and when we live in You, we live in wealth, in sure repose, in constant joy.

We battle with the sons of men against a thousand errors and unrighteousnesses, but when we flee to You, all is truth and purity and holiness, and our hearts find peace. Above all, we have to battle with ourselves, and we are very much ashamed of ourselves. After many years of great mercy, after tasting the powers of the world to come, we still are so weak, so foolish. But when we get away from self to God, there we find truth and purity and holiness, and our hearts rest in peace, wisdom, completeness, delight, joy, and victory.

Oh, bring us now, we pray, near to Yourself. Let us bathe ourselves in communion with our God. Blessed be the love that chose us before the world began. We can never sufficiently adore You for Your sovereignty, the sovereignty of love that saw us in the ruins of the Fall, yet loved us notwithstanding all.

We praise the God of the eternal council chamber and the everlasting covenant. Yet we struggle to find sufficiently worthy

words with which to praise Him who gave us grace in Christ His Son, before He spread the starry sky.

We also bless You, O God, as the God of our redemption, for You have loved us so much that You even gave Your dear Son for us. He gave Himself, His very life for us, so that He might redeem us from all iniquity and sanctify us for Himself to be His special people, zealous for good works (Titus 2:14).

We can never sufficiently adore free grace and dying love. The wonders of Calvary never cease to be wonders. They grow marvelous in our eyes as we think of Him who washed us from our sins in His own blood. Nor can we cease to praise the God of our regeneration, who found us dead and made us live, found us at enmity and reconciled us, found us loving the things of this world and lifted us out of the morass and mire of selfishness and worldliness into the love of divine, everlasting things.

O Spirit of God, we love You this day, especially for dwelling in us. How can You abide in so crude a habitation? How can You make these bodies Your temples? And yet You did so. For that, let Your name be held in reverence as long as we live.

O Lord, we want to delight ourselves in You this day. Give us faith and love and hope so that, with these three graces, we may draw very near to the triune God. You will keep us, You will preserve us, You will feed us, You will lead us, and You will bring us to the mind of God. There You will show us Your love, and in the glory everlasting and boundless, there You will make us know and taste and feel the joys that cannot be expressed.

But a little longer waiting and we will come to the golden shore. But a little longer fighting and we will receive the crown of life that does not fade away.

Lord, get us up above the world. Come, Holy Spirit, heavenly Dove, mount and bear us on Your wings, far from these inferior sorrows and inferior joys, up where eternal ages roll. May we ascend in joyful contemplation, and may our spirits come back again, strong for all service, armed for all battles, armored for all dangers, and made ready to live heaven on earth, until by and by we will live heaven in heaven. Great Father, be with Your waiting people. Any in great trouble, may You greatly help. Any who are despondent, may You sweetly comfort and cheer. Any who have erred and are suffering under their own sin, may You bring them back and heal their wounds. Any who this day are panting after holiness, may

You give them the desire of their hearts. Any who are longing for usefulness, may You lead them into ways of usefulness.

Lord, we want to live while we live. We do pray that we may not merely groan out an existence here below, or live as earthworms crawling back into our holes and dragging now and then a dry leaf with us. Rather, give us the ability to live as we ought to live, with a new life that You have put into us, with the divine awakening that has lifted us as much above common men as men are lifted above the beasts that perish.

Do not let us always be hampered like poor half-hatched birds within the eggshell. May we chip the shell today and get out into the glorious liberty of the children of God. Grant us this, we pray.

Lord, visit our churches. We have heard Your message to the churches at Ephesus; it is a message to us also. Do not let any of us lose our first love. Do not let our churches grow cold and dead. We are not, we fear, what we once were. Lord, revive us! All our help must come from You. Give back to the church its love, its confidence, its holy daring, its consecration, its liberality, its holiness. Give back all that it ever had, and give it much more. Take every member and wash his feet most tenderly. Sweet Lord, set us with clean feet in a clean road, with clean hearts to guide us. May You bless us, as You are disposed to do, in a divine way.

Bless us, our Father, and let all the churches of Jesus Christ partake of the same care and tenderness. Walking among the golden candlesticks, Lord, trim every lamp and make every light, even though it burns but feebly now, to shine out gloriously through Your care.

Now bless the sinners. Lord, convert them. O God, save men. Save this great city, this wicked city, this slumbering, dead city. Lord, arouse it, arouse it by any means, so that it may turn to its God. Lord, save sinners all the world over.

Let Your precious Word be fulfilled: *"Behold, he cometh with clouds"* (Rev. 1:7). Why do You wait? Do not wait, O Lord. And now unto the Father, Son, and Holy Spirit be glory forever and ever.

7

"Let All the People Praise Thee"

Our Father, when we read Your description of human nature, we are sure it is true, for You have seen man ever since his fall, and You have been grieved at heart concerning him. Moreover, You have such a love toward him that You did not judge him harshly. Every word that You have spoken must be according to truth. You have measured and computed the iniquity of man, for You have laid it on the Well Beloved, and we know You have not laid on Him more than is just.

O God, we are distressed and greatly bowed down when we see the condition to which we and all our race have fallen. *"Where is boasting then?"* (Rom. 3:27). And yet we grieve to say that we do boast, have boasted, and that our fellowmen are great at boasting. Instead, we ought to lay our hands upon our mouths before You.

It is a wonder to us that You should look upon man at all. The most hateful object in creation must be a man, because he killed Your Son, because he has multiplied rebellions against Your holy law. Yet truly there is no sight that gives You more pleasure than man, for Jesus became a man. The brightness of His glory covers all our shame, and the pureness and perfection of His obedience shines like the sun in the midst of the darkness. For His sake, You are well pleased, and You dwell with us.

Lord, we once thought that those descriptions of our hearts were somewhat exaggerated, but we do not think so now. Truly we perceive that had it not been for restraint that held us like chains, we, in our unregenerate state, were capable of anything. Even now, when we are regenerate, the old sin that remains in us is capable of reaching a high degree of infamy. If the new life did not restrain the old death, we do not know what we might yet become.

We once thought we were humble, but we soon found that our pride will feed on any current flattery that is laid at our door. We thought we were believers, but sometimes we are so doubting, so unbelieving, so vexed with skepticism, that we would not certainly choose to follow. That is Your work in us. By nature we are such liars that we think You are a liar, too—the surest token of our untruthfulness is that we think that You could be untrue.

Oh, these wicked hearts of ours! Do they not have enough kindling in them to set on fire the course of nature? If only a spark were to fall into them, any one of our members left to itself would dishonor Christ, deny the Lord who bought us, and turn back into perdition.

We are altogether ashamed. Truly in us is fulfilled Your own Word: *"That thou...never open thy mouth any more because of thy shame"* (Ezek. 16:63). Your love to us has silenced us. That great love has hidden boasting away from us—Your great love, with which You loved us even when we *"were dead in trespasses and sins"* (Eph. 2:1); Your great love with which You have loved us still, despite our poor manners, our wanderings, our shortcomings, and our excesses.

Oh, the matchless love of God! Truly if there is any glory, it must all be the Lord's. If there is any virtue, it is the result of grace. If there is anything whatsoever that lifts us above the Devil himself, it is the work of the divine Spirit, to whom be glory!

At the remembrance of all this, and being in Your presence, we rejoice that our unrighteousness is covered, that we are free from condemnation, and that we are the favored of the Lord. You have allowed us, O Lord, to taste of the love that is not merely laid up for us, for we have enjoyed it and do enjoy it still.

Our hearts know the Father's love, for we *"have received the Spirit of adoption, whereby we cry, Abba, Father"* (Rom. 8:15). We joy and rejoice in the redemption of our spirits, and we expect the redemption of our bodies, when at the coming of the Lord, they, too, *"shall be raised incorruptible, and we shall be changed"* (1 Cor. 15:52).

O Jesus, You will bring Israel out of Egypt, and not a hoof will be left behind—no, not a bone or any piece of Your elect will be left in the hands of the Adversary. We will come out clean, delivered by Him who does nothing by halves, but who on the cross said, *"It is finished"* (John 19:30), and who much more will say it on His throne. Glory be unto the Father, Son, and Holy Spirit, who lifted us up from

our ruin and condemnation, made us new creatures, justified us, and guaranteed us eternal life that will be manifested at the coming of the Lord. All glory be unto His blessed name forever and ever!

Now, Lord, during the few days that remain to us here below, let it be all our business to cry, *"Behold the Lamb"* (John 1:29)! Oh, teach these hearts to be always conscious of Your love; and then teach these lips that they may express as best they can with Your divine help the matchless story of the Cross. Oh, give us the privilege of winning many to Jesus. Do not let us be barren, but may we be able to cry that we are the beloved of the Lord, and our offspring is with us. May we have many spiritual offspring who will go with us to the throne, so that we may say before Him, *"I and the children whom the LORD hath given me"* (Isa. 8:18).

Lord, bless the work of the churches and all their branches. Let Your kingdom come into the hearts of multitudes through the churches. Remember all churches that are really at work for Jesus, and all private individuals, workers alone, workers by themselves. Let the Lord's own name be made known by tens of thousands. Give the Word, and may the company of those who publish it be great. Let our beloved country know Christ and come to His feet. Let the dark places of our cities be enlightened with the sweet name of Jesus. And then let the heathen know You, and the ends of the earth hear of You.

Oh, from the tree declare Your salvation, and from the throne let it be published in the proclamations of a king. *"Let the people praise thee, O God; let all the people praise thee"* (Ps. 67:3).

Our hearts seem as if they have nothing else to ask for when they reach this point. Yet we want to go back a moment and say, "Lord, forgive our sins; Lord, sanctify our persons; Lord, guide us in difficulty; Lord, supply our needs. May He teach us, perfect us, comfort us, and prepare us for the appearing of His Son from heaven!"

And now we come back to a theme that still seems to engross our desires. Oh, that Christ would come! Oh, that His Word would be made known to the ends of the earth! Lord, they die, they perish, they pass away by multitudes! Every time the sun rises and sets, they pass away! Do not wait, we entreat You. Give wings to the feet of Your messengers and fire to their mouths, so that they may proclaim the Word with Pentecostal swiftness and might. Oh, that Your kingdom would come, and Your will be done on earth as it is in heaven, *"for thine is the kingdom, and the power, and the glory, for ever. Amen"* (Matt. 6:13).

8

A Prayer for Holiness

Our Father, we worship and love You. It is one point of our worship that You are holy. There was a time when we loved You for Your mercy, for we knew no more. But now You have changed our hearts and made us in love with goodness, purity, justice, true holiness. We understand now why the cherubim and seraphim continually cry, *"Holy, holy, holy, Lord God Almighty"* (Rev. 4:8).

We adore You because You are holy, and we love You for Your infinite perfection. Now we sigh and cry after holiness ourselves. Sanctify us wholly, spirit, soul, and body. Lord, we mourn over the sins of our pasts and our present shortcomings. We bless You, for You have forgiven us. We are reconciled to You by the death of Your Son. There are many who know that they have been washed, and that He who bears away sin has borne their sin away. These are they who cry to You to be delivered from the power of sin, to be delivered from the power of temptation without, but especially from indwelling sin within.

Lord, purify us in head, heart, and hand. If it is necessary that we should be put into the fire to be refined as silver is refined, we would even welcome the fire, if we may be rid of the dross. Lord, save us from constitutional sin, from sins of temperament, from sins of our surroundings. Save us from ourselves in every shape, and grant us especially to have the light of love strong within us.

May we love You, God. May we love You, O Savior. May we love the people of God as being members of one body in connection with You. May we love the guilty world with the love that desires its salvation and conversion. May we love not in word only, but in deed and in truth (1 John 3:18). May we help the helpless, comfort the mourner, sympathize with the widow and fatherless, and may

we always be ready to put up with wrong, to be long-suffering, to be very patient, full of forgiveness, counting it a small thing that we should forgive our fellowmen since we have been forgiven by God. Lord, tune our hearts to love, and then give us an inward peace, a restfulness about everything.

May we have no burden to carry because, though we have a burden, we have rolled it upon the Lord. May we take up our cross, and because Christ has once died on the cross, may our cross become a comfort to us. May we count it all joy when we fall into various trials, knowing that in all this God will be glorified, His image will be stamped on us, and the eternal purpose will be fulfilled, in which He has predestined us *"to be conformed to the image of his Son"* (Rom. 8:29).

Lord, look upon Your people. We could pray about our troubles, but we will not do so right now. We will only pray against our sins. We could come to You about our weariness, about our sickness, about our disappointment, about our poverty, but we will leave all that for now. We will only come about sin. Lord, make us holy, and then do what You will with us.

We ask You, help us to adorn the doctrine of God our Savior in all things. If we are fighting against sin—*"the sin which doth so easily beset us"* (Heb. 12:1)—Lord, lend us heavenly weapons and heavenly strength so that we may cut the giants down, these men of Anak that come against us. (See Numbers 13:33.) We feel very feeble. Oh, make us *"strong in the Lord, and in the power of his might"* (Eph. 6:10). May we never let sin have any rest in us. May we chase it, drive it out, slay it, hang it on a tree, abhor it, and may we *"cleave to that which is good"* (Rom. 12:9).

Some of us are trying, striving after some excellent virtue. Lord, help strugglers. Enable those who contend against great difficulties to see greater grace, have more faith, and be nearer to God. Lord, we will be holy, and by Your grace we will never rest until we are. You have begun a good work in us, and You will carry it on (Phil. 1:6). You will work in us to will and to do of Your own good pleasure (Phil. 2:13).

Lord, help the converted child to be correct in his relationship to his parents. Help the Christian father and mother to be right in dealing with their children. May they not *"provoke...[their] children to anger, lest they be discouraged"* (Col. 3:21). Take away willfulness from the young. Take away impatience from the old. Lord, help Christian men of business to act uprightly. May Christian

masters never be harsh with their servants, with their workers. May Christian workers give to their masters what is just and equal in the way of work in return for wages. May we as Christians always stand on our rights, but also be willing to minister to the needs of others.

Oh, that as Christians we might be humble! Lord, take away that stiff-necked, proud look. Take away from us the spirit of "stand away, for I am holier than thou." Make us reach out to men of low social standing, yes, and even to men of low morals, low character. May we seek them out, seek their good. Oh, give to the church of Christ an intense love for the souls of men. May it make our hearts break to think that they will perish in their sin. May we grieve every day because of the sin of our cities. Put a mark on our foreheads, and let us be known to You as men who sigh and cry for all the abominations that are done in the midst of our cities (Ezek. 9:4).

O God, save us from a hard heart, an unkind spirit, that is insensible to the woes of others. Lord, preserve Your people also from worldliness, from rioting, from drunkenness, from clamoring and lewdness, from strife and envy, from everything that would dishonor the name of Christ that we bear. Lord, make us holy. Our prayer comes back to this: make us holy. Cleanse the inside and let the outside be clean, too. Make us holy, O God. Do this for Christ's sake. It is not that we hope to be saved by our own holiness, but holiness is salvation. When we are holy, we are saved from sin.

Lord, help Your poor children to be holy. Oh, keep us so if we are so. Keep us even from stumbling, and present us faultless before Your presence at last (Jude 24). We pray for friends who are ill, for many who are troubled because of the illness of others. We bring before You every case of trouble and trial known to us and ask for Your gracious intervention. We pray for Your ministers everywhere. For Your missionary servants, we ask You to remember those who are making great sacrifice out in the hot sun or in the cold and frozen North. Everywhere preserve those who for Christ's sake carry their lives in their hands.

Our brothers and sisters, in poverty many of them, working for Christ, Lord accept them and help us to help them. Do remember the Sunday school teachers, the city missionaries, along with those who visit and hand out tracts door-to-door, and all who in any way endeavor to bring Christ to the notice of men. Oh, help them all.

We will offer but one more prayer, and it is this. Lord, look in pity on any who are not in Christ. May they be converted. May they pass from death to life and never forget it. May they see the eternal light for the first time, and may they remember it even in eternity. Father, help us. Bless us now for Jesus' sake.

9

Glorious Liberty

Our Father, we bless Your name that we can say from the bottom of our hearts, *"Abba, Father"* (Rom. 8:15). It is the chief joy of our lives that we have become the children of God by faith that is in Christ Jesus, and we can in the deep calm of our spirits say, *"Our Father which art in heaven, Hallowed be thy name. Thy kingdom come. Thy will be done in earth, as it is in heaven"* (Matt. 6:9–10).

Lord, we thank You for the liberty that comes to our emancipated spirits through the adoption that You have made us to enjoy. When we were in servitude, the chains were heavy, for we could not keep Your law. There was an inward spirit of rebellion. When the commandment came, it irritated our corrupt nature, sin revived, and we died.

Even when we had some inner striving for better things, the power that was in us lusted to evil, and the spirit of Hagar's Ishmael was upon us. We wanted to get away from the Father's house. We were wild men, men of the wilderness, and we did not love living in the Father's house.

O God, we thank You that we have not been cast out. Indeed, if You had cast out the child of the bondwoman, You would have cast us all out, but now through sovereign grace all is altered with us. Blessed be Your name. It is a work of divine power and love over human nature, for now we are the children of the promise, certainly not born according to the strength of the human will, or of blood, or of birth, but born by the Holy Spirit through the power of the Word, *"begotten...again unto a lively hope by the resurrection of Jesus Christ from the dead"* (1 Pet. 1:3), children of the Great Father who is in heaven, having His life within us. Now, like Isaac, we are heirs according to promise and heirs of the promise. We

dwell at home in the Father's house, and our souls are satisfied as with marrow and fatness, and our mouths will praise You as with joyful lips (Ps. 63:5).

O God, we would not trade places with angels, much less with kings of the earth. To be indeed Your sons and daughters—the thought of it brings to our souls a present heaven, and the fruition of it will be our heaven, to dwell forever in the house of the Lord, and leave it no more, but to be His sons and His heirs forever and ever.

Our prayer is for others who are still in bondage. We thank You, Lord, that You have given them the spirit of bondage and made them to fear. We are glad that they are brought to feel the evil of sin, to feel the perfection of Your law, to know something of the fiery nature of Your justice, and so to be shut up unto salvation by grace through faith. But, Lord, do not let them remain long under the harsh teacher, but may the schoolmaster with his rod bring them to Christ. (See Galatians 3:24.)

Lord, cure any of Your chosen of self-righteousness. Deliver them from any hope in their own abilities, but keep them low. Bring them out of any hope of salvation by their own prayers or their own repentance. Bring them to cast themselves upon Your grace to be saved by trusting in Christ. Emancipate them from all observance of days, weeks, months, years, and things of human institution. Bring them into the glorious liberty of the children of God so that Your law may become their delight, so that You may become their strength and their all, and so that Your Son may become their joy and their crown. We do pray this with all our hearts.

Lord, deliver any of Your children from quarreling with You. Help us to be always at one with our God. *"It is the LORD: let him do what seemeth him good"* (1 Sam. 3:18), and blessed be His name forever and ever.

God bless our country, and the sister country across the ocean, and all lands where Your name is known and reverenced, and heathen lands where it is unknown. Everywhere may the Lord's kingdom come and His name be glorified. Glory be to the Father, and to the Son, and to the Holy Spirit, as it was in the beginning, is now, and ever will be, world without end.

10

The Music of Praise

O blessed God, we must be helped by Your Spirit or we cannot worship You fittingly. Behold, the holy angels adore You, and the hosts redeemed by blood bring everlasting hallelujahs to Your feet. What are we, the creatures of a day, polluted with sin, that we should think that we can praise You? And yet the music of praise would not be complete if Your children did not join in it, even those of them who are still in this world below. Help us, then. Enable us to tune our harps and to bring forth music from our spirits.

Truly, Lord, if there are any creatures in the world that can praise You, we ought to do so. Each one among us feels that he has some special reason for gratitude. Lord, it is an unspeakable mercy to know You—to know You as our reconciled God, to know You as our Father in Christ Jesus, who has forgiven us all our trespasses. Oh, it is unspeakably sweet to come and rest in You, and to know that there is now no cause of quarrel between us and You. On the contrary, we realize that we are bound to one another by a covenant that in infinite tenderness and mercy You have made, so that Your people might have strong consolation and might boldly take hold of You.

Oh, the joy of knowing that we are Yours forever, Yours in the trials of life, and Yours in the last dread trial of death, and then Yours in resurrection, Yours throughout eternity! We do therefore worship You, O God, not under coercion, nor under terror or pressure, but cheerfully and gladly, ascribing unto You praise, power, dominion, glory, and honor, world without end.

We wish we knew how to do something for You. We pray that we may be helped to do so before we die. May every fleeting hour confess that we have brought Your Gospel some renown. May we

so live as to extend the Redeemer's kingdom at least in some little measure. May ours not be fruitless, wasted lives. May no faculty of ours lay by and rust, but to the utmost of our capacity, may we be helped by the divine Spirit to spend the whole of our lives in real adoration.

We know that he who serves is actually praying, he who gives is actually praising, and he who obeys is actually adoring. The life is the best music. Oh, set it to good music, we pray, and help us throughout all our lives to keep to the right notes. May there be no false pitch in all the singing of our lives, but let all be according to that sacred score that is written out so fully in the life music of our Lord.

We implore You to look down upon Your children and cheer us. Lord, lift us up. Come, Holy Spirit, like a fresh, invigorating wind. Let our spirits, through Your Spirit, rise upward toward God.

With much shamefacedness we acknowledge our transgressions and sins. However, there are some who have never felt the burden of sin at all. Lord, lay it on them; press them with it. Almighty God, vex their souls. Let them find no rest until they find rest in You. May they never be content to live and die in sin, but in Your infinite mercy, come to them and make them sorry for their sin.

As for Your people, we are grieved to think that we do not live better than we do. Blessed be Your name for every fruit of holiness, for every work of faith, but oh, for more. You have changed the tree; it is no longer a bramble. It can bring forth figs, but now we want to bring forth more of these sweet fruits.

Lord, make us to love Christ intensely, to love the souls of men most heartily, to love Your truth with earnestness, to love the name of Jesus above everything. May we be ravished with the sound of it. May the Lord give us every grace, not only love, but faith, hope, holy gentleness, meekness, patience, and brotherly love. Build us up, we pray, Lord, in all knowledge and in all experience. Give us, along with submission to Your will, holy resignation, great watchfulness, much carefulness in our speech, so that we may rule the tongue and so rule the whole body.

Lord, may You pour out Your Spirit upon us so that every chamber of our nature may be sweetened and perfumed with the indwelling of God, until our imaginations only delight in things chaste and pure; until our memories cast out the vile stuff from the dark chambers; until we expect and long for heavenly things; until

our treasure all is in heaven, and our hearts are there. Take our highest manhood, Lord, and saturate it in Your love, until, like Gideon's fleece, it is filled with dew, every lock and every single fleck of it, not a single portion of it left unmoistened by the dew from heaven.

How we bless You for many who are striving to walk as Christ walked, and who are also trying to bring others to Christ. O Lord, help us in this struggle after holiness and usefulness. As You have given to many the desire of their hearts in this respect up to a certain measure, now enlarge their hearts, and give them more both of holiness and usefulness. May we be like trees *"planted by the rivers of water"* (Ps. 1:3), so that we ourselves may be vigorous. Give us the ability to bring forth abundant fruit according to our season (v. 3), to the everlasting praise and glory of God.

Our desire is that we may be quickened in our progress toward the celestial life. Visit us with Your salvation. Lord, let us not only have life, but let us have it more abundantly (John 10:10). May we every one of us quicken his pace, and may we run more earnestly than ever toward the mark that is set before us.

Remember all Your church throughout the whole world. Prosper missionary operations. Be with any ministers or missionaries who are depressed for lack of success. Be with any who are rejoicing because of success. May each heart be kept in a right state, so that You may use Your servants to the utmost of possibility.

O God, send us better days than these, we pray. We thank You for all the light there is, but send us more light. We thank You for what life there is among Christians, but send more of it.

Bind the churches together in unity, and then give them such speed, such force, such power, that they will break into the ranks of the Adversary and the victory be unto Christ and to His people.

Remember our dear country. Bless the head of our nation. Remember all those who lead our legislature. Be gracious to all ranks and conditions of men. Have mercy on all who are poor and needy, on all who are sick and sorrowing, and who are tossed upon the sea. Remember the prisoners and those who have no helper. Be gracious to those who are in the summons of death. Finally, let the day come when the Son will shine forth in all His brightness, even Christ Jesus will be manifested, to be admired in them who believe and to make glad the whole creation. Do not wait, O Son of Righteousness, but come forth speedily. We ask it for Your name's sake.

11

Under the Blood

Jehovah, our God, we thank You for leaving on record the story of Your ancient people. It is full of instruction to us. Help us to take its warning to avoid the faults into which they fell! You are a covenant God, and You keep Your promises. Your Word never fails. We have proved this to be so:

> Thus far we find that promise good,
> Which Jesus ratified with blood.

But as for ourselves, we are like Israel of old, a fickle people. We confess with great shame that although there are days when we take the tambourine and sing with Miriam *"unto the LORD, for he hath triumphed gloriously"* (Exod. 15:1), yet, not many hours later, we are thirsty, and we cry for water, and we murmur in our tents. Bitter Marah turns our hearts (vv. 22–25), and we are grieved with You, our God. When we behold Your Sinai covered in smoke, we bow before You with reverence and awe, but there have been times when we have set up the golden calf and have said of some earthly things, *"These be thy gods, O Israel"* (Exod. 32:4). We believe with intensity of faith and then doubt with a horribleness of doubt.

Lord, You have been very patient with us. Many have been our provocations, many have been Your chastisements, but

> Your strokes are fewer than our crimes,
> And lighter than our guilt.

You *"hath not dealt with us after our sins; nor rewarded us according to our iniquities"* (Ps. 103:10). Blessed be Your name!

And now fulfill that part of the covenant wherein You have said, *"A new heart also will I give you, and a new spirit will I put*

within you" (Ezek. 36:26). *"I will put my fear in their hearts, that they shall not depart from me"* (Jer. 32:40). Hold us fast, and then we will hold fast to You. Turn us, and we will be turned. Keep us, and we will keep Your statutes.

We cry to You that we may no longer provoke You. We beg You to send the serpents among us rather than to let sin come among us. Oh, that we might have our eyes always on the bronze serpent that heals all the bites of evil (Num. 21:9), but may we not look to sin or love it. Do not let the devices of Balaam and of Balak prevail against us, to lead Your people away from their purity. Do not let us be defiled with false doctrine or with unholy living, but may we walk as the separated people of God and keep ourselves unspotted from the world. Lord, we do not want to grieve Your Spirit. May we never vex You so as to lead You in Your wrath to say, *"They shall not enter into my rest"* (Heb. 3:11). Bear with us still for the dear sake of Him whose blood is upon us. Bear with us still. Do not send the destroying angel as You did to Egypt, but again fulfill that promise of Yours: *"When I see the blood, I will pass over you"* (Exod. 12:13).

Just now may we be consciously passed over by the Spirit of condemnation. May we know in our hearts that *"there is therefore now no condemnation to them which are in Christ Jesus"* (Rom. 8:1). May we feel the peace-giving power of divine absolution. May we come into Your holy presence with our feet washed in the bronze laver, hearing our Great High Priest say to us, "[You are] *clean every whit"* (John 13:10). Thus made clean, may we draw near to God through Jesus Christ our Lord.

Further, our heavenly Father, we come before You now washed in the blood, wearing the snowy-white robe of Christ's righteousness, and we ask You to remember Your people. Some are sorely burdened. Lighten the burden or strengthen the shoulder. Some are bowed down with fear, and perhaps they mistrust You. Forgive the mistrust, and give a great increase of faith so that they may trust You where they cannot trace You. Lord, remember any who bear the burdens of others. Some cry to You day and night about the sins of the times, about the wanderings of Your church. Lord, hear our prayers! We want to bear this yoke for You, but help us to bear it without the fear that causes us to distrust You. May we know that You will take care of Your own case and preserve Your own truth, and may we thus be restful about it all.

Some are crying to You for the conversion of relatives and friends. They have taken up this burden to follow after Jesus in the

matter of cross bearing. Grant them to see the desire of their hearts fulfilled. God, save our children and children's children, and if we have unconverted relatives of any kind, Lord, have mercy on them for Christ's sake. Give us joy in them—as much joy in them as Christians as we have had sorrow about them as unbelievers.

Further, be pleased to visit Your church with the Holy Spirit. Renew the Day of Pentecost in our midst. In the midst of all gatherings of Your people, may there come the descension of the holy fire, the uprising of the heavenly wind. May matters that are now slow and dead become quick and full of life, and may the Lord Jesus Christ be exalted in the midst of His church, which is His fullness, *"the fulness of him that filleth all in all"* (Eph. 1:23). May multitudes be converted. May they come flocking to Christ with holy eagerness to find in Him a refuge, even as the doves fly to their dovecotes.

Oh, for salvation work throughout these islands and across the sea and in every part of the world, especially in heathen lands. Bring many to Christ's feet, we pray You, everywhere that men are ready to lay down their lives to impart the heavenly life of Christ. Work, Lord; work mightily! Your church cries to You, "Do not leave us." We can do nothing without You! Our strength is wholly Yours. Come to us with great power, and let Your Word have free course and be glorified.

Remember everyone who calls You Father. May a Father's love look on all the children. May the special need of each one be supplied, the special sorrow of each one be eased. May we be growing Christians; may we be working Christians; may we be perfected Christians; may we come to *"the measure of the stature of the fulness of Christ"* (Eph. 4:13). Lord Jesus, You are a great pillar. In You all fullness dwells (Col. 1:19). You began Your ministry with filling the waterpots full. You filled Simon Peter's boat until it began to sink. You filled the house where Your people met together with the presence of the Holy Spirit. You fill heaven. You will surely fill all things. Fill us; oh, fill us today with all the fullness of God! Thus make Your people joyful, strong, gracious, and heavenly!

But we cannot end our prayer when we have prayed for just Your people, though we have asked large things. We want You to look among the thousands and millions all around us who do not know You. Lord, look on the masses who go nowhere to worship. Have pity on them. *"Father, forgive them; for they know not what*

they do" (Luke 23:34). Give them a desire to hear Your Word. Send the people a desire for their God.

O Lord, take sinners in hand Yourself. Come and reach obstinate, hardened minds. Let the careless and the frivolous begin to think about eternal things. May there be an uneasiness of heart, a sticking of the arrows of God in their bodies. May they seek the Great Physician and find healing this very day. Lord, You say, *"To day if ye will hear* [My] *voice, harden not your heart"* (Ps. 95:7–8), and we take up the echo. Save men today, even today. Bring them Your Spirit in power so that they may be willing to rest in Christ. Lord, hear, forgive, accept, and bless for Jesus' sake. Amen.

12

On Holy Ground

O*ur Father which art in heaven, Hallowed be thy name. Thy kingdom come. Thy will be done in earth, as it is in heaven"* (Matt. 6:9–10). I fear that we often begin our prayers with petitions for ourselves, putting our daily bread before Your kingdom and the pardoning of our sins before the hallowing of Your name. We do not want to do so today, but guided by our Lord's model of prayer, we want to first pray for Your glory. Here, great God, we want to adore You. You have made us and not we ourselves; we are Your people, and the sheep of Your pasture (Ps. 100:3). All glory be unto You, Jehovah, the only living and true God.

With heart and mind, memory and fear, hope and joy, we worship the Most High. It well becomes us to take our shoes off our feet when we draw near to God, for the place where we stand is holy ground. If God in the bush demanded the unsandaled foot of the prophet (Exod. 3:4–5), how much more will God in Christ Jesus?

With the lowliest reverence, with the truest love, we worship God in Christ Jesus, uniting in this act with all the redeemed host above, with angels and principalities and powers. We cannot cast crowns at Your feet, for we do not have any yet, but if there is any virtue, if there is any praise, if there is about us anything of grace and good report, we ascribe it all to God. We cannot veil our faces with our wings, for we have none, but we veil them with something better than angelic wings: the blood and righteousness of Jesus Christ. With these we cover our faces, with these we cover our feet, and with these we fly up to God in holiest fellowship. *"Blessing, and honour, and glory, and power, be unto him that sitteth upon the throne, and unto the Lamb for ever and ever"* (Rev. 5:13).

Great God, we long that You may be known to the ends of the earth, that the idols may be utterly abolished. We long that false

doctrine may fly like birds of darkness before the light and Your coming. Reign in the hearts of our fellowmen, Lord; subdue sin, and under Your feet let drunkenness, unchastity, oppression, and every form of wickedness be put away by the Gospel of Jesus Christ and His Holy Spirit.

Oh, that today, even today, many hearts might be won to God! Convince men of the wrong of being alienated from God, put into their hearts sorrow for sin and dread of the wrath to come, and lead and drive men to Christ. Oh, how we pray for the salvation of our fellowmen, not so much for their sakes as for the sake of the glory of God and the rewarding of Christ for His pain.

With all our hearts we pray, *"Thy kingdom come. Thy will be done in earth, as it is in heaven"* (Matt. 6:10). Lord, help us to do Your will. Take the crippled kingdom of our personhood and reign over it. Let spirit and body be consecrated to God. May there be no reserves. May everything be given up to You. Reign forever! Pierced King, despised and nailed to a tree, sit on the glorious, high throne in our hearts. May our lives prove that You are Lord over us by our every thought, desire, imagination, word, and act, in every respect being under Your divine control.

Out of their very hearts, Your people breathe to You the prayer that You may reign over us without a rival. O Savior, use for Yourself what You have bought with blood, and drive out the Enemy. Let no power have any dominion over us except the power of Your good Spirit, who works righteousness and peace.

We pray today also that Your truth may prevail against the many antichrists that have gone forth against it. Our Father, restore a pure language to Your Zion once again. Take away, we pray, the itching for new doctrine, the longing for what is thought to be scientific and wise above what is written, and may Your church come to her moorings. May she cast anchor in the truth of God and there abide. If it is Your will, may we live to see brighter and better times.

If it might be so, we pray for our Lord to come very speedily to end these sluggish years, these long, delaying days. But if He does not come soon, put power into Your truth, and quicken Your church so that she may become energetic for the spread of Your Gospel, so that Your kingdom may come. First and above everything, we seek the glory of God.

We ask for grace so that we may live with this end in view. May we lay our lives down for it. May this be our morning thought, and the thought that we have in our minds when we lie awake at

night: What should I do, my Savior, to praise You? How can I make You illustrious and win another heart to Your throne?

Now bless us. Forgive our trespasses since we have sinned against You. Seal our pardon in our consciences, and make us feel that as we truly forgive those who trespass against us, so You have forgiven us all our iniquities. We pray that You do not lead us into temptation. Do not try us, Lord, or allow the Devil to try us. If we must be tried, then deliver us from evil, and especially from the Evil One, so that he may get no dominion over us.

Oh, keep us, Lord. This life is so full of trials. Many are perplexed about temporary things. Do not let the Enemy lead them to do or think anything amiss because of the difficulty of supply. Others are blessed with prosperity. Lord, do not let it be a curse to them. Let them know how to abound as well as to suffer loss (Phil. 4:12). In all things may they be instructed to glorify God, not only with all they are, but with all they have, and even with all they do not have. By a holy contentment, may they do without what it does not please You to bestow.

And then, Lord, give us day by day our daily bread. Provide for Your poor people. Do not let them think that the provision for them rests fully on themselves, but may they cry to You, for You have said of the person who lives righteously, *"Bread shall be given him; his waters shall be sure"* (Isa. 33:16). If we follow You, if You lead us into a desert, You will scatter our path with manna. May Your people believe this, and let them have no care, but like the birds of the air, which neither sow nor gather into barns and yet are fed, so may Your people be (Matt. 6:26).

Above all, give us spiritual help. Give us wisdom, which is profitable to get. Give us the absence of all self-seeking and a complete yielding up of our desires to the will of God. Help us to be as Christ was, who was not His own, but gave Himself to His Father for our sins. Likewise, may we for His sake give ourselves up to do or suffer the will of our Father who is in heaven.

Remember Your people and their families, and convert their children. Give us help and strength. Spare precious lives that are in danger. Be gracious to any who are dying. May the life of God swallow up the death of the body. Prepare us all for Your glorious advent. Keep us waiting and watching, and do come quickly according to our hearts' desires, for we pray, *"Thy kingdom come. Thy will be done in earth, as it is in heaven....For thine is the kingdom, and the power, and the glory, for ever. Amen"* (Matt. 6:10, 13).

221

13

The Wings of Prayer

Our Father, Your children who know You delight themselves in Your presence. We are never happier than when we are near You. We have found a little heaven in prayer. It has eased our load to tell You of its weight. It has relieved our wound to tell You of its sting. It has restored our spirits to confess to You their wanderings. There is no place like the mercy seat for us.

We thank You, Lord, that not only have we found benefit in prayer, but we have been greatly enriched in the answers to it. You have opened Your hidden treasures to the voice of prayer. You have supplied our necessities as soon as we have cried unto You. Yes, we have found it true, *"Before they call, I will answer; and while they are yet speaking, I will hear"* (Isa. 65:24).

We bless You, Lord, for instituting the blessed ordinance of prayer. What could we do without it? We take great shame to ourselves that we should use it so little. We pray that we may be people of prayer, taken up with it, that it may take us up and bear us up as on its wings toward heaven.

And now at this hour, hear the voice of our supplication. First, we ask at Your hands, great Father, complete forgiveness for all our trespasses and shortcomings. We hope we can say with truthfulness that from our hearts we forgive all those who have in any way trespassed against us. There does not lie in our hearts, we hope, any thought of enmity toward anyone. However we have been slandered or wronged, we want to, with our innermost hearts, forgive and forget all.

We come to You and pray that, for Jesus' sake, and through the virtue of the blood once *"shed for many for the remission of sins"* (Matt. 26:28), You would give us perfect pardon of every transgression. Blot out, Lord, all our sins like a cloud, and let them never be seen again. Grant us also the peace-speaking word of promise applied by the Holy Spirit, that *"being justified by faith, we*

have peace with God through our Lord Jesus Christ" (Rom. 5:1). Let us be forgiven and know it. May there remain no lingering question in our hearts about our reconciliation with God, but by a firm, full assurance based on faith in the finished work of Christ, may we stand as forgiven men and women against whom transgression will never again be mentioned.

And then, Lord, we have another mercy to ask that is the burden of our prayer. It is that You would help us to live the lives that pardoned men should live. We have only a little time to remain here, for our lives are only a vapor; soon they vanish away. But we are most anxious that we may spend the time of our stay here in holy fear, that grace may be upon us from the beginning of our Christian lives even to the earthly close of them.

Lord, You know there are some who have not yet begun to live for You, and the prayer is now offered that they may today be born again. Others have lived in Your ways a long time and are not weary of them. We are sometimes surprised that You are not weary of us, but assuredly we delight ourselves in the ways of holiness more than we ever did. Oh, that our ways were directed to keep Your statutes without slip or flaw. We wish we were perfectly obedient in thought, word, and deed, entirely sanctified. We will never be satisfied until we wake up in Christ's likeness (Ps. 17:15), the likeness of perfection itself. Oh, work in us this same thing, we pray. May experience teach us more and more how to avoid occasions of sin. May we grow more watchful. May we have a greater supremacy over our own spirits. May we be able to control ourselves under all circumstances, and act in such a way that if the Master were to come at any moment, we would not be ashamed to give an account.

Lord, we are not what we want to be. This is our sorrow. Oh, that You would, by Your Spirit, help us in our walks of life to adorn the doctrine of God our Savior in all things. As businessmen, as working people, as parents, as children, as servants, as masters, whatever we may be, may we be such that Christ may look upon us with pleasure. May His joy be in us, for only then can our joy be full (John 15:11).

Dear Savior, we are Your disciples. You are teaching us the art of living, but we are very dull and very slow. Besides, there is such a bias in our corrupt nature, and there are such examples in the world, and the influence of an ungodly generation affects even those who know You. Oh, dear Savior, do not be impatient with us,

but still school us at Your feet, until at last we will have learned some of the sublime lessons of self-sacrifice, meekness, humility, fervor, boldness, and love, which Your life is fit to teach us. O Lord, we implore You, mold us into Your own image. Let us live in You and live like You. Let us gaze upon Your glory until we are transformed by the sight and become Christlike among the sons of men.

Lord, hear the confessions of any who have backslidden, who are marring Your image rather than perfecting it. Hear the prayers of any who are conscious of great defects during the past. Give them peace of mind by pardon, but give them strength of mind also to keep clear of such mischief in the future. O Lord, we are sighing and crying more and more after You. The more we have of You, the more we want You. The more we grow like You, the more we perceive our defects, and the more we long for a higher standard, to reach even unto perfection itself.

Oh, help us! Spirit of the living God, continue to travail in us. Let the groanings that cannot be uttered continue to be within our spirits (Rom. 8:26), for these are growing pains, and we will grow while we can sigh and cry, while we can confess and mourn. Yet this is not without a blessed hopefulness that He who *"hath begun a good work in* [us] *will perform it until the day of Jesus Christ"* (Phil. 1:6).

Bless, we pray, at this time, the entire church of God in every part of the earth. Prosper the work and service of Christian people, however they endeavor to spread the kingdom of Christ. Convert the heathen. Enlighten those who are in any form of error. Bring the entire church back to the original form of Christianity. Make her first pure, and then she will be united. Oh, Savior, let Your kingdom come. Oh, that You would reign and that Your will would *"be done in earth, as it is in heaven"* (Matt. 6:10)!

We ask You to use every one of us according to the ability we possess to be used. Take us, and let no talent lie dormant in the treasure-house, but may every pound of Yours be used in trading for You in the blessed market of soulwinning. Oh, give us success. Increase the gifts and graces of those who are saved. Bind us to one another in closer unity than ever. Let peace reign. Let holiness adorn us.

Hear us as we pray for all countries, and then for all sorts of people, from the sovereign on the throne to the peasant in the cottage. Let the blessing of heaven descend on men through Jesus Christ our Lord. Amen.

14

"Bless the Lord, O My Soul!"

Lord, we are longing to draw near to You. May Your Spirit draw us near. We come by the way of Christ our Mediator. We could not approach You, O God, if it were not for Him, but in Him we come boldly to the throne of heavenly grace (Heb. 4:16). Nor can we come without thanksgiving—thanksgiving from the heart, such as the tongue can never express. You have chosen us from before the foundation of the world, and this wellspring of mercy sends forth streams of lovingkindness never ceasing. Because we were chosen, we have been redeemed with precious blood. Bless the Lord! We have been called by the Holy Spirit out of the world, and we have been led to obey that wondrous call that has quickened and renewed us, made us the people of God, and given us adoption into the divine family. Bless the Lord!

Our hearts want to pause as we remember the greatness of each one of Your favors, and we want to say, *"Bless the LORD, O my soul: and all that is within me, bless his holy name"* (Ps. 103:1). When we consider our utter unworthiness before conversion, and our great faultiness since, we cannot help but admire the riches of abounding grace that God has manifested to us unworthy ones. Bless the Lord!

When we think of all that You have promised to give, which our faith embraces as being really ours since the covenant makes it sure, we do not know how to proclaim abundantly enough the memory of Your great goodness. We want to make our praises equal to our expectations, and our expectations equal to Your promises. We can never rise so high. We give to You, however, the praise of our entire being. Unto Jehovah, the God of Abraham, the God of Isaac, and the God of Jacob, the Creator of the world, the Redeemer of men, unto Jehovah be glory forever and ever, and let

all His people praise Him. *"Let the redeemed of the LORD say so, whom he hath redeemed from the hand of the enemy"* (Ps. 107:2).

O Lord, Your works praise You, but Your saints bless You. This will be our heaven—our heaven of heavens eternally—to praise and magnify the great and ever blessed God. This day may many men and women break forth and say with the Virgin Mary, *"My soul doth magnify the Lord, and my spirit hath rejoiced in God my Saviour"* (Luke 1:46–47). This day may there go up sweet incense of praise laid privately by holy hands upon the altar of God. May the place be filled with the smoke of it, not perhaps to the consciousness of every one, but to the acceptance of God, who will smell a sweet savor of rest in Christ, and then in the praises of His people in Him.

But, Lord, when we praise You, we have to fold the wing. We have to cover the face and cover the feet and stand before You to worship in another fashion, for we confess that we are evil, evil in our nature. Though renewed by sovereign grace, Your people cannot speak of being clean, being rid of sin. There is sin that dwells in us that is our daily plague. O God, we humble ourselves before You. We ask that our faith may clearly perceive the blood of the atonement and the covering of the perfect righteousness of Christ. May we come afresh, depending alone on Jesus. "I, the chief of sinners am, but Jesus died for me." May this be our one hope, that Jesus died and rose again, and that for His sake we are *"accepted in the beloved"* (Eph. 1:6).

May every child of Yours have his conscience purged from dead works to serve the true and living God. May there be no cloud between us and our heavenly Father—not even a mist, not even the morning mist that is soon gone. May *"we walk in the light, as [God] is in the light"* (1 John 1:7). May our fellowship with the Father and with His Son, Jesus Christ, be unquestionable. May it be fuel. May it fill us with joy. May it be a most real fact this day. May we enjoy it to the full, knowing whom we have believed, knowing who is our Father, knowing who it is that dwells in us, even the Holy Spirit.

Take away from us everything that might hinder our delighting ourselves in God. May we come to God this day with a supreme joy. May we speak of Him as "God, my exceeding joy, my own God is He." O God, give us a sense of property in Yourself. May we come near to You, having no doubt and nothing whatsoever that would spoil the beautiful simplicity of a childlike faith that looks up

into the great face of God and says, *"Our Father which art in heaven"* (Matt. 6:9).

There are those who have never repented of sin and have never believed in Christ, and consequently the wrath of God abides on them. They are living without God, living in darkness. O God, in Your great mercy, look upon them. They do not look at You, but may You look at them. May the sinner see his sin and mourn, see His Savior and accept Him, see himself saved, and go on his way rejoicing. Father, grant us this.

Once more we pray that You would bless Your church. Lord, quicken the spiritual lives of Your believers. You have given to Your church great activity, for which we thank You. May that activity be supported by a corresponding inner life. Do not let us get busy here and there with Martha, and forget to sit at Your feet with Mary (Luke 10:39–42). Lord, restore to Your church the love of strong doctrine. May Your truth yet prevail. Purge out from among Your church those who would lead others away from the truth as it is in Jesus, and give back the old power and something more. Give us Pentecost—yes, many Pentecosts in one—and may we live to see Your church shine forth as clear as the sun, as fair as the moon, and as *"terrible as an army with banners"* (Song 6:4).

God, grant that we may live to see better days. But if perilous times should come in these last days, make us faithful. Raise up in England, raise up in Scotland, men who will hold the truth firmly as their fathers did. Raise up in every country where there has been a faithful church, men who will not let the ship drift upon the rocks. O God of the judges, You who did raise up first one and then another when the people went astray from God, raise up for us still (for our Joshuas are dead) Deborahs, Baraks, Gideons, Jephthahs, and Samuels, who will maintain for God His truth and defeat the enemies of Israel. Lord, look upon Your church in these days. Lord, revive us. Lord, restore us. Lord, give power to Your Word again so that Your name may be glorified in all the earth.

Remember the church of God in this land in all its various phases and portions, and pour out Your Spirit upon it. Remember the multitude of Your people across the sea in America; prosper them and bless them with Your increase. Wherever You have a people, may Jesus dwell with them and reveal Himself to His own for Christ's sake, to whom be glory with the Father and with the Holy Spirit, forever and ever. Amen.

15

"He Ever Liveth"

Our God, we come to You by Jesus Christ, who has gone within the veil on our behalf and *"ever liveth to make intercession for* [us]" (Heb. 7:25). Our poor prayers could never reach You if it were not for Him, but His hands are full of sweet perfume, which makes our pleading sweet to You. His blood is sprinkled on the mercy seat, and now we know that You always hear those who approach You through that ever blessed name.

We have deeply felt our entire unworthiness even to lift up our eyes to the place where Your honor dwells. You have made us die to our self-righteousness. We pray now because we have been quickened. We have received a new life, and the breath of that life is prayer. We have risen from the dead, and we make intercession through the life that Christ has given us. We plead with the living God with living hearts because He has made us alive.

Our first prayer is for those who do not pray. There is an ancient promise of Yours that says, *"I am found of them that sought me not: I said, Behold me, behold me, unto a nation that was not called by my name"* (Isa. 65:1). Prove the sovereignty of Your grace, the priority of Your power, which runs before the will of man, by making many willing in this, the day of Your power. Call the things that are not as though they were. May the day come in which they who are in their graves will hear the voice of God, and those who hear will live.

How often You show Your mighty power. O Lord, we bless You that the voice of God has called many to Christ. Those who are hardened have felt a softness stealing over their spirits. Those who were careless have been compelled to sit down and think. Those that were wrapped up in earthly things have been compelled to think of eternal things. Thinking, they have been disturbed and driven to

despair, but afterward led to You, even to You, dear Savior, who was lifted high upon the cross so that by Your death sinners might live.

But, Lord, we next pray that Your own people would know the quickening of the Spirit of God. Lord, we thank You for the very least life in God, for the feeblest ray of faith and glimmering of hope. We are glad to see anything of Christ in any man, but You have come, O Savior, not only that we might have life, but that we might have it more abundantly (John 10:10), so our prayer is that there may be abundance of life.

Make Your people *"strong in the Lord, and in the power of his might"* (Eph. 6:10). Lord, we find when we walk close to You that we have no desire for the world. When we get away altogether from the things that are seen and temporal, and live upon the invisible and eternal (2 Cor. 4:18), then we have angels' food—better than that, the food of Christ Himself, for his flesh is meat indeed, and His blood is drink indeed (John 6:55). Then we have meat to eat that the world does not know about. We ask You to raise all our brothers and sisters in Christ into the high and heavenly frame of mind in which they will be *in* the world and not be *of* it. Whether they have little or much of temporal things, may they be rich in You and full of joy in the Holy Spirit, and so be blessed men and women.

We pray for some of Your own people who seem to be doing very little for You. Lord, have mercy on those whose strength runs toward the world, and who give but little of their strength to the spreading of the Gospel and the winning of souls. Oh, let none of us fritter away our existence. May we begin to live since Christ has died. May we reckon that because He died, we died to all the world, and because He lives, we live in newness of life. Lord, we thank You for that newness of life.

We praise Your name for a new heaven and a new earth. We bless You that we now see what we never saw before and hear what we never heard before. Oh, that we might enter into the very secret place of this inner life. May we have as much grace as can be obtained. May we become perfect after the manner of Your servant Paul, but still press forward, seeking still to be more and more conformed to the image of Christ.

Lord, make us useful. Oh, let no believer live for himself. May we be trying to bring others to Christ. May our fellow workers and neighbors all know how we live. If they do not understand the secret

of that life, may they still see the fruit of that life and ask, "What is this?" May they inquire their way to Christ, and may they be sanctified, too.

O Lord, we ask You to visit Your church. May none of us imagine that we are living uprightly unless we are bringing others to the Cross. Oh, keep us from worldliness. Keep us much in prayer. Keep us with the light of God shining upon us. May we be a happy people, not because we are screened from affliction, but because we are walking in the light of God.

Again, we offer prayer for the many efforts that are scattered abroad today. May they do good wherever they are. We pray for all churches. Lord, revive them all. Wherever Christ is preached, may it be proved that He draws all men unto Himself. May the preaching of Christ today be especially effective. Oh, that You would raise up many who would preach Christ, simply, boldly, and with the Holy Spirit sent down from heaven. Send us better days. Send us days of refreshing, straight from Your presence.

Lord, shake the earth with Your power. Oh, that the heathen lands may hear the Word of God and live! But first convert the church, and then You will convert the world. Oh, deal with those who depart from the faith and grieve Your Holy Spirit. Bring them back again to their first love. May Christ be fully and faithfully preached everywhere to the glory of His name. Now forgive us every iniquity, and lift us beyond the power of every sin. Lift us into heavenly places to pray and praise You. Make our homes full of sacred power.

Last of all, come, Lord Jesus. This is the great cry of our souls. Even so, come quickly, come quickly, Lord Jesus. Amen (Rev. 22:20).

16

The Great Sacrifice

O Father God, we well remember when we were called to You. With a sweet, wooing voice, You told us to return. You personally hung out the lights of mercy so that we might know the way home. Your dear Son Himself came down to seek us. But we wandered still. It brings tears to our eyes to think that we were so foolish and wicked, for we often extinguished the light within. Conscience we tried to harden. We sinned against light and knowledge with a high hand against our God.

You often brought us very low, even to our knees. We cried for mercy, but we rose to sin again. Blessed was that day when You struck the blow of grace—that effective blow. Then You withered up our splendor, and all our perfection was rolled in the dust. We saw ourselves slain by the law, lost, ruined, and undone. Then we rolled to and fro in the tempests of our thoughts, staggering like drunken men at our wits' end. Then we cried unto You in our trouble. Blessed be Your name forever, for You delivered us.

Oh, happy day that sealed our pardon with the precious blood of Jesus accepted by faith! We want to recall the memory of that blessed season by repeating it. We come again now to the cross whereon the Savior bled. We give another look of faith to Him. We trust we never take our eyes off Him, but if we have done so, we want to look anew. We want to gaze upon the body of the Son of God, pierced with nails, parched with thirst, bleeding, dying, because *"it pleased the LORD to bruise him; he hath put him to grief"* (Isa. 53:10).

Lord God, we see in Your crucified Son a sacrifice for sin. We see how You have *"made him to be sin for us...that we might be made the righteousness of God in him"* (2 Cor. 5:21). We again accept Him to be everything to us. This is the victim by whose blood

231

the covenant is made through faith. This is the Passover Lamb by the sprinkling of whose blood all Israel is secured. You have said, *"When I see the blood, I will pass over you"* (Exod. 12:13). This is the blood that gives us access into what is within the veil. This is the blood that is now drink indeed to our souls. We rejoice in the joy that this new wine of the covenant has given to our spirits.

We want to take afresh the cup of salvation and call upon the name of the Lord. We want to pay our vows now in the midst of all the Lord's people and in the courts of His house. This is a part of the payment of our vows—that we bless the Lord Jesus, who has put away our sin. We bless Him that He has redeemed us unto Himself, not with corruptible things such as silver and gold, but with His own precious blood (1 Pet. 1:18–19).

We again declare ourselves today to be the Lord's. We are not our own; we are bought with a price (1 Cor. 6:19–20). Lord Jesus, renew Your grasp of us; take us over again. With even greater speed than ever before, we surrender ourselves to You, and so *"bind the sacrifice with cords, even unto the horns of the altar"* (Ps. 118:27). Lord, I am Your servant, and the son of Your handmaid. You have loosed my bonds. The Lord lives! Blessed be my Rock. From now on I hide myself within that Rock. For Him I live.

May the Lord enable all His people to give themselves up to Jesus again with sincere and undivided hearts. Lord, place in us anew the marks and tokens of Your possession, until every one of us who can will say, *"From henceforth let no man trouble me: for I bear in my body the marks of the Lord Jesus"* (Gal. 6:17).

We bless You, Lord, for that mark to which some of us can look back with much joy. It is not on our hands alone, nor on our foreheads alone, nor on our feet alone, nor on our hearts alone. Our whole bodies have been buried with Christ in baptism unto death (Rom. 6:4). By our willing consecration, our whole bodies, souls, and spirits belong to Christ from now on and forever.

Our Father, there is one prayer that has kept rising to my lips even while I have been talking with You. It comes from my very heart. It is that You would bring others to Yourself. O God of Jacob, have You not said, *"Yet will I gather others to him, beside those that are gathered unto him"* (Isa. 56:8)? Have You not given to Your Son the heathen for His inheritance, and the uttermost parts of the earth for His possession (Ps. 2:8)? Lord, give Your Son the reward of His travail. Give Him a part of that reward this day

wherever He is preached. Oh, that some might be moved with the love of Christ.

Lord, some do not know who You are. Convince them of Your deity and Your power to save. Lord, many of them do not think. They live as if there will be an end to them when they die. O divine Spirit, convince them of judgment to come. Set before each careless eye that day of terrible splendor when all people must give an account for every idle word that they have spoken (Matt. 12:36). O divine Spirit, teach unreasonable men true reason. Teach the callous sensitivity. Look upon them, Jesus, just as You did on those of the synagogue, not with anger, but with grief because of the hardness of their hearts. Cry again, *"Father, forgive them; for they know not what they do"* (Luke 23:34). Bring many, many this very day to Your dear feet that were nailed to the cross. How we long for this. Deny us what You will, only bring sinners to Yourself.

Lord Jesus, You are gone from us. We rejoice that this is the fact, for You have taught us that it was to our advantage that You went, and that the Comforter would be with us. But, Lord, let us not miss that promised presence of the Comforter. May He be here to help us in all works of faith and labors of love, and may we feel that He has come among us and is dwelling with us because He is convincing the world of sin, of righteousness, and of judgment to come (John 16:7–8).

O Spirit of God, bring men to accept the great propitiation, to see their sin washed away in the crimson flood whose fount was opened when the heart of Christ was pierced. May blood-washed sinners begin to sing on earth that everlasting anthem that will be sung by all the redeemed in heaven.

We implore You now, Lord, to look upon all Your people, and grant every one a blessing. Some are in great trouble. Deliver them, we pray. Others may be in great peril, though they have no trouble. May the Lord save His people from the evils of prosperity. It may be that some of Your own people find it hard to worship because of cares. May they be able, like Abraham, when the birds came down upon the sacrifice, to drive them away.

O Spirit of God, make us all more holy. Work in us more completely the image of Christ. We long to be like the Lord Jesus Christ in spirit and character and in unselfishness of life. Give us the character of Christ, we pray. Redemption from the power of sin is purchased with His blood, and we crave for it. We pray that we

may daily receive it. Let the whole militant church of Christ be blessed.

Put power into all faithful ministries. Convert this country; save it from abounding sin. Let all the nations of the earth know the Lord, but especially bless those nations where our Lord Jesus is worshiped this day in the same fashion.

May the Lord bless His people. Bring the church to break down all bonds of nationality, all limits of sects, and may we feel the blessed unity that is the very glory of the church of Christ. Let the whole earth be filled with His glory. Our prayer can never cease until we reach this point: *"Thy kingdom come. Thy will be done in earth, as it is in heaven"* (Matt. 6:10). Nothing less than this can we ask for.

Now hear us as we pray for those in government and all in authority, and ask Your blessing to rest upon this land. Let Your blessing extend over all the family of man. We ask it for Christ's sake. Amen.

17

Oh, for More Grace!

Our Father, You do hear us when we pray. You have provided an Advocate and Intercessor in heaven now. We cannot come to You unless Your Holy Spirit gives us the desire and helps us while we plead. May we know Christ and have Him to be our all in all. He is everything to us. More than all we find in Him. We do accept You, Lord Jesus, to be *"made unto us wisdom, and righteousness, and sanctification, and redemption"* (1 Cor. 1:30). We will not look outside of You for anything, for everything is in You. Our sin is pardoned. Our sinful nature is subdued. We have a perfect righteousness. We have an immortal life. We have a sure hope. We have an immovable foundation. Why should we look beyond You? Why should we look within to ourselves, knowing that You are the only well from which we will draw living water, the only foundation upon which we will be built? We want to thrust out new roots this day, and take a fresh hold on the blessed soil in which grace has planted us.

O Savior, reveal Yourself anew; teach us a little more; help us to go a little deeper into the divine mysteries. May we grip You and grasp You. May we draw from You the nourishment for our spirits. May we be in You as a branch is in the tree, and may we bear fruit from You. Without You, we can do nothing.

Forgive Your servants, we pray, for any wanderings during the past. If we have forgotten You, do not forget us. If we have acted apart from You, forgive the act. Blot out the sin. Help us in the future to live only in You, to speak, and even to think, only in union with our living Head. Take away from us all life that is contrary to the life of Christ. Bring us into complete subjection in Him, until for us to live is Christ in every single act of life. May we walk humbly with God in joyful faith in the finished work of Christ.

Savior, look on Your beloved ones, and give blessings according to our necessities. We cannot pray a prayer that would comprise all, but You, our Great Intercessor, can plead for each one and get for each one of us the blessing wanted. Are we depressed? Give us stronger faith. Have we become worldly? Pardon this great offense, and lead us back into spiritual things. Have we become joyous but have forgotten the Source of joy? Lord, sweeten and savor that joy with the sweet perfume of Your own presence. Are we to preach but feel weak? Oh, be our strength. Are we involved in the Sunday school program and have seen little success? Lord, teach us how to teach. Give us our boys and girls as our spiritual reward. Are we sick? Do we have those who vex us because they are unholy and ungodly? This, indeed, is a terrible trial to many. Lord, help them, both in their personal sickness and in this great spiritual trouble. Do we have dear ones whom we love with all our hearts who languish before our eyes? Lord, have pity on them; restore them, and give them patience to bear pain. Give us resignation to Your will in this matter. Whatever the trial of Your servants, make a way of escape that we may be able to bear it (1 Cor. 10:13).

Our great concern, however, is to grow in grace and to become like our Master. We struggle and struggle, but how small is our progress! Lord, help us in any matter in which we have felt defeated. If we have been betrayed through lack of watchfulness, Lord, forgive and help another time. If any of Your servants have lost the brightness of their evidence, lead them to come to Christ as sinners if they cannot come as saints. And if, through Satan's temptation, any are sorely pressed even to keep standing, hold them up. If any have fallen, help them to say, *"Rejoice not against me, O mine enemy: when I fall, I shall arise"* (Mic. 7:8).

Now, look in great mercy on those who are unconverted. Lord, save them. Some are quite careless. Lord, they are dead. Come and quicken them. We cannot see, but You can. Oh, that some of the most callous and hardened might be softened by the touch of Your Spirit this very day. Others who are not careless, who are seeking eternal life, but who are going the wrong way, the way of works, may they be shown their error; may they be led in the way by You; may they look, and, looking, live. We know how many of them are wanting to be this and that before they take Christ to be all in all. May they cease their seeking by finding everything in Christ. Since You are a prayer-hearing God, and a God of pardon, issue many a pardon from Your heavenly court today, sealed with the Redeemer's

blood, signed with the Father's name. Oh, today, Lord, before men grow old in sin, before they die in their sins, save them with an everlasting salvation.

God, bless our country and our sovereign. God, bless this city. May there be no disquiet between the different orders of men—the employer and the employed—but may there be a general spirit of goodwill given to the people of this city, and may You prosper us.

Remember all people, especially the poor, the widows, and the fatherless, and any who are depressed in spirit, whose depression tends toward the failure of reason. Lord, restore them, and those who are dying. O Lord, do not let them die without hope. May Your believing people learn to pass away without even tasting the bitterness of death. May they enter into rest, each one walking in his own uprightness (Isa. 57:2).

Save this age from its own intellectual pride. Give back the spirit of simple faith in Christ, for we desire His glory. *"For thine is the kingdom, and the power, and the glory, for ever. Amen"* (Matt. 6:13).

18

The Peace of God

O ur God, we do not stand far away as Israel did in Sinai, nor does a dark veil hang between Your face and ours, but the veil has been torn by the death of our divine Lord and Mediator, Jesus Christ. In His name, we come to the mercy seat all sprinkled with blood. Here we present our prayers and our praises, accepted in Him.

We confess that we are guilty. We bow our heads and confess that we have broken Your law and the covenant of which it is a part. If You were to deal with us under the covenant of works, none of us could stand. We must confess that we deserve Your wrath and to be banished forever from Your presence. But You have made a new covenant, and we come under its divine shadow. We come in the name of Jesus. He is our High Priest. He is our righteousness. He is the Well Beloved in whom You, O Lord, are well pleased.

Holy Spirit, teach us how to pray. Let us know how to pray as we should. Our first prayer is, "May You be adored and reign over the whole earth. Hallowed be Your name." We desire to see all men submit themselves to Your gracious government. We wish especially that in the hearts of Your own, there may be an intense love for You and a perfect obedience to You. Grant this to each one of us. I want each one of us to pray, "Lord, sanctify me. Make me obedient. Write Your law upon my heart and upon my mind." Make our nature so pure that temptation cannot defile it.

"*Lead us not into temptation, but deliver us from evil*" (Matt. 6:13). May our course be very clean; may our path be very straight. May we keep our garments unspotted from the world. In thought, desire, and imagination, in will and in purpose, may we be holy, for God is holy (Lev. 11:44).

O God, we pray again, fulfill that covenant promise, "*I will take away the stony heart out of your flesh, and I will give you an*

238

heart of flesh" (Ezek. 36:26). May we be very tender toward You. May we feel Your faintest admonition. May even the gentlest breath of Your Spirit suffice to move us. May we not be "*as the horse, or as the mule, which have no understanding: whose mouth must be held in with bit and bridle, lest they come near unto thee*" (Ps. 32:9), but may we be like children who are obedient to their father. May we cheerfully yield our members to be "*instruments of righteousness*" (Rom. 6:13). May we have natural desires worked in our new nature for all that is pure and honest, unselfish and Christlike.

Oh, Spirit of God, dwell in us. Is this not also a covenant promise: "*I will put my spirit within you, and cause you to walk in my statutes*" (Ezek. 36:27)? Dwell with us, Holy Spirit. Rule over us, Holy Spirit. Transform us into Your own likeness, O Holy Spirit! Then we will be clean; then we will keep the law. We want to offer a prayer to You for those who are quite foreign to the work of the Spirit of God, who have never owned their God, who have lived as if there were no God. Open their eyes so that they may see God, even though that sight should make them tremble and wish to die. Oh, let none of us live without our God and Father. Take away the heart of stone; take away the frivolities, the foolishness, the giddiness of our youth, and give us the ability to earnestly seek true joy where it can alone be found—in reconciliation to God and conformity to His will.

Lord, save the careless; save the sinful. Take away the drunkard from his drink. Deliver the unholy and unjust men from their filthiness. Renew the lives of the dishonest and false. Lord, renew any who are lovers of pleasure, who are dead while they live, and any who are lovers of self, whose lives are bound by the narrowness of their own being. Regenerate them; make them new creatures in Christ.

Lord God the Holy Spirit, may faith grow in men. May they believe in Christ unto the saving of their souls. May their little faith brighten into strong faith, and may their strong faith ripen into the full assurance of faith. May we all have this last blessing. May we believe God fully, and may we never waver. Resting in the Great Surety and High Priest of the New Covenant, may we feel "*the peace of God, which passeth all understanding*" (Phil. 4:7), and may we enter into Your rest.

Bless Your people who are at rest, and deepen that rest. May the rest that You give be further enhanced by the rest that they

239

find when they take Your yoke upon them and learn from You (Matt. 11:29). May Your Word be very sweet to them. May there come over our spirits a deep calm, as when Christ hushed both winds and waves. May we feel not only resignation to Your will, but delight in it, and pleasure in all the Lord provides. May we rest in our God and be quite happy in the thought that You remember our sins and our iniquities no more. You have brought us into covenant with Yourself by a covenant that can never fail. Therefore, like David, may we say, *"Although my house be not so with God; yet he hath made with me an everlasting covenant, ordered in all things, and sure"* (2 Sam. 23:5).

Lord, bless Your Word throughout the world. Prosper all missionary efforts among the heathen, all work among the Islamic nations. And send Your grace to the churches at home. Turn the current of thought that is set so strongly in the wrong direction, and bring men to love the simplicities of the Gospel. Remember our country in great mercy, and may You give the blessing to all ranks and conditions of men. May multitudes come to Christ from among the poorest of the poor. Let the wealthy be led away from their sin and brought to Jesus' feet. Be gracious to the sovereign and royal family and to all who are in authority over us. May peace and order be maintained, and do not let the peace of the world be broken.

But what of all this? Our hearts go far beyond all this: *"Thy will be done in earth, as it is in heaven....For thine is the kingdom, and the power, and the glory, for ever"* (Matt. 6:10, 13). Come, Lord Jesus; come quickly (Rev. 22:20). All things are in Your hand. Come quickly. The cries of Your people persuade You; *"the Spirit and the bride say, Come"* (Rev. 22:17). O our Redeemer, do not delay. To the Father, to the Son, and to the Holy Spirit, the God of Abraham, and the God of our Lord Jesus Christ, be glory forever and ever. Amen.

19

To Be like Christ

Blessed are You, O God. Teach us Your statutes! Because You are the infinitely blessed One, You can impart blessing, and You are infinitely willing to do so. Therefore, we approach You with great confidence through Jesus Christ Your Son, whom You have made blessed forevermore.

O Lord, hear the voice of Your servants this day. According to Your infinite love and wisdom, *"according to* [Your] *riches in glory by Christ Jesus"* (Phil. 4:19), answer us.

First, we want to confess before You, O God, the sin we have committed, mourning over it. Touch each one now with such tenderness of heart that every one of us may lament that You should have even a few things against us, if they are only a few. In the great love of our blessed Master, He said to His churches, *"Notwithstanding I have a few things against thee"* (Rev. 2:20). O Lord, if You have so kept us by Your grace that there have been only a few things against us, still help us to mourn much over them. Oh, Infinite Love, can we sin against You at all? How debased is our nature then! Forgive, sweet Savior; forgive sins against Your love and blood, against Your wounds and death. Give us Your Spirit, O Savior, more fully, so that we may live Your life while we are here among the sons of men. As You are, even so also are we in this world, and we want the parallel to become more close and perfect every day!

Forgive those who have never felt the guilt of sin, who live in it, who are carnally minded, who are therefore dead. Quicken them by Your divine Spirit. Take away the pleasure that they feel in sin. Deliver them from being the bond slaves of it. Alas, we know the sorrow of sometimes being captured by it, but still we are not yet slaves. The Spirit, the life of God in Jesus Christ, has made us *"free*

241

from the law of sin and death" (Rom. 8:2). Deliver sinners, Lord. Bring them up out of the horrible pit. Deliver them from the death of their nature, and save them by the Spirit of the living God. Apply the precious blood of Jesus to their hearts and minds.

Lord, hear us who are Your children, in whom *"the Spirit itself beareth witness with our spirit, that we are the children of God"* (Rom. 8:16). Hear us while we bring before You our daily struggles. Blessed be Your name! There are some sins that You have helped us overcome, and now they are trodden beneath our feet with many a tear that we ever should have been in bondage to them. But there are rebellions within our nature still. We think that we are becoming holy, and behold, we discover that we are under the power of pride, that we are self-conceited. Lord, help us to master pride.

When we try to be humble before You, we find ourselves falling into idleness and inactivity. Lord, slay sloth within us, and never let us find a pillow of ease in the doctrines of grace while a single sin still remains. Besides, great God, the raging lusts of the flesh sometimes pounce on us like wild beasts. Help us to be watchful so that we are not torn and wounded by them. Keep us, Lord, for without Your keeping, we cannot keep ourselves.

Alas, we are even sometimes subject to unbelief. If trials come that we do not expect or if our bodies grow faint, how liable we are to begin to doubt the faithful promise and thereby grieve the Holy Spirit. Lord, we cannot bear this. It is not enough for us that our garments are clean and that we walk uprightly before men. We long to walk before You in such a way that nothing would grieve Your Spirit, nothing would vex the tender love of our Beloved. Come, divine Spirit, and exercise Your cleansing power upon us according to Your promise, *"I will cleanse their blood that I have not cleansed: for the LORD dwelleth in Zion"* (Joel 3:21).

Oh, that everything might help us toward purity, for we crave it. We attend the things of the Spirit, and there is groaning within us to be utterly delivered from the things of the flesh, so that we may be a cleansed temple in spirit, soul, and body, fit for the indwelling of the Holy One of Israel. Lord, help us, we pray, in our daily lives, to be as Christ was. If we are men of sorrows, may there be the same luster to our sorrow that there was to His, in patience and holy submission to divine law. If we are men of activity, may our work be like His, for He *"went about doing good"* (Acts 10:38). In all ways, may we seek the good of our fellowmen and the glory of our God.

We wish that the zeal for Your house would consume us. We pray that we would be full of sacred warmth. We desire that our lips would be touched with a live coal so that a fire would be perpetually flaming and burning in us. We want to be living sacrifices unto God.

Bless us, we pray, in the areas of our example and influence. May we always have a beneficial effect on others. May there be a sweetness and a light about us that all must be obliged to perceive. We do not crave this for our own honor, but so that our light may *"so shine before men, that they may see* [our] *good works, and glorify* [our] *Father which is in heaven"* (Matt. 5:16). Lord, grant us this!

Bless the unconverted among us. Bring them in, dear Savior; bring them in. Help the saved among us to *"compel them to come in, that* [Your] *house may be filled"* (Luke 14:23). May a sacred compulsion be used so that they may not be left outside to starve in the highways and hedges, but be brought in to the gospel feast.

Lord, bless our country at this time. May You be gracious to those who have the helm of affairs so that in the midst of great difficulty they may be wisely and graciously directed. God, bless those in government with every mercy, and let all who are in authority share the divine favor. Bless other countries, too, for whom we most earnestly pray, especially for our family in Christ across the Atlantic. We bless and praise You that we have so many there who are not only of our own kin by nationality, but also kin in Christ. God bless them, as well as those in the South Seas. Lord, bless the church of Christ there. Remember the struggling ones on the continent of Europe, and all the missionaries who are laboring in foreign fields.

Oh, Savior, let Your kingdom come. When will this earth be delivered from superstition and unbelief? May You hear creation's groans and come quickly. O great Deliverer, You are the joy of the earth. You are still the expected of the tribes of Israel. Come, we pray, absent love, dear unknown, fairest of ten thousand, come a second time to earth to the sons of men, and especially to Your bride, the church. Even so, come quickly, Lord Jesus. Amen (Rev. 22:20).

20

The Look of Faith

Our Father, we have listened to Your gracious words. Truly Your paths overflow with abundance. Wherever You are, mercy abounds. Before Your feet, rivers of grace spring up. When You come to man, it is with the fullness of pardoning love. You bid us to come and seek You while You may be found (Isa. 55:6). We come now. May Your Holy Spirit help us. May Jesus lead the way and be our Mediator now!

Blessed be Your name! There are many who sought Your face years ago. Since then, we have tasted that You are gracious, and we know by delightful experience that You do indeed give milk and honey to those who trust You. Oh, we wish we had known You earlier.

Lord, You have been full of truth and faithfulness to us throughout every step of our journey, and though You have not withheld the rod of the covenant from us, we are as grateful for that now as for the kisses of Your lips. You have dealt well with Your servants according to Your Word (Ps. 119:65). Blessed be Your name forever and ever.

But there are some who have never come to You. They are hearers, but hearers only. They have listened to gracious invitations thousands of times, but they have never accepted them. Say to them, "You have gone this far, but you will proceed no further in your carelessness and trifling. Here you will stay and turn to your God." O Savior, You have all power in heaven and earth; therefore, You can, through the preaching of Your Word, influence the hearts of men. Turn them, and they will be turned. Oh, do it this day, Lord.

We want to come to You now in our prayers. As we came at first, we want to come again. We want to renew our vows, we want

to repeat our repentance and our faith, and then look at the bronze serpent and touch the hem of Your garment. We want to begin again. O Lord, help us to do it in sincerity and truth. First, we confess that we are by nature lost and by practice ruined. *"We are all as an unclean thing, and all our righteousnesses are as filthy rags"* (Isa. 64:6). We want to lie at those dear pierced feet, bleeding at heart because of sin, wounded, mangled, crushed by the Fall and by our transgression. We confess that if You were to number our sins against us and deal with us accordingly, we would be sent to the lowest hell.

We have no merit, no claim, no righteousness of our own. Now, dear Savior, we look to You. Oh, that some might look for the first time. Oh, that those of us who have long looked would fix our happy gaze again upon that blessed substitutionary sacrifice in whom is all our hope. Dear Savior, we do take You to be everything to us, our Sin-Bearer and our Sin-Destroyer. We do not have a shadow of a hope anywhere but in You—Your life, Your death, Your resurrection, Your ascension, Your glory, Your reign, Your second advent. These are the only stars in our sky.

We look up to You and are filled with light. But, oh, dear, dear Savior, we dare not turn to ordinances. We dare not turn to our own prayers and tears and almsgiving. We dare not look to our own works. We only look to You. Your wounds, Emmanuel, bleed the balm that heals our wounds. Your head once crowned with thorns, Your body once laid in the silent tomb, Your Godhead once covered and concealed from man, but now resplendent amid triumphant hosts—these we gaze upon. If we must perish trusting in You, we must perish. But we know we cannot, for You have bound up our salvation with Your glory, and because You are a glorious Savior forever, none who trust in You will ever be ashamed.

We do trust You now. If all our past experience has been a mistake, we will begin at the Cross today. If we have never had any experience of You before, we would begin today. Oh, hear, Lord, hear our prayer:

> Dear Savior, draw reluctant hearts;
> To You let sinners fly.

By Christ's agony and bloody sweat, by His cross and passion, by His precious death and burial, we implore You, hear us now! We plead with You for some who are not pleading for themselves. O

Spirit of God, do not let it be so any longer. Sweetly use Your key to open the locked door and come into men's hearts and dwell there so that they may live.

We have a thousand things to ask. We would like to plead for our country and for all countries. We would like to plead with You for the sick and for the dying, for the poor and for the fatherless. We have innumerable blessings to ask, but somehow they all fade away from our prayer just now, and this is our one cry: "Save, Lord, we pray. Even now send salvation! Come, Holy Spirit, to open blind eyes and unstop deaf ears and quicken dead hearts."

Father, glorify Your Son so that Your Son may glorify You. Holy Spirit, take of these things of Christ and reveal them unto us. We gather all our prayers in that salvation through the blood of the Lamb. Amen.

21

Boldness at the Throne of Grace

O God! We do not want to speak to You as from a distance, or stand like trembling Israel under the law at a distance from the burning mount. We have not come to Mount Sinai, but to Mount Zion, and that is a place for holy joy and thankfulness, not for terror and bondage. Blessed be Your name, O Lord! We have learned to call You *"our Father which art in heaven"* (Matt. 6:9). There is reverence, for You are in heaven. But there is sweet familiarity, for You are our Father.

We want to draw very near to You now through Jesus Christ the Mediator, and we want to be bold to speak to You as a man speaks with his friend. Have You not said by Your Spirit, *"Let us therefore come boldly unto the throne of grace"* (Heb. 4:16)? We might well flee from Your face if we only remembered our sinfulness. Lord, we do remember it with shame and sorrow. We are grieved to think we have offended You and have neglected Your sweet love and tender mercy so long. But we have *"now returned unto the Shepherd and Bishop of* [our] *souls"* (1 Pet. 2:25). Led by such grace, we look to Him whom we crucified. We have mourned for Him and then have mourned for our sin.

Now, Lord, we confess our guilt before You with tenderness of heart. We pray that You would seal home to every believer that full and free, that perfect and irreversible charter of forgiveness that You gave to all who put their trust in Jesus Christ. Lord, You have said, *"If we confess our sins,* [You are] *faithful and just to forgive us our sins, and to cleanse us from all unrighteousness"* (1 John 1:9). There is the sin confessed. There is the ransom accepted. Therefore, we know we have peace with God, and we bless that glorious One

247

who has come *"to finish the transgression, and to make an end of sins, and...to bring in everlasting righteousness"* (Dan. 9:24), which by faith we take unto ourselves and You impute unto us.

Now, Lord, will You be pleased to cause all Your children's hearts to dance within them for joy? Oh, help Your people to come to Jesus again today. May we be looking unto Him now as we did at first. May we never take our eyes away from His divine person, from His infinite merit, from His finished work, from His living power, or from the expectancy of His speedy coming to *"judge the world with righteousness, and the people with his truth"* (Ps. 96:13).

Bless all Your people with some special gift. If we might make a choice of one, it would be this: *"Quicken* [us] *according to thy word"* (Ps. 119:25). We have life. Give it to us more abundantly. Oh, that we might have so much life that out of the midst of us there might *"flow rivers of living water"* (John 7:38). Lord, make us useful. Dear Savior, use the very least among us. Take the one talent and let it be invested for interest for the great Father. May it please You to show each one of us what You would have us to do. In our families, in our businesses, in the walks of ordinary life, may we be serving the Lord. May we often speak a word for His name and help in some way to scatter the light among the ever growing darkness. Before we go to be with You, may we have sown some seed that we will bring with us on our shoulders in the form of sheaves of blessing.

O God, bless our Sunday schools, and give a greater interest in such work, that there may be no lack of men and women who are glad and happy in teaching the young. Impress this, we pray, upon Your people just now. Move men who have gifts and ability to preach the Gospel. There are many who live in villages, and there is no preaching of the Gospel near them. Lord, set them to preaching themselves. May You move some hearts so powerfully that their tongues cannot be quiet any longer, and may they attempt in some way, either personally or by supporting someone, to bring the Gospel into dark, benighted hamlets so that the people may know the truth.

O Lord, stir up the dwellers in this great, great city. Arouse us to the spiritual destitution of the masses. O God, help us all by some means, by any means, by every means, to get at the ears of men for Christ's sake so that we may reach their hearts. We send up an exceedingly great and sorrowful cry to You on behalf of the

millions who enter no place of worship, but rather violate its sanctity and despise its blessed message. Lord, wake up London, we implore You. Send us another Jonah. Send us another John the Baptist. Oh, that Christ Himself would send forth multitudes of laborers among this thick-standing corn, for *"the harvest truly is plenteous, but the labourers are few"* (Matt. 9:37). O God! Save this city; save this country; save all countries, and let Your kingdom come. May every knee bow, and may all confess that Jesus Christ is Lord (Phil. 2:10–11).

Our most earnest prayers go up to heaven to You now for great sinners, for men and women who are polluted and depraved by the filthiest of sins. With sovereign mercy make a raid among them. Come and capture some of these so that they may become great lovers of Him who forgives them, and may they become great champions for the Cross.

Lord, look upon the multitudes of rich people in this city who know nothing about the Gospel and do not wish to know. Oh, that somehow the spiritually poor might be rich with the Gospel of Jesus Christ. And then, Lord, look upon the multitude of the poor and the working classes who think religion is a perfectly unnecessary thing for them. By some means, we pray, get them to think and bring them to listen, for *"faith cometh by hearing, and hearing by the word of God"* (Rom. 10:17).

Above all, O Holy Spirit, descend more mightily. O God, flood the land until there are streams of righteousness. Is there not a promise that says, *"I will pour water upon him that is thirsty, and floods upon the dry ground"* (Isa. 44:3)? Lord, set Your people praying. Stir up the church to greater prayerfulness.

Now, as You have told us to do, we pray for the people among whom we dwell. We pray for those in authority in the land, asking every blessing for those in government; Your guidance and direction for the Parliament; and Your blessing to all judges and rulers and also upon the poorest of the poor and the lowest of the low. Lord, bless the people. *"Let the people praise thee, O God; let all the people praise thee"* (Ps. 67:3), for Jesus Christ's sake. Amen.

22

The Presence of the Word

Our Father in heaven, our hearts are full of gratitude to You for Your Word. We bless You that we have it in our homes, and that You have given to many of us an understanding and enjoyment of it. Although as yet we do not know what we will know, we have learned from it what we never can forget—that which has changed our lives, has removed our burdens, has comforted our hearts, has set our faces like flints against sin, and has made us eager for perfect holiness.

We thank You, Lord, for every page of the Book, not only for its promises that are inexpressibly sweet, but for its precepts in which our souls delight, and especially for the revelation of Your Son, our Lord and Savior Jesus Christ. We thank You for the manifestation of Him in the types and shadows of the Old Testament. These are inexpressibly glorious to us, full of wondrous value, inexpressibly dear, because in them and through them we see the Lord. But we bless You much more for the clear light of the New Testament, for giving us the key to all the secrets of the Old Testament. Now, as we read the Scriptures of the New Covenant, we understand the language of the Old and are made to joy and to rejoice in it. Father, we thank You for the Book. We thank You for the glorious Man, the God whom the Book reveals as our Savior.

Now we thank You for the blessed Spirit, for without His light upon our understanding, we would have learned nothing. *"The letter killeth, but the spirit giveth life"* (2 Cor. 3:6). Blessed are our eyes that have been touched with heavenly eye-salve. Blessed are the hearts that have been softened and have been made ready to receive the truth in the love of it! Blessed be the sovereign grace of God, who has chosen unto Him a people who delight in His Word and who meditate on it both day and night!

Our hearts are full of praises to God for this Book of Truth, for this unmeasurable wealth of holy knowledge. Lord, make us enjoy it more and more. May we feed on this manna. May we drink from this well of life. May we be satisfied with it, and by it be conformed to the image of the God from whom it came.

Now, Lord, our prayer to You at the mention of Your sacred Book is that You would write it upon the fleshly tablets of our hearts more fully. We want to know the truth so that the truth may make us free (John 8:32). We want to feel the truth so that we may be sanctified by it. Oh, let it be in us a living seed that will produce in us a life acceptable before God, a life that will be seen in everything that we do unto the living God, for we remember that You are not the God of the dead, but of the living.

Lord, we ask that Your Word may chasten us whenever we go astray. May it enlighten us whenever for a moment we get into darkness. May Your Word be the supreme ruler of our being. May we give ourselves up to its sacred law to be obedient to its every hint, wishing in all things, even in the least things, to do the will of God from the heart and to have every thought brought into captivity to the mind of the Spirit of God (2 Cor. 10:5).

Bless Your people. Bless them by saturating them with the Word of Your truth. O Lord, they are out in the world so much. Oh, grant that the world may not take them away from their God. Instead, may they get the world under their feet. Do not let them be buried in it, but may they live upon it, treading it beneath their feet. May the spiritual always gain the victory over the material. Oh, that the Word of God might be with us when we are in the midst of an ungodly generation. May the Proverbs furnish us with wisdom, the Psalms comfort us, the Gospels teach us the way of holiness, and the Epistles instruct us in the deep things of the kingdom of God.

Lord, educate us for a higher life, and let that life be begun here. May we always be in school, always disciples. When we are out in the world, may we try to put into practice what we have learned at Jesus' feet. What He tells us in darkness, may we proclaim in the light. What He whispers to us in our prayer closets, may we shout forth from the housetops.

Oh, dear, dear Savior, what could we do without You? We are as yet in banishment. We have not come into the land of light and glory. It is on the other side the river, in the land where You dwell, Your land of Emmanuel. Until we come there, may You be with us.

We have said to ourselves, How can we live without our Lord? Then we have said to You, *"If thy presence go not with* [us], *carry us not up hence"* (Exod. 33:15). Oh, be to us this day like the fiery, cloudy pillar that covered all the camp of Israel. May we dwell in God. May we live and move in God. May we be conscious of the presence of God to a greater extent than we are conscious of anything else.

Bless the churches. Look on them, Lord. Cast an eye of love upon the little companies of the faithful, wherever they may be, and help them and their pastors. In every place may the churches be a light in the midst of this crooked and perverse generation. O God, we are waiting and watching for a display of Your great power among the people.

It is an age of great luxury and great sin and gross departures from the truth. We implore You, defend Your own. When Your ark was carried captive among the Philistines and set up in Dagon's temple, Dagon fell before it (1 Sam. 5:3). Then You *"smote* [Your] *enemies in the hinder parts:* [You] *put them to a perpetual reproach"* (Ps. 78:66). You can do the same again, and we pray it may be so. Oh, for the stretched out hand of God! We are longing to see it in the conversion of great multitudes by the Gospel. May those who have said, "Aha, the Gospel has lost its power," be made foolish by the wisdom of the Most High, even as Jannes and Jambres were made foolish when they could not do with their enchantments what God did through His servant.

O Jehovah, You are the true God, God of Abraham, Isaac, and Jacob. You, O God, are our God forever and ever. You will be *"our guide even unto death"* (Ps. 48:14). You who spoke by the apostles speak still by Your servants. Let Your Word have as much power as when You said, *"Let there be light,"* and *"there was light"* (Gen. 1:3). Oh, for the lifting up of Your voice! Let confusion and darkness once again hear the voice of Him who makes order and who gives life. Oh, how we want to stir You up, gracious God. Our prayers would take the form of that ancient one: *"Awake, awake, put on strength"* (Isa. 51:9). Are You not He who cut Egypt and wounded the crocodile? Do You not still have the same power to smite and to vindicate Your own truth and to deliver Your own redeemed?

O Lamb, slain from before the foundation of the world (Rev. 13:8), You are still sitting upon the throne, for He who is on the throne looks like a Lamb that has been recently slain. O Jesus, we pray, take unto Yourself Your great power. Divide the spoil with

the strong. Take the purchase of Your precious blood, and rule *"from the river* [even] *unto the ends of the earth"* (Ps. 72:8).

Here we are before You. Look on us in great pity. Lord, bless Your own people. With favor surround them as with a shield (Ps. 5:12). Lord, save the unsaved. In great compassion draw them by the attractive magnet of the Cross; draw them to Yourself; compel them to come so that the wedding may be furnished with guests.

With one heart we lift up our prayer on the behalf of the teachers of the young. We thank You, Lord, that so many men and women are ready to give their Sabbath's rest to this important service. Oh, grant that zeal for teaching the young may never burn low in the church. May any who are taking no part in it and who ought to be, be aroused at once to begin the holy effort. Bless the teachers of the teenage classes. May their young men and women join the church. May there be no gap between the school and the church. Bridge that distance by Your sovereign grace. But equally bless the teachers of the infants and of the younger children. May conversion go on among the young. May there be multitudes of such conversions. In effect, we pray that no child would leave the Sunday school unsaved. Oh, save the children, great Lover of the little ones. You who allowed them to come to You, You will not forget them, but You will draw them and accept them. Lord, save the children. Let all the classes participate in the blessing that we seek, and by this blessed agency may this nation be kept from heathenism.

May this city especially be preserved from its dogged disregard of the Sabbath, and its carelessness about the things of God. Oh, bless the Sunday schools in every part of London, and let Jesus Christ be glorified among the little ones. May there be heard again loud hosannas in the streets of Jerusalem from the babes and nursing infants, from whose mouths You have ordained strength (Ps. 8:2). Lord, be with the dear workers throughout today and make it a high day, a festival of prayer and faith, a time when Jesus the Lord will especially meet with them and bless them.

God, bless our country! God, save our sovereign! Grant guidance at this time to all with regard to the political affairs of this nation. Grant Your blessing to all ranks and conditions of men, and let every nation call You blessed. Let all tongues speak the name of Jesus and all men own Him as Lord and King. We ask it in His name. Amen.

23

God's Unspeakable Gift

O Lord, many of us feel like the lame man at the Beautiful Gate. Come by this way and make the lame ones perfectly sound. O Lord, You can do by Your servants today what You did by them in the olden times. Work miracles of mercy even upon outer-court worshipers who are too lame to get into the Holy Place.

But there are many who feel like that man when he was restored. We want to follow our Restorer, the Prince of Life, into the temple, *"walking, and leaping, and praising God"* (Acts 3:8). He has gone into the temple in the highest sense, up to the throne of God. Made whole, He climbs, and we follow, up the steps of the temple one by one. We come ever nearer to God's throne.

Lord, You have done such great things for us that we feel the drawing of Your love. *"The LORD hath appeared of old unto me, saying, Yea, I have loved thee with an everlasting love: therefore with lovingkindness have I drawn thee"* (Jer. 31:3). Draw us, Lord, into the inner sanctuary.

Lord, though healed of a former lameness so that now we have strength, we need a further touch from You. We are so apt to become dull and stupid. Help us, Jesus. A vision of Your face will brighten us, but to feel Your Spirit touching us will make us vigorous. Oh, for the leaping and the walking of the man born lame. May we dance with holy joy like David before the ark of the covenant. May a holy exhilaration take possession of every part of us. May our mouths be filled with laughter, and our tongues with singing, for *"the LORD hath done great things for us; whereof we are glad"* (Ps. 126:3).

Help Your people to put on Christ. May we live like those who are alive from the dead, for He is the quickening Spirit. Is any part

of us still dead? Lord, quicken it. May the life that now possesses our hearts take possession of our heads. May the brain be active in holy thought. May our entire being respond to the life of Christ, and may we live in newness of life.

With pleasure we fall down on our faces and worship the Son of God today. It is such a wonder that He loves us. He has done such wonderful things for us and in us that we may still call Him God's unspeakable gift. He is unspeakably precious to our souls. You know all things, Lord. You know that we love You. May that love bubble up today like a boiling cauldron. May our hearts overflow. If we cannot speak what we feel, may that holy silence be eloquent with the praise of God.

Lord, send Your life throughout the entire church. Visit Your church; restore sound doctrine and holy, earnest living. Take away from professing Christians their love of frivolities, their attempts to meet the world on its own ground, and give back the old love of the doctrines of the Cross and Christ. May free grace and dying love again be the music that refreshes the church and makes her heart exceeding glad.

Lord, wake up dead hearts. If there are seeds of grace lying dormant in any soul, may they begin to bud. May the bulb down at the heart send forth its golden cup and drink in of the light, the life of God. Oh, save today. *"The LORD thy God in the midst of thee is mighty; he will save"* (Zeph. 3:17). Our very hearts are speaking now much more loudly and sweetly than our lips can speak. Lord, save sinners. Great High Priest, have compassion on the ignorant and those who are not of the way. Great Shepherd of the sheep, gather the lambs within Your arms. Find the lost sheep, throw them on Your shoulders, and bring them home rejoicing.

Lord, with all our hearts we pray for our country. As You bid us, we pray for those in authority, for the sovereign as supreme, for the Parliament, for all magistrates and rulers. We pray also for the poor and the downtrodden. Lord, look upon the poor and make them rich in faith. Comfort them in heart by the Holy Spirit. Let Your light and Your truth go forth to the most distant parts of the earth. *"Let the people praise thee, O God; let all the people praise thee"* (Ps. 67:3). Give us times of refreshing. May we have a visit from Christ by the power of His Spirit. Until He comes, may there be a blessed time of peace and salvation.

"Thy kingdom come. Thy will be done in earth, as it is in heaven" (Matt. 6:10). And may You come Yourself, Great King.

May our eyes, if it please You, behold You on earth. But if not, if we fall asleep before that blessed day, we can say, *"I know that my redeemer liveth...and though after my skin worms destroy this body, yet in my flesh shall I see God"* (Job 19:25–26).

Bless every Sunday school teacher, every tract distributor, every open-air preacher. Bless, we pray, all nurses, all deacons and missionaries of the City Mission, all Bible readers, and all others who in any way seek to bring men to Christ. O God, flood the world with a baptism of Your power, and let the whole earth *"be filled with the knowledge of the glory of the LORD, as the waters cover the sea"* (Hab. 2:14).

We ask all in that dear name that made the lame man whole, the name that is sweet to God in heaven and dear to us below. Unto Father, Son, and Holy Spirit be glory forever. Amen.

24

"Deliver Us from Evil"

O God, do not let us be formalists or hypocrites during this time of prayer. We feel how easy it is to bow our heads and cover our faces, and yet our thoughts may be all astray; our minds may be wandering hither and yon, so that there can be no real prayer at all. Come, Holy Spirit; help us feel that we are in the immediate presence of God. May this thought lead us to sincere, earnest petitioning.

There are some who do not know You, God. You are not in their thoughts. They make no acknowledgment of You, glorious One, but do their business and guide their lives as if there were no God in heaven or in earth. Strike them now with a sense of Your presence. May Your eternal power come before their thoughts, and now may they join Your reverent people in approaching Your mercy seat.

We come for mercy, great God. It must always be our first request, for we have sinned against a just and holy law of which our consciences approve. We are evil, but Your law is holy and just and good. We have offended knowingly. We have offended again and again. After being chastened, we have still offended. Even we who are forgiven, who through Your rich love have been once for all washed from every stain, sin grievously. We confess it with much shame and bitter self-reproach that we sin against such tender love and against the indwelling Holy Spirit, who is in His people and who checks us and quickens our consciences, so that we sin against light and knowledge when we sin.

Wash us yet again. When we ask for this washing, it is not because we doubt the efficacy of former cleansing. Then we were washed in blood. Now, O Savior, repeat with us what You did to the Twelve when You took a towel and basin and washed their feet.

You told them that he who had been washed had no need except to wash his feet. After that was done, he was *"clean every whit"* (John 13:10). Oh, let Your children be in that condition now—*"clean every whit"*—and may we know it. Thus being clean, may we have boldness to enter into the Holy of Holies by the blood of Christ. May we now come and stand where the cherubim were, where the glory still shines forth. There before a blood-sprinkled mercy seat, washed and cleansed, may we pour out our prayers and praises.

As for those who never have been washed, we repeat our prayer for them. Bring them, O Lord, bring them at once to a deep sense of sin and to the complete realization of Your unmerited grace through the shed blood of Your Son. May we see them take their first complete washing. From now on, may they become the blood-washed and blood-redeemed consecrated ones, belonging forever to Him who has made them white through His atoning sacrifice.

Blessed Lord, since You do permit Your washed ones to come close to You, we want to approach You now with the courage that comes from faith and love and ask of You this thing: help us to overcome every tendency to evil that is still within us, and enable us to wear armor of such strength that the arrows of the Enemy from without may not penetrate it, that we may not be wounded again by sin. Deliver us, we pray, from doubts within and fears without, from depression of spirit, and from the outward assaults of the world. Make us and keep us pure within, and then let our lives be conducted with such holy vigilance and watchfulness that there may be nothing about us that would bring dishonor to Your name. May those who most carefully watch us see nothing but what would adorn the doctrine of God our Savior in all things.

Lord, help Your people to be right as parents. May none of us spoil our children. May there be no poorly managed families to cry out against us. Help us to be right as employers. May there be no oppression, no hardness, and no unkindness. Help us to be right as employees. May there be no slipshod service, no pilfering, but may there be everything that adorns the Christian character. Keep us right as citizens. May we do all we can for our country and for the times in which we live. Keep us right, we pray, as citizens of the higher country. May we be living for it, to enjoy its privileges and to bring others within its borders, that multitudes may be made citizens of Christ through our means.

Lord, help us to conduct ourselves fittingly as church members. May we love our brothers and sisters. May we seek their good,

their edification, their comfort, their health. May those of us who are called to preach have grace equal to that responsibility. Lord, make every Christian be aware of the blood of all those around him. We know that there are some who profess to be Your people who do not seem to care one bit about the souls of their fellowmen. God forgive this inhumanity to men, this treason to the King of Kings. Rouse the church, we pray, to a tenderness of heart toward those among whom we dwell.

Let all the churches feel that they are ordained to bless their neighbors. Oh, that the Christian church in England might begin to take upon itself its true burden. Let the church in London especially, with its mass of poverty and sin around it, care for and love the people. May all Christians rouse themselves to do something for the good of men and for the glory of God. Lord, use us for Your glory. Shine upon us, O Emmanuel. May we reflect Your brightness. Dwell in us, O Jesus, that out of us may come the power of Your life. Cause Your church to work miracles, because the Miracle Worker is in the midst of her. Oh, send us times of revival, seasons of great refreshing, and then times of aggression when the army of the Lord of Hosts will push its way into the very center of the adversary and overthrow the foe in the name of the King of Kings.

Now forgive Your servants all that has been amiss, and strengthen in Your servants all that is good and right. Sanctify us to Your service, and hold us to it. Comfort us with Your presence. Elevate us into Your presence. Make us like You. In all things glorify Yourself in us, whether we live or die.

O Lord, bless the poor. Remember the needy among Your own people. Help and relieve them. Bless the sick, and be very near the dying. May the Lord comfort them.

Bless our country. Let every mercy rest upon those in government. Send peace to disquieted districts. Give wisdom to our senators in making and in attending to the keeping of the law. And may Your kingdom come not here only, but in every land and nation. Remember with the plenitude of Your grace lands across the sea. Let the whole earth be filled with Your glory. We ask it for Jesus' sake. Amen.

25

"The Washing of Water by the Word"

O Jehovah, our God, You love Your people; You have placed all the saints in the hand of Jesus; and You have given Jesus to be their leader, commander, and husband. We know that You delight to hear us cry on the behalf of Your church, for You care for her, and You are ready to grant to her according to the covenant provisions that You have laid up in store for Christ Jesus. Therefore, we begin this prayer by entreating You to behold and visit the vine and the vineyard that Your right hand has planted. *"Look upon Zion, the city of our solemnities"* (Isa. 33:20). Look upon those whom You have chosen from before the foundation of the world, whom Christ has redeemed with blood, whose hearts He has won and holds, and who are His own though they are in the world.

Holy Father, keep Your people, we pray, for Jesus' sake. Though they are in the world, do not let them be of it, but may there be a marked distinction between them and the rest of mankind. Even as their Lord was holy, harmless, undefiled, and separate from sinners, so may it be with believers in Christ. May they follow Him. May they not know the voice of strangers but come out from the rest so that they may follow Him outside the camp (Heb. 13:13).

We cry to You for the preservation of Your church in the world, and especially for her purity. Oh, Father, keep us, we implore You, with all keeping, so that the Evil One does not touch us. We will be tempted, but do not let him prevail against us. In a thousand ways he will lay snares for our feet, but deliver us *"as a bird out of the snare of the fowlers"* (Ps. 124:7). May the snare be broken so that we may escape. Do not let Your church suffer dishonor at any

time, but may her garments always be white. Do not let those who come in among her who are not of her utterly despoil her. O Christ, as You groaned concerning Judas, so may Your children cry to You concerning any who have fallen aside into crooked ways, lest the cause of Christ in the earth should be dishonored. O God, cover, we pray, all the people of Christ with Your feathers (Ps. 91:4). Keep the church even until Christ returns, who, having loved His own who were in the world, loves them even to the end (John 13:1).

We want to ask just now that our feet may be washed. We trust You have bathed us once for all in the sin-removing fountain. You have also washed us in the waters of regeneration and given us the renewing of our minds through Jesus Christ. But now we cry for daily cleansing! Do You see any fault in us? We know that You do. Wash us so that we may be clean. Are we deficient in any virtue? Oh, supply it so that we may exhibit a perfect character to the glory of Him who has made us anew in Christ Jesus. Or is there something that would be good if not carried to excess? Be pleased to modify it, lest one virtue would overpower another, and we would not be the image of Christ completely.

O Lord and Master, You who washed Your disciples' feet of old, still be very patient toward us, very gracious toward our provoking faults, and go on with us, we pray, until Your great work is completed and we are brothers of the First Born, like unto Him. Gracious Master, we wish to conquer self in every respect. We desire to live for the glory of God and the good of our fellowmen. May You enable us especially to overcome the body with all its affections and lusts. May the flesh be kept under. Let no appetite of any kind of the grosser sort prevail against our personhood, lest we be dishonored and unclean. Do not let even the most refined power of the natural mind be permitted to come forward to the extent that it mars the dominion of the Spirit of God within us.

Oh, help us not to be so easily moved even by pain. May we have much patience. Do not let the prospect of death ever cause us any fear, but may the spirit so get the mastery of the body that we know nothing can hurt the true man. The inner newborn man cannot be smitten, nor is it to die. It is holy, incorruptible, and lives and abides forever in the life that is in Christ Jesus.

Oh, for a complete conquest of self. Especially render us unaffected by praise, lest we be too sensitive to censure. Let us believe that to have the approval of God and of our own consciences is quite enough. May we be content, gracious God, to bear the

faultfinding of unreasonable men and the misrepresentations of our own brothers. If those whom we love do not love us, may we love them nevertheless. If they misjudge us by mistake, let us have no hard feelings toward them. God, grant that we may never misjudge one another. Does not our Judge stand in the courtroom? Oh, keep us like little children who do not know, but expect to know hereafter, and are content to believe things that they do not understand. Lord, keep us humble, dependent, yet serenely joyful. May we be calm and quiet even as a weaned child, yet may we be earnest and active.

O Savior, make us like Yourself. We do not wish so much to do as to be. If You will make us to be right, we will do right. We find how often we have to put a constraint upon ourselves to be right. Oh, that we were like You, Jesus, so that we had only to be ourselves, to behave in our perfect holiness! We will never rest until this is the case, until You have made us inwardly holy. Then words and actions must be holy as a matter of course. Now, here we are, Lord, and we belong to You. Oh, it is because we are Your own that we have hope. You will make us worthy of You. Your possession of us is our hope of perfection. You wash our feet because we are Your own. Oh, how sweet is the mercy that first took us to its heart and made us all its own and now continues to deal tenderly with us. Being Christ's own, may we have that of Christ within us that all may see and that proves us to be Christ's own!

We bring before You all Your saints and ask You to attend to their trials and troubles. Some we know are afflicted personally, others in their dear friends and families, and some in their temporal state, having been brought into sore distress. Lord, we do not know the trials of all Your people, but You do, for You are the Head, and the pains of all the members are centered in You. Help Your people.

Now we pray that You would grant us the blessing that we have already sought, and let it come upon all the churches of our beloved country. May the Lord revive true and undefiled religion here and in all the other lands where Christ is known and preached. Let the day come when heathendom becomes converted, when the crescent of Mohammed wanes into eternal night, and when she who sits on the Seven Hills and exalts herself in the place of God is cast down to sink like a millstone in the flood.

Let the blessed Gospel of the eternal God prevail. *"Let the whole earth be filled with his glory"* (Ps. 72:19). Oh, that we may

live to see that day. Lord, bless our country. Have pity on it. God, bless those in government with every mercy and blessing. Oh, let the people see Your hand and understand why it is laid upon them, so that they may turn from wrongdoing and seek righteousness and follow after peace. Then will the blessing return. May You hear us as we often cry to You in secret on behalf of this misled land. Lord, deliver it, and lift up the light of Your countenance upon it yet again, for Jesus' sake. Amen.

26

Prayer Answered and Unanswered

G od of Israel, our Lord and King forever and ever! Help us now by the sacred Spirit to approach You appropriately with deepest reverence, but not with servile fear; with holiest boldness, but not with presumption. Teach us as children to speak to the Father, and yet as creatures to bow before our Maker.

Our Father, we want to first ask You whether You have anything against us as Your children. Have we been asking of You amiss, and have You given us what we have sought? We are not conscious of it, but it may be so. Now we are brought as an answer to our presumptuous prayers into a more difficult position than the one we occupied before. Now it may be that some creature comfort is nearer to us than our God. We would have been better off without it and to have dwelt in our God and there to have found our joy. But now, Lord, in these perilous circumstances, give us grace so that we may not turn away from You.

If our position is not such as You would have allotted to us had we been wiser, nevertheless grant that we may be taught to behave ourselves appropriately even now, lest the mercies You have given should become a cause of stumbling and the obtaining of our hearts' desires should become a temptation to us.

Rather, we feel inclined to bless You for the many occasions in which You have not answered our prayers, for You have said that we did ask amiss and therefore we could not have (James 4:3). We desire to register this prayer with You—that whenever we do ask amiss, You would in great wisdom and love be pleased to refuse us.

O Lord, if we at any time press our suit without sufficient resignation, do not regard us, we pray. Though we cry to You day and night concerning anything, if You see that we err, do not regard the voice of our cry, we ask You. It is our hearts' desire now,

in our cooler moments, that this prayer of ours might stand on record as long as we live: *"Nevertheless not my will, but thine, be done"* (Luke 22:42).

O Lord, in looking back, we are obliged to remember with the greatest gratitude the many occasions in which You have heard our cries. When we have been brought into deep distress and our hearts have sunk within us, then we have cried to You, and You have never refused to hear us. The prayers of our lusts You have rejected, but the prayers of our necessities You have granted. Not one good thing has failed of all that You have promised.

You have given to us exceedingly abundantly above what we asked or even thought, for there was a day when our present condition would have been regarded as much too high for us ever to reach. In looking back, we are surprised that those who lay among the pots of Egypt should now sit every man under his vine and fig tree, that those who wandered in the wilderness in a solitary way should now find a city to dwell in, that we who were prodigals in rags should now be children in the Father's house, and that we who were companions of swine should now be made heirs of God and joint-heirs with Christ. What encouragement we have to pray to such a prayer-hearing God, who far exceeds the requests of His children.

"Blessed be the name of the Lord forever," our innermost hearts are saying. "Amen, blessed be His name!" If it were only for answered prayer or even for some unanswered prayers, we would continue to praise and bless You as long as we have any being (Ps. 104:33).

Now, Lord, listen to the voice of Your children's cry. Wherever there is a sincere heart seeking for greater holiness, may You answer that request. Wherever there is a broken spirit seeking reconciliation with You, be pleased to answer it now. You know where there is prayer, though it is unuttered, and even the lips do not move. Oh, hear the publican who dares not lift his eye to heaven. Hear him when he cries, *"God be merciful to me a sinner"* (Luke 18:13). Hear those who seem to themselves to be appointed unto death. Let the sighing of the prisoner come before You! Oh, that You would grant peace and rest to every troubled spirit all over the world who now desires to turn his face to the Cross and to see God in Christ Jesus.

O Lord, if there are any of Your servants concerned about the cares of others, we thank You for them. Raise up in the church many intercessors who would plead for the prosperity of Zion and

give You no rest until You establish her and make her a joy in the land.

Oh, there are some of us who have cried to You about our country. You know how in secret we have groaned and sighed over evil times. You have begun to hear us already, for which we desire to praise and bless Your name. But we do not cease to pray for this land that You would roll away from it all its sin, that You would deliver it from the curse of drunkenness, rescue it from unbelief, ritualism, rationalism, and every form of evil, so that this land might become a holy land.

O Lord, bring the multitudes of workingmen to listen to the Gospel. Break in, we pray, upon their stolid indifference. Lord, give them a love of Your house, a desire to hear Your Gospel. Then may You look upon the poor rich, so many of whom know nothing about You and are worshiping their own wealth. Lord, grant that the many for whom there are no special gospel services, but who are wrapped up in self-righteousness, be brought to hear the Gospel of Jesus so that they also may be brought to Christ. God, bless this land with more gospel light, gospel life, and gospel love. You will hear us, O Lord.

Then we want to pray for our children, that they might be saved. Some of us no longer need to pray for our children's conversions, for our prayers have been heard already. But there are others who have children who worry them and grieve their hearts. O God, save sons and daughters of godly people. Do not let them have to sigh over their children as Eli and Samuel did. May they see their sons and daughters become children of the living God. We want to pray for our coworkers, for our neighbors, for our relatives of near or far degree, that all might be brought to Jesus. Do this, O God, in Your infinite mercy.

As we are now making intercession, we want to pray according to Your Word for all kings and for all who are in authority, so that we may lead quiet and peaceable lives. We pray for all nations also. O Lord, bless and remember the lands that sit in darkness, and let them see a great light. May missionary endeavors be abundantly successful. Let the favored nations where our God is known, especially this land and the land across the mighty ocean, which love the same Savior and speak the same language, be always favored with the divine presence and with abundant prosperity and blessing.

And now, Father, glorify Your Son! In scattering pardons through His precious blood, glorify Your Son! In sending forth the Eternal Spirit to convict men and bring them to His feet, Father, glorify Your Son! In enriching Your saints with gifts and graces and building them up into His image, Father, glorify Your Son! In the gathering together of the whole company of His elect and in the hastening of His kingdom and His coming, Father, glorify Your Son! Beyond this prayer we cannot go: *"Glorify thy Son, that thy Son also may glorify thee"* (John 17:1). Unto Father, Son, and Holy Spirit be glory forever and ever. Amen.

Epilogue

Call unto me, and I will answer thee,
and show thee great and mighty things,
which thou knowest not.
—Jeremiah 33:3

Some of the most learned works in the world smell of the midnight oil, but the most spiritual and most comforting books and sayings of men usually have an aroma about them of damp prison. I could cite many instances, but John Bunyan's *Pilgrim's Progress* may suffice instead of a hundred others. And this good Scripture text of ours, all moldy and chilled with the prison in which Jeremiah lay, has nevertheless a brightness and a beauty about it that it might never have had if it had not come as a cheering word to the prisoner of the Lord, who was shut up in the court of the prison house.

God's people have always, when in the worst of conditions, found out the best of their God. He is good at all times, but He seems to be at His best when they are at their worst. "How could you bear your long imprisonment so well?" said one to the Landgrave of Hesse, who had been locked up for his attachment to the principles of the Reformation. He replied, "The divine consolations of martyrs were with me." Doubtless there is a consolation deeper and stronger than any other, which God keeps for those who, being His faithful witnesses, have to endure exceedingly great tribulation from the enmity of man.

There is a glorious aurora for the frigid zone, and stars glisten in Northern skies with unusual splendor. The Scottish preacher Samuel Rutherford had a quaint saying, that when he was cast into the cellars of affliction, he remembered that the Great King always kept His wine there. He began to seek at once for the wine bottles and to drink of the well-refined wine.

They who dive in the sea of affliction bring up rare pearls. You know, my companions in affliction, that it is so. You whose bones have been ready to come through your skin because of lying long upon the weary couch, you who have seen your earthly goods carried away from you and have been reduced nearly to poverty, you who have gone to the graveside even seven times until you have feared that your last earthly friend would be borne away by unpitying death, you have proved that He is a faithful God and that, as your tribulations abound, so your consolations also abound by Christ Jesus (2 Cor. 1:5). My prayer is that some other prisoners of the Lord may have this text's joyous promise spoken inwardly to them. I pray that you who are tightly shut away and cannot come forth because of a present heaviness of spirit may hear Him say, as with a soft whisper in your ears and in your hearts, *"Call unto me, and I will answer thee, and show thee great and mighty things, which thou knowest not."*

The text naturally divides itself into three distinct truths. I will explain these as I am enabled by God the Holy Spirit. First, prayer is commanded: *"Call unto me."* Second, an answer is promised: *"And I will answer thee."* Third, faith is encouraged: *"And show thee great and mighty things, which thou knowest not."*

GOD'S COMMAND TO PRAY

The first truth of this Scripture is that prayer is commanded. We are not merely counseled and recommended to pray, but commanded to pray. This is tremendous graciousness on God's part. If a hospital is built and free admission is given to the sick when they seek it, no order is made that a man *must* enter its gates. A soup kitchen may be well-stocked for the depths of winter, and notice may be circulated that those who are poor may receive food upon application, but no one thinks of passing a law compelling the poor to come and wait in line to take the charity. It is thought to be enough to offer it without issuing a mandate that men *must* accept it. Yet so strange is man's mentality on the one hand that it makes him need a command to be merciful to his own soul, and so marvelous is the condescension of our gracious God on the other that He issues a command of love, without which not one man born of Adam would partake of the gospel feast, but would rather starve than come.

Worldly Distractions

It is even so in the matter of prayer. God's own people need a command to pray, or else they would not receive it. How is this? Because, dear friends, we are very subject to fits of worldliness, if indeed that is not our usual state. We do not forget to eat. We do not forget to be diligent in business. We do not forget to go to our beds to rest. But we often forget to wrestle with God in prayer and to spend, as we ought to spend, long periods in consecrated fellowship with our Father and our God.

With too many professing believers, the worldly ledger is so bulky that you cannot move it, and the Bible, representing their devotion, is so small that you could almost put it in your pocket. Hours for the world! Moments for Christ! The world has the best of our time, and our prayer closets the leftover fragments. We give our strength and freshness to the ways of money, and our weakness and fatigue to the ways of God. This is why we need to be commanded to attend to that very act that ought to be our greatest happiness, as it is our highest privilege to perform—to meet with Him. *"Call unto me,"* He says, for He knows that we are apt to forget to call upon Him. *"What meanest thou, O sleeper? arise, call upon thy God"* (Jonah 1:6) is an exhortation that is needed by us as well as it was needed by Jonah in the storm.

Burdened Hearts

He understands what heavy hearts we have sometimes, when we are under a sense of sin. Satan says to us, "Why should you pray? How can you hope to prevail? In vain you say, *'I will arise and go to my father'* (Luke 15:18), for you are not worthy to be one of his hired servants. How can you see the King's face after you have played the traitor against Him? How will you dare to approach the altar when you have yourself defiled it and when the sacrifice that you would bring is a poor, polluted one?"

O beloved, it is well for us that we are commanded to pray, or else in times of heaviness we might not. If God commands me, unfit as I may be, I will creep to the footstool of grace. Since He says, *"Pray without ceasing"* (1 Thess. 5:17), though my words fail me and my heart itself wanders, I will stammer out the wishes of my

270

hungering soul and say, "O God, at least teach me to pray, and help me to prevail with You."

Frequent Unbelief

Are we not commanded to pray also because of our frequent unbelief? Unbelief whispers, "What profit is there if you do seek the Lord about that matter?" The foul fiend of hell suggests to you, "This is a case quite out of the bounds of those things in which God has intervened. Therefore, if you were in any other position, you might rest upon the mighty arm of God, but here your prayer will not help you. It is too trivial a matter. It is too connected with temporal things. It is a matter in which you have sinned too much. It is too high, too hard, too complicated a piece of business. You have no right to take that before God!" So the Devil continues.

Therefore, there stands written as an everyday precept, suitable to every case into which a Christian can be cast, *"'Call unto me.'* Are you sick? Do you want to be healed? Cry unto Me, for I am a Great Physician. Does providence trouble you? Are you fearful that you will not respect what is right in the sight of man? *'Call unto me!'* Do Your children trouble you? Do you feel that which is sharper than an adder's tooth—a thankless child? *'Call unto me.'* Are your griefs little, yet painful, like small points and pricks of thorns? *'Call unto me!'* Is your burden heavy as though it would make your back break beneath its load? *'Call unto me!'"*

"Cast thy burden upon the LORD, *and he shall sustain thee: he shall never suffer the righteous to be moved"* (Ps. 55:22). In the valley; on the mountain; on the barren rock; in the briny sea, submerged beneath the billows, and lifted up by and by upon the crest of the waves; in the furnace when the coals are glowing; in the gates of death when the jaws of hell would shut themselves upon you—cease not, for the commandment ever says to you, *"Call unto me."* Prayer is still mighty and must prevail with God to bring you your deliverance. These are some of the reasons that the privilege of supplication is also spoken of as a duty in Holy Scripture. There are many more, but these will suffice for now.

A Sure and Abiding Command

Additionally, we ought to be very glad that God has given us this command in His Word that it may be sure and abiding. You



pray. It may be that you do not take particular notice of the inclination at first, but it comes again and again: "Get alone and pray!"

I find that in the matter of prayer, I am myself very much like a waterwheel, which runs well when there is plenty of water but turns with very little force when the brook is growing shallow. I could also be likened to a ship that flies over the waves and puts out all her canvas when the wind is favorable, but has to tack about most laboriously when there is only a little of the favoring breeze.

Now, it strikes me that whenever our Lord gives you the special inclination to pray, you should double your diligence. *"Men ought always to pray, and not to faint"* (Luke 18:1). Yet when He gives you the special longing to pray and you feel a special enjoyment in it, you have, over and above the command that is constantly binding, another command that should compel you to cheerful obedience. At such times, I think we may stand in the position of David, to whom the Lord said, *"When thou hearest the sound of a going* [marching] *in the tops of the mulberry trees...then thou shalt bestir thyself"* (2 Sam. 5:24). That *"going in the tops of the mulberry trees"* may have been the footsteps of angels hastening to help David. Then David was to smite the Philistines.

When God's mercies are approaching, their footsteps are our desires to pray. Our desires to pray should be at once an indication that His time to favor Zion is coming. Sow plentifully now, for you can sow in hope. Plow joyously now, for your harvest is sure. Wrestle now, Jacob, for you are about to be made a prevailing prince, and your name will be called Israel. Now is your time, spiritual merchants: the market is high; trade much. Your profit will be large. See to it that you use the golden hour well, and reap your harvest while the sun shines. When we enjoy visitations from on high, we should be particularly constant in prayer. If some other less-pressing duty must be set aside for a season, it will not go amiss, and we will not lose out. When God specially bids us to pray by the urgings of His Spirit, then we should stir ourselves in prayer.

GOD'S ANSWERS TO PRAYER

God's Nature

Let us now look at the second point: an answer is promised. We should not tolerate for a minute the ghastly and grievous thought that God will not answer prayer. His nature, as manifested

in Christ Jesus, demands the answer. He has revealed Himself in the Gospel as a God of love, *"full of grace and truth"* (John 1:14). How can He refuse to help those of His creatures who humbly in His own appointed way seek His face and favor?

On one occasion, the Athenian senate found it convenient to meet together in the open air. As they were sitting in their deliberations, a sparrow, pursued by a hawk, flew in the direction of the senate. Being hard-pressed by the bird of prey, it sought shelter in the coat of one of the senators. He, being a man of rough and vulgar mold, took the bird from his coat, threw it to the ground, and so killed it. Whereupon the whole senate rose in an uproar and, without a single dissenting voice, condemned him to die. They judged him unworthy of a seat in the senate with them or to be called an Athenian, since he did not give help to a creature that confided in him.

Can we suppose that the God of heaven, whose nature is love, could tear out of His garment the poor fluttering dove that flies from the eagle of justice into the garment of His mercy? Will He give the invitation to us to seek His face, and when we, with much trepidation and fear, do summon courage enough to fly to Him, will He then be unjust and ungracious enough to forget to hear our cry and to answer us? Let us not think so harshly of the God of heaven.

God's Past Character

Let us recollect next His past character as well as His nature. I mean the character that He has won for Himself by His past deeds of grace. Consider, beloved, the one stupendous display of bounty: *"He...spared not his own Son, but delivered him up for us all"* (Rom. 8:32). If I were to mention a thousand illustrations, I could not give a better picture of the character of God than that one deed. However, not only my inference, but the inspired conclusion of the apostle is, *"How shall he not with him also freely give us all things?"* (v. 32).

If the Lord did not refuse to listen to my voice when I was a guilty sinner and an enemy, how can He disregard my cry now that I am justified and saved? How is it that He heard the voice of my misery when my heart did not hear it and would not seek relief, if after all He will not hear me now that I am His child and His friend? The bleeding wounds of Jesus are the sure guarantees for

answered prayer. George Herbert in that quaint poem of his, *The Bag,* represents the Savior as saying,

> If ye have anything to send or write
> (I have no bag, but here is room)
> Unto My Father's hands and sight,
> (Believe Me) it shall safely come.
> That I shall mind what you impart
> Look, you may put it very near My heart,
> Or if hereafter any of friends
> Will use Me in this kind, the door
> Shall still be open; what he sends
> I will present and somewhat more
> Not to his hurt.

Surely, George Herbert's thoughts were that the Atonement was in itself a guarantee that prayer must be heard, and that the great gash made near the Savior's heart, which let light into the very depths of the heart of Deity, was proof that He who sits in heaven would hear the cry of His people. You misread Calvary if you think that prayer is useless.

God's Own Promise

But, beloved, we also have the Lord's own promise for it, and He is a God who cannot lie. *"Call upon me in the day of trouble: I will deliver thee"* (Ps. 50:15). Has He not said, *"Whatsoever ye shall ask in prayer, believing, ye shall receive"* (Matt. 21:22)? We cannot pray, indeed, unless we believe this doctrine: *"For he that cometh to God must believe that he is, and that he is a rewarder of them that diligently seek him"* (Heb. 11:6). If we have any question at all about whether our prayer will be heard, we are comparable to him who wavers: *"But let him ask in faith, nothing wavering. For he that wavereth is like a wave of the sea driven with the wind and tossed. For let not that man think that he shall receive any thing of the Lord"* (James 1:6–7).

Our Own Experiences

Furthermore, it is not necessary, but it may strengthen the point to add that our own experiences lead us to believe that God

275

will answer prayer. I must not speak for you, but I may speak for myself. If there is anything I know, anything that I am quite assured of beyond all question, it is that praying breath is never spent in vain. If no other human being can say it, I dare to say it, and I know that I can prove it. My own conversion is the result of long, affectionate, earnest, unrelenting prayer. My parents prayed for me, God heard their cries, and here I am to preach the Gospel. Since then I have ventured on some things that were far beyond my mere capacity, but I have never failed because I have cast myself upon the Lord. You know as a church that I have not hesitated to indulge large ideas of what we might do for God, and we have accomplished all that we purposed. I have sought God's aid, assistance, and help in all my many undertakings. Though I cannot tell here the story of my private life in God's work, yet if it were written, it would be a standing proof that there is a God who answers prayer.

God has heard my prayers, not now and then, not once or twice, but so many times that it has grown into a habit with me to spread my case before God with the absolute certainty that whatsoever I ask of God, He will give to me. It is not just a "perhaps" or a "maybe." I know that my Lord answers me, and I dare not doubt. It would be foolishness if I did.

As I am sure that a certain amount of leverage will lift a weight, so I know that a certain amount of prayer will get anything from God. As the rain cloud brings the shower, so prayer brings the blessing. As spring scatters flowers, so supplication ensures mercies. In all labor there is profit, but most of all in the work of intercession I am sure of this, for I have reaped it. As I put trust in our currency and have never failed yet to buy what I want when I produce the cash, so I put trust in God's promises. I intend to do so until I find that He tells me that they are worthless coins and will not do as trade in heaven's market. But why should I speak? Oh, beloved, you all know in your own selves that God hears prayer. If you do not, then where is your Christianity? Where is your belief? You will need to learn the first elements of the truth, for all saints, young or old, count it certain that He hears prayer.

Submission to God's Will

Still remember that prayer is always to be offered in submission to God's will. When we say that God hears prayer, we do not mean that He always gives us literally what we ask for. However,

we do mean this: that He gives us what is best for us, and that if He does not give us the mercy we ask for in silver, He bestows it upon us in gold. If He does not take away the thorn in the flesh, yet He says, *"My grace is sufficient for thee"* (2 Cor. 12:9), which amounts to the same in the end.

Lord Bolingbroke said to the Countess of Huntingdon, who founded a body of Calvinistic Methodists, "I cannot understand, Your Ladyship, how you can make earnest prayer to be consistent with submission to the divine will." "My lord," she replied, "that is a matter of no difficulty. If I were a courtier of some generous king, and he gave me permission to ask any favor I pleased of him, I would be sure to put it this way, 'Will Your Majesty be graciously pleased to grant me such and such a favor? But at the same time, though I very much desire it, if it would in any way detract from Your Majesty's honor, or if in Your Majesty's judgment it seems better that I do not have this favor, I will be just as content to go without it as to receive it.' So you see, I might earnestly offer a petition, and yet I might submissively leave it in the king's hands."

So it is with God. We never offer prayer without inserting that clause, either in spirit or in words, *"Nevertheless not as I will, but as thou wilt"* (Matt. 26:39). *"Not my will, but thine, be done"* (Luke 22:42). We can only pray without an "if" when we are quite sure that our will is God's will because God's will is fully our will. A much slandered poet has well said,

> Man, regard thy prayers as a purpose of love to thy soul,
> Esteem the providence that led to them as an index of God's
> good will;
> So shalt thou pray aright, and thy words shall meet with
> acceptance.
> Also, in pleading for others, be thankful for the fullness of thy
> prayer;
> For if thou art ready to ask, the Lord is more ready to bestow.
> The salt preserveth the sea, and the saints uphold the earth;
> Their prayers are the thousand pillars that prop the canopy of
> nature.
> Verily, an hour without prayer, from some terrestrial mind,
> Were a curse in the calendar of time, a spot of the blackness of
> darkness.
> Perchance the terrible day, when the world must rock into
> ruins,

Will be one unwhitened by prayer—shall He find faith on the
earth?
For there is an economy of mercy, as of wisdom, and power,
and means;
Neither is one blessing granted, unbesought from the treasury
of good:
And the charitable heart of the Being, to depend upon whom is
happiness,
Never withholdeth a bounty, so long as His subject prayeth;
Yea, ask what thou wilt, to the second throne in heaven,
It is thine for whom it was appointed; there is no limit unto
prayer:
But and if thou cease to ask, tremble, thou self-suspended
creature,
For thy strength is cut off as was Samson's: and the hour of
thy doom is come.

ENCOURAGEMENT TO BELIEVE GOD

I come to our third truth, which I think is full of assurance to
all those who exercise the hallowed art of prayer: faith is encour-
aged. *"I will...show thee great and mighty things, which thou
knowest not."*
This word was originally spoken to a prophet in prison. There-
fore, in the first place, it applies to every teacher. Indeed, since
every teacher must be a learner, it also has a bearing upon every
learner of divine truth. The best way by which a prophet, teacher, or
learner can know the reserved truths, the higher and more myste-
rious truths of God, is by waiting upon God in prayer.

Prayer Promotes Learning

I especially noticed in reading the book of Daniel, how Daniel
found out Nebuchadnezzar's dream. The soothsayers, magicians,
and astrologers of the Chaldees brought out their curious books
and strange instruments, and began to mutter *abracadabra* and all
sorts of mysterious incantations, but they failed. What did Daniel
do? He set himself to pray. Knowing that the prayer of a united
body of people has more prevailing power than the prayer of one,
Daniel called together his compatriots and told them to unite with
him in earnest prayer that God would be pleased in His infinite
mercy to open up the vision.

Epilogue

> *Then Daniel went to his house, and made the thing known to Hananiah, Mishael, and Azariah, his companions: that they would desire mercies of the God of heaven concerning this secret; that Daniel and his fellows should not perish with the rest of the wise men of Babylon. Then was the secret revealed unto Daniel in a night vision. Then Daniel blessed the God of heaven.* (Dan. 2:17–19)

In the case of John, who was the Daniel of the New Testament, you remember he saw a book in the right hand of Him who sat on the throne—a book sealed with seven seals that none was found worthy to open or to look upon. What did John do? The book was eventually opened by the Lion of the tribe of Judah, who had prevailed to open the book. But it is written first, before the book was opened, *"I wept much"* (Rev. 5:4). Yes, the tears of John, which were his liquid prayers, were, as far as he was concerned, the sacred keys by which the book was opened.

Pastors in the ministry, Sunday school teachers, and all of you who are learners in the college of Christ Jesus, remember that prayer is your best means of study. Like Daniel, you will understand the dream and its interpretation when you have sought God. Like John, you will see the seven seals of precious truth unloosed after you have wept much.

> *Yea, if thou criest after knowledge, and liftest up thy voice for understanding; if thou seekest her as silver, and searchest for her as for hid treasures; then shalt thou understand the fear of the LORD, and find the knowledge of God.* (Prov. 2:3–5)

Stones are not broken except by an earnest use of the hammer, and the stone-breaker usually goes down on his knees. Use the hammer of diligence, and let the knee of prayer be exercised, too, and there is not a stony doctrine in Revelation that is useful for you to understand that will not fly into fragments under the exercise of prayer and faith. *"Bene orasse est bene studuisse"* was a wise sentence of Luther, which has so often been translated and quoted, "To have prayed well is to have studied well."

You can force your way through anything with the leverage of prayer. Thoughts and reasoning may be like the steel wedges that may open a way into truth, but prayer is the lever, the crowbar that forces open the iron chest of sacred mysteries so that we may

279

get the treasure hidden in it for those who can force their way to reach it. *"Until now the kingdom of heaven suffereth violence, and the violent take it by force"* (Matt. 11:12). Take care that you work with the mighty implement of prayer, and nothing can stand against you.

Prayer Promotes Deeper Experience

We must not, however, stop there. We have applied the text to only one case. It is applicable to a hundred. We single out another. The saint may expect to discover deeper experience and to know more of the higher scriptural life by being much in prayer. There are different translations of our text, Jeremiah 33:3. One version says, *"I will show thee great and fortified things which thou knowest not."* Another reads, *"Great and reserved things which thou knowest not."* Now, all the developments of spiritual life are not similarly easy to attain. There are the common experiences and feelings of repentance, faith, joy, and hope, which are enjoyed by the entire family. But there is an upper realm of rapture, of communion and conscious union with Christ, which is far from being the common dwelling place of believers. All believers see Christ, but all believers do not put their fingers into the prints of the nails or thrust their hand into His side. We do not have the high privilege of John to lean upon Jesus' chest, or of Paul to be caught up into the third heaven. In the ark of salvation, we find a lower, second, and third story—all are in the ark, but all do not abide on the same level. Most Christians, as to the river of experience, are only up to the ankles. Others have waded until the stream is up to their knees. Some find it chest-high. How few find it a river to swim in, the bottom of which they cannot touch!

Beloved, there are heights in experimental knowledge of the things of God that the eagle's discerning eye and philosophic thought have never seen. There are secret paths that the lion's reason and judgment have not as yet learned to travel. God alone can take us there, but the chariot in which He takes us up, and the fiery steeds that pull that chariot, are prevailing prayers. Prevailing prayer is victorious over the God of mercy: *"By his strength he had power with God: yea, he had power over the angel, and prevailed: he wept, and made supplication unto him: he found him in Bethel, and there he spake with us"* (Hos. 12:3–4).

Prevailing prayer takes the Christian to Carmel and enables him to cover heaven with clouds of blessing and earth with floods of mercy. Prevailing prayer bears the Christian aloft to Pisgah and shows him the reserved inheritance. It elevates him to Tabor and transfigures him until he is in the likeness of his Lord, until *"as he is, so are we in this world"* (1 John 4:17). If you want to reach something higher than ordinary groveling experience, look *"to the rock that is higher than* [you]" (Ps. 61:2); look with the eye of faith through the windows of unrelenting prayer. To grow in experience then, there must be much prayer.

Prayer Brings Deliverance

Have patience with me while I apply this text to two or three more situations. It is certainly true of one suffering under trial: if he waits upon God in much prayer, he will receive greater deliverances than he has ever dreamed of—*"great and mighty things, which thou knowest not."* Here is Jeremiah's testimony: *"Thou drewest near in the day that I called upon thee: thou saidst, Fear not. O Lord, thou hast pleaded the causes of my soul; thou hast redeemed my life"* (Lam. 3:57–58).

David's is the same: *"I called upon the LORD in distress: the LORD answered me, and set me in a large place....I will praise thee: for thou hast heard me, and art become my salvation"* (Ps. 118:5, 21). And again: *"Then they cried unto the LORD in their trouble, and he delivered them out of their distresses. And he led them forth by the right way, that they might go to a city of habitation"* (Ps. 107:6–7).

"My husband is dead," the poor woman cried to Elisha, *"...and the creditor is come to take unto him my two sons to be bondmen"* (2 Kings 4:1). She hoped that Elisha would possibly say, "What are your debts? I will pay them." Instead of that, he multiplied her oil and said, *"Go, sell the oil, and pay thy debt, and"* (what was the *"and"*?) *"live thou and thy children of the rest"* (v. 7). So often it will happen that God will not only help His people through the miry places along the way, so that they may just stand on the other side of the swamp, but He will bring them safely far ahead on the journey. It was a remarkable miracle when, in the midst of the storm, Jesus Christ came walking on the sea and the disciples received Him into the ship; not only was the sea calm, but

"immediately the ship was at the land whither they went" (John 6:21).

That was a mercy over and above what they had asked. I sometimes hear people pray and make use of a quotation that is not in the Bible: "He is able to do exceeding abundantly above what we *can* ask or think." It is not written that way in the Bible. I do not know what we can ask or what we can think. But the Bible says, "[He] *is able to do exceeding abundantly above all **that we ask** or think"* (Eph. 3:20, emphasis added).

Let us then, dear friends, when we are in great trial, simply say, "Now I am in prison. Like Jeremiah, I will pray, for I have God's command to do it. I will watch as he did, expecting that God will show me reserved mercies that I know nothing of at present." He will not merely bring His people through the battle, covering their heads in it, but He will bring them forth with banners waving, to divide the spoil with the mighty and to claim their portion with the strong (Isa. 53:12). Expect great things of a God who gives such great promises as these.

Prayer Makes Us Useful

Again, here is encouragement for the worker. I am happy to say that you are probably doing something for Christ. My dear friend, wait upon God much in prayer, and you have the promise that He will do greater things for you than you know of. We do not know how much capacity for usefulness there may be in us. That donkey's jawbone lying there on the ground, what can it do? Nobody knows. But when it gets into Samson's hands, what can it *not* do? No one knows what it cannot do now that a Samson wields it. And you, friend, have often thought yourself to be as contemptible as that bone. You have said, "What can I do?" But when Christ by His Spirit grips you, what can you not do? Truly you may adopt Paul's language and say, *"I can do all things through Christ which strengtheneth me"* (Phil. 4:13).

However, do not depend on prayer without effort. In a certain school there was one girl, a very gracious, simple-hearted, trustful child, who knew the Lord. As usual, grace developed itself in the child according to the child's position. Her lessons were always prepared the best of any in the class. Another girl said to her, "How is it that your lessons are always so well done?" "I pray to

God to help me to learn my lessons," she said. Well, thought the other, then I will do the same. The next morning when she stood up in the class, she knew nothing. When she was disgraced, she complained to the other, "Why, I prayed that God would help me learn my lesson, and I do not know any of it. What is the use of prayer?" "But did you sit down and try to learn it?" "Oh, no," she said, "I never looked at the book." "Ah," then said the other, "I asked God to help me to learn my lesson, but then I sat down to study and kept at it until I knew it well. I learned it easily because my earnest desire, which I had expressed to God, was, 'Help me to be diligent in endeavoring to do my duty.'" So is it with some who come to prayer meetings and pray and then fold their arms and go away, hoping that God's work will go on. This is like the woman who sang, "Fly abroad, thou mighty Gospel," but did not put a penny in the plate. Her friend touched her and said, "But how can it fly if you don't give it wings to fly with?"

There are many who appear to be very mighty in prayer, wondrous in supplications, but they require God to do what they can do themselves. Therefore, God does nothing at all for them. "I shall leave my camel untied," said an Arab once to Mohammed, "and trust to providence." "Tie it up tight," said Mohammed, "and then trust to providence." So you who say, "I will pray and trust my church, or my class, or my work to God's goodness," may rather hear the voice of experience and wisdom that says, "Do your best. Work as if all rested on your toil, as if your own arm would bring your salvation. When you have done all, cast yourself on Him without whom it is in vain to rise up early and to sit up late, and to eat the bread of anxiety (Ps. 127:2), and if He gives you success, give Him the praise."

Comfort for Intercessors

I want to point out that this promise ought to prove useful for the comfort of those who are intercessors for others. You who are calling upon God to save your children, to bless your neighbors, to remember your husband or your wife in mercy, may find assurance from this: *"I will...show thee great and mighty things, which thou knowest not."* A celebrated minister in the last century, one Mr. Bailey, was the child of a godly mother. This mother had almost ceased to pray for her husband, who was a man of a most ungodly character and a bitter persecutor. The mother prayed for her boy,

and while he was still eleven or twelve years of age, eternal mercy met with him. So sweetly instructed was the child in the things of the kingdom of God that the mother requested him—and for some time he always did so—to conduct family prayer in the house. Morning and evening this little one laid open the Bible. Though the father would not deign to stop for the family prayer, on one occasion he was rather curious, so he stopped on the other side of the door to listen. God blessed the prayer of his own child under thirteen years of age to his conversion. The mother might well have read my text with streaming eyes and said, "Yes, Lord, You have shown me great and mighty things which I knew not. You have not only saved my boy, but through my boy, You have brought my husband to the truth."

You cannot guess how greatly God will bless you. Only go and stand at His door, for you cannot tell what is in reserve for you. If you do not beg at all, you will get nothing. But if you beg, He may not only give you, as it were, the bones and leftover meat, but He may say to the servant at His table, "Take that choice meat, and set it before the poor man."

Ruth went to glean. She expected to get a few good ears, but Boaz said, *"Let her glean even among the sheaves, and reproach her not"* (Ruth 2:15). Furthermore, he said to her, *"At mealtime come thou hither, and eat of the bread, and dip thy morsel in the vinegar"* (v. 14). She found a husband where she only expected to find a handful of barley. So in prayer for others, God may give us such mercies that we will be astounded at them, since we expected but little. Hear what is said of Job, and learn its lesson:

> The LORD said...my servant Job shall pray for you: for him will I accept: lest I deal with you after your folly, in that ye have not spoken of me the thing which is right, like my servant Job....And the LORD turned the captivity of Job, when he prayed for his friends: also the LORD gave Job twice as much as he had before. (Job 42:7–8, 10)

Instructions for Those Seeking Salvation

Finally, some of you are seeking for your own conversion. God has quickened you to solemn prayer about your own souls. You are not content to go to hell; you want heaven. You want to be washed in the precious blood. You want eternal life. Dear friends, I ask you

to take this text—God Himself speaks it to you: *"Call unto me, and I will answer thee, and show thee great and mighty things, which thou knowest not."* Take God at His Word at once. Get home, go into your room, shut the door, and try Him. Young man, I say, try the Lord. Young woman, prove Him. See whether He is true or not. If God is true, you cannot seek mercy at His hands through Jesus Christ and get a negative reply. He must open mercy's gate to you who knock with all your heart, for His own promise and character bind Him to it. May God help you, believing in Christ Jesus, to cry aloud unto Him, and His answer of peace is already on the way to meet you. You will hear Him say, "[Your] *sins, which are many, are forgiven"* (Luke 7:47).

The Lord bless you for His love's sake. Amen.

Book
Four

Finding Peace
in Life's Storms

1

Saved in Hope

We are saved by hope: but hope that is seen is not hope:
for what a man seeth, why doth he yet hope for?
But if we hope for that we see not, then do
we with patience wait for it.
—Romans 8:24–25

We who are believers are saved right now. In a certain sense, we are completely saved. We are entirely saved from the guilt of sin. The Lord Jesus took our sin and bore it in His own body on the cross. He offered an acceptable atonement that did away with the iniquity of all His people once and for all. The penalty of sin has been paid for by our great Substitute and, by faith, we have accepted His sacrifice. *"He that believeth on him is not condemned"* (John 3:18).

When we receive Christ by faith, we are immediately saved from the defilement of evil and have free access to God our Father. By faith, we are saved from the ruling power of sin in our lives. As Romans 6:14 says, *"Sin shall not have dominion over you: for ye are not under the law, but under grace."* In the heart of every Christian, the crown has been removed from the head of sin and the strength of its arm has been broken by the power of faith. Sin strives to gain control, but it cannot win the victory, for he who is born of God does not delight in committing sin. He does not sin as a daily habit. Instead, the believer guards and protects himself so that the Evil One does not touch him.

Now, the Scripture passage that we will be focusing on comes from the eighth chapter of Romans, and it reads, *"We are saved by hope."* However, this does not seem to agree with other parts of

Holy Scripture. Everywhere in the Word of God we are told that we are saved by faith. For example, Romans 5:1 says, *"Therefore being justified by faith."* Faith, not hope, is the saving grace, except that in some respects, hope is equivalent to faith. In the original Greek, the meaning of Romans 8:24 is "We were saved *in* hope." If the passage were translated in this way, it would prevent misunderstanding. As the distinguished commentator Bengel said,

> The words do not describe the means, but the manner of salvation. We are so saved that there may even yet remain something for which we may hope, both of salvation and glory.

Believers receive the salvation of their souls as the culmination of their faith. They receive salvation by faith, so that they may also receive it by grace. We are saved *by* faith and *in* hope.

Therefore, we rejoice right now in the salvation that we have already obtained and that we already enjoy by faith in Christ Jesus. Yet we are conscious that there is something more than this to be obtained. We will receive salvation in a larger sense that we do not yet see. For at the present moment, we find ourselves living inside temporary tabernacles. *"For we that are in this tabernacle do groan, being burdened"* (2 Cor. 5:4). And all around us, creation is clearly experiencing labor pains. We can see signs of the earth's contractions in the unrest, upheaval, and anguish occurring in nature.

Things are not the way God originally made them. Thorns are growing in earth's plowed fields; a disease has fallen on her flowers; there is mildew on her grain. The heavens weep and saturate our harvests; the depths of the earth move and shake our cities with earthquakes. Frequent tragedies and disasters foreshadow a great future that will be born as a result of these labor pains.

Nowhere on earth can a perfect paradise be found. Even the best things of our world point to something better. And all of creation groans with us in the pains of labor. Even we who have received the firstfruits of the Spirit and are blessed and saved, groan within ourselves, waiting for something further, a glory not yet seen. We have not yet attained salvation but are pressing on. The first thirstiness of our parched, sinful souls has been quenched, but we have still greater desires within us. We hunger and thirst for righteousness with insatiable longings. Before we ate of the Bread of Heaven, we were hungry for the equivalent of pig slop. Now,

however, our newborn nature has brought us a new appetite, which the whole world could not satisfy.

What is the cause of this hunger? That is not a difficult question to answer. Our griefs, longings, and unsatisfied desires fall under two general areas. First, we long to be totally free from sin in every form. Second, we long to be free from our physical bodies and to receive our resurrected bodies.

LONGING FOR FREEDOM FROM SIN

We are burdened by the evil that is in the world. We are troubled by the evil conversations of the ungodly, and we are grieved by their temptations and persecutions. The fact that *"the whole world lieth in wickedness"* (1 John 5:19) and that people reject Christ and perish in unbelief is a source of great distress to us. We could even wish to live in a deserted area, far from civilization, so that we might commune with God in peace and never hear anything more about blasphemy, murmuring, depravity, and crime. This world is not our home, for it is polluted. We are looking for a great deliverance when we will be taken out of this world to dwell in perfect fellowship with others.

Yet even the presence of the ungodly would be a small matter if we could be completely delivered from sin within ourselves. This is among the *"things not seen"* (Heb. 11:1) that will be fulfilled at a later time. If a person were free from all tendency to sin, he would not be liable to temptation any longer. He would not need to guard against it. If something cannot possibly be burned or blackened, fire cannot hurt it. However, we feel that we must avoid temptation because we are conscious that there are logs or kindling within us that may soon catch fire. Our Lord said, *"The prince of this world cometh, and hath nothing in me"* (John 14:30). But when the Enemy comes to us, he finds not only something, but much that is compatible with his purposes. Our hearts all too readily echo the voice of Satan. When he sows his weeds, the fields of our old natures soon produce a harvest. Evil remains even in those who have been redeemed, and it infects all the faculties of their minds.

Oh, if only we could get rid of the memory of sin! What a torment it is for us to remember dirty words and snatches of obscene songs. If only we were free of sin in our thought lives! Do we mourn enough over sins in our thoughts and imaginations? A person may

sin, and sin horribly, in his thoughts, even though he may not sin in his actions. Many people have committed fornication, adultery, theft, and even murder in their imaginations by finding pleasure in the thought of them, and yet they may never have fallen into any of these sins in an overt way. If only our imaginations and our whole inner natures were purged of the corruption that is in them, which ferments into something rancid.

There is evil inside us that makes us exclaim from day to day, *"O wretched man that I am! who shall deliver me from the body of this death?"* (Rom. 7:24). If anyone reading this book is saying, "I never feel that way," I pray to God that he may soon experience it. Those who are content with themselves know very little about true spiritual perfection. A healthy child grows, and so does a healthy child of God. The nearer we come to perfect cleanness of heart, the more we will mourn over the tiniest spot of sin and the more we will recognize as sin things that we once excused. He who is most like Christ is most conscious of imperfection and is impatient to be rid of the least sin. When someone says, "I have reached the goal," I am very concerned for him, for I believe he has not yet begun to run.

As for me, I endure many growing pains and feel far less pleased with myself than I used to. I have a firm hope of something better, but if it were not for hope, I would consider myself truly unhappy to be so conscious of my need and so racked with desires. Therefore, this is one major source of our spiritual groaning. We are saved, but we are not completely delivered from tendencies to sin. Neither have we reached the fullness of holiness. *"There remaineth yet very much land to be possessed"* (Josh. 13:1).

LONGING FOR OUR RESURRECTED BODIES

Another reason for this "winter of our discontent" is our bodies. Paul called the body *"vile"* (Phil. 3:21), and indeed it is, when compared with what it will be when it is formed in the image of Christ Jesus. It is not vile in itself, viewed as the creation of God, for it is fearfully and wonderfully made (Ps. 139:14). There is something very noble about the body of man, who has been created to walk on two feet and to look upward and to gaze toward heaven. A body that has been so marvelously prepared to house the mind and to obey the soul's commands is not to be despised. A body that can be the temple of the Holy Spirit is no lowly structure; therefore, let us

not despise it. We should be eternally grateful that we have been made human beings—that is, if we also have been made new in Christ Jesus and have *"put on the new man"* (Eph. 4:24). The body came under the power of death through the Fall, and it remains under its power. Because of this, it is destined to die sooner or later, unless the Lord suddenly returns. And even then, the body must be changed, for flesh and blood, in its present state, cannot inherit the kingdom of God.

And so, our poor bodies are not well matched with our new-born souls, since they have not yet been born again. They are somewhat dull and dreary dwellings for heaven-born spirits! With their aches and pains; weariness and infirmity; need of sleep, food, and clothing; susceptibility to cold, heat, accident, and decay, as well as to excessive labor and exhausting toil; they are pitifully incapable of serving those who are sanctified. They drag down and hinder spirits that otherwise might soar to great heights. Consider how often bad health snuffs out the noble flame of high resolve and holy desires. Think about how often pain and weakness freeze the cheerful streams of the soul. When will we be freed from the chains of this natural body and put on the wedding dress of the spiritual body? Since sin dwells in our hearts and we are clothed in mortal clay, we are glad that our salvation is nearer to us now than when we first believed, and we long to enter into the full enjoyment of it.

Our Scripture text gives us a great amount of encouragement about this. There will come a time when we will be fully delivered from the cause of our present groaning. We will receive a salvation so wide that it will cover all our needs and even all our desires. A salvation awaits us whose parameters are immense and eternal. Anything we could wish for is encompassed within it. This is what our text is talking about when it says, *"We are saved by hope."* By hope, we have taken hold of this great and wide salvation.

In light of all this, I want to describe for you the kind of hope that has a firm grip on the greater salvation that we are longing for.

The Goal of Our Hope

Complete Perfection

Our hope, first of all, is in our own complete perfection in Christ. We have set our faces toward holiness, and by God's grace

we will never rest until we attain it. Every sin that is in us is doomed, not only to be conquered, but to be put to death. The grace of God does not help us to hide our sins but to destroy them.

We are to deal with sin as Joshua dealt with the five enemy kings when they hid in the cave at Makkedah. While Joshua was busy with the battle, he said, *"Roll great stones upon the mouth of the cave"* (Josh. 10:18). For a while, our sins are shut up by restraining grace, as in a cave. Great stones are rolled at the cave's mouth, for our sins would escape if they could and once more snatch at the reins of our lives. However, we intend to deal with them more effectively later on in the power of the Holy Spirit. When Joshua said, *"Bring out those five kings unto me"* (v. 22), he struck and killed them and then hanged them. By God's grace, we will never be satisfied until we hate and denounce all our natural inclinations to sin and they are utterly destroyed. We hope in expectation for a day when not a taint of past sin or an inclination for future sin will remain in us. We will still retain free will and freedom of choice, but we will choose only good. Believers who are now in heaven are not passive beings who are driven along the path of obedience by a power that they cannot resist. As intelligent beings with free wills, they freely choose to be holy before the Lord. We, too, will enjoy forever the glorious liberty of the children of God, which is found in constantly choosing what is good and right. In this way, we will experience unbroken happiness. Ignorance will no longer exist, for we will all be taught by the Lord and will know as we are known. We will be perfect in our service to God and completely delivered from all self-will and the desires of the flesh; we will be near to our God and will be like Him. As Isaac Watts has written,

> Sin, my worst enemy before,
> Shall vex my eyes and ears no more;
> My inward foes shall all be slain,
> Nor Satan break my peace again.

What a heaven this will be! I think that if I could become absolutely free from every tendency to sin, I would not care where I lived—on earth or in heaven, at the bottom of the sea with Jonah or in the low dungeon with Jeremiah. Purity is peace; holiness is happiness. He who is holy as God is holy will be happy as God is happy. This is the chief goal of our hope.

The Redemption of Our Bodies

Another goal is the redemption of our bodies. Read the verses in which Paul taught that truth:

> *And if Christ be in you, the body is dead because of sin; but the Spirit is life because of righteousness. But if the Spirit of him that raised up Jesus from the dead dwell in you, he that raised up Christ from the dead shall also quicken your mortal bodies by his Spirit that dwelleth in you.* (Rom. 8:10–11)

When we die, we will leave our bodies behind for a while. We will not, therefore, in regard to our entire beings, be perfect until the Resurrection. We will be morally perfect, but since a complete person is made up of body and soul, we will not be physically perfect while one part of us remains in the tomb. When the resurrection trumpet sounds, our bodies will rise, but they will rise in a redeemed state. Our regenerated spirits are very different from what our spirits were when they were under the bondage of sin. In the same way, when our bodies are resurrected, they will be greatly different from what they are now.

The diseases caused by sickness and age will be unknown among glorified believers, for they will be as the angels of God. No one will enter into glory lame, maimed, frail, or deformed. No one will be blind or deaf. There will be no paralysis or wasting away from tuberculosis. We will possess everlasting youth. The body that is sown in weakness will be raised in power and will immediately obey the commands of its Lord. Paul said, *"It is sown a natural* [soulish] *body"* (1 Cor. 15:44), appropriate for the soul, and *"it is raised a spiritual body"* (v. 44), appropriate for the spirit, the highest nature of man. I suppose we will inhabit the kind of body that cherubim wear when they fly *"upon the wings of the wind"* (2 Sam. 22:11), or the kind of body that seraphim inhabit when, like *"a flame of fire"* (Heb. 1:7), they rush to obey Jehovah's commands. Whatever they will be, our poor bodies will be very different from what they are now. At present, they are shriveled bulbs that will be put into the earth. But they will rise as glorious flowers, golden cups to hold the sunlight of Jehovah's face.

We do not yet know the greatness of their glory, except that they will be formed like the glorious body of Jesus Christ. Therefore,

this is the second goal of our hope, that we will receive glorified bodies that will be able to unite with our purified spirits.

Our Spiritual Inheritance

Viewed in another light, the goal of our hope is that we will enter into our spiritual inheritance. Paul said, *"If children, then heirs; heirs of God, and joint-heirs with Christ"* (Rom. 8:17). Whether we own only a little or a great amount in this life, our estates are nothing compared with what God holds in trust for us, what He has pledged that we will receive on the Day when we will come of age. The fullness of God is the heritage of believers. All that can make a person blessed and noble and complete is reserved for us. Measure, if you can, the inheritance of Christ, who is Heir of all things! What must be the portion of the well-beloved Son of the Highest? Whatever it is, it is ours, for we are joint-heirs with Christ. We will be with Him and see His glory; we will wear His image; we will sit on His throne. I cannot tell you more, for my words are poverty-stricken. I wish that we would all meditate on what the Scripture reveals about this subject until we know everything that can be known about it. Our hope looks for many things; it looks for everything. Rivers of pleasure, of pleasures forevermore, are flowing for us at God's right hand.

Paul wrote of *"the glory which shall be revealed in us"* (v. 18). He said that it is *"a far more exceeding and eternal weight of glory"* (2 Cor. 4:17). *Glory*—what a word! Glory is to be our ours, even though we are poor sinners. Grace is sweet but what must glory be? And this glory is to be revealed in us, around us, over us, and through us, for all eternity.

Paul also wrote of *"the glorious liberty of the children of God"* (Rom. 8:21). *Liberty* is such a delightful word! We love the idea of liberty, especially when we hear the sounds of freedom coming from the silver bugles of those who fight with tyrants. But what will it be like when the trumpets of heaven proclaim eternal freedom to every spiritual slave! There is no comparison between human and heavenly liberty, the liberty of the children of God. We will have the freedom to enter into the Holy of Holies, to dwell in God's presence, and to see His face forever and ever.

The apostle also spoke of *"the manifestation of the sons of God"* (v. 19). Here on earth, we are hidden away in Christ as gems

in a jewelry box. Later on, we are to be revealed as jewels in a crown. Christ was revealed to the Gentiles after He had been hidden for a while. In the same way, we who are presently unknown are to be revealed before men and angels. *"Then shall the righteous shine forth as the sun in the kingdom of their Father"* (Matt. 13:43). I cannot tell you what this manifestation will be like. *"Eye hath not seen, nor ear heard, neither have entered into the heart of man, the things which God hath prepared for them that love him"* (1 Cor. 2:9). And although *"God hath revealed them unto us by his Spirit"* (v. 10), our spirits have been able to receive only a small part of this revelation.

I suppose that only someone who has had the privilege of seeing the eternal home of those who have been perfected in Christ can tell us what it is like. And I imagine that even he could not do so, for language could not describe it. When Paul was in paradise, he heard words, but he did not tell us what they were, for he said that it was not lawful for a man to speak them. They were too divine for mortal tongues to speak.

Not yet, but later on, the object of our hope will be revealed to us. Do not think less of it because it will come in the future, for the interval of time is inconsequential. What are a few months or years? What if a few hundred years intervene before we are resurrected? They will quickly sweep by us, like the wing of a bird, and then! Oh, then! The invisible will be seen; the unutterable will be heard; eternal life will be ours forever and ever. This is our hope.

THE NATURE OF OUR HOPE

Now, this hope in which we are saved consists of three things: belief, desire, and expectancy.

Our hope of being completely delivered from sin in our spirits and of being rescued from all sickness in our bodies, arises out of a solemn assurance of our salvation. The revelation of Him who has brought life and immortality to light, bears witness to us that we also will obtain glory and immortality. We will be raised in the image of Christ and will share in His glory. This is our belief because we know that Christ has been raised and glorified and that we are one with Him.

We not only believe this, but fervently desire it. We desire it so much that, at times, we want to die so that we may enter into it.

All the time, but especially when we get a glimpse of Christ, our souls long to be with Him.

This desire is accompanied by confident expectation. We expect to see the glory of Christ and to share in it, as much as we expect to see tomorrow morning. Actually, we may not live to see the sun tomorrow morning, but we will certainly see the King in His beauty in the land that is very far away.

We believe it, we desire it, and we expect it. That is the nature of our hope. It is not an indefinite, hazy, groundless wish that things will turn out all right, such as when people say, "I hope things will go well for me," even though they live carelessly and do not seek God. Rather, it is a hope that is made up of accurate knowledge, firm belief, spiritual desire, and an expectancy that is fully warranted.

This hope is grounded on the Word of God. God has promised us complete salvation; therefore, we believe in it, desire it, and expect it. Jesus has said, *"He that believeth and is baptized shall be saved"* (Mark 16:16). The widest meaning that we can give to the word *saved* must be God's meaning for it, since His thoughts are always above our thoughts. We expect God to do what He has said, to the fullest extent of His promise, for He will never back off from His word or fail to keep His commitments. We have committed our souls to the care of the Savior, who has declared that He will save His people from their sins. We are trusting in our Redeemer.

> *For I know that my redeemer liveth, and that he shall stand at the latter day upon the earth: and though after my skin worms destroy this body, yet in my flesh shall I see God.*
>
> *(Job 19:25–26)*

Our bodies will be raised imperishable. The Word of God contains many more precious words to the same effect, and we hold onto them, certain that what God has promised He also is able to carry out. We will die without any doubt that we will rise again, even as we have already committed to the dust many of our loved ones in the firm and certain hope of their resurrection to eternal life. The farmer drops his seed into the ground and does not doubt that he will see it rise again. Similarly, we bury the bodies of believers and will eventually resign our own bodies to the grave in the certain expectation that they will live again as surely as they

have lived at all. This is a hope worth having, for it is grounded on the Word of God, the faithfulness of God, and His power to carry out His own promise. Therefore, we have a very sure and steadfast hope, and no one who has it will be put to shame.

This hope is stirred up within us by the Spirit of God. We would never have known this hope if the Holy Spirit had not awakened it in our hearts. Ungodly people have no such hope and never will have. It is only when people are renewed that this hope enters into them, since then the Holy Spirit dwells in them. And because of this, I rejoice with unspeakable joy. If my hope of perfection and immortality has been instilled in me by God, then it has to be fulfilled, for the Lord never would inspire a hope that would put His people to shame. The true God has never given mankind a false hope. That could never happen. The God of hope, who has taught you to expect salvation from sin and all its effects, will do for you according to the expectation that He Himself has inspired. Therefore, be very confident and patiently wait for the joyful Day when the Lord will appear.

This hope operates within us in a holy manner, as every gracious and holy thing that comes from God must do. It purifies us, as John said: *"And every man that hath this hope in him purifieth himself, even as he is pure"* (1 John 3:3). We are so certain of this inheritance that we prepare for it by putting off all things that are contrary to it and putting on all things that suit it. We try to live in the prospect of glory.

How often it has occurred to me (and, I imagine, to you) to say, regarding something, "How will this look in the Day of Judgment?" We have acted generously or consecrated ourselves, not because we cared anything about what people would think of it but because we looked at it in the light of the coming glory. Our greatest motivation is that a crown of life is reserved for us that will never fade.

This blessed hope makes us feel that it is shameful for us to sin, shameful that princes and princesses of the royal bloodline should play in the mire like children of the gutter. Instead, we willingly live as those who are destined to live forever in inexpressible light. We cannot walk in darkness, for we are to live in a splendor that makes the sun seem pale. We are to be immersed in the fellowship of the Trinity. Should we, therefore, be the slaves of Satan or the servants of sin? God forbid! This blessed hope draws us toward God and lifts us out of the pit of sin.

ANTICIPATING OUR HOPE

In reality, we have already received the greater salvation about which I have been writing. This occurred when we first understood and accepted the hope of eternal life. By faith, we have obtained the first part of salvation, which is forgiveness from sin and justification through Christ. And by faith, we also have fellowship with God and access into His countless blessings. Some of us are as conscious of this as we are of eating and drinking. But besides all this, through our hope, we have received the down payment of the fuller range of salvation, which is total deliverance from sin and the complete redemption of our bodies from pain and death. We have this salvation in hope, and we *"rejoice in hope of the glory of God"* (Rom. 5:2). Now, what does all this mean?

In our hope, we saw that salvation had been secured for us by the promise of grace. As soon as we believed in Christ, our faith secured forgiveness for us, and we exclaimed, "We are not yet free from our tendency to sin, but since we have believed in Christ for salvation, we will surely be perfected. He could not have come to give us a partial and imperfect salvation. He will perfect everything that concerns us." In hope, we saw within the promise of salvation much that we have not yet experienced. Knowing that the entire promise is equally certain, we expect the future mercy as surely as, in faith, we are enjoying the present blessing.

Moreover, in hope, we saw the promise of the full harvest in the firstfruits. Sin has been subdued by grace, but we expect to see it utterly exterminated. When the Holy Spirit came to dwell within us, our hope concluded that the body would be delivered as surely as the soul had been. The moment that faith introduced hope into the heart, hope said, "I have complete salvation—not in the sense that I am experiencing it now, but Christ Jesus holds it in trust for me."

As the priest in the Old Testament waved the sheaf of the firstfruits before the Lord as an acceptable sacrifice, we, in hope, offered the firstfruits of our faith to God and so took possession of the full harvest of salvation. When God gave you and me a love for Jesus and deliverance from the dominion of evil, these firstfruits signified a perfect salvation that has yet to be revealed in us. Our first joy in salvation was like a tuning of our harps for everlasting song. Our first peace was like the dawning light of a never-ending day. When we first saw Christ and worshiped Him, our adoration

was our initial bowing before the throne of God and of the Lamb. Therefore, in hope we were saved. Hope brought us the source of perfection, the pledge of immortality, the beginnings of glorification.

Moreover, in hope, we are so sure about this coming blessing that we consider it already obtained. Suppose you get a confirmation from a trader with whom you have conducted overseas business. He says, "I have procured the goods you have ordered and will send them by the next ship, which will probably arrive at such and such a time." Then another trader calls and asks you if you want to buy the same kind of goods, and you reply, "No, I already have them." Have you spoken the truth? Certainly, for although you do not have them in your warehouse, they have been invoiced to you. You know that they are on the way, and you are so used to trusting your foreign trader that you regard the goods as yours. The agreement has been made that makes them yours.

It is the same way with heaven, perfection, and immortality. The deed has been done that makes these the heritage of believers. We have confirmation from One whom we cannot doubt, our Lord Jesus, that He has gone to heaven to prepare a place for us and that He will come again and receive us to Himself (John 14:3). In hope, we are so sure of this fact that we consider it done. We may also draw practical conclusions from our hope.

A good old proverb tells us, "Never count your chickens before they are hatched." However, in this case, you may count the chickens just as accurately while the birds are in their eggs, as when they are hatched, for the apostle said, *"I reckon that the sufferings of this present time are not worthy to be compared with the glory which shall be revealed in us"* (Rom. 8:18). He was so sure of the hope of eternal life that he kept an account. He put down the sufferings of his life in his expenditure column and placed the glory that will be revealed among his assets. He declared that his assets were vast, but that his expenditures were so utterly insignificant that they were not worth noticing.

Moreover, the apostle Paul was so sure that he would receive his inheritance that he yearned for it intensely. We who are in this body groan for our full adoption as children of God (Rom. 8:23). Our groanings do not arise from doubt but from eagerness. Our confident anticipation causes us to have an intense desire to receive what we have been promised. It is useless to cry for what you will never have. The child who cries because he cannot have the

moon is foolish. But to groan for what I am certain to receive is proper and appropriate and shows the strength of my faith.

The apostle was so sure of receiving the hope of his salvation that he triumphed in it. He said that we are *"more than conquerors through him that loved us"* (Rom. 8:37). In other words, although we are not yet perfect, and although our bodies have not yet been delivered from pain, we are so sure of perfection and complete deliverance that we joyfully endure all things, triumphing over every difficulty.

Friend, you will not be poor much longer. You will live where the streets are paved with gold. Your head will not ache much longer, for it will wear a crown of glory and bliss. Do not allow shame or embarrassment to bother you, for people will not be able to laugh at you much longer. You will be at the right hand of God the Father, and the glory of Christ will clothe you forever. It is an infinite blessing that we have such a hope, and are so sure of it that we anticipate its joys before they actually come to us. Yes, we were saved in hope.

THE SPHERE OF OUR HOPE

The sphere of hope is *"things not seen"* (Heb. 11:1). As our Scripture text says, *"Hope that is seen is not hope: for what a man seeth, why doth he yet hope for?"* Therefore, a Christian's real possession is not what he sees. Suppose that God prospers him in this world and he has riches. Let him be grateful, but let him confess that these are not his treasure. One hour with the Lord Jesus Christ will bring more satisfaction to the believer than the largest amount of wealth. Although the believer may prosper in this world, he will ridicule the idea of making the world his inheritance. A thousand worlds, with all the joy that they could yield, are nothing compared with our promised inheritance. Our hope does not concern itself with insignificant things. It leaves the mice of the barn to the owls and soars on eagle's wings where nobler joys are waiting to be received.

Beyond, beyond this lower sky,
 Up where eternal ages roll;
Where solid pleasures never die,
 And fruits immortal feast the soul.

However, it is clear that at the present time we do not enjoy these glorious things for which we hope. The unbeliever exclaims, "Where is your hope?" and we confess that we do not see the objects of our hope. For instance, we cannot claim to be perfect already. Neither do we expect to be perfect while we are in this body. But we believe that we will be perfected in the image of Christ at the time appointed by the Father. By no means are our bodies free from sickness right now. Aches and pains and weariness remind us that our bodies are under the power of death because of sin. Yet our firm conviction is that we will wear the heavenly image, just as we now wear the earthly image.

These are subjects of hope and, therefore, they are beyond our present experience. Let us not be discouraged about this. Hope must have something to feed on. We cannot have all of heaven and yet remain on earth. My dear believer, if you feel tormented by sin within you and your holiness seems battered and spotted, you can be fully persuaded that He who has promised complete salvation is able to do it.

Do not judge yourself any longer by what you do, what you see, what you feel, or what you are. Rise into the sphere of the things that will be. When there is no joy in the present, you can know that there is infinite joy in the future. Do not say, "Oh, but that is a long way off." That is not true. Many who are reading this book may be sixty, seventy, or even eighty years old. Your time to be with Christ cannot be far away, for the thread of your lives is snapping. Some of us are middle-aged, but since we have already reached the average age of life, we have to acknowledge that our lease will soon run out also. And since so many people are snatched away in their prime, we may at any moment be caught up to the land for which we hope.

We should not worry about what we will do ten years from now, for it is very likely that by that time we will have entered into the promised rest. We will be serving the Lord day and night in His temple (Rev. 7:15) and will be gazing on His face with unspeakable joy. Even if some of us should be doomed to exile from heaven for another fifty years, the time will soon fly away.

Let us work to our utmost for the glory of God while we are still here on earth, for the moments slip away. Do you remember this time last year? It seems like it was only the other day. Boys and girls think that a year is a long time, but older folks have a different opinion. The years no longer seem long to us, now that we

are growing gray. For me, time travels so fast that its axles are hot with speed.

Fear exclaims, "Oh, for a little breathing room!" But Hope answers, "No, let the years fly away, for then we will be home all the sooner."

There is only a step between us and heaven. Let us not worry about things below. We are like people on an express train who see a disagreeable sight out the window; it is gone before they have time to think about it. And if they experience some discomfort along the way, if they have been put into a third-class compartment when they had a first-class ticket, they do not worry about it if it is a short journey. "Never mind," they say. "We have just passed the last station and will be in the terminal shortly."

Let us project ourselves into the future. We do not need much dynamite of imagination to send us there. We can leap that little distance by hope and seat ourselves among the thrones above. Resolve, at least for today, that you will not linger in a cloudy, earthbound frame of mind, but will mount to the bright, cloudless eternity. Oh, to leave these muddy streams and bathe in the river of hope, whose crystal waters flow from the pure fountain of divine joy.

THE EFFECT OF OUR HOPE

Now let us look at the effect of our hope, which our Scripture text describes in this way: *"We with patience wait for it."* We wait, and we must wait, but not like criminals awaiting their execution. We wait like a bride anticipating her wedding. We wait with patience, constancy, desire, and submission. The joy is sure to come; we have no doubt about it. Therefore, we do not complain and grumble, as if God had missed His appointment and had delayed us unnecessarily. No, the time that God has decided is the best, and we are content with it.

We neither desire to linger here nor to depart at any time but the Lord's appointed time. Rowland Hill, the English postal reformer, is said to have searched out an aged friend who was dying, so that he could send a message to his friends in heaven. He playfully added a word of hope that the Master had not forgotten old Rowland and would let him come home in due time. Yet he never dreamed that he could actually be left behind. Among the last expressions of

the famous John Donne was this: "I were miserable if I might not die." This would be a horrible world, indeed, if we were doomed to live in it forever. Imagine such a terrible reality.

I met a man some time ago who told me that he would never die, but would, at certain intervals, throw off the effects of age and start on a new phase of life. He kindly came to tell me how I could enjoy the same thing, but since I have no ambition for earthly immortality, such an offer did not tempt me. He told me I could renew my youth and become young again for hundreds of years, but I declined the gift at any price. I have no desire for anything of the sort. My most comfortable prospect about this life is that it will melt away into eternal life.

It seems to me that the most joyful thing about the most joyful life here on earth is that it leads upward to a different and better state. I am not unhappy or discontented, but since I have a good hope that my soul and body will be perfected, and a sure prospect of face-to-face fellowship with God, how can I speak well of anything that divides me from my joy?

Yes, eternal life will surely come; therefore, let us patiently wait for it. When Satan attacks us, when temptation threatens to overcome us, when affliction wears us down, when doubts torment us, let us stand firm and bear the temporary trial, for we will soon be out of range of gunshot. The consummation will come; it has to come, and when it comes we will no longer remember our suffering. We will be filled with joy that our heaven has been born to us and we to it.

Now, then, if you do not believe in God, tell me what your hope is. Make it known in the world and let everyone evaluate it. What is your hope? To live long? Yes, and then what? To bring up a family? Yes, and then what? To see your children comfortably settled in life? Yes, and then what? To be the grandparent of numerous grandchildren? Yes, and then what? To reach extreme old age in peaceful retirement? Yes, and then what? The curtain falls. Let me lift it. The cemetery. The throne of God. Your spirit is sentenced. The trumpet of the Resurrection sounds. Final doom. Body and spirit in hell forever.

Without Christ, you have no better prospect than that. I implore you to open your eyes and see what is to be seen. May the Lord have mercy on you and give you a better hope. As for you who believe in Christ, I urge you to begin today to sing the songs of eternal life. Ease your pilgrim life with songs of hope.

2

The Anchor of Your Soul

Wherein God, willing more abundantly to show unto the
heirs of promise the immutability of his counsel, confirmed it by
an oath: that by two immutable things, in which it was impossible
for God to lie, we might have a strong consolation, who have fled for
refuge to lay hold upon the hope set before us: which hope we have
as an anchor of the soul, both sure and stedfast, and which
entereth into that within the veil; whither the forerunner
is for us entered, even Jesus, made an high priest
for ever after the order of Melchisedec.
Hebrews 6:17–20

Faith is the divinely appointed way of receiving the blessings of grace. One of the main declarations of the Gospel is *"He that believeth…shall be saved"* (Mark 16:16). The wonders of creation, the disclosures of divine revelation, and the workings of providence are all intended to create and encourage the principle of faith in the living God. When God reveals anything, He wants us to believe it. It is true of all the books of Holy Scripture that *"these are written, that ye might believe…and that believing ye might have life"* (John 20:31).

If God conceals anything, He does so to cause us to trust in Him. What we already know leaves little room for trust. Conversely, we have to depend on Him for what we do not know. Providence sends us various trials and all of them are for the purpose of exercising and increasing our faith. At the same time, in answer to prayer, providence brings us a variety of proofs of the faithfulness of God, and these evidences serve to refresh our faith.

In this way, the works and the words of God cooperate to educate men in the grace of faith. You might presume, however, from

the doctrine of certain teachers, that the Gospel message is "Whosoever *doubts* will be saved," and that nothing could be more useful or honorable than for a person's mind to hang in perpetual suspense, for him to be sure of nothing, confident of the truth of no one, not even of God Himself.

The Bible gives a eulogy to the memory of its heroes, and it writes as their epitaph, *"These all died in faith"* (Heb. 11:13). However, the modern gospel ridicules faith and establishes the new virtue of keeping up with the very latest thought of the age. Simple trust in the truthfulness of God's Word, which our ancestors taught was the basis of all faith, seems to be at a discount now with so-called learned men and women who are able to handle "modern thinking."

It is shameful that some ministers who profess Christ are worshiping at this shrine and are working hard to gain the reputation of being intellectual and philosophical by scattering doubts everywhere. The doctrine of the "blessedness of doubt" is as opposed to the Gospel of Jesus Christ as darkness is to light or as Satan is to Christ Himself. It has been invented to quiet the consciences of proud men and women who refuse to yield their minds to God's rule.

Have faith in God, for faith is, in itself, a virtue of the highest order. No virtue is more truly excellent than simple confidence in the Eternal, which a person is enabled to exhibit by the grace of the Holy Spirit. And not only is faith a virtue in itself, it is the origin of all virtues. A person who believes God gains strength for work, patience for suffering, wholeheartedness for love, earnestness for obedience, and zealousness for service. Faith is the root from which all that can beautify the human character grows. Far from being opposed to good works, faith is the ever flowing fountain from which they proceed. Take faith away from a person who professes Christ, and you have cut off the source of his strength; as with Samson, you have cut his hair and left him with no power either to defend himself or to conquer his enemies.

"The just shall live by faith" (Rom. 1:17). Faith is essential to the vitality of Christianity, and anything that weakens faith weakens the chief source of spiritual power. My friend, not only does our own experience teach us this, and the Word of God declare it, but all of human history is an example of the same truth. Faith is force. Why, even when people have been mistaken, if they have believed the mistake, they have displayed more power than people who have

known the truth but have not wholeheartedly believed it. The influence that a person has in dealing with his fellowmen lies very much in the force of conviction that his beliefs have over his own soul.

If you teach a person the truth so that he believes it with his whole heart, then you have given him both the capability and the tools with which he may move the world. To this day, the whole earth trembles under the footsteps of Martin Luther. Why? He was strong in faith. Luther was a living believer. The academics with whom he had to contend were mere disputers, and the priests, cardinals, and popes with whom he came into contact were mere dealers in dead traditions; therefore, he struck down their ideas unsparingly and with great devastation. With his whole being, he believed in what he had learned from God. Revelation 2:27 says, *"He shall rule them with a rod of iron; as the vessels of a potter shall they be broken."* That was the way Martin Luther was. As an iron rod among potters' vessels, he smashed to pieces the pretenders of his age.

What has been true in history all along is most certainly true now. It is by believing that we become strong. That is clear enough. Whatever supposed excellence there may be in the much-prized qualities of being open-minded, having a cultured intellect, or maintaining the unsettled judgment of honest disbelief, I am unable to discern it. I see no reference to these things in Scripture.

The Bible does not praise unbelief nor present motives or reasons for cultivating it. Experience has not proved that unbelief gives strength for life's battles or wisdom for life's complexities. Unbelief is a close relative of gullibility. Unlike true faith, unbelief has a tendency toward being led by the nose by any falsehood. Unbelief yields no consolation for the present, and its outlook for the future is by no means comforting. We find no hint in the Bible of a sublime land in the clouds where people who praise their own intellectual ability will eternally baffle themselves and others. We read no prophecy in Scripture of a celestial hall of science where skeptics may weave new deceptions and forge new objections to the revelation of God. There is a place for the unbelieving, but it is not heaven.

Now, moving on to our text, in which no uncertainty is expressed, we see clearly that the Lord does not want us to be in an unsettled condition. He wants us to put an end to all uncertainty and questioning. According to the laws of men, a fact is established

when an honest man has sworn to it. In the same way, we read that *"God, willing more abundantly to show unto the heirs of promise the immutability of his counsel, confirmed it by an oath."*

Accommodating the weakness of human faith, He Himself swore by what He declared and therefore gave us a Gospel that was doubly certified by the promise and the oath of the everlasting God. Surely, angels must have wondered when God lifted His hand to swear to what He had promised, and they must have concluded that, from then on, there would be an end to all strife, because of the confirmation that the Lord gave to His covenant in this way.

As we explore the meaning of the Scripture text, I must direct you to its most conspicuous metaphor. This world is like a sea—restless, unstable, dangerous, never at a standstill. Human affairs may be compared to waves driven and tossed by the wind. As for us, we are the ships that go upon the sea and are subject to its changes and motions. We are likely to be carried off course by currents, driven by winds, and tossed by storms. We have not yet come to the true *terra firma,* the dry land, which, in our metaphor, means the eternal rest that will come to the people of God. God does not want us to be *"carried about with every wind of doctrine"* (Eph. 4:14), and therefore He has been pleased to weld an anchor of hope for us that is very sure and steadfast, so that we may outride the storm.

In this passage of Scripture, I am going to focus on the set of truths that is suggested by the image of an anchor. I pray that if you know the meaning of that anchor, you may feel it holding you securely by its grip. And if you have never possessed that anchor before, I pray that you will be enabled to cast it overboard for the first time and to feel, throughout the rest of your life, the strong comfort that such a safeguard is sure to give to your believing heart.

THE PURPOSE OF THE ANCHOR

The purpose of an anchor, of course, is to hold a ship firmly in one place when winds and currents would otherwise move it off course or into dangerous conditions. God has given us certain truths that are intended to hold our minds securely to truth, holiness, and perseverance—to put it simply, to hold us to Himself.

To Keep Us from Shipwreck

Why does a vessel need to be held securely? The most important reason is to keep it from being shipwrecked. The ship may not need an anchor in calm waters when, on a wide ocean, a little drifting may not be a very serious matter. But there are weather conditions in which an anchor becomes altogether essential. When a gale force wind is rushing toward the shore, blowing full strength, and the vessel cannot hold its course and is in danger of being driven against the rocky coast, then the anchor is worth its weight in gold. If the ship cannot be anchored, there will be nothing left of it in a very short time except a few pieces of debris. The ship will go to pieces and every seaman will be drowned. This is the time to let down the strongest anchor and let the ship defy the wind.

Our God does not intend for His people to be shipwrecked. However, we would be shipwrecked and lost if we could not be held fast in the hour of temptation. Beloved, if every wind of doctrine whirled you about at will, you would soon drift far away from the truth as it is in Jesus, and your faith would be shipwrecked. But you cost your Lord too much for Him to lose you. He bought you at too great a price and values you too much to see you broken to pieces on the rocks. Therefore, He has provided a glorious safeguard for you so that when Satan's temptations, your own sinful nature, and the trials of the world attack you, hope may be the anchor of your soul, both sure and steadfast.

How much we need this anchor! We see others fall into the error of the wicked, overcome by the deceitfulness of unrighteousness and abandoned forever as castaways, *"having no hope, and without God in the world"* (Eph. 2:12).

If you have been sailing on the great waters of life for any length of time, you must be well aware that if it were not for everlasting truths, which continue to hold you securely, your spirit would quickly have been thrown into everlasting darkness long ago, and the proud waters would have gone over your soul long before this. When the mighty waves rose, it must have seemed to you as if your poor boat had gone down to the bottom of the sea, and if it had not been for the unchanging love and immovable faithfulness of God, your heart would have utterly failed. Nevertheless, here you are today, accompanied by grace, provisioned by mercy, steered by heavenly wisdom, and propelled by the Spirit's power.

Thanks to the anchor, or rather to the God who gave it to you, no storm has overwhelmed you. Your ship is under way for the port of glory.

To Keep Us in Peace

An anchor is also needed to keep a vessel from distress, for even if it is not wrecked, it is a miserable thing to be driven here and there, to the north and then to the south, in whatever direction the winds may shift. Similarly, a person who is controlled by external influences is unhappy. He flies along like a feather in the breeze or rolls along the ground like something blown by a windstorm. We need an anchor to hold us so that we may remain peaceful and find rest for our souls. I praise God that there are solid and sure truths that have been infallibly certified to us. These truths operate powerfully on the mind in order to prevent it from being harassed and dismayed.

Our Scripture passage speaks of *"strong consolation."* Is that not a magnificent truth? We do not merely have a consolation that will hold us securely and bear us up against storms in times of trouble, but a *strong* consolation, so that when trouble bursts forth with unusual strength, like a furious tornado, the strong consolation, like a powerful anchor, may be more than a match for the forceful temptation and may enable us to triumph over all. The person who has a strong belief is very peaceful.

> Hallelujah! I believe!
> Now the giddy world stands fast,
> For my soul has found an anchor
> Till the night of storm is past.

To Keep Us from Losing Ground

An anchor is also needed to keep us from losing the headway that we have made. Suppose a ship is making good progress toward its intended port but then the wind changes and blows directly at it. The vessel is in danger of being carried back to the port from which it started or to an equally undesirable port, unless it can resist the turbulent wind; therefore, it puts down its anchor. The captain says to himself, "I have made it this far, and I am not going to be carried back. I am going to let down my anchor and stop here."

Believers are sometimes tempted to return to the country out of which they came, that is, to their old ways of living. They are half-inclined to renounce the things that they have learned and to conclude that they never have been taught by the Lord at all. Our old sinful nature grabs hold of us and pulls us back, and the Devil also endeavors to drive us back. If we did not have something secure to hold onto, we would go back.

Certain cultured teachers would have us believe that there is nothing very sure. They say that although black is black, it is not very black, and although white is white, it is not very white (and from certain standpoints, no doubt, black is white and white is black!). If it could be proved that there are no eternal realities, no divine certainties, no infallible truths, then we might willingly surrender what we know, or think we know, and wander about on the ocean of speculation as vagabonds of mere opinion. But while we have the truth, which has been taught to our own spirits by the Holy Spirit, we cannot drift from it. And we will never drift from it, even though people may consider us to be fools for our steadfastness.

Beloved, do not aspire to the kind of love and goodwill that grows out of uncertainty. There are saving truths, and there are *"damnable heresies"* (2 Pet. 2:1). Jesus Christ is not both yes and no at the same time. His Gospel is not a deceitful mixture of the honey of heaven and the bitterness of hell, flavored to suit the taste of either good or bad. There are fixed principles and revealed facts. Those who know anything about divine things from personal experience have cast their anchors down, and when they have heard the chains going down, they have joyfully said, "I know the truth and have believed it. In this truth I stand secure and immovable. The winds may blow fiercely, but they will never move me from this anchorage. Whatever I have attained by the teaching of the Spirit, I will hold onto tightly as long as I live."

To Keep Us Faithful and Useful

Moreover, the anchor is necessary so that we may be faithful and useful. The person who is easily moved and believes one thing today and another tomorrow, is fickle. Who knows where we will find him next? Of what use is he to young people or to those who are weak in faith or, indeed, to anyone else? Like a wave of the sea that is driven and tossed by the wind, what service can he give in

the work of the Lord, and how can he influence others for good? He himself does not believe; how can be make others believe? I think that the Christian who knows orthodox theology but who does not really believe is responsible for more unfaithfulness to God than a person who believes heresies. In other words, I am afraid that a person who earnestly believes an error has a less harmful influence on others than a person who holds the truth with indifference and with secret unbelief. The latter is tolerated in godly company, for he professes to be a believer and he is therefore able to cause harm within the body of Christ. You might say he stabs at piety beneath her shield. This person is not sure of anything; he only "hopes" and "trusts," and when defending truth, he concedes that there is much to be said on both sides, so that he kisses and stabs at the same time.

In summary, our God has provided us with an anchor to hold us securely so that we will not be shipwrecked, to keep us in peace, to prevent us from losing ground, and to enable us to remain faithful and useful. These purposes are the result of God's kindness and wisdom toward us. Let us bless the Lord who has so graciously cared for us.

THE SUBSTANCE OF THE ANCHOR

We must remember that making anchors is very important work. The anchorsmith has a very responsible job, for if he makes his anchor badly or of weak material, I pity the captain of the ship when a storm comes on! Anchors are not made of cast iron or of any kind of metal that happens to be handy. They are made of wrought iron, strongly welded, and of tough, compact material, which will bear all the strain that is likely to come upon them at the worst of times. If anything in this world should be strong, it should be an anchor, for safety and life often depend on it.

In the same way, we must consider what our spiritual anchor is made of. Our text reads, *"That by two immutable things, in which it was impossible for God to lie, we might have a strong consolation."* Our heavenly anchor has two great blades, made of two divine things, each of which acts as a holdfast. And in addition to being divine, they are expressly said to be *"immutable,"* that is, they cannot change.

Two Unchangeable Things

The first blade of the anchor is God's promise, which is a sure and stable thing indeed. We readily accept the promise of someone whom we know is an honest and reliable person. But he may forget to fulfill his promise or may be unable to do so. Neither of these things can occur with the Lord. He cannot forget, and He cannot fail to do as He has said. What a certain thing the promise of Jehovah must be! If you only had the Lord's Word to trust in, surely your faith would never stagger.

When the Lord utters a promise, He never goes back on it, for *"the gifts and calling of God are without repentance"* (Rom. 11:29). Has he said something that He does not intend to do? Has He promised something that will not hold true? He never changes, and His promise remains from generation to generation.

The second blade of the spiritual anchor is God's oath, which is the other unchangeable thing. How could it be altered? Beloved, I hardly dare to write about this sacred topic of God's oath, His solemn assertion, His swearing by Himself! Imagine the majesty, the awe, the certainty of this!

God has pledged the honor of His name, and it is inconceivable that, under such circumstances, He will retract His commitments and deny His own declarations. On the contrary,

> The Gospel bears my spirit up.
> A faithful and unchanging God
> Lays the foundation for my hope
> In oaths, and promises, and blood.

These, then, are two divine assurances, which, like the blades of the anchor, hold us securely. Who dares to doubt the promise of God? Who can have the audacity to distrust His oath?

Moreover, our Scripture passage says that it is impossible for God to lie about His promise and oath. *"In which it was impossible for God to lie."* It is inconsistent with the very idea of God that He should be a liar. A lying God would be a contradiction in terms, a self-evident incongruity. It is not possible. God must be true: true in His nature, true in His thoughts, true in His purposes, true in His actions, and certainly true in His promises and in His oath. *"In which it was impossible for God to lie."* Oh, beloved, what blessed

314

security we have in these things! If hope cannot rest on such assurances, what can it rest upon?

The Promise

Yet what are we really referring to when we talk about the promise and the oath? The promise is the promise given to Abraham that his seed would be blessed and that in this seed all nations of the earth would be blessed also. To whom was this promise made? Who are the seed? In the first place, the seed is Jesus, who blesses all nations. Next, the apostle Paul showed us in Romans 4:13–16 that this promise was not made to the seed according to the flesh but according to the Spirit. Who, then, are the seed of Abraham according to the Spirit? Why, they are believers, for Abraham is the father of the faithful, and God's promise, therefore, is confirmed to all who exhibit the faith of believing Abraham. To Christ Himself and to all who are in Christ, the covenant is made sure, so that the Lord will bless them forever and make them blessings.

The Oath

And what is the oath? It may refer to the oath that the Lord swore to Abraham after the Patriarch had offered up his son, which is recorded in Genesis 22:16–18. However, I think you will agree with me if I say that it more likely refers to the oath recorded in Psalm 110, which I want you to note very closely. *"The LORD hath sworn, and will not repent, Thou art a priest for ever after the order of Melchizedek"* (v. 4). I think this is what is referred to, because the twentieth verse of our text goes on to say, *"Whither the forerunner is for us entered, even Jesus, made an high priest for ever after the order of Melchisedec."*

Now, beloved, I want you to really grasp the meaning of this anchor. One of the strong blades of the anchor is that God has promised to bless the faithful. He has declared that the seed of Abraham, namely, believers, will be blessed and will be made a blessing. The other blade of the anchor is equally strong and able to hold the soul; it is the oath of the priesthood, by which the Lord Jesus is declared to be a Priest forever on our behalf. He is not an ordinary priest like Aaron was. He did not begin and end a temporary

priesthood. Instead, He is without *"beginning of days, nor end of life"* (Heb. 7:3). He lives on forever. Christ is a Priest who has finished His sacrificial work, who has gone in within the veil, and who sits forever at the right hand of God because His work is complete and His priesthood remains eternally sufficient. This is a blessed anchor for my soul: to know that my Priest is within the veil, my King of Righteousness and King of Peace is before the throne of God for me, representing me, and therefore I am forever secure in Him. What better anchor could the Comforter Himself devise for His people? What stronger comfort can the heirs of promise desire?

OUR HOLD ON THE ANCHOR

Notice also the hold that we ourselves have on the anchor. It would be of no use for us to have an anchor, however good it was, unless we had a firm hold on it. An anchor may be sure and may have a firm grip, but there must be a strong cable to connect the anchor with the ship. Formerly, it was very common for ships to use a fibrous cable, but large vessels are not content to run the risk of breakage. Therefore, they use a chain cable for the anchor. It is a wonderful thing to have a solid, substantial connection between your soul and your hope, to have a confidence that is truly your own, from which you can never be separated.

Our text speaks plainly about laying hold of the anchor: "[That] *we might have a strong consolation, who have fled for refuge to lay hold upon the hope set before us."* We must personally lay hold of the hope. The hope is available, but we are required to grasp it and hold it fast. With an anchor, the cable must pass through the ring in order to be bound to it. In the same way, faith must lay hold of the hope of eternal life. The meaning of the original Greek verb for *lay hold* implies, "to lay hold of our hope by strong force and to hold it in such a way that we will not lose our grip when a greater force tries to pull it from us." We must take firm hold of firm truth.

Beloved, some people have a cloudy hope, and they also seem to have a very doubtful way of laying hold of it. I suppose it is natural that it should be so. As for me, I desire to be taught something certain, and then I pray to be certain that I have learned it. Oh, to get the same kind of grip on truth as the old warrior had on his sword. After he had fought and conquered, he could not separate

his hand from his sword, for his hand stuck to his sword as if it were glued to it. It is a blessed thing to get hold of the doctrine of Christ in such a way that you would have to be dismembered before it could be taken from you, for it has grown into your very self. Be sure that you have a secure hold on your sure anchor.

"But," someone may ask, "may we really lay hold of it?" My answer is that the text says it is *"set before us"* so that we may *"lay hold upon the hope."* You may grasp it, for it is set before you. Suppose you were very weak and hungry. If you came to someone's house and your host said, "Sit down," and you sat down at the table, and then he set before you a good cut of meat, some very delicious fruit, and other tasty food, would you hesitate, wondering if you could eat them? No, you would conclude that you were free to do so because your host had set them in front of you.

This is just like the invitation of the Gospel. Your hope is set before you. For what purpose is it set there? So that you may turn your back on it? Of course not. Lay hold of it, for wherever we encounter truth, it is both our duty and our privilege to lay hold of it. All the authorization that a sinner needs for laying hold of Christ is found in the fact that God has set Him forth to be the sacrifice for our sins.

Imagine that you are on a ship in a storm and you see an anchor. Do you ask, "May I use this anchor?" No, it has been placed there for that very purpose. I guarantee you that there is not a ship captain alive who would not use an anchor during a severe storm. And he would not ask any questions about it. The anchor might not belong to the ship, it might happen to be on board as a piece of merchandise, but he would not care an atom about that. He would say, "The ship must be saved. Here is an anchor. I am going to throw it overboard." Act this way with the gracious hope that God provides for you in the Gospel of Jesus Christ: lay hold of it now and forever.

Furthermore, notice that our hold on the anchor should be a present thing and a conscious matter, for we read, *"Which hope we have."* We are conscious that we have it. No one has any right to be at peace if he does not know that he has obtained a good hope through grace. May you be able to say, "I have this hope."

Now, it is a good thing to have a cable made of the same metal as the anchor. Similarly, it is a blessed thing when our faith is of the same divine character as the truth upon which it lays hold. We need a God-given hope in order to seize the God-given promise of which our hope is made. The correct procedure is to grasp God's

promise with a God-inspired confidence. In this way, it is as if, right down from the vessel to the anchor, the holdfast is one piece, so that at every point it is equally adapted to bear the strain. Oh, that we may have precious faith in a precious Christ, precious confidence in His precious blood. May God grant it to you, and may you exercise it at this very moment.

THE ANCHOR'S HOLD ON US

A ship holds its anchor securely by its chain cable, but at the same time, the most important thing is that the anchor keeps its own hold on the ship. Because it has dug into the ground on the sea bottom, it holds the vessel hard and fast. Beloved, do you know anything about your hope holding you? It will hold you if it is a good hope; you will not be able to get away from it. Instead, when you are under temptation or when your spirit is depressed, when you are under trial and affliction, you will not only hold your hope, which is your duty, but your hope will hold you, which is your privilege.

When the Devil tempts you to say, "I give up," an unseen power will reply out of the infinite deeps, "But I will not give you up. I have a hold on you, and nothing will separate us." Beloved, our security depends far more on God holding onto us than on our holding onto Him. Our hope in God, that He will fulfill His promise and oath, has a mighty power over us, and it is far more than equal to all the efforts of the world, the flesh, and the Devil to drag us away.

How does our divine anchor hold so firmly? *"Which hope we have as an anchor of the soul, both sure and stedfast."* It is sure regarding its own nature. The Gospel is no cunningly devised fable. God has spoken it; it is a mass of facts; it is pure, unqualified truth, and the great seal of God Himself has been set upon it. Then, too, this anchor is steadfast; it never moves from where it is lodged. It is sure in its nature and steadfast when in use; therefore, it is safe for practical application. If you have believed in Christ for eternal life and are expecting God to be as good as His word, have you not found that your hope sustains you and maintains you in your position of faith?

Beloved, the result of using this anchor will be very comfortable to you. It will not prevent you from being tossed about, for a ship

that is at anchor may rock a good deal and the passengers may become very seasick, but it cannot be driven away from where it is anchored. Its passengers may suffer discomfort, but they will not suffer shipwreck. A good hope through grace will not deliver you from inward conflicts altogether. More than that, it will even involve them. It also will not screen you from outward trials; in fact, it will be sure to bring them. However, it will save you from all real peril.

The condition of every believer in Jesus is very similar to that of the landlubber on board ship who, when the sea was rather rough, asked, "Captain, we are in great danger, are we not?" He received no answer, and so he said, "Captain, don't you see great fear?" Then the old seaman gruffly replied, "Yes, I see plenty of fear, but not a bit of danger." It is often that way with us; when the winds are blowing and the storms are raging, there is plenty of fear, but there is no danger. We may be greatly tossed around, but we are quite safe, for we have an anchor of the soul that is both sure and steadfast and will not move.

THE ANCHOR'S UNSEEN GRIP

Best of all, there is the anchor's unseen grip, *"which entereth into that within the veil."* Our hope has such a grip on us that we are aware of it. It is like a boy with a kite. The kite is up in the clouds where he cannot see it, but he knows that it is there, for he feels it pull. When you are on a ship, you feel the pull of the anchor, and the more the wind rages, the more you feel the anchor holding you.

When a person can see an anchor, it is doing nothing, unless it happens to be a small anchor in shallow water. When an anchor is of use, it is gone from our sight. It has gone overboard with a splash. Far below, among the fish, lies the iron holdfast, quite out of sight.

We cannot see our spiritual anchor, and it would be of no use if we could see it. Our good hope has gone to heaven, and it is pulling and drawing us toward itself. Its use begins when it is out of sight, but it pulls, and we can feel the heavenly pressure.

Where is your hope? Do you believe because you can see? That is not believing at all. Do you believe because you can feel? That is feeling; it is not believing. But *"blessed are they that have not seen, and yet have believed"* (John 20:29). Blessed is he who believes

against his feelings, yes, and hopes against hope. It is a strange thing to hope against hope, to believe in things that are impossible, to see things that are invisible. He who can do that has learned the art of faith. Our hope is not seen; it lies in the waves, or as the text says, *"within the veil."* I am not going to run the analogy too closely, but a seaman might say that his anchor is within the watery veil, for a veil of water is between him and it, and therefore it is concealed. This is the confidence that we have in God, *"whom having not seen, [we] love"* (1 Pet. 1:8).

> Let the winds blow, and billows roll,
> Hope is the anchor of my soul.
> But can I by so slight a tie,
> An unseen hope, on God rely?
> Steadfast and sure, it cannot fail,
> It enters deep within the veil,
> It fastens on a land unknown,
> And moors me to my Father's throne.

Even though our anchor has gone out of sight, thank God that it has taken a very firm grip and *"entereth into that within the veil."* What hold can be equal to the one that a believer has on his God when he can exclaim, "You have promised. Therefore, do as You have said"?

No grasp is firmer than this: "Lord, You have sworn it, and You cannot go back on Your promise. You have said that he who believes in You is justified from all sin. Lord, I believe You. Therefore, be pleased to do as You have said. I know You cannot lie. You have sworn that Christ is a priest forever (Heb. 5:6), and I am resting in Him as my Priest who has made full atonement for me. I therefore hold You to Your oath. Accept me for the sake of Jesus' sacrifice. Can You reject a soul for whom Your own Son is pleading? He is able to save to the uttermost those who come to God by Him, because He continually lives to make intercession for them (Heb. 7:25). My Lord, this is the hold that I have upon You. This is the anchor that I have cast into the deep, mysterious attributes of Your marvelous nature. I believe You, and You will not make me ashamed of my hope."

What a hold you have on the living God when you rely on His promise and oath! Therefore, you hold Him as Jacob held the angel, and you will surely win the blessing at His hands.

Note, next, that when an anchor has a good grip on the seafloor, the more the ship pulls, the tighter the anchor's hold becomes. Imagine that when the anchor goes down, it drops onto a hard rock and cannot get a grip on anything. Later on, however, it slips off the rock, lands on the bottom of the sea, and digs into the soil. As the cable draws the anchor on, the blades go deeper and deeper until the anchor almost buries itself, and the more it is pulled on, the deeper it descends. Finally, the anchor gets such a hold that it seems to say, "Now, north wind, blow all you want! You must tear up the floor of the sea before I will let the ship go."

Times of trouble send our hope deep down into fundamental truths. You may never have known affliction. If you have always been wealthy, you have never experienced need. If you have been healthy all your life, you have never gone through a trying illness. If so, you do not have half the grip on the glorious hope that those who have been tried have. Much of the unbelief in the Christian church comes out of those who profess Christ but who have never had their faith put to the test. When you have to rough it, you need solid Gospel. A hardworking, hungry man cannot live on whipped cream. He must have something solid to nourish him. In the same way, a person who is being tried feels that he must have a Gospel that is true, and he must believe that it is true, or else his soul will starve.

Now, in our Scripture text, God swore an oath, and if God swears a promise, do we not have the most solid of assurances? The righteous owe their faithful and holy God, the Three in One, no less than the firmest imaginable faith. Therefore, when greater trouble comes, believe even more firmly, and when your ship is tossed in deeper waters, believe even more confidently. When your head is aching and your heart is pounding, when all earthly joy has fled, and when death comes near, believe even more. Grow even more and more confident that your Father cannot lie. Yes, *"let God be true, but every man a liar"* (Rom. 3:4). In this way, you will receive the strong comfort that the Lord intends for you to enjoy.

OUR MEDIATOR

The text concludes with this very precious reflection, that although our hope cannot be seen, we have a Friend in the unseen land where our hope has found its hold. In anxious moments, a

sailor might almost wish that he could go down to the bottom of the sea with his anchor and make sure that it is firmly secured. He cannot do that, but we have a Friend who has gone to take care of everything for us. Our anchor is within the veil; it is where we cannot see it. However, Jesus is there, and our hope is inseparably connected with His person and work.

We know for a fact that Jesus of Nazareth, after His death and burial, rose from the grave, and that forty days afterward, in the presence of His disciples, He went up into heaven. We know this as a historical fact. We also know that He rose into the heavens as the all-inclusive seed of Abraham, in whom all the faithful are found. Since He has gone there, we will surely follow, for He is the firstfruits of the full harvest.

OUR HIGH PRIEST

According to the text, our Lord Jesus has gone within the veil as our *"high priest."* Now, a high priest who has gone within the veil has gone into the place of acceptance on our behalf. A Melchizedek high priest is one who has boundless power to bless and to save completely. Jesus Christ has offered one blood sacrifice for sin, namely, Himself, and now He sits forever at the right hand of God the Father. Beloved, He reigns where our anchor has entered; we rest in Christ's finished work, His resurrection power, and His eternal kingship. How can we doubt this?

OUR FORERUNNER

We are informed next that Jesus has gone within the veil as a *"forerunner."* Why is He called a forerunner if others are not to enter in after Him? He has gone to lead the way. He is the pioneer, the leader of the great army, the firstfruits from the dead, and if He has gone to heaven as a forerunner, then we who belong to Him will follow after Him. That reflection should make our hearts joyful.

We are also told that, as a forerunner, our Lord has entered for us. That is, He has entered to take possession in our names. When Jesus went into heaven, it was as if He looked around at all the thrones and all the palms and all the harps and all the crowns and said, "I take possession of all these in the name of My redeemed.

I am their Representative and claim the heavenly places in their names." As surely as Jesus is in heaven as the possessor of all things, each one of us will also come to his inheritance in due time.

Our Lord Jesus is drawing us to heaven by His intercession. We only have to wait a little while and we will be with Him where He is. He pleads for our homecoming, and it will come to pass before long. No sailor wants his anchor to return to the ship before it is safe, for if it does so in a storm, matters look very ugly.

Our anchor will never return to us, but it is drawing us home; it is drawing us to itself, not downward beneath devouring waves but upward to ecstatic joys. Do you not feel it? You who are growing old, do you not feel it drawing you home? Many ties hold us here, but perhaps they are getting fewer with you. Perhaps your dear wife has passed away or your beloved husband is now gone. It may be that many of your children have passed away, too, as well as many of your friends. When this happens, it helps to draw us upward. If this is the case with you, I think that at this very moment, you must feel as if you were about to change from a ship that floats the waters to an eagle that can fly through the air. Perhaps you have often longed to mount up on wings while singing,

> Oh that we now might grasp our guide!
> Oh that the word were given!
> Come, Lord of Hosts, the waves divide,
> And land us all in heaven!

My cable has grown shorter lately. A great many of its links have vanished. I am nearer to my hope than when I first believed; every day, my hope nears fruition. Let our joy in this state of things become more exultant. Only a few more weeks or months or years and we will dwell above. There we will need no anchor to hold us fast. However, we will eternally bless God for graciously producing such a marvelous anchor for our unstable minds while we were tossed upon this sea of care.

Think about this. What will you do if you have no anchor? A storm is coming on. I see the threatening clouds, and I hear the strengthening winds of the distant hurricane. What will you do? May the Lord help you to flee for refuge immediately to the hope that is set before you in Christ Jesus.

3

Songs in the Night

God, even our own God, shall bless us.
God shall bless us.
—Psalm 67:6–7

What an extremely pleasant title: *"God, even our own God."* What loveliness and liveliness of heart must have been in the man who first applied that endearing name to the God of Jacob! Though it has been thousands of years since the sweet singer of Israel spoke of the Lord of Hosts in this way, the name has a freshness and even a novelty about it to believing ears. *"God, even our own God."* I cannot resist touching that string again, because the note is so enchanting to my soul! The words *own* and *our own* always seem to spread an atmosphere of delicious fragrance around anything with which they are connected. A poet wrote about one's own homeland in this way:

> Breathes there the man, with soul so dead,
> Who never to himself hath said,
> "This is my own, my native land"?

Whether it is a wasteland, a wilderness, or a vast plain, all men love their own fatherland, and when they are in exile, they are smitten with homesickness for their own country. It is the same way with regard to the houses in which we were raised. Your old homestead may have been in a poor neighborhood, but still it was your own home, and a thousand kindly thoughts gather around the fireside where you snuggled beneath a parent's arm when you were a child.

Why, all our relatives are dear to us by the fact that they are our own. *Father* is a silver word at all times, but *our father, our own father*—how the name grows richer and turns to a golden word! *Our own child, our own brother, our own husband, our own wife*—the words are extremely melodious. We even feel that the Bible is all the more dear to us in our own language. The Old Testament, as the Jews' book, coming from God in Hebrew, and the New Testament, as a book for the Greeks, coming to the Gentiles in the Greek tongue, were priceless treasures. However, translated into our own familiar language and, on the whole, translated so well, our own English versions are doubly dear to us. The sweetness of the words *our own* led me to call the hymnbook from which my congregation sings, "Our Own Hymn Book," hoping that perhaps the very name might help to weave their affections around it.

But what can I say of *"our own God"*? Words fail to express the depth of joy and delight that is contained within these three monosyllables, *"our own God."* He is our own by the eternal covenant in which He gave Himself to us, with all His attributes, with all that He is and has, to be our portion forever and ever. *"The LORD is my portion, saith my soul"* (Lam. 3:24). Also, He is *"our own God"* in the fact that we chose Him. We made this choice very freely, but we were guided by His eternal Spirit, so that while we would have chosen our own ruin, we were graciously led to choose the Lord because He had chosen us first.

He is *"our own God"*: ours to trust, ours to love, ours to run to in every dark and troublesome night, ours to commune with in every bright and sunny day, ours to be our guide in life. He is our help in death and our glory in immortality. He is *"our own God"* by providing us His wisdom to guide our path, His power to sustain our steps, His love to comfort our lives, His every attribute to enrich us with more than royal wealth. The person who can truthfully, out of a pure heart, look up to the throne of the infinite Jehovah and call Him, "my own God," has said a more eloquent thing than anything that ever flowed from the lips of the Greek orator, Demosthenes, or fell from the tongue of the Roman orator, Cicero. Those to whom *"our own God"* is a household phrase are favored beyond all other people.

> Our God! how pleasant is the sound!
> How charming to repeat!
> Well may those hearts with pleasure bound,
> Who thus their Lord can greet!

I think the psalmist used this expression in this sublime psalm as a kind of argument and assurance of the blessing that he foretold. *"God shall bless us"* is a true statement; it is to be believed. However, *"Our own God, shall bless us"* is a statement that brings conviction to the most timid. It wears assurance on its forehead; it is clothed with its own evidence. If the Lord has been gracious enough to make Himself our own God, He did not do this for nothing. There is a loving intention in it. Since in the tenderness of His compassion He has said, *"I will be their God, and they shall be my people"* (Ezek. 37:27), it must be with the purpose of blessing us with unspeakable blessings in Christ Jesus. Underneath the surface, there is a powerful meaning that we are urged to understand in this delightful title, and the more we think about it, the more we will see it.

The words *"God shall bless us"* have been sounding in my ears like far-off bells, ringing their way with a movement of music into the depths of my soul. May the same angelic melody captivate the ears of all of my fellow believers in Christ Jesus: *"God shall bless us....God shall bless us."*

To illustrate the truth that God will bless us, I will introduce you to three personified feelings and show you how they influence our trust in God.

FEAR

White-faced Fear can be found everywhere. She meddles with everything, intruding into the bedroom of Faith and disturbing the banquets of Hope. Fear stays with some people as if she were an ongoing guest and is entertained as though she were a dear, familiar friend.

What does Fear say to us in regard to our comforting Scripture text? Fear inquires, "Will God really bless us? Lately, He has withheld His hand. There have been many hopeful signs, but they have disappointed us. We have been expecting the blessing for a long time, we thought we had seen signs of it, but it has not come. We have heard of revivals and rumors of revivals; men have risen up who have preached the Word of God with power, and in some places there have been many conversions. But still, to a great extent, we have not received the blessing. God has not visited us as He did in the past.

"We have seen the clouds in the morning and have expected rain. We have noticed the dew and have hoped for moisture. But

these things have vanished, and we are still left without the blessing. A thousand disappointments in the past lead us to fear that the blessing may not come."

My answer is this: "Listen to this, Fear, and be comforted. What if you have been too hasty and rash and have misjudged the will of the Lord? Is that any reason why He should forget His promise and refuse to hear the voice of prayer? Take an example from nature. Clouds have passed over the sky every day for many weeks now, and I have very often said, 'It will certainly rain today, and the thirsty fields will be refreshed.' Yet not a drop has fallen, up to this point. Still, it has to rain before long.

"It is the same way with God's mercy. It may not come today, and tomorrow may not see it, but *'the Lord is not slack concerning his promise, as some men count slackness'* (2 Pet. 3:9). He has His own appointed time, and He will be punctual, for while He is never ahead of schedule, He is never behind it. In due season, in answer to the prayers of His people, He will give them a shower of blessings. All kinds of gracious blessings will descend from His right hand. He will tear open the heavens and come down in majesty, for *'God shall bless us.'*"

"Yes," Fear replies, "but we have seen so many counterfeits of the blessing. We have seen revivals in which intense excitement has, for a while, seemed to produce great results, but the excitement has subsided and the results have disappeared. Have we not heard the sound of trumpets and the loud boasting of men again and again, and has it not only been all pride and vanity?"

What Fear says is sorrowfully true. There is no doubt that much of revivalism has been a sham. There has been much nonsense, much hot air, in the Christian church, which has been terribly harmful. The very name of *revival* has been made to stink in some places because of the dishonor associated with it. But this is no reason why a glorious and real revival should not still come from the presence of the Lord, and this is what I earnestly hope for and vehemently pray for.

Remember the revival that swept through New England in the days of Jonathan Edwards? No one could call that spurious; it was as true and real as any work of God on the face of the earth could be. Nor could anyone describe the work of George Whitefield and John Wesley as only a temporary movement or something short-lived. God was revealing Himself and working grace in a marvelous manner. Moreover, the effects of this work of God still exist today

and will remain even to the coming of the Lord Jesus Christ. Therefore, we may expect that since He already has given them at other times, God will bless His people with real and substantial advances. He will come to the front lines of battle and make His enemies see that there is an irresistible power in the Gospel of Jesus Christ.

"So, Fear, you may remember the counterfeits of the past in order to learn from them. However, do not remember them as a reason for being discouraged and depressed, for *'God, even our own God, shall bless us.'*"

"Yet," Fear replies, "see how much there is in the present that is unlike the blessing and that, instead of prophesying good, indicates evil! Only a few are proclaiming the Gospel boldly and simply. On the other hand, there are many who oppose the Gospel with their philosophies or their superstitions."

"But listen, Fear; *'God shall bless us,'* even though there may be only a few of us. God's salvation does not depend on many or few. Numbers do not matter. Remember how His servant Gideon went up to fight against the Midianites, not with thousands, for that was too many for the Lord of Hosts, but with the few hundred men who lapped the water instead of getting down on their knees to drink? And even these men did not use any weapons except broken pitchers, torches, and trumpets. Gideon defeated the multitudes of Midian with only these few things.

"Do not say that Omnipotence is short of instruments to do His will. He could make the very sand of the seashore into preachers of the Gospel if He wanted to. And if He needed tongues to tell about His love, He could make each stone a preacher or each leaf on the trees a witness for Jesus. It is not instrumentality that is necessary and of first importance. What we need most is the power that moves the instrumentality, which makes the weakest strong and without which even the strongest are weak."

I heard it said the other day that the religion of Jesus Christ cannot be expected to prosper in some places unless it has a fair start. And that remark came from someone who is supposed to be a church leader! A fair start, indeed! When you put Christianity into any arena, the only thing it asks is for the freedom to be able to use its spiritual weapons. And even where that is denied, it still triumphs. If Christianity develops its own innate strength and is left alone by the kings and princes of this world, it will work its own way.

Now, I just said that the Gospel needs to be left alone. However, let governments oppose it if they want to. Our faith will still overcome the opposition. Let them withdraw their patronage, that deadly thing that paralyzes all spiritual life, and the liberated truth of God will surely prevail. We do not tremble, then. We must not. The servants of God may be poor, they may not be gifted, they may be only a few in number. Yet God, even our own God, *will* bless us. It does not matter if we are as few in number as the twelve apostles or if we are as uneducated as they were. They made old Rome's empire shake from end to end and brought colossal systems of idolatry down to the ground. The Christianity of today will do the same, if God returns to it in power, if in the midst of its weakness, He valiantly fights and causes the armies of the Enemy to retreat.

But Fear always finds room for complaining. Therefore, she says, "The future, the black and gloomy future! What can we expect from this wicked generation, this perverse people, except that we will be allowed once more to be devoured by the spirit of antichrist or to be lost in the mists of unbelief? "

According to Fear, our prospects are truly appalling. However, I confess, not using her telescope, I discern no such signs of the times. Yet Fear says so, and there may be something to it. But even if this is so, it is counterbalanced in our minds by the belief that God, even our own God, will bless us. Why should He change? He has helped His church in the past. Why not now? Is she undeserving? She has always been so. Has she backslidden? She has done so many times before, yet He has visited her and restored her. Why not now? Instead of gloomy predictions and fears, it seems to me that there is reason for the brightest expectations. But we must fall back on the divine promise and believe that God, even our own God, will bless us in our generation as He used to do in former days.

Remember the ship that was tossed by the storm on the Galilean lake? There was certainly a dreary outlook for that boat. Before long, the ship would have been driven against the rocky shore and would have sunk beneath the waves. But this was not the case, for walking on the waves, which hardened to glass beneath His feet, was the Man who loved the group of men on that boat, and He would not allow them to die. It was Jesus, walking on the waves of the sea. He came into the vessel, and immediately the calm was as profound as if no wave had risen against the boat and no wind had blown.

329

In the same way, in the darkest times of the church's history, Jesus has, in due time, always appeared walking on the waves of her troubles, and then her rest has been glorious. Let us not, therefore, be afraid. Instead, throwing fear aside, let us rejoice with the most joyful expectation. What can there be to fear? *"God is with us"* (Isa. 8:10). Is that phrase not the battle cry before which demons flee and all the hosts of evil turn their backs? *"Emmanuel... God with us"* (Matt. 1:23). Who dares to stand against that? Who will defy the Lion of the tribe of Judah? They can bring their might and their spears, but if God is for us, who can be against us? Or if any are against us, how can they stand? God is our own God. Will He let His own church be trampled in the mire? Will the bride of Christ be led into captivity? Will His beloved, whom He bought with blood, be delivered into the hands of her enemies? God forbid! Because He is God, because He is for us, because He is our own God, we set up our banners and each of us cheerfully sings:

> For yet I know I shall Him praise,
> Who graciously to me
> The health is of my countenance,
> Yea, mine own God is He.

DESIRE

Now I am going to change the song altogether by introducing a second character, Desire.

Energetic, bright-eyed, and warmhearted, Desire says, "Yes, God will bless us, but if only we had the blessing now! We hunger and thirst for it. We covet it as a miser covets gold. But what kind of blessing will come, and in what way will our own God bless us?"

My answer is this: "When God comes to bless His people, He brings *all* grace with Him, for in the treasures of the covenant there are not only some things, but all things; not a few supplies for some of the church's needs, but an overflowing supply from which all her needs will be replenished. When the Lord blesses His church, He will give the grace of revival to all her members. They will begin to live in a higher, nobler, happier way than they have done before."

One of the highest gifts the Holy Spirit gives is to stir up the church and make her members active. This is greatly needed; I believe it is lacking among Christians today. I know certain Christians

who are among the most earnest believers outside of heaven. Yet other believers are a very long way off from that and need to be brought into a more healthy spiritual state. Many churches are too much like the foolish virgins in Matthew 25 who slept because the bridegroom did not come right away. There is too much apathy, too little love for God, too little consecration to His cause, too little grieving and longing for the souls of men. When the Lord visits His church, the first result will be the renewal of the life of His own beloved. Then the blessing will come again as people outside of the church are converted and as they are added to her membership.

I hope we will never think that God is blessing us unless we see sinners saved. Ministers are seriously deluded when they think they are prospering and yet do not see any conversions. I trust that I will be very uneasy if the number of conversions declines in my church. If God returns to His church, we will hear, to our right and to our left, "What must we do to be saved?" The astonished church will see such a multitude of children born to her that she will exclaim in amazement, *"Who hath begotten me these?"* (Isa. 49:21), and, *"Who are these that fly as a cloud, and as the doves to their windows?"* (Isa. 60:8). When these two blessings come—an awakened church and souls converted—then the Word of the Lord will be fulfilled, *"The LORD will give strength unto his people; the LORD will bless his people with peace"* (Ps. 29:11).

The church will be strong; she will have the ability to refute her adversaries by pointing to her converts. She will become bold because she will see the results of her work. She will cease to doubt, for faith will be replenished with evidence. Then peace will reign. The young converts will bring in a flood of new joy; their fresh blood will make the old blood of the church leap in its veins, and old and young, rejoicing together, will delight in the abundance of peace. If you are a member of such a church, may the blessing continue and increase, and may all churches receive a blessing from the God of Israel that will make them rejoice with unspeakable joy.

Now, in spite of this, Desire says, "I see what the blessing is, but to what extent will God give it and to what degree may we expect it?"

My answer is, "God will give to you according to the amount of your confidence in Him."

We are satisfied all too soon when the blessing begins to come down from above. We stop like Joash, the king of Israel, when we

have shot only one or two arrows, and we deserve to be rebuked in the language of Elisha the prophet: *"Thou shouldest have smitten five or six times; then hadst thou smitten Syria till thou hadst consumed it"* (2 Kings 13:19). We are content with drops when we can have the cup full to the brim. We are childishly satisfied with a mere jar of water when we can have barrels and rivers and oceans, if only we have faith enough to receive them. If half a dozen people were converted in each of our churches this Sunday, we would be jubilant with thanksgiving, but should we not be sorry if there are not six hundred?

Who are we that, by our narrow expectations, we limit the Holy One of Israel? Can we draw a line around Omnipotence and say, "You may go up to this point, but no further"? Is it not wiser to extend our desires and expand our hopes, since we are dealing with One who knows no limits or boundaries? Why not look for years of plenty that will eclipse the famous seven years of plenty in Egypt during Joseph's day? Why not expect clusters of grapes that will surpass those that the Israelites found in the Promised Land? Why are we so stingy, so stunted, so narrow in our imaginations?

Let us grasp at greater things, for it is reasonable, with the Lord to trust in, to look for greater things. I picture days in which every sermon I preach will shake the building with its power, in which unbelievers will be converted to God by the thousands, as in the Day of Pentecost. Is Pentecost to be the greatest trophy of God's power? Is the first sheaf to be greater than the harvest? How can that be? We believe that if God will visit His church again, and I trust He is going to do so, we will see nations born in a day. The Gospel of Jesus Christ, which has painfully limped along like a wounded deer, will suddenly take wing like a mighty angel and fly throughout heaven proclaiming that Jesus Christ is both Lord and God. Why not? Who can justify the absence of the strongest hope, since He is able to do exceedingly abundantly above what we ask or even think (Eph. 3:20)?

I can hear Desire say, "Yes, I understand what the blessing is and that it can be had in any measure, but how is it to be obtained, and when will it come?"

Follow along with me in a very brief review of the psalm that is our text, because that will help us to answer the question, "When is it that *'God, even our own God, shall bless us'*?" Psalm 67 begins with *"God be merciful unto us"* (v. 1). That prayer is the voice of a repentant people confessing their past wrongs. God will bless His

church when she acknowledges her faults and humbles herself; when with a repentance in keeping with the Gospel, she stands before the mercy seat and cries out, *"God be merciful unto us."*

We must never expect the Lord to bless a proud and conceited church, a hard-hearted and indifferent church. When a church is humbled to the dust under a sense of its own shortcomings, then God will be pleased to look on it in mercy. I gather, from the context of the first verse, that God blesses His people when they begin to pray, as well as when they confess their sins. The prayer is urgent, humble, and believing; therefore, it has to speed to the throne of God. *"God be merciful unto us, and bless us; and cause his face to shine upon us"* (Ps. 67:1). These agonizing desires will be part of the mourning of a church that is conscious of having lost the blessing somewhat and that is ill at ease until it is restored. We are sure to receive the blessing from God when the entire church is interceding with urgency and persistence.

Prayer is the best resort of an earnest people. I can testify to this. In my church, we have had prayer meetings in which everyone has been stirred, much as the trees of the forest are moved in the wind, and afterward the presence of God has always been manifested by the conversion of souls. Our best times of prayer have always been followed by joyful harvests of new believers. Churches everywhere must be prayerful, intensely so, or else they cannot expect that the sound of abundant rain will be heard throughout their land. I call on the church to awake to confess her sin, to awake to struggle in prayer for the souls of men. Then the Lord God will visit us from on high. Come, Holy Spirit, and rouse Your slumbering people. Stir up the lazy multitude of believers, for when Your power is felt, then the bright day of triumph has dawned upon us.

As the psalm progresses, it speaks of praise more than it does of prayer. *"Let the people praise thee, O God; let all the people praise thee....Then shall the earth yield her increase"* (vv. 3, 6). The church needs to improve with regard to praising God. When we receive mercy, if we accept it silently and without gratitude, we cannot expect to have more. But when every drop of favor makes us bless the Lord who gives to such undeserving ones, we will soon have more and more and more.

Praise ought to be universal: *"Let all the people praise thee."* It ought to be joyful and hearty. Each believer should rejoice in the practice of praise and put all his strength into it. When will we all

wake up to this? When will all the Lord's elect magnify His glorious name as they should? When will we sing at our work, sing in our households, sing the praises of God everywhere? When prayer and praise are sacredly blended and the church becomes thoroughly eager to receive the divine blessing, then God, even our God, will bless us.

I believe that when a great visitation of mercy is coming upon the church, there are certain signs that are given to more spiritual believers, which assure them that it is coming. Elijah could hear *"a sound of abundance of rain"* (1 Kings 18:41) before a single drop had fallen, and many devout believers of God have had the conviction that a time of refreshing was coming, long before it came. Some people are especially sensitive to works of God, just as some people's bodies are especially sensitive to changes of weather before they arrive. As Columbus was sure that he was coming to land because he saw strange land birds and pieces of floating seaweed and broken wood, often a Christian minister feels sure that he is drawing near to a time of amazing blessing. He can scarcely tell others why he feels so sure, yet to him the indications are totally sufficient.

It is as if doves come flying into our hands to tell us that the waters of indifference and worldliness are receding. They bring us olive branches, signifying that grace will surely flourish among our people, and this lets us know that the time when God is going to favor the church is indeed coming. Have you never seen the ancient prophet rise and take his harp down from the wall, begin to tune it, put every string in order, lay his fingers on the unaccustomed strings, and start to sweep the strings with unusual energy and delight? Have you never asked him, "Old harper, minstrel consecrated to the Lord, why do you strike your harp with a song that is so cheerful?" And has he not replied, "Because I see, at a great distance, the silken banners of a triumphant host returning victorious from the fight. It is the church, made more than a conqueror through Him who loves her. I hear the moving of the wings of angels; they are rejoicing over people who are repentant, and the church is glad, for her glory has returned, seeing that her sons are many." Believers who are enlightened with the light of heaven feel the shadow of the coming mercy and hear the far-off wheels of the chariot of mercy.

These signs, of course, will only be perceptible by a few, but there are other signs that may be discerned by many believers. For

example, it is a very certain sign that the Lord will bless His people when they experience an unusual and insatiable craving for a divine visitation, when they feel as if the church could not go on any longer as she is now doing, when they begin to fret and pant and sigh and hunger and thirst for something better.

I pray to God that all Christians will be gloriously dissatisfied without more conversions. And when this dissatisfaction arises in the hearts of Christians, it is generally a sure indication that God is enlarging the hearts of His people so that they may receive a larger blessing. Then these prepared believers will experience sacred yearnings of intense excitement, pangs of holy purpose, mysterious longings to which they were strangers before. These will be transformed into impulses that they will be unable to resist. People who formerly could not speak about the Lord will suddenly be able to. Others who were never considered masters of intercession will become mighty in prayer. There will be tears in eyes that have been dry for a long time. We will find believers who formerly kept in the background and were never before zealous now talking to sinners and winning converts. These stirrings of God's hand, these sacred and mysterious motions of His ever blessed Spirit, are signs that He intends to bless His church to a large degree. And, beloved, when everyone begins to search within himself to see whether there is any obstacle to the blessing, when every single member of the church exposes his heart to allow God to search him and exclaims, "Take away from me everything that hinders Your work, equip me for greater usefulness, put me where You will gain glory through me, for I am consecrated to You," then we will hear the sound like *a going in the tops of the mulberry trees* (2 Sam. 5:24), as King David did. Then we will see the flowers spring up, and we will know that the time of the singing of birds is drawing near and that spring and summer are close at hand.

May God send us more and more of these gracious signs! I think I see them even now. Perhaps my wish is father to my thought, but I think I see sufficient signs that God intends to visit His church, even now. But we must believe it, we must accept it, and we must work in accordance with this expectation by praying and praising and working and striving in unity. If we do, rest assured that the year in which this occurs will be noted for such an amazing display of divine power that it will be an *annus mirabilis,* a remarkable year, a year of our Lord, a year of grace, a year whose days will be as the days of heaven on earth.

HOPE

Lastly, I introduce you to a far more beautiful being than either of the other two: the sweet, bright-eyed maiden, Hope. Have you never heard the story of her matchless song? In her youth, she learned a song that she sings continually to the accompaniment of a well-tuned harp. Here are the words of her enchanting ballad: *"God shall bless us. God shall bless us."* She has often been heard singing this in the night, and the stars have suddenly shone in the black sky. *"God shall bless us."* She has been known to sing this in the midst of storms, and the soothing song has been followed by calm seas.

Once upon a time, certain strong laborers were sent out by a great king to level an ancient forest—to plow it, to sow it, and to bring the harvest to him. These laborers were brave and strong and willing enough for work, and they certainly needed all their strength, and more. One stalwart laborer was named Industry. His brother, Patience, with muscles of steel, went with him and did not tire in the longest days, under the heaviest labors. To help them, they had Zeal, clothed with enthusiastic and indomitable energy. Side by side worked Zeal's relative, Self-denial, and his friend, Persistence. They all went out to their labor, and they took their beloved sister Hope with them to encourage them in their toils. It was a good thing that they did, for the forest trees were huge and needed many sturdy blows of the ax before they would fall to the ground. One by one, they yielded, but the labor was immense and incessant.

At night, when they went to their rest, the day's work always seemed so light, for as they crossed the threshold, Patience, wiping the sweat from his brow, would be encouraged, and Self-denial would be strengthened, for they heard a sweet voice within sing, *"God, even our own God, shall bless us. God shall bless us."* They cut down the giant trees to the music of that song; they cleared the acres one by one; they tore the huge roots from the ground; they plowed the soil; they sowed the corn; then they waited for the harvest. They were often very discouraged, but they were held to their task by silver chains and golden shackles. They were held by the sweet sound of the voice that chanted so constantly, *"God, even our own God, shall bless us."* They could never refrain from service, for Hope could never refrain from song. They were ashamed to be discouraged, they were alarmed to be despairing, for the voice rang

out clearly and continually, morning and evening, *"God, even our own God, shall bless us. God shall bless us."*

You know the meaning of this parable; you recognize that voice. May you hear it in your soul today! We are few, too few for this great work, but God will bless us, and therefore we are enough. We are weak and have only a little knowledge; we have little experience and slender wisdom. Yet God will bless us, and we will be wise enough and strong enough. We are undeserving, full of sin, fickle, and frail; but God will bless us, and our unworthiness will be a contrast in which to set the precious diamond of His mercy. God *will* bless us—there are glorious promises that guarantee the blessing. The promises must be kept, for they are *"yea"* and *"Amen"* (2 Cor. 1:20) in Christ Jesus.

The nations must bow down before the Messiah. Ethiopia must stretch out her arms to receive her King. God will bless us. He has blessed His people. Let Egypt tell how God overthrew the enemies of His Israel. Let Canaan witness how He struck down and killed kings and overthrew mighty kings and gave their land for a heritage, a heritage for His people. God will bless us. He has given us His Son; *"how shall he not with him also freely give us all things?"* (Rom. 8:32). He has given us His Holy Spirit to remain with us forever. How can He deny us any help that we need or any essential blessing?

Our text is a song for each Christian man and woman engaged in holy work. It is a song for all the diligent teachers of Sunday school classes. If you have seen no good come out of your work and are growing somewhat discouraged, here is a psalm to raise your sinking spirits: *"God shall bless us."* Continue on and teach the Gospel to the youngsters with redoubled zeal. This is a refreshing note for the minister who has been plowing a thankless soil and has not yet seen any harvest. *"God shall bless us."* Do not cease from your energetic labors. Go back to your work, for you have such a blessing still to come that you may well rejoice even in the prospect of its coming.

Let each worker go forth to that form of Christian service to which his Master has appointed him, hearing this bird of paradise singing beautifully in his ears, *"God shall bless us."* Like David's harp playing before Saul, it drives away despair. Like the silver trumpets of the priests, it proclaims a jubilee. Oh, if only, like the rams' horns of Israel, it may level Jericho!

I want this song, *"God shall bless us,"* to stir you and move you and make you dash along like a mighty host of warriors. God is with us. He will bless us. Why do you lack enthusiasm? Why are you growing weary? Why are you looking to a human arm for strength? Why do you fear your enemies? Why are you lazy? Why are you going to bed to sleep? God will bless us. Get up, you soldiers, and snatch the victory! Farmers, gather in the harvest! Sailors, hoist your sails, for the favorable winds are coming! God *will* bless us. Oh, that fire from the altar would touch our lips (Isa. 6:5–7)! And what can be a better instrument with which to carry the flaming coal than the golden tongs of the text, *"God shall bless us"*?

Let me give you one word of warning. Suppose the Lord should bless "us" Christians, in the plural, and not "you," in the singular? What if there are showers of mercy and they do not drop on you? What if He should grant a sign for good upon His people but you are left out? It may happen, for it has happened in the past. And if this dreary possibility becomes a reality for you, it will make you worse instead of better, for as in the story of Gideon, there is nothing as dry as the fleece that remains unmoistened when the floor is wet. There are none as lost as those who are lost while others are saved.

Be alarmed, because this could be your situation! Yet this does not need to be the case. *"Seek ye the* Lord *while he may be found, call ye upon him while he is near"* (Isa. 55:6). He has abundant pardons to give, and He will give them freely to all who ask. All He requires of you is that you trust His Son. Ask the Holy Spirit to give you faith. Trust Him! Rest upon the merit of His precious blood, and you will not be left out when He dispenses His favors. Instead, you will sing as cheerfully as all the rest, *"God, even our own God, shall bless us. God shall bless us."*

4

The Gift of Memory

This I recall to my mind, therefore have I hope.
—Lamentations 3:21

Memory is very often the servant of hopelessness. Despairing minds think about every dark prediction from the past and every gloomy aspect of the present. Memory stands like a servant, clothed in sackcloth, presenting to his master a cup of mingled wormwood and gall (Jer. 9:15). Like the mythical Roman god, Mercury, who was a messenger, he hurries, with wings on his heels, to gather fresh thorns with which to fill the pillows on which we are already sleeping uneasily and to bind fresh twigs with which to whip our already bleeding hearts.

There is, however, no need for this. Wisdom will transform memory into an angel of comfort. The same memory that may in its left hand bring so many dark and gloomy signs can be trained to carry a wealth of hopeful signs in its right hand. It does not need to wear a crown of iron; it may wear a band of gold, decorated with stars. In John Bunyan's allegorical book, *The Pilgrim's Progress,* when Christian was locked up in Doubting Castle, memory formed the club with which the famous giant beat his captives so terribly. They remembered how they had left the right road, how they had been warned not to do so, and how, in rebellion against their better natures, they had wandered into By-path Meadow. They remembered all their past misdeeds, their sins, their evil thoughts and evil words, and all these were like knots of wood in the club, causing sad bruises and wounds in their poor suffering bodies.

However, one night, the same memory that had whipped them, helped to set them free, for it whispered something in Christian's

ear. He then cried out as one half-amazed, "What a fool I am to lie in a stinking dungeon when I can walk in freedom! I have a key in my inside coat pocket, called Promise. It will, I am persuaded, open any lock in Doubting Castle." So he put his hand into his coat pocket and, with much joy, pulled out the key and thrust it into the lock. And though the lock of the great iron gate, as Bunyan put it, "went damnable hard," the key did open it and all the others, too. And so, by this blessed act of memory, poor Christian and Hopeful were set free.

Note that our text records an act of memory on the part of Jeremiah. In Lamentations 3:20, the prophet told us that memory had brought him to despair. *"My soul hath them still in remembrance, and is humbled in me."* And then, in our text, he told us that this same memory brought him life and comfort again: *"This I recall to my mind, therefore have I hope."* We may establish, then, as a general principle, that if we would exercise our memories a little more, we could, in our very deepest and darkest distresses, strike a match that would instantaneously light the lantern of comfort. God does not need to create a new thing in order to restore believers to joy. If they would prayerfully rake the ashes of the past, they would find light for the present, and if they would turn to the Book of Truth and the throne of grace, their flame would shine as before. I will apply this general principle to the situations of three kinds of Christians.

THE BELIEVER WHO IS IN DEEP TROUBLE

The first is the believer who is in deep trouble. This is not an unusual circumstance for an heir of glory. A Christian is seldom at ease for very long. The believer in Jesus Christ inherits the kingdom through much tribulation. In the third chapter of Lamentations, you will observe a list of matters that memory brought before the mind of Jeremiah, and which gave him comfort. First is the fact that however deep our present affliction is, it is by the Lord's mercy that we are not consumed (v. 22). This is a low beginning, certainly. The comfort is not very great, but when a very weak man is at the bottom of a pyramid, you must not give him a steep step at first, if he is ever going to climb it. Give him only a small stone to step on the first time, and when he gets more strength, then he will be able to take a greater stride.

Therefore, consider where you might have been. Look down through the gloomy entranceway of the grave to that realm of darkness that is like the valley of the shadow of death, full of confusion and without any kind of order. Can you discern a sound like a rushing back and forth of multitudes of guilty and tormented spirits? Do you hear their grievous crying and their frightening gnashing of teeth? Can your ears stand to hear the clanking of their chains? Can your eyes stand to see the fury of the flames? They are forever, forever, forever shut out from the presence of God and shut in with demons and despair! They lie in flames of misery so terrible that the dream of a despairing maniac cannot imagine their anguish. God has cast them away and pronounced His curse on them, appointing them to blackness of darkness forever. This might have been your fate. Contrast your present position with theirs, and you have reason to sing rather than to mourn. Why should a living man complain (Lam. 3:39)?

Have you ever seen those loathsome dungeons in Venice that are below the watermark of the canal? After winding through narrow, dark, stifling passages, you may creep into little cells in which a person can scarcely stand up straight, where no ray of sunlight has ever entered since the foundations of the palace were laid. They are cold, filthy, and black with dampness and mildew, the breeding ground of fever, the place of death. And yet those places would be a luxury to live in compared to the everlasting burning of hell. It would be an extraordinary luxury to lost spirits to lie there in lonely misery with moss growing on their eyelids, if they could only escape for a little while from a guilty conscience and the wrath of God. Friend, you are neither in those dungeons nor in hell; therefore, gather up courage, and say, as Jeremiah did in the third chapter of Lamentations, *"It is of the LORD's mercies that we are not consumed, because his compassions fail not"* (v. 22).

This may be small comfort to you. But then, if this small flame yields only a little heat, it may lead to something better. When you light a fire in your fireplace, before which you hope to sit down in warmth and comfort, you do not first expect to light the logs. You use kindling wood, and soon the more solid material gives off a pleasant glow. In the same way, this thought, which may seem so light and small, may be like the kindling of a heavenly fire of comfort for you who now are shivering in your grief.

Something better awaits us, for Jeremiah reminds us that there are some mercies, at any rate, that still continue. *"His compassions*

fail not. They are new every morning: great is thy faithfulness" (Lam. 3:22–23). You may have been reduced in wealth, and you may be very poor. This is very difficult, yet be thankful if you are still in good health. Just walk into the hospital and look at the work being done there. Sit down by one patient and listen to his story of pain and weariness, and surely you will leave the hospital thinking, "I thank God that with all my poverty I do not have sickness to complain of, and therefore I will sing of the mercies that I do enjoy."

Are you sick and are you dragging your weary body around? Then I invite you to accompany me to the dark and miserable ghettos, where people languish in poverty in the heart of our cities, in wretched obscurity, and no one pities them. If you notice their hard-earned meals, too meager to yield sufficient nourishment, and the miserable dwellings that are their only rest, you will escape from the foul den of filthy poverty and say, "I will bear my sickness, for even that is better than filth, starvation, and nakedness." Your situation may be distressing, but there are others in still worse conditions. If you open your eyes and choose to do so, you can always see at least this reason for thankfulness: you have not yet been plunged into the lowest depth of misery.

There is a very touching story of a poor woman with two children who did not have a bed for them to lie on and scarcely any clothes to cover them. In the depth of winter, they were nearly frozen, and the mother took the door of a cellar off its hinges and set it up in front of the corner where they crouched down to sleep, so that some of the draft and cold might be kept from them. One of the children whispered to her when she complained of how badly off they were, "Mother, what do those little children do who have no cellar door to put up in front of them?" Even there, you see the little heart found a reason for thankfulness, and we, if we are driven to our worst extremity, will still honor God by thanking Him that His compassions do not fail but are new every morning. This, again, is not a very high step, but still it is a little farther up than the other, and the weakest may readily reach it.

Lamentations 3 offers us a third source of consolation. *"The LORD is my portion, saith my soul; therefore will I hope in him"* (v. 24). You have lost much, but you have not lost your portion. Your God is your all; therefore, if you have lost everything except God, you still have your all left, since God is all. The text does not say that God is only part of our portion, but the whole portion of our spirits. All the riches of our hearts are concentrated in Him. How

can we be sorrowful, since our Father lives? How can we be robbed, since our treasure is in heaven? Imagine that it is daylight, the sun is shining bright, and I am holding a lighted candle. Someone blows it out. Should I sit down and cry because my candle has been extinguished? No, not while the sun shines. God is my portion, and if I lose some little earthly comfort, I will not complain, for heavenly comfort remains.

One of the English kings, who was haughty and proud, had a quarrel with the citizens of London. He wanted to alarm the bold citizens with a terrible threat that would intimidate them. He said that if they were not careful, he would remove his court from Westminster, a borough of London. At this, the valiant Lord Mayor begged to inquire whether His Majesty meant to take away the Thames River, for as long as the river remained, His Majesty might take himself wherever he pleased.

In the same way, the world warns us, "You cannot hold out. You cannot rejoice. This trouble will come and that adversity will happen." We reply, "As long as you cannot take our Lord away, we will not complain." "Philosophers," said the wise man, "can dance without music." And true believers in God can rejoice when outward comforts fail them. The person who drinks out of the bottle, like Ishmael, the son of the slave woman, may have to complain of thirst. (See Genesis 21:9–15.) However, he who dwells at the well, like Isaac, the child of promise, will never experience need. May God grant us grace, then, to rejoice in our deepest distress, because the Lord is our sure possession, our perpetual heritage of joy. We have now advanced to some degree of hope, but there are other steps to ascend.

The prophet then reminds us of another channel of comfort, that God is always good to all who seek Him. *"The LORD is good unto them that wait for him, to the soul that seeketh him"* (Lam. 3:25). He may strike us harder than He ever has before, but if we can maintain the heavenly state of prayer, we may rest assured that He will turn from blows to kisses yet. When a beggar who is very needy sees another beggar at the door of some great man, he will watch while the other beggar knocks, and if the door is opened and the man is generously received and helped, he will knock with boldness also.

Are you very sad and depressed? The Lord is good to those who seek Him. Thousands have come from His door, but none have had any reason to complain of being given a cold reception, for in

every case, He has filled the hungry with good things. Therefore, go boldly and knock, for He gives liberally and does not find fault.

Prayer is an available resource for all kinds of dilemmas or difficulties. In *The Pilgrim's Progress,* when the City of Mansoul was besieged, it was in the depth of winter and the roads were very bad, but even then prayer could travel on them. I will venture to affirm that if all earthly roads were so bad that they could not be traveled, and if Mansoul were completely surrounded so that there was not a gap left through which we could break our way to get to the king, the road upward would always be open. No enemy can barricade that; no blockading ships can sail between our souls and the haven of the mercy seat. The ship of prayer can sail through all temptations, doubts, and fears, straight up to the throne of God, and while she may have left the port with only griefs and groans and sighs, she will return loaded with a wealth of blessings. You have hope, then, for you can always pray.

> The mercy seat is open still;
> Here let our souls retreat.

We are getting into deeper waters of joy, so let us take another step, and this time we will gain even greater comfort from the fact that it is good to be afflicted. Lamentations 3 tells us, *"It is good for a man that he bear the yoke in his youth"* (v. 27). A little child needs to be coaxed to take his medicine. He may be very sick and his mother may assure him that the medicine will cure him, but the child says, "No, it is too bitter. I cannot swallow it." Adults do not need to be persuaded in this way. The bitterness of medicine is nothing to them. They think of the health that it will bring, and so they drink it and do not even wince. Now, we may cry and murmur if we are little children and have not called to remembrance the fruit that affliction bears. But if we are adults in Christ Jesus, and have learned that *"all things work together for good to them that love God"* (Rom. 8:28), we will take the cup very cheerfully and willingly, and we will bless God for it.

Why should I dread to descend the mine shaft of affliction if it leads me to the gold mine of spiritual experience? Why should I cry out when the sun of my prosperity goes down, if in the darkness of my adversity I will be better able to count the starry promises with which my faithful God has been pleased to gem the sky? Go away, sun, for in your absence we will see ten thousand suns, and when

your blinding light is gone, we will see worlds in the dark that were hidden from us by your light. Many a promise is written in invisible ink, which you cannot read until the fire of trouble brings out the letters. *"It is good for me that I have been afflicted; that I might learn thy statutes"* (Ps. 119:71). Beloved, Israel went into Egypt poor, but came out with jewels of silver and gold. The Israelites had worked, it is true, at the brick furnaces, and had suffered bitter bondage, but they were bettered by it. They came out enriched by all their tribulations.

A child had a little garden in which she planted many flowers, but they never grew. She put them in tenderly and carefully, but they would not live. Then she sowed seeds; they sprang up, but very soon they withered away. So she ran to get her father's gardener, and when he came to look at it, he said, "I will make a nice garden for you, so that you may grow whatever you want." He brought a pick, and when the little child saw the terrible pick, she was afraid for her little garden. The gardener struck his tool into the ground and began to make the earth move and shake, for his pickax had caught the edge of a huge stone that underlay almost all of the little plot of ground. All the little flowers were dug up, and the garden was ruined for a while, so that the little girl cried quite a lot. He told her he would make it a beautiful garden yet, and so he did, for having removed the stone that had prevented all the plants from taking root, he soon filled the ground with flowers that lived and flourished. In much the same way, the Lord has come and has turned over all the soil of your present comfort to get rid of some big stone that was at the bottom of all your spiritual prosperity and would not let your soul flourish. Do not weep as the child did, but be comforted by the blessed results, and thank your Father's tender hand.

One more step, and surely then we will have good ground to rejoice. The third chapter of Lamentations reminds us that these troubles do not last forever. When they have produced their proper result, they will be removed, for *"the Lord will not cast off for ever"* (v. 31).

Who told you that the night would never end in day? Who told you that the sea would recede until all that was left was a vast track of mud and sand? Who told you that the winter would proceed from frost to frost, from snow, ice, and hail to deeper snow and still more heavy storms? Who told you this? Do you not know that day follows night, that the rains come after the waters recede,

that spring and summer come after winter? Then, hope! Always have hope, for God does not fail you. Do you not know that your God loves you in the midst of all this?

When mountains are hidden in the darkness of night, they are as real as they are in daylight, and God's love is as true to you now as it was in your brightest moments. No father continually disciplines. God hates the rod as much as you do. He only desires to use it for the reason that should make you willing to receive it, that it brings about your lasting good. You will yet climb Jacob's ladder with the angels and see Him who sits at the top of it—your covenant God. You will yet, amid the splendors of eternity, forget the trials of time or only remember them to bless the God who led you through them and brought about your lasting good by them. Come, sing in the night (Job 35:10). Rejoice in the midst of the flames. Make the desert blossom like the rose (Isa. 35:1). Cause the desert to resound with your exuberant joy, for these light afflictions will soon be over, and then, forever with the Lord, your bliss will never diminish!

Therefore, dear friend, memory may be, as the English poet Coleridge called it, the "bosom-spring of joy," and when the Holy Spirit bends it to His service, it may be chief among earthly comforters.

THOSE WHO THINK THEY HAVE LOST SALVATION

Next, I will apply the principle of memory to the believer who thinks he has lost his salvation. It is my habit, in my ministry, to avoid extremes as much as possible and to keep to the narrow path of truth. I believe in both the doctrine of predestination and the doctrine of free will, and I follow the narrow path between those mountains. It is the same way with all other truths. I know some who think that doubts are not sins. I regret their thinking. I know others who believe that doubts are impossible where there is any faith. I cannot agree with them. I have heard of people ridiculing that very precious and admirable hymn that begins, "'Tis a point I long to know." I do not dare to ridicule it myself, for I have often had to sing it. I wish it were not so, but I am compelled to confess that doubts have troubled me. The true position, with regard to the doubts and fears of believers, is this: these things are sinful and are not to be cultivated but are to be avoided. However, most Christians,

to a greater or lesser extent, do suffer them, and they are not proof that a person is destitute of faith, for the very best of Christians have been subject to them.

If you are struggling with anxious thoughts, let me urge you to call to mind, in the first place, matters of the past. Perhaps you should pause and let your heart speak to you. Do you remember the place, the spot of ground, where Jesus first met with you? Perhaps you do not. Well, do you remember happy times when He has brought you to His banqueting house? Can you remember times when He has graciously delivered you? As it says in the Psalms, *"I was brought low, and he helped me"* (Ps. 116:6), and, *"Thou hast been my help"* (Ps. 63:7). When you were in those circumstances in the past, you thought you were in overwhelming trouble. You have since passed through them. Can you find no comfort in them now?

Years ago, the sea was usually so stormy at the southern tip of Africa that when the frail sailing ships of the Portuguese went sailing south, they named it the Cape of Storms. However, after the cape had been well navigated by bolder sailors, they named it the Cape of Good Hope. In your experience, you have had many a Cape of Storms, but you have weathered them all, and now, let them be a Cape of Good Hope to you. Remember, *"Thou hast been my help, therefore in the shadow of thy wings will I rejoice"* (v. 7). Say with the psalmist, *"Why art thou cast down, O my soul? and why art thou disquieted in me? hope thou in God: for I shall yet praise him"* (Ps. 42:5).

I remember some hills like Mizar (v. 6), on which my soul has had such sweet fellowship with God that I thought I was in heaven. I remember moments of awful agony in my soul when, in an instant, my spirit leaped to the uppermost heights of ecstasy at the mention of my Savior's name. There have been times at the Lord's Table, in private prayer, and in listening to His Word, when I could say,

> My willing soul would stay
> In such a frame as this,
> And sit and sing herself away,
> To everlasting bliss.

Let me remember all these things and have hope, for,

> Did Jesus once upon me shine,
> Then Jesus is for ever mine.

God never loves and afterward hates. His will never changes. It is not possible that He who said, *"I have graven thee upon the palms of my hands"* (Isa. 49:16), should ever forget or cast away those who once were dear to Him.

Possibly, however, that may not be comforting to you. I urge you to recall the fact that others have found the Lord true to them. They cried to God, and He delivered them. Perhaps one of them was your mother. Perhaps she is now in heaven, and you are toiling and struggling onward here below. Do you not remember what she told you before she died? She said that God had been faithful and true to her. She had been left a widow when you were only a child, and she told you how God had provided for her, and for you, and the rest of your little needy family, in answer to her pleadings. Do you believe your mother's testimony? Will you not rest, with your mother's faith, upon your mother's God?

There are older Christians who could testify to you that after fifty or sixty years in which they have walked before the Lord in the land of the living, they cannot put their finger on any date and say, "Here God was unfaithful," or, "Here He left me in my time of trouble." I am young, but I have gone through many tribulations that were painful to some degree, and I can say—and must say it, for if I do not speak, the rocks might cry out against my ungrateful silence—He is a faithful God and He remembers His servants. He does not leave them in their times of trouble. Can you also say, in the words of our text, *"This I recall to my mind, therefore have I hope"*?

Remember, and perhaps this may be a comfort to you, that although you think you are not a child of God at all now, if you look within, you will see some faint traces of the Holy Spirit's hand. The complete picture of Christ is not there, but can you not see the pencil drawing, the outline, the charcoal sketch? "What do you mean?" you ask. Do you want to be a Christian? Do you have any desire for God? Can you say with the psalmist, *"My heart and my flesh crieth out for the living God"* (Ps. 84:2)? Oh, I have had to console myself with this when I could not see a single Christian grace beaming in my spirit. I have had to say, "I know I never will be satisfied until I get to be like my Lord." *"One thing I know, that, whereas I was blind, now I see"* (John 9:25)—see enough, at least, to know my own defects and emptiness and misery. I have just enough spiritual life to feel that I want more and that I cannot be satisfied unless I have more. Well, now, where God the Holy Spirit

has done as much as that, He will do more. Where He begins the good work, we are told that He will carry it on and perfect it in the Day of our Lord Jesus Christ (Phil. 1:6). Call that to mind and you may have hope.

I want you to know that there is a promise in the Bible that exactly describes and suits your situation, but you must search your Bible and pray in order to discover it. There is a story that illustrates this well. A young man had been left heir to all of his father's property, but an adversary disputed his right. The case was to come to court, and while this young man felt sure that he had a legitimate right to everything, he could not prove it. His legal advisor told him that more evidence was needed than he could bring. He did not know how to get this evidence. The young man went to an old chest where his father used to keep his papers. He emptied everything out, and as he turned the writings over and over and over, he discovered an old parchment. He undid the red tape with great anxiety, and there it was, the very thing he wanted, his father's will, in which the estate was spoken of as being left entirely to him. He went into court boldly enough with that.

Now, when we get doubts, it is a good thing to turn to the Old Book and read it until at last we can say, "That is it—that promise was made for me." Perhaps it is this one: *"When the poor and needy seek water, and there is none, and their tongue faileth for thirst, I the LORD will hear them, I the God of Israel will not forsake them"* (Isa. 41:17). Or perhaps it is, *"Whosoever will, let him take the water of life freely"* (Rev. 22:17). I beg you to rummage through the Old Book. And you—poor, doubting, despairing Christian—will soon stumble on some precious parchment, as it were, that God the Holy Spirit will make for you the title deed of immortality and life.

If these memories are not sufficient for you, I have one more. I am not going to tell you something new, but still it is the best thing that was ever said out of heaven: *"Christ Jesus came into the world to save sinners"* (1 Tim. 1:15). You have heard that a thousand times, and it is the best music you have ever heard. If I am not a saint, I am a sinner, and if I may not go to the throne of grace as a child, I will go as a sinner.

A certain king was accustomed, on set occasions, to entertaining all the beggars of the city. Around him sat his royal guests,

dressed in rich apparel. The beggars sat at the same table in their rags of poverty. Now, it happened that, on a certain day, one of the regular royal guests had ruined his silken clothing so that he did not dare to put it on. He felt, "I cannot go to the king's feast today, for my robe is filthy." He sat weeping until the thought struck him, "Tomorrow, when the king holds his feast, some will come as courtiers, happily clothed in their beautiful finery, but others will come and be made quite as welcome and they will be dressed in rags. Well," he said, "as long as I may see the king's face and sit at the king's table, I will enter among the beggars." So without mourning because he had lost his silken clothing, he put on the rags of a beggar, and he saw the king's face as well as if he had worn his scarlet and fine linen clothing. My soul has done this a great many times, and I ask you to do the same. If you cannot come as a saint, come as a sinner; only do come, and you will receive joy and peace.

In a deplorable accident that occurred in the north of England in one of the coal pits, when a considerable number of the miners were down below, the top of the pit fell in, and the shaft was completely blocked up. Those who were down below sat together in the dark and sang and prayed. They gathered in a spot where the last remains of air could be breathed. There they sat and sang after the lights had gone out because the air would not support a flame. They were in total darkness, but one of them said he had heard that there was a connection between that pit and an old pit that had been worked years ago. He said it was a low passage, which a man might get through by lying flat on the ground and crawling all the way. The passage was very long, but they crept through it. At last they came out to light at the bottom of the other pit, and their lives were saved.

If my present way to Christ as a saint gets blocked up, if I cannot go straight up the shaft and see the light of my Father farther up, there is an old method, the old-fashioned way by which sinners go, by which poor thieves go, by which prostitutes go. I will crawl along humbly, flat on the ground. I will crawl along until I see my Father and exclaim, "Father, I am not worthy to be called your son. Make me like one of your hired servants, if I may only live in your house." In your worst situation, you can still come as a sinner. *"Christ Jesus came into the world to save sinners"* (1 Tim. 1:15). Call this to mind, and you may have hope.

THOSE SEEKING GOD

Perhaps you are seeking God and are greatly troubled with the fear that you cannot be saved. I will give you some general truths that may give you hope.

First of all, some of you are troubled about the doctrine of election. I believe it and receive it with joy, and you may rest assured that it is true, no matter how much it troubles you. Though you may not like it, it is true. Remember that it is not a matter of opinion as to what you like or do not like, as to what you think or do not think. You must turn to the Bible, and if you find it there, you must believe it. Pay close attention to what I have to say about this. You have got the idea that some people will be sent to hell, simply because it is the will of God that they should be sent there. Throw the idea overboard because it is a very wicked one and cannot be found in Scripture.

Why, it would be a hell inside a man's conscience if he knew that he was condemned merely because God willed that he should be. Yet this could never be the case, for the very essence of hell is sin, and a sense of having willfully committed it. There could not be any flames of hell if there were not this conviction in the minds of the people suffering them: "I knew my duty, but I did not do it. I willfully sinned against God and I am here, not because of anything He did or did not do, but because of my own sin." Therefore, if you drive away the dark thought that God sends people to hell indiscriminately, you may be on the road to comfort.

Also, remember that whatever the doctrine of election may be or may not be, the Gospel gives a free invitation to needy sinners. *"Whosoever will, let him take the water of life freely"* (Rev. 22:17). Now, you may say, "I cannot reconcile the two." There are a great many other things that you cannot do. God knows where these two things meet, even though you do not, and I hope you do not intend to wait until you are a philosopher before you will be saved. If you do, it is likely that while you are trying to be wise by persistently remaining a virtual fool, you will find yourself in hell, where your wisdom will not do you any good.

God commands you to trust Christ and promises that all believers will be saved. Leave your difficulties until you have trusted Christ, and then you will have a capacity to understand them better than you do now. In order to understand gospel doctrine, you

must believe in Christ first. What does Christ say? *"No man cometh unto the Father, but by me"* (John 14:6). Election is the Father's work. The Father chooses sinners; Christ makes the atonement. Therefore, you must go to Christ, the Atoning Sacrifice, before you can understand the Father, the God of election. Do not persist in going to the Father first. Go to the Son as He tells you to.

Also, even if your own idea of the doctrine of election were the truth, you would have nothing to lose by seeking the Lord.

> I can but perish if I go,
> I am resolved to try;
> For if I stay away I know,
> I must for ever die.

> But if I die with mercy sought,
> When I the King have tried,
> That were to die, delightful thought,
> As sinner never died.

Trust Christ, even if you should perish, and you will never perish if you trust in Him.

Well, if that difficulty is removed, I can imagine someone else saying, "Yes, but mine is a case of great sin." Recall this to mind and you will have hope: *"Christ Jesus came into the world to save sinners; of whom,"* Paul said, *"I am chief"* (1 Tim. 1:15). Paul was the chief of sinners, and he went through the door of mercy. There can be none greater than the chief. Where the chief went through, you also can go through. If the chief of sinners has been saved, why not you? Why *not* you?

I heard of a woman who would not cross the Salt-Ash Bridge in Plymouth, England, after it was constructed. She said she did not believe it was safe. She saw trains go over it, so that the bridge sustained hundreds of tons at a time, but she shook her head and said that she wondered how people were so immensely presumptuous as to cross it. When the bridge was totally clear and not a train was on it, she was asked if she would walk on it then. Well, she did venture a little way, but she trembled the whole time, for fear that her weight would make it fall. It could bear hundreds of tons, but she thought that it could not sustain her! It is much the same case with you. The stupendous bridge that Christ has flung across the wrath of God will bear the weight of your great sin, for it has already sustained ten

thousand who have made it across and will bear millions of sinners yet to the shore of their eternal rest. Remember that, and you may have hope.

"But," I hear someone saying, "I believe I have committed the unpardonable sin." My dear friend, I do not believe that you have. I want you to remember one thing. The unpardonable sin is a sin that is unto death. A sin that is unto death means one that brings death on the conscience. The man who commits it never has any conscience afterward; he is dead at that point. Now, you have some feeling; you have enough life to wish to be saved from sin; you have enough life to long to be washed in the precious blood of Jesus. You have not committed the unpardonable sin; therefore, have hope. The Bible says, *"All manner of sin and blasphemy shall be forgiven unto men"* (Matt. 12:31).

But you reply, "Oh, I cannot repent; my heart is so hard." Remember that Jesus Christ has been exalted to give repentance and forgiveness of sins, and you may come to Him to *receive* repentance. You do not need to bring it to Him. Come without any repentance, and ask Him to give it to you. He will give it. There is no doubt whatsoever that if the soul seeks softness and tenderness, it has that softness and tenderness to some degree even now and will have it to the fullest extent before long.

"Oh," you say, "but I have a general unfitness and incapacity for being saved." Then, dear friend, I want you to remember that Jesus Christ has a general fitness and a general capacity for saving sinners. I do not know what you need, but I do know that Christ has it. I do not know the full extent of your disease, but I know that Christ is the Great Physician who can meet it. I do not know how hard and stubborn and dull and ignorant and blind and dead your nature may be, but I do know that "[Christ] *is able also to save them to the uttermost that come unto God by him"* (Heb. 7:25). What you are has nothing to do with the question, except that it is the damage to be undone. The true answer to the question of how you are to be saved lies in the bleeding body of the pure Lamb of God. Christ has all salvation in Himself. He is Alpha; He is Omega. He does not begin to save and leave you to perish, nor does He offer to complete what you must first begin. He is the foundation as well as the pinnacle. He begins with you as the green blade, and He will finish with you as the full ear of corn.

Oh, I wish I had a voice like the trumpet of God that will wake the dead at the Last Day! If I might only have it to utter

one sentence, it would be this one: "Your help is found in Christ." As for you, nothing hopeful can be found in your human nature. It is death itself; it is rottenness and corruption. Turn, turn your eyes away from this despairing mass of black depravity, and look to Christ. He is the sacrifice for human guilt. His is the righteousness that covers sinners and makes them acceptable before the Lord. Look to Him as you are: black, foul, guilty, leprous, condemned. Go as you are. Trust Jesus Christ to save you, and as you remember this, you will have a hope that *"maketh not ashamed"* (Rom. 5:5), which will endure forever.

I have tried to give you words of comfort and words in season, and I have tried to express them in plain language, too. But, O Comforter, what can we do without You? You must remove our sadness. To comfort souls is God's own work. Let me conclude this chapter, then, with the words of the Savior's promise: *"And I will pray the Father, and he shall give you another Comforter, that he may abide with you for ever"* (John 14:16). And let our prayer be that He would remain with us to His own glory and to our everlasting comfort.

5

When All Looks Hopeless

Then Jesus answered...Bring him hither to me.
—Matthew 17:17

When our Lord Jesus Christ was on earth, His kingdom was so extensive that it touched the confines of both heaven and hell. We see Him at one moment discoursing with Moses and Elijah in His glory, as though He were at the gates of heaven, and then, in a few hours, we see Him confronting an evil spirit, as though He were defying the infernal pit.

It is a long journey from patriarchs to demons, from prophets to devils. Yet mercy prompts Him and power supports Him, so that He is equally glorious in either place. What a glorious Lord He was, even while He was in His humiliation. How glorious He is now! How far His goodness reaches. Truly, He has dominion from sea to sea. His empire reaches to the extremes of human condition. Our Lord and Master hears with joy the shout of a believer who has vanquished his enemy, and at the same hour, He inclines His ear to the despairing wail of a sinner who has given up all confidence in self and desires to be saved by Him. At one moment He is accepting the crown that the warrior brings Him from the well-fought fight, and at another moment He is healing the brokenhearted and binding up their wounds.

There is a notable difference between the scene of the triumphant believer who is dying and entering into his rest and the first weeping repentance of a Saul of Tarsus who is seeking mercy from the Savior whom he has persecuted. Yet the Lord's heart and eyes are with both. Our Lord's transfiguration did not disqualify Him from casting out demons, nor did it make Him feel too sublime and

spiritual to grapple with human ills. Therefore, even now, as He is at the right hand of the Father, the glories of heaven do not turn His attention from the miseries of earth, nor do they make Him forget the cries and tears of the weak who are seeking Him in this valley of tears.

The case of the deaf and mute demoniac, which is the context for the Lord's statement in our text, is a very remarkable one. All sin is the evidence that the soul is under the dominion of Satan. All who are unconverted are really possessed by the Devil in a certain sense. He has established his throne within their hearts, and he reigns there and rules the members of their bodies. *"The spirit that now worketh in the children of disobedience"* (Eph. 2:2) is the name that Paul gives to the Prince of Darkness. But these satanic possessions are not alike in every case, and the casting out of Satan, although always effected by the same Lord, is not always accomplished in the same way.

Many of us praise God that when we lived in sin, we were not given over to a passionate enthusiasm for it—there was method in our madness. We claim no credit for this, but we do thank God that we were not whirled along like things that are blown in a windstorm, but were restrained and kept within the bounds of outward propriety. We are also grateful that when we were awakened and alarmed regarding our sin, and we fell under the iron rod of Satan, we were not all brought into that utter despair, that horror of great darkness, that inward tormenting agony, which some have to endure. And when Jesus came to save us, although we were greatly hindered by Satan, there was no foaming at the mouth in pride and wallowing in obstinate lust and cutting ourselves in raging desperation, analogous to the book of Mark's description of this particular incident of demon possession. The Lord opened our hearts gently with His golden key, entered the room of our spirits, and took possession.

For the most part, the conquests that Jesus achieves in the souls of His people, although accomplished by the same power, are more quietly accomplished than in the case we are considering. Let us give thanks to the God of grace for this. Yet every now and then, there are these strange, out-of-the-way cases of people in whom Satan seems to run riot and to exert the utmost force of his malice. These are also the cases in which the Lord Jesus displays the exceeding greatness of His power, when in almighty love, He dethrones the Tyrant and casts him out, never to return again. If

there is one such distressed person reading this book, I will be justified in helping him, for,

> *If a man have an hundred sheep, and one of them be gone astray, doth he not leave the ninety and nine, and goeth into the mountains, and seeketh that which is gone astray?*
> *(Matt. 18:12)*

I pray that I may reach those who are far from God, and may, by the Holy Spirit's anointing, liberate those who are bound with shackles of iron so that they may become free in the Lord, for if the Son makes them free, they will be free indeed (John 8:36).

First, with my Lord's help, I will talk about the significance of the deplorable case recorded in the text. Then I will describe the one resource available to us and conclude by admiring the sure result.

A HOPELESS SITUATION

The physical miracles of Christ are types of His spiritual works. The wonders that He worked in the natural world have their analogies in the spiritual world; the outward and natural are symbolic of the inward and spiritual. Now, the demoniac who was brought by his father for healing is not distinctly representative of a case of gross sin, though the spirit is called an evil one, and Satan is always defiling; but it is an example of the great horror, disturbance of mind, and raving despair caused by the Evil One in some minds, to their torment and jeopardy.

Observe that the disease appeared every now and then in overwhelming attacks of mania, in which the man was utterly beyond his own control. The epileptic fit threw the poor victim in all directions. We have seen depressed people in whom despondency, mistrust, unbelief, and despair have raged at times with unconquerable fury. They have not so much entertained these evil guests as been victims of them. As Mark puts it, the spirit *"taketh him"* (Mark 9:18). In the same way, such forlorn ones have been captured and carried off by giant Despair. The demons have whipped them, chasing them into dry places. They have sought rest and found none. They have refused to be comforted, and like sick men, their souls have abhorred all kinds of food; they have demonstrated no power to struggle with their melancholy—they have not thought

of resisting. They have been swept off their feet and carried completely out of themselves in a transport of misery. Such cases are not at all uncommon. Satan, knowing that his time is short and perceiving that Jesus is coming quickly to the rescue, lashes his poor slaves with excessive malice to see if by any means he can utterly destroy his victims before the Deliverer arrives.

The poor victim in our text was filled at times with a terrible anguish, an anguish that he expressed by foaming at the mouth, wallowing on the ground, and crying out. Sometimes, in his dreadful falls, he bruised himself, and his delirium led him to dash himself against anything that was near him, causing himself new injuries. Only those who have experienced it can describe what the pains of conviction of sin are like when they are aggravated by the suggestions of the Enemy. Some of us have gone through this to a degree and can declare that it is hell on earth. We have felt the weight of the hand of an angry God. We know what it is to read the Bible and not find a single promise in it that would suit our situation. Instead, every page seemed to glow with threats, as if curses like lightning blazed from it. Even the choicest passages have seemed to rise up against us, as though they said, "Do not intrude here. These comforts are not for you. You have nothing to do with things such as these." We have bruised ourselves against doctrines and precepts and promises and even the Cross itself. We have prayed, and our very prayers have increased our misery. We have even fallen against the mercy seat; we consider our prayers to be only babbling sounds that are obnoxious to the Lord. We have gone to church, and the preacher has seemed to frown on us and to rub salt into our wounds and to aggravate our situation. Even the Scripture reading and the hymns and the prayers have appeared to be in league against us, and we have gone home more despondent than before.

I hope you are not passing through such a state of mind as this, for it is of all things, next to hell itself, one of the most dreadful. In such a plight, men have cried out with Job,

> *Therefore I will not refrain my mouth; I will speak in the anguish of my spirit; I will complain in the bitterness of my soul. Am I a sea, or a whale, that thou settest a watch over me? When I say, My bed shall comfort me, my couch shall ease my complaint; then thou scarest me with dreams, and terrifiest me through visions: so that my soul chooseth strangling, and death rather than my life. I loathe it; I would not live alway: let me alone; for my days are vanity.* (Job 7:11–16)

I thank God that the final outcome of this slavery is often the kind that makes angels sing for joy, but while the black night endures, it is a horror of darkness, indeed. Put a martyr on the rack or even fasten him with an iron chain to the stake and let the flames burn around him. If his Lord will only smile upon him, his anguish will be nothing compared with the torture of a spirit scorched and burned with an inward sense of the wrath of God. Such a person can join in the lament of Jeremiah and cry,

> *He hath set me in dark places, as they that be dead of old. He hath hedged me about, that I cannot get out: he hath made my chain heavy. Also when I cry and shout, he shutteth out my prayer....He hath bent his bow, and set me as a mark for the arrow. He hath caused the arrows of his quiver to enter into my reins....He hath filled me with bitterness, he hath made me drunken with wormwood.* (Lam. 3:6–8, 12–13, 15)

"The spirit of a man will sustain his infirmity; but a wounded spirit who can bear?" (Prov. 18:14). To groan over unforgiven sin, to dread its well-deserved punishment, to fear everlasting burning, these are things that make men suffer intensely and make them think that life is a burden.

We learn from the text that the evil spirit, at the times when it took full possession of the man's son, sought his destruction by hurling him in different directions. Sometimes it threw him into the fire, and sometimes it threw him into the water. It is the same way with deeply distressed souls. One day they seem to be all on fire with earnestness and zeal, with impatience and concern, but the next day they sink into a horrible coldness and apathy of soul, from which it appears to be utterly impossible to rouse them. All sensitive yesterday, all apathetic today. They are uncertain; you do not know where to find them. If you deal with them as you would deal with someone who is in danger from the fire of petulance, your efforts are wasted, for in the next few minutes, they will be in danger from the water of indifference. They fly to extremes. Their situation is like the fables of souls in purgatory, who suffer alternately in an oven and in cells of ice.

You would suppose, from the way in which a person like this speaks at one moment, that he believes he is the blackest of sinners, but in a short time, he denies that he feels any sort of repentance for sin. You would imagine, to hear him talk at one time, that

he would never cease to pray until he found the Savior, but later on he tells you that he cannot pray at all and that it is just a mockery for him to bend his knee in prayer. People like this continually change; they are more fickle than the weather. Their color comes and goes like a chameleon. They are compulsive and erratic, full of convulsions and contortions. A person would be more than human if he could know their minds for a month at a time, for they vary more often than the moon. Their conditions laugh us to scorn; their troubles baffle all our efforts at comforting them. Only Jesus Christ Himself can deal with them. It is a good thing to add that He has special skill in dealing with desperate diseases and finds delight in healing those whom all others have left for lost.

To add to the difficulties of this deplorable case, the son was deaf. Mark's account of the incident records Jesus as saying, *"Thou dumb and deaf spirit, I charge thee, come out of him"* (Mark 9:25). Because the son was deaf, there was no way of reasoning with him at all; not a sound could pass through those sealed ears. With other people, you might speak to them, and a soft word might calm the agitation of their minds. But no word, however gentle, could reach this poor tormented spirit, who was not capable of receiving either sound or sense. And are there not people like this today, to whom words are wasted breath? You may quote promises, you may supply encouragement, you may explain doctrines, but it is all nothing to them; they end where they began. Like squirrels in revolving cages, they never get anywhere.

Oh, the twisting and turning, the complex and distorted reasoning of poor tormented minds! It is certainly easy enough to tell them to believe in Jesus, but if they understand you, it is in such a vague way that it is necessary to explain it again, and you will have to clarify that explanation still further. Simply to cast themselves upon the blood of Jesus and to rest upon His finished work, is of all things most plain. A child's ABCs could not be plainer, and yet for all that, it is not clear to them. They will appear to comprehend you and then go off on a tangent; they will appear to be convinced and, for a time, to give up their doubts and fears, but meet them half an hour later, and you will find that you have been speaking to a wall, addressing yourself to the deaf. Oh, what a distressing situation! May the Lord have mercy on such people, for man's help is hopeless in these cases. Praise God that He has brought help through One who is mighty, who can make the deaf hear, causing His voice

to resound with sweet encouragement in the deathlike stillness of the dungeons of despair.

In addition to this, it appears that the afflicted one was mute. He was incapable of articulate speech because of the demonic possession. Since he cried out when the Devil left him, it would seem to have been a case in which all the instruments of speech were present but articulation had not been learned. There was utterance of an incoherent sort; the speech apparatus was there, but nothing intelligible came forth except the most heartrending cries of pain.

There are many such "spiritually mute" people. They cannot explain their own condition. If they talk to you, what they say is incoherent; they contradict themselves every five sentences. You know that they are speaking what they believe to be true, but if you did not know that, you might think that they were telling you falsehoods that contradict each other. Their experience is a string of contradictions, and their speech is even more complicated than their experience.

It is very hard and difficult to talk with them for any length of time; it wears out one's patience. And if it wears out the patience of the hearer, how burdensome must it be to the miserable speaker! They pray, but they do not dare to call it prayer. Instead, to them, it is like the chattering of a seagull or a swallow. They talk with God about what is in their poor helpless hearts, but it is such a confusion and mixture of things that when they have finished they wonder whether they have prayed or not. It is the cry—the bitter, anguishing cry—of pain, but it cannot be translated into words. It is an awful groan, an unutterable yearning and longing of the Spirit (Rom. 8:26), but they themselves scarcely know what it means.

You may be weary with the details of this grievous case, but I have not yet concluded the sorrowful story. If you have never experienced anything like this, thank God for it, but at the same time, pity and pray for those who are passing through this state of mind. Appeal to God to give them the hope of the great Healer; pray that He would come and deliver them, for their plight is past the ability of man.

The father of the demoniac told Jesus that his son was wasting away. How could it be otherwise with someone who was burdened down by such a mass of afflictions, who was perpetually tormented so that the natural rest of sleep was constantly broken? It is not likely that a person's strength could be maintained for long in a system so racked and torn. Keep in mind that despair vastly weakens

the soul. I have even known it to weaken the body until the worn-out sufferer has said with David, *"My moisture is turned into the drought of summer"* (Ps. 32:4).

To feel the guilt of sin, to fear the coming punishment, to have a dreadful warning in one's ears of the *"wrath to come"* (Matt. 3:7), to fear death and to expect it every moment, and above all, to disbelieve God and write bitter things against Him, this is something that makes one's bones rot and one's heart wither. John Bunyan, in his book, *Grace Abounding,* perfectly describes a person who has been left like a shrub in the desert, so that he is unable to see good when it comes. Bunyan depicts a mind that is tossed up and down on ten thousand waves of unbelief, never resting at any time but perpetually disturbed and distracted with surmises, suspicions, and foreboding. Now, if these kinds of attacks were to continue constantly and not sometimes cease, if there were not little pauses, as it were, between the fits of unbelief, surely the person's heart would utterly fail, and he would die and go to his eternal home, a prey to his own cruel unbelief.

The worst point in the case of the demoniac was that all this had continued for years. Jesus asked how long he had been in this condition, and his parent replied, "Since he was a child." Sometimes God permits, for purposes that we do not understand, the deep distress of a tempted soul to last for years. I do not know for how many years a person might have to struggle, but certainly some have had to battle with unbelief until their lives were nearly over, and only in the twilight of their lives were they given faith and spiritual understanding. When they thought they must die in the dark, the Holy Spirit appeared to them, and they were encouraged and comforted.

The Puritans used to quote the remarkable experience of Mrs. Honeywood as an example of the extraordinary way in which the Lord delivers His chosen. Year after year, she was in bondage to melancholy and despair, but she was set free by the gracious providence of God in an almost miraculous way. She picked up a slender piece of Venetian glassware, and saying, "I am as surely damned as that glass is dashed to pieces," she hurled it down on the floor, when to her surprise, and the surprise of all, I do not know how, the glass was not so much as chipped or cracked. That circumstance first gave her a ray of light, and she afterward cast herself upon the Lord Jesus. Sometimes extraordinary light has been given to extraordinary darkness. God has brought the prisoner up

out of the innermost cell where his feet had been securely fastened with chains, and after years of bondage, He has at last given perfect and delightful liberty.

One more thing about this case. The disciples had failed to cast the demon out. On other occasions they had been successful. They had said to their Master, *"Even the devils are subject unto us"* (Luke 10:17). But this time they were utterly defeated. They had done their best; they appear to have had some faith or they would not have attempted the task, but their faith was not at all equal to the emergency. Scribes and Pharisees gathered around them and began to mock them, and if any of the apostles had been able to perform the deed, they would gladly have done it. However, there they stood, defeated and dismayed. The poor patient before them was racked and tormented, and they were unable to give him the slightest comfort.

It becomes a truly painful situation when an anxious soul has gone to the house of God for years and yet has found no consolation; when a person who is troubled in spirit has sought but not received help from ministers or other Christian men and women; when prayers have been offered and not answered; when tears have been shed and have been unavailing; when books that have been a comfort to others have been studied without result; when teachings that have converted thousands fail to be effective. And yet there are such instances in which all human means are defeated and when it seems as impossible to comfort the poor troubled one as to calm the waves of the sea or to hush the voice of thunder. There are still people in which an evil spirit and the Holy Spirit are brought into distinct conflict, in which the evil spirit displays all his malice and brings the person to the uttermost height of distress, in which, I trust, the Holy Spirit will yet display His saving power and lead the soul out of its prison to praise the name of the Lord.

If you do not know the Lord, you may be thinking to yourself, "I thank God that I know nothing about these things." Pause before you thank God for this, for as bad and deplorable as this state is, it would be better for you to be in it than to remain altogether without spiritual sensitivity. It would be better for you to go to heaven burned and branded, scourged and scarred every step of the road, than to slide gently down to hell as many people are doing— sleeping sweetly while devils carry them along the road to perdition. It is a little thing, after all, to be tormented and troubled for a

time by internal distress, if by God's intervention, it will ultimately end in joy and peace in believing. However, it is an immeasurably dreadful thing to have *"Peace, peace"* sung in one's ears *"when there is no peace"* (Jer. 6:14), and then forever to discover that you are a castaway in the pit from which there will be no escape.

Instead of being thankful, you should tremble. Yours is that terribly prophetic calm that travelers frequently perceive on the Alpine summit. Everything is still. The birds stop singing, fly low, and cower with fear. The hum of bees among the flowers is hushed. A horrible stillness rules the hour, as if death had silenced all things by stretching his awful scepter over them. Do you not perceive what is surely about to happen? The thunder is preparing; the lightning will soon cast forth its mighty fires. The earth will rock; the granite peaks will be dissolved. All nature will shake beneath the fury of the storm. That solemn calm is yours today. Do not rejoice in it, for the tempest is coming: the whirlwind and the tribulation that will sweep you away and utterly destroy you. It is better to be troubled by the Devil now than to be tormented by him forever.

THE ONE RESOURCE

So far, I have brought before you a very distressing subject. I pray that the Holy Spirit will help me while I remind you of the one resource.

The disciples were baffled. The Master, however, remained undefeated and said, *"Bring him hither to me."* Now, when we are faced with difficult situations, we ought to use whatever means we have as far as the means will go. We are obligated, further, to make the means more effective than they ordinarily are. Prayer and fasting are prescribed by our Lord as the means of connecting ourselves to greater power than we would otherwise possess. There are conversions that will never happen by the methods of ordinary Christians. We need to pray more and to keep our bodies completely under control through self-denial. When we enjoy closer communion with God through prayer and fasting, we will be able to handle the more distressing cases. The church of God would have far more strength to wrestle with this ungodly age if her members prayed and fasted more often.

There is a mighty effectiveness in these two gospel ordinances of prayer and fasting. The first links us to heaven; the second separates us from earth. Prayer takes us to the banqueting table of God; fasting overturns the indulgent tables of earth. Prayer allows us to feed on the Bread of Heaven, and fasting delivers our spirits from being encumbered with the fullness of bread that perishes.

When Christians raise themselves to the uttermost possibilities of spiritual vigor, they will be able, by God's Spirit working in them, to cast out demons that today, without the prayer and fasting, laugh them to scorn. But even with all that, the most advanced Christian will still face mountainous difficulties that even prayer and fasting do not seem to alleviate. These difficulties must be brought directly to the Master and His personal skill, as the disciples discovered. The Lord tenderly commands us, "Bring them to me."

As I give you the practical application of this text, let me beg you to remember that Jesus Christ is still alive. Simple as that truth is, you need to be reminded of it. We very often estimate the power of the church by looking to her ministers, her ordinances, and her members. However, the power of the church does not lie there; it lies in the Holy Spirit and in an ever living Savior. Jesus Christ died, that is true, but He lives again, and we may come to Him today just as that anxious father did in the days when our Lord was on earth. It is said that miracles have ceased. Natural miracles may have, but spiritual miracles have not. We do not have the power to work either kind. Christ has the power to work any kind of miracle, and He is still willing and able to work spiritual miracles in the midst of His church. I delight to think of my Lord as a living Christ with whom I can speak and discuss every situation that occurs in my ministry, a living Helper to whom I may bring every difficulty that occurs in my own soul and in the souls of others. Do not think that He is dead and buried! Do not seek Him among the dead! Jesus lives and is as able to deal with these cases of distress and sorrow as when He was here below.

Remember, too, that Jesus lives in the place of authority. When He was here, He had power over demons, but in heaven He has still greater power. Here on earth, He veiled the splendor of His divinity, but now in heaven, His glory beams magnificently and all hell confesses the majesty of His power. There is no demon, however forceful, who will not tremble if Jesus merely speaks or even so much as looks at him. Today, Jesus is the Master of hearts and consciences.

By His secret power, He can work upon every one of our minds; He can lower us or He can exalt us; He can cast down or He can lift up.

No situation will ever be hard for Him. We only have to bring our needs to Him. He lives—lives in the place of power—and He can achieve the desires of our hearts. Moreover, Jesus lives in the place of observation, and He still graciously intervenes. I know we are tempted to think of Him as someone far away who does not see the sorrows of His church. However, I tell you, beloved, Christ's honor is as much concerned at this moment with the defeat or victory of His servants as it was when He came down from the mountaintop and encountered the man and his demoniac son. From the battlements of heaven, Jesus looks upon the work of His ministers, and if He sees them defeated, He is jealous for the honor of His Gospel and is as ready to intervene and win the victory now as He was then. We only have to look up to our Lord. He does not sleep as the false god Baal did in the Old Testament. He is not callous to our troubles or indifferent to our griefs. Blessed Master, You are able to comfort and are strong to deliver! We only have to bring the matter that distresses us before You, and You will deal with it according to Your compassion.

We should also remember, as a warning to us, that Jesus Christ expects us to treat Him as a living, powerful, intervening One and to confide in Him as such. We do not know what we miss through our lack of faith. We believe that certain people are in a hopeless condition, and therefore we dishonor Christ and injure them. We abandon some cases, giving up instead of presenting them constantly to Him; we limit the Holy One of Israel; we grieve His Spirit and trouble His holy mind. However, if as children trust their fathers, we would trust in Jesus unstaggeringly, with an Abrahamic faith, believing that what He has promised He also is able to perform, then we would see even such cases as the one in our text soon brought into the light of day. The *"oil of joy"* would be given instead of mourning and the *"garment of praise for the spirit of heaviness"* (Isa. 61:3).

Now, I earnestly urge parents and relatives and any who have children or friends who are distressed, to make a point of taking their dear ones to Jesus. Do not doubt Him—you will displease Him if you do. Do not hesitate to tell Him the situation of your loved one. Hurry to Him and lay the sick one before Him. And even if while you are praying, the case should become worse instead of better, do not hesitate. You are dealing with the infinite Son of God, and you do not need to fear; you must not doubt. May God

grant us grace in all aspects of our daily troubles to bring everything to the Lord Jesus, especially in matters concerning our spirits.

THE SURE RESULT

When the man's son was brought before our Lord, the case looked thoroughly hopeless. He was deaf and mute; how could the Master deal with him? Besides that, he was foaming at the mouth and wallowing on the ground. What opening was there for divine power? I do not wonder that his father said, *"If thou canst do any thing, have compassion on us, and help us"* (Mark 9:22). As I wrote earlier, in most other instances, the voice of Jesus calmed the person's spirit; however, that voice could not reach his mind, for his ears were sealed. The Savior had never before been presented with a more thoroughly far-gone case, which was, to all appearances, hopeless; yet the cure was divinely certain, for Jesus, without hesitating for a moment, said to the unclean spirit, *"Thou dumb and deaf spirit, I charge thee, come out of him"* (v. 25). Christ has power to command demons with authority. They do not dare to disobey. The Savior added, *"And enter no more into him"* (v. 25). Where Jesus heals, he heals forever. Once the soul is brought out of prison, it will not go back again. If Christ says, "I forgive," the sin is forgiven. If He speaks peace, the peace will be like a river that never ceases; it will run until it melts away into the ocean of eternal love. There was no hope for a remedy, yet the cure was absolutely certain when Jesus put forth His healing hand. If you are broken and despondent, there is nothing that you or I can do; but there is nothing that He cannot do. Only go to Him, and with a word He will give you peace, a peace that will never be broken again but will last until you enter into eternal rest.

Nevertheless, we read that the word of Christ, though it was certain to have the victory, was staunchly opposed. The Devil had great wrath, for he knew that his time was short. He began to tear at the poor victim and to exert all his devilish force upon him. The pitiful son was foaming at the mouth and wallowing on the ground; after this terrible agitation, he fell down as if he were dead. Often, at first, the voice of Christ will cause a person's spirit to be more troubled than before, not because Jesus troubles us, but because Satan revolts against Him. A poor tempted person may even lie

down in despair as if he were dead, and those around him may cry, "He is dead!" but even then, the healing hand of tenderness and love will come, at whose touch the person will survive.

If at any time, you should consider yourself to be like one who is dead, if your last hope should expire, if there should seem to be nothing before you but *"a certain fearful looking for of judgment and fiery indignation"* (Heb. 10:27), it is then that Jesus will intervene. Learn the lesson that you cannot have gone too far from Christ. Believe that your limits are only limits to you and not to Him. The highest sin and the deepest despair together cannot baffle the power of Jesus. If you were between the very jaws of hell, Christ could snatch you out. If your sins had brought you even to the gates of hell, so that the flames flashed into your face, if you then looked to Jesus, He could save you. If you are brought to Him when you are at death's door, eternal mercy will still receive you. How is it that Satan has the impudence to make men despair? Surely it is a piece of his infernal impertinence that he dares to do it. Despair, when you have an omnipotent God to help you? Despair, when the precious blood of the Son of God has been given for sinners? Despair, when God delights in mercy? Despair, when the silver bell of hope rings, *"Come unto me, all ye that labour and are heavy laden, and I will give you rest"* (Matt. 11:28)? Despair, while life lasts, while mercy's gate stands wide open, while the messengers of mercy call you to come? Despair, when you have God's word, *"Though your sins be as scarlet, they shall be as white as snow; though they be red like crimson, they shall be as wool"* (Isa. 1:18)?

I repeat, it is infernal impertinence that has dared to suggest the idea of despair to a sinner. Christ unable to save? It can never happen. Christ outdone by Satan and by sin? Impossible. A sinner with diseases too many for the Great Physician to heal? I tell you that if all the diseases of men were concentrated in you, and all the sins of men were heaped on you, and blasphemy and murder and fornication and adultery and every sin that is possible or imaginable had all been committed by you, the precious blood of Jesus Christ, God's dear Son, would still cleanse you from all sin. If you will only trust my Master—and He is worthy to be trusted and deserves your confidence—He will save you even now. Why delay, why raise questions, why debate, why deliberate, mistrust, and suspect? Fall into His arms. He cannot reject you, for He Himself has said, *"Him that cometh to me I will in no wise cast out"* (John 6:37).

Only the Master can save you. It is my responsibility to tell you about the Gospel, but I know that you will not hear it, or that if you do hear it, you will reject it unless Christ comes with power by His Spirit. Oh, may He come today and say to the evil spirit within you, "Come out of him, you foul spirit, and do not return to him. Let him go, for I have redeemed him with My most precious blood." I pray, dear friend, that God the Holy Spirit may bless these words so that the bars of iron may be unfastened, the gates of brass may be opened, and the captives of the Enemy may be brought out to liberty. May the Lord bless these captives for His name's sake.

6

Christo in You

And hope maketh not ashamed; because the love of God
is shed abroad in our hearts by the Holy Ghost
which is given unto us.
—Romans 5:5

Pentecost is repeated in the heart of each believer when the love of God is poured out into his heart by the Holy Spirit. Let me give you a little bit of historical analogy to illustrate this. The Lord's disciples were deeply sorrowful when He died on the cross. The distress that came upon them as they thought of His death and His burial in Joseph's sepulcher was very painful. But after a little patience and experience, their hope revived, for their Lord rose from the dead, and they saw Him ascend into heaven. Their hopes were bright concerning their Lord who had gone into glory and had left them a promise that He would come again and cause them to share in His victory. After that hope had been conceived in them, they were, in due time, made partakers of the Holy Spirit, whose divine influence was poured out on them so that they were filled with His power. They were made bold. They were not ashamed of their hope but proclaimed it through the preaching of Peter and the other disciples. The Holy Spirit had visited them; therefore, they fearlessly proclaimed to the world the Lord Jesus, their *"hope of glory"* (Col. 1:27).

Truly, history repeats itself. The history of our Lord is the foreshadowing of the experience of all His people. What happened to the Firstborn happens, to some degree, to all the children of God. We have an excellent example of this in the first part of Romans 5, from which our text comes. Verse three mentions our tribulation—our

agony, our crossbearing. The passage goes on to say that out of our patience and experience a blessed hope arises in due season. We are renewed by our Lord's resurrection life and come out of our sorrow. He raises us up from the grave of our affliction. Then we receive the divine visitation of the Holy Spirit, and we enjoy our Pentecost: *"The love of God is shed abroad in our hearts by the Holy Ghost which is given unto us."* I trust you know what this means and are now enjoying it.

As a result of that visitation by the Holy Spirit, our hope becomes clear and assured, and we are led to give a full and bold testimony concerning our hope and the blessed One who is the substance of it. I hope that you have already proved that you are not ashamed. If not, I hope you will do so. Our God has visited us in mercy and endowed us with the Holy Spirit, who is His choice gift to His children. The Holy Spirit dwelling in us has caused us to know and feel the love of God, and now we cannot help speaking and telling others about what the Lord has made known to us. Thus, on a small scale, we have repeated a portion of early church history in our own personal story. You will find that, not only in this case, but in all cases, the life of the believer is the life of Christ in miniature. He who originally said, *"Let us make man in our image"* (Gen. 1:26), still follows the model of Christ when making a person into a *"new creature"* (2 Cor. 5:17) in the image of His Son.

Now let us examine some of the mystery of our spiritual experience. The passage in Romans 5 that I mentioned above is like a little map of the inner life:

> *Tribulation worketh patience; and patience, experience; and experience, hope: and hope maketh not ashamed; because the love of God is shed abroad in our hearts by the Holy Ghost which is given unto us.* *(Rom. 5:3–5)*

This passage can only be fully understood by people of God who have had it written in capital letters on their own hearts. *"Tribulation worketh patience,"* said the apostle. This is not true in the natural. Normally, "Tribulation worketh impatience," and impatience misses the fruit of experience and sours into hopelessness. Ask any who have buried a dear child or lost their wealth or suffered pain in their bodies, and they will tell you that the natural result of affliction is to produce irritation against providence, rebellion against God, questioning, unbelief, faultfinding, and all

sorts of evils. But what a wonderful change takes place when the heart is renewed by the Holy Spirit! Then, but not until then, *"tribulation worketh patience."*

He who is never troubled cannot exercise patience. Angels cannot exhibit patience since they are not capable of suffering. In order for us to possess and exercise patience, it is necessary for us to be tried, and a great degree of patience can only be obtained by a great degree of trial. You have heard of the patience of Job. Did he learn it among his flocks or with his camels or with his children when they were feasting? No, truly, he learned it when he sat among the ashes and scraped himself with a piece of broken pottery and when his heart was heavy because of the death of his children. Patience is a pearl that is found only in the deep seas of affliction; and only grace can find it there, bring it to the surface, and adorn the neck of faith with it.

Then, patience provides us with personal experience in learning the character of God. In other words, the more we endure and the more we test the faithfulness of God, the more we prove His love and the more we perceive His wisdom. He who has never endured may believe in the sustaining power of grace, but he has never experienced it. You must put to sea to know the skill of the divine Pilot, and you must be battered by the storm before you can know His power over winds and waves. How can we see Jesus in His full power unless there is a storm for Him to calm? Our patience works in us an experiential acquaintance with the truth, the faithfulness, the love, and the power of our God. We bow in patience, and then we rise in the joyful experience of heavenly support. What better wealth can a person have than to be rich in experience? Experience teaches. This is the real school for God's children. I hardly think that we learn anything thoroughly without the rod of affliction. Certainly we know best the things that have been a matter of personal experience. We need that truth to be burned into us with the hot iron of affliction before it can be of use to us. After that, no one may trouble us, for our hearts bear the brand of the Lord Jesus. This is the way in which patience works experience.

It is rather extraordinary that the Scripture then says that experience works hope. It is not extraordinary in the sense of being questionable, for there is no hope as bright as that of the believer who knows the faithfulness and love of God through experience. But does it not seem extraordinary that this heavy tribulation, this

grievous affliction, this painful chastisement, should nevertheless bring forth for us this particular bright light, this morning star of hope, this messenger of the everlasting day of glory? Beloved, divine chemistry wonderfully brings out fine gold from metal that we thought was worthless!

The Lord in His grace spreads a bed for His own people on the threshing floor of tribulation, and there, like Boaz in the book of Ruth, we take our rest. He sets to music the roar of the floods of trouble. Out of the foam of the sea of sorrow He causes the bright spirit of hope that *"maketh not ashamed"* to arise. Therefore, this passage, from which our text comes, is a choice extract from the inner life of a spiritual man. It is a fragment of the mystery of our spiritual lives. We must read it with spiritual understanding.

Now, our text describes none other than the house of God and the gate of heaven. You can see in it a temple for the worship of the Divine Trinity. Read both the fifth and sixth verses of Romans 5, and notice that all three members of the Trinity are mentioned:

> *The love of God* [the Father] *is shed abroad in our hearts by the Holy Ghost which is given unto us. For when we were yet without strength, in due time Christ died for the ungodly.*

The blessed Three in One! The Trinity is needed to make a Christian, the Trinity is needed to encourage a Christian, the Trinity is needed to complete a Christian, and the Trinity is needed to create in a Christian the hope of glory.

I always like these passages that bring us so near to the Trinity. They make me want to adore the Godhead in the words of the doxology:

> Glory be unto the Father, and to the Son,
> and to the Holy Ghost.
> As it was in the beginning, is now,
> and ever shall be, world without end!
> Amen.

It is a very dear thing to be called upon to offer special worship to the one true God, the Three in One, and to feel one's heart readily inclined to do so. By faith, we bow with the multitudes of the redeemed before the all-glorious throne and worship Him who lives forever. We adore Him wholeheartedly when we think of the

unity of the Sacred Three in our salvation! Divine love is bestowed on us by the Father, made manifest in the death of the Son, and poured out into our hearts by the Holy Spirit. Oh, to feel communion with the triune God! Let us bow before the sacred majesty of Jehovah, and as we explore our text, let us allow the Holy Spirit to teach us its truths so that through it, we may enter His temple.

The text reads: *"Hope maketh not ashamed; because the love of God is shed abroad in our hearts by the Holy Ghost which is given unto us."* The apostle had been progressing until he came to the hope of glory. When he reached that height, he could not help saying something concerning it. Turning away from his main subject, as was often his custom, he gave us a few glowing sentences about the believer's hope.

He first explains the confidence of our hope—that *"hope maketh not ashamed."* Next, he describes the reason for our confidence, which I hope you are enjoying today, for we are confident that we will never be disappointed in our hope because the love of God has been poured out into our hearts by the Holy Spirit. Then, he reveals the result of this confident hope, that we are not ashamed of the Gospel of Christ and that we are witnesses to the world.

THE CONFIDENCE OF OUR HOPE

Some people have no hope, or they have a hope of which they might justifiably be ashamed. Ask those who deny the validity of the Scriptures what their hope for the future is. "I will die like a dog," they will answer, "and when I am dead, that will be the end of me." If I had such a wretched hope as that, I certainly would not go around the world proclaiming it. I would not think of gathering a large audience and saying to them, "Friends, rejoice with me, for we are to die like cats and dogs." It would never strike me as being a matter to celebrate.

The agnostic knows nothing, and therefore I suppose that he hopes for nothing. I do not see anything to become enthusiastic about in this stance, either. If I had no more hope than that, I would be ashamed. The Roman Catholic's best hope is that when he dies he may come out all right in the end, but meanwhile he will have to undergo the purging fires of purgatory. I do not know much about that place, for I cannot find any mention of it in Holy

Scripture. However, those who know it well, because they invented it and keep its keys, describe it as a dreary place, to which even great bishops and cardinals must go. I have seen, personally seen, invitations to the faithful to pray for eternal rest for the spirit of an eminent cardinal; and if this is the fate of the princes of the church, where must ordinary people go? There is no great excellence in this hope. I do not think I would call people together in order to say to them, "Rejoice with me, for when we die we will all go to purgatory." They would fail to see any particular grounds for rejoicing. I do not think I would say much about it, and if anybody were to question me about it, I would try to evade the point and declare that it was a deep mystery that would be better left to the clergy.

But we are not ashamed of our hope. We believe that Christians who are absent from the body are present with the Lord (2 Cor. 5:8). We look for a city that has foundations, whose Builder and Maker is God (Heb. 11:10). We are not ashamed to hope for glory and immortality and eternal life.

Not Ashamed of the Object of Our Hope

Moreover, we are not ashamed of the object of our hope. We do not believe that heaven consists of indecent, carnal pleasures. We do not believe in an Islamic paradise of sensual delights, or we might very well be ashamed of our hope. Whatever imagery we may use, heaven is a pure, holy, spiritual, and refined happiness. The false prophet would not have regarded this as a sufficient bait for his followers. Yet our hope is this: that our Lord will come a second time with all His holy angels, and *"then shall the righteous shine forth as the sun in the kingdom of their Father"* (Matt. 13:43). We believe that if we die before that time, we will sleep in Jesus and will be blessed with Him. *"To day shalt thou be with me in paradise"* (Luke 23:43) is not for the thief only, but for all of us who have entrusted our spirits to the crucified Savior. At His coming we expect a glorious resurrection. When He descends from heaven with a shout, with the voice of the archangel and the trumpet of God, then our spirits will be restored to our bodies, and we will live with Christ as complete, renewed persons. We believe, and are sure, that from that day we will be with Him forever. He will grant us the right to share in His throne, His crown, and His heaven—forever and ever! The more we talk about the promised bliss, the

more we feel that we could not possibly be ashamed of the hope of glory.

The ultimate reward of faith, the ultimate reward of a life of righteousness, is such that we rejoice in the prospect of it. Our glorious hope includes purity and perfection: freedom from all sin and the possession of every virtue. Our hope is that we will be like our perfect Lord and that we will be with Jesus where He is so that we may see His glory. Our hope is fulfilled in this promise: *"Because I live, ye shall live also"* (John 14:19). We will not merely exist, but *live,* which is another and a higher matter. Our life will be the life of God in our spirits forever and ever. We are not ashamed of this hope. We press forward to attain it.

Not Ashamed of the Ground of Our Hope

Our hope rests on the solemn promises of God, which He has made to us by His prophets and apostles and confirmed in the person and work of His dear Son. Since Jesus Christ died and rose from the dead, we who are one with Him by faith are certain that we will rise again from the dead and live with Him. The fact that Christ was resurrected is our assurance that we will be resurrected, and His entrance into glory is the pledge of our glorification, because we have been made one with Him by the purpose and grace of God.

We all fell with Adam because all humanity is born in him. In the same way, we will rise and reign with Jesus because we are now in Him. God is not the God of the dead but of the living; He *is* the God of Abraham, Isaac, and Jacob, and therefore these men are still alive. We believe the same thing concerning all who die in the faith, that they have not ceased to be but are all alive in Him. Our hope is not established on reasoning, which may possibly, in a dim way, prove the immortality of the spirit and the future reward of the righteous. Rather, our hope is founded upon the Word of God, which states the truth of eternal life clearly and plainly and leaves no room for doubt. If the Bible is a lie, we must give up our hope; however, since we have not followed *"cunningly devised fables"* (2 Pet. 1:16) but have received the testimony of faithful eyewitnesses to our Lord's resurrection and ascension, we believe the Holy Record and are not ashamed of our hope. What God has promised is sure, and what God has done fully confirms it. Therefore, we have no fear.

Not Ashamed That We Possess Our Hope

Now, somebody may say to us with a sneer, "So, you expect to be in glory, do you?" Our reply is, "Yes, we do, and we are not ashamed to receive the mild accusation you bring, for our confidence is well grounded. Our expectation is not based on any proud claim of personal merit but on the promises of a faithful God. Let us recall some of these promises. He has said, *"He that believeth on me hath everlasting life"* (John 6:47). We do believe in Him, and therefore we know that we have eternal life. He has declared in His Word that *"whom he justified, them he also glorified"* (Rom. 8:30). We are justified by faith; therefore, we will be glorified. Our hope is not based on mere feeling but on the fact that God has promised everlasting life to those who believe in His Son, Jesus Christ. We have heard our Lord pray, *"Father, I will that they also, whom thou hast given me, be with me where I am; that they may behold my glory"* (John 17:24). We believe that the Father has given us to Jesus because we have been led to put our trust in Him, and faith is the sure sign and symbol of divine election. Therefore, since we are Christ's, we expect to be with Him where He is.

We also read in the Word of the Lord, *"Whosoever believeth in him should not perish, but have everlasting life"* (John 3:16); therefore, we hold onto that promise and know that we have everlasting life. This appears to be a strictly logical argument. Unless it is a mistake and God has not said that the believer will live forever, we are under no delusion in expecting eternal life. But God's Word is the surest thing there is, and we are not ashamed to hold onto any claim that truthfully arises out of it. We dare to believe that God will keep His word to us and to all other believers.

Not Ashamed regarding the Certainty of Our Hope

In addition, beloved, we are not ashamed of the absolute certainty that our hope will be realized. We believe that if, indeed, we are justified by faith and have peace with God, we have a hope of glory that will not fail us in the end or on the way to the end. We do not expect to be deserted and to be left to fall from grace, *"for he hath said, I will never leave thee, nor forsake thee"* (Heb. 13:5). We do not expect to be left to ourselves, which would mean our sure and certain ruin, but we do expect that He who has begun a good

work in us will perfect it until the Day of Christ (Phil. 1:6). We are certain that He who has created this hope in us will justify that hope by fulfilling it in due time. He will preserve us through long life if we are to live a long time; He will maintain a living hope in us when the time comes for us to die; and He will remember even our dust and ashes when they are hidden in the grave. *"Who shall separate us...from the love of God, which is in Christ Jesus our Lord?"* (Rom. 8:35, 39). It is written, *"He that believeth and is baptized shall be saved"* (Mark 16:16). And this is the way it will be. The believer will not *"perish from the way"* (Ps. 2:12) or during the way. Has God not said, *"I will put my fear in their hearts, that they shall not depart from me"* (Jer. 32:40)? He will not allow His children to stumble and fall. He says, *"I give unto* [my sheep] *eternal life; and they shall never perish, neither shall any man pluck them out of my hand"* (John 10:28). We will never be deceived in our trust in Jesus. No one will be able to say, "I trusted the Lord Christ to keep me, and He has not kept me. I rested in Jesus to preserve my spiritual life, and He has not preserved me." Never. We will not be ashamed of our hope.

THE REASON FOR THIS CONFIDENCE

I have introduced you to the confidence that makes believers— especially tried and experienced believers—full of the hope that *"maketh not ashamed."* My second purpose is to focus on the reason for this confidence. Why do believers who possess the good hope rejoice in it?

The Love of God

One of the main supports of this hope is the love of God. I expect one day to sit among the angels and to see the face of my Best Beloved. I do not expect this because of anything in me or anything that may ever be done by me but simply because of the infinite love of God. I do not trust my love for God, only God's love for me. We trust Him because He loves us. We are sure that He will fulfill our hope because He is too loving to fail us.

It is from the love of God that all our hopes begin, and it is upon the love of God that all our hopes depend. If it were not for the Father's love, there never would have been a covenant of grace.

If it were not for His infinite love, no atoning sacrifice would have been provided. If it were not for His active love, no Holy Spirit would have given us life and renewed us. If it were not for His unchanging love, all that is good in us would soon pass away. If it were not for love almighty, love unchangeable, love unbounded, we could never hope to see the face of the King in His beauty in the land that is very far off. He loves us, and therefore He leads us and feeds us and establishes us forever. Does your heart not confess this? If that love could be suspended for a moment, if it were to cease sustaining you for an instant, where would you be? The love of God is the chief reason for our hope in Him.

Observe, dear believer, that the actual reason for our confidence is that *"the love of God is shed abroad in our hearts by the Holy Ghost."* The Holy Spirit is in the heart of every believer, and He is occupied with many acts of grace. Among other things, He pours out the love of God in the hearts in which He resides. Let me give you an illustration of this. Suppose that an ornate box filled with precious perfume is placed in a room. The dormant scent is contained within the box. It is an exquisite perfume, but no one has yet breathed in its fragrance. The love of God that comes into the believer's heart is like that rare fragrance; until it is poured out, it is not enjoyed. The Holy Spirit takes that box and opens it, and the sweet scent of divine love streams forth and completely fills the believer. This love penetrates, permeates, enters, and occupies his entire being. A delightful scent streams through an entire room when the fragrance of roses is poured out. In the same way, when a devout believer reflects on the love of God, and the Holy Spirit helps his meditations, the theme fills his mind, memory, imagination, reason, and emotions. It is an engrossing subject and is not to be confined to any one faculty, any more than you could keep the aroma of spices within a certain narrow space.

Moreover, as perfume delights the sense of smell, the love of God, when poured out in the power of the Holy Spirit, imparts an extraordinary sweetness to our emotions. All the garments of the Lord of love smell of myrrh and aloes and cassia (Ps. 45:8). What sweetness can be compared with the love of God? That the eternal and infinite One should really love mankind, and love it to such a degree as He has done, is a truth that is at once surprising and joyful. It is the root from which the lily of perfect joy springs. This is an ivory palace in which every resident is made glad. You may meditate on that love until you are overcome and carried away by

it, and until your soul, before you are aware of it, becomes like *"the chariots of Amminadib"* (Song 6:12).

Also, perfume not only permeates the air and delights all who are in the room, but it remains there. You may take the perfume away, but a sweet scent remains for many hours in a room that was once filled with it. Some scents seem to stay forever. Perhaps you went to your dresser drawer the other day and noticed a delicious scent of lavender, yet you had not had a sachet in there since last year. Fragrance lingers. A few drops of a pure fragrance will perfume a wide area and remain long after the bottle from which they were poured has been taken away.

When the love of God comes into the heart and is poured out by the Holy Spirit, who is the great Master of the art of diffusing love, it remains in the heart forever. Everything else may cease, but love remains. For a moment we may seem to forget the love of God when we are in the midst of the business of the world, but as soon as the pressure is removed, we return to our rest. The sweet perfume of divine love overcomes the rank odor of sin and never abandons the heart that has known its excellent delights.

If I may change the analogy, the love of God that is poured out in the heart by the Holy Spirit is like a rain cloud, black and full of overflowing blessings, which pours out a shower of innumerable silver drops that fertilize every place that they fall, making drooping plants lift up their heads and rejoice in the heaven-sent revival. After a while, a gentle steam rises from the spot where the rain fell, which ascends to heaven and forms fresh clouds. The love of God is poured into our hearts in the same way and permeates our nature until our spirits drink it in and its new life produces flowers of joy and fruits of holiness. Later on, our grateful praise ascends like the incense that smoked on Jehovah's altar in the temple. Love is poured out in us, and it works upon our hearts to love in return.

Leaving these analogies, the shedding abroad of the love of God into the heart by the Holy Spirit means this: He gives us an intense appreciation and sense of that love. We have heard of it, believed in it, and meditated upon it. Finally, we are overpowered by its greatness. *"God so loved the world, that he gave his only begotten Son"* (John 3:16). We cannot measure such love. We become affected by it; we are filled with wonder and admiration. Its greatness, its uniqueness, it distinction, its infinity—all these amaze us. It is poured out into our hearts.

Then we truly begin to take personal possession of His love. We exclaim, "He loved *me*; He gave Himself for *me*." We begin to feel that God's love was not only love for men in general but love for us in particular, and we are now completely swept off our feet. When we believe in this special love for us, we are ready to dance for joy. Faith perceives that it is true, and then we *"praise* [the Lord] *upon the high sounding cymbals"* (Ps. 150:5). This is followed, as a matter of course, by a giving back of love, which the human heart must feel. *"We love him, because he first loved us"* (1 John 4:19). We doubted it once; we cannot doubt it now.

If we were to be asked three times, as Peter was, *"Lovest thou me?"* (John 21:15), we would answer humbly but most emphatically, *"'Thou knowest all things; thou knowest that I love thee'* (v. 17). Lord, I could not live without loving You. I would a thousand times rather that I had never been born than be without love for You. Although I do not love You as I ought to and my heart desires a far greater love for You, I do love You in deed and in truth. You know that I do, and I would be false to my own conscience if I denied it." This is what it means to have the love of God poured out in your heart by the Holy Spirit who has been given to us: to know it, enjoy it, appropriate it, rejoice in it, and come under its divine influence. May this sweet perfume never be removed from my innermost soul!

Christ Died for the Ungodly

Next, I want you to notice the special sweetness that struck the apostle Paul as being so amazingly noteworthy. He went on to tell us what affected him most. He said, *"When we were yet without strength, in due time Christ died for the ungodly"* (Rom. 5:6). That is the second point to be considered, that God would give His Son to die for the *ungodly*. The fact that God would love those who love Him, that God would love His renewed people who are striving for holiness, is indeed delightful, but the most overpowering thought of all is that He loved us when there was nothing good in us whatsoever. He has loved us since before the foundation of the world. He saw that we were fallen and lost, and His love resolved to send His Son to die for us. Jesus did not come because we were good but because we were evil. He did not give Himself for our righteousness but for our sins. What motivated God to act in love was not any

excellence in His human creation that existed at that time or was foreseen to exist in the future, but simply the good pleasure of the God of love. Love was born of God Himself. It was so great in the heart of God that

> He saw us ruined in the Fall,
> Yet loved us notwithstanding all.

He loved us when we hated Him; He loved us when we opposed Him, when we cursed Him, when we persecuted His people and blasphemed His ways. What a marvelous fact! Oh, that the Holy Spirit would bring home that truth to our hearts and make us feel its energy! I cannot possibly express the immensity of God's love for you, much less pour it out within you, but the Holy Spirit can do it, and then how captivated you will be, how humbled and yet how full of praise you will be for the Most High God!

Therefore, the apostle was not content to remind us of God's immense love for us. He also did not want us to forget that Christ died for us. Beloved, that Christ should love us in heaven was a great thing; that He should then come down to earth and be born in Bethlehem was a greater thing. That He should live a life of obedience for our sakes was a wonderful thing, but that He should die, this is the climax of love's sacrifice, the summit of the mountain of love.

Some sights in the world astonish us once or twice and then grow commonplace. However, the Cross of Christ grows on us; the more we know of it, the more it surpasses knowledge. To a believer who has been saved for two thousand years, the sacrifice of Calvary is even more of a marvel than when he first saw it. That God Himself should take our nature and that, in that nature, He should die a death like a felon who is put on display on an execution post, in order to save us who were His enemies, is a thing that could not be believed if it had been told to us on any less authority than God's. It is altogether miraculous, and if you will let it take possession of you until it is poured out in your heart by the Holy Spirit, you will feel that there is nothing worth knowing, believing, or admiring compared with this. Nothing can ever rival our interest in the Cross of Christ. We may study many fields of knowledge, but the knowledge of a crucified Savior will still remain the most sublime of all the sciences.

Christ Will Save Us by His Life

Furthermore, the apostle went on to say that the Lord must forever love us now that we are reconciled. He put it in this way: If God loved us when we were His enemies, He will surely continue to love us now that we are His friends. If Jesus died for us when we were rebels, He will refuse us nothing now that He has reconciled us. If He reconciled us by His death, surely He can and will save us by His life (Rom. 5:10). If He died to reconcile enemies, surely He will preserve the reconciled.

Do you see the whole argument? It is very full of reasons for upholding our hope of glory and causing us not to be ashamed of it. When the great God makes us feel the surpassing greatness of His love, we banish all doubt and dread. We infer from the character of His love, which we have seen in the past, that He cannot possibly abandon us in the future. What, die for us and then leave us? What, pour out His heart's blood for our redemption and yet permit us to be lost? Will Jesus, robed in the crimson of His own atonement through death, manifest Himself to us—something He does not do to the world—and then, after all this, say to us, *"Depart from me, ye cursed"* (Matt. 25:41)? Impossible! He never changes. Our hope has, for the keystone of its arch, the unchanging love of Jesus Christ, who is *"the same yesterday, and to day, and for ever"* (Heb. 13:8). The Holy Spirit has poured out the love of God in Christ Jesus into our hearts in such a way that we feel quite sure that nothing can separate us from it. And as long as we are not divided from it, our hope of glory is as sure as the throne of the Eternal.

The apostle also reminded us that *"we have now received the atonement"* (Rom. 5:11). We already feel that we are one with God. Through the sacrifice of the Lord Jesus, we are at peace with God. We love Him; our quarrel with Him has ended. We delight in Him; we long to glorify Him. Now, this delightful sense of reconciliation is a satisfactory assurance of grace and glory. The hope of glory burns in the golden lamp of a heart that has been reconciled to God by Jesus Christ. Since we are now in perfect accord with God, longing only to be and to do just what He would have us to be and to do, we have the beginnings of heaven within us, the dawn of the perfect day. Grace is glory in the bud. Agreement with God is the seed of perfect holiness and perfect happiness. If we are under the dominion

of holiness, if there is nothing that we would continue to hold onto if we knew that it was contrary to the mind of our holy Lord, then we may be assured that He has accepted us and that we have His life in us and will finally come into His glory. He who has caused His enemies to become His wholehearted friends will not permit this gracious work to be undone or His holy purpose to fail. Our present delight in God is the pledge of our endless joy in Him. Therefore, we are not ashamed of our hope.

The Holy Spirit Is Working in Us

One more thought about this. Note well that the apostle not only mentions the love of God and the fact that it has been poured out into our hearts, but he also mentions the divine Person by whom this has been accomplished. The pouring out of God's love into our hearts has been brought about by the Holy Spirit who has been given to us. This could have been done only by the Holy Spirit. Would you ever have been captivated by the love of God through the influence of the Devil? Would you ever have been overpowered and filled with excessive joy in the love of God through the power of your own fallen human nature? Judge for yourself! Those who have felt the love of God poured out into their hearts can say without a doubt, "This is the finger of God; the Holy Spirit has worked this in me." Nothing short of the Holy Spirit can effect it. Someone may say, "Thank God that I have had the privilege to hear powerful preaching!" That may have been the case, and yet you may never have felt the love of God within your heart. Preachers can shed love abroad by preaching, but they cannot shed it abroad in people's hearts. A higher influence than human oratory must deal with the inner nature.

Perhaps you were alone in your room or walking by the roadside when the sweet savor of love stole into your heart. Oh, the love of God! The amazing, immeasurable, incomprehensible love of the Father! Oh, to feel this until our very souls are inflamed with it and our unloving nature is all on fire with love for the great Lover of the souls of men! Who can do this except the Holy Spirit? And how did we come to have the Holy Spirit except by the free gift of God, whose gifts and calling *are without repentance"* (Rom. 11:29)? God does not give and then take; His gifts are ours forever. If the Holy Spirit has been given to you, is He not the pledge of God's love? Does the New Testament not describe Him as the deposit, the down payment

of the inheritance? Is a deposit not the security for all the rest? Would the Holy Spirit set His seal to a document that, in the end, would prove to be so faulty that it could not effect its purpose? Never. If the Holy Spirit dwells in you, He is the guarantee of everlasting joy. Where grace is given by His divine indwelling, glory must follow. When the Holy Spirit comes into a person, He comes to make His home. He will remain in us until we are caught up to the higher realms to see our Lord's face forever.

THE RESULT OF OUR CONFIDENT HOPE

This confident hope produces inward joy. The person who knows that his hope of glory will never fail him because of the great love of God that he has tasted, will hear music at midnight. The mountains and the hills will break out into singing wherever he goes. He will be found rejoicing *"in hope of the glory of God"* (Rom. 5:2), especially in times of tribulation. His most profound comfort will often be enjoyed in his deepest affliction, because then the love of God will be especially revealed in his heart by the Holy Spirit, whose name is the *"Comforter"* (John 14:16). Then he will perceive that the rod of correction has been dipped in mercy, that his losses have been sent in fatherly love, and that his aches and pains have been measured out with gracious purpose. In our affliction, God is doing nothing to us that we would not wish for ourselves if we were as wise and loving as God is. My friend, you do not need gold to make you happy; you do not even need health to make you glad. If you will only get to know and feel divine love, the fountains of delight will be poured out to you—you will be introduced to the banquets of happiness.

Our inward joy brings with it the grace of holy boldness in the declaration of our hope. Christians do not show unbelievers the joy of their hope often enough. We do not wear our best uniforms or say enough of the joy of being in the Lord's service or speak enough of the wages that our Lord will pay at the end of the day. We are as silent as if we were ashamed of our hope. We even go around mourning, although we have reason to be the happiest people on God's earth. I am afraid that we do not have enough experience of having had divine love poured out into our hearts. If the perfume were within us, it would be perceived by those who are around us. When you pass a perfume factory, you immediately perceive the

sweet scent. Let us cause unbelievers to know the fragrance of our joyous hope. Let us especially tell those who seem most likely to laugh at us, for I have learned by experience that some of these are most likely to be affected.

Many times a new convert has written to an unbelieving friend to tell him of his great change and of his new joy, and that friend has put the letter aside with a sneer or a joke. However, after a while he has thought it over and has said to himself, "There may be something in this. I am a stranger to the joy of which my friend speaks, and I certainly need all the joy I can get, for I am dejected enough." Let me tell you that all unbelievers are not the fools that some would take them to be. They are aware of an unrest within their hearts, and they hunger for something better than this empty world can give them. Because of this, it frequently happens that as soon as they learn what is good, they accept it. Even if they are not hungering for God, I do not know any better way of making someone long for food than for you yourself to eat. The onlooker will feel his mouth water and will suddenly get an appetite.

In the parable of the prodigal son, the servants were ordered to bring out the best robe and to put it on him, to put a ring on his hand and shoes on his feet. However, the father did not tell them to take the son and make him eat. What he said was, *"Let us eat, and be merry"* (Luke 15:23). He knew that when his hungry son saw others feasting, he would start eating, too. When those who belong to the divine family eat and drink in happy fellowship and are merry with the Lord in feasting upon divine love, the poor hungry brother will desire to join you, and he will be encouraged to do so.

May we enjoy true godliness so much that we never bring shame upon it or feel shame concerning it. Come, then, you who have a hope of glory, let all men see that you are not ashamed of it. Act as decoy birds to others. That is, let the sweet notes of your happy lives attract them to Jesus! May the Lord cause you to disperse the love that He has poured out into your hearts, and may that which perfumes your hearts also perfume your houses, your businesses, your conversations, and your entire lives! Let all who meet you see *"Christ in you, the hope of glory"* (Col. 1:27).

Book
Five

The Practice of Praise

1

The Philosophy of Abundant Praise

They shall abundantly utter the memory of thy great
goodness, and shall sing of thy righteousness.
—Psalm 145:7

P salm 145 is called "David's Psalm of Praise." You will see all through it that he had a strong desire for God to be greatly magnified. Hence he used a variety of expressions and repeated himself in his holy zeal. If you run your eye down the psalm, you will notice such words as these: *"I will extol thee....I will bless thy name"* (v. 1). *"Every day will I bless thee; and I will praise thy name for ever and ever"* (v. 2). *"Great is the LORD, and greatly to be praised"* (v. 3). *"One generation shall praise thy works to another"* (v. 4). *"I will speak of the glorious honour of thy majesty"* (v. 5). *"Men shall speak of the might of thy terrible acts"* (v. 6). You will see other similar words, down to the last verse: *"My mouth shall speak the praise of the LORD: and let all flesh bless his holy name for ever and ever"* (v. 21).

David was not content with declaring that Jehovah is worthy of praise or with pleading that His praise ought to be felt in the heart, but he had it publicly spoken of, openly declared, plainly uttered, and joyfully proclaimed in song. The inspired psalmist, moved by the Holy Spirit, called upon all flesh and all the works of God to sound forth the praises of the Most High. Will we not respond to the call?

In outlining his design for praise, David spoke in verse five of the majesty of God, the glorious King. It seems that his eye was dazzled by the glorious splendor of that august throne, so he cried

out, *"I will speak of the glorious honour of thy majesty"* (Ps. 145:5). Then he pondered the power of that throne of majesty and of the force with which its just decrees are carried out, and so in verse six he exclaimed, *"Men shall speak of the might of thy terrible acts: and I will declare thy greatness"* (v. 6). Here he briefly spoke about both the majesty and the might of the venerable Almighty. However, when he turned his thoughts to the divine goodness, he enlarged and used words that indicated the stress that he laid on his subject and his desire to linger over it: *"They shall abundantly utter the memory of thy great goodness"* (v. 7).

Now, our desire is that we also may praise and magnify the name of the infinite Jehovah without restraint or limit, and may especially have our hearts enlarged and our mouths opened wide to speak abundantly of His great goodness. In all of the congregation of believers, may the text become true: *"They shall abundantly utter the memory of thy great goodness."* Also, having uttered it in plain speech, may we all rise a step higher and sing of His righteousness with glad music.

I hope that you see the objective, an aim in which I trust you sympathize. Come, one and all, and praise the Lord. Is the invitation too wide? Observe the ninth verse: *"The LORD is good to all: and his tender mercies are over all his works. All thy works shall praise thee"* (vv. 9–10). I will not limit the invitation of the Lord. Since you all drink of the river of His bounty, render to Him such praises as you can.

But there is a special invitation to His saints. Come and bless His name with spiritual, inward, enlightened praise. *"Bless the LORD, O house of Levi: ye that fear the LORD, bless the LORD"* (Ps. 135:20). In your heart of hearts, extol, adore, and make Him great, for it is written, *"Thy saints shall bless thee"* (Ps. 145:10). Truly this was not written in vain. Let our souls bless the Lord today as the Holy Spirit moves within us.

We will focus on two things so that we may promote the objective we have in view. The first is the method of securing the abundant utterance of God's praise for His goodness; the second is the motives for desiring to secure this abundant utterance.

HOW TO HAVE ABUNDANT PRAISE

To begin, let us discover the method of securing abundant utterance of divine praise concerning His goodness. Our text gives us

the mental philosophy of abounding praise, and it shows us the plan by which such praise may be secured. The steps are such as the best philosophical logic approves.

Carefully Observe God's Goodness

First, we will be helped to abundant praise by careful observation. Notice the text: *"They shall abundantly utter the memory of thy great goodness."* In order to recall a memory, there must first be observation. A man does not remember what he never knew. This is clear to all, and therefore the point is virtually implied in the text. In proportion to the impression a fact or a truth makes on the mind, in that same proportion it is likely to abide in the memory. If you hear a sermon, the thing that you remember afterward is the point that most forcibly strikes you while you are listening to the discourse. At the time, you say, "I will jot that down. I do not want to forget it, because it comes so closely home to me." Whether you use your pencil or not, memory obeys your wish and records it on her tablets.

The dealings of God toward us are just the same. If we want to remember His goodness, we must let it make an impression on us. We must notice it, consider it, meditate on it, estimate it, and allow it to exert its due influence on our hearts. Then we will not need to say that we must try to remember, for we will remember as a matter of course. The impression, having been clearly and deeply made, will not easily fade away, but we will recall it later. The first thing, therefore, toward the plentiful praising of God is a careful observation of His goodness.

Now, see what it is that we are to observe: God's goodness. Too many are blind to that blessed object of observation. They receive the bounties of providence, but do not see the hand of God in them. They are fed by His liberality and guided by His care, but attribute all that they receive to themselves or to secondary agents. God is not in all their thoughts, and consequently His goodness is not considered. They have no memory of His goodness because they have made no observation of it.

Some indeed, instead of observing the goodness of God, complain of His unkindness to them and imagine that He is needlessly severe. Like the unprofitable servant in the parable, they say, *"I knew thee that thou art an hard man"* (Matt. 25:24). Others sit in

judgment of His ways, as recorded in Holy Scripture, and dare to condemn the Judge of all the earth. Denying the goodness of Jehovah, they attempt to set up another God than the God of Abraham, Isaac, and Jacob, who, for this enlightened century, is a God much too sternly just. However, we worship Jehovah, the God of Abraham, Isaac, and Jacob, the Father of our Lord and Savior Jesus Christ, and none other than He. At present, many adore new gods, unknown to our forefathers, not like the God of the Old Testament, who in the opinion of modern philosophers is as much out-of-date as Jupiter himself. This day we say with David, *"This God is our God for ever and ever"* (Ps. 48:14). *"O come, let us worship and bow down: let us kneel before the LORD our maker. For he is our God; and we are the people of his pasture, and the sheep of his hand"* (Ps. 95:6–7).

As we find the Lord revealed both in the Old and the New Testaments, making no division in the revelation, but regarding it as one grand whole, we behold abundant goodness in Him. Mingled with that awful justice that we would not wish to deny, we see surpassing grace, and we delight that God is love. He is gracious and full of compassion, slow to anger, and of great mercy. We have no complaints to make against Him. We wish to make no alteration in His dealings or in His character. He is our exceeding joy. The whole heart rejoices in the contemplation of Him. *"Who is like unto thee, O LORD, among the gods? who is like thee?"* (Exod. 15:11).

We are then to consider what many will not try to believe: that there is great goodness in Jehovah, the God of creation, providence, and redemption; the God of paradise, Sinai, and Calvary. We are to acquaint ourselves thoroughly with Him as He has made Himself known. We are to continually consider His great goodness, so that we may retain the memory of it.

If we are willing to see, we will not lack for opportunities to behold His goodness every day. It is to be seen in so many acts that I will not begin the list, since I would never complete it. His goodness is seen in creation. It shines in every sunbeam, glitters in every dewdrop, smiles in every flower, and whispers in every breeze. Earth, sea, and air, teeming with innumerable forms of life, are all full of the goodness of the Lord. Sun, moon, and stars affirm that the Lord is good, and all terrestrial things echo the proclamation. His goodness is also to be seen in the providence that rules over all. Let rebellious spirits murmur as they may; goodness is enthroned in God's kingdom, and evil and suffering are intruders

there. God is good toward all His creatures, but especially toward the objects of His eternal love, for whom *"all things work together for good"* (Rom. 8:28).

However, we can see the noblest form of divine goodness in the domain of grace. Begin with the goodness that shines in our election. Follow the silver thread through redemption, the mission of the Holy Spirit, the calling, the adoption, the preservation, and the perfecting of the chosen. Then you will see riches of goodness that will astound you. Dwell where you may within the kingdom of redemption, and you will see rivers, even oceans, of goodness. I leave it to your mind to remember these things and to your lips to speak abundantly of the memory of the Lord's great goodness in the wonders of His salvation. It is not my design to speak for you, but to stir you up to speak for yourself.

Observe the Greatness of God's Goodness

The point that struck the psalmist, and should strike us, is the greatness of His goodness. The greatness of the goodness will be seen by the contemplative mind by considering the person upon whom the goodness rests. "Why is this done to me?" will often be the utterance of a grateful spirit. That God should be good to any of His people shows His mercy, but that He should make me to be one of His and deal so well with me, here His goodness does exceed itself! *"Who am I, O Lord GOD? and what is my house?...Is this the manner of man, O Lord?"* (2 Sam. 7:18–19). It is great goodness, since it visits people so insignificant, so guilty, and so deserving of wrath. Blessed be God that He is good to people so ungrateful, to people who cannot even at the best make any adequate return, who, alas, do not even make such return as they could. Lord, when I consider what a brutish creature I am, it is easy to confess the greatness of Your goodness.

The greatness of His goodness becomes apparent when we think of the greatness of God the Benefactor. *"What is man, that thou art mindful of him? and the son of man, that thou visitest him?"* (Ps. 8:4). That God Himself should bless His people, that He should come in the form of human flesh to save His people, that He should dwell in us, walk with us, and be to us a God, a very present help in trouble, is a miracle of love. Is this not great goodness? I could very well understand the infinity of His benevolence committing us to the

charge of angels, but it is amazing that it is written, *"I the LORD do keep it; I will water it every moment: lest any hurt it, I will keep it night and day"* (Isa. 27:3). Oh, the greatness of such personal condescension, such personal care! Heir of heaven, from the fountain of all goodness you will drink, and not from its streams alone. God Himself is your portion and the lot of your inheritance (Ps. 16:5). You are not set aside with lesser creatures; the Creator Himself is yours. Will you not remember this and so keep alive the memory of His goodness?

The greatness of the goodness is on some occasions made manifest by the evil from which it rescues us. Nobody knows the blessing of health as well as he who has been tortured with pain in every limb. Then he blesses Jehovah Rapha, the healing Lord, for his restoration. None knows what salvation means like he who has been crushed under the burden of guilt and has been racked by remorse. Did you ever feel yourself condemned by God and cast out from His presence? Did the pangs of hell commence in your startled conscience? Did your soul long for death rather than life, while thick clouds and darkness enshrouded your guilty spirit? If so, when the Lord has put away your sin and said, *"Thou shalt not die"* (2 Sam. 12:13), when He has brought you forth from prison, broken your chains, and set your feet upon a rock, then has the new song been in your mouth, even eternal praise. Then have you known it to be great goodness that thus delivered you.

We may imagine what the bottom of the sea is like. We may conceive what it must be like to be borne down to the lowest depths, where seaweed is wrapped around dead men's heads. Yet, I assure you, our imaginations poorly realize what Jonah experienced when the floods encompassed him and he sank to the bottom of the sea. When the Lord brought his life up from corruption (Jonah 2:6), then he had a strong, vivid memory of the great goodness of God, knowing he had been delivered from such death.

It is in the storm that we learn to *"praise the LORD for his goodness, and for his wonderful works to the children of men"* (Ps. 107:8). If I might have it so, I could wish my whole life to be as calm as a fair summer's evening when scarcely a breeze stirs the happy flowers. I could desire that nothing might again disturb the serenity of my restful spirit. But were it to be so, I suspect I would know but little of the great goodness of the Lord. The sweet singer in Psalm 107 ascribed the song of gratitude not to dwellers at home, but to wanderers in the wilderness; not to those who are always at

liberty, but to emancipated captives; not to the strong and vigorous, but to those who barely escape the gates of death; not to those who stand on a glassy sea, but to those who are tossed on a raging ocean.

Doubtless we would not perceive the greatness of goodness if we did not see the depth of the horrible pit from which it snatches us. You were almost ruined in business, friend, but you escaped by the skin of your teeth. Then you praised God for His great goodness. The physicians gave up on your dear child and your wife apparently sickened to the point of death, but both of them have been spared. Here you see the heights and depths of mercy. Now, therefore, lay up this great goodness in your memory to be the material for future psalms of praise.

Recall His Great Benefits

This is not the only way of estimating God's great goodness. You may estimate it by the actual greatness of the benefits bestowed. He gives like a king—no, He gives as only God can give. Behold, your God has not given you a few minted coins of gold, but He has endowed you with the mines themselves. He has not, as it were, handed you a cup of cold water, but He has brought you to the flowing fountain and given the well itself to you. God Himself is ours: *"The LORD is my portion, saith my soul"* (Lam. 3:24).

If you must have a little list of what He has given you, ponder the following: He has given you a name and a place among His people. He has given you the rights and the nature of His sons. He has given you the complete forgiveness of all your sins, and you have it now. He has given you a robe of righteousness, which you are wearing now. He has given you a superlative loveliness in Christ Jesus. He has given you access to Him and acceptance at the mercy seat. He has given you this world and the world to come. He has given you all that He has. He has given you His own Son, and how can He now refuse you anything? Oh, He has given as only God could.

The greatness of His goodness my tongue can never hope to tell. As for myself, I will speak of my Lord as I find Him, for the old proverb tells us do so. Whatever you say, I have nothing to speak except what is good of my God, my King, from my childhood until now. He amazes me with His mercy. He utterly astounds me with

His lovingkindness. He causes my spirit almost to swoon with delight beneath the sweetness of His love.

Yet He has not spared me the rod, nor will He. Blessed be His name for that also. *"Shall we receive good at the hand of God, and shall we not receive evil?"* (Job 2:10) asked the patriarch. But we will go beyond that and assert that evil is no evil when it comes from His hand. Everything that He ordains is good. We may not see it to be so at the time, but so it is. Our heavenly Father seems to rise from good to better, and from better to yet better still in infinite progression. He causes the roadways of our lives to rise higher and higher, and carries them over lofty mountains of lovingkindness. Our paths wind ever upward to yet higher summits of abounding mercy. Therefore, let His praise increase, and the name of the Lord be greater still.

I want to urge you, dear friend, to observe the goodness of God carefully for your soul's good. There is a great difference between eyes and no eyes. Yet many have eyes and still do not see. God's goodness flows before them, but they say, "Where is it?" They breathe it but ask, "Where is it?" They sit at the table and are fed upon it. They wear it on their limbs. It is in the very beating of their hearts, and yet they wonder, "Where is it?" Do not be so blind. *"The ox knoweth his owner, and the ass his master's crib"* (Isa. 1:3). Let us not be slower than beasts of the field, but let us know the Lord and consider His great goodness.

Diligently Remember

I have said that the text contains the philosophy of great praise, and we see this in the second stage of the process, namely, diligent memory. That which has made an impression on the mind by observation is fastened on the memory. Memory seems to lie in two things: first, in retaining an impression, and then in recollecting it at a future time. I suppose that, more or less, everything that happens to us is retained in the mind, but it is not easy to reproduce the fainter impressions when you wish to do so. I know that in my own mind are a great many things that I am sure I can remember, yet I cannot always recall them instantly. Give me a quarter of an hour to run through a certain arrangement of ideas, and I can say, "Oh yes, I have it. It was in my mind, but I could not recollect it at the time." Memory collects facts and afterward recollects

them. The matters before us are recorded by memory, but the tablet may be misplaced. The perfection of memory is to preserve the tablet in a well-known place from which we can bring it forth at any moment.

I have dwelt at length on observation with the idea that you may begin correctly from the very outset. By getting vivid impressions, you may be the better able to retain and to recall them. We cannot utter what we have forgotten. Thus, we need close observation to establish a strong memory concerning the Lord's great goodness.

Familiarize Yourself with God's Word

How are we to strengthen our memory about God's goodness? First, we should be well acquainted with the documents in which His goodness is recorded. A man may be said to keep in memory a fact that did not happen in his own time, but hundreds of years before he was born. He remembers it because he has seen the document in which the fact is recorded. In a certain sense, this is within the range of memory. It is within the memory of man, the united memory of the race, because it has been recorded and can be retrieved. Beloved, be familiar with the Word of God. Stock your memory with the ancient records of His great goodness. Drink in the whole narrative of the evangelists, and do not despise Moses and the prophets. Soak in the Psalms, the Song of Solomon, and other such books until you come to know the well-recorded goodness of the Lord. Have His words and deeds of goodness arranged and ready at hand. Let them be at your fingertips, as it were, because they are in your heart's core. Then you will be sure to abundantly utter the memory of His goodness, for *"out of the abundance of the heart the mouth speaketh"* (Matt. 12:34).

Be Baptized and Receive Communion

Next, if you want to strengthen your memory, diligently observe memorials. There are two in the Christian church. There is the memorial of your Savior's death, burial, and resurrection as set forth in believers' baptism, in which we are buried and risen with the Lord Christ. Do not forget that memorial of His deep anguish when He was immersed in grief and plunged in agony, for He instructs you

to observe it. As for the Holy Supper, never neglect it, but be often at the table, where again you set forth His death until He comes. He has instructed you to do this in remembrance of Him. Cherish devoutly the precious memorial. Great events in nations have been preserved in the memory of future generations by some ordained ceremonial. The Lord's Supper is of that kind. Therefore, observe well the table of the Lord so that you do not forget His great goodness. See how the Jews kept their Exodus in mind by means of the Passover lamb; how they ate it after the sprinkling of the blood; how they talked to their children and told them of the deliverance from Egypt, abundantly uttering the memory of God's goodness; and how after supper they sang a hymn, even as our text tells us to sing of the goodness of God. Strengthen your memories, then, by reverent attention to the historical documents and the memorial ordinances.

Cherish Personal Experiences

Still, the most important is the memory of what has happened to you, your own personal experience. I will not give a penny for your religion unless it has had an effect on you. The power of prayer! What about that? Have you ever received an answer to prayer? Have you ever wrestled with the angel and come away victorious? What do you know about prayer if you never have? You are very orthodox, but unless the doctrines of grace have brought to your soul the grace of the doctrines, and you have tasted and handled them, what do you know about them? You have nothing to remember.

Oh, dear heart, were you ever born again? Then you will remember His great goodness. Were you ever cleansed from your sin and justified in Christ? You will remember His great goodness. Have you been renewed in heart so that you hate sin and live in holiness? If so, you will remember, because you know something that flesh and blood has not revealed to you. Let every personal mercy be written on your personal memory.

Associate God's Goodness with Objects around You

I have heard that the practice of mnemonics, or the strengthening of the memory, lies in the following of certain methods. According to some, you link one idea with another and recollect a date

by associating it with something that you can see. Practice this method in the present case. Remember God's goodness by the objects around you that are associated with it. For instance, let your bed remind you of God's mercy in the night watches, and let your table bring to remembrance His goodness in supplying your daily needs. My garments, when I put them on this morning, reminded me of times when my hand was not capable even of that simple task. All around us there are memoranda of God's love if we choose to read them. The memory of some deed of divine goodness may be connected with every piece of furniture in your room. There is the old armchair where you wrestled with God in great trouble and received a gracious answer. You cannot forget it. You do not pray as well anywhere else as you do there. You have become attached to that particular chair. That well-thumbed Bible—your special one—is getting rather worn now and is marked up a good deal. Nevertheless, out of that very copy the promises have gleamed forth like the stars in heaven, and so it helps your memory to use it.

I remember a poor man giving me what I thought was great praise. I visited him in the hospital, and he said, "You seem to have filled this room with your texts, for everything reminds me of what I have heard you say. As I lie here, I recall your stories and sayings." In much the same way, we should recollect what God has done for us by looking at the various places, circumstances, times, and persons that were the surroundings of His mercy. Oh, for a clear remembrance of God's goodness.

Put God's Blessings in Order

Memory is sometimes helped by classification. When you send your maid to a shop for a variety of articles, she may forget something unless you arrange the order of the list so that one suggests another. Take care to set God's mercies in order. Enumerate them as you can, and so fix them in your memory.

Use Other Memory Devices

At other times, when people have very bad memories, they like to jot down on a bit of paper the things that are important to remember. I have often done so, and then have placed the paper

where I have never found it again. A thread tied around the finger and many other memory devices have been tried. I do not mind what method you use, as long as you try to recall God's mercy to you by some means or other. Do make some record of His goodness. You remember the day that you lost that money, do you not? "Yes, very well." You recall the day of the month of Black Friday, or Black Monday. You have evil days indelibly noted in the black notebook of memory. Do you remember as well the days of God's special lovingkindness to you? You should do so. Carefully take note of noteworthy benefits and mark remarkable blessings. Thus, you will in future days *"abundantly utter the memory of* [God's] *great goodness."*

Speak about God's Mercy

The first two processes for securing abundant praise are observation and remembrance. The next is utterance: *"They shall abundantly utter."* The word contains the idea of boiling or bubbling up like a fountain. It signifies a holy fluency about the mercy of God. We have quite enough fluent people around, but many of them are idlers for whom Satan finds abundant things to say. It does not matter how fluent men and women are, if they will be fluent on the topic now before us. Open your mouths. Let the praise pour forth. Let it come, rivers of it. Stream away! Gush away, all that you possibly can. *"They shall abundantly utter the memory of thy great goodness."* Do not stop the joyful speakers. Let them go on forever. They do not exaggerate, for they cannot. You say they are enthusiastic, but they are not half up to pitch yet. Encourage them to become more excited and speak even more fervently. Go on, go on. Pile it up. Say something greater, grander, and more fiery still! You cannot exceed the truth. You have come to a theme where your most fluent powers will fail in utterance. The text calls for a sacred fluency, and I would exhort you liberally to exercise it when you are speaking of the goodness of God.

"They shall abundantly utter [it]*."* That is, they will constantly be doing it. They will talk about God's goodness all day long. When you step into their homes, they will begin to tell you of God's goodness to them. When you bid farewell to them at night, you will hear more last words on the favorite theme. Very likely they will repeat themselves, but that does not matter. You cannot have too much of

this truly good thing. Just as the singers in the temple repeated again and again the chorus, *"His mercy endureth for ever"* (see Psalm 136), so may we repeat our praises. Some of God's mercies are so great and sweet that if we never had another throughout eternity, the recollection of the single favor might forever remain. The splendor of divine love is so great that a single manifestation of it is often all that we can bear. To have two such revelations at once would be as overpowering as if God would make two suns when one already fills the world with light. Oh, praise the Lord with boundless exultation. Rouse all your faculties to this service, and *"abundantly utter the memory of* [His] *great goodness."*

You cannot praise abundantly unless your memory supplies materials. On the other hand, your memory will lose strength unless you utter what you know. When you went to school and had a lesson to learn, you found out that by reading your lesson aloud, you learned it more quickly because your ear assisted your eye. Uttering the divine goodness is a great help to the memory of it. By teaching, we learn. By giving the truth expression, we deepen its impression on our minds.

Sing about God's Goodness and Righteousness

Now I come to the last part of this admirable process. When we have abundantly uttered, then we are to sing. In the old Greek mythology, Mnemosyne, the goddess of memory, is the mother of the Muses, and surely where there is a good memory of God's lovingkindness, the heart will soon produce a song. But what is surprising in the text is that when the joy is described as mounting from simple utterance to song, it takes on another theme: *"They...shall sing of thy righteousness."* When the heart is most adoring and selects the grandest theme for reverent song, it chooses the meeting of goodness and righteousness as its topic. How sweet is that melody: *"Mercy and truth are met together; righteousness and peace have kissed each other"* (Ps. 85:10).

The Atonement is the gem of the heart's poetry. Does your heart not burn within you at the very mention of the glorious deed of Jesus our great Substitute? Parnassus is outdone by Calvary; the Castalian spring is dried up and Jesus' wounded side has opened another fountain of song. The goodness of the Lord to us in all the blessings of His providence we gladly recite, but when we

tell of the grace that led our Lord Jesus Christ to bleed and die, *"the just for the unjust, that he might bring us to God"* (1 Pet. 3:18), our music leaps to nobler heights. Incomparable wisdom ordained a way in which God could be righteous to the sternness of severity, and yet could be good, illimitably good, to those who put their trust in Him. Therefore, lift up your music until the golden harps find themselves outdone.

Thus, we have explained the method of securing an abundant utterance. May the Holy Spirit help us to carry it out.

THE MOTIVATION FOR ABUNDANT PRAISE

Now, we will very briefly note the motives for this abundant utterance. These lie very near at hand.

A Compelling Desire

The first is, because we cannot help it. The goodness of God demands that we speak of it. If the Lord Jesus Himself would charge His people to be silent about His goodness, they would scarcely be able to obey the command. They would, like the man who was healed, blaze abroad the mighty work that He had done. But, bless His name, He has not told us to be quiet. He allows us to utter the memory of His great goodness abundantly. The stones of the street would cry out as we went along if we did not speak of His love.

Some of you good people seldom speak of the goodness of God. Why is this? I wonder how you can be so coldly quiet. "Oh," said one young man when he first fell in love, "I must speak or I will burst." We have sometimes felt the same way, when restrained testimony became fire within our bones. Is it not a sacred instinct to tell what we feel within? The news is too good to keep. Fully indulge the holy propensity of your renewed nature. Your soul says, "Speak." If etiquette says, "Hush, they will think you a fanatic," do not regard it, but speak aloud. Let them think you are a fanatic if they please. Play the organ softly when the subject is your own praise, but when it comes to the praises of God, pull out all the stops. Thunderous music is too little for His infinite deserving.

Competing Voices

Another motive for abundantly uttering the praises of God is that other voices are clamorous to drown it. What a noisy world this is with its conflicting, discordant cries. "Here," cries one. "Look there," shouts another. This uproar would drown the notes of God's praise unless His people uttered them again and yet again. The more there is said against our God, the more we should speak for Him.

Whenever you hear a man curse, it would be wise to say aloud, "Bless the Lord." Say it seven times for every time he curses, and make him hear it. Perhaps he will want to know what you are doing, which will then give you an opportunity of asking what he is doing. He will have more difficulty in explaining himself than you will in explaining yourself. Do try if you can to make up for the injuries done to the dear and sacred name of God by multiplying your praises in proportion as you hear Him spoken ill of. I say, unless you give forth abundant utterance, God's praise will be buried under heaps of blasphemy, ribaldry, nonsense, error, and idle talk. Abundantly utter it so that some of it, at least, may be heard.

Our Own Benefit

Praise the Lord abundantly because it will benefit you to do so. How bright the past looks when we begin to praise God for it. When we say, *"I am the man that hath seen affliction"* (Lam. 3:1), we are filling the cup of memory with gall and wormwood (v. 19). But when we see the goodness of God in it all, we turn the handkerchief with which we wiped our tears into a flag of victory, and with holy praise, in the name of our God, we wave His banner.

As for the present, if you think of God's mercies, how different it seems. A man comes to his dinner table and does not enjoy what is there, because he misses an expected delicacy. But if he were as poor as some people, he would not turn his nose up, but would bless the goodness that has given him so much more than he deserves. Even some Christians that I know are growlers, in general always finding fault. The best things in the world are not good enough for them. Oh, beloved, *"abundantly utter the memory of* [God's] *great goodness,"* and you will find nothing to grumble at, nothing to complain about, but everything to rejoice in.

As for the future, if we remember God's goodness, how joyfully we will march into it. There is the same goodness for tomorrow as for yesterday, and the same goodness for old age as for youth; the same God to bless me when I grow gray as when I was a babe in my mother's arms. Therefore, I go forward to the future without hesitation or suspicion, abundantly recounting the lovingkindness of the Lord.

The Benefit of Others

Again, I think we ought to do this because of the good it does for other people. If you abundantly talk of God's goodness, you are sure to benefit your neighbors. Many are comforted when they hear of God's goodness to their friends. Put on a long face and lament the trials of the way. Sit down with somber believers and enjoy a little comfortable misery. Then see whether crowds will ask to share your vinegar bottle.

> While here our various wants we mourn,
> United groans ascend on high,

says Dr. Watts, and I am afraid he speaks the truth. However, very few will be led in this way to resolve, *"We will go with you: for we have heard that God is with you"* (Zech. 8:23). Is it good reasoning if men say, "These people are so miserable that they must be on the way to heaven"? We may hope they are, for they evidently want some better place to live in. But then it may be questioned if such folks would not be wretched even in heaven. Dear friend, you would not be much attracted by sanctimonious misery. Therefore, do not try it yourself.

On the contrary, talk much of the goodness of the Lord, wear a smiling face, let your eyes sparkle, and go through the world as the Lord's free man, not looking like a slave under the lash or a prisoner in bonds. We have glorious reasons for being happy. Let us be so, and soon we will hear people asking, "What is this? Is this religion? I thought religious people felt bound to be down in the dumps and to go mourning and sighing all their days." When they see your joy, they will be tempted to come to Christ. There is a blessed attraction in a holy, happy life. Praise His name forevermore. *"Abundantly utter the memory of* [His] *great goodness,"* and you will bring many to Christ.

Such happy utterance will also help to comfort your own Christian friends and fellow sufferers. There is a great deal of misery in the world—now more than usual. Many are sorrowing from various causes. Therefore, my dear friend, be happier than ever before. That venerable man of God, now in heaven, our dear old Dransfield, when it was a very foggy morning in November, always used to come into the vestry before the sermon and say, "It is a dreary morning, dear pastor. We must rejoice in the Lord more than usual. Things around us are dark, but within and above, all is bright. I hope we will have a very happy service today." He would shake hands with me and smile, until he seemed to carry us all into the middle of summer. What if the weather is bad? Bless the Lord that it is not worse than it is. We are not altogether in Egyptian darkness. The sun does shine now and then, and we are sure it has not blown out. So when we are sick, let us thank God that we will not be ill forever, for there is a place where the inhabitants are never sick. Today, if your harps have been hanging on the willows, take them down (see Psalm 137:1–4); if you have not praised the Lord as you should, begin to do so. Wash your mouths and get rid of the sour flavor of murmuring about bad trade and bad weather.

Sweeten your lips with the pleasant confection of praise. If anyone should confess to me that he has sinned by going too far in blessing God, I would for once become a priest and give him absolution. I never tried my hand at that business before, but I think I can manage that much. Praise God extravagantly if you can. Try it. Say to yourself, "I will go beyond all boundaries in this matter," for there are no limits to what God deserves, for He ever blesses.

The Glory of God

Lastly, let us praise and bless God because it is the way in which He is glorified. We cannot add to His glory, for it is infinite in itself, but we can make it more widely known by simply stating the truth about Him. Do you not want to give honor to God? Would you not lay down your life so that the whole earth might be filled with His glory? Well, if you cannot cover the earth with His praise as the waters cover the sea, you can at least contribute your portion to the flood.

Do not keep back your praises, but bless and magnify His name, *"from the rising of the sun unto the going down of the same"* (Ps. 113:3). It will lift the earth upward and heavenward if we all

unite in praise. We will see it rising, as it were, beneath our feet, and ourselves rising with it, until we stand as upon the top of some lofty alp that has pierced the vault of heaven. We will be among the angels, feeling as they feel, doing as they do, and losing ourselves as they lose themselves in the eternal hallelujah of *"Blessing, and honour, and glory, and power, be unto him that sitteth upon the throne, and unto the Lamb for ever and ever"* (Rev. 5:13).

2

More and More

But I will hope continually,
and will yet praise thee more and more.
—Psalm 71:14

When sin conquered the realm of manhood, it slew all the minstrels except those of hope. For humanity, amid all its sorrows and sins, hope sings on. To believers in Jesus, there remains a royal race of minstrels, for we have a hope of glory, a living hope, a hope eternal and divine. Because our hope abides, our praise continues. *"I will hope continually, and will yet praise thee."* Because our hopes grow brighter and are every day nearer and nearer to their fulfillment, the volume of our praise increases. *"I will hope continually, and will yet praise thee more and more."*

A dying hope would bring forth declining songs. As the expectations grew more dim, the music would become more faint. But a hope immortal and eternal, flaming forth each day with more intense brightness, brings forth a song of praise that always gathers new force as it continues to rise. See well to your faith and your hope, for otherwise God will be robbed of His praise. It will be in proportion to how much you hope for the good things that He has promised to your faith that you will render to Him the praise that is His royal revenue, acceptable to Him by Jesus Christ, and abundantly due from you.

David had not been slack in praising God. Indeed, he was a sweet singer in Israel, a choirmaster unto the Lord. Yet he vowed to praise Him more and more. Those who do much already are usually the people who can do more. David was old. Would he praise God more when he was infirm than he had when he was young and vigorous? If he could not excel with loudness of voice, he

would excel with eagerness of heart. What his praise might lack in sound, it would gain in solemn earnestness. Also, he was in trouble in Psalm 71, yet he would not allow the heyday of his prosperity to surpass the dark hour of his adversity in its notes of loving adoration. For him there could be no going back on any account.

David had adored the Lord when he was but a youth and kept his father's flock. Harp in hand, beneath the spreading tree, he had worshiped the Lord his Shepherd, whose rod and staff were his comfort and delight. When he was an exile, he had made the rocky fortresses of Adullam and Engedi resound with the name of Jehovah. Later, when he had become king in Israel, his psalms had been multiplied, and his harp strings were daily accustomed to the praises of the God of his salvation.

How could that zealous songster make an advance in praise? See him dancing before the ark of the Lord with all his might; what more of joy and zeal can be manifest? Yet he says, *"I...will yet praise thee more and more."* His troubles had been multiplied of late, and his infirmities, too. Yet for all that, no murmuring escaped him, but he resolved that his praise would rise higher and higher until he continued it in better lands forever and ever.

Beloved, I pray that the Holy Spirit may make my word stimulating to you. Our subject is that of praising God more and more. I do not intend to entreat you to praise God; I will take it for granted that you are doing so, though I fear this assumption will be a great mistake in the case of many. Those who do not praise God at all cannot be urged to praise Him more and more. I am directing myself to those who now love to praise God. I charge you to resolve with David: *"I...will yet praise thee more and more."*

RECOUNTING MANY REASONS TO PRAISE GOD

Our first business will be to urge ourselves to this resolution. Why should we praise God more and more? I am overwhelmed with the multitude of arguments that surround me. So many crowd around me that I cannot number them in order but must seize them at random.

Our Current Lack of Praise

It is humbling to remember that we may very well praise God more than we have done, for we have praised Him very little up to

this point. What we believers have done in glorifying God falls far, far short of what is due Him. Personally, upon consideration, we each must admit this. Think, my dear believer, about what the Lord has done for you. Some years ago you were in sin, death, and ruin, but He called you by His grace. You were under the burden and curse of sin, but He delivered you. Did you not expect in your first joy of pardon to have done more for Him, to have loved Him more, to have served Him better? What returns have you made for the blessings that you have received? Are they at all fitting or adequate? I look at a field loaded with precious grain and ripening for the harvest. I hear that the farmer has expended so much in rent, so much on the plowing, so much in enriching the soil, so much for seed, so much more for necessary weeding. There is the harvest, which yields a profit: he is contented.

I see another field. It is my own heart, and yours is the same. What has the God done for it? He has reclaimed it from the wild waste by a power no less then omnipotent. He has hedged it, plowed it, and cut down the thorns. He has watered it as no other field was ever watered, for the bloody sweat of Christ has moistened it in order to remove the primeval curse. God's own Son has given His all so that this barren waste may become a garden. All the things that have been done would be hard to enumerate. What more could have been done none can say. Yet what is the harvest? Is it proportional to the labor expended? Is the work rewarded? I am afraid that if we cover our faces with our hands, or with a blush, it will be the fittest reply to the question. Here and there a withered ear is a poor recompense for the tillage of infinite love. Let us, therefore, be shamed into a firm resolve and say with resolute spirit, "By the good help of infinite grace, I, at any rate, having been so great a dawdler, will quicken my pace. '*I...will yet praise thee more and more.*'"

The Profit of Praise

Another argument that presses upon my mind is this: when we have praised God up until now, we have not found the service to be a weariness to ourselves, but it has always been to us both a profit and a delight. I would not speak falsely even for God, but I can testify that the happiest moments I have ever spent have been occupied with the worship of God. I have never been so near heaven as when adoring before the eternal throne. I think every

Christian could say the same. Among all the joys of earth—and I will not depreciate them—there is no joy comparable to that of praise. The innocent happiness of the fireside, the chaste happiness of household love, even these are not to be mentioned side by side with the joy of worship, the rapture of drawing near to the Most High. Earth, at her best, yields only water, but this divine occupation is as the wine of Cana's marriage feast.

The purest and most exhilarating joy is the delight of glorifying God and anticipating the time when we will enjoy Him forever. Now, if God's praise has been no wilderness to you, return to it with zest and ardor, saying, *"I...will yet praise thee more and more."* If anyone supposes that you grow weary in the service of the Lord, tell him that His praise is such freedom, such recreation, such joy, that you desire never to cease from it. As for me, if men call God's service slavery, I desire to be a bond slave forever and want to be branded with my Master's name indelibly. I want to have my ear bored to the doorpost of my Lord's house, and leave no more. (See Exodus 21:2–6.) My soul joyfully sings:

> Let Thy grace, Lord, like a fetter,
> Bind my wandering heart to Thee.

This will be my ambition—to be more and more subservient to the divine honor. This will be gain—to be nothing for Christ's sake. This is my all in all—to praise You, my Lord, as long as I have any being.

God's Many Mercies

A third reason readily suggests itself. We surely ought to praise God more today than ever before because we have received more mercies. Even of temporal favors we have been large partakers. Begin with these, and then rise higher. Some of you may well be reminded of the great temporal mercies that have been lavished upon you. Today you are in a state similar to Jacob's when he said, *"With my staff I passed over this Jordan; and now I am become two bands"* (Gen. 32:10). When you first left your parent's house to follow a toilsome occupation, you had little money and poor prospects, but where are you now as far as temporal circumstances and position? How highly God has favored some of you! Joseph has risen from the dungeon to the throne; David has gone from the

sheepfold to a palace. Look back to what you were, and give the Lord His due. *"He raiseth up the poor out of the dust...to set them among princes"* (1 Sam. 2:8). You were unknown and insignificant, and now His mercy has placed you in prominence and esteem. Is this nothing? Do you despise the bounty of heaven? Will you not praise the Lord more and more for this? Surely, you should and must do so, or else feel the withering curse that blasts ingratitude wherever it dwells.

Perhaps divine providence has not dealt with you exactly in that way, but with equal goodness and wisdom has revealed itself to you in another form. Perhaps you have continued in the same sphere in which you started, but you have been enabled to pursue your work, have been kept in health and strength, and have been supplied with food and clothing. Best of all, you have been blessed with a contented heart and a sparkling eye. My dear friend, are you not thankful? Will you not praise your heavenly Father more and more?

We should not overemphasize temporal mercies to the point that we become worldly, but I am afraid there is a greater likelihood of our underestimating them and becoming ungrateful. We must beware of so undervaluing them that we lessen our sense of the debt that we owe God.

We must speak of great mercies sometimes. Come now; I will ask you a question: Can you count your great mercies? I cannot count mine. Perhaps you think it is easy to list them. I find it an endless task. I was thinking the other day what a great mercy it is to be able to turn over in bed. Some of you smile, perhaps. Yet I do not exaggerate when I say I clapped my hands for joy when I found myself able to turn in bed without pain. Right now, it is to me a very great mercy to be able to stand upright. We carelessly imagine that there is only a dozen or two of great mercies, such as having our children around us or enjoying good health. But in trying times, we see that many minor matters are also great gifts of divine love and entail great misery when they are withdrawn. Sing, then, as you draw water at the springs. As the brimming vessels overflow, praise the Lord *"more and more."*

But should we not praise God more and more when we think of our spiritual mercies? What favors we have received of this higher sort! Ten years ago you were bound to praise God for the covenant mercies you had even then enjoyed. Now, how many more have been bestowed upon you? How many upliftings amid darkness?

How many answers to prayer? How many directions in dilemma? How many delights of fellowship? How many helps in service? How many successes in conflict? How many revelations of infinite love? To adoption there has been added all the blessings of being an heir; to justification, all the security of acceptance; to conversion, all the energies of indwelling.

Remember, as there was no silver cup in Benjamin's sack until Joseph put it there, so there was no spiritual good in you until the Lord of mercy gave it. Therefore, praise the Lord. Louder and louder still may your song be. Praise Him on the high-sounding cymbals (Ps. 150:5). Since we cannot hope to measure His mercies, let us immeasurably praise our God. *"I...will yet praise thee more and more."*

God's Faithfulness

Let us go on a little further. All of us have proved through the years the faithfulness, unchangeableness, and truthfulness of God. We have proved these attributes by their bearing the strain of our misbehavior when we have sinned against God. We have proved them by the innumerable benefits the Lord bestows on us. Will all this experience end in no result? Will there be no growth in gratitude where there is such an increase of obligation? God is so good that every moment of His love demands a lifetime of praise.

It should never be forgotten that every Christian, as he grows in grace, should have a loftier idea of God. Our highest conception of God falls infinitely short of His glory, but a mature Christian enjoys a far clearer view of what God is than he had at first. Now, the greatness of God is ever a claim for praise. *"Great is the LORD, and"*—what follows?—*"greatly to be praised"* (1 Chron. 16:25). If God is greater to me than He was before, let my praise be greater. If I think of Him more tenderly as my Father, if I have a clearer view of Him in the terror of His justice, if I have a clearer view of the splendors of His wisdom by which He devised the atonement, if I have larger thoughts of His eternal, unchangeable love, let every advance in knowledge compel me to say, *"I...will yet praise thee more and more."*

May I sincerely pray, *"'I have heard of thee by the hearing of the ear: but now mine eye seeth thee. Wherefore* [while] *I abhor myself, and repent in dust and ashes'* (Job 42:5–6), my praise for You

will rise even higher. Up to Your throne will my song ascend. I only saw the skirts of Your garment, as it were, but You have hidden me in the cleft of the rock, Jesus, and made Your glory pass before me. I will praise You even as the seraphim do and will compete with those before the throne in magnifying Your name." We learn very little in Christ's school if the practical result of it all does not make us cry, *"I...will yet praise thee more and more."*

Our Proximity to Heaven

Still choosing here and there a thought out of thousands, I would remind you that another good reason for praising God more is that we are getting nearer to the place where we hope to praise Him perfectly world without end. Never do the church walls ring more joyously than when the congregation unites in singing about the Father's house on high and having tents pitched "a day's march nearer home."

Heaven is indeed the only home of our souls, and we will never feel that we have come to our rest until we have reached its mansions. One reason that we will be able to rest in heaven is that there we will be able to perpetually achieve the object of our creation. Am I nearer heaven? Then I will be doing more of the work that I will do in heaven. I will soon use the harp, so let me be carefully tuning it. Let me rehearse the hymns that I will sing before the throne. Even though the words in heaven will be sweeter and richer than any that poets can assemble together here, yet the essential song of heaven will be the same as those we are presenting to Jehovah here below:

> They praise the Lamb in hymns above,
> And we in hymns below.

The essence of their praise is gratitude that He suffered and shed His blood; it is the essence of our praise, too. They bless Emmanuel's name for undeserved favors bestowed upon unworthy ones, and we do the same.

My aged brothers and sisters, I congratulate you, for you are almost home. Be fuller of praise than ever. Quicken your footsteps as the glorious land shines more brightly. You are close to the pearly gates. Sing on, though your infirmities increase. Let the

song grow sweeter and louder until it melts into the infinite harmonies.

The Impudence of God's Enemies

Do I need to give another reason that we should praise God more and more? If I must, I would throw this one onto the scale, that surely at this present juncture we ought to be more earnest in the praise of God because God's enemies are very earnest in laboring to dishonor Him. These are times when scoffers are boundlessly impudent. I become angry when I read about the French revolutionists' talk of having "demolished God." It strikes me as an even sadder thing when I read the propositions of their philosophies that suggest they should become religious again and should bring God back for another ten years at least—an audacious recommendation as blasphemous as proclaiming the triumph of atheism.

Perhaps, however, the Parisians speak more honestly than we do here, for among us we have abounding disloyalty that pretends to reverence Scripture while it denies its clearest teachings. Also we have what is quite as bad, a superstition that thrusts Christ aside for the human priest, elevates the sacraments as everything, and makes simple trust in the great atonement to be as nothing. Now, those who hold these views are not sleepers, nor do they relax their efforts. Alas, we may be very quiet and lukewarm about religion, but these people are earnest propagators of their faith, or no faith—they will cover sea and land to make one proselyte. As we think of these busy servants of Satan, we ought to chide ourselves and say, "Should Baal be so diligently served and Jehovah have such a sleepy advocate? Be stirred, my soul! Awake, my spirit! Rise up at once, and praise your God more and more."

Our Hunger and Thirst for God

But while I give you these few arguments out of many that come to mind, the thought cheers my spirit that with those of you who know and love God, there is little need for me to mention reasons because your own souls hunger and thirst to praise Him. If you are kept away for a little time from the public service of God,

you long for the assemblies of God's house and envy the swallows that build their nests beneath the eaves. If you are unable to accomplish the service that you were accustomed to performing for Christ's church, the hours drag wearily along. As the Master found it His meat and His drink to do the will of Him who sent Him (John 4:34), so also when you are unable to do that will, you, too, are like a person deprived of his meat and drink, and an insatiable hunger grows in you. Christian, do you yearn to praise God? I am sure you feel now, "Oh, that I could praise Him better!"

Perhaps you are in a position in which you have work to do for Him, and your heart is saying, "How I wish I could do this work more thoroughly to His praise!" Or possibly you are in such a condition of life that you can do little, and you often wish that God would make a change for you, not that it should be one fuller of comfort, but one in which you could be more serviceable. Above all, I know you wish you were rid of sin and everything that hinders your praising God more and more. Well, then, I do not need to argue, for your own heart pleads the holy cause.

Allow me to illustrate this point with a story. I know a person who has been privileged for a long time to lift his voice in the choir of the Great King. In that delightful labor, none was more happy than he. The longer he was engaged in the work, the more he loved it. Now, it came to pass that on a certain day, this songster found himself shut out of the choir. He would have entered to take his part, but he was not permitted. Perhaps the King was angry; perhaps the songster had sung carelessly; perhaps he had acted unworthily in some other matter; or possibly his Master knew that his song would grow sweeter if he were silenced for a while. Why it happened I do not know, but this I know, that it caused great searching of heart. Often this chorister begged to be restored, but he was just as often repulsed, and somewhat roughly, too. For more than three months, this unhappy songster was kept in enforced silence, with fire in his bones and no vent for it. The royal music went on without him. There was no lack of song, for which he rejoiced, but he longed to take his place again. I cannot tell you how eagerly he longed. At last the happy hour arrived. The King gave His permission that he might sing again. The songster was full of gratitude, and I heard him say, "My Lord, since I am again restored, *'I will hope continually, and will yet praise thee more and more.'*"

415

RIDDING OURSELVES OF HINDRANCES TO PRAISING GOD

Now let us turn to another point. Let us in the Spirit's strength drive away all hindrances to praising God more and more.

Our Lethargy

One of the deadliest things is dreaminess or sleepiness. A Christian readily falls into this state. I notice it even in the public congregation. Very often the whole service is gone through mechanically. That same dreaminess falls on many professing Christians and abides with them. Instead of praising God more and more, it is all they can do to keep up the old strain—and they barely do so. Let us shake ourselves from all such lethargy. Surely if there were any service in which a man would be wholly awake and alert, it is in praising and magnifying God. A sleepy angel at the throne of God or a cherub nodding during sacred song is ridiculous to imagine. Will such an insult to the majesty of heaven be seen on earth? No! Let us say to all that is within us, "Awake!"

Worldly Distractions

The next hindrance would be a divided focus. We cannot, however we may resolve, praise God more and more if, as we grow older, we allow this world to take up our thoughts. If I say, *"I...will yet praise thee more and more,"* yet I am striking out right and left with projects of amassing wealth, or I am plunging myself into greater business cares unnecessarily, my actions belie my resolutions. Not that I want to stop enterprise. There are periods in life when a man may be enabled to praise God more and more by extending the bounds of his business. But there are people I know who praised God very well in a certain condition, but were not content to let well enough alone; they are now set on aggrandizing themselves. They have given up teaching Sunday school, being on the visitation committee, or some other form of Christian service, because their money-getting demanded all their strength. Beloved, you will find it small gain if you gain in this world but lose in praising God. As we grow older, it is wise to concentrate more and

more of our energies on the one thing, the only thing worth living for—the praise of God.

A Wrong Self-Concept

Another great obstacle to praising God more is self-contentment. This, again, is a condition into which we may very easily fall. Our real belief is—only we never say it when we may be overheard—that we are all very fine people indeed. We may confess when we are praying, as well as at other times, that we are miserable sinners, and I dare say we have some belief that this is so. But for all that, there is within our minds the conviction that we are very respectable people and are doing exceedingly well on the whole. Comparing ourselves with other Christians, we think it is much to our credit that we are praising God as well as we are. Now, I have put this very roughly, but is this not what our hearts have said to us at times? Such a loathsome thought it is that a sinner should grow content with himself.

Self-satisfaction is the end of progress. Dear friend, why compare yourself with the dwarfs around you? If you must compare yourself with others, look at the giants of former days. Better still, relinquish altogether the evil habit, for Paul tells us it is not wise to compare ourselves among ourselves. (See 2 Corinthians 10:12.) Look to our Lord and Master, who towers high above us in peerless excellence. No, we dare not flatter ourselves, but with humble self-abasement we resolve to praise the Lord more and more.

Relying on Past Accomplishments

To rest on past laurels is another danger. We did so much for God when we were young. Occasionally I have met drones in the Christian hive whose boast is that they made a great deal of honey years ago. I see men resting on their oars today, but they startle me with a description of the impetus they gave to the boat years ago. You should have seen them in those former times, when they were master-rowers. What a pity that these brothers cannot be aroused to do their first works. It would be a gain to the church, but it would be an equal benefit to themselves. Suppose God would say, "Rest on the past. I gave you great mercies twenty years ago; live on them." Suppose the eternal and ever beloved Spirit would

say, "I did a great work in you thirty years ago. I withdraw Myself, and I will do no more." Where would you be then? Yes, if you still have to draw afresh upon the eternal fountains, do praise the Source of all.

Deep Affliction

May God help us then to shake off all those things that would prevent our praising Him! Possibly there is some afflicted one, in so low a state, so far pressed by poverty or bodily pain, that he is saying, "I cannot praise God more and more. I am ready to despair." Dear believer, may God give you full submission to His will. Then the greater your troubles, the sweeter will be your song.

I heard from an old parson a short, sweet story that touched my heart. A poor widow and her little child were sitting together in great need, both feeling the pinch of hunger. The child looked up into the mother's face and said, "Mother, God won't starve us, will He?" "No, my child," said the mother, "I do not think He will." "But, mother," said the child, "if He does, we will still praise Him as long as we live, won't we, Mother?" May those who are gray-headed be able to say what the child said, and to carry it out. *"Though he slay me, yet will I trust in him"* (Job 13:15). *"Shall we receive good at the hand of God, and shall we not receive evil?"* (Job 2:10). *"The LORD gave, and the LORD hath taken away; blessed be the name of the LORD"* (Job 1:21). *"I...will yet praise thee more and more."*

HOW TO PRAISE GOD IN EVERYDAY LIFE

Very briefly, let us apply ourselves to the practical carrying out of this resolution. I have given you arguments for it and have tried to remove impediments. Now for a little help in the performance of it. How do we begin to praise God more and more?

Prepare Your Heart

Earnestness says, "I will undertake some fresh duty this afternoon." Stop just a minute. If you want to praise God, would it not be beneficial to first begin with yourself? The musician said, "I will praise God better," but the pipes of his instrument were dirty.

He had better look to them first. If the strings have slipped from their proper tension, it would be well to correct them before beginning the tune. If we would praise God more, it is not to be done as boys rush into a swimming pool—head first. No, prepare yourself by making your heart ready. You need the Spirit's aid to make your soul fit for praising God. It is not every fool's work. Go then to your chamber, confess the sins of the past, and ask the Lord to give you much more grace that you may begin to praise Him.

Improve Your Private Devotions

If we want to praise God more and more, let us improve our private devotions. God is much praised by really devout prayer and adoration. Preaching is not fruit: it is sowing. True song is fruit. I mean this: that the green blade of the wheat may be the sermon, but the kernel of wheat is the hymn you sing, the prayer in which you unite. The true result of life is praise to God. "The chief end of man," says the catechism, and I cannot put it better, "is to glorify God, and enjoy Him forever." When we glorify God in our private devotions, we are answering the true end of our being. If we desire to praise God more, we must ask for grace that our private devotions may rise to a higher standard. I am more and more persuaded from my own experience that in proportion to the strength of our private lives with God, so will be the force of our character and the power of our work for Him among men. Let us look well to this.

Praise God Every Day and Everywhere

Again, however, I hear the zealous young man or woman saying, "Well, I will attend to what you have said. I will see to private prayer and to heart work, but I mean to begin some work of usefulness." You are quite right, but wait a little. I want to ask you this question: Are you sure that your own personal conduct in your everyday life has as much of the praise of God in it as it might have? It is all a mistake to think that we must come to a church building to praise God. You can praise God in your shops, in your kitchens, and in your bedrooms. It is all a mistake to suppose that Sunday is the only day in which to praise God. Praise Him on Mondays, Tuesdays, Wednesdays, every day, everywhere. All places are holy to holy people, and all activities holy to holy men, if they

do them with holy motives, lifting up their hearts to God. Whether a man works in a shop or plants seeds on his farm, that which is done as unto the Lord and not unto men is true worship.

I like the story of the maid, who, when asked upon joining the church, "Are you converted?" said, "I hope so, sir." "What makes you think you are really a child of God?" "Well, sir, there is a great change in me from what there used to be." "What is that change?" "I don't know, sir; there is a change in all things. But there is one thing in particular: I always sweep under the mats now." Many a time she had hidden the dust under the mat. It was not so now. It is a very excellent reason for believing that there is a change of heart when work is conscientiously done.

There is a set of mats in all our houses where we are accustomed to hiding the dirt. When a man in his business sweeps under the mats—you merchants have your mats, you know—when he avoids the evils that custom tolerates but God condemns, then he has marks of grace within. Oh, to have a conduct molded by the example of Christ! If any man lived a holy life, though he never preached a sermon or even sang a hymn, he praised God. The more conscientiously he acted, the more thoroughly he praised God.

Serve God More

These inner matters being considered, let us go on to increase our actual service for God. Let us do what we have been doing of Christian teaching, visiting, and so on. However, in all, let us do more, give more, and labor more. Who among us is working at his utmost or giving at his utmost? Let us quicken our speed. Suppose we are already doing so much that all the time we can possibly spare is fully occupied. Let us do what we do better. Some Christian churches do not need more ministries but need more force put into them. You may skip over the seashore sand and scarcely leave an impression, but if you take heavy steps, there is a deep footprint each time. In our service for God, may we tread heavily and leave deep footprints on the sands of time.

"Whatsoever ye do, do it heartily, as to the Lord" (Col. 3:23). Throw yourselves into it; do it with all your might. *"Thou shalt love the LORD thy God with all thine heart, and with all thy soul, and with all thy might"* (Deut. 6:5). Oh, to be enabled to serve God after this fashion—this would be to praise Him more and more!

Though I do not say that you can always tell how much a man praises God by the quantity of work that he does for God, yet it is not a bad gauge. It was an old adage of Hippocrates, the ancient physician, that you could judge a man's heart by his arm, by which he meant that he judged his patient's heart by his pulse. As a rule, though there may be exceptions, you can tell whether a man's heart beats truly for God by the work that he does for God. You who are doing much, do more; and you who are doing little, multiply that little, I pray you, in God's strength, and so praise Him more and more.

Speak His Praises

We could praise God much more if we threw more of His praise into our common conversation—if we spoke more of Him when we are out and about or when we sit at home. We could praise Him more and more if we fulfilled our consecration and obeyed the precept, *"Whether therefore ye eat, or drink, or whatsoever ye do, do all to the glory of God"* (1 Cor. 10:31).

Sing His Praises

We would do well if we added to our godly service more singing. The world sings. The millions have their songs. I must say the taste of the populace is very remarkable just now as to its favorite songs. Many of them are so absurd and meaningless that they are unworthy of an idiot. Yet these things will be heard from men, and places will be thronged to listen to the stuff. Now, why should we—with the grand psalms we have of David, with the noble hymns of Cowper, Milton, and Watts—why should we not sing as well as they? Let us sing the songs of Zion. They are as cheerful as Sodom's songs. Let us drown out the howling nonsense of Gomorrha with the melodies of the New Jerusalem.

THE IMPORTANCE OF PRAISE

Finally, I desire that every Christian here would labor to be impressed with the importance of the subject that I have tried to bring before you. *"I...will yet praise thee more and more."* Why, some of you have never praised God at all! Suppose you were to die

today—and soon you must—where would you go? To heaven? What would heaven be to you? There can be no heaven for you. They praise God in the only heaven I have ever heard of. The environment of heaven is gratitude, praise, and adoration. You do not know anything about this, and therefore it would not be possible for God to make a heaven for you. God can do all things except make a sinful spirit happy, or violate truth and justice.

You must either praise God or be miserable. You do have a choice: you must either worship the God who made you, or else you must be wretched. It is not that He kindles a fire for you or casts on it the brimstone of His wrath, but your wretchedness begins within yourself, for to be unable to praise is to be full of hell. To praise God is heaven. When immersed in adoration, we are completely filled with happiness, but to be totally devoid of gratitude is to be totally devoid of joy.

Oh, that a change might come over you who have never blessed the Lord, and may it happen today! May the work of regeneration take place now! There is power in the Holy Spirit to change your heart of stone in a moment into a heart of flesh, so that instead of being cold and lifeless, it will palpitate with gratitude. Do you not see Christ on the cross dying for sinners? Can you look on that impartial love and not feel some gratitude for such love as is there exhibited? Oh, if you but look to Jesus and trust Him, you will feel a flash of life come into your soul. With it will come praise, and then you will find it possible to begin the happy life. As you praise God more and more, so will that happy life be expanded and perfected in bliss.

But Christians, the last word is for you. Are you praising God more and more? If you are not, I am afraid of one thing: that you are probably praising Him less and less. It is a certain truth that if we do not go forward in the Christian life, we go backward. You cannot stand still. There is a drift one way or the other. Now, he who praises God less than he did, and goes on to praise Him less tomorrow, and less the next day, and so on—where will he go, and what is he? Evidently he is one of those who *"draw back unto perdition"* (Heb. 10:39), and there are no persons on whom a more dreadful sentence is pronounced. Their terrible sentence was often spoken of by Paul, and most terribly by Peter and Jude: *"Trees whose fruit withereth, without fruit, twice dead, plucked up by the roots...wandering stars, to whom is reserved the blackness of darkness for ever"* (Jude 12–13). It would have been infinitely better for

422

them not to have known the way of righteousness, than having known it, after a fashion, to have turned aside! Better never to have put their hands to the plow, than having done so, to turn back from it.

But, beloved, I am *"persuaded better things of you, and things that accompany salvation, though* [I] *thus* [write]" (Heb. 6:9). I pray that God will lead you on from strength to strength, for that is the path of the just. May you grow in grace, for life is proved by growth. May you march like pilgrims toward heaven, singing all the way. The lark may serve us as a final picture and an example of what we all should be. We should be mounting. Our prayer should be, "Nearer, my God, to Thee." Our motto might well be, "Higher! Higher! Higher!" As we mount, we should sing, and our song should grow louder, clearer, fuller of heaven. Upward, beloved. Sing as you soar. Sing until you are dissolved in glory. Amen.

3

Morning and Evening Songs

To show forth thy lovingkindness in the
morning, and thy faithfulness every night.
—Psalm 92:2

T he rabbis have a notion that this psalm was sung by Adam in Paradise. There are no reasons why we should believe it was so, and there are a great many why we should be sure it was not. It is not possible that Adam could have sung concerning brutish men and fools, and the wicked springing up like grass, while he was still the only man and was himself unfallen. Still, at least the first part of the psalm might have come as suitably from the lips of Adam as from our tongues. If Milton could put into Adam's mouth this language:

> These are Thy glorious works, Parent of good,
> Almighty; Thine this universal frame.
> Thus wondrous fair, Thyself how wondrous then!

Milton might with equal fitness have made Adam say,

> *It is a good thing to give thanks unto the LORD, and to sing*
> *praises unto thy name, O most High: to show forth thy lov-*
> *ingkindness in the morning, and thy faithfulness every*
> *night....For thou, LORD, hast made me glad through thy*
> *work: I will triumph in the works of thy hands. (Ps. 92:1–2, 4)*

The Jews have for a long time used this psalm in the synagogue worship on their Sabbath. It is very suitable for the Sabbath,

not so much in appearance, for there is little or no allusion to sabbath rest in it, but because on that day above all others, our thoughts should be lifted up from all earthly things to God Himself. The psalm tunes the mind to adoration and so prepares it for Sunday worship. It supplies us with a noble subject for meditation—the Lord, the Lord alone—lifting us up even above His works into a contemplation of Himself and His mercies toward us. Oh, that always on Sundays when we come together, we might assemble in the spirit of praise, feeling that it is good to give thanks unto the name of the Most High! I pray that whenever we assemble together with other believers, we could always say, *"Thou, LORD, hast made me glad through thy work: I will triumph in the works of thy hands."*

There is no doubt that in this second verse there is an allusion to the offering of the morning and the evening lambs. In addition to the great Passover celebration once a year, and the other feasts and fasts, each of which brought Christ prominently before the mind of those Jews who were instructed by the Spirit of God, a lamb was offered every morning and every evening, as if to remind them that they needed daily cleansing for daily sin. At that time there was always a remembrance of sin, seeing that the one great sacrifice that puts away sin forever had not yet been offered. (See Hebrews 10:3–12.) Though now we need no morning or evening lamb and the very idea of a repetition of the sacrifice of Christ is most horribly profane and blasphemous to us, yet we should remember continually the one perfect sacrifice and never wake in the morning without beholding *"the Lamb of God, which taketh away the sin of the world"* (John 1:29), or fall asleep at night without turning our eyes anew to Him who on the bloody cross was made sin for us.

Our text, however, is meant to speak to us concerning praise. Praise should be the continual exercise of believers. It is the joyful work of heaven. It should be the continual joy of earth. We are taught by the text, I think, that while praise should be given only to the One who is in heaven, and we should adore perpetually our triune God, there should be variety in our unity. We bless the Lord only; we have no music but for Him. But we do not always praise Him in the same fashion. As there were different instruments of music—the tambourine, the psaltery, the harp—so, too, there are different subjects, a subject for the morning and a subject for the evening; lovingkindness to be shown forth at one time, and faithfulness to be

425

sung about at another. I wish that men would study more the praise they profess to present unto God.

I sometimes find, even in the public worship of my congregation, simple as it is, that there is evidently a lack of thought among us. The timing of our music is not maintained with the precision that would grow out of thoughtfulness. There is a tendency to sing more slowly, as if devotion were wearying, if not wearisome. Too frequently, I fear, the singing becomes mechanical, as if the tune had mastered the singer, as if the praiser did not govern the tune by making those inflections and modulations of voice that the sense would suggest if sung with all the heart and with the understanding also.

The very posture of some people indicates that they are going through the hymn, but the hymn is not going through their hearts, nor ascending to God on the wings of soaring gratitude. I have also noticed with sadness the way in which, if there happens to be a chorus at the close—a "Hallelujah" or "Praise God"—some will drop into their seats as if they had not thought enough to recollect that it was coming, and then, with a jerk and all confused, they stand up again, being so asleep in heart that anything out of the ordinary routine is too much for them. I am far from caring about postures or tones, but when they indicate lack of heart, I do care, and so should you. Remember well that there is no more music to God's ear in any service than there is heart-love and holy devotion. You may make floods of music with your organ if you like, or you may make equally good music—and some of us think even better— with human voices, but it is not music to God, either of instrument or voice, unless the heart is there. Further, the heart is not fully there nor the whole man unless the soul glows with praise.

In our private praise, also, we ought to think more of what we are doing and concentrate our entire energies on this sacred exercise. Should we not sit down before we pray and ask ourselves, "What am I going to pray for? I bow my knee at my bedside to pray: should I not pause and consider the things I ought to ask for? What do I want, and what are the promises that I should plead, and why is it that I may expect that God should grant me what I want?" Would we not pray better if we spent more time in consideration?

When we come to praise, we should not rush into our praises helter-skelter, but engage in them with prepared hearts. I notice that when musicians are about to perform, they tune their instruments.

There is also a preparation of themselves in rehearsals before they perform their music in public. In the same way, our souls ought to rehearse the subject for which they are about to bless God. We ought to come before the Lord, both in public and in private, with subjects of praise that our thoughts have considered—not offering unto the Lord what has cost us nothing, but with a warm heart pouring out before His throne adoration based on subjects of thanksgiving appropriate to the occasion. It seems that this is what the psalmist would have us to do: *"To show forth thy lovingkindness in the morning, and thy faithfulness every night."* It is not mere praise, but varied praise, praise with distinct subjects at appointed seasons.

MORNING WORSHIP

Let us first consider from the text the subject of morning worship. Second, we will focus on the subject of evening devotion. We need to practice both.

A Fitting Time to Worship

First, then, notice morning worship: *"To show forth thy lovingkindness in the morning."* There cannot be a more suitable time for praising God than in the morning. Everything around is congenial then. Even in this great wilderness of brick and wood in which we live, the gleams of sunlight in these summer mornings seem like songs, songs without words, or rather music without sounds. Out in the country, when every blade of grass twinkles with its own drop of dew, when all the trees glisten as if they were lit up with sapphires by the rising dawn, when a thousand birds awake to praise their Maker in harmonious concerts, all casting their entire energies and all their hearts into the service of holy song, it seems most fitting that the key of the morning should be in the hand of praise. When the daylight lifts its eyelid, it should look out upon grateful hearts. We ourselves have newly risen from our beds, and if we are in a right state of mind, we are thankful for the night's sleep.

> The evening rests our wearied head,
> And angels guard the room:

427

> We wake, and we admire the bed
> That was not made our tomb.

Every morning is a sort of resurrection. At night we lay down to sleep, stripped of our garments, as our souls will be of their bodily array when we come to die, but the morning wakes us. If it is a Sunday morning, we do not put on our work clothes but find our Sunday clothes ready at hand. Even so, we will be satisfied when we wake up in our Master's likeness (Ps. 17:15), no more to put on the soiled raiment of earth, but to find it transformed into a Sunday robe in which we will be beautiful and fair, even as Jesus our Lord Himself. Now, as every morning brings to us, in fact, a resurrection from what might have been our tomb, and delivers us from the image of death that through the night we wore, it ought to be saluted with thanksgiving. As the great resurrection morning will be awakened with the sound of the trumpet's far-sounding music, so let every morning, as though it were a resurrection to us, awaken us with hymns of joy.

> All praise to Thee who safe hast kept
> And hast refreshed me while I slept.
> Grant, Lord, when I from death shall wake
> I may of endless life partake.

"To show forth thy lovingkindness in the morning." We are full of vigor then. We will be tired before night comes around. Perhaps in the heat of the day we will be exhausted. Let us take care, while we are fresh, to give the cream of the morning to God. As one poet said,

> The flower, when offered in the bud,
> Is no mean sacrifice.

Let us give the Lord the bud of the day, its virgin beauty, its unsullied purity. Say what you will about the evening—and there are many points about it that make it an admirable season for devotion—yet the morning is the choice time. Is it not a queenly hour? See how it is adorned with diamonds more pure than those that flash in the crowns of Eastern potentates. The old proverb declares that those who want to be rich must rise early. Surely those who want to be rich toward God must do so. No dews fall in the middle of the day, and it is hard to keep up the dew and freshness

of one's spirit in the worry, care, and turmoil of midday. But in the morning the dew should fall on our fleece until it is saturated. It is well to wring it out before the Lord and give Him our morning's vigor, our morning's freshness and zeal.

The Mornings of Our Lives

You will see, I think, without my enlarging on the topic, that there is a fitness in the morning for praising God. But I will not merely confine the text to the morning of each day, because the same fitness pertains to the morning of our days in total. Our youth, our first hours of the day of life, ought to be spent in showing forth the lovingkindness of God. Dear young friends, you may rest assured that nothing can happen to you so blessed as to be converted while you are young. I bless God for my having known Him when I was fifteen years of age. However, I have often felt like that Irishman who said that he was converted at twenty, and he wished it had been twenty-one years before. I have often felt the same desire. Oh, that it could have been possible for the very first breath to have been consecrated to God, for the first rational thought to have been one of devotion, for the first act of judgment to have been exercised upon divine truth, and for the first pulsing of affection to have been toward the Redeemer who loved us and gave Himself for us! What blessed reflections would fill the space now occupied with penitent regrets.

The first part of a Christian life has charms peculiar to itself. In some respects:

> That age is best which is the first,
> For then the blood is warmer.

I know the latter part of life is riper and more mellow. There is a sweetness about autumn fruit. But the basket of early fruit—the first ripe fruit—this is what God desires. Blessed are they who *"show forth* [God's] *lovingkindness in the morning!"*

The Bright Times in Life

This verse may also signify those periods of life that are bright like the morning to us. We have our ups and downs, our ebbs and flows, our mornings and nights. Now, it is our duty and privilege

during our bright days to show forth God's lovingkindness. It may be that some of you have had so rough a life that you consider your nights to be more numerous than your days. Others of us could not, even in common honesty, subscribe to such a belief. No, blessed be God, our mornings have been very numerous. Our days of joy and rejoicing, after all, have been abundant—infinitely more abundant than we might have expected they could be, dwelling as we do in the land of sorrows. Oh, when the joyous days are here, let us always consecrate them by showing forth God's lovingkindness.

Do not imitate some people, who, if they are prospering, make a point of not owning to it. If they make money, for instance—well, they are "doing pretty well." "Pretty well," do they call it? There was a time when if they had been doing half as well, they would have been ready to jump for joy. How often the farmer, when his crop could not be any larger, and when the field is loaded with it, will say, "Well, it is a very fair crop." Is that all that can be said? What robbery of God! This talk is far too common on all sides and ought to be most solemnly rebuked. When we have been enjoying a long stretch of joy, peace, and prosperity, instead of saying that it is so, we speak as if God has dealt very well with us on the whole, but at the same time has done nothing very remarkable for us.

I saw a tombstone the other day that pleased me. I do not know that I ever saw an epitaph of that kind before. I think it was for a woman who died at the age of eighty. The inscription said of her, "Who after a happy and grateful enjoyment of life, died." Now, that is what we ought to say, but we talk as if we were to be pitied for living, as if we were little better off than toads under a plow or snails in a tub of salt. We whine as if our lives were martyrdoms and every breath a woe. But it is not so. Such conduct slanders the good Lord. Blessed be the Lord for creating us. Our lives have mercies, yes, innumerable mercies. Notwithstanding the sorrows and the troubles of life, there are joys and blessings beyond all counting. There are mornings in which it becomes us to show forth the lovingkindness of the Lord. See, then, the seasons—the morning of each day, the morning of our days, and the morning of our brightness and prosperity.

God's Lovingkindness

The psalmist suggests that the best topic for praise on such occasions is lovingkindness. *"To show forth thy lovingkindness in*

the morning." Truly I confess that this is a theme that might suit nights as well as days, although no doubt he saw an appropriateness in allotting this topic to the morning. Truly it might suffice for all day long. Was there ever such a word in any language like that word *"lovingkindness"*? I have sometimes heard Frenchmen talking about their language, and I have no doubt it is a very beautiful tongue. Germans glorify the speech of their fatherland. I have heard our Welsh friends extolling their unpronounceable language, declaring it is the very tongue that was spoken in Paradise—very likely indeed. But I venture to say that no language beneath the sky has a word in it that is richer than this: *"lovingkindness."*

It is a dual deliciousness. Within it are long chains of sweetnesses linked together. *"Lovingkindness"* is the kind of word with which to cast spells that should charm away all fears. It was said of George Whitefield that he could have moved an audience to tears by saying the word *Mesopotamia*. I think he could have done it better with *"lovingkindness."* Put it under your tongue now. Let it lie there. *"Lovingkindness."* Kindness. Does that mean "kinnedness"? Some say "kinned-ness" is the root sense of the word—such feeling as we have to our own kin, for blood is ever thicker than water, and we act toward our kindred as we cannot readily do toward strangers. Now, God has made us His kin. In His own dear Son, He has taken us into His family. We are children of God: *"heirs of God, and joint-heirs with Christ"* (Rom. 8:17). There is a "kinned-ness" from God to us through our great kinsman Jesus Christ.

However, the word is only half understood when you get to that, for it is *"lovingkindness."* For a surgeon to set a man's limb when it is out of joint or broken is kindness, although he may do it somewhat roughly and in an offhand manner. But if he does it very tenderly, covering the lion's heart with the lady's hand, then he shows lovingkindness. A man is picked up on the battlefield, put into an ambulance, and carried to the hospital. That is kindness. But if that poor soldier's mother could come into the hospital and see her boy suffering, she would show him lovingkindness, which is something far more. A child run over in the street and taken to the hospital would be cared for, I have no doubt, with the greatest kindness. However, after all, send for the child's mother, for she will give him lovingkindness. In the same way, the Lord deals with us. He gives us what we need in a fatherly manner. He gives us what we need in the tenderest fashion. It is kindness; it is "kinned-ness."

431

But it is also the combination of the two: it is lovingkindness. The very heart of God seems to be written out in this word. We could hardly apply it in full force to any but our Father who is in heaven.

Now, here is a subject for us to sing about in the morning. Where should I begin, with the hope of covering this subject? It is an endless one. Lovingkindness begins—I must correct myself—it never did begin. It had no beginning. *"I have loved thee with an everlasting love: therefore with lovingkindness have I drawn thee"* (Jer. 31:3). Everlasting love, therefore, is what we must begin to sing of. That everlasting love was infinite in its preparations: before we were created, the Lord made a covenant on our account and resolved to give His only begotten Son so that we could be saved from wrath through Him. The lovingkindness of God our Father appeared in Jesus Christ. Oh, let us always be talking about this!

I wonder why it is, when we meet each other, that we do not begin at once to say, "Have you been thinking over the lovingkindness of the Lord in the gift of His dear Son?" Indeed, it is such a marvelous thing that it should not be a nine days' wonder with us. It ought to fill us with astonishment every day of our lives. Now, if something wonderful happens, everybody's mouth is full of it. We speak to one another about it at once, while, like the Athenians, all our neighbors are eager to hear. Let our mouths, then, be full of the marvelous lovingkindness of God. For fear that we might leave the tale half untold, let us begin early in the morning to rehearse the eternal love manifested in the great gift of Jesus Christ.

If we have already spoken about these things and wish for variety, let us speak concerning the lovingkindness of God to each one of us in bringing us to Jesus. What a history each man's own life is. I suppose that if any one of our lives should be fully recorded, it would be more wonderful than a romance. I have sometimes seen a sunset of which I have said, "Now, if any painter had depicted that, I would have declared that the sky never looked that way, it is so strange and unique." In the same way, if some of our lives were to be fully written out, many would say, "It could not have been so." Perhaps you have read Huntingdon's *Bank of Faith,* for instance. Many people say, "Oh, it is a bank of nonsense." Yet I believe that it is correct and bears the marks of truth upon its very face. I believe that the man did experience all that he has written, though he may not always have told us everything in the best possible manner. Many other people's lives would be quite as

wonderful as his if they could be written down. Tell, then, of God's lovingkindness to yourself especially. Rehearse, if to no other ear than your own, and to the ear of God, the wondrous story of how

> Jesus sought you when a stranger
> Wandering from the fold of God.

Tell how His grace brought you to Himself and so into eternal life. Then, sing of the lovingkindness of God to you since your new birth. Remember the mercies of God. Do not bury them in the grave of ingratitude. Let them glisten in the light of gratitude. I am sure that you will find this a blessed morning portion that will sweeten the whole day. The psalmist would have you begin the day with it, because you will need the entire day to complete it. Indeed, you will need all the days of life and all eternity. I agree with Addison—though the expression is somewhat hyperbolic:

> But, oh, eternity's too short
> To utter half Thy praise.

What a blessed subject you have before you—the lovingkindness of the Lord—not yourself. That is a horrible subject to speak about. When I hear believers get up and glory in their own attainments and graces, I remember the words of the wise man: *"Let another man praise thee, and not thine own mouth"* (Prov. 27:2). Above all things, when a man says that he has made great advances in sanctification, it is sickening and clearly proves that he has not learned the meaning of the word *humility*. I hope the eyes of some of our friends will be opened, and that they will come to loathe the Devil's meat that now deceives them. May spiritual self-conceit be shunned as a deadly evil, and may we no longer see it held up among us as a virtue. No, let our mouths be filled with God's praise, but not with our own.

We must not let our tongues be always occupied with our griefs, either. If you have a skeleton in your house, why should you always invite every friend who visits you to inspect the uncomely thing? No, instead tell what God has done for you out of His lovingkindness. I have heard—and I repeat the story because it ought to be repeated, simple as it is—of a pastor who frequently called on a poor, bedridden woman who very naturally always told him of

her pains and her needs. He knew all about her rheumatism: he had heard of it fifty times. At last he said to her, "My dear sister, I sympathize with you deeply, and I am never at all tired of hearing your complaints, but could you not now and then tell me something about what the Lord does for you—something about your enjoyments, how He sustains you under your pain, and so on?" It was a rebuke well put and well taken. Ever afterward there was less said about the griefs and more heard about the blessings. Let us resolve, precious Lord, *"to show forth thy lovingkindness in the morning."*

Showing Forth His Lovingkindness

Thus we have considered the time—morning—and the topic—lovingkindness. Now we are bound to observe the manner in which we are to deal with the subject. The psalmist says we are to show it forth, by which I suppose he means that we are not to keep to ourselves what we know about God's lovingkindness.

In the morning every Christian ought to show it forth first in his own bedroom before God. He should express his gratitude for the mercies of the night and the mercies of his whole life. Then let him, if it is possible, show it forth in his family. Let him gather them together and worship the Lord and bless Him for His lovingkindness. And then, when the Christian goes into the world, let him show forth God's lovingkindness. I do not mean by talking of it to everyone he meets—casting pearls before swine, as it would be with some men—but by the very way that he speaks, acts, and looks.

A Christian ought to be the most cheerful of men, so that others say, "What makes him look so happy? He is not rich. He is not always in good health. He has his troubles, but he seems to bear all so well and to skip lightly along the pathway of life." By our cheerful conversation, we ought to show forth in the morning God's lovingkindness. "Ah," says one, "but what about when you are depressed in spirit?" Do not show it if you can help it. Do as your Master said, *"Appear not unto men to fast"* (Matt. 6:18). Do not imagine that the appearance of sadness indicates sanctity—it often means hypocrisy. To conceal one's own griefs for the sake of cheering others implies a self-denying sympathy that is the highest kind of Christianity.

Let us present *"the sacrifice of praise"* (Heb. 13:15) in whatever company we may be. But when we get among God's own people, then is the time for a whole burnt offering. Among our own kin we may safely open our box of sweets. When we find a brother who can understand the lovingkindness of the Lord, let us tell it forth with sacred delight. We have choice treasures that we cannot show to ungodly eyes, for they would not appreciate them. But when we meet with eyes that God has opened, then let us open the treasure chest and say, "Brother, rejoice in what God has done for us. See His lovingkindness to me His servant, and His tender mercies that have been ever of old."

Thus, beloved friends, I have set before you a good morning's work. I think, if God's Spirit helps us to attend to it, we will come out of our rooms with our breath smelling sweet with the praises of God. We will go into the world without care, much more without anger. We will go calmly to our work and meet our cares quietly and happily. The joy of the Lord will be our strength (Neh. 8:10). A good rule is never to look into the face of man in the morning until you have looked into the face of God. An equally good rule is always to have business with heaven before you have any business with earth. Oh, it is a sweet thing to bathe in the morning in the love of God—to bathe in it, so that when you come forth out of the ivory chambers of communion where you have been made glad, your garments will smell of the myrrh and aloes and cassia of holiness.

Do we all attend to this? I am afraid we are in too much of a hurry, or we get up too late. Could we not rise a little earlier? If we could steal even a few minutes from our beds, those few minutes would scatter their influence over the entire day. It is always bad to start on a journey without making sure that the transportation is reliable. In the same way, it often happens that the time saved by omitting examination turns out to be a dead loss when the traveler has advanced a little on his journey. Not one minute, but a hundred minutes may be lost by the lack of a little attention at first. Set the morning watch with care, if you want to be safe throughout the day. Begin well if you want to end well. Take care that the helm of the day is set right toward the point you want to sail to; then whether you make much progress or little, you will be that far in the right direction. The morning hour is generally the index of the day.

EVENING WORSHIP

Now let us turn to the second part of our subject. The psalmist says, *"To show forth...thy faithfulness every night."*

A Choice Time to Praise God

The night, beloved, is a particularly choice time for praising God's faithfulness. "Oh," says one, "I am very tired." Well, that may be, but it is a pity that we should be reduced to such a condition that we are too tired to praise God. A holy man of God used to always say, when others asked him, "Can you pray?" "Thank God, I am never too tired to pray." If anything can arouse us, the service of Christ should do it. There should be within us an enthusiasm that kindles at the very thought of prayer. Have you never known an army on the march, weary and ready to drop, but the band played some enlivening tune that stirred the men until they had gone the last few miles as they could not have done if it had not been for the inspiration of the refrain? Let the thought of praising God wake up our wearied energies, and do not let God be robbed of His glory at the close of the day.

The close of the day is calm, quiet, and fit for devotion. God walked in the Garden in the cool of the day, before man fell, and Adam went forth to meet Him. Isaac walked in the fields in the evening, and there he received a blessing. The evening is the sabbath of the day and should be the Lord's.

God's Faithfulness

Now, notice the topic that is set for the evening: it is faithfulness. *"To show forth...thy faithfulness every night."* Why at night? Because we have had a little more experience with our God. We have a day's more experience than we had in the morning. Therefore, we have more power to sing of God's faithfulness. We can look back now upon the day and see promises fulfilled. May I ask you to look over today? Can you not notice some promises that God has kept toward you? Show forth His faithfulness, then. Provision has been given you. He promised to give it; He has given it. Protection has been afforded you, more than you know of, infinitely more. Guidance also has been given in points where you otherwise would

436

have gone very much astray. Illumination has been granted to you, and comfort also in a season of depression, as well as upholding in a time of temptation. God has given you much today. If He has taken anything away from you, still bless His name. It was only what He had given, and He had a right to take it. Look through the day, and you will find that God has acted toward you as He promised that He would act. You have had trouble, you say. Did He not say, *"In the world ye shall have tribulation"* (John 16:33)? Has He not spoken concerning the rod of the covenant? Affliction only illustrates His faithfulness.

Carefully observe the fulfilled promises of each day. It is a good custom to conclude the day by recounting its special mercies. I do not believe in keeping a detailed diary of each day's events, for one is apt, for lack of something to put down, to write what is not true, or at least not real. I believe there is nothing more stilted or untruthful, generally, than a religious diary. It easily degenerates into self-deceit. Still, most days, if not all our days, reveal singular instances of providence, if we will but recognize them. It has been said, "He that notices providences shall never be without a providence to notice." I believe we let our days glide by us, unobservant of the wondrous things that are in them, and so we miss many enjoyments. The uneducated person sees little beauty in the wild flowers:

> The primrose by the river's brim,
> A yellow primrose it is to him,
> And it is nothing more.

We, for lack of thought, let great mercies go by us. They are trifles to us and nothing more. Oh, let us change our ways and think more of what God has done. Then we will utter a song concerning His faithfulness every night.

Do you notice in the text that word *"every"*? It does not say, *"to show forth thy lovingkindness* [every] *morning,"* although it means that. No, concerning the nights it is very distinct: *"And thy faithfulness **every** night"* (emphasis added). It is a cold night. Did He not promise winter? Now it has come. The cold only proves His faithfulness. It is a dark night, but then it is a part of His covenant that there should be nights as well as days. Supposing that there were no nights and no winters, where would the covenant that God made with the earth be? But every change of temperature in the

beautiful vicissitudes of the year, and every variation of light and shade, only illustrate the faithfulness of God. If you happen to be full of joy now, you can tell of divine faithfulness in rendering love and mercy to you. But if, on the other hand, you are full of trouble, tell of God's faithfulness, for now you have an opportunity of proving it. He will not leave you. He will not forsake you. His Word says, *"When thou passest through the waters, I will be with thee; and through the rivers, they shall not overflow thee"* (Isa. 43:2). Depend on it that this promise will be faithfully fulfilled.

The Night of Life

Beloved friends, you who are getting old and are nearing the night of life, you are specially fitted to show forth the Lord's faithfulness. The young people may tell of His lovingkindness, but older people must tell of His faithfulness. You can speak of forty or fifty years of God's grace to you, and you can confidently affirm that He has not once failed you. He has been true to every word that He has spoken. Now, I charge you, do not withhold your testimony. If young people are silent, they are guilty, but they might speak, perhaps, another day. But for you advanced Christians to be silent will be sinful indeed, for you will not have another opportunity in this world of showing forth the faithfulness of God. Bear witness now, before your eyes are closed in death! The faithfulness of God every night is a noble subject for His gray-haired servants.

Showing Forth His Faithfulness

It truly is our great business to show forth His faithfulness. Oh, beloved, do let us publish abroad the faithfulness of God. I wonder sometimes that there should be any doubts in the world about the doctrine of the final perseverance of the saints. I think the reason that there are any doubts is this: those professing Christians who fall are very conspicuous, and everybody knows about them. If a high-flying professing Christian makes a foul end of his boastings, why, that is talked of everywhere. They speak of it in Gath and publish it in the streets of Askelon. (See 2 Samuel 1:20.)

On the other hand, those thousands of true believers who stay on their course cannot, of course, say much about themselves. It

would not be right for them to do so, but I wish they could sometimes say more about the unfailing goodness and unchangeable truthfulness of God, to be a check to the effect produced by backsliders. Then the world could know that the Lord does not cast away His people whom He did foreknow, but that He gives strength to them even in their fainting and bears them through. If there is any one topic that Christians ought to speak about thankfully, bravely, positively, continuously, it is the faithfulness of God to them. It is that on which Satan takes a dead aim in the minds of many tempted ones. Therefore, you should center the strength of your testimony on God's faithfulness, so that tried saints may know He does not forsake His people.

As a part of our own local congregations, let us unitedly declare how faithful God has been! The history of my church has been very wonderful. When we were few and feeble, cast off and brought low, God appeared for us. Then we began to prosper, and we also began to pray. And what prayers they were! Surely the more we prayed, the more God blessed us. We have now had almost twenty years of uninterrupted blessing. We have had no fits and starts, revivals and retreats, but onward has been our course. In the name of God, it has been a steady, continued progress, like the growth of a cedar upon Lebanon. Up to this time, God has always heard prayer in this place. The very building that houses us was an answer to prayer. There is scarcely an institution connected with it that could not write upon its banner, "We have been blessed by a prayer-hearing God." It has become our habit to pray, and it is God's habit to bless us.

Oh, let us not grow weary and abate in our prayers or our praises! If we do, we will be limited in ourselves, but not in God. God will not leave us while we prove Him in His own appointed way. If we will continue steadily in earnest intercession and thanksgiving, our local churches may enjoy many more years of equal or greater prosperity, if it so pleases God. We have used no carnal attractions to gather people together to worship. We have procured nothing to please their tastes by way of elaborate music, fine dress, painted windows, processions, and the like. We have used the Gospel of Jesus without any rhetorical embellishments, simply spoken as a man speaks to a friend. God has blessed it, and He will bless it still.

Now, dear friends, each one of you can say of yourselves, as well as of your church, that God has been faithful to you. Tell it to

your children. Tell them that God will save sinners when they come to Him, for He saved you. Tell it to your neighbors. Tell them He is faithful and just to forgive us our sins if we confess them to Him, and to save us from all unrighteousness, for He forgave you. (See 1 John 1:9.) Tell every trembler you meet that Jesus will by no means cast out any who come to Him (John 6:37). Tell all seekers that if they seek, they will find, and that to everyone who knocks, the door of mercy will be opened (Matt. 7:7–8). Tell the most despondent and despairing that Jesus Christ came into the world to save sinners, even the very chief (1 Tim. 1:15). Make known His faithfulness every night.

At the end, when your last night comes and you gather up your feet in the bed, like Jacob, let your last testimony be centered on the Lord's faithfulness. Like glorious old Joshua, end your life by saying, *"Not one thing hath failed of all the good things which the LORD your God spake concerning you; all are come to pass"* (Josh. 23:14). The Lord bless you, dear friends, and grant that you all may know His lovingkindness and His faithfulness. Amen.

4

Acceptable Praises
and Vows

Praise waiteth for thee, O God, in Zion:
and unto thee shall the vow be performed. O thou that
hearest prayer, unto thee shall all flesh come.
—Psalm 65:1–2

U pon Zion was erected an altar dedicated to God for the offering of sacrifices. Except when prophets were commanded by God to sacrifice elsewhere, burnt offerings were to be offered only there. The worship of God upon the high places was contrary to the divine command:

> *Take heed to thyself that thou offer not thy burnt offerings in*
> *every place that thou seest: but in the place which the LORD*
> *shall choose in one of thy tribes, there thou shalt offer thy*
> *burnt offerings, and there thou shalt do all that I command*
> *thee.* (Deut. 12:13–14)

For this reason, the tribes on the other side of Jordan, when they erected a memorial altar, disclaimed all intention of using it for the purpose of sacrifice. They said plainly,

> *God forbid that we should rebel against the LORD, and turn*
> *this day from following the LORD, to build an altar for burnt*
> *offerings, for meat offerings, or for sacrifices, beside the altar*
> *of the LORD our God that is before his tabernacle. (Josh. 22:29)*

In fulfillment of this ancient type, we also *"have an altar, wherefore they have no right to eat which serve the tabernacle"*

441

(Heb. 13:10). No observers of materialistic ritualism may intrude into our spiritual worship. They have no right to eat at our spiritual altar, and there is no other at which they can eat and live forever. There is but one altar—Jesus Christ our Lord. All other altars are impostors and idolatrous inventions. Whether of stone, wood, or brass, they are the toys with which those who have returned to the beggarly elements of Judaism amuse themselves, or else the apparatus with which clerical jugglers dupe the sons and daughters of men.

Holy places made with hands are now abolished. They were once the figures of the true, but now that the substance has come, the type is done away with. The all-glorious person of the Redeemer, God and Man, is the great center of Zion's temple and the only real altar of sacrifice. He is the church's Head, the church's Heart, the church's Altar, Priest, and All in All. *"Unto him shall the gathering of the people be"* (Gen. 49:10). Around Him we all congregate, even as the tribes did around the tabernacle of the Lord in the wilderness.

When the church is gathered together, we may compare it to the assemblies on Mount Zion, where the tribes of the Lord went up unto the testimony of Israel. There the song was raised, not so much from each separate worshiper as from all combined there. As the praise rose to heaven, it was not only the praise of each one, but the praise of all. So where Christ is the center, where His one sacrifice is the altar on which all offerings are laid, and where the church unites around that common center, rejoicing in that one sacrifice, there we find the true Zion. If we, who gather in Christ's name around His one finished sacrifice, present our prayers and praises entirely to the Lord through Jesus Christ, we are *"come unto mount Zion, and unto the city of the living God, the heavenly Jerusalem, and to an innumerable company of angels, to the general assembly and church of the firstborn, which are written in heaven"* (Heb. 12:22–23). This is Zion, even this house in the far-off islands of the Gentiles. We can say indeed, *"Praise waiteth for thee, O God, in Zion; and unto thee shall the vow be performed."*

We will, with devout attention, notice two things: the first is our holy worship that we desire to render, and then the stimulative encouragement that God provides for us: *"O thou that hearest prayer, unto thee shall all flesh come."*

THE HOLY OFFERING OF WORSHIP

First, let us consider the holy offering of worship that we desire to present to God. It is twofold: there is praise, and there is also a vow—a praise that waits, and a vow of which performance is promised.

Praise Is Adoration's Main Ingredient

Let us think, first of all, of the praise. This is the chief ingredient of the adoration of heaven. What is thought to be worthy of that world of glory ought to be the main portion of the worship of earth. Although we will never cease to pray as long as we live here below and are surrounded by so many needs, we should never pray in such a way that we forget to praise. *"Thy kingdom come. Thy will be done in earth, as it is in heaven"* (Matt. 6:10) must never be left out just because we are pressed with needs and, therefore, hasten to cry, *"Give us this day our daily bread"* (v. 11). It will be a sad hour when the worship of the church becomes only a solemn wail. Notes of exultant thanksgiving should always ascend from her solemn gatherings. *"Praise the LORD, O Jerusalem; praise thy God, O Zion"* (Ps. 147:12). *"Praise ye the LORD. Sing unto the LORD a new song, and his praise in the congregation of saints. Let Israel rejoice in him that made him: let the children of Zion be joyful in their King"* (Ps. 149:1–2). Let it abide as a perpetual ordinance, while sun and moon endure: *"Praise waiteth for thee, O God, in Zion."* Never think little of praise, since holy angels and saints made perfect count it their lifelong joy. Even the Lord Himself said, *"Whoso offereth praise glorifieth me"* (Ps. 50:23).

The tendency among us has been to undervalue praise as a part of public worship, whereas it should be second to nothing. We frequently hear of prayer meetings and seldom hear of praise meetings. We acknowledge the duty of prayer by setting apart certain times for it, but we do not always acknowledge the duty of praise. I hear of "family prayer," but do I ever hear of "family praise"? I know you cultivate private prayer, but are you as diligent also in private thanksgiving and secret adoration of the Lord? In everything we are to give thanks (1 Thess. 5:18). It is as much a biblical precept as this one: *"In every thing, by prayer and*

supplication with thanksgiving let your requests be made known unto God" (Phil. 4:6).

I have often said that prayer and praise are like the breathing in and out of air and make up that spiritual respiration by which the inner life is instrumentally supported. We take in an inspiration of heavenly air as we pray; we breathe it out again in praise unto God from whom it came. If, then, we want to be healthy in spirit, let us be abundant in thanksgiving. Prayer, like the root of a tree, seeks for and finds nutriment; praise, like the fruit, renders a revenue to the owner of the vineyard. Prayer is for ourselves; praise is for God. Let us never be so selfish as to abound in the one and fail in the other. Praise is a slender return for the boundless favors we enjoy. We must not be slack in rendering it in our best music, the music of a devout soul. *"Praise the LORD; for the LORD is good: sing praises unto his name; for it is pleasant"* (Ps. 135:3).

All Praise Belongs to God

Let us notice the praise that is mentioned in our text, which is to be a large matter of concern to the Zion of God whenever the believers are gathered together. First, observe that it is praise rendered exclusively to God. *"Praise waiteth for thee, O God, in Zion."* May all the praise be for Him, with no praise for man or for any other who may be thought to be, or may pretend to be, worthy of praise. I have sometimes gone into places called houses of God where praise has waited for a woman (the Virgin Mary), where praise has waited for the saints, where incense has smoked to heaven, and where songs and prayers have been sent up to deceased martyrs and confessors who are supposed to have power with God. In Rome it is so, but in Zion it is not so. Unto God, and God alone, the praise of His true church must ascend.

If Protestants are free from this deadly error, I fear they are guilty of another, for in our worship we too often minister to our own selves. We do so when we make the tune and manner of the song more important than the substance of it. I am afraid that where organs, choirs, and soloists are left to do the praising for the congregation, men's minds are more occupied with the performance of the music than with the Lord, who alone is to be praised. God's house is meant to be sacred unto Himself, but too often it is

made an opera house, and Christians form an audience, not an adoring assembly. The same thing may happen, unless great care is taken, amid the simplest worship, even though everything that does not taste of gospel plainness is excluded, for in that case we may drowsily drawl out the words and notes with no heart whatsoever. To sing with the soul, this only is to offer acceptable praise. We do not come together to amuse ourselves, to display our powers of melody or our aptness in creating harmony. We come to pay our adoration at the footstool of the Great King, to whom alone be glory forever and ever. True praise is for God and for God alone.

You must take heed that the minister, who, above all, would reject a share of praise, is not set up as a demigod among you. Refute the old slander that the pastor is your only priest. Look higher than the pulpit, or you will be disappointed. Look above an arm of flesh, or it will utterly fail you. I may say to you concerning the best preacher on earth, "Give God the praise, for we know that this man is a sinner." If we pastors thought that you paid superstitious reverence to us, we would, like Paul and Barnabas, rip our clothes and cry,

> *Sirs, why do ye these things? We also are men of like passions with you, and preach unto you that ye should turn from these vanities unto the living God, which made heaven, and earth, and the sea, and all things that are therein.* (Acts 14:15)

It is not to any man, to any priest, to any order of men, to any being in heaven or earth besides God, that we should burn the incense of worship. To God alone will all the praise of Zion ascend.

It is to be feared that some of our praise ascends nowhere at all, but it is as though it were scattered to the winds. We do not always believe and experience God. *"He that cometh to God must believe that he is, and that he is a rewarder of them that diligently seek him"* (Heb. 11:6). This is as true of praise as of prayer. *"God is a Spirit: and they that* [praise] *him must* [praise] *him in spirit and in truth"* (John 4:24), for *"the Father seeketh such"* (v. 23) to praise Him. If we do not lift our eyes and our hearts to Him, we are only misusing words and wasting time. Our praise is not as it should be if it is not reverently and earnestly directed to the Lord of Hosts. It is vain to shoot arrows without a target: we must aim exclusively for God's glory in our holy songs.

Praise God Continually

Note, next, that our praise should be continual. *"Praise waiteth for thee, O God, in Zion."* Some translators believe that the main idea is that of continuance. Praise remains and abides; Zion does not break up when the assembly is gone. We do not leave the holiness in the building, for it never was in the stone and the timber, but only in the living assembly of the faithful:

> Jesus, where'er Thy people meet
> There they behold Thy mercy seat;
> Where'er they seek Thee, Thou art found,
> And every place is hallow'd ground.

> For Thou within no walls confined
> Inhabitest the humble mind;
> Such ever bring Thee where they come
> And going take Thee to their home.

The people of God, since they never cease to be a church, should maintain the Lord's praise perpetually as a community. Their assemblies should begin with praise and end with praise and should always be conducted in a spirit of praise. There should be in all our assemblies a spiritual incense altar, always smoking with *"the pure incense of sweet spices, according to the work of the apothecary"* (Exod. 37:29), the thanksgiving that is made up of humility, gratitude, love, consecration, and holy joy in the Lord. It should be for the Lord alone, and it should never go out day nor night.

"His mercy endureth for ever" (Ps. 136:1), and so our praises should endure forever. He makes the dawning of the morning to rejoice. Let us celebrate the rising of the sun with holy psalm and hymn. He makes the closing in of the evening to be glad. Let Him have our evening praise. *"One generation shall praise thy works to another, and shall declare thy mighty acts"* (Ps. 145:4). Could His mercy cease, there might be some excuse for holding back our praises. But, even if it should seem to be so, men who love the Lord would say with Job, *"Shall we receive good at the hand of God, and shall we not receive evil?...The LORD gave, and the LORD hath taken away; blessed be the name of the LORD"* (Job 2:10; 1:21).

Let our praise abide, continue, remain, and be perpetual. It was a good idea of Bishop Farrar, that in his own house, he would keep up continual praise to God. Since he had a large household that numbered twenty-four, he set apart each one for an hour in the day to be engaged especially in prayer and praise, that he might surround the day with a circle of worship. We could not do that. To attempt it might be superstition on our part. However, to fall asleep blessing God, to rise in the night to meditate on Him, and when we wake in the morning to feel our hearts leap at the prospect of His presence during the day, this is attainable for us. We ought to strive to reach it.

It is much to be desired that all day long, in every vocation and every recreation, the soul should spontaneously pour forth praise, even as birds sing, flowers perfume the air, and sunbeams cheer the earth. We want to be incarnate song, praise enshrined in flesh and blood. From this delightful duty we would desire no cessation and ask no pause. *"Praise waiteth for thee, O God, in Zion."* God's praise may come and go from the outside world, where all things ebb and flow, for it lies beneath the moon, and there is no stability in it. But amid God's people, who dwell in Him and possess eternal life, in them His praise should perpetually abide.

True Praise Waits on God

Another point, however, is clear on the surface of the words. *"Praise waiteth for thee"* hints that praise must be humble. The servants "wait" in the king's palace. There the messengers stand, equipped for any mission; the attendants tarry, prepared to obey; and the courtiers surround the throne, all eager to receive the royal smile and to fulfill the high command. Our praises ought to stand like ranks of messengers, waiting to hear what God's will is, for this is what it means to praise Him.

Furthermore, true praise lies in the actual doing of the divine will, even to the extent of pausing in sacred reverence until God the Lord tells us what that will may be. It is true praise to wait subserviently on Him. Praises may be looked upon as servants that delight to obey their Master's bidding. There is such a thing as an unholy familiarity with God. This age is not so likely to fall into it as some ages have been, for there is little familiarity with God of any sort now. Public worship has become more formal, stately, and distant. How seldom do we meet with the intense nearness to God

that Luther enjoyed! But, however near we come to God, still He is God, and we are His creatures. Truly, He is *"our Father,"* but be it ever remembered that He is *"our Father which art in heaven"* (Matt. 6:9). *"Our Father"*—therefore He is near and intimate. *"Our Father which art in heaven"*—therefore we humbly, solemnly bow in His presence. There is a familiarity that runs into presumption. There is another familiarity that is so sweetly tempered with humility that it does not intrude. *"Praise waiteth for thee"* with a servant's uniform donned, a servant's ear to hear, and a servant's heart to obey. Praise bows at His footstool, feeling that it is still an unprofitable servant.

Praise Can Be Silent

But, perhaps, you are aware, dear friends, that there are other translations of this verse. *"Praise waiteth for thee"* may be read, "Praise is silent unto Thee," or, "Praise is silent before Thee." One of the oldest Latin commentators translates it, "Praise and silence belong unto Thee." I am told that in the King of Spain's Bible, it reads, "The praise of angels is only silence before Thee, O Jehovah." When we do our best, our highest praise is but silence before God, and we must praise Him with confession of shortcomings. Oh, that we, too, as our poet puts it, might:

> Loud as His thunders speak His praise,
> And sound it lofty as His throne!

But we cannot do this. When our notes are most uplifted and our hearts most joyous, we have not spoken all His praise. Compared with what His nature and glory deserve, our most earnest praise has been little more than silence. Oh, have you not often felt it to be so? Those who are satisfied with formal worship think that they have done well when the music has been correctly sung. However, those who worship God in spirit feel that they cannot magnify Him enough. They blush over the hymns they sing and retire from the assembly of the saints mourning that they have fallen far short of His glory.

Oh, for an enlarged mind to rightly conceive His divine majesty. Next, for the gift of utterance to clothe the thought in fitting language. Then, for a voice like many waters, to sound forth the

noble strain. Alas! As yet, we are humbled at our failures to praise the Lord as we would like:

> Words are but air, and tongues but clay,
> And His compassions are divine.

How, then, will we proclaim to men God's glory? When we have done our best, our praise is but silence before the merit of His goodness and the grandeur of His greatness. Yet it may be well to observe here that acceptable praise to God presents itself under a variety of forms. There is praise for God in Zion, and it is often spoken; but there is often praise for God in Zion, and it is silence. There are some who cannot sing vocally, but perhaps, before God, they sing best. There are some, I know, who sing very harshly and inharmoniously—that is to say, to our ears. Yet God may accept them rather than the noise of stringed instruments carefully touched.

There is a story told of one godly man's being much troubled by a good old lady who would sit near him and sing with a most horrible voice very loudly—as those people generally do who sing badly. At last he begged her not to sing so loudly. But when she said, "It comes from my heart," the honest man of God retracted his rebuke and said, "Sing away. I would be sorry to stop you."

When praise comes from the heart, who would wish to restrain it? Even the shouts of the old Methodists, their "hallelujahs" and "glorys," when uttered in fervor, were not to be forbidden, for *"if these should hold their peace, the stones would immediately cry out"* (Luke 19:40). But there are times when those who sing, and sing well, have too much praise in their souls for it to enclose itself in words. Like some strong liquors that foam and swell until they burst each hoop that binds the barrel, so it is that sometimes we need a larger channel for our souls than that of mouth and tongue. We long to have all our nerves and tendons made into harp strings and all the pores of our bodies made mouths of thankfulness. Oh, that we could praise with our whole nature, not one single hair of our heads or drop of blood in our veins keeping back from adoring the Most High! When this desire for praise is most vehement, we fall back upon silence and quiver with the adoration that we cannot speak. Silence becomes our praise.

> A sacred reverence checks our songs,
> And praise sits silent on our tongues.

449

It would be well, perhaps, in our public services, if we had more often the sweet relief of silence. I am persuaded that frequent silence is most beneficial. The occasional unanimous silence of all the saints when they bow before God would, perhaps, better express and more fully promote devout feeling than any hymns that have been composed or songs that could be sung. To make silence a habitual part of worship might be pretentious and formal, but to include it occasionally, even frequently, in the service would be advantageous and profitable. Let us, then, by our silence, praise God, and let us always confess that our praise, compared with God's deserving, is but silence.

Praise Waits Expectantly

I want to add that there is in the text the idea that praise waits for God expectantly. When we praise God, we expect to see more of Him soon and, therefore, wait for Him. We bless the King, but we desire to draw nearer to Him. We magnify Him for what we have seen, and we expect to see more. We praise Him in His outer courts, for we will soon be with Him in the heavenly mansions. We glorify Him for the revelation of Himself in Jesus, for we expect to be like Christ and to be with Him where He is. When I cannot praise God for what I am, I will praise Him for what I will be. When I feel dull and dead about the present, I will take the words of our delightful hymn and say,

> And a new song is in my mouth,
> To long-loved music set;
> Glory to Thee for all the grace
> I have not tasted yet.

My praise should not only be thanksgiving for the past, which is but discharging a debt of gratitude, but my faith needs to anticipate the future and wait upon God to fulfill His purposes. Then I will begin to pay my praise even before the mercy comes.

We Have Many Reasons to Praise God

Let us for a moment present our praise to God, each one of us on his own account. We have our common mercies. We call them common, but, oh, how priceless they are. Health to be able

450

to assemble together and not to be stretched out on a bed of sickness, I count better than bags of gold. To have our reason and not to be confined in an asylum. To have our children still around us and dear relatives still with us. To have bread to eat and clothes to put on. To have been kept from defiling our character. To have been preserved today from the snares of the Enemy! These are Godlike mercies, and for all these, our praises will wait upon God.

Here I take up the thoughts suggested by the psalm itself in the next verse, and you will doubly praise God. *"Iniquities prevail against me: as for our transgressions, thou shalt purge them away"* (Ps. 65:3). Infinite love has made us completely clean, though we were black and filthy. We are washed—washed in priceless blood. Praise Him for this! Go on with the passage: *"Blessed is the man whom thou choosest, and causest to approach unto thee"* (v. 4). Is not the blessing of access to God an exceedingly choice one? Is it a light thing to feel that we, *"who sometimes were far off are made nigh by the blood of Christ"* (Eph. 2:13) because of electing love?

"Blessed is the man whom thou choosest." You who have been eternally chosen, can you be silent? Has God favored you above others, and can your lips refuse to sing? No, you will magnify the Lord exceedingly, because He has chosen Jacob unto Himself and Israel for His special treasure.

Let us read on and praise God that we have an abiding place among His people: *"That he may dwell in thy courts"* (Ps. 65:4). Blessed be God, we are not to be cast forth and driven out after a while, but we have a guaranteed inheritance among the sons of God. We praise Him that we have the satisfaction of dwelling in His house as children. *"We shall be satisfied with the goodness of thy house, even of thy holy temple"* (v. 4). But I simply say to you, there are ten thousand reasons for taking down the harp from the willows. (See Psalm 137:1–4.) I know no reason for permitting it to hang there idle. There are ten thousand times ten thousand reasons for speaking well of *"Christ* [who] *hath loved us, and hath given himself for us"* (Eph. 5:2).

"The LORD hath done great things for us; whereof we are glad" (Ps. 126:3). I remember hearing in a prayer meeting this delightful verse mutilated in prayer: *"The LORD hath done great things for us; whereof we* [desire to be] *glad."* Oh, how I dislike mauling, mangling, and adding to a text of Scripture. If we are to have the Scriptures revised, let it be by scholars and not by every ignoramus.

"Desire to be glad" indeed? This is fine gratitude to God when He *"hath done great things for us."* If these great things have been done, our souls must be glad and cannot help it. They must overflow with gratitude to God for all His goodness.

Remember and Perform Your Vows

That covers the first part of our holy sacrifice. Attentively let us consider the second, namely, the vow. *"Unto thee shall the vow be performed."*

We are not given to vow-making these days. There was a time when it was done far more often. It may be that had we been better men we would have made more vows. It may possibly be that had we been more foolish men we would have done the same. The practice was so abused by superstition that devotion has grown half-ashamed of it. But most of us have, at any rate, bound ourselves with occasional vows. I do confess a vow I have not kept as I desire: the vow made at my conversion. I surrendered myself, body, soul, and spirit, to Him who bought me with a price, and the vow was not made by way of excess of devotion or superfluously—it was but my *"reasonable service"* (Rom. 12:1). You have done that. Do you remember the love of your betrothal, the time when Jesus was very precious and you had just entered into the marriage bond with Him? You gave yourselves up to Him to be His forever and forever. It is a part of worship to perform that vow. Renew it now; make another surrender of yourselves to Him whose you are and whom you serve. Say, *"Bind the sacrifice with cords, even unto the horns of the altar"* (Ps. 118:27). Oh, for another thong to strap the victim to the altar horn! Does the flesh struggle? Then let it be more tightly bound, never to escape from the altar of God.

Beloved, many of us did, in effect, make a most solemn vow at the time of our baptism. We were *"buried with* [Christ] *by baptism into death"* (Rom. 6:4), and unless we were greatly pretending, we vowed that we were dead in Christ and buried with Him. We also professed that we were risen with Him. Now, should the world live in those who are dead to it, and should Christ's life be absent from those who are risen with Him? We gave ourselves up then and there, in that solemn act of spiritual burial. Recall that scene, I pray you. As you do so, blush and ask God that your vow may yet be performed. The hymn writer Philip Doddridge well expressed it:

> Baptized into your Savior's death,
> Your souls to sin must die;
> With Christ your Lord ye live anew,
> With Christ ascend on high.

Some such vow we made, too, when we united ourselves to the church of God. There was an understood compact between us and the church that we would serve it, that we would seek to honor Christ by holy living, increase the church by propagating the faith, seek its unity and comfort by our own love and sympathy with the members. We had no right to join the church if we did not mean to give ourselves up to it, under Christ, to aid in its prosperity and increase. There was a stipulation made and a covenant understood when we entered into communion and league with our family in Christ. How about that? Can we say that, as unto God and in His sight, the vow has been performed? Yes, we have been true to our covenant in a measure. Oh, that it were more fully so!

Some of us made another vow when we gave ourselves, under divine call, wholly to the work of the Christian ministry. Though we have taken no orders and received no earthly ordination—for we are no believers in man-made priests—yet implicitly it is understood that the man who becomes a minister of the church of God is to give his whole time to his work and that his body, soul, and spirit should be thrown into the cause of Christ. Oh, that this vow were more fully performed by pastors of the church! Elders and deacons, when you accepted your office, you knew what the church meant. She expected holiness and zeal of you. The Holy Spirit made you overseers so that you might feed the flock of God. Your office proves your obligation. You are practically under a vow. Has that vow been performed? Have you performed it in Zion unto the Lord?

Besides that, making vows has been the occasional practice of godly men in times of pain and losses. Does not the following hymn say so?

> Among the saints that fill Thine house,
> My offerings shall be paid;
> There shall my zeal perform the vows,
> My soul in anguish made.

> Now I am Thine, forever Thine,
> Nor shall my purpose move!

> Thy hand hath loosed my bands of pain
> And bound me with Thy love.
>
> Here in Thy courts I leave my vow,
> And Thy rich grace record.
> Witness, ye saints, who hear me now
> If I forsake the Lord.

In times of affliction, you said, "If I am ever raised up, and my life is prolonged, it will be better spent." You also said, "If I am delivered out of this great trouble, I hope to consecrate more of my income to God." Another time you said, "If the Lord will return to me the light of His countenance and bring me out of this depressed state of mind, I will praise Him more than ever before." Have you remembered all this? Recently, having recovered from an illness, I admonish myself as well as you. I only wish I were a better hearer. Then I would exhort myself in this respect, saying, "I charge you, my heart, to perform your vow."

Some of us, dear friends, have made vows in times of joy, the season of the birth of the firstborn child, the recovery of the wife from sickness, the merciful restoration that we have ourselves received, times of increasing goods, or seasons when the splendor of God's face has been unveiled before our wondering eyes. Have we not made vows as Jacob did when he woke up from his wondrous dream, took the stone that had been his pillow, poured oil on its top, and made a vow unto the Most High? We have all had our Bethels. Let us remember that God has heard us, and let us perform unto Him the vows that our souls made in their times of joy.

However, I will not try to open the secret pages of your private notebooks. You have had tender passages that you would not desire me to read aloud. If your life were written, you would say, "Let these incidents not be told; they were only between my soul and God." There are some chaste and blessed love passages between you and Christ that must not be revealed to men. Have you forgotten how you then said, *"I am my beloved's, and my beloved is mine"* (Song 6:3)? What you promised when you saw all His goodness made to pass before you! Now I have to *"stir up your pure minds by way of remembrance"* (2 Pet. 3:1) and bid you to present unto the Lord the double offering of your heart's praise and of your performed vow. *"O magnify the LORD with me, and let us exalt his name together"* (Ps. 34:3).

BLESSED ENCOURAGEMENT

Now, I must include a few words about the blessed encouragement afforded us in the text for the presentation of these offerings unto God. Here it is: *"O thou that hearest prayer, unto thee shall all flesh come."* Observe, here, that God hears prayer. In some aspects, prayer is the lowest form of worship, and yet He accepts it. It is not the worship of heaven, and, in a measure, it is selfish. Praise is superior worship, for it is elevating. It is the utterance of a soul that has received good from God and is returning its love to Him in acknowledgment. Praise has a sublime aspect.

Now, observe that if prayer is heard, then praise will be heard, too. If the lower form, on weaker wing as it were, reaches the throne of the Majesty on high, how much more shall the angelic wing of praise bear itself into the divine presence. Prayer is heard by God. Therefore, our praises and vows will be heard, also. This is a very great encouragement, because it seems terrible to pray if you are not heard, and discouraging to praise God if He will not accept the praises. What would be the use of it? But if prayer and, even more so, praise are most surely heard, then let us continue and abide in thanksgiving. The Lord says, *"Whoso offereth praise glorifieth me"* (Ps. 50:23).

Observe also according to the text, that all prayer, if it is true prayer, is heard by God, for that is why the psalmist said, *"Unto thee shall all flesh come."* Oh, how glad I am at that word. My poor prayer—will God reject it? Yes, I might have feared so if He had said, "Unto Me shall all spirits come." Behold, beloved, He takes the larger part as it were, and looks at prayer in His infinite compassion, perceiving it to be what it is—a feeble thing, a cry coming from poor, fallen flesh. And He puts it this way, *"Unto [Me] shall all flesh come."* My broken prayer, my groaning prayer, will get to Him. Though it seems to me a thing of flesh, it is nevertheless inspired in me by His Spirit. My song, though my voice is hoarse and oftentimes my notes are most feeble, will reach Him. Though I groan because my song is so imperfect, even that will come to Him. Prayer, if it is sincere, will be received by God through Jesus Christ, notwithstanding all its faultiness. Then so it will be with our praises and our vows.

Again, prayer is always and habitually received by God. *"O thou that hearest prayer."* Not "did hear it," or, "on a certain occasion

455

may have heard it"; He ever hears prayer. If He always hears prayer, He always hears praise. Is it not delightful to think that God does hear my praise—though it is but that of a child or a poor unworthy sinner—and does accept it in spite of its imperfections, and does accept it always? Oh, I will sing another hymn today. I will sing a new song tomorrow. I will forget my pain. I will forget for a moment all my cares. If I cannot sing aloud because of those with me, yet will I set the bells of my heart ringing. I will make my soul full of praise. If I cannot let it out of my mouth, I will praise Him in my soul, because He always hears me.

You know it is hard to do things for one who never accepts what you do. Many a wife has said, "Oh, it is hard. My husband never seems pleased. I have done all I can, but he takes no notice of little deeds of kindness." But how easy it is to serve a person who, when you have done any little thing, says, "How kind it was of you," and thinks much of it. Ah, poor child of God, the Lord thinks much of your praises, your vows, your prayers. Therefore, do not be slack to praise and magnify Him unceasingly.

Further, we have not quite finished with that word, *"Unto thee shall all flesh come."* All flesh will come because the Lord hears prayer. Then all my praises will be heard, and all the praises of all sorts of men, if sincere, will come unto God. The great ones of the earth will present praise, and the poorest of the poor also, for He will not reject them.

Lord, would You put it so, *"Unto* [Me] *shall all flesh come,"* and yet would You say, "But not such a one as you?" Would You exclude me? Beloved, fear not that God will reject you. I am reminded of a good, earnest, believing woman who in prayer said, "Lord, I am content to be the second You would forsake, but I cannot be the first." The Lord says all flesh will come to Him, and it is implied that He will receive them when they come—all sorts of men, all classes and conditions of men. Then He will not reject me if I come, nor my prayers if I pray, nor my praise if I praise Him, nor my vows if I perform them. Come then, let us praise the Lord. Let us worship and bow down. Let us kneel before the Lord our maker, for *"we are the people of his pasture, and the sheep of his hand"* (Ps. 95:7).

Finally, beloved, there may be difficulties in your way. Iniquities may hinder you, or infirmities; but there is the promise, *"Thou shalt purge them away"* (Ps. 65:3). Infirmities may check you, but note the word of divine help: *"Blessed is the man whom*

thou...causest to approach unto thee" (v. 4). He will come to your aid and lead you to Himself. Infirmities, therefore, are overcome by divine grace.

Perhaps your emptiness hinders you. *"We shall be satisfied with the goodness of thy house"* (v. 4). It is not your goodness that is to satisfy either God or you, but God's goodness is to satisfy. Come, then, with your iniquity; come with your infirmity; come with your emptiness. Come if you have never come to God before. Come and confess your sin to God, and ask for mercy. You can do no less than ask. Come and trust His mercy that endures forever because it has no limit. Do not think harshly of Him, but come and lay down at His feet. If you perish, perish there. Come and tell your grief. Pour out your heart before Him. Turn the vessel of your nature upside down, drain out the last dregs, and pray to be filled with the fullness of His grace. Come to Jesus. He invites you. He will enable you.

Your cry will reach the sacred ear. "But I have not prayed before," you say. Everything must have a beginning. Oh, that your beginning might come now. It is not because you pray well that you are to come, but because the Lord hears prayer graciously; therefore, all flesh will come. You are welcome. None can block your way. Come! This is mercy's welcome hour.

May the Lord's cords of love be thrown around you. May you be drawn now to Him. Come by way of the Cross. Come resting in the precious atoning sacrifice, believing in Jesus. He has said, *"Him that cometh to me I will in no wise cast out"* (John 6:37). The grace of our Lord be with you. Amen.

5

The Power of Prayer and the Pleasure of Praise

Ye also helping together by prayer for us, that for the
gift bestowed upon us by the means of many persons thanks
may be given by many on our behalf. For our rejoicing is this,
the testimony of our conscience, that in simplicity and godly
sincerity, not with fleshly wisdom, but by the grace of God,
we have had our conversation in the world,
and more abundantly to you-ward.
—2 Corinthians 1:11–12

The apostle Paul had, by unique providence, been delivered from imminent peril in Asia. During the great riot at Ephesus, Paul's life was greatly in jeopardy when Demetrius and his fellow shrine-makers raised a great tumult against him because they saw that their craft was in danger. Paul thus wrote, *"We were pressed out of measure, above strength, insomuch that we despaired even of life"* (2 Cor. 1:8). The apostle attributed his preservation to God alone. If he referred also to the occasion when he was stoned and left for dead, it is very appropriate that he blessed *"God which raiseth the dead"* (v. 9).

Moreover, the apostle argued from the fact that God had thus delivered him in the past, was still his helper in the present, and would be with him also in the future. Paul was a master at all arithmetic; his faith was always a ready reckoner. We find him here computing by the Believer's Rule of Three: he argues from the past to the present, and from the present to things yet to come. The verse preceding our text is a brilliant example of this arriving

458

at a comfortable conclusion by the Rule of Three: *"Who delivered us from so great a death, and doth deliver: in whom we trust that he will yet deliver us"* (2 Cor. 1:10). Because God is *"the same yesterday, and to day, and for ever"* (Heb. 13:8), His love in time past is an infallible assurance of His kindness today, and an equally certain pledge of His faithfulness tomorrow, whatever our circumstances may be, however perplexing our path may be, and however dark our horizon. If we argue by the rule of "He did, He does, He will," our comfort can never be destroyed. Take courage, afflicted one. If you had a changeable God to deal with, your soul might be full of bitterness. However, because He is *"the same yesterday, and to day, and for ever,"* every repeated manifestation of His grace should make it easier for you to rest in Him. Every renewed experience of His fidelity should confirm your confidence in His grace. May the blessed Spirit teach us to grow in holy confidence in our ever faithful Lord.

Although Paul thus acknowledged God's hand, and God's hand alone, in his deliverance, yet he was not so foolish as to deny or undervalue the secondary causes. On the contrary, having first praised the God of all comfort, he then remembered with gratitude the earnest prayers of the many loving intercessors. Gratitude to God must never become an excuse for ingratitude to man. It is true that the Almighty shielded the apostle from the Gentiles, but He did it in answer to prayer. The chosen vessel was not broken by the rod of the wicked, for the outstretched hand of the God of heaven was his defense; however, that hand was outstretched because the people of Corinth and the saints of God everywhere had prevailed at the throne of grace by their united prayers. With gratitude, those successful pleadings were mentioned in the text: *"Ye also helping together by prayer for us."* Paul desired the believers to unite their praises with his, *"that for the gift bestowed upon us by the means of many persons thanks may be given by many on our behalf."* He added that he had a claim on their love, since he was not as some who were unfaithful to their trust, but his conscience was clear that he had preached the Word simply and with sincerity.

We will, first, acknowledge the power of unified prayer; second, urge you to praise in harmony with other believers; and in the third place, press our joyful claim upon you—a claim that is not ours alone, but belongs to all ministers of God who in sincerity labor for souls.

THE POWER OF UNITED PRAYER

First, then, dear friends, it is my duty and my privilege to acknowledge the power of united prayer. It has pleased God to make prayer the abounding and rejoicing river through which most of our choice mercies flow to us. It is the golden key that unlocks the well-stocked granaries of our heavenly Joseph. It is written on each of the mercies of the covenant, *"I will yet for this be inquired of by the house of Israel, to do it for them"* (Ezek. 36:37). There are mercies that come unsought, for God has been found by those who did not seek Him. But there are other favors that are bestowed only on those who ask and therefore receive, who seek and therefore find, who knock and therefore gain an entrance.

The Purposes of Prayer

Why God is pleased to command us to pray at all is not difficult to discover, for prayer glorifies God by putting man in the humblest posture of worship. In prayer, the creature acknowledges his Creator with reverence, and confesses Him to be the Giver of every good and perfect gift (James 1:17). The eye is lifted up to behold the glory of the Lord, while the knee is bent to the earth in the lowly acknowledgment of weakness. Though prayer is not the highest mode of adoration (or otherwise it would be continued by the saints in heaven), it is the most humble, and so the most fitting to set forth the glory of the perfect One as it is beheld by imperfect flesh and blood.

From the *"our Father,"* in which we claim relationship, right on to *"the kingdom, and the power, and the glory"* (Matt. 6:9, 13), which we ascribe to the only true God, every sentence of prayer honors the Most High. The groans and tears of humble petitioners are as truly acceptable as the continual *"Holy, holy, holy"* (Isa. 6:3) of the cherubim and seraphim, for in their very essence, all truthful confessions of personal fault are but homage paid to the infinite perfection of the Lord of Hosts. More honored is the Lord by our prayers than by the unceasing smoke of the holy incense of the altar that stood before the veil.

Moreover, the act of prayer teaches us our unworthiness, which is no small blessing to such proud beings as we are. If God gave us favors without requiring us to pray for them, we would

never know how poor we are, but a true prayer is an inventory of needs, a catalog of necessities, an exposure of secret wounds, a revelation of hidden poverty. While it is a petition to divine wealth, it is a confession of our emptiness. I believe that the most healthy state of a Christian is to be always empty and always dependent on the Lord for supplies; to be always poor in self and rich in Jesus; to be as weak as water personally, but mighty through God to do great exploits. Therefore, the exercise of prayer, while it adores God, lays the creature where he should be—in the very dust.

Prayer is in itself, apart from the answer that it brings, a great benefit to the Christian. As the runner gains strength for the race by daily exercise, so we acquire energy for the great race of life by the sacred labor of prayer. Prayer plumes the wings of God's young eaglets, so that they may learn to mount above the clouds. Prayer clothes God's warriors and sends them forth to combat with their muscles firm. An earnest pleader comes out of his prayer closet rejoicing like a strong man ready to run his race. Prayer is that uplifted hand of Moses that routs the Amalekites more than the sword of Joshua. It is the arrow shot from the chamber of the prophet, foreboding defeat to the Syrians. Prayer clothes the believer with the attributes of Deity, girds human weakness with divine strength, turns human folly into heavenly wisdom, and gives to troubled mortals the serenity of the immortal God. Thank You, Lord, for the mercy seat, a choice gift of Your marvelous lovingkindness. Help us to use it rightly.

Just as many mercies are conveyed from heaven in the ship of prayer, so there are many choice, special favors that can only be brought to us by the fleets of unified prayer. God will give to his lonely Elijahs and Daniels many good things, but if *"two of you shall agree on earth as touching any thing that they shall ask"* (Matt. 18:19), there is no limit to God's bountiful answers. Peter might never have been freed from prison if the whole church had not prayed unceasingly for him. Pentecost might never have come if all the disciples had not been *"with one accord in one place"* (Acts 2:1), waiting for the descent of the tongues of fire.

The Purposes of United Prayer

God is pleased to give many mercies to one intercessor, but at times He seems to say, "You will all appear before Me and entreat

My favor, for I will not see your face unless even your younger brothers and sisters are with you." Why is this, dear friends? I take it that thus our gracious Lord sets forth His esteem for the communion of the saints. "I believe in the communion of saints" is one article of the great Christian creed, but how few there are who understand it. There is such a thing as real union among God's people. We may be called by different names, "but all the servants of our King, in heaven and earth, are one."

We cannot afford to lose the help and love of our Christian family. Augustine said, "The poor are made for the rich, and the rich are made for the poor." I do not doubt that strong saints are made for weak saints, and that the weak saints bring special blessings upon the full-grown believers. There is a fitness in the whole body. Each joint owes something to every other, and the whole body is bound together by what every joint supplies. There are certain glands in the human body that the anatomist hardly understands. However, if these glands were removed, the whole body would doubtless suffer to a high degree.

Likewise, beloved, there may be some believers of whom we may say, "I do not know the purpose for them. I cannot tell what good that Christian does." Yet if that apparently useless member were removed, the whole body might suffer, the whole frame might become sick, and the whole heart might faint. This is probably the reason that many a weighty gift of heaven's love is only granted to combined petitioning: so that we may perceive the use of the whole body and may be compelled to recognize the vital union that divine grace has made and daily maintains among the people of God.

Is it not a happy thought, dear friends, that the very poorest and most obscure church member can add something to the body's strength? We cannot all preach, we cannot all rule, we cannot all give gold and silver, but we can all contribute our prayers. There is no convert, even though he may be only two or three days old in grace, who cannot pray. There is no bedridden sister in Jesus who cannot pray. There is no sick, aged, obscure, illiterate, or penniless believer who cannot add his supplications to the general stock. This is the church's riches. While we put boxes at the door or pass the offering baskets so that we may receive offerings for God's cause, remember there is a spiritual chest within the church, into which we should all drop our loving intercessions, as into the treasury of the Lord. Even the widow who does not have two mites can give her offering to this treasury.

See, then, dear friends, what union and communion there are among the people of God, since there are certain mercies that are only bestowed when the saints unitedly pray. How we ought to feel this bond of union and pray for one another! How, as often as the church meets together for prayer and supplication, we should all make it our bound duty to be there! Those of you who are absent from the prayer meetings for any little excuse need to reflect how much you rob the whole body. The prayer meeting is an invaluable institution, ministering strength to all other meetings and ministries. Are there any of you who might, by a little managing of your time and compressing of your labors, be able to attend more often? What if you should lose a customer; do you not think that this loss could be well made up to you by your gain on other days? Even if the loss were not made up, would not the spiritual profit much more than counterbalance any temporal loss? Do not forget *"the assembling of [y]ourselves together, as the manner of some is"* (Heb. 10:25).

United Prayer for Ministers

We are now prepared for a further observation. This united prayer should especially be made for the ministers of God. It is for them particularly that this public prayer is intended. Paul asked for it: *"Brethren, pray for us"* (2 Thess. 3:1). All God's ministers to the end of time will ever confess that this is the secret source of their strength. The prayers of the people must be the might of the ministers. Should I try to show you why the minister more than any other man in the church needs the earnest prayers of the people? Is his position not the most perilous? Satan's orders to the hosts of hell are, *"Fight neither with small nor great, save only with the king* [ministers of God]*"* (1 Kings 22:31). He knows if he can once smite one of these through the heart, there will be a general confusion, for if the champion is dead, then the people flee. It is around the standard-bearer that the fight is heaviest. There the battle-axes ring upon the helmets, and the arrows are bent upon the armor. The Enemy knows that if he can cut down the standard or split open the skull of its bearer, he will strike a heavy blow and cause deep discouragement.

Press around us ministers, men at arms! Knights of the red cross, rally for our defense, for the fight grows hot. We urge you

that if you elected us to the office of the ministry, stand fast at our sides in our hourly conflicts. I noticed when returning from Rotterdam, when we were crossing the sandbar at the mouth of the Meuse, where because of a neap tide and a bad wind the navigation was exceedingly dangerous, that orders were issued, "All hands on deck!" I think the life of a minister is so perilous that I may well cry, "All hands on deck. Every man to prayer." Let even the weakest saint become faithful in supplication.

Moreover, the minister, standing in such a perilous position, has a solemn weight of responsibility resting on him. Every man should be his brother's keeper in a measure, but woe to the watchmen of God if they are not faithful, for at their hands will the blood of souls be required. At their door will God lay the ruin of men if they do not preach the Gospel fully and faithfully. There are times when this burden of the Lord weighs upon God's ministers until they cry out in pain as if their hearts would burst with anguish.

As the vessel crossed that sandbar, I noted the captain himself was pitching the lead into the sea. When someone asked why he did not let the sailors do it, he said, "At this point, just now, I dare not trust any man but myself to throw the lead, for we have barely six inches between our ship and the bottom." Indeed, we felt the vessel touch once or twice most unpleasantly. So there will come times with every preacher of the Gospel, if he is what he should be, when he will be in anguish for his hearers and will not be able to discharge his duty by proxy, but must personally labor for men's eternal destinies. He will not even trust himself to preach, but will call on God for help since he is now overwhelmed with the burden of men's souls. Do pray for us. If God gives us to you, and if you accept the gift most cheerfully, do not despise both God and us by leaving us penniless and poverty-stricken because your prayers have been withheld.

Moreover, the preservation of the minister is one of the most important objectives for the church. You may lose a sailor from the ship, and that is very bad, both for him and for you. However, if the pilot should fall over, or the captain suddenly become ill, or the helmsman be washed from the wheel, then what does the vessel do? Thus, though prayer is to be offered for every person in the church, yet for the minister it is to be offered first and foremost, because of the position he occupies.

Remember how much more is asked of him than of you. If you are to keep a private table for individual instruction, he is, as it were, to keep a public table as a feast of good things for all comers. How will he do this unless his Master gives him rich provisions? You are to shine like a candle in a house; the minister has to be like a lighthouse to be seen far across the deep. How will he shine the whole night long unless he is trimmed by his Master and fresh oil is given to him from heaven? His influence is wider than yours: if it is for evil, he will be a deadly upas tree, with spreading boughs poisoning all beneath his shadow. But if God makes him a star, his ray of light will cheer whole nations and whole periods of time with its genial influence. If there is any truth in this, I implore you to yield your minister generously and constantly the aid of your prayers.

Earnest Prayer

In the original language, the word for *"helping together"* implies very earnest work. Some people's prayers have no effort in them, but the prayer that prevails with God is a real workingman's prayer in which the petitioner, like Samson, shakes the gates of mercy and labors to pull them up rather than be denied an entrance. We do not want fingertip prayers, which only touch the burden; we need shoulder prayers, which bear a load of earnestness and are not to be denied their desire. We do not want those dainty runaway knocks at the door of mercy that some give when they show off at prayer meetings, but we ask for the knocking of a man who means to have his petition granted, and means to stay at mercy's gate until it opens and all his needs are supplied.

The energetic vehemence of the man who is not to be denied, but intends to take heaven by storm until he wins his heart's desire, is the prayer that ministers covet of their people. Philipp Melanchthon, a Protestant Reformer, derived great comfort from the information that certain poor weavers, women and children, had met together to pray for the Reformation. For Melanchthon, that was solid ground for comfort. You can be sure that it was not Luther only, but the thousands of poor people who sang psalms behind the plow and the hundreds of serving men and women who interceded that made the Reformation what it was. We are told about Paulus Phagius, a celebrated Hebrew scholar who helped to introduce the Reformation into England, that his most frequent

request of his young scholars was that they would continue in prayer so that God might answer by pouring out a blessing.

I have repeatedly said that all the blessing God has given, all the increase in Metropolitan Tabernacle, has been due, under God, to the earnest, fervent prayers of the saints. There have been heaven-moving seasons in this local body. We have had times when we have felt we would die sooner than not be heard, when we have carried our church on our heart as a mother does her child, when we felt a yearning and a travailing in birth for men's souls. *"What hath God wrought!"* (Num. 23:23), we may truly say when we see our churches daily increasing and the multitudes hanging on our words to hear the Gospel. Should we now cease from prayer? Should we say to the Great High Priest, "Enough"? Should we now pluck the glowing coals from the altar and quench the burning incense? Should we now refuse to bring the morning and evening lambs of prayer and praise to the sacrifice?

Children of God, being armed and carrying bows, will you turn your backs in the day of battle for your church? The floodwaters are divided before you. The Jordan is driven back. Will you refuse to march through the depths? Your God goes before you. The shout of a King is heard in the midst of your hosts. Will you now be cowardly and refuse to go up to possess the land? Will you now lose your first love? Will *"Ichabod"* (1 Sam. 4:21) be written on the forefront of your church? Will it be said that God has forsaken you? If not, return to your knees, with all the force of prayer! If not, begin your vehement supplications once more! If not—if you do not want to see good blighted and evil triumphant—clasp hands, and in the name of Him who ever lives to intercede, be powerful in prayer so that the blessing may descend right where you are. *"Ye also helping together by prayer for us."*

The Importance of United Praise

I must now urge you to praise. Praise should always follow answered prayer. The mist of earth's gratitude should rise as the sun of heaven's love warms the ground. Has the Lord been gracious to you and inclined His ear to the voice of your supplication? Then praise Him as long as you live. Do not deny a song to Him who has answered your prayer and given you the desire of your heart. To be silent over God's mercies is to incur the guilt of shocking ingratitude,

and ingratitude is one of the worst of crimes. I trust, dear friends, you will not act as wickedly as the nine lepers who, after they had been healed of their leprosy, did not return to give thanks to the healing Lord.

The Purposes of Praise

To forget to praise God is to refuse to benefit ourselves, for praise, like prayer, is exceedingly useful to the spiritual man. It is a high and healthy exercise. To dance like David before the Lord is to quicken the blood in the veins and make the pulse beat at a healthier rate. Praise gives to us a great feast, like that of David, who gave to every man a good piece of meat and a flagon of wine.

Praise is the most heavenly of Christian duties. The angels do not pray, but they do not cease to praise both day and night. (See Revelation 4:8.) To bless God for mercies received is to benefit our fellowmen; *"the humble shall hear thereof, and be glad"* (Ps. 34:2). Others who have been in similar circumstances will take comfort when we say, *"O magnify the LORD with me, and let us exalt his name together....This poor man cried, and the LORD heard him, and saved him out of all his troubles"* (vv. 3, 6). Tongue-tied Christians are a sad dishonor to the church. We have some whom the Devil has gagged, and the loudest music they ever make is when they are chomping the bit of their silence. I desire in all such cases that their tongues may sing.

Let us go a step further. As praise is good and pleasant, blessing man and glorifying God, united praise is especially commendable. Unified praise is like music in concert. The sound of one instrument is exceedingly sweet, but when hundreds of instruments, both wind and stringed, are all combined, then the orchestra sends forth a noble volume of harmony. The praise of one Christian is accepted before God as a grain of incense, but the praise of many is like a censer full of frankincense, wafting its smoke before the Lord. Combined praise is an anticipation of heaven, for in that general assembly they altogether with one heart and voice praise the Lord.

> Ten thousand are their tongues,
> But all their joys are one.

Public praise is very agreeable to the Christian himself. How many burdens has it removed? I am sure when I hear the shout of

praise, it warms my heart. It is at times a little too slow for my taste, and I must urge my congregation to quicken their tempo, so that the rolling waves of majestic praise may display their full force. Yet with all drawbacks, to my heart there is no music like the music I hear in the local congregation. My Dutch friends praise the Lord so very slowly that one might very well go to sleep, lulled by their lengthened strains. Even there, however, the many voices make a grand harmony of praise. I love to hear God's people sing when they really do sing, not when it is somewhere between harmony and discord. Oh, for a sacred song, a shout of lofty praise in which every person's soul beats the time, every man's tongue sounds the tune, and each singer feels a high ambition to excel his fellow worshiper in gratitude and love! There is something exceedingly delightful in the union of true hearts in the worship of God. When these hearts are expressed in song, sweet are the charming sounds.

I think the church ought to have a praise meeting once a week. We have prayer meetings at least one evening a week, and many have prayer meetings every morning, but why do we not have praise meetings? Seasons should be set apart for services made up of praise from beginning to end. Let us try the plan at once.

Praise for Pastors

As I said that unified prayer should be offered especially for ministers, so should united praise take the same direction: the whole company should praise and bless God for the mercy rendered to the church through its pastors. Hear how the apostle Paul puts it again: *"That for the gift bestowed upon us by the means of many persons thanks may be given by many on our behalf."* Beloved, we ought to praise God for good ministers, for when they die, much of their work dies with them. It is astonishing how a reformation will press on while Luther and Calvin live, and how it will cease directly when the reformers die. The spirits of good men are immortal only in a sense. The churches of God in this age are like the Israelites in the times of the judges: when the judges died, they went after graven images again. So it is now, too. While God spares the pastor, the church prospers, but when the man dies, the zeal which he blew to a flame smolders among the ashes. In nine cases out of ten, if not in ninety-nine out of every hundred, the prosperity of a

church rests on the minister's life. God so ordains it to humble us. There should be gratitude, then, for the spared life of your pastor.

We should also have great gratitude for preserved character, because when a minister falls, what a disgrace it is! When you read in the newspapers the sad case of the Reverend So-and-So who chose to call himself a Baptist minister, everybody says, "What a shocking thing! What a bad lot those Baptists must be." Now, any fool in the world can call himself a Baptist minister. Our liberty is so complete that no law or order exists. Any man who can get a dozen to hear him is a minister, at least to them. Therefore, you can suppose that there may be some hypocrites who will take the name in order to get some sort of reputation. If the true minister is kept and made to hold fast to his integrity, there should be constant gratitude to God on his behalf.

If the minister is well supplied with good material, if he is like a springing well, if God gives him to bring forth from His treasury things both new and old to feed the people, there should be hearty thanks. If the pastor is kept sound, if he does not go aside to philosophy on the one hand nor to a narrowness of doctrine on the other, there should be thanksgiving for it. If God gives to the masses the desire to hear the teachings, and above all, if souls are converted and saints are edified, there should be never ceasing honor and praise to God.

I am referring now to what you know, and you are just giving mental agreement, perhaps thinking there is not much to it. However, if you were to live in Holland these days for even a short time, you would soon appreciate these remarks. While traveling there, I stayed in houses with godly men, men of God with whom I could hold sweet communion who cannot attend what was once their place of worship. Why not? "Sir," they say, "how can I go to a place of worship when most of the ministers deny every word of Scripture—not only the ministers of the Reformed church, but of every sect in Holland? How can I listen to the traitors who swear to the Calvinistic or Lutheran articles, and then go into the pulpit and deny the reality of Christ's resurrection, or assert that the ascension of Jesus is a mere spiritual parable?"

In the Netherlands, they are fifty years ahead of us in unbelief. We will soon catch up with them if men of a certain school are allowed to multiply. The Dutch ministers have taken great strides in advancing false doctrine, to the point that the people who love the truth (and there are multitudes who are willing to hear it) are

absolutely compelled to refuse to go to church at all, lest by their presence they imply their assent to the heretical and false doctrines that are preached every Sunday.

If God were once to take away from England the ministers who preach the Gospel boldly and plainly, you would cry to God to give you the candlestick back again. We may indeed say of England, "With all thy faults, I love thee still." We have a few men of all denominations who are sliding from the truth, but they are nothing yet. They are a drop in a bucket compared with the churches of Christ. Those among us who are not as Calvinistic as we wish, never dispute the inspiration of Scripture or doubt the truth of justification by faith. We still have faithful men who preach the whole truth of the Gospel.

Be thankful for your ministers. If you were placed where some believers are, you would cry out to God, "Lord, send us back your prophets. Send us a famine of bread or of water, but do not send us a famine of the Word!"

I praise God for the help He bestowed on me in the very arduous work in Holland from which I just returned. Praise be to God for the acceptance that He gave me in that country among all of the people. I speak to His praise, and not to mine, for this has been a vow with me: that if God would give a harvest, I would not have an ear of corn of it, but He would have it all. I found in all the places where I went great multitudes of people—crowds who could not understand me, but who wanted to see my face because God had blessed my translated sermons to their souls; many who treated me with brotherly kindness and, with tears in their eyes, invoked in the Dutch language every blessing upon my head. I had hoped to preach to some fifties and hundreds. Instead of that, there were so many that the great cathedrals were not too large. This surprised me and made me glad and caused me to rejoice in God.

I thank God for the acceptance that He gave me among all ranks of the people. While the poor crowded to shake hands until they almost pulled me in pieces, it pleased God to move the heart of the queen of Holland to send for me. For over an hour, I was privileged to talk with her concerning the things that make for our peace. I sought no interview with her, but it was her own wish. Then I lifted up my soul to God that I might talk of nothing but Christ and might preach to her of nothing but Jesus. So it pleased the Master to help me, and I left that very amiable lady, not having failed to declare the whole counsel of God.

I was gratified indeed to find myself cordially received by all denominations, so that on the Saturday in Amsterdam, I preached in the Mennonite church in the morning and at the Old Dutch Reformed church in the evening. The next Sunday morning I was in the English Presbyterian church, and then again in the evening in the Dutch Free church. When I sometimes spoke in the great cathedrals, not only were the poor in attendance, but the nobility and the gentry of the land, who could understand English better than most of the poor, who have had no opportunity to learn it.

While going from town to town, I felt the Master helping me continually to preach. I never knew such elasticity of spirit, such an abounding of heart in my life before. I came back, not wearied and tired, though preaching twice every day, but fuller of strength and vigor than when I first set out. I give God the glory for the many souls who have been converted through the reading of the printed sermons, and for the loving blessings of those who followed us to the ship with many tears, saying to us, *"Do thy diligence to come before winter"* (2 Tim. 4:21), urging us once more to preach the Word in that land.

There may be mingled with this some touch of egotism. The Lord knows whether it is so or not, but I am not conscious of it. I do bless His name that in a land where there is so much philosophy, He helped me to preach the truth so simply that I never uttered a word as a mere doctrinalist, but preached Christ and nothing but Christ. Rejoice with me, dear ones. If you will not, I must rejoice alone, but any loaf of praise is too great for me to eat it all.

THE MINISTER'S CLAIM TO PRAYER AND PRAISE

I need to urge the joyful claims that the apostle Paul gave in 2 Corinthians 1:12, as a reason that there should be prayer and praise for your minister, as well as for me:

For our rejoicing is this, the testimony of our conscience, that in simplicity and godly sincerity, not with fleshly wisdom, but by the grace of God, we have had our conversation in the world, and more abundantly to you-ward.

The Simple Presentation of the Gospel

After all, a man's comfort must come, next to the finished salvation of God, from the testimony of his own conscience. To a minister, what a testimony it is that he has preached the Gospel in simplicity. There are two aspects to preaching with simplicity: preaching not with double-mindedness, saying one thing and meaning another; preaching not as oarsmen row, looking one way and pulling another; but rather preaching, meaning exactly what is said, having a single heart, desiring God's glory and the salvation of men. And what a blessing it is to have preached the Gospel simply—without hard words, without polished phrases, never studying elocutionary graces, never straining after oratorical embellishments. How accursed must be the life of a man who pollutes the pulpit with the dignity of eloquence. How desperate will be his deathbed when he remembers that he made an exhibition of his powers of speech rather than of the solid things that make for winning souls. The conscience that can speak of having dealt with God's truth in simplicity will rest easy.

Paul said, also, that he had preached the Gospel with sincerity—that is, he had preached as he meant it and felt it, preached it so that none could accuse him of being false. The Greek word has a hint in it of sunlight. He is the true minister of God who preaches what he would wish to have displayed in the sunlight, or who has the sunlight shining right through him. I am afraid none of us are like clear glass—most of us are colored a little—but he is happy who seeks to get rid of the tinted matter as much as possible, so that the light of the Gospel may shine straight through him as it comes from the Sun of Righteousness.

Paul had preached with simplicity and sincerity, and he added, *"Not with fleshly wisdom."* Oh, the stories I have heard of what fleshly wisdom will do! I have learned a valuable lesson during the last two weeks that I wish England would learn. There are three schools of theological error in Holland. Each one leaps over the back of its fellow: some of them hold that the facts of Scripture are only myths; others of them say that there are some good things in the Bible, though there are a great many mistakes; and others go further still and fling the whole Bible away altogether as to its inspiration, even though they still preach it and lean on it, saying that they do so only for the edification of the uneducated, merely holding it up for the sake of the common masses (though I ought to

add, merely to get their living, as well). How sad that the church has gone to such a length as that—the Old Dutch Reformed church, the very mirror of Calvinism, standing fast and firm in its creeds to all the doctrines we love, and yet gone astray to licentious liberty. How earnestly we decry fleshly wisdom!

I am afraid, dear friends, that some of you, when you hear a minister, want him to express the message well. You find fault unless he shows some degree of talent. I wonder whether that is not a sin. I am half inclined to think it is. I sometimes ponder whether we ought to look less and less to talent and more and more to the matter of the Gospel that is preached; whether it is a weakness if we are profited more by a man who is blessed with great speaking abilities; whether we should revert to the days of fishermen and give men no sort of education whatsoever, but just send them to preach the truth simply, rather than go the present lengths of giving men all sorts of learning that is of no earthly use to them, but that only helps them to pervert the simplicity of God. I love that phrase in this text, *"Not with fleshly wisdom."*

And now I lay my claim—as my conscience bears me witness— I lay my claim to this same boasting of the apostle Paul. I have preached God's Gospel in simplicity. I have preached it sincerely— the Searcher of all hearts knows that. I have not preached it with fleshly wisdom for one excellent reason: I have not any wisdom of my own and have been compelled to keep to the simple testimony of the Lord. But if I have done anything, it has been done by the grace of God. If any success has been achieved, it has been grace that has done it all.

The Minister's Efforts on His Congregation's Behalf

"And more abundantly to you-ward." Though my word has gone forth to many lands and my testimony belts the globe, yet more especially to my congregation has my ministry been directed. I have warned them; I have entreated them; I have exhorted them; with them have I pleaded; over them have I wept; for them have I prayed. To some of them I have been a spiritual parent in Christ; to many of them like a nursing parent; to many of them a teacher and an edifier in the Gospel; and, I hope, to all of them a sincere friend in Christ Jesus. Therefore, I claim their prayers for me as their pastor.

Though there are many who remember their pastors in their prayers, I exhort you, inasmuch as their efforts have been especially *"to you-ward,"* let them especially have your prayers. Some will say that it is unkind of me to suppose that you do not pray for your pastors. I do not suppose it out of unkindness, but know that some forget to intercede and thank God for their pastors. Continue to pray for them! Rejoice that the Lord has given them to you for your edification and exhortation!

Most likely, your whole congregation is not saved yet. There are probably some who hear the pastor's preaching who are not yet converted. Plead with God for their sakes. There are some hard hearts unbroken; ask God to make the hammer strike. While there are some still unmelted, pray to God that He would make the Word like a fire. Pray for your ministers that God may make them mighty. The church needs still more of the loud voice of God to wake it from its sleep. Ask God to bless all His appointed servants. Energetically plead with Him that His kingdom may come, and His will may be done on earth as it is in heaven.

I pray that all of you will believe in Jesus, for until you do, you cannot pray or praise! Oh, that you all believed in Jesus! Remember, this is the only way of salvation. Trust Jesus, for *"he that believeth on him is not condemned: but he that believeth not is condemned already, because he hath not believed in the name of the only begotten Son of God"* (John 3:18). Trust Jesus and you will be saved. May Christ accept you now for His own love's sake. Amen.

6

A Lifelong Occupation

By him therefore let us offer the sacrifice
of praise to God continually, that is, the fruit of
our lips giving thanks to his name.
—Hebrews 13:15

It is instructive to notice where this verse stands in the whole passage. The connecting verses are a golden setting to this gem of the text. Here we have a description of the believer's position before God. He is finished with all carnal ordinances and has no interest in the ceremonies of the Mosaic law. As believers in Jesus, who is the substance of all the outward types, we have no more to do with altars of gold or of stone. Our worship is spiritual, as well as our altar:

> We rear no altar, Christ has died;
> We deck no priestly shrine.

What then? Are we to offer no sacrifice? Far from it. We are called upon to offer to God a continual sacrifice. Instead of presenting in the morning and evening a sacrifice of lambs, and on certain holy days bringing bulls and sheep to be slain, we are to present to God continually the sacrifice of praise. Being done with the outward, we now give ourselves entirely to the inward and to the spiritual. Do you see your calling, beloved?

Moreover, the believer is now, if he is where he ought to be, like his Master, *"without the camp." "Let us go forth therefore unto him without the camp, bearing his reproach"* (Heb. 13:13). What

does this mean? If we are outside the camp, have we nothing to do? Are we cut off from God as well as from men? Should we fume and fret because we are not of the world? On the contrary, let us ardently pursue higher objects and yield up our disentangled spirits to the praise and glory of God.

Do we come under contempt, as the Master did? Is it so, that we are *"bearing his reproach"*? Should we sit down in despair? Will we be crushed beneath this burden? No, truly while we lose honor ourselves, we will ascribe honor to our God. We will count it all joy that we are counted worthy to be reproached for Christ's sake. Let us now praise God continually. Let the fruit of our lips be a still bolder confession of His name. Let us more and more earnestly make known His glory and His grace. If reproach is bitter, praise is sweet. We will drown the drops of gall in a sea of honey. If to have our name cast out as evil should seem to be derogatory to us, let us all the more see to it that we give the Lord the glory due His name. While the enemy reproaches us continually, our only reply should be to offer *"the sacrifice of praise"* continually to the Lord our God.

Moreover, the apostle said that *"here have we no continuing city"* (Heb. 13:14). Well, then, we will transfer the continuance from the city to the praise: *"Let us offer the sacrifice of praise to God continually."* If everything here is going, let it go; but we will not cease to sing. If the end of all things is at hand, let them end; but our praises of the living God will abide world without end. Set free from all the hampering effects of citizenship here below, we will begin the employment of citizens of heaven. It is not ours to arrange a new socialism or to be dividers of inheritances. We belong to a kingdom that is not of this world, a city of God, eternal in the heavens. It is not ours to pursue the dreams of politicians, but to offer the sacrifices of God-ordained priests. Since we are not of this world, it is ours to seek the world to come and press forward to the place where the saints in Christ will reign forever.

You see then, beloved, that the text is rather an unexpected one in its connection. But when properly viewed, it is the fittest that could be. The more we are made to feel that we are strangers in a strange land, the more we should devote ourselves to the praises of God, with whom we sojourn. Crucified to the world, and the world crucified to us, let us spend and be spent in the praises of Him who is our sole trust and joy. Oh, to praise God continually and never to be put off from praising Him, whatever the world may do!

My great business is to stir you up, dear friends, as many of you as have been made kings and priests unto God by Jesus Christ, to exercise your holy office. To that end, I will first, concerning the Christian, describe the sacrifice; second, examine its substance; third, recommend its exercise; and last, urge its commencement at once. *P-483* *P 484* *P 487*

A Description of the Sacrifice

A Sacrifice Presented by Christ

First, concerning a believer, let me describe his sacrifice. *"By him therefore."* At the very threshold of all offering of sacrifice to God, we begin with Christ. We cannot go a step without Jesus. Without a Mediator we can make no advance to God. Apart from Christ there is no acceptable prayer, no pleasing sacrifice of any sort. *"By him therefore."* We cannot move a lip acceptably without Him who *"suffered without the gate"* (Heb. 13:12).

The High Priest of our profession meets us at the sanctuary door. We place our sacrifices into His hands, so that He may present them for us. You would not wish it to be otherwise, I am sure. If you could do anything without Him, you would feel afraid to do it. You only feel safe when He is with you, and you are *"accepted in the beloved"* (Eph. 1:6). Be thankful that at the beginning of your holy service, your eyes are turned toward our Lord. You are to offer continual sacrifice, looking to Jesus. Behold, our great Melchizedek meets us! Let us give Him tithes of all and receive His blessing, which will repay us a thousandfold. Let us never venture upon a sacrifice apart from Him, lest it be the sacrifice of Cain or the sacrifice of fools. He is the altar that sanctifies both gift and giver; therefore, let our sacrifices both of praise and of almsgiving be presented unto God by Him.

A Continual Sacrifice

Next, observe that this sacrifice is to be presented continually. *"By him therefore let us offer the sacrifice of praise to God continually."* Attentively treasure that word. It will not do for you to say, "We have been exhorted to praise God on Sundays." No, I have not exhorted you to such occasional duty. The text says *"continually,"*

and that means seven days a week. I would not have you say, "He means that we are to praise God in the morning when we awake, and in the evening before we fall asleep." Of course, do that unfailingly. But that is not what I have to set before you.

"Let us offer the sacrifice of praise to God continually"—that is to say, without ceasing. Let us make an analogy to the verse that says, *"Pray without ceasing"* (1 Thess. 5:17), and say, "Praise without ceasing." Not only in this place or that place, but in every place, we are to praise the Lord our God. Not only when we are in a happy frame of mind, but when we are downcast and troubled. The perfumed smoke from the altar of incense is to rise toward heaven both day and night, from the beginning of the year to the year's end. Not only when we are in the assembly of the saints are we to praise God, but when we are called to pass through Vanity Fair, where sinners congregate. *"Bless the LORD at all times"* (Ps. 34:1). Offer the sacrifice of praise to God not just alone in your secret chamber, which is fragrant with the perfume of your communion with God, but in the field, in the street, and in the hurry and noise of the factory.

You cannot always be speaking His praise, but you can always be living His praise. The heart once set on praising God will, like the stream that leaps down the mountainside, continue still to flow in its chosen course. A soul saturated with divine gratitude will continue to give forth the sacred aroma of praise, which will permeate the atmosphere of every place and make itself known to all who have a spiritual nostril to discern sweetness.

No moment can exist when it would be right to suspend the praises of God: *"therefore let us offer the sacrifice of praise to God continually."* This should be done, not only by some—pastors, elders, deacons, and special workers—but by all believers. The apostle said, *"Let us."* Thus he calls upon all of us who have any participation in the great sacrifice of Christ to go with Him outside the camp, and then and there to stand with Him in our places and continually offer the sacrifice of praise unto God. You see, then, that the two important points are as follows: always, and always through Christ.

A Sacrifice of Praise

The apostle goes on to tell us what the sacrifice is. It is *"the sacrifice of praise."* Praise is heart worship, or adoration. Adoration

is the grandest form of earthly service. We ascribe unto Jehovah, the one living and true God, all honor and glory. When we see His works, when we hear His Word, when we taste His grace, when we mark His providence, when we think upon His name, our spirits bow in the lowliest reverence before Him and magnify Him as the glorious Lord. Let us abide continually in the spirit of adoration, for this is praise in its purest form.

Praise is heart-trust and heart-contentment in God. Trust is adoration applied to practical purposes. Let us go into the world trusting God, believing that He orders all things well, resolving to do everything as He commands, for His character and His commandments are not grievous to us. We delight in the Lord as He is pleased to reveal Himself; let that revelation be what it may. We believe not only that God is, but that *"he is a rewarder of them that diligently seek him"* (Heb. 11:6). Let us so praise Him that we will not be baffled if our work brings us no immediate recompense, for we are satisfied that He is not unrighteous and will not forget our work of faith.

Let us praise Him by being perfectly satisfied with anything and everything that He does or appoints. Let us take a hallowed delight in Him and in all that concerns Him. Let Him be to us, *"God* [our] *exceeding joy"* (Ps. 43:4). Do you know what it is to delight yourselves in God? Then, in that continual satisfaction, offer Him continual praise. Life is no longer sorrowful, even amid sorrow, when God is in it, its soul and crown. It is worthwhile to live the most afflicted and tried life, as long as we know God and taste His love. Let Him do what seems good to Him, as long as He will but be God to us and permit us to call Him our Father and our God.

Praise is heart-enjoyment, the indulgence of gratitude and wonder. The Lord has done so much for me that I must praise Him or feel as if I had a fire shut up within me. I may speak for many of you, for you also are saying, *"'He hath done great things'* (Joel 2:20) for us." The Lord has favored you greatly. Before the earth was, He chose you and entered into covenant with you. He gave you to His Son and gave His Son to you. He has manifested Himself to you as He does not to the world. Even now He breathes a childlike spirit into you, whereby you cry, *"Abba, Father"* (Rom. 8:15). Surely you must praise Him! How can you ever satisfy the cravings of your heart if you do not extol Him? Your obligations rise above you as high as the heavens above the earth. The vessel

of your soul has foundered in this sea of love and gone down fifty fathoms deep in it. High over its masthead, the main ocean of eternal mercy is rolling with its immeasurable billows of grace. You are swallowed up in the fathomless abyss of infinite love. You are absorbed in adoring wonder and affection. Like Leah when Judah was born, you cry, *"Now will I praise the LORD"* (Gen. 29:35).

In addition to this, do you not have the praise of heart-feeling, while within you burns an intense love for God? Could you love anyone as you love God? After you have poured out the stream of your love upon the dearest earthly ones, do you not feel you have something more within, which all created vessels could not contain? The heart of man yields love without limitation, and the stream is too large for the repository into which it flows, as long as we love a created being. Only the infinite God can ever contain all the love of a loving heart. There is a fitness for the heart and a fullness for its emotions when Jehovah is the heart's one object of love. My God, I love You! You know all things. You know that I love You.

Instead of complaining to the Lord because of certain stern truths that we read concerning Him, we are enabled in these to worship Him by bowing our reason to His revelation. That which we cannot understand, we nevertheless believe, and believing, we adore. It is not ours to accuse the Almighty, but to submit to Him. We are not His censors, but His servants. We do not legislate, but love. He is good, supremely good in our esteem, and infinitely blessed in our hearts. We do not consider what He ought to be, but we learn what He is, and as such we love and adore Him. Thus have I gone all around the shell of praise, but what it really is each one must discover for himself.

Ways to Praise God

The text evidently deals with spoken praise: *"Let us offer the sacrifice of praise to God continually, that is, the fruit of our lips giving thanks to his name,"* or as the Revised Version puts it, *"The fruit of lips which make confession to his name."* So, then, we are to utter the praises of God, and it is not sufficient to feel adoring emotions. The priesthood of believers requires them to praise God with their lips. Should we not sing a great deal more than we do? Psalms and hymns and spiritual songs should abound in our homes. It is our duty to sing as much as possible.

We should praise as much as we pray. "I have no voice!" says one. Cultivate it until you have. "But mine is a cracked voice!" Ah, well! It may be cracked to human ears and yet be melodious to God. To Him the music lies in the heart, not in the sound. Praise the Lord with song and psalm. A few godly men whom I have known have gone about the fields and along the roads humming sacred songs continually. These are the troubadours and minstrels of our King. Happy profession! May more of us become such birds of paradise! Hear how the ungodly world pours out its mirth. Oftentimes their song is so silly it is utterly devoid of meaning. Are they not ashamed? Then let us not be ashamed. Children of God, sing the songs of Zion, and let your hearts be joyful before your King. *"Is any merry? let him sing psalms"* (James 5:13).

But if we cannot sing so well or so constantly as we would desire, let us talk. We cannot say that we cannot talk. Perhaps some might be better if they could not talk quite so much. As we can certainly talk continually, let us as continually offer to God *"the sacrifice of praise"* by speaking well of His name. Talk of all His wondrous works. Let us *"abundantly utter the memory of* [His] *great goodness"* (Ps. 145:7). Let us *"praise the LORD for his goodness, and for his wonderful works to the children of men"* (Ps. 107:8).

Many whom you judge to be irreligious would be greatly interested if you were to relate to them your personal story of God's love to you. But if they are not interested, you are not responsible for that. Only tell it as often as you have opportunity. We charge you, as Jesus did the healed man, *"Go home to thy friends, and tell them how great things the Lord hath done for thee, and hath had compassion on thee"* (Mark 5:19). Speak and speak again for the instruction of others, for the confirmation of those who have faith, and for the routing of the doubts of those who believe not. Tell what God has done for you.

Does not our conversation need more flavoring with the praise of God? We put into it too much vinegar of complaint and forget the sugar of gratitude. This year, when the harvest seems to have been snatched from between the jaws of the destroyer, our friends say, "Well, things look a shade better." I am glad to get them up even as high as that. Hear the general talk: "Things are very bad. Business is dreadful. Trade never was so bad." Surely, we had better mend our talk and speak more brightly and cheerfully of what God does for us! How can we *"offer the sacrifice of praise to God*

continually" if we perpetually rail at His providence? Christian, if you are ever driven to a murmur, let it be only a momentary mistake of weakness, but return to contentment and gratitude, which is your proper and acceptable condition. Hear the word of the Lord, which says, *"Neither murmur ye, as some of them also murmured, and were destroyed of the destroyer"* (1 Cor. 10:10).

Praise means this, that you and I are appointed to tell forth the goodness of God, just as the birds of spring wake up before the sun and begin singing—and all of them singing with all their might. Become the choristers of God. Praise the Lord evermore, even as they do who, with songs and choral symphonies, day and night, circle His throne rejoicing. This is your holy and privileged office.

"Well," says one, "I cannot force myself to praise." I do not want you to force yourself to it. This praise is to be natural. It is called the fruit of the lips. In the book of Hosea, from which the apostle was quoting, it says, *"The calves of our lips"* (Hos. 14:2). Whether the word is *"calves"* in the Hebrew original or not is a matter in dispute; but the translators of the Septuagint certainly read it *"fruit,"* and this seems more clear and plain. The apostle, in quoting it from the Greek translation, endorsed it as being correct.

These lips of ours must produce fruit. Our words are leaves—how soon they wither! The praise of God is the fruit that can be stored up and presented to the Lord. Fruit is a natural product. It grows without force; it is the free outcome of the plant. So let praise grow out of your lips at its own sweet will. Let it be as natural to you, as regenerated men and women, to praise God as it seems to be natural to profane men to blaspheme His sacred name.

This praise is to be sincere and real. The next verse tells us, *"But to do good and to communicate forget not: for with such sacrifices God is well pleased"* (Heb. 13:16). Doing good is joined with praise to God. Many will give God a torrent of words, but scarcely a drop of true gratitude in the form of substance consecrated. When I am pressed with many cares about the Lord's work, I often wish that some of the congregation would be a little more mindful of its monetary needs. I would be much relieved if those who can spare it would help different portions of our home service. It should be the joy of a Christian to use his substance in his Master's service. When we are in a right state of heart, we do not need anybody to call on us to extract a pledge from us, but we go and ask, "Is there anything that needs help? Is any part of the Lord's business in need?"

I often sigh as I see less prominent ministries left without help, not because friends would not aid if they were pressed to do so, but because there is not a ready mind to look out for opportunities. Yet that ready mind is the very fat of the sacrifice. I long to see everywhere Christian friends who will not wait to be asked, but will make the Lord's business their business by taking in hand a branch of work in the church, or among the poor, or for the spread of the Gospel. Let your gift be an outburst of a free and gracious spirit, which takes delight in showing that it does not praise God in word only, but in deed and in truth. Let us excel in generous gifts. Let us see that everything is provided for in the house of the Lord, and that there is no lack in any quarter. This practical praising of the Lord is the life office of every true believer.

THE SUBSTANCE OF THE SACRIFICE #2

Second, let us briefly examine the substance of this sacrifice. *"Let us offer the sacrifice of praise to God continually."* To praise God continually will require a childlike faith in Him. You must believe His Word, or you will not praise His name. Doubt snaps the harp strings. Questions mar all melody. Trust Him, lean on Him, enjoy Him—you will never praise Him unless you do. Unbelief is the deadly enemy of praise.

Faith must lead you into personal communion with the Lord. It is to Him that the praise is offered, and not to our fellowmen. The most beautiful singing in the world, if it is intended for the ears of musical critics, is worth nothing. Praise is only that which is meant for God. "O my Lord, my song will find You! Every part of my being will have its tribute to sing. I will sing unto the Lord, and unto the Lord alone." You must live in fellowship with God, or you cannot praise Him.

You must have an overflowing content, a real joy in Him, also. Brothers and sisters, be sure that you do not lose your joy. If you ever lose the joy of your Christianity, you will lose its power. Do not be satisfied to be a miserable believer. An unhappy believer is a poor creature, but he who is resigned to being so is in a dangerous condition. Depend on it; greater importance is attached to holy happiness than most people think. As you are happy in the Lord, you will be able to praise His name. Rejoice in the Lord that you may praise Him.

Jn 17:13 Jesus prayed that I might have His joy fulfilled in me.

There must also be a holy earnestness about this. Praise is called a sacrifice because it is a very sacred and solemn thing. People who came to the altar with their victims came there with the hush of reverence, the trembling of awe. We cannot praise God with levity. He is in heaven, and we are on the earth. He is thrice holy, and we are sinful. We must take off our shoes in lowly reverence and worship with intense adoration, or else He cannot be pleased with our sacrifices. When life is real, life is earnest. It must be both real and earnest when it is spent in the praise of the Almighty.

To praise God continually, you need to cultivate perpetual gratitude. Surely it cannot be hard to do that! Remember, every misery averted is a mercy bestowed. Every sin forgiven is a favor granted. Every duty performed is also a grace received. The people of God have an inexhaustible treasury of good things provided for them by the infinite God. For all these blessings, we should overflow with praise for Him. Let your praises be like the waters of fountains that are abundantly supplied. Let the stream leap to heaven in bursts of enthusiasm. Let it fall to earth again in showers of beneficence. Let it fill the basin of your daily life and run over into the lives of others. Then, in a waterfall of glittering joy, let it still descend.

In order to praise, you will need a deep and ardent admiration of the Lord God. Admire the Father. Think much of His love. Acquaint yourself with His perfections. Admire the Son of God, the altogether lovely One. As you mark His gentleness, self-denial, love, and grace, allow your heart to be wholly enamored of Him. Admire the patience and humility of the Holy Spirit that He should visit you, dwell in you, and bear with you. It cannot be difficult to the sanctified and instructed heart to be filled with a great admiration of the Lord God. This is the raw material of praise. An intelligent admiration of God, kindled into flame by gratitude and fanned by delight and joy, must ever produce praise. Living in personal relationship with God and trusting Him as a child trusts his father, the soul cannot have difficulty with continually offering *"the sacrifice of praise"* to God through Jesus Christ.

A CALL TO PRAISE

Third, I want to recommend this blessed exercise of praise. *"Offer the sacrifice of praise to God continually,"* because in so doing,

you will discover your reason for being. Every creature is happiest when it is doing what it is made for. A bird that is made to fly abroad pines in a cage. An eagle would die in the water, even as a fish that is made to swim would perish on the river's bank. Christians are made to glorify God. We are never in our element until we are praising Him. The happiest moments you have ever spent were those in which you lost sight of everything inferior and bowed before Jehovah's throne with reverent joy and blissful praise. I can say it is so with me, and I do not doubt it is so with you. When your whole soul is full of praise, you have at last reached the goal at which your heart is aiming. Your ship is now in full sail. Your life moves on smoothly and safely. This is the groove along which it was made to slide. Before, you were trying to do what you were not made to do, but now you are at home. Your new nature was fashioned for praising God, and it finds rest in doing so. Keep to this work. Do not degrade yourself by less divine employment.

Praise God because it is His due. Should Jehovah be left unpraised? Praise is the rent that He asks of us for the enjoyment of all things. Will we be slow to pay? *"Will a man rob God?"* (Mal. 3:8). When it is such a happy work to give Him His due, will we neglect it? It blesses us to bless the Lord. Should we be stingy with God in giving Him glory? He is not stingy with us when bestowing His goodness. Come, if you have become sorrowful lately, shake off your gloom, and awake all your instruments of music to praise the Lord! Do not let murmuring and complaining be so much as mentioned among His saints. *"Give unto the LORD the glory due unto his name"* (Ps. 29:2). Should not the Lord be praised? Surely the very stones and rocks must break their everlasting silence in indignation if the children of God do not praise His name.

Praise Him continually, for it will help you in everything else. A man full of praise is ready for all other holy exercises. Such is my bodily pain and weakness that I could not force myself to prepare this exhortation if I did not feel that I must urge believers to praise God. I thought that my pain might give emphasis to my words. I do praise the Lord. I must praise Him. It is a duty that I hope to perform in my last moments, with the help of the Holy Spirit. Praise helps me to minister.

Whenever you go to any kind of service, even though it is nothing better than opening the shop and waiting behind the counter, you will do it all the better when you are in the spirit of praise and gratitude. If you are a domestic servant and can praise

God continually, you will be a comfort in the house. If you are a master and are surrounded with the troubles of life, if your heart is always blessing the Lord, you will keep up your spirits and will not be sharp and ill-tempered with those around you. Praising the Lord is both meat and medicine. Birds of heaven, strange to say, this singing will plume your wings for flight! The praises of God put wings on pilgrims' heels, so that they not only run, but fly.

Praise will preserve us from many evils. When the heart is full of the praise of God, it does not have time to find fault and grow proudly angry with others. Somebody has said a very nasty thing about us. Well, we will answer him when we have finished the work we have in hand, namely, praising God continually. At present we have a great work to do and cannot come down to bicker. Self-love and its natural irritations die in the blaze of praise. If you praise God continually, the vexations and troubles of life will be cheerfully borne. Praise makes the happy man a strong man. *"The joy of the LORD is your strength"* (Neh. 8:10). Praising God makes us drink of the brook by the way and lift up our heads. We cannot fear while we can praise. Nor can we be bribed by the world's favor or cowed by its frown. Praise makes angels of us. Let us abound in it.

Let us praise God because it will be a means of usefulness. I believe that a life spent in God's praise would in itself be a missionary life. Consider that matronly sister who has never delivered a sermon, or even a lecture, but all her days has lived a quiet, happy, useful, loving life. All of her family have learned from her to trust the Lord. Even when she will have passed away, they will feel her influence, for she is the angel of the house. They will say of her, *"Being dead* [she] *yet speaketh"* (Heb. 11:4). A heart full of praise is eloquent for God. Mere verbiage, what is it but as autumn leaves, which will be consumed in smothering smoke? But praise is golden fruit to be presented in baskets of silver unto the dresser of the vineyard.

Praise God because this is what God loves. Notice how the verse after our text puts it: *"With such sacrifices God is well pleased"* (Heb. 13:16). Would we not do anything and everything to please God? It seems too good to be true that we can impart any pleasure to the ever blessed One. Yet it is so, for He has declared that He is well pleased with the praises and the gifts of His children. Therefore, let us withhold nothing from our dear Father, our blessed God. Can I please Him? Tell me what it is; I will do it right away. I will not deliberate, but without reservation I make haste. If I deliberate, it will only be in order to make the service twice as

large or perform it in more careful style. If I may praise Him, it will be honor, it will be heaven to me.

To close this recommendation, remember that the practice of praise will equip you for heaven. The following hymn expresses a frequent desire:

> I would begin the music here
> And so my soul should rise.

You can begin the music here—begin the hallelujahs of glory by praising God here and now. Think of how you will praise Him when you see His face and never sin again. Exceedingly magnify the Lord even now, and rehearse the music of the skies. In glory you may rise to a higher key, but let the song be the same even here. Praise Him! Praise Him more and more! Rise on rungs of praise up the ladder of His glory, until you reach the top and are with Him to praise Him better than ever before. Oh, that our lives may not be broken, but may be all one piece—one psalm, forever rising, verse by verse, into the eternal hallelujahs!

#4 AN IMMEDIATE START

The final point to be learned from the text is this: let us begin at once. The verse reads, *"Let us offer the sacrifice of praise...continually."* It does not say, "Eventually get to this work, when you are able to give up business and have retired to the country, or perhaps when you are near death." Rather, it says, "Now *'let us offer the sacrifice of praise.'"*

Listen! Who is speaking? Whose voice do I hear? I know. It is the apostle Paul. He says, *"Let us offer the sacrifice of praise!"* Where are you, Paul? His voice sounds from within a low place. I believe he is shut up in a dungeon. Lift up your hand, Paul! I can hear the clanking of chains. Paul cries, *"'Let us offer the sacrifice of praise.'* I, Paul the aged, in prison in Rome, wish you to join with me in a sacrifice of praise to God." We will do so, Paul. We are not in prison, we are not all aged, and none of us have shackles on our wrists. We can join heartily with you in praising God, and we do so. Come, let us praise God.

> Stand up and bless the Lord,
> Ye people of His choice;

Stand up and bless the Lord your God
With heart and soul and voice.

You have heard Paul's voice; now hear mine. Join with me, and let us offer the sacrifice of praise. As His church and people, we have received great favors from the Lord's hand. Come, let us join together with heart and hand across time and space to bless the name of the Lord and worship joyfully before Him. With words and with gifts, *"let us offer the sacrifice of praise...continually."* If I could select you, call upon you by name, and say, "Come, *'let us offer the sacrifice of praise,'"* I am sure many of you would reply, "Ah, if nobody else can praise Him, we can, and we will." Well, well, kindly presume it has been done so far as the outward expression is concerned, but inwardly let us at once *"offer the sacrifice of praise to God"* through Jesus Christ.

Let us stir one another to praise. Let us spend today, tomorrow, and all the rest of our days in praising God. If we catch one another grumbling a little or coldly silent, let us, in kindness to each other, give the needed rebuke. It will not do to murmur. We must praise the Lord. Just as the leader of an orchestra taps his baton to call all to attention and then to begin playing, so I now arouse and stir you to *"offer the sacrifice of praise"* unto the Lord.

The apostle has put us rather in a fix: he compels us to offer sacrifice. Did you notice what he said in the tenth verse? *"We have an altar"* (Heb. 13:10), not a material altar, but a spiritual one. Yet *"we have an altar."* May the priests of the old law offer sacrifice on it? *"Whereof they have no right to eat which serve the tabernacle"* (v. 10). They ate of the sacrifices laid on the altars of the old law, but they have no right here. Those who keep to ritualistic performances and outward ceremonials have no right here. Yet *"we have an altar."* Brothers and sisters, can we imagine that this altar is given to us by the Lord never to be used? Is no sacrifice to be presented on the best of altars? *"We have an altar."* What then? If we have an altar, do not allow it to be neglected, deserted, unused. It is not for spiders to spin their webs upon. It is not fitting that it should be smothered with the dust of neglect. *"We have an altar."* What then? *"Let us offer the sacrifice of praise to God continually."* Do you not see the force of the argument? Obey it.

Beside the altar, we have a High Priest. There is the Lord Jesus Christ, dressed in His robes of glory and beauty, standing within the veil at this moment, ready to present our offerings.

488

Should He stand there and have nothing to do? What would you think of our Great High Priest waiting at the altar with nothing to present to God from His redeemed? No, *"by him therefore let us offer the sacrifice of praise to God continually."* People of God, bring your praises, your prayers, your thank offerings, and present them to the Almighty!

If you will read the entire context of the key verse, you may well offer your holy sacrifices, because the passage brings before you many things that should compel you to praise God. Behold your Savior in His passion, offered outside the gate! Gaze upon His bleeding wounds, His sacred head so bloodstained, His face so full of anguish, His heart bursting with the agony of sin! Can you see that sight and not worship the Lord God? Behold redemption accomplished, sin pardoned, salvation purchased, hell vanquished, death abolished, and all this achieved by your blessed Lord and Master! Can you see all this and not praise Him? His precious blood is falling on you, making you clean, bringing you near to God, making you acceptable before the infinite holiness of the Most High! Can you see yourself thus favored, and behold the precious blood that did it, and not praise His name?

Away in the distance, seen dimly, perhaps, but yet not doubtfully, behold *"a city which hath foundations, whose builder and maker is God"* (Heb. 11:10). White-robed, the purified are singing to their golden harps, and you will soon be there. When a few more days or years have passed, you will be among the glorified. A crown and a harp are reserved for you. Will you not begin to praise God and glorify Him for the heaven that is in store for you? With these two sights so wonderfully contrasted—the passion and the paradise, Jesus in His humiliation and Jesus in His glory—you find yourself a sharer in both these wondrous scenes. Surely if you do not begin to offer the perpetual sacrifice of thanksgiving and praise to God, you must be something harder than stone. May we begin today those praises that will never be suspended throughout eternity!

Oh, that you, who have never praised God before, would begin now! Alas! Some of you have no Christ to praise and no Savior to bless. Yet you do not need to remain that way. By faith you may lay hold upon Jesus, and He then becomes yours. Trust Him, and He will justify your trust. Rest in the Lord, and the Lord will become your rest. When you have trusted, then waste no time, but at once begin the business for which you were created, redeemed, and

called. Fill the censor with the sweet spices of gratitude and love, and lay on the burning coals of earnestness and fervency. Then, when praise begins to rise from you like pillars of smoke, swing the censor to and fro in the presence of the Most High. More and more laud, bless, and magnify the Lord who lives forever. Let your heart dance at the sound of His name, and let your lips show forth His salvation.

May the Lord anoint you this day to the priesthood of praise for Christ's sake! Amen.

Book
Six

Satan, a Defeated Foe

1

Satan Considers
the Saints

*And the LORD said unto Satan,
Hast thou considered my servant Job?*
—Job 1:8

How very uncertain are all terrestrial things! How foolish would that believer be who would lay up his treasure anywhere except in heaven! Job's prosperity promised as much stability as anything can beneath the moon. Doubtless the man had round about him a large household of devoted and attached servants. He had accumulated wealth of a kind that does not suddenly depreciate in value. He had oxen, donkeys, and cattle. He did not have go to markets or fairs and trade with his goods to procure food and clothing. He carried on the processes of agriculture on a very large scale around his own homestead and probably grew within his own territory everything that his establishment required. His children were numerous enough to promise a long line of descendants. His prosperity needed nothing to make it complete. It had come to its flood tide; what could make it ebb?

Up there, beyond the clouds, where no human eye could see, there was a scene enacted that heralded no good for Job's prosperity. The spirit of evil stood face to face with the infinite Spirit of all good. An extraordinary conversation took place between these two beings.

When called to account for his doings, the Evil One boasted that he had gone *"to and fro in the earth, and* [walked] *up and down in it"* (Job 1:7), insinuating that he had met with no hindrance to his will and had found no one to oppose his moving freely and acting at

his own pleasure. He had marched everywhere like a king in his own dominions, unhindered and unchallenged.

The great God reminded him that there was at least one place among men where he had no foothold and where his power was unrecognized, namely, in the heart of Job. There was one man who stood like an impregnable castle, garrisoned by integrity, and held with perfect loyalty as the possession of the King of heaven. The Evil One defied Jehovah to try the faithfulness of Job by telling Him that the patriarch's integrity was due to his prosperity, and that he served God and shunned evil from sinister motives because he found his conduct profitable to himself. The God of heaven took up the challenge of the Evil One and gave him permission to take away all the mercies that he supposed to be the props of Job's integrity. God allowed him to pull down all the supports and buttresses and see whether the tower would not stand in its own inherent strength without them. In consequence of this, all Job's wealth went in one black day, and not even a child was left to whisper comfort.

A second interview between the Lord and His fallen angel took place. Job was again the subject of conversation. The Great One, again defied by Satan, permitted him even to touch Job in his bone and in his flesh, until the prince became worse than a pauper. He who was rich and happy was poor and wretched, filled with disease from head to foot and reduced to scraping himself with a broken piece of pottery to gain a poor relief from his pain.

Let us see in this the mutability of all earthly things. *"He hath founded it upon the seas"* (Ps. 24:2) is David's description of this world. If it is founded on the seas, can you be surprised that it changes often? Do not put your trust in anything beneath the stars. Remember that "change" is written on the forefront of nature. Therefore, do not say, "My mountain stands firm; it will never be moved." The glance of Jehovah's eye can shake your mountain into dust; the touch of His foot can make it melt like wax or go up in smoke.

Set your affection on things above, where Christ is sitting at the right hand of God (Col. 3:1–2). Let your heart and your treasure be *"where neither moth nor rust doth corrupt, and where thieves do not break through nor steal"* (Matt. 6:20).

The words of Bernard may help instruct us:

> That is the true and chief joy which is not conceived from the creature, but received from the Creator, which

(being once possessed thereof) none can take from thee: compared with which all other pleasure is torment, all joy is grief, sweet things are bitter, all glory is baseness, and all delectable things are despicable.

This is not, however, our subject in this chapter. Accept what I have written as merely an introduction to our main discourse. The Lord asked Satan, *"Hast thou considered my servant Job?"* Let us deliberate, first, in what sense the Evil Spirit may be said to consider the people of God. Second, let us notice what it is that he considers about them. Third, let us comfort ourselves by the reflection that One who is far above Satan considers us in a higher sense.

SATAN'S CONSIDERATIONS

First, then, in what sense may Satan be said to consider the people of God? Certainly not in the usual biblical meaning of the term *"consider."* *"O LORD; consider my trouble"* (Ps. 9:13). *"Consider my meditation"* (Ps. 5:1). *"Blessed is he that considereth the poor"* (Ps. 41:1). Such consideration implies goodwill and a careful inspection of the object of benevolence with regard to a wise distribution of favor. In that sense, Satan never considers anyone. If he has any benevolence, it must be toward himself.

All his considerations of other creatures are of the most malevolent kind. No meteoric flash of good flits across the black midnight of his soul, nor does he consider us as we are told to consider the works of God, that is, in order to derive instruction as to God's wisdom and love and kindness. He does not honor God by what he sees in His works or in His people. It is not in him to *"go to the ant, thou sluggard; consider her ways, and be wise"* (Prov. 6:6). Rather, he goes to the Christian and considers his ways and becomes more foolishly God's enemy than he was before.

The consideration that Satan pays to God's saints is this: he regards them with wonder when he considers the difference between them and himself. A traitor, when he knows the thorough villainy and the blackness of his own heart, cannot help being astounded when he is forced to believe another man to be faithful. The first resort of a treacherous heart is to believe that all men would be just as treacherous, and are really so at bottom. The traitor thinks that all men are traitors like himself, or would be, if it paid them better than fidelity.

When Satan looks at the Christian and finds him faithful to God and to His truth, he considers him as we consider a phenomenon—perhaps despising him for his folly, yet marveling at him and wondering how he can act this way. He seems to say, "I, a prince, a peer of God's parliament, would not submit my will to Jehovah. I thought it better to reign in hell than serve in heaven. I did not keep my proper domain, but fell from my throne. How is it that these stand? What grace is it that keeps these? I was a vessel of gold, and yet I was broken. These are earthen vessels, but I cannot break them! I could not stand in my glory—what can be the matchless grace that upholds them in their poverty, in their obscurity, in their persecution, still faithful to the God who does not bless and exalt them as He did me!"

It may be that he also wonders at their happiness. He feels within himself a seething sea of misery. There is an unfathomable gulf of anguish within his soul. When he looks at believers, he sees them quiet in their souls, full of peace and happiness, often without any outward means by which they are comforted, yet rejoicing and full of glory. He goes up and down through the world and possesses great power. There are many slaves to serve him, yet he does not have the happiness of spirit possessed by yonder humble working-woman, obscure, unknown, stretched out on the bed of weakness, having no servants to wait on her. He admires and hates the peace that reigns in the believer's soul.

His consideration may go further than this. Do you not think that he considers them to detect, if possible, any flaw and fault in them, by way of solace to himself? "They are not pure," says he, "these blood-bought ones, these elect from before the foundation of the world. They still sin! These adopted children of God, for whom the glorious Son bowed His head and breathed His last, even they offend!"

How he must chuckle, with such delight as he is capable of, over the secret sins of God's people. If he can see anything in them inconsistent with their profession, anything that appears to be deceitful and thus like himself, he rejoices. Each sin born in the believer's heart cries to him, "My father! My father!" Then he feels something like the joy of fatherhood as he sees his foul offspring. He looks at the *"old man"* (Eph. 4:22) in the Christian and admires the tenacity with which it maintains its hold, the force and vehemence with which it struggles for mastery. He gleefully observes the craft and cunning with which every now and then, at set intervals,

at convenient opportunities, the old nature puts forth all its force. He considers our sinful flesh and makes it one of the books in which he diligently reads. One of the fairest prospects the Devil's eye ever rests on is the inconsistency and the impurity that he can discover in the true child of God. In this respect, he had very little to consider in God's true servant, Job.

This is just the starting point of his consideration. I do not doubt that he views the Lord's people, and especially the more prominent leaders among them, as the great barriers to the progress of his kingdom. Just as the engineer, endeavoring to make a railway, keeps his eye very much fixed on the hills and rivers, and especially on the great mountain through which it will take months to laboriously bore a tunnel, so Satan, in looking upon his various plans to carry on his dominion in the world, considers men like Job.

Satan must have thought much about Martin Luther. "I could ride the world over," he probably said, "if it were not for that monk. He stands in my way. That strong-headed man hates and attacks my kingdom. If I could get rid of him, I would not mind if fifty thousand smaller saints stood in my way." He is sure to consider God's servant if there is *"none like him"* (Job 1:8), if he stands out distinct and separate from others. Those of us who are called to the work of the ministry must expect from our position to be the special objects of his consideration. When the magnifying glass is at the eye of that dreadful warrior, he is sure to look out for those who by their uniforms are discovered to be the officers, and he tells his sharpshooters to be very careful to aim at these. "For," he says, "if the standard-bearer falls, then the victory will be more readily gained for our side, and our opponents will be easily put to flight."

If you are more generous than other believers, if you live nearer to God than others, as the birds peck most at the ripest fruit, so may you expect Satan to be most busy against you. Who cares to contend for a province covered with stones and barren rocks, and ice-bound by frozen seas? But in all times there is sure to be a contention after the fertile valleys where the crops are plenteous, and where the farmer's toil is well rewarded. Thus, for you who honor God most, Satan will struggle very sternly. He wants to pluck God's jewels from His crown, if he can, and take the Redeemer's precious stones even from the breastplate itself.

In this way, Satan considers God's people. Viewing them as hindrances to his reign, he contrives methods by which he may remove them out of his way or turn them to his own account.

Darkness would cover the earth if he could blow out the lights. There would be no fruit to wave like the cedars of Lebanon if he could destroy that handful of corn upon the top of the mountains (Ps. 72:16). Hence, his perpetual consideration is to make the faithful fall from among men.

It does not require much wisdom to discern that the great object of Satan in considering God's people is to do them injury. I scarcely think he hopes to destroy the really chosen and blood-bought heirs of life. My notion is that he is too smart for that. He has been foiled so often when he has attacked God's people that he can hardly think he will be able to destroy the elect. You remember what the soothsayers, who are very closely related to him, said to Haman: *"If Mordecai be of the seed of the Jews, before whom thou hast begun to fall, thou shalt not prevail against him, but shalt surely fall before him"* (Est. 6:13). He knows very well that there is a royal seed in the land against whom he fights in vain.

It strikes me that if he could be absolutely certain that any one soul was chosen by God, he would scarcely waste his time in attempting to destroy it, although he might seek to worry and to dishonor it. However, most likely Satan no more knows who God's elect are than we do, for he can only judge as we do, by outward actions, though he can form a more accurate judgment than we can, through longer experience and being able to see persons in private where we cannot intrude. Yet into God's book of secret decrees, his black eye can never peer. *"By their fruits"* (Matt. 7:16) he knows them, and we know them in the same manner.

Since, however, we are often mistaken in our judgment, he, too, may be also. And it seems to me that he therefore makes it his policy to endeavor to destroy us all—not knowing in which case he may succeed. He goes about *"seeking whom he may devour"* (1 Pet. 5:8), and since he does not know whom he may be permitted to swallow up, he attacks all the people of God with vehemence.

Someone may say, "How can one Devil do this?" He does not do it by himself. I do not know that many of us have ever been tempted directly by Satan—we may not be notable enough among men to be worth his trouble. But he has a whole host of inferior spirits under his supremacy and control. As the centurion said of himself, so he might have said of Satan, "[He says to this spirit], *Go, and he goeth; and to another, Come, and he cometh; and to my servant, Do this, and he doeth it"* (Matt. 8:9). Thus all the servants of God will more or less come under the direct or indirect assaults of the Great Enemy of

souls, and that with a view of destroying them. For he would, *"if it were possible...deceive the very elect"* (Matt. 24:24).

Where he cannot destroy, there is no doubt that Satan's object is to worry. He does not like to see God's people happy. I believe the Devil greatly delights in some ministers, whose tendency in their preaching is to multiply and foster doubts and fears, and to present grief and despondency as the evidences of God's people. "Ah," says the Devil, "preach on. You are doing my work well, for I like to see God's people mournful. If I can make them stop their singing and go around with miserable faces, I reckon I have done my work very completely."

My dear friends, let us watch against those deceptive temptations that pretend to make us humble but really aim at making us unbelieving. Our God takes no delight in our suspicions and mistrusting. See how He proves His love in the gift of His dear Son Jesus. Banish, then, all your ill-surmising, and rejoice in unmoved confidence. God delights to be worshiped with joy. *"O come, let us sing unto the LORD: let us make a joyful noise to the rock of our salvation. Let us come before his presence with thanksgiving, and make a joyful noise unto him with psalms"* (Ps. 95:1–2). *"Be glad in the LORD, and rejoice, ye righteous: and shout for joy, all ye that are upright in heart"* (Ps. 32:11). *"Rejoice in the Lord alway: and again I say, Rejoice"* (Phil. 4:4). Satan does not like this.

Martin Luther used to say, "Let us sing psalms and spite the Devil." I have no doubt Martin Luther was pretty nearly right, for that lover of discord hates harmonious, joyous praise. Beloved brother, the Archenemy wants to make you wretched here, if he cannot have you hereafter. In this, no doubt, he is aiming a blow at the honor of God. He is well aware that mournful Christians often dishonor the faithfulness of God by mistrusting it. Thus he thinks if he can worry us until we no longer believe in the constancy and goodness of the Lord, he will have robbed God of His praise. *"Whoso offereth praise, glorifieth me"* (Ps. 50:23), says God. So Satan lays the ax at the root of our praise, so that God may cease to be glorified.

Moreover, if Satan cannot destroy a Christian, how often has he spoiled his usefulness? Many a believer has fallen, not to break his neck—that is impossible—but he has broken some important bone and has gone limping to his grave! We can recall with grief some men who were once prominent in the church and who were running well, but who suddenly through the stress of temptation fell into sin. Their names were never mentioned in the church again except with

bated breath. Everybody thought and prayed that they were saved *"as by fire"* (1 Cor. 3:15), but certainly their former usefulness never could return. It is very easy to go back in the heavenly pilgrimage, but it is very hard to retrieve your steps.

You may soon turn aside and blow out your candle, but you cannot light it quite so quickly. Friend, beloved in the Lord, watch against the attacks of Satan and stand fast, because you, as a pillar in the house of God, are very dear to the church. We cannot spare you. As a father or as a mother in our midst, we honor you, and we do not wish to mourn and lament or to be grieved by hearing the shouts of our adversaries while they cry, "Aha! Aha! This is just what we wanted!" Alas! There have been many things done in our Zion of which we say: *"Tell it not in Gath, publish it not in the streets of Askelon; lest the daughters of the Philistines rejoice, lest the daughters of the uncircumcised triumph"* (2 Sam. 1:20).

May God grant us grace as a church to stand against the schemes of Satan and his attacks, that having done his worst, he may gain no advantage over us. After having considered, reconsidered, and carefully counted our towers and bulwarks, may he be compelled to retire because his battering rams cannot jar so much as a stone from our ramparts, and his slings cannot slay one single soldier on the walls.

Before I leave this point, I would like to say that perhaps it may be suggested, "How is it that God permits this constant and malevolent consideration of His people by the Evil One?" One answer doubtless is that God knows what is for His own glory, and that He gives no account of His matters. Having permitted free agency and having allowed for some mysterious reason the existence of evil, it does not seem agreeable with His having done so to destroy Satan, but He gives him power that it may be a fair hand-to-hand fight between sin and holiness, between grace and craftiness.

Also, let it be remembered that, incidentally, the temptations of Satan are of service to the people of God. Fénelon said that they are the file that rubs off much of the rust of self-confidence. I may add, they are the horrible sound in the sentinel's ear, which is sure to keep him awake. One theologian remarked that there is no temptation in the world that is so bad as not being tempted at all, for to be tempted will tend to keep us awake. Whereas being without temptation, flesh and blood are weak. Though the spirit may be willing, yet we may be found falling into slumber. Children do not run away from their father's side when big dogs bark at them. The howlings of the

Devil may tend to drive us nearer to Christ, may teach us our own weakness, may keep us upon our own watchtower, and may be made the means of preservation from other ills. *"Be sober, be vigilant; because your adversary the devil, as a roaring lion, walketh about, seeking whom he may devour"* (1 Pet. 5:8).

May we who are in a prominent position be permitted to affectionately make one earnest request. *"Brethren, pray for us"* (1 Thess. 5:25), that exposed as we are to the consideration of Satan, we may be guarded by divine power. Let us be made rich by your faithful prayers so that we may be kept even to the end.

SATAN'S INJURIOUS VIEW

Second, specifically what does Satan consider with a view toward the injury of God's people?

It cannot be said of him, as it is of God, that he knows us totally. However, since he has now been dealing with poor fallen humanity for nearly six thousand years, he must have acquired very vast experience in that time. Having been all over the earth and having tempted the highest and the lowest, he must know very well what the springs of human action are and how to play upon them.

Satan watches and considers, first of all, our particular infirmities. He looks us up and down, just as I have seen a horse dealer do with a horse. He soon finds out where we are faulty. I, a common observer, might think the horse an exceedingly good one as I see it running up and down the road, but the dealer sees what I cannot see and knows how to handle the creature in such a way that he soon discovers any hidden mischief. Satan knows how to look at us and size us up from heel to head, so that he says of this man, "His infirmity is lust"; of that one, "He has a quick temper"; of another, "He is proud"; or of that other, "He is slothful." The eye of malice is very quick to perceive a weakness, and the hand of enmity soon takes advantage of it. When the Archenemy finds a weak place in the walls of our castles, he takes care where to plant his battering ram and begin his siege. You may conceal your infirmity, even from your dearest friend, but you will not conceal it from your worst Enemy. He has lynx eyes and detects in a moment the weak point in your armor. He goes about with a match, and though you may think you have covered all the gunpowder of your heart, he knows how to find a crack to put his

match through. Much mischief will he do, unless eternal mercy prevents.

He takes care also to consider our states of mind. If the Devil would attack us when our minds are in certain moods, we would be more than a match for him. He knows this and shuns the encounter. Some men are more vulnerable to temptation when they are distressed and desponding. The Fiend will then assail them. Others will be more liable to catch fire when they are jubilant and full of joy, so that is when he will strike his spark into the tinder. Certain people, when they are overly vexed and tossed to and fro, can be made to say almost anything. Others, when their souls are like perfectly placid waters, are just then in a condition to be navigated by the Devil's vessel.

As the worker in metals knows that one metal is to be worked at a particular heat and another at a different temperature, as those who have to deal with chemicals know that at a certain heat one fluid will boil while another reaches the boiling point much earlier, so Satan knows exactly the temperature at which to work us to his purpose. Small pots boil quickly when they are put on the fire, and so do little men with quick tempers. Larger vessels require more time and heat before they will boil, but when they do, it is a boil indeed, not soon forgotten or abated.

The Enemy, like a fisherman, watches his fish, adapts his bait to his prey, and knows in what seasons and times the fish are most likely to bite. This hunter of souls comes secretly. Often we are overtaken in a fault or caught in a trap through an unwatchful frame of mind. That rare collector of choice sayings, Thomas Spencer, said the following, which is much to the point:

> The chameleon, when he lies on the grass to catch flies and grasshoppers, takes upon him the color of the grass, as the polypus does the color of the rock under which he lurks, that the fish may boldly come near him without any suspicion of danger. In like manner, Satan turns himself into that shape that we least fear, and sets before us such objects of temptation as are most agreeable to our natures, so he may the sooner draw us into his net; he sails with every wind, and blows us the way that we incline ourselves through the weakness of nature. Is our knowledge in the matter of faith deficient? He tempts us to error. Is our conscience tender? He tempts us to scrupulosity, and too much preciseness. Has our conscience, like the ecliptic line, some latitude? He tempts us

to carnal liberty. Are we bold-spirited? He tempts us to presumption. Are we timorous and distrustful? He tempts us to desperation. Are we of a flexible disposition? He tempts us to inconstancy. Are we stiff? He labors to make obstinate heretics, schismatics, or rebels of us. Are we of an austere temper? He tempts us to cruelty. Are we soft and mild? He tempts us to indulgence and foolish pity. Are we hot in matters of religion? He tempts us to blind zeal and superstition. Are we cold? He tempts us to Laodicean lukewarmness. Thus he lays his traps, that one way or other, he may ensnare us.

He also takes care to consider our position among men. There are a few people who are most easily tempted when they are alone. They are then subjected to great heaviness of mind, and they may be driven to most awful crimes. Perhaps most of us are more liable to sin when we are in company. In some company I never would be led into sin; into another society I could scarcely venture. Many are so full of levity that those of us who are inclined the same way can scarcely look them in the face without feeling our own besetting sin rising. Others are so somber that if they meet a brother of a similar mind, they are pretty sure between them to invent an evil report of the good land. Satan knows where to overtake you in a place where you lie open to his attacks. He will pounce upon you, swooping like a bird of prey from the sky, where he has been watching for the moment to make his descent with the prospect of success.

How, too, he considers our condition in the world! He looks at one man and says, "That man has property; it is of no use my trying these certain deceits with him. But here is another man who is very poor; I will catch him in that net." Then, again, he looks at the poor man and says, "Now, I cannot tempt him to this folly, but I will lead the rich man into it." As the sportsman has one gun for wild fowl and another for deer and game, so has Satan a different temptation for various orders of men. I do not suppose that the Queen's temptation ever will annoy the housekeeper. I do not suppose, on the other hand, that the housekeeper's temptation will ever be very serious to me. Probably you could escape from mine, though I do not think you could. I sometimes fancy I could bear yours, though I question if I could. Satan knows, however, just where to smite each of us. Our position, our capabilities, our education, our standing in society, our calling—all may be doors through which he may attack us.

You who have no calling at all are in special peril. I wonder the Devil does not swallow you instantly. The most likely man to go to

hell is the man who has nothing to do on earth. I say that seriously. I believe that a much worse evil cannot happen to a person than to be placed where he has no work. If I should ever be in such a state, I would get employment at once for fear I would be carried off, body and soul, by the Evil One. Idle people tempt the Devil to tempt them.

Let us have something to do; let us keep our minds occupied. If not, we make room for the Devil. Industry will not make us gracious, but the lack of work may make us vicious. Always have some work to do. As Isaac Watts said,

> In books, or work, or healthful play,
> I would be busy too,
> For Satan finds some mischief still
> For idle hands to do.

Books, work, or such recreations as are necessary for health should occupy our time. For if I throw myself down in indolence, like an old piece of iron, I must not wonder that I grow rusty with sin.

I am not finished with this subject yet. Satan, when he makes his investigations, notices all the objects of our affection. I do not doubt that when he went around Job's house, he observed it as carefully as thieves do a jeweler's premises when they are planning to break in. They very cunningly take account of every door, window, and lock. They do not fail to look at the house next door, for they may have to reach the treasure through the building that adjoins it.

When the Devil looked around, jotting down in his mind all Job's position, he thought to himself, "There are the camels, the oxen, the donkeys, and the servants—yes, I can use all these very admirably." "Then," he thought, "there are the three daughters! There are the seven sons, and they all go feasting. I know where to catch them, and if I can just blow the house down when they are feasting, that will afflict the father's mind more severely, for he will say, "Oh, that they had died when they had been praying, rather than when they had been feasting and drinking wine.'"

"I will also put down in the inventory," said the Devil, "his wife. I dare say I will need her," and accordingly it came to that. Nobody could have done what Job's wife did. None of the servants could have said that sad sentence so stingingly, or—if she meant it very kindly—none could have said it with such a fascinating air as Job's own wife. "Bless God and die," as it may be read, or more usually, *"Curse God, and die"* (Job 2:9). Oh, Satan, you have plowed with Job's heifer, but

you have not succeeded. Job's strength lies in his God, not in his hair, or else you might have shaved him as Samson was shorn!

Perhaps the Evil One had even inspected Job's personal sensitivities, and so selected that form of bodily affliction that he knew to be most dreaded by his victim. He brought upon him a disease that Job may have seen and shuddered at in poor men outside the city gates.

Beloved, Satan knows quite as much in regard to you. You have a child, and Satan knows that you idolize him. "Ah," he says, "there is a place for my wounding him." Even your marriage partner may be made a quiver in which hell's arrows will be stored until the time may come, and then he or she may prove the bow from which Satan will shoot them. Watch even your neighbor and your husband or wife, for you do not know how Satan may get an advantage over you.

Our habits, our joys, our sorrows, our private moments, our public positions—all may be made weapons of attack by this desperate Foe of the Lord's people. We have snares everywhere, in our beds and at our tables, in our houses and in the street. There are snares and traps in company; there are pits when we are alone. We may find temptations in the house of God as well as in the world, traps in our high estate, and deadly poisons in our abasement. We must not expect to be rid of temptations until we have crossed the Jordan, and then, thank God, we are beyond the gunshot of the Enemy. The last howling of the dog of hell will be heard as we descend into the chilly waters of the black stream, but when we hear the hallelujah of the glorified, we will be finished with the Black Prince forever and ever.

HIGHER CONSIDERATIONS

Satan considered, but there was a higher consideration that overrode his consideration.

In times of war, the military strategists and mine specialists of one side will lay out a minefield. It is a very common counteraction for the other side to undermine the first mines. This is just what God does with Satan. Satan is laying mines, and he plans to light the fuse and blow up God's building. But all the while God is undermining him, and he blows up his own mine before he can do any real mischief.

The Devil is the greatest of all fools. He has more knowledge but less wisdom than any other creature. He has more subtlety than all

the beasts of the field, but it is well called subtlety, not wisdom. It is not true wisdom; it is only another shape of folly.

All the while that Satan was tempting Job, he little knew that he was answering God's purpose, for God was looking on and considering the whole picture and holding the Enemy as a man holds a horse by its bridle. The Lord had considered exactly how far he would let Satan go.

The first time that Satan came against Job, God did not permit him to touch Job's flesh—perhaps that was more than Job could have borne at that time. Have you ever noticed that if you are in good strong bodily health, you can bear losses and crosses, and even bereavements, with something like calmness? Now that was the case with Job. Perhaps if the disease had come first and the rest had followed, it might have been a temptation too heavy for Job. But God, who knows just how far to let the Enemy go, will say to Satan, "Thus far, and no farther."

By degrees Job became accustomed to his poverty; in fact, the trial had lost all its sting the moment he said, *"The LORD gave, and the LORD hath taken away"* (Job 1:21). That enemy was slain. It was buried, and this was the funeral oration: *"Blessed be the name of the LORD"* (v. 21).

When the second trial came, the first trial had qualified Job to bear the second. It may be a more severe trial for a man in the possession of great worldly wealth to suddenly be deprived of the bodily power of enjoying it, than to lose all first and then lose the health necessary for its enjoyment.

Having already lost all, Job might almost have said, "I thank God that now I have nothing to enjoy, and therefore the loss of the power to enjoy it is not so wearisome. I do not have to say, 'How I wish I could go out in my fields and see to my servants,' for they are all dead. I do not wish to see my children; they are all dead and gone. I am thankful that they are. Better so, than that they should see their poor father sit on a dunghill like this."

He might have been almost glad if his wife had gone, too, for certainly it was not a particularly merciful blessing when she was spared. Possibly, if he had had all his children around him, it might have been a harder trial than it was. The Lord, who weighs mountains in scales, had meted out his servant's woe.

Did not the Lord also consider how He would sustain his servant under the trial? Beloved, you do not know how blessedly our God poured the secret oil on Job's fire of grace while the Devil was

throwing buckets of water on it. He said to Himself, "If Satan does much, I will do more. If he takes away much, I will give more. If he tempts the man to curse, I will fill him so full of love for Me that he will bless Me. I will help him; I will strengthen him; yes, I will uphold him with the right hand of My righteousness." (See Isaiah 41:10.)

Christian, take the following two thoughts and put them under your tongue as a wafer made with honey. You will never be tempted without express license from the throne where Jesus pleads. On the other hand, when He permits it, He *"will with the temptation also make a way to escape"* (1 Cor. 10:13) or give you grace to stand under it.

In the next place, the Lord considered how to sanctify Job by this trial. Job was a much better man at the end of the story than he was at the beginning. *"That man was perfect and upright"* (Job 1:1) at first, but there was a little pride about him. We are poor creatures to criticize such a man as Job, but still there was in him a sprinkling of self-righteousness, I think, that his friends brought out. Eliphaz and Zophar said such irritating things that poor Job could not help replying in strong terms about himself that were rather too strong. There was a little too much self-justification in his self-defense.

He was not proud, as some of us are, of a very little. He had much to be proud of, at least in the eyes of the world, but yet there was the tendency to be exalted with it. Though the Devil did not know it, perhaps if he had left Job alone, that pride might have developed fruit, and Job might have sinned. However, he was in such a hurry that he would not let the bad seed ripen, but hastened to destroy it. So the trials became the Lord's tool to bring Job into a more humble, and consequently, a more safe and blessed state of mind.

Moreover, observe how Satan was a lackey to the Almighty! Job all this while was being enabled to earn a greater reward. All his prosperity was not enough. God loved Job so much that He intended to give him twice the property. He intended to give him his children again. He meant to make him a more famous man than ever, a man whose name would ring down through the ages, a man who would be talked of through all generations. He was not to be the man of Uz, but of the whole world. He was not to be heard of by a handful in one neighborhood, but all men are to hear of Job's patience in the hour of trial.

Who was to do this? Who was to fashion the trumpet of fame through which Job's name would be blown? The Devil went to the forge and worked away with all his might to make Job illustrious!

507

Foolish Devil! He was piling up a pedestal on which God would set his servant Job, that he may be looked upon with wonder by all ages.

To conclude, Job's afflictions and Job's patience have been a lasting blessing to the church of God, and they have inflicted incredible disgrace upon Satan. If you want to make the Devil angry, throw the story of Job in his face. If you desire to have your own confidence sustained, may God the Holy Spirit lead you into the patience of Job. How many saints have been comforted in their distress by this story of patience! How many have been saved out of the jaws of the lion and from the paw of the bear by the dark experiences of the patriarch of Uz. Oh, Archfiend, how you are taken in your own net! You threw a stone that fell on your own head. You made a pit for Job, but fell into it yourself. You are taken in your own craftiness. Jehovah has made fools of the wise and driven the diviners mad.

Beloved, let us commit ourselves in faith to the care and keeping of God. Come poverty, come sickness, come death, we will in all things through Jesus Christ's blood be conquerors. By the power of His Spirit, we will overcome at the last. I pray that we are all trusting in Jesus. May those who have not trusted Him be led to begin right now. And God will have all the praise in us all, forevermore. Amen.

2

Satan in a Rage

*And there appeared a great wonder in heaven; a woman clothed
with the sun, and the moon under her feet, and upon her head a
crown of twelve stars: and she being with child cried, travailing in
birth, and pained to be delivered.*

*And there appeared another wonder in heaven; and behold a
great red dragon, having seven heads and ten horns, and seven
crowns upon his heads.*

*And his tail drew the third part of the stars of heaven, and
did cast them to the earth: and the dragon stood before the woman
which was ready to be delivered, for to devour her child as soon
as it was born.*

*And she brought forth a man child, who was to rule all
nations with a rod of iron: and her child was caught up
unto God, and to his throne.*

*And the woman fled into the wilderness, where she hath a
place prepared of God, that they should feed her there a thousand
two hundred and threescore days.*

*And there was war in heaven: Michael and his angels fought
against the dragon; and the dragon fought and his angels, and pre-
vailed not; neither was their place found any more in heaven.*

*And the great dragon was cast out, that old serpent, called the
Devil, and Satan, which deceiveth the whole world: he was cast out
into the earth, and his angels were cast out with him.*

*And I heard a loud voice saying in heaven, Now is come salvation,
and strength, and the kingdom of our God, and the power of his
Christ: for the accuser of our brethren is cast down, which accused
them before our God day and night.*

*And they overcame him by the blood of the Lamb, and by the word
of their testimony; and they loved not their lives unto the death.*

*Therefore rejoice, ye heavens, and ye that dwell in them. Woe to the
inhabiters of the earth and of the sea! for the devil is come down
unto you, having great wrath, because he knoweth that he
hath but a short time.
And when the dragon saw that he was cast unto the earth, he
persecuted the woman which brought forth the man child.
And to the woman were given two wings of a great eagle, that she
might fly into the wilderness, into her place, where she is nourished
for a time, and times, and half a time, from the face of the serpent.
And the serpent cast out of his mouth water as a flood after the
woman, that he might cause her to be carried away of the flood.
And the earth helped the woman, and the earth opened her mouth,
and swallowed up the flood which the dragon cast out of his mouth.
And the dragon was wroth with the woman, and went to make war
with the remnant of her seed, which keep the commandments of
God, and have the testimony of Jesus Christ.
—Revelation 12:1–17*

The great battle in the heavenlies has been fought. Our glorious Michael has forever overthrown the Dragon and cast him down. In the highest regions, the great principle of evil has received a total defeat through the life and death of our Lord Jesus. Atonement has been made for human sin, and the great quarrel between God and man has come to a happy end. Everlasting righteousness has been brought in, and the peace of God reigns in heaven. The conflict henceforth rages here below. In these inferior regions, the prince of this world is warring mightily against the cause of God and truth. This causes much woe to the sons of men, woe that will never end until Satan's power is altogether taken away.

Observe concerning our Archenemy that he exercises forethought and care when he undertakes evil enterprises. Whatever foolish men may do, the Devil is thinking. Others may be heedless and thoughtless, but he is anxious and full of consideration. He knows that his time, or opportunity, is short. He looks ahead to its close, for he is no careless waster of time and forgetter of the end. He values his opportunity to maintain his kingdom, to distress the people of God, and to dishonor the name of Christ. Since it is but a short time, he treats it as such.

He infers the brevity of his time from the victory that Jesus has already gained over him. In reading the twelfth chapter of

Revelation, we saw how the Child who is to *"rule all nations with a rod of iron"* was *"caught up unto God, and to his throne."* Then we saw the war in heaven and how the Devil was cast out into the earth and his angels with him. Then a loud voice was heard on high, saying, *"Now is come salvation, and strength, and the kingdom of our God, and the power of his Christ: for the accuser of our brethren is cast down, which accused them before our God day and night."* Very well may the old Serpent conclude that he will be routed on earth since he has already sustained so dire a defeat that he has fallen from heaven, never to rise again. Because the man-child Christ Jesus has met him in conflict, met him when as yet all his power was unbroken, and has cast him down from his high places, he is persuaded that his reign is ended and that his opportunity is short.

Even now Satan feels around him a chain, which is lengthened for a while but will be tightened by and by. Then he will roam the earth no longer, but lie as a captive in his prison. Fallen as this apostate spirit has become, he has wit enough to look ahead to the future. Oh, that men were half as awake and would remember their end. I beg you to notice this fact concerning the Evil Spirit, that you, too, may learn to acquire knowledge and then use it for practical purposes. Why should it always be that the powers of darkness appear to act more wisely than the children of light? For once I would point out a matter in which our worst Foe may teach us a lesson.

Among men there are some who know a great many important matters but act as if they do not know them. Their knowledge is so much waste heaped up in the storeroom of their minds and never brought into the workshop to be used for practical purposes.

For instance, we know our mortality and yet live as if we were never meant to die. There is great necessity for many of us to pray the following prayer: *"So teach us to number our days, that we may apply our hearts unto wisdom"* (Ps. 90:12). We must know that our time is short and that our lives will soon come to an end, and yet we fail to know it practically, for we are not as earnest as dying men ought to be. In this the Archenemy is not as foolish as we are, for he so well knows that his time is short that he remembers the fact and is activated by it.

Note well the direction in which this knowledge operates on him. It excites his emotions. The deepest emotion of which he is capable is anger, for he does not know how to love. Wrath is his very soul, as hatred is his very life. He knows nothing of gentleness, nothing of affection, and therefore the fact that his time is short stirs

the master passion within him, and he has great wrath. His evil nature is all on fire, and his excitement is terrible.

How much the shortness of our time ought to stir our hearts! With what ardency of love and fervency of zeal ought we to pass the days of our sojourning here! Knowing that the time of our departure is at hand, and that the season in which we can serve God among the sons of men is very brief, we ought to be excited to flaming zeal and passionate love. We are not half as stirred as we ought to be. Devils feel great hatred. Why is it that we do not feel great love? Should they be more eager to destroy than we are to save? Should they be all alive while we are half dead?

Nor is the result of knowing that his time is short merely emotional on the part of the Archfiend, for in consequence of his great wrath, he is moved to make earnest efforts. His energy is excited, he persecutes the woman whose seed he dreads, and he pours floods out of his mouth against her. There is nothing that Satan can do for his evil cause that he does not do. We may be halfhearted, but he never is. He is the very image of ceaseless industry and untiring earnestness. He will do all that can be done in the time of his permitted range. We may be sure that he will never lose a day.

My beloved, you and I, on the other hand, should be moved by the shortness of our opportunity to an equal energy of incessant industry, serving God continually, because *"the night cometh, when no man can work"* (John 9:4). My friend, if you want your children brought to Christ, speak to them, for they will soon be without a father. If you wish your employees to be saved, labor for their conversion, for they will soon be without an employer. If you desire your brother to be converted, speak to him, for your sisterly love will not help him much longer. Minister, if you want to save your congregation by the Spirit of God, seek to do it at once, for your tongue will soon be silent. Sunday school teacher, if you want your class to be gathered into the Good Shepherd's fold, treasure up every Sunday's opportunities, for in a short time the place that knows you now will know you no more forever.

Thus, as of old, *"the Israelites went down to the Philistines, to sharpen every man his share, and his coulter, and his ax, and his mattock"* (1 Sam. 13:20), so I have urged you to quicken your diligence by the example of the Prince of Darkness. Should we not learn wisdom from his subtlety and zeal from his fury? Will he discern the signs of the times and therefore stir himself, while we sleep on? Will evil encompass the sea and land while the children of God creep

about in idleness? God forbid. I entreat you, my friends, awake out of your sleep and see the great wrath of the old Dragon.

The text tells us that the shortness of Satan's opportunity stirs his wrath. We may gather a general rule from this one statement: in proportion as the Devil's time is shortened, so his energy is increased. We may take it as an assured fact that when he rages to the uttermost, his opportunities are nearly over. He has great wrath, knowing that his time is short. I hope there will be some instruction in this, and some comfort for all those who are on the right side. May the Holy Spirit make it so.

In the world around us, we must not think that things go altogether wrong when the powers of evil become strong. We would be foolish if we wept in despair because the tares are ripening, for is not the wheat ripening, too? True, the dead become more corrupt, but if the living become more active, why should we lament? Because blasphemy grows loud, because infidels seek to undermine the foundation of the faith, or because the clouds of superstition grow more dense, we must not therefore conclude that we have fallen upon evil times, the like of which were never seen before.

Oftentimes the development of evil is an indication that there is an equal or a greater development of good. The climax of ill is frequently its end. Do you not know that in the world of nature the darkest time of night is right before the dawning of the day? May it not be the same in the spiritual and moral world? Does not the old proverb tell us concerning the year, that "as the day lengthens, the cold strengthens"? As the spring comes with lengthened days, the frosts often grow more sharp and hard. Is it not also plain to the simplest mind that the turning of the tide happens when the ebb has reached its utmost?

Even so, when evil is at its height, it is nearest to its fall. Look for confirmation to the pages of history. When no straw was given to make bricks, Moses was used by God to deliver the oppressed. When Pharaoh would by no means let the people go and his yoke seemed riveted upon the neck of Israel, then the right arm of God was made bare, and the Red Sea beheld His vengeance. When despots grow most tyrannical, liberty's hour is coming. When the lie becomes exceedingly bold and wears a brazen front, then it is that truth confounds her. When Goliath stalks abroad and defies the armies of Israel, then is the stone already in the sling and the David near at hand to lay the giant low. Do not, therefore, dread the coming of greater opposition, or the apparent increase in strength of those

oppositions that already exist, for it has always been so in the history of events that the hour of the triumph of evil is the hour of its doom. When Belshazzar profanes the holy vessels, the handwriting blazes on the wall. When Haman is at the king's banquet of wine seeking the blood of the whole race of the Jews, the gallows are prepared for him upon his own roof.

It will be seen, even to the last hour of history, that the Devil rages all the more when his empire is nearer to its end. At the very last, he will go about to deceive the nations that are in the four quarters of the earth, Gog and Magog, to gather them together to battle. They will come up in great hosts, fierce for the conflict, to *"the battle of that great day of God Almighty"* (Rev. 16:14) at Armageddon. It will then seem as if the light of Israel must be quenched and the truth of God utterly extinguished. But in that dread hour, the Lord will triumph gloriously, and He will smite His adversaries in their final overthrow. Then will the angel standing in the sun invite the vultures and all the fowls that fly in the midst of heaven to gather to the grim feast of vengeance, to eat the flesh of horsemen and men of might. Then also will *"the devil that deceived them* [be] *cast into the lake of fire and brimstone...and shall be tormented day and night for ever and ever"* (Rev. 20:10). Then also will the shout be heard, *"Alleluia: for the Lord God omnipotent reigneth"* (Rev. 19:6). On the greatest possible scale, the greatness of the Dragon's wrath is a sure prophecy of the end of his reign.

Now, what is true on a great scale is true on a small scale. Missionaries in any country will generally find that the last onslaught of heathenism is the most ferocious. We will find that whenever falsehood comes into contact with the truth and error is driven to its last entrenchments, they fight for life, tooth and nail, with all their might. The wrath is great because their time is short. In any village or town in England, or in any other country, whenever the opposition to the Gospel reaches its most outrageous pitch and men seem as if they would murder the preacher of the Word, you may reckon that the power of the opposition is almost over.

After the mad fit, active persecution will cease. There will come a time of calm and, perhaps, of general reception of the Gospel. Once the bad passions of mankind have boiled up, they will cool down again. Has not God promised to restrain them? As the burning heat of the noon sun does not last forever but gradually abates when it has reached the hottest point, so is it with the wrath of man, which the foul Fiend so often uses for his base purposes.

The same truth will apply to every individual man. When God begins His great work in a sinner's heart to lead him to Christ, it is no bad sign if the man feels more hatred for God than ever, more dislike for good things than before. We need not despair if he is driven into greater sin than ever. The ferocity of the temptation indicates the vigor with which Satan contends for any one of his black sheep. He will not lose his subjects if he can help it, and so he puts forth all his strength to keep them under his power. He is especially diligent and furious when the power of grace is about to prevail for their salvation.

The general fact is further illustrated in the cases of many believers. There are times when, in the believer's heart, the battle rages horribly. He hardly knows whether he is a child of God at all and is ready to give up all hope. He cannot pray or praise, for he is so distracted. He cannot read the Scriptures without horrible thoughts. It seems as if he must utterly perish, for no respite is given him in which to refresh his heart, the attacks are so continual and violent. Such dreadful excitements are often followed by years of peace, quiet usefulness, holiness, and communion with God. Satan knows that God is about to set a limit to his vexations of the good man, and so he rages extremely because his opportunity is short. It is very remarkable that some of the greatest of the saints have died in the midst of the most fearful conflicts for the same reason: the dog howled at them because he knew that they would soon be out of his reach.

You would not suppose that Martin Luther, a man so brave and strong that he could defy the Pope and the Devil, should on his dying bed be woefully unsure. Yet it was so: his worst struggle was the closing one. He was more than a conqueror, but the fight was severe, as if the Devil, that old coward, waited until he had his antagonist down, waited until he was weak and feeble, and then leaped upon him to worry him if he could not devour him. Truly Luther had bothered the Devil, and we do not wonder at the malice of the Fiend. Satan knew that he would soon be out of the reach of his fiery arrows forever, and therefore he had to have a last shot at him.

It was precisely the same case with John Knox. Having been observed to sigh deeply and asked the cause of it, Knox replied,

> I have formerly, during my frail life, sustained many tests and many assaults of Satan, but at present he has assailed me most fearfully, and put forth all his strength to devour, and make an end of me at once. Often before has he placed my sins

515

before my eyes, often tempted me to despair, often endeavored to ensnare me by the allurements of the world; but these weapons were broken by the sword of the Spirit, the Word of God, and the Enemy failed. Now he has attacked me in another way: the cunning Serpent has labored to persuade me that I have merited heaven and eternal blessedness by the faithful discharge of my ministry. But, blessed be God, who has enabled me to beat down and quench this fiery dart by suggesting to me such passages of Scripture as these: *"What hast thou that thou didst not receive?"* (1 Cor. 4:7) and *"By the grace of God I am what I am:...not I, but the grace of God which was with me"* (1 Cor. 15:10). Upon this, as one vanquished, he left me.

Wherefore I give thanks to my God through Jesus Christ, who has been pleased to give me the victory, and I am persuaded that the Tempter shall not again attack me, but, within a short time, I shall, without any great pain of body or anguish of mind, exchange this mortal and miserable life for a blessed immortality through Jesus Christ.

Do you wonder that the Devil was eager to have another knock at one who had given so many knocks to his dominion? Do not therefore be at all surprised if Satan rages against you, nor marvel if you yourself should seem to be given into his power. Rather, rejoice in this, that his great wrath is the token of the shortness of his time. He wages war with us all the more cruelly because he knows that he will ultimately be defeated. His degraded mind delights in petty malice. If he cannot destroy, he will disturb. If he cannot kill, he will wound.

Subtle as he is, he acts very foolishly in pursuing a hopeless object. In his war against any one of the seed of the woman, he knows that he is doomed to defeat, yet he gnaws at the heel that breaks his head. It is the doom of evil to persevere in its spite after it knows that all is in vain—to be forever vanquished by the invincible Seed of the living God, and yet forever to return to the fray. Sisyphus forever rolling upward a huge stone that returns upon him is a true picture of the Devil vainly laboring to remove the truth out of its place. Satan's efforts are indeed *"labour in vain"* (Gal. 4:11).

I want to call attention to one particular instance of this fact, which is seen in the soul who is coming to Christ, for whom Satan often has great wrath, knowing that his time is short. My object is to comfort those who are awakened and are seeking the Savior. If they are harassed, I desire that they may find peace, rest, and hope very quickly. When the poor man who was possessed with an evil spirit

was being brought to Christ, we read that *"as he was yet a coming, the devil threw him down, and tare him"* (Luke 9:42). That is the way of the great Enemy: when he is about to be cast out, his energy is more displayed than ever, that if possible he may destroy the soul before it has obtained peace with God.

May the sacred Comforter help me while I try to give encouragement on this subject.

SATAN KNOWS HIS TIME IS SHORT

Our first topic will be this: how does Satan know when his time is short in a soul? He watches over all souls who are under his power with incessant maliciousness. He goes about the camp like a sentinel, spying out every man who is likely to be a deserter from his army.

In some men's hearts he dwells at ease, like a monarch in his palace. Their minds are his favorite mansions. He goes in and out as he pleases and makes himself comfortably at home. He counts the man's nature as his own inheritance and works his own evil pleasure in him. Alas, the deceived man yields his members as instruments of unrighteousness and is willingly held enthralled. (See Romans 6:13.) All the man's faculties are the many chambers for Satan to dwell in, and his emotions are many fires and forges for Satan to work with.

Eventually, if divine grace intervenes, there comes a change. Satan, who has lived there twenty, thirty, forty, fifty, sixty years, begins to think that he will not be able to keep this residence of his much longer. He perceives that his time is short. I suppose he perceives it first by discovering that he is not quite so welcome as he used to be. The man loved sin and found pleasure in it, but now sin is not so sweet as it was; its flavor is dull and insipid. The charms of vice are fading. Its pleasures are growing empty, vain, and void. This is a token of a great change.

At one time, whenever a sin came near, the soul kept an open house to entertain it with all hospitality, but now it is not half so eager. Even the indwelling habitual lusts do not yield as much contentment as before, nor is as much provision made for them. The Black Prince and his court are out of favor, and this is a hint that he must soon be gone. When sin loses its sweetness, Satan is losing his power. The Adversary perceives that he must soon stretch his dragon wings when he sees that the heart is growing weary of him and is breaking away from his fascinations.

He grows more sure of his speedy ejection when he does not get the accommodation he used to have. The man was once eager for sin. He went in the pursuit of vice, hunted after it, and put himself in the way of temptation. Then Satan reigned securely. But now the man begins to forsake the haunts where sin walks openly. He abandons the cups of excitement that inflame the soul. You find him going to a place of worship and listening to a sermon, where before he frequented the taverns and enjoyed a sinful song at a music hall.

The Devil does not like this change and takes it as a warning that he will soon have to give up the key. The man does not drink as he once did, or swear as he once did, nor does he readily yield himself up to every temptation. The fish is getting shy of the bait. The awakened man has not yet decided for Christ, but he is no longer at ease in bondage, no longer the glad slave of iniquity. He is on the wrong road, but he does not run on it. On the contrary, he pauses, heaves a sigh, and wishes he could leave the evil road, wishes he knew how to leap a hedge and get into the narrow way. Satan notices all this, and he says to himself, "There is not the preparation made for me that there used to be. There is little readiness to run on my errands. Therefore, I perceive that my time is short."

Satan is still more convinced of the shortness of his possession of a man's heart when he hears knocking at that heart's door a hand whose power he has felt. He knows the kind of knock it is: a gentle but irresistible knocking upon the heart. Continual, perpetual, persevering is the knock of One who means to enter. The knock is by One who has a hole in His hand. He knocks not as one whose power lies in a blow, but as one whose tears and love are his battery of attack. He has an energy of compassion, an irresistibleness of gentle love. As Satan hears His knock, when he perceives that the tenant of the house hears it too and is half inclined to open the door, he is afraid. When the heart relents at the sound of the Gospel summons, he trembles more. If the knocking still continues, waking up the tenant in the dead of night, a sound heard amid the noise of traffic and above the laughter of fools, he says, "My time is short." He knows the hand that broke his head of old, and its knocking is ominous to him.

He knows that in the gentleness of Jesus there is an irresistible energy that must and will prevail. He therefore knows that his possession of the tenement is precarious when the Gospel is felt in the heart. Between the knocks he hears a voice that says, *"Open to me...for my head is filled with dew, and my locks with the drops of*

the night" (Song 5:2), and he knows that this pleading voice bodes the downfall of his power.

Another indication to the Enemy that his time is short is when he knows that the tenant of the house steals away sometimes to court and asks for a warrant of eviction against him. You know what I mean—when the man feels that he cannot himself get rid of sin and cannot in his own strength conquer Satan, and therefore cries, "O God, help me. O God, for Christ's sake, drive out the old Dragon from my soul, I implore You." This is asking for a warrant of eviction. This is going to the court of heaven and pleading with the Great King to issue a summons and send His officer to eject the intruder, that he may no longer pollute the spirit.

"Ah," says the Evil One, "this is not the place for me much longer, for, behold, he prays." More fierce than the flames of hell to Satan are the prayers of convinced sinners. When they pray, he must be gone. He must cry, "Retreat!" when men sound the trumpet of prayer. There is no staying in the camp any longer when the advance guard of prayer has come to take possession.

One thing more always makes Satan know that his time is short. That is when the Holy Spirit's power is evidently at work within the mind. Light has come in, and the sinner sees and knows what he was ignorant of before. Satan hates the light as much as he loves darkness. Like an owl in the daylight, he feels that he is out of place. Life comes in, too, by the Holy Spirit. The man feels, becomes sensitive, and becomes penitent. Satan, who loves death and always abides among the tombs, is bound to fly away from life. The Holy Spirit is beginning to work upon the man very graciously. Satan knows every throb of the Spirit's power, for it is the death of his power. So he says, "I will go to the place from where I came out, for this house trembles as if it were shaken with an earthquake and gives me no rest." Joyful tidings for a heart long tormented by this fierce Fiend! Away, Enemy; your destructions will soon come to a perpetual end!

SATAN'S DISPLAY OF RAGE

Second, this brings me to notice that, inasmuch as the shortness of his tenure stirs up the rage of Satan, we must next observe how he displays his great wrath. His fury rages differently in different people.

On some Satan displays his great wrath by stimulating outward persecution. The man is not a Christian yet, he is not actually converted yet, but Satan is so afraid that he will be saved that he sets all his dogs upon him. The poor soul goes into the workplace. Though he would give his eyes if he could say, "I am a Christian," he cannot quite say so. Yet his coworkers begin to pounce on him as much as if he were indeed one of the hated followers of Jesus. They scoff at him because he is serious and sober, because he is beginning to think and to be decent, because he begins to listen to the Gospel and to care for the best things. Before the Christ child was born, the Dragon longed to devour Him. Before a man becomes a Christian, the prince of the power of the air labors, if possible, to destroy him.

The Devil will lose nothing by being behind. He begins as soon as grace begins. Now, if the grace of God is not in the awakened man, and his reformation is only a spasm of remorse, it is very likely that he will be driven back from all attendance on the means of grace by the ribald remarks of the ungodly. However, if the Lord Jesus Christ has really been knocking at his door and the Spirit of God has begun to work, this opposition will not serve its purpose. The Lord will find wings for this poor soul so that he may flee away from the trial that as yet he is not able to bear.

I have sometimes known such opposition even to tend to undo Satan's work and accomplish quite the opposite purpose. I know one who was very troubled about the truth of Scriptures and about the doctrines of the Gospel, although he was a sincere searcher into the truth. He began to attend the church that I pastor and to listen to the Gospel, as an inquirer rather than as a believer. As yet he could not state that he was a Christian, though he half wished he could. Now, it came to pass that the opposition that he immediately received from the world strengthened his faith in the Bible and became a sort of missing link between him and the truth. The sneers of his comrades had this effect. He said to himself, "Why should they all attack me on the bare supposition of my being a Christian? If I had been a Muslim or a Jew, they would have regarded me with curiosity and let me alone. But inasmuch as they only suspect me of becoming a Christian, they are all down on me with contempt and anger. Now, why is this? Is not this a proof that I am right and that the Word of God is right, for did it not say that there should be enmity between the seed of the Serpent and the seed of the woman (Gen. 3:15)?"

The Devil did not know what he was doing when he opposed that young man and made a believer of him by that which was

meant to drive him into unbelief. If the men of this world oppose the faith of our Lord Jesus Christ more fiercely than any other, surely it must be that there is something special in it, something opposed to their sinful ways or to their proud hopes, something that is of God. That was the inference that my young friend drew from the treatment he received, and that inference established him in the faith. Thus, you see, Satan often hopes to save his dominion when his time is short through vehement persecution against the awakening sinner.

Much worse, however, is his other method of showing his wrath, namely, by vomiting floods out of his mouth to drown our newborn hope, if possible. When the hopeful hearer has not yet found peace and rest, Satan will sometimes try him with doubts, blasphemies, and temptations such as he never knew before. The tempted one has been amazed and has said to himself, "How is this? Can my desire for Christ be the work of God? I get worse and worse. I never felt as wicked as this until I began to seek a Savior." Yet this is no strange thing, fiery though the trial is.

Satan will suggest all the doubts he can about the inspiration of Scripture, the existence of God, the deity of Christ, and everything else that is revealed, until the poor heart that is earnestly longing for salvation will scarcely know whether there is anything true at all. The man will be so jumbled in his thoughts that he will hardly know whether he is on his head or his heels. *"They reel to and fro, and stagger like a drunken man, and are at their wit's end"* (Ps. 107:27). The more they read the Bible and the more they attend to the means of grace, the more they will be tempted to be skeptical and atheistic. Doubts they never knew before will torment them even while they strive to be devout. The evil tenant has notice to leave, and he makes up his mind to do all the damage within his power while he is still within the doors. See how he breaks up precious truths and dashes down the richest hopes, and all with the detestable design of venting his spite upon the poor soul.

At such a time, also, Satan will often arouse all the worst passions of our nature and drive them into unruly riot. The awakened sinner will be astonished as he finds himself harassed by temptations more base and foul than he has ever felt before. He will resist and strive against the assault, but it may be so violent that it staggers him. He can scarcely believe that the flesh is so utterly corrupt. The man who is anxiously seeking to go to heaven seems at such a time as if he were dragged down by seven strong demons to the eternal

depths of perdition. He feels as if he had never known sin before or had been so completely beneath its power. The satanic troops sleep as if in a quiet garrison while the man is under the spell of sin, but once the heart is likely to be captured by Emmanuel's love, the infernal soldiers put on their worst manner and trample down all the thoughts and desires of the soul.

Satan may also attack the seeker in another form, with fierce accusations and judgments. He does not accuse some men, for he is quite sure that they are his very good friends. But when a man is likely to be lost to him, he alters his tone and threatens and condemns. He cries, "What, you be saved? It is impossible! You know what you used to be. Think of your past life." Then he rakes up a very hell before the man's eyes. "You!" he accuses. "Why even since you have pretended to be a little better and have begun to attend to the means of grace, you know you have looked back with a longing eye and hungered for your old pleasures. It is quite out of the question that you should be a servant of Christ! He will not have such a ragamuffin as you in His house. The great Captain will never march at the head of a regiment that is disgraced by receiving such as you."

In *The Pilgrim's Progress*, Bunyan described Apollyon as standing across the road and swearing by his infernal den that the pilgrim should go no further. There would he spill his soul. Then he began to fling at him all types of fiery darts. Among them was this one: "Thou didst faint at first setting out, when thou wast almost choked in the gulf of Despond. Thou wast almost persuaded to go back at the sight of the Lions. Thou hast been false already to thy new Lord!"

Think for a moment of the Devil chiding us for sin! Oh, that the poor burdened soul could laugh at this hypocritical accuser, for he hates to be despised and yet he very well deserves it. Laugh at him, virgin daughter of Zion, for this great wrath of his is because his time is short. Who is he that he should bring an accusation against us? Let him mind himself. He has enough to answer for. When he turns to being an accuser, it is enough to make the child of God laugh him to scorn. Yet it is not easy to laugh when you are in this predicament, for the heart is ready to break with anguish.

Satan at such times has been known to pour into the poor troubled mind floods of blasphemy. I do not recollect as a child having heard blasphemy. Carefully brought up and kept out of harm's way, I think it could only have been once or twice that I ever heard profane language. Yet, when I was seeking the Lord, I distinctly remember

the spot where the most hideous blasphemies that ever passed through the human mind rushed through my mind. I clapped my hands over my mouth for fear I would utter one of them. They were none of my inventing, nor had I revived them from my memory. They were the immediate suggestions of Satan himself, who was determined, if possible, to drive me to despair.

Read the story of John Bunyan's five years of torture under this particular misery, and you will see how Satan would say to him, "Sell Christ. Sell Christ. Give up Christ." As he went about his daily business, he would have it ringing in his ears, "Sell Christ. Sell Christ." When at last in a moment of torment, Bunyan thought he said, "Let Him go, if He will," then came the accusation, "Now it is all over with you. Jesus will have nothing to do with you, for you have given Him up. You are a Judas; you have sold your Lord." Then, when the poor man sought the Lord with tears and found peace again, some other dreadful insinuation would dog his heels. John Bunyan was too precious a servant of the Devil for him to lose readily. The Enemy had perhaps some idea of what kind of servant of God the converted tinker would become, and what sort of dreams would charm the hearts of many generations, so he would not let him go without summoning all the tribes of hell to wreak their vengeance on him if they could not detain him in their service. Yet Bunyan escaped, and so will others in a similar case.

Oh, bond slave of the Devil, may you have grace to steal away to Jesus. Hasten away from Satan's power at once. Otherwise he will, as long as he has any opportunity, manifest his great wrath toward you.

HOW TO DEAL WITH SATAN'S ATTACKS

Third, let us consider how we are to meet all of this. How must Satan be dealt with while he is showing his great wrath because his power is short?

I should say, first, if he is putting himself in this rage, let us get him out all the more quickly. If he remains quiet, even then we ought to be eager to be rid of his foul company. But if he shows this great rage, let us get him out right away. In God's name, let the Dragon be smitten if he is raving. If there is any opportunity of getting him out, back door or front door, do it right away; do not loiter or linger even for a single hour. A Devil raging, making us blaspheme and

then accusing us, tempting us and betraying us, is such a dangerous occupant of a heart that he is not to be borne. Out he must go, and out at once. It is better to have a den of lions dwelling in our houses than the Devil within our hearts.

Lord, turn him out at once by Your own grace. We decide once and for all to wage war with him. We will linger no longer; we dare not. We will procrastinate no more; it is more than our lives are worth. Not tomorrow, but today, must the tyrant go. Not in a little while, but now, at this very moment, O Lord, drive the old Dragon from his throne with all his hellish crew!

That is the first advice I give you. Let the Enemy be cast out at once by divine grace.

The next thing is, inasmuch as we cannot get him out by our own unaided efforts, let us cry to the strong for strength, who can drive out this prince of the power of the air. There is life in a look at Jesus Christ. As soon as that life comes, away goes this Prince of Darkness as to his domination and reigning power. Oh, soul, there is nothing left for you but to look to Jesus Christ alone. Worried as you are and almost devoured, now is your time to put your trust in Jesus, who is mighty to save.

You know the text in Amos that speaks of the shepherd taking out of the lion's mouth two legs or a piece of an ear (Amos 3:12). The sheep was almost devoured, but still he pulled out from between the lion's jaws the last relics of his prey. If you seem to be reduced to two legs and a piece of an ear, still our glorious Shepherd can pull you out from between the lion's teeth and make you whole again, for He will not lose His sheep even at its last extremity.

What can you do against Satan? You would with pleasure be rid of him, but what can you do? Do nothing but this: cry to his Master against him. He may be mighty, but set the Almighty One upon him. He who accuses you, refer him to your Advocate. When he brings your sin before you, throw the blood of atonement in his face. Here is a text that will drive him down to his den: *"The blood of Jesus Christ his Son cleanseth us from all sin"* (1 John 1:7). Another is, *"This is a faithful saying, and worthy of all acceptation, that Christ Jesus came into the world to save sinners; of whom I am chief"* (1 Tim. 1:15). Quit battling with the wily Foe. Do not answer the old deceiver. If he tells you that you are a blasphemer, admit it. If he says you are utterly lost, acknowledge it. Then cast yourself at Jesus' feet, and He will overcome your Foe and set you free.

One more comfort for you is this: the more he rages, the more must your poor, troubled heart be encouraged to believe that he will soon be gone. I venture to say that nothing will make him go sooner than your full belief that he has to go. Courageous hope is a weapon that he dreads. Tell him he must soon be gone. He has been accusing you and pouring venom into your mind, making you believe that it is your blasphemy, when it is not yours but his. Say to him, "Ah, but you will be gone soon. You may rage, but you will have to be gone."

"I have full possession of you," he says, "soul and body, and I triumph over you."

Respond to him, "And would you triumph over me as you do if you did not know that you will soon be driven out?"

"Ah," says he, "you will be lost, you will be lost." He howls at you as if ready to devour.

Say to him, "If I was sure to be lost, you would not tell me so; you would sing sweet songs in my ears and lure me to destruction. You have to go; you know you do."

"Oh," says he, "it is impossible for you to be saved. You will be damned. You will have the hottest place in hell."

"But who sent you to tell me that?" you reply. "You have never spoken the truth yet. You are a liar from the beginning, and you are only saying this because you have to go. You know you have to go." Tell him so, and it is not long before he will depart. Say, *"Rejoice not against me, O mine enemy: when I fall, I shall arise"* (Mic. 7:8).

Tell him you know his Master. Tell him he may nibble at your heel, but you recall the One who broke his head. Point to his broken head. He always tries to hide it if he can. Tell him his crown is battered to pieces, and tell him where that deed was done and by whose blessed hand.

As you tell him these things, he will shrink back. You will find yourself alone with Jesus only. Then will Jesus say to you, *"Where are those thine accusers?"* (John 8:10). You will look around and the Enemy will be gone. Then your blessed Master will say, *"Neither do I condemn thee: go, and sin no more"* (v. 11). May the Lord grant us such a riddance of our Archenemy this very moment for Christ's dear sake. Amen.

3

Satanic
Hindrances

Satan hindered us.
—1 Thessalonians 2:18

P aul, Silas, and Timothy were very desirous to visit the church
at Thessalonica, but they were unable to do so for the singular
reason announced in this text, namely, *"Satan hindered us."*
It was not from lack of willingness, for they had a very great attach-
ment to the Thessalonian believers, and they longed to look them in
the face again. They said of the Thessalonians,

> *We give thanks to God always for you all, making mention of*
> *you in our prayers; remembering without ceasing your work of*
> *faith, and labour of love, and patience of hope in our Lord Jesus*
> *Christ, in the sight of God and our Father.* (1 Thess. 1:2–3)

Their desire to visit the church together was overruled, but being
anxious for its welfare, they sent Timothy alone to minister for a
time in its midst. It was not lack of desire that hindered them, but
lack of power.

They were not prevented by God's special providence. We find
on certain occasions that Paul was not allowed to go precisely where
his heart would have led him. *"They assayed to go into Bithynia: but*
the Spirit suffered them not" (Acts 16:7). They *"were forbidden of the*
Holy Ghost to preach the word in Asia" (v. 6); however, their course
was directed toward Troas so that they might preach in Europe the
unsearchable riches of Christ.

They could not, however, trace their absence from Thessalonica to any divine interposition. It appeared to them to proceed from the great Adversary; *"Satan hindered them."* How Satan did so would be useless to state dogmatically, but we may form a reasonable conjecture. I find in the margin of my pulpit Bible, a note by one commentator that is probably correct: "Satan hindered Paul by raising such a storm of persecution against him at Berea, and other places, that it was deemed prudent to delay his visit until the storm was somewhat allayed."

However, I can hardly surmise this to have been the only hindrance, for Paul was very courageous. Having a strong desire to visit Thessalonica, he would not have been kept away by fear of opposition. He did not shun the hottest part of the battle, but like a truly valiant champion, delighted most to be found in the thick of his foes. Possibly the antagonism of the various philosophers whom he met with at Athens and the evident heresies at Corinth, from which it seems that this epistle was written, may have called for his presence on the scene of action. He felt that he could not leave struggling churches to their enemies. He must contend with the grievous wolves and unmask the evil ones who wore the garb of angels of light.

Satan had moved the enemies of the truth to industrious opposition, and thus the apostle and his companions were hindered from going to Thessalonica. It may be that Satan had stirred up dissensions and discords in the churches that Paul was visiting, and therefore he was obliged to stop first in one and then in another to settle their differences, to bring to bear the weight of his own spiritual influence on the various divided sections of the church to restore them to unity. Well, whether persecution, philosophic heresy, or the divisions in the church were the outward instruments, we cannot tell, but Satan was assuredly the prime mover.

You will perhaps wonder why the Devil should care so much about Paul and his whereabouts. Why should he take so much interest in keeping these three men from that particular church? This leads us to observe what wonderful importance is attached to the action of Christian ministers. Here was the master of all evil, the prince of the power of the air, intently watching the journeying of three humble men. And he was apparently far more concerned about their movements than about the doings of Nero or Tiberius. These despised heralds of mercy were his most dreaded foes. They preached the name that makes hell tremble. They declared that righteousness

against which satanic hate always vents itself with its utmost power. With such malicious glances, the Archenemy watched their daily path. What cunning hands hindered them at all points!

It strikes us that Satan wanted to keep these apostolic men from the church of Thessalonica because the church was young and weak. Thus, he thought that if it was not fostered and helped by the preaching and presence of Paul, he might yet slay the young child. Moreover, since long ago he has had a fierce hatred of the preaching of the Gospel, and possibly there had been no public declaration of the truth throughout Thessalonica since Paul had gone. He was afraid lest the firebrands of the truth of the Gospel should again be flung in among the masses and a gracious conflagration should take place.

Besides, Satan always hates Christian fellowship. It is his policy to keep Christians apart. Anything that can divide saints from one another, he delights in. He attaches far more importance to godly relationships than we do. Since union is strength, he does his best to promote separation. Just so, he would keep Paul away from these believers who might have gladdened his heart, and whose hearts he might have cheered. He would hinder their brotherly intimacy so that they might miss the strength that always flows from Christian communion and Christian sympathy.

This is not the only occasion in which Satan has hindered good men. Indeed, this has been his practice in all ages. We have selected this one particular incident so that some who are hindered by Satan may draw comfort from it, and so that we may have an opportunity (if the Spirit of God enables us) of saying a good and forceful word to any who think it is strange that this fiery trial has happened to them.

SATAN'S HABIT OF HINDRANCE

Let us observe that it has been Satan's practice from old to hinder, wherever he could, the work of God.

"Satan hindered us" is the testimony that all the saints in heaven will bear against the Archenemy. This is the witness of all who have written a holy line on the historic page or carved a consecrated name on the rock of immortality: *"Satan hindered us."*

In the sacred writings, we find Satan interfering to hinder the completeness of the personal character of individual saints. The man

of Uz was blameless and upright before God, and to all appearances would persevere in producing a finished picture of what the believer in God should be. Indeed, Job had so been enabled to live that the Archfiend could find no fault with his actions and only dared to impute wrong motives to him. Satan had considered Job, yet he could find no mischief in him. But then he hinted, *"Hast not thou made an hedge about him, and about his house, and about all that he hath on every side?"* (Job 1:10).

Satan sought to turn the blessing that Job was giving to God into a curse, and therefore he buffeted him severely. He stripped him of all his substance. The evil messengers followed on one another's heels, and their tidings of woe only ceased when his goods were all destroyed and his children had all perished. The poor afflicted parent was then struck in his bone and in his flesh until he was reduced to sitting on a dunghill and scraping himself with a piece of broken pottery. Even then the picture had no blot of sin upon it, and the ink pen was held with a steady hand by the patient one. Therefore Satan made another attempt to hinder Job's retaining his holy character. He stirred his wife to say, *"Dost thou still retain thine integrity? curse God, and die"* (Job 2:9). This was a great and grievous hindrance to the completion of Job's marvelous career, but glory be to God, the man of patience not only overcame Satan, but he also made him a stepping-stone to a yet greater height of illustrious virtue. You know about the patience of Job, which you would not have known if Satan had not illuminated it with the blaze of flaming afflictions. Had not the vessel been burnt in the furnace, the bright colors would not have been so fixed and abiding. The trial through which Job passed brought out the luster of his matchless endurance in submission and resignation to God.

Now, just as the Enemy of old waylaid and harassed the patriarch to hinder his perseverance in the fair path of excellence, so will he do with us. You may be congratulating yourself, saying, "I have so far walked consistently. No man can challenge my integrity." Beware of boasting, for your virtue will yet be tried. Satan will direct his engines against that very virtue for which you are the most famous. If you have been a firm believer up to this point, your faith will soon be attacked. If up until now you have been meek like Moses, expect to be tempted to speak unadvisedly with your lips. The birds will peck at your ripest fruit, and the wild boar will dash his tusks at your choicest vines. Oh, that we had among us more prominence of piety, more generosity of character, more faithfulness of behavior! In all

these respects, I do not doubt, many have set out with the highest aims and intentions. Alas! How often have they had to cry, *"Satan hindered us!"*

This is not the Enemy's only business, for he is very earnest in endeavoring to hinder the emancipation of the Lord's redeemed ones. You know the memorable story of Moses. When the children of Israel were in captivity in Egypt, God's servant stood before their haughty oppressor with his rod in his hand. In Jehovah's name, he declared, *"Thus saith the LORD, Let my people go, that they may serve me"* (Exod. 8:1). A sign was required. The rod was cast upon the ground, and it became a serpent. At this point, Satan hindered. *"Jannes and Jambres withstood Moses"* (2 Tim. 3:8). We read that the magicians did the same thing with their enchantments. Whether it was by devilish arts or by sleight of hand, we need not now inquire. In either case, they did the Devil service, and they did it well, for Pharaoh's heart was hardened when he saw that the magicians apparently produced the same miracles as Moses had.

Beloved, take this as a type of Satan's hindrances to the Word of the Lord. Christ's servants came forth to preach the Gospel. Their ministry was attended with signs and wonders. "My kingdom is shaken," said the Prince of Evil; "I must get busy." Right away he sent magicians to work lying signs and wonders without number. Apocryphal wonders were and are as plentiful as the frogs of Egypt. Did the apostles preach the sacrifice of Christ? The Devil's apostles preached the sacrifice of the mass. Did the saints uplift the cross? The Devil's servants upheld the crucifix. Did God's ministers speak of Jesus as the one infallible Head of the church? The Devil's servants proclaimed the false priest of Rome as standing in that same place. Romanism is a most ingenious imitation of the Gospel. It is the *"magicians* [doing] *so with their enchantments"* (Exod. 8:7).

If you study well the spirit and genius of the great Antichrist, you will see that its great power lies in its being an exceedingly clever counterfeit of the Gospel of the Lord Jesus Christ. To the extent that tinsel could counterfeit gold, candlelight could rival the sun in its glory, and a drop in a bucket could imitate the sea in its strength, the spirit of Antichrist has copied God's great masterpiece, the Gospel of our Lord Jesus Christ. To this day, as God's servants scatter the pure gold of truth, their worst enemies are those who issue worthless coins on which they have feloniously stamped the image and superscription of the lying of kings.

You have another case further on in history—all Old Testament history is typical of what is going on around us now. God was about to give a most wonderful system of instruction to Israel and to the human race, by way of type and ceremony, in the wilderness. Aaron and his sons were selected to represent the Great High Priest of our salvation, the Lord Jesus Christ. In every garment that they wore, there was a symbolic significance. Every vessel of that sanctuary in which they ministered taught a lesson. Every single act of worship, whether the sprinkling of blood or the burning of incense, was made to teach precious and important truths to the sons of men. What a noble volume was unfolded in the wilderness at the foot of Sinai! How God declared Himself and the glory of the coming Messiah in the persons of Aaron and his sons!

What then? With this Satan interfered. Moses and Aaron could say, *"Satan hindered us."* Korah, Dathan, and Abiram arrogantly claimed a right to the priesthood. On a certain day, they stood with bronze censors in their hands, thrusting themselves impertinently into the office that the Lord had assigned to Aaron and to his sons. The earth opened and swallowed them up alive (see Numbers 16:1–35): this was a true prophecy of what will become of those who thrust themselves into the office of the priesthood where none but Jesus Christ can stand.

You may see the parallel this day. Christ Jesus is the only priest who offers the sacrifice of blood, and He brings that sacrifice no more, for having once offered it, He has perfected forever those who are set apart (Heb. 10:14). *"This man, after he had offered one sacrifice for sins for ever, sat down on the right hand of God"* (v. 12). Paul, with the strongest force of logic, proved that Christ does not offer a continual sacrifice, but that, having offered it once for all, His work was finished, and He now sits at the right hand of the Father.

This doctrine of a finished atonement and a completed sacrifice seemed likely to overrun the world. It was such a gracious unfolding of the divine mind that Satan could not look upon it without desiring to hinder it. Therefore, look on every hand, and you can see Korah, Dathan, and Abiram in those churches that are branches of the Anglican and the Roman. To this very day, men call themselves "priests" and read prayers from a book in which the catechism states, "Then shall the priest say...." These falsely appropriate to themselves a priesthood other than that which is common to all the saints. Some of them even claim to offer a daily sacrifice, to celebrate an unbloody sacrifice at the thing that they call an altar. They claim

to have power to forgive sin, saying to sick and dying persons, "By authority committed unto me, I absolve you from all your sins." This is the great hindrance to the propagation of the Gospel—the priestly pretensions of a set of men who are no priests of God, though they may be priests of Baal. Thus the ministers of Jesus are made to cry, *"Satan hinder*[s] *us."*

Take another instance of satanic hatred. When Joshua had led the tribes across the Jordan, they were to attack the various cities that God had given them for a heritage. From Dan to Beersheba, the whole land was to be theirs. After the taking of Jericho, the first contact that they had with the heathen Canaanites ended in disastrous defeat to the servants of God; *"they fled before the men of Ai"* (Josh. 7:4). Here again you hear the cry, *"Satan hindered us."* Joshua might have gone from city to city exterminating the nations, as they justly deserved to be, but Achan had taken of the accursed thing and hidden it in his tent; therefore no victory could be won by Israel until his theft and sacrilege had been put away.

Beloved, this is symbolic of the Christian church. We might go from victory to victory, our home mission operations might be successful, and our foreign agencies might be crowned with triumph if it were not that we have Achans in the camp at home. When churches have no conversions, it is more than probable that hypocrites concealed among them have turned away the Lord's blessing. You who are inconsistent, who make the profession of religion the means of getting wealth, you who unite yourselves with God's people, but at the same time covet the costly Babylonian garment and the wedge of gold, you are those who cut the muscles of Zion's strength. You prevent the Israel of God from going forth to victory. Little do we know, beloved, how Satan has hindered us.

We, as the church, have had much reason to thank God. But how many more might have been added to the church if it had not been for the coldness of some, the indifference of others, the inconsistency of a few, and the worldliness of many more? Satan hinders us not merely by direct opposition, but by sending Achans into the midst of our camp.

I will give you one more picture. View the building of Jerusalem after it had been destroyed by the Babylonians. When Ezra and Nehemiah were found building, the Devil surely stirred up Sanballat and Tobiah to cast down. There was never a revival of religion without a revival of the old enmity. If ever the church of God is to be built, it will be in troubled times. When God's servants are active,

Satan is not without vigilant followers who seek to counteract their efforts.

The history of the Old Testament church is a history of Satan endeavoring to hinder the work of the Lord. I am sure you will admit it has been the same since the days of the Lord Jesus Christ. When He was on earth, Satan hindered Him. Satan dared to attack Christ to His face personally. When that failed, Pharisees, Sadducees, Herodians, and men of all sorts hindered Him. When the apostles began their ministry, Herod and the Jews sought to hinder them. When persecution did not work, then all sorts of heresies and schisms broke out in the Christian church. Satan still hindered them. A very short time after the ascension of our Lord, the precious sons of Zion, comparable to fine gold, had become like earthen pitchers,. The glory had departed and the luster of truth was gone because by false doctrine, lukewarmness, and worldliness, Satan hindered them.

When the Reformation dawned, God raised up a Luther, but the Devil brought out an Ignatius Loyola (founder of the Jesuits) to hinder him. If God had His reformers, His Latimers and His Wycliffes, the Devil had his opposers, his Gardiners and Bonners. When in the modern reformation Whitefield and Wesley thundered like the voice of God, there were ordained reprobates found to hinder them, to hold them up to reproach and shame.

Never, since the first hour struck in which goodness came into convict with evil, has it ceased to be true that Satan hindered us. From all points of the compass, all along the line of battle, in the vanguard and in the rear, at the dawn of day and at midnight, Satan hindered us. If we toil in the field, he seeks to break the plowshare. If we build the walls, he labors to cast down the stones. If we would serve God in suffering or in conflict, everywhere Satan hinders us.

SATAN'S HINDERING TACTICS

Second, we will now indicate many ways in which Satan has hindered us.

The Prince of Evil is very busy in hindering those who are just coming to Jesus Christ. Here he spends the main portion of his skill. Some of us who know the Savior recollect the fierce conflicts that we had with Satan when we first looked to the Cross and lived.

Others of you are just passing through that trying season. I will address myself to you. Beloved friends, you long to be saved, but ever

since you have given any attention to these eternal things, you have been the victim of deep distress of mind. Do not marvel at this. This is usual, so usual as to be almost universal.

I would wonder if you are not perplexed about the doctrine of election. It will be suggested to you that you are not one of the chosen of God, although your common sense will teach you that it might just as well be suggested to you that you are, since you know neither the one nor the other, nor indeed can know until you have believed Jesus. Your present business is with the precept that is revealed, not with the election that is concealed. Your business is with that exhortation, *"Believe on the Lord Jesus Christ, and thou shalt be saved"* (Acts 16:31).

It is possible that the great fighting ground between predestination and free will may be the dry and desert place in which your soul is wandering. Now you will never find any comfort there. The wisest of men have despaired of ever solving the mystery of those two matters, and it is not probable that you will find any peace in worrying yourself about it. Your business is not with metaphysical difficulty, but with faith in the atonement of the Lord Jesus Christ, which is simple and plain enough.

It is possible that your sins now come to your remembrance, and though once you thought little enough of them, now it is hinted to you by satanic malice that they are too great to be pardoned. I urge you to reveal the lie of this by telling Satan this truth, that *"all manner of sin and blasphemy shall be forgiven unto men"* (Matt. 12:31).

However, the verse goes on to say that *"the blasphemy against the Holy Ghost shall not be forgiven unto men."* It is very likely that the sin against the Holy Spirit much torments you. You read that *"unto him that blasphemeth against the Holy Ghost it shall not be forgiven"* (Luke 12:10). In this, too, you may be greatly tried. I wonder not that you are, for this is a most painfully difficult subject. One fact may cheer you: if you repent of your sins, you have not committed the unpardonable offense, since that sin necessitates hardness of heart forever. As long as a man has any tenderness of conscience and any softness of spirit, he has not so renounced the Holy Spirit as to have lost His presence.

It may be that you are the victim of blasphemous thoughts. Torrents of the filth of hell have been pouring through your soul. At this, do not be astonished, for there are some of us who delight in holiness and are pure in heart, who nevertheless have been at times sorely

tried with thoughts that were never born in our hearts, but were injected into them. These suggestions are born in hell, not in our spirits. They are hated and loathed but are cast into our minds to hinder and trouble us.

Satan may hinder you as he did the child who was brought to Jesus. We read about him that as he *"was yet a coming, the devil threw him down, and tare him"* (Luke 9:42). Do come notwithstanding. Though seven demons were in him, Jesus would not cast the coming sinner out. Even if you feel a conviction that the unpardonable sin has fallen to your lot, yet dare to trust in Jesus. If you do that, I warrant you there will be a joy and a peace in believing that will overcome Satan, who has *"hindered us."*

But I must not stop long on any one point when there are so many. Satan is sure to hinder Christians when they are earnest in prayer. Have you not frequently found, dear friends, when you have been most earnest in supplication, that something or other will dart across your mind to make you cease from the exercise? It appears to me that we shake the tree and no fruit drops from it. Just when one more shake would bring down the luscious fruit, the Devil touches us on the shoulder and tells us it is time to be gone, and so we miss the blessing we might have attained. I mean that just when prayer would be the most successful, we are tempted to abstain from it. When my spirit has sometimes laid hold upon the angel, I have been painfully conscious of a counter-influence urging me to cease from such petition and let the Lord alone, for His will would be done. If the temptation did not come in that shape, yet it came in another, to cease to pray because prayer after all could not avail. Oh, beloved, I know if you are much in prayer you can sing Cowper's hymn:

> That various hindrances we meet
> In coming to the mercy seat.

The same is true of Christians when under the prompting of the Spirit of God or when planning any good work. You were prompted to speak to someone. "Run, speak to that young man" was the message in your ear. You did not do it: Satan hindered you. You were told on a certain occasion—you do not know how, but believe me we ought to pay great respect to these inward whispers—to visit a certain person and help him. You did not do it: Satan hindered you. You were sitting down by the fire one evening reading a missionary report concerning Afghanistan or some district destitute of the truth.

You thought, "Now I have a little money that I could give to this purpose." Then it came across your mind that there is another way of spending it more profitably for your family: so Satan hindered you. Or you yourself thought of doing a little in a certain district by way of preaching and teaching or some other form of Christian effort. As sure as you began to plan it, something or other arose, and Satan hindered you. If he possibly can, he will come upon God's people in those times when they are full of thought and ardor and ready for Christian effort, that he may murder their infant plans and cast these suggestions of the Holy Spirit out of their minds.

How often, too, has Satan hindered us when we have entered into the work! In fact, beloved, we never ought to expect a success unless we hear the Devil making a noise. I have taken it as a certain sign that I am doing little good when the Devil is quiet. It is generally a sign that Christ's kingdom is coming when men begin to lie against you and slander you and the world is in an uproar, casting out your name as evil.

Oh, those blessed storms! Do not give me calm weather when the air is still and heavy and when lethargy is creeping over one's spirit. Lord, send a hurricane. Give us a little stormy weather. When the lightning flashes and the thunder rolls, then God's servants know that the Lord is abroad, that His right hand is no longer kept inactive, that the moral atmosphere will get clear, that God's kingdom will come and His will be done on earth, even as it is in heaven.

"Peace, peace, peace" is the flap of the Dragon's wings. The stern voice that proclaims perpetual war is the voice of the Captain of our salvation. You ask, "How is this?"

> *Think not that I am come to send peace on earth: I came not to send peace, but a sword. For I am come to set a man at variance against his father, and the daughter against her mother, and the daughter in law against her mother in law. And a man's foes shall be they of his own household.* (Matt. 10:34–36)

Christ does make physical peace. There is to be no strife with the fist, no blow with the sword. But moral and spiritual peace can never exist in this world where Jesus Christ is, as long as error is there.

You know, beloved, that you cannot do any good thing without the Devil being sure to hinder you. What then? Up and at him! Cowardly looks and faint counsels are not for warriors of the Cross. Expect fighting and you will not be disappointed. Whitefield used to say

that some ministers would go from the first of January to the end of December with a perfectly whole skin. The Devil never thought them worth attacking. But let us begin to preach the Gospel of Jesus Christ with all our might and soul and strength, and men will soon begin laughing at us and ridiculing us. If they do, so much the better. We are not alarmed because Satan hinders us.

Nor will he only hinder us in working. He will hinder us in seeking to unite with one another. We are about to make an effort, as Christian churches in London, to come closer together, and I am happy to find indications of success. But I should not be amazed if Satan hinders us, and I ask your prayers that Satan may be routed in this matter and that the union of our churches may be accomplished. In my church, we have walked together in peace for a long time, but I should not marvel if Satan tries to hinder our walking in love, peace, and unity.

Satan will hinder us in our communion with Jesus Christ. When at His table, we think to ourselves, "I will have a sweet moment now," just then vanity intrudes. Like Abraham, you offer the sacrifice, but the unclean birds come down upon it, and you need to drive them away. *"Satan hindered us."* He is not omnipresent, but by his numerous servants, he works in all kinds of places and manages to distract the saints when they would serve the Lord.

RULES FOR DISCERNMENT

In the third place, there are two or three rules by which these hindrances may be detected as satanic.

I think I hear somebody saying to himself, "Yes, I would have risen in the world and would be a wealthy man now if Satan had not hindered me." Do not believe it, dear friend. I do not believe that Satan generally hinders people from getting rich. He would just as soon have them be rich as poor. He delights to see God's servants set upon the pinnacle of the temple, for he knows the position to be dangerous. High places and God's praise seldom well agree. If you have been hindered in growing rich, I should rather set that down to the good providence of God that would not place you where you could not have borne the temptation.

"Yes," said another, "I intended to live in a certain neighborhood and do well but have not been able to go. Perhaps that is the Devil." Perhaps it is. Perhaps it is not. God's providence knows best where

to place us. We are not always choosers of our own locality. We are not always to conclude when we are hindered and disappointed in our own intentions that Satan has done it, for it may very often be the good providence of God.

But how may I tell when Satan hinders me? I think you may tell, first, by the purpose. Satan's object in hindering us is to prevent our glorifying God. If anything has happened to you that has prevented your growing holy, useful, humble, and sanctified, then you may trace that to Satan. If the distinct object of the interference to the general current of your life has been that you may be turned from righteousness to sin, then from the objective you may guess the author. It is not God who does this, but Satan. Yet know that God does sometimes put apparent hindrances in the way of His own people, even in regard to their usefulness and growth in grace. But His objective is still to be considered: it is to try His saints and so to strengthen them. The purpose of Satan is to turn them from the right road and make them take the crooked way.

You may tell the suggestions of Satan, again, by the method in which they come: God employs good motives, Satan bad ones. If what has turned your attention away from your the Lord has been a bad thought, a bad doctrine, a bad teaching, a bad motive—that never came from God; that must be from Satan.

Again, you may tell the suggestions from their nature. Whenever an impediment to usefulness is pleasing or gratifying to you, consider that it came from Satan. Satan never brushes the feathers of his birds the wrong way. He generally deals with us according to our tastes and likings. He flavors his bait to his fish. He knows exactly how to deal with each man and how to use the motive that will fall in line with the suggestions of the carnal nature. Now, if the difficulty in your way is rather contrary to yourself than for yourself, then it comes from God. If that which now is a hindrance brings you gain, pleasure, or advantage in any way, rest assured it came from Satan.

We can tell the suggestions of Satan, once more, by their season. Hindrances to prayer, for instance, if they are satanic, come out of the natural course and relation of human thoughts. It is a law of the mind that one thought suggests another, which suggests the next, and so on, as the links of a chain are one after the other. But satanic temptations do not come in the regular order of thinking: they dash upon the mind unexpectedly. My soul is in prayer, so it would be unnatural that I should then blaspheme, yet then the blasphemy

comes. Therefore it is clearly satanic and not from my own mind. If I am set upon doing my Master's will but a cowardly thought assails me, that idea, which differs from the natural bent of my mind and thoughts, may be at once ejected as not being mine and may be set down to the account of the Devil, who is the true father of it.

By these means I think we may tell when Satan hinders, and when the hindrance is our own heart, or when it is of God. We ought to carefully watch that we do not put the saddle on the wrong horse. Do not blame the Devil when it is yourself. On the other hand, when the Lord puts a bar in your way, do not attribute this to Satan and so go against the providence of God. It may be difficult at times to see the way of duty, but if you go to the throne of God in prayer, you will soon discover it. *"Bring hither the ephod"* (1 Sam. 23:9), said David when he was in difficulty. Do you say the same? Go to the Great High Priest, whose business it is to give forth the oracle! Upon His chest hangs the Urim and Thummim, and you will find direction from Him in every time of difficulty and dilemma.

ACTING AGAINST HINDRANCES

Supposing that we have ascertained that hindrances in our way really have come from Satan, what do we do then? I have but one piece of advice, and that is to go on, hindrance or no hindrance, in the path of duty as God the Holy Spirit enables you.

If Satan hinders you, I have already hinted that this opposition should cheer you. "I did not expect," said a Christian minister, "the work to be easy in this particular pastorate, or else I would not have come here. I always count it my duty to show the Devil that I am his enemy, and if I do that, I expect that he will show me that he is mine." If you are now opposed and you can trace that opposition distinctly to Satan, congratulate yourself upon it. Do not sit down and fret. Why, it is a great thing that a poor creature like you can actually vex the great Prince of Darkness and win his hate. It makes the race of man the more noble when it comes in conflict with a race of spirits and stands toe to toe even with the Prince of Darkness himself.

It is a dreadful thing, doubtless, that you should be hindered by such an adversary, but it is most hopeful, for if he were your friend, you might have cause to fear indeed. Stand up against him, because you now have an opportunity of making a greater gain than you could have had if he had been quiet. You could never have had a

victory over him if you had not engaged in conflict with him. The poor saint would go on his inglorious way to heaven if he were untempted, but being tormented, every step of his pathway becomes glorious. Our position today is like that described by Bunyan in *The Pilgrim's Progress*, when from the top of the palace the song was heard:

> Come in, come in,
> Eternal glory thou shalt win.

Now merely to ascend the stairs of the palace, though safe work, would not have been very ennobling. However, when the foes crowded around the door and blocked every stair, the hero came to the man with the inkstand, who sat in front of the door, and said, "Write my name down, sir." Then to get from the lowest step to the top where the bright ones were singing made every inch glorious. If devils did not oppose my path from earth to heaven, I might travel joyously, peacefully, safely, but certainly without renown. But now, when every step is contested in winning our pathway to glory, every single step is covered with immortal fame. Press on then, Christian. The more opposition, the more honor.

Be in earnest against these hindrances when you consider again what you lose if you do not resist him and overcome him. To allow Satan to overcome me would be eternal ruin to my soul. Certainly it would forever blast all hopes of my usefulness. If I retreat and turn my back in the day of battle, what will the rest of God's servants say? What shouts of derision would ring over the battlefield! How the banner of the covenant would be trailed in the mire! Why, we must not, we dare not, play the coward. We dare not give way to the insinuation of Satan and turn from the Master, for the defeat would then be too dreadful to be endured.

Beloved, let me feed your courage with the recollection that your Lord and Master has overcome. See Him there before you. He of the crown of thorns has fought the Enemy and broken his head. Satan has been completely vanquished by the Captain of your salvation. That victory was representative—He fought and won it for you.

You have to contend with a defeated Foe, one who knows and feels his disgrace. Though he may fight with desperation, yet he does not fight with true courage, for he is hopeless of ultimate victory. Strike, then, for Christ has smitten him. Down with him, for Jesus

has had him under His foot. You, weakest of all the host, triumph, for the Captain has triumphed before you.

Lastly, remember that you have a promise to help you prepare for battle and be courageous this day. *"Resist the devil, and he will flee from you"* (James 4:7). Christian minister, do not resign. Do not think of sending in your resignation because the church is divided and the Enemy is making headway. Resist the Devil. Flee not, but make him flee. Christian young men, you who have begun to preach in the street, distribute tracts, or visit from house to house, though Satan hinders you very much, I urge you to redouble your efforts. It is because Satan is afraid of you that he resists you, because he would rob you of the great blessing that is now descending on your head. Resist him, and stand fast. You Christian pleading in prayer, do not let go of your hold upon the covenant angel now. For now that Satan hinders you, it is because the blessing is descending. You are seeking Christ, so do not close those eyes or turn away your face from Calvary's streaming tree. Now that Satan hinders you, it is because the night is almost over and the day star begins to shine. Beloved, you who are most tormented, most sorrowfully tried, most weighed down, yours is the brighter hope. Be now courageous. Play the warrior for God, for Christ, for your own soul. The day will come when you with your Master will ride triumphant through the streets of the New Jerusalem with sin, death, and hell captive at your chariot wheels, and you with your Lord crowned as victor, having overcome through the blood of the Lamb.

May God bless you, dear friends. I do not know to whom this chapter may be most suitable, but I believe it is sent especially to certain tried saints. May the Lord enable them to find comfort in it. Amen.

4

Christ, the Conqueror
of Satan

*And I will put enmity between thee and the woman,
and between thy seed and her seed; it shall bruise thy head,
and thou shalt bruise his heel.*
—Genesis 3:15

This is the first gospel sermon that was ever delivered upon the surface of this earth. It was a memorable discourse indeed, with Jehovah Himself for the preacher, and the whole human race and the Prince of Darkness for the audience. It must be worthy of our heartiest attention.

Is it not remarkable that this great gospel promise should have been delivered so soon after the transgression? As yet no sentence had been pronounced upon either of the two human offenders, but the promise was given under the form of a sentence pronounced upon the Serpent. Not yet had the woman been condemned to painful travail, or the man to exhausting labor, or even the soil to the curse of thorn and thistle. Truly *"mercy rejoiceth against judgment"* (James 2:13). Before the Lord had said, *"Dust thou art, and unto dust shalt thou return"* (Gen. 3:19), He was pleased to say that the Seed of the woman would bruise the Serpent's head. Let us rejoice, then, in the swift mercy of God, which in the early watches of the night of sin, came with comforting words to us.

These words were not directly spoken to Adam and Eve, but they were directed distinctly to the Serpent himself, and that by way of punishment to him for what he had done. It was a day of cruel triumph to him. Such joy as his dark mind is capable of had filled him,

for he had indulged his malice and gratified his spite. He had in the worst sense destroyed a part of God's works. He had introduced sin into the new world, had stamped the human race with his own image, and had gained new forces to promote rebellion and to multiply transgression. Therefore, he felt the sort of gladness that a fiend can know who bears a hell within him.

But now God comes in, takes up the quarrel personally, and causes him to be disgraced on the very battlefield upon which he had gained a temporary success. He tells the Dragon that He will undertake to deal with him; this quarrel would not be between the Serpent and man, but between God and the Serpent. God says, in solemn words, *"I will put enmity between thee and the woman, and between thy seed and her seed."* He promises that there will rise in fullness of time a champion who, though He may suffer, will smite the power of evil in a vital part by bruising the Serpent's head. It seems to me that this was the more comforting message of mercy to Adam and Eve, because they could feel sure that the Tempter would be punished, and since that punishment would involve blessing for them, the vengeance due to the Serpent would be the guarantee of mercy to themselves.

Perhaps, however, by thus indirectly giving the promise, the Lord meant to say, "Not for your sakes do I this, fallen man and woman, nor for the sake of your descendants. Rather, for My own name and honor's sake, that it be not profaned and blasphemed among the fallen spirits. I undertake to repair the mischief that has been caused by the Tempter, that My name and My glory may not be diminished among the immortal spirits who look down upon the scene." All this was very humbling but yet consolatory to our parents if they thought of it, seeing that mercy given for God's sake is always to our troubled apprehension more sure than any favor that could be promised to us for our own sakes. The divine sovereignty and glory afford us a stronger foundation of hope than merit, even if merit could be supposed to exist.

Now we must note concerning this first gospel sermon that on it the earliest believers steadied themselves. This was all that Adam had by way of revelation, and all that Abel had received. This one lone star shone in Abel's sky; he looked up to it and believed. By its light he spelled out "sacrifice," and thus he brought of the firstlings of his flock and laid them upon the altar. He proved in his own person how the seed of the Serpent hated the seed of the woman, for his brother killed him for his testimony. Although Enoch, the seventh

from Adam, prophesied concerning the Second Advent, yet he does not appear to have uttered anything new concerning the first coming, so that still this one promise remained as man's sole word of hope. The torch that flamed within the gates of Eden just before man was driven forth lit up the world to all believers until the Lord was pleased to give more light, and to renew and enlarge the revelation of His covenant, when He spoke to His servant Noah.

Those silvery-haired fathers who lived before the Flood rejoiced in the mysterious language of our text. Resting on it, they died in faith. Nor, beloved, must you think it a slender revelation, for it is wonderfully full of meaning if you attentively consider it. If it had been on my heart to handle it doctrinally this morning, I think I could have shown you that it contains the whole Gospel. There lie within it, as an oak lies within an acorn, all the great truths that make up the Gospel of Christ.

Observe that here is the grand mystery of the incarnation. Christ is that Seed of the woman who is spoken of here. There is a broad hint as to how that incarnation would be brought about. Jesus was not born after the ordinary manner of the sons of men. Mary was overshadowed by the Holy Spirit, and the Holy One that was born of her was, concerning His humanity, the seed of the woman only. As it is written, *"Behold, a virgin shall conceive, and bear a son, and shall call his name Immanuel"* (Isa. 7:14). The promise plainly teaches that the Deliverer would be born of a woman. Viewed carefully, it also foreshadows the divine method of the Redeemer's conception and birth.

So also is the doctrine of the two seeds plainly taught here: *"I will put enmity between thee and the woman, and between thy seed and her seed."* There was evidently to be in the world a seed of the woman on God's side against the Serpent, and a seed of the Serpent that would always be on the evil side, even as it is to this day. The church of God and the temple of Satan both exist. We see an Abel and a Cain, an Isaac and an Ishmael, a Jacob and an Esau. Those who are born after the flesh are the children of their father the Devil, for his works they do. But those who are born again, being born of the Spirit after the power of the life of Christ, are thus in Christ Jesus the seed of the woman, and contend earnestly against the Dragon and his seed.

Here, too, the great fact of the sufferings of Christ is foretold clearly: *"Thou shalt bruise his heel."* Within those words, we find the whole story of our Lord's sorrows from Bethlehem to Calvary.

"It shall bruise thy head." Here is the breaking of Satan's regal power; here is the clearing away of sin; here is the destruction of death by resurrection; here is the leading of captivity captive in the Ascension; here is the victory of truth in the world through the descent of the Spirit; here is the latter-day glory in which Satan will be bound; and lastly, here is the casting of the Evil One and all his followers into the lake of fire. The conflict and the conquest are both encompassed by these few fruitful words.

The words may not have been fully understood by those who first heard them, but to us they are now full of light. The text at first looks like a flint, hard and cold; but sparks fly from it plentifully, for hidden fires of infinite love and grace lie concealed within. Over this promise of a gracious God, we ought to rejoice exceedingly.

We do not know what our first parents understood by it, but we may be certain that they gathered a great amount of comfort from it. They must have understood that they were not then and there to be destroyed, because the Lord had spoken of a *"seed."* They could reason that it must be that Eve would live if there would be a seed from her. They understood, too, that if that Seed was to overcome the Serpent and bruise his head, it must herald good to themselves: they could not fail to see that there was some great, mysterious benefit to be conferred upon them by the victory that their Seed would achieve over the instigator of their ruin. They continued on in faith upon this, and were comforted in travail and in toil. I do not doubt that both Adam and his wife, in this faith, entered into everlasting rest.

I intend to handle this text in three ways. First, we will notice its facts. Second, we will consider the experience within the heart of each believer that attests to those facts. Third, we will find the encouragement that the text and its connection as a whole afford to us.

THE FACTS

The facts are four, and I call your earnest attention to them. The first is that enmity was stirred up. The text begins, *"I will put enmity between thee and the woman."* The woman and the Serpent had been very friendly. They had conversed together. She thought at the time that the Serpent was her friend. She was so much his friend that she took his advice in the face of God's precept and was willing to believe bad things of the great Creator because this wicked, crafty Serpent insinuated the same. Now, at the moment that God spoke, that

friendship between the woman and the Serpent had already in a measure come to an end, for she had accused the Serpent to God by saying, *"The serpent beguiled me, and I did eat"* (Gen. 3:13). So far, so good. The friendship of sinners does not last long. Eve and the Serpent had already begun to quarrel, and then the Lord came in and graciously took advantage of the quarrel that had commenced, and said, "I will carry this disagreement a great deal further. I will put enmity between the Serpent and the woman."

Satan counted on man's descendants being his allies, but God would break up this covenant with hell and raise up a Seed that would war against the satanic power. Thus we have here God's first declaration that He would set up a rival kingdom to oppose the tyranny of sin and Satan, that He would create in the hearts of a chosen seed an enmity against evil so that they would fight against it, and with many a struggle and pain would overcome the Prince of Darkness. The divine Spirit has abundantly achieved this plan and purpose of the Lord, combating the Fallen Angel by a glorious man, making man to be Satan's foe and conqueror.

From this point onward, the woman was to hate the Evil One, and I do not doubt that she did so. She had abundant cause for doing so. As often as she thought of him, it would be with infinite regret that she could have listened to his malicious and deceitful talk. The woman's seed has also evermore had enmity against the Evil One. I do not mean the carnal seed, for Paul tells us, *"They which are the children of the flesh, these are not the children of God: but the children of the promise are counted for the seed"* (Rom. 9:8). I do not mean the carnal seed of the man and the woman, but rather the spiritual seed, even Christ Jesus and those who are in Him. Wherever you meet these, they hate the Serpent with a perfect hatred. We would if we could destroy from our souls every work of Satan, and out of this poor afflicted world of ours we would root up every evil that he has planted.

That glorious Seed of the woman—for God did not speak of many seeds, but of one Seed—you know how He abhorred the Devil and all his devices. There was enmity between Christ and Satan, for He came to destroy the works of the Devil and to deliver those who are under bondage to him. For that purpose was He born in the flesh; for that purpose did He live; for that purpose did He die; for that purpose He has gone into glory; and for that purpose He will come again, that everywhere He may root out His Adversary and utterly destroy him and his works from among the sons of men.

Putting enmity between the two seeds was the commencement of the plan of mercy, the first act in the program of grace. Of the woman's seed it was henceforth said, *"Thou lovest righteousness, and hatest wickedness: therefore God, thy God, hath anointed thee with the oil of gladness above thy fellows"* (Ps. 45:7).

The second prophecy, which has also turned into a fact, concerns the coming of the Champion. The Seed of the woman by promise is to champion the cause and oppose the Dragon. That Seed is the Lord Jesus Christ. The prophet Micah said,

> *But thou, Bethlehem Ephratah, though thou be little among the thousands of Judah, yet out of thee shall he come forth unto me that is to be ruler in Israel; whose goings forth have been from of old, from everlasting. Therefore will he give them up, until the time that she which travaileth hath brought forth.*
>
> *(Mic. 5:2–3)*

To none other than the Babe who was born in Bethlehem of the blessed virgin can these words of prophecy refer. She it was who conceived and bore a Son. Concerning her Son we sing, *"For unto us a child is born, unto us a son is given: and the government shall be upon his shoulder: and his name shall be called Wonderful, Counsellor, The mighty God, The everlasting Father, The Prince of Peace"* (Isa. 9:6). One memorable night at Bethlehem, when angels sang in heaven, the Seed of the woman appeared. As soon as he saw the light, the old Serpent, the Devil, planted into the heart of Herod the desire to slay Jesus, but the Father preserved Him and allowed none to lay hands on Him.

As soon as Jesus publicly came forward upon the stage of action, thirty years later, Satan met Him toe to toe. You know the story of the temptation in the wilderness, and how there the woman's Seed fought with him who had been a liar from the beginning. The Devil assailed Him three times with all the artillery of flattery, malice, craft, and falsehood, but the peerless Champion stood unwounded and chased His foe from the field. Then our Lord set up His kingdom, called one and another unto Himself, and carried the war into the Enemy's country. In many places He cast out devils. He spoke to the wicked, unclean spirit, *"Thou dumb and deaf spirit, I charge thee, come out of him"* (Mark 9:25), and the demon was expelled. Legions of devils flew before Him; they sought to hide themselves in swine to escape from the terror of His presence. *"Art thou come*

hither to torment us before the time?" (Matt. 8:29) was their cry when the wonder-working Christ dislodged them from the bodies that they tormented. Yes, He made His own disciples mighty against the Evil One, for in His name they cast out devils, until Jesus said, *"I beheld Satan as lightning fall from heaven"* (Luke 10:18).

Then there came a second personal conflict, for I take it that Gethsemane's sorrows were to a great degree caused by a personal assault of Satan, for our Master said, *"This is your hour, and the power of darkness"* (Luke 22:53). He said also, *"The prince of this world cometh, and hath nothing in me"* (John 14:30). What a struggle it was.

Though Satan had nothing in Christ, yet he sought if possible to lead Him away from completing His great sacrifice. There our Master's *"sweat was as it were great drops of blood falling down to the ground"* (Luke 22:44) in the agony that it cost Him to contend with the Fiend. Then it was that our Champion began the last fight of all and won it to the bruising of the Serpent's head. Nor did He end until He had spoiled principalities and powers and made a show of them openly.

> Now is the hour of darkness past,
> Christ has assumed His reigning power;
> Behold the great accuser cast
> Down from his seat to reign no more.

The conflict of our glorious Lord continues in His seed. We preach Christ crucified, and every sermon shakes the gates of hell. We bring sinners to Jesus by the Spirit's power, and every convert is a stone torn down from the wall of Satan's mighty castle. Yes, the day will come when everywhere the Evil One will be overcome, and the words of John in Revelation will be fulfilled:

> *And the great dragon was cast out, that old serpent, called the Devil, and Satan, which deceiveth the whole world....And I heard a loud voice saying in heaven, Now is come salvation, and strength, and the kingdom of our God, and the power of his Christ: for the accuser of our brethren is cast down, which accused them before our God day and night.* (Rev. 12:9–10)

Thus did the Lord God in the words of our text promise a Champion who would be the Seed of the woman, between whom and

Satan there would be war forever and ever. That Champion has come; the Man-child has been born. Though the Dragon is raging with the woman and makes war with the remnant of her seed that keep the testimony of Jesus Christ, yet the battle is the Lord's, and the victory falls to Him whose name is *"Faithful and True, and in righteousness he doth judge and make war"* (Rev. 19:11).

The third fact that comes out in the text, though not quite in that order, is that our Champion's heel would be bruised. Do you need me to explain this? You know how all through Christ's life His heel—that is, His lower part, His human nature—was perpetually being made to suffer. He carried our sicknesses and sorrows. But the bruising came mainly when, both in body and in mind, His whole human nature was made to agonize, when His soul was exceedingly sorrowful even unto death, when His enemies pierced His hands and His feet, and when He endured the shame and pain of death by crucifixion.

Look at your Master and your King on the cross, all stained with blood and dust! There was His heel most cruelly bruised. When they took down that precious body, wrapped it in fair white linen and in spices, and laid it in Joseph's tomb, they wept as they handled that casket in which the Deity had dwelt, for there again Satan had bruised His heel. It was not merely that God had bruised Him, *"yet it pleased the LORD to bruise him"* (Isa. 53:10). But the Devil had let loose Herod, Pilate, Caiaphas, the Jews, and the Romans—all of them his tools—upon Him whom he knew to be the Christ, so that He was bruised by the old Serpent.

That is all, however! It was only His heel, not His head, that was bruised! The Champion rose again. The bruise was not mortal nor continual. Though He died, still so brief is the interval in which He slumbered in the tomb that His holy body had not seen corruption, and He came forth perfect and lovely in His manhood, rising from His grave as from a refreshing sleep after so long a day of unresting toil! Oh, the triumph of that hour! As Jacob only limped with his injured hip when he overcame the angel, so Jesus just retained a scar in His heel, and that He bears to the skies as His glory and beauty. Before the throne He looks like a lamb that has been slain, but in the power of an endless life He lives unto God.

Then comes the fourth fact, namely, that while His heel was being bruised, He was to bruise the Serpent's head. The figure represents the Dragon as inflicting an injury upon the Champion's heel, but at the same moment the Champion Himself with that heel

crushes the head of the Serpent with fatal effect. By His sufferings Christ has overthrown Satan, by the heel that was bruised He has trodden upon the head that devised the bruising.

> Lo, by the sons of hell He dies;
> But as He hangs 'twixt earth and skies,
> He gives their prince a fatal blow,
> And triumphs o'er the powers below.

Though Satan is not dead, my beloved—I was about to say, I would to God that he were. Though he is not converted, and never will be, nor will the malice of his heart ever be driven from him, yet Christ has so far broken his head that he has missed his mark altogether. He intended to make the human race the captives of his power, but they are redeemed from his iron yoke. God has delivered many of them, and the day will come when He will cleanse the whole earth from the Serpent's slimy trail, so that the entire world will be full of the praises of God.

Satan thought that this world would be the arena of his victory over God and good. Instead, it is already the grandest theater of divine wisdom, love, grace, and power. Heaven itself is not so resplendent with mercy as the earth is, for it is here that the Savior poured out His blood.

No doubt, he thought that when he had led our race astray and brought death upon us, he had effectually marred the Lord's work. He rejoiced that we would all pass under the cold seal of death, and that our bodies would rot in the sepulcher. Had he not spoiled the handiwork of his great Lord? God may make man as a curious creature with intertwined veins and nerves, tendons and muscles, and He may put into his nostrils the breath of life; but, "Ah," says Satan, "I have infused a poison into him that will make him return to the dust from which he was taken."

But now, behold, our Champion whose heel was bruised has risen from the dead and given us a pledge that all His followers will rise from the dead also. Thus Satan was foiled, for death will not retain a bone, nor a piece of a bone, of one of those who belonged to the woman's seed. At the trump of the archangel, from the earth and from the sea, we will arise, and this will be our shout: *"O death, where is thy sting? O grave, where is thy victory?"* (1 Cor. 15:55). Satan, knowing this, feels already that by the resurrection his head is broken. Glory be to the Christ of God for this!

In multitudes of other ways, the Devil has been vanquished by our Lord Jesus, and so will he ever be until he is cast into the lake of fire.

COMPARING OUR EXPERIENCES

Let us now view our experiences as they correspond to these facts. Now, brothers and sisters, we were by nature, those of us who have been saved, the heirs of wrath even as others. Regardless of how godly our parents were, the first birth brought us no spiritual life, for the promise is to them *"which were born, not of blood, nor of the will of the flesh, nor of the will of man, but* [only to those who are born] *of God"* (John 1:13). *"That which is born of the flesh is flesh"* (John 3:6); you cannot make it anything else. The flesh, or carnal mind, abides in death; it is not reconciled to God, nor indeed can it be. He who is born into this world but once, and knows nothing of the new birth, must place himself among the seed of the Serpent, for only by regeneration can we know ourselves to be the true seed.

How does God deal with us who are His called and chosen ones? He means to save us, and how does He work to that end? The first thing He does is that He comes to us in mercy and puts enmity between us and the Serpent. That is the very first work of grace. There was peace between us and Satan once. When he tempted, we yielded. Whatever he taught us, we believed. We were his willing slaves.

But perhaps you, my beloved, can recall when you first began to feel uneasy and dissatisfied. The world's pleasures no longer pleased you. All the juice seemed to have been taken out of the apple, and you had nothing left but the hard core, which you could not eat at all. Then you suddenly perceived that you were living in sin, and you were miserable about it. Though you could not get rid of sin, you hated it, sighed over it, and cried and groaned. In your heart of hearts, you remained no longer on the side of evil, for you began to cry, *"O wretched man that I am! who shall deliver me from the body of this death?"* (Rom. 7:24).

In the covenant of grace of old, you were already ordained to be the woman's seed, and now the decree began to discover itself in life bestowed upon you and working in you. The Lord in infinite mercy dropped the divine life into your soul. You did not know it, but there it was, a spark of the celestial fire, the living and incorruptible seed that abides forever. You began to hate sin, and you groaned under it

as under an irritating yoke. More and more it burdened you; you could not bear it, and you hated the very thought of it.

So it was with you. Is it so now? Is there still enmity between you and the Serpent? Indeed, you are more and more the sworn enemies of evil, and you willingly acknowledge it.

Then came the Champion; that is to say, *"Christ in you, the hope of glory"* (Col. 1:27) was formed. You heard of Him and understood the truth about Him. It seemed a wonderful thing that He would be your substitute and stand in your place, that He would bear your sin and all its curse and punishment, and that He should give His righteousness and His very self to you so that you might be saved. Ah, then you saw how sin could be overthrown, did you not? As soon as your heart understood Christ, then you saw that *"what the law could not do, in that it was weak through the flesh"* (Rom. 8:3), Christ was able to accomplish. You understood that the power of sin and Satan under which you had been in bondage, and which you now loathed, could and would be broken and destroyed because Christ had come into the world to overcome it.

Next, do you recollect how you were led to see the bruising of Christ's heel and to stand in wonder and observe what the enmity of the Serpent had worked in Him? Did you not begin to feel the bruised heel yourself? Did not sin torment you? Did not the very thought of it vex you? Did not your own heart become a plague to you? Did not Satan begin to tempt you? Did he not inject blasphemous thoughts into your mind and urge you on to desperate measures? Did he not teach you to doubt the existence of God, the mercy of God, and the possibility of your salvation, and so on? This was his nibbling at your heel. He is up to his old tricks still. As the poem says,

> He worries whom he can't devour,
> With a malicious joy.

Did not your worldly friends begin to annoy you? Did they not give you the cold shoulder because they saw something about you so strange and foreign to their tastes? Did they not impute your conduct to fanaticism, pride, obstinacy, bigotry, and the like? Ah, this persecution is the Serpent's seed beginning to discover the woman's seed and to carry on the old war. What did Paul say? *"But as then he that was born after the flesh persecuted him that was born after the Spirit, even so it is now"* (Gal. 4:29). True godliness is an unnatural

and strange thing to them, and they cannot do away with it. Though there are no stakes for them to burn us on, nor racks for them to stretch us on, yet the enmity of the human heart toward Christ and His seed is just the same, and it very often shows itself in a *"trial of cruel mockings"* (Heb. 11:36), which to a tender heart is very hard to bear. Well, this is your heel being bruised in sympathy with the bruising of the heel of the glorious Seed of the woman.

But, beloved, do you know something of the other fact, that we conquer because the Serpent's head is broken in us? Is not the power and dominion of sin broken in you? Do you not feel that you cannot sin because you are born of God? Some sins that were masters of you once do not trouble you now. I know a man guilty of profane swearing, and from the moment of his conversion, he has never had any difficulty in the matter. I know a man snatched from drunkenness, and the cure by divine grace has been very wonderful and complete. I know people delivered from unclean living, and they at once became chaste and pure, because Christ has dealt the old Dragon such blows that he could not have power over them in that respect. The chosen seed do sin and mourn it, but they are not slaves to sin; their hearts do not go after it. They have to say sometimes, *"The evil which I would not, that I do"* (Rom. 7:19), but they are wretched if they do. With their hearts they consent to the law of God, that it is good. They sigh and cry that they may be helped to obey it, for they are no longer under the slavery of sin. The Serpent's reigning power and dominion is broken in them.

It is broken next in this way, that the guilt of sin is gone. The great power of the Serpent lies in unpardoned sin. He cries, "I have made you guilty. I brought you under the curse."

"No," we say, "we are delivered from the curse and are now blessed, for it is written, *'Blessed is he whose transgression is forgiven, whose sin is covered'* (Ps. 32:1). We are no longer guilty, for who will lay anything to the charge of God's elect? Since Christ has justified, who is he that condemns?" (See Romans 8:33–34.) Here is a swinging blow for the old Dragon's head, from which he will never recover.

Oftentimes the Lord also grants us to know what it is to overcome temptation, and so to break the head of the Fiend. Satan allures us with many baits. He has studied our points well; he knows the weakness of the flesh. But many times, blessed be God, we have completely foiled him to his eternal shame! The Devil must have felt himself small that day when he tried to overthrow Job, when he

dragged him down to a dunghill, robbed him of everything, covered him with sores, and yet could not make him yield. Job conquered when he cried, *"Through he slay me, yet will I trust in him"* (Job 13:15). A feeble man had vanquished a Devil who could raise the wind, blow down a house, and destroy the family who were feasting in it. Though he is the Devil and is crowned prince of the power of the air, yet the poor bereaved patriarch was one of the woman's seed and won the victory over him through the strength of the inner life.

> Ye sons of God oppose his rage,
> Resist, and he'll be gone:
> Thus did our dearest Lord engage
> And vanquish him alone.

Moreover, dear beloved, we have this hope that the very being of sin in us will be destroyed. The day will come when we will be without spot or wrinkle or any such thing; and we will stand before the throne of God, having suffered no injury whatsoever from the Fall and from all the schemes of Satan, for *"they are without fault before the throne of God"* (Rev. 14:5). What triumph that will be! *"The God of peace shall bruise Satan under your feet shortly"* (Rom. 16:20). When He has made you perfect and free from all sin, as He will do, you will have bruised the Serpent's head indeed. Also, when Satan sees you come up from the grave like one who has been perfumed in a bath of spices, and when he sees you arise in the image of Christ— with the same body that was sown in corruption and weakness, now raised in incorruption and power (1 Cor. 15:42–43)—then will he feel an infinite chagrin and know that his head is bruised by the woman's seed.

I ought to add that every time any one of us is made useful in saving souls, we repeat the bruising of the Serpent's head. When you go, dear sister, among those poor children and pick them up from the gutters, where they are Satan's prey, where he finds the raw material for thieves and criminals, and when through your means, by the grace of God, the little wanderers become children of the living God, then you in your measure bruise the old Serpent's head. I urge you, do not spare him. When we, by preaching the Gospel, turn sinners from the error of their ways so that they escape from the power of darkness, again we bruise the Serpent's head. Whenever in any way you are blessed to the aiding of the cause of truth and righteousness in the world, you, too, who were once beneath his power, and even now sometimes have to suffer from his nibbling at your heel, you

tread upon his head. In all deliverances and victories, you overcome and prove the promise true:

> *Thou shalt tread upon the lion and adder: the young lion and the dragon shalt thou trample under feet. Because he hath set his love upon me, therefore will I deliver him: I will set him on high, because he hath known my name.* (Ps. 91:13–14)

ENCOURAGEMENT

Let us think awhile about the encouragement that our text and the context yield to us, for it seems to me to abound. I want you, beloved, to exercise faith in the promise and be comforted.

The text evidently encouraged Adam very much. I do not think we have attached enough importance to the conduct of Adam after the Lord had spoken to him. Notice the simple but conclusive proof that he gave of his faith. Sometimes an action may be very small and unimportant, and yet as a straw shows which way the wind blows, that small act may display at once, if it is thought over, the whole state of the man's mind.

Adam acted in faith upon what God said, for we read, *"And Adam called his wife's name Eve* [or Life]; *because she was the mother of all living"* (Gen. 3:20). She was not yet a mother at all, but since the life was to come through her by virtue of the promised Seed, Adam showed his full conviction of the truth of the promise.

There stood Adam, fresh from the awesome presence of God. What more could he say? He might have said with the prophet, *"My flesh trembleth for fear of thee"* (Ps. 119:120), but even then he turned around to his fellow culprit as she stood there trembling too, and called her Eve, mother of the life that was yet to be. It was grandly spoken by father Adam; it makes him rise in our esteem. Had he been left to himself, he would have murmured or at least despaired, but no, his faith in the new promise gave him hope. He uttered no deploring word against the condemnation to till with toil the unthankful ground, nor on Eve's part was there a word of lament over the appointed sorrows of motherhood. They each accepted the well-deserved sentence with the silence that denoted the perfection of their resignation. Their only words were full of simple faith. There was no child on whom to set their hopes, nor would the true Seed be born for many ages. Yet Eve was to be the mother of all living, and Adam called her so.

Exercise the same kind of faith, my friend, on the far wider revelation that God has given to you, and always extract the utmost comfort from it. Make it a point, whenever you receive a promise from God, to get all you can out of it. If you carry out that rule, it will be wonderful what comfort you will gain. Some go by the principle of getting as little as possible out of God's Word. I believe that such a plan is the proper way with a man's word; always understand it at the minimum, because that is what he means. But God's Word is to be understood at the maximum, for He will do exceedingly abundantly above what you ask or even think (Eph. 3:20).

Notice by way of further encouragement that we may regard our reception of Christ's righteousness as an installment of the final overthrow of the Devil. *"Unto Adam also and to his wife did the* LORD *God make coats of skins, and clothed them"* (Gen. 3:21). A very gracious, thoughtful, and instructive deed of divine love! God heard what Adam said to his wife and saw that he was a believer. So He came and gave him the type of the perfect righteousness that is the believer's portion. He covered him with lasting raiment. No more fig leaves, which were a mere mockery, but a close-fitting garment that had been procured through the death of a victim. The Lord brought that and put it on him, and Adam could no more say, "I am naked." How could he? God had clothed him.

Now, beloved, let us take this one item out of the promise that is given us concerning our Lord's conquest over the Devil, and let us rejoice in it. Christ has delivered us from the power of the Serpent, who opened our eyes and told us we were naked. By covering us from head to foot with righteousness that adorns and protects us, He makes us comfortable in heart and beautiful in the sight of God, and we are no longer ashamed.

Next, by way of encouragement in pursuing the Christian life, I would say to young people, expect to be assailed. If you have fallen into trouble through being a Christian, be encouraged by it. Do not at all regret or fear it, but rejoice in that day and leap for joy, for this is the constant token of the covenant. (See Luke 6:22–23.) There is enmity between the Seed of the woman and the seed of the Serpent still. If you did not experience any of it, you might begin to fear that you were on the wrong side. Now that you suffer under the sneer of sarcasm and oppression, rejoice and triumph, for now you are a partaker with the glorious Seed of the woman in the bruising of His heel.

Still further encouragement comes from this. Your suffering as a Christian is not brought upon you for your own sake; you are partners with the great Seed of the woman and are allies with Christ. You must not think the Devil cares much about you: the battle is against Christ in you. Why, if you were not in Christ, the Devil would never trouble you. When you were without Christ in the world, you might have sinned as you liked. Your relatives and co-workers would not have been at all grieved with you, and they would rather have joined you in your sin. But now the Serpent's seed hates Christ in you. This exalts the sufferings of persecution to a position far above all common afflictions.

I have heard of a woman who was condemned to death during the reign of Mary Tudor. Before her time came to be burned, a child was born to her, and she cried out in her pain. A wicked adversary who stood by said, "How will you bear to die for your religion if you make such ado?"

"Ah," she said, "now I suffer in my own person as a woman, but then I will not suffer, but Christ in me." Nor were these idle words, for she bore her martyrdom with exemplary patience and rose in her chariot of fire in holy triumph to heaven. If Christ is in you, nothing will dismay you, but you will overcome the world, the flesh, and the Devil by faith.

Last of all, let us always resist the Devil with this belief, that he has received a broken head. I am inclined to think that Luther's way of laughing at the Devil was a very good one, for he is worthy of shame and everlasting contempt. Luther once threw an inkstand at the Devil's head when he was tempting him very sorely. Though the act itself appears absurd enough, yet it was a true type of what that greater reformer was all his life long. The books he wrote were truly a flinging of the inkstand at the head of the Fiend.

That is what we have to do. We are to resist him by all means. Let us do this bravely and tell him to his face that we are not afraid of him. Tell him to recollect his bruised head, which he tries to cover with a crown of pride or with an infidel doctor's hood. We know him and see the deadly wound he bears. His power is gone; he is fighting a lost battle; he is contending against omnipotence. He has set himself against the oath of the Father, against the blood of the incarnate Son, and against the eternal power of the blessed Spirit—all of which are engaged in the defense of the seed of the woman in the day of battle. Therefore, beloved, be steadfast in resisting the Evil One, being strong in faith, giving glory to God.

'Tis by Thy blood, immortal Lamb,
Thine armies tread the tempter down;
'Tis by Thy word and powerful name
They gain the battle and renown.

Rejoice ye heavens; let every star
Shine with new glories round the sky:
Saints, while ye sing the heavenly war,
Raise your Deliverer's name on high.

5

Satan Departing,
Angels Ministering

*And when the devil had ended all the temptation,
he departed from him for a season.
—Luke 4:13*

*Then the devil leaveth him, and, behold, angels came
and ministered unto him.
—Matthew 4:11*

Beloved friends, we have very much to learn from our Lord's temptation. He was tempted in all points, as we are (Heb. 4:15). If you will study the temptation of Christ, you will not be ignorant of Satan's devices. If you see how He defeated the Enemy, you will learn what weapons to use against your great Adversary. If you see how our Lord conquers throughout the whole battle, you will learn that, as you keep close to Him, you will be *"more than conquerors through him that loved us"* (Rom. 8:37).

From our Lord's temptation we learn, especially, to pray, *"Lead us not into temptation"* (Matt. 6:13). Let us never mistake the meaning of that petition. We are to pray that we may not be tempted, for we are poor flesh and blood and are very frail. It is for us to cry to God, *"Lead us not into temptation."*

But we also learn a great deal from the close of our Lord's great threefold trial. We find Him afterward peaceful, ministered unto by angels, and rejoicing. That should teach us to pray, "But if we must be tempted, *'deliver us from evil'* (v. 13)", or, as some render it very correctly, "Deliver us from the Evil One."

First, we pray that we may not be tempted at all; and then, as a supplement to that prayer, yielding the whole matter to divine wisdom, we pray, "But if it is necessary for our personal growth in grace, for the verification of our graces, and for God's glory that we should be tempted, Lord, deliver us from evil, and especially deliver us from the personification of evil, the Evil One!"

With that as an introduction, for a short time let me call on you to notice in our text, first, the Devil leaving the tempted One: *"Then the devil leaveth him."* Second, we will keep to the book of Matthew and notice the angels ministering to the tempted One after the Fallen Angel had left Him. Then, third, we will mark the limitation of the rest that we may expect, the limitation of the time in which Satan will be gone. Luke put it this way: *"When the devil had ended all the temptation, he departed from him for a season."* Some express it, "until an opportune time," when he would again return, and our great Lord and Master would once more be tried by his wicked wiles.

THE DEVIL LEAVING

First, we have as the subject for our happy consideration, the Devil leaving the tempted One. When did the Devil depart from our Lord? When he had finished the temptation. It must have been a great relief to our divine Master when Satan left Him. The very air must have been purer and more fit to be breathed. His soul must have felt a great relief when the Evil Spirit had gone away.

However, we are told he did not go until he had finished all the temptation. So Luke put it: *"When the devil had ended all the temptation, he departed from him for a season."* Satan will not go until he has shot the last arrow from his quiver. Such is his malice that as long as he can tempt, he will tempt. His will desires our total destruction, but his power is not equal to his will. God does not give him power such as he would like to possess. There is always a limit set to his assaults. When Satan has tempted you thoroughly and ended all his temptation, then he will leave you. Since you have not yet undergone all forms of temptation, so you may not expect absolutely and altogether to be left by the Archenemy. You may suffer a long time from his attacks before he will stay his hand, for he will try all that he possibly can to lead you into evil and to destroy the grace that is in you.

Still, he does come to an end with his temptations sooner than he desires. Just as God has said to the mighty sea, *"Hitherto shalt*

thou come, but no further: and here shall thy proud waves be stayed" (Job 38:11), so says He to the Devil. When He permitted Satan to try the graces of Job and to prove his sincerity, He let him go just so far, but no further. When he asked for a further stretch of power, still there was a limit. There is always a limit to Satan's power. When he reaches that point, he will be pulled up short because he can do no more.

You are never so much in the hand of Satan that you are out of the hand of God. You are never so tempted, if you are a believer, that there is not a way of escape for you (1 Cor. 10:13). God permits you to be tried for many reasons that perhaps you could not altogether understand but that His infinite wisdom understands for you. But He will not allow *"the rod of the wicked"* to *"rest upon the lot of the righteous"* (Ps. 125:3). It may fall there, but it will not stay there. The Lord may let you be put into the fire, but the fire will be heated no hotter than you are able to bear. *"When the devil had ended all the temptation, he departed from him."*

Satan did not depart from Christ, however, until he had also failed in every temptation. When the Lord had foiled him at every point, had met every temptation with a text of Holy Scripture, and had proved His own determination to hold fast His integrity and not let it go, then the Enemy departed. Oh, brothers and sisters, if you can hold out, if you can stand against this and then against that, if you are strong against frowns and strong against flatteries, if you are strong against prosperity and strong against adversity, if you are strong against sly insinuations and strong against open attacks, then the Enemy will depart from you! You will have won the day by God's grace, even as your Master did.

"Well," someone is saying, "I wish that he would depart from me, for I have been sorely troubled by him." To this I say most heartily, "Amen."

Let us think, for a minute or two, about when Satan will depart from the child of God, as he did from the great Son of God. I have no doubt that he will do that when he finds that it is necessary for him to be somewhere else. Satan is not everywhere, and cannot be, for he is not divine. He is not omnipresent. But as someone has said, although he is not present everywhere, it would be hard to say where he is not, for he moves so swiftly and is such an agile spirit that he seems to be here and there and everywhere. Also, where he is not in person, he is represented by that vast host, the legions of fallen spirits, who are under his control. And even where they are not, he

carries out his evil devices by leaving the leaven to work and the evil seeds to grow, when he himself has gone elsewhere.

Quite probably, not many times in one's life is any man called into conflict with Satan himself personally. There are too many of us now for him to give all his time and strength to any one. He has to be somewhere else. Oh, I long to be the means of multiplying the number of God's people by the preaching of the Word, so that the Gospel of the grace of God may fly abroad and bring in myriads, so that the Devil may have more to do and therefore not be able to give so much of his furious attention, as he goes in one direction and then another, to individual children of God.

He also leaves God's people very quickly when he sees that they are sustained by superior grace. He hopes to catch them when grace is at a low ebb. If he can come upon them when faith is very weak, when hope's eyes are dim, when love has grown cold, then he thinks that he will make an easy capture. But where we are filled with the Spirit as the Master was (God grant that we may be), he looks us up and down, and he quickly veers off. Like an old pirate who stays on the lookout for merchant vessels, when he meets with ships that have plenty of guns on board and hardy hands to give him a warm reception, he goes after some other craft not quite so well able to resist his assaults.

Oh, brothers and sisters, do not be mere Christians or only barely Christians with just enough grace to let you see your imperfections. But pray to God to give you mighty grace, so that you may *"be strong in the Lord, and in the power of his might"* (Eph. 6:10). Then, after the Devil has tested you and found that the Lord is with you and that God dwells in you, you may expect that, as it was with your Master, so it will be with you: Satan will leave you.

Sometimes I think, however, that Satan personally leaves us because he knows that, for some men, not to be tempted is a greater danger than to be tempted. "Oh," you say, "how can that be?" Brothers, sisters, do you know nothing of carnal security, of being left—as you think—to grow in grace and to be very calm, very happy, very useful, and to find beneath you a sea of glass with not a ripple on the surface? You say, "Yes, I do know that experience and have been thankful for it."

Have you never found creeping over you, at the same time, the idea that you are somebody, that you are getting wonderfully experienced, that you are an important child of God, rich and increased in

goods? And have you not been like David, who wrote these words: *"In my prosperity I said, I shall never be moved"* (Ps. 30:6)?

Possibly you have looked askance on some of your friends, who have been trembling and timid, crying to God from day to day to keep them. You have been Sir Mighty, Lord Great-One, and everybody should bow down before you. Ah, yes, you have now fallen into a worse condition than even those are in who are tempted of Satan! A calm in the tropics is more to be dreaded than a tempest. In such a calm everything becomes still and stagnant. The ship scarcely moves. It is like a painted ship on a painted sea, and it gets to be in something like the state described by Coleridge's *Ancient Mariner*:

> The very deep did rot:
> Alas, that ever this should be!
> And slimy things with legs did crawl
> Over the slimy sea.

"Oh," you say, "that is horrible!" Yes, and that is the tendency of a soul that is at peace with itself and is not *"emptied from vessel to vessel"* (Jer. 48:11). I fear that is often the case with those who believe themselves to be supernaturally holy.

A curious fact can be proved by abundant evidence, namely, that the boast of human perfection is closely followed by obscenity and licentiousness. The most unclean sects that have ever defaced the pages of history have been founded by those who had the notion that they were beyond temptation, that they had ceased to sin and never could transgress again.

"Ah," says Satan, "this notion does my work a great deal better than tempting a man. When I tempt him, then he stands up to resist me. He has his eyes open; he grasps his sword and puts on his helmet. He cries to God, 'Lord, help me!' as he watches night and day. The more tempted he is, the more he looks to God for strength. But if I leave him quite alone, and he goes to sleep, then he is not in the battle. If he begins to feel quite secure, then I can steal in upon him secretly, and make a speedy end of him." This is one reason that Satan leaves some men untempted. A roaring Devil is better than a sleeping Devil. There is no temptation much worse than that of never being tempted at all.

Again, I do not doubt that Satan leaves us—for I know that he must—when the Lord says to him what He said in the wilderness, *"Get thee hence, Satan"* (Matt. 4:10). The Lord does say that when

He sees one of His poor children dragged about, tortured, wounded, and bleeding. He says, "*'Get thee hence, Satan.'* I permit you to fetch in My stray sheep, but not to worry them to death. *'Get thee hence, Satan.'*" The old Hell-Dog knows his Master, and he flies at once.

This voice of God will come when the Lord sees that we cast ourselves wholly upon Him. In casting our burdens upon the Lord, we might not be able to get rid of them. The better way is to cast both ourselves and our burdens upon the Lord. The best way of all is to get rid of the burdens entirely, to cast ourselves without our burdens upon the Lord.

Let me tell you a story of a gentleman who, riding along in his wagon, saw a man carrying a heavy pack and asked him if he would like a ride. "Yes, and thank you, sir." But the man kept his pack on his back while riding. When the gentleman asked why he did not take his pack off and set it down, the man replied, "Why, sir, it is so kind of you to give me a ride that I do not like to impose upon your good nature, and I thought that I would carry the pack myself."

"Well," said the other, "you see, it makes no difference to me whether you carry it or do not carry it, for I am carrying you and your pack. You might as well unstrap it and set it down."

In the same way, friend, when you cast your burden upon God, unstrap it. Why should you carry it yourself when God is prepared to bear it? Beloved, there are times when we forget that we can come and absolutely yield ourselves, saying, "Lord, here I am—tempted, poor, and weak—but I come and rest in You. I do not know what to ask at Your hands, but Your servant has said in Psalm 55:22, *'Cast thy burden upon the LORD, and he shall sustain thee: he shall never suffer the righteous to be moved.'* I lie at Your feet, my Lord. Here I am; here would I be. Do with me what seems good in Your sight, only deal in tender mercy with Your servant." Then will the Lord rebuke the Enemy. The waves of the sea will be still, and there will come a great calm.

So much for the Devil leaving the one who is tempted. He does so—he must do so—when God commands it.

MINISTERING ANGELS

Second, let us think of the angels ministering to the tempted One. The angels came and ministered to our Lord after Satan was gone.

Notice that they did not come while our Lord was in the battle. Why not? Because it was necessary that He should tread the winepress alone (Isa. 63:3), and because it was more glorious for Him to have no one with Him! Had there been any angels there to help Him in the duel with the Adversary, they might have shared the honor of the victory. But they were stopped until the fight was over. When the Foe was gone, then the angels came.

It has been noted that Scripture does not say that the angels came very often and ministered to Jesus. This makes me think that they were always near, that they hovered within earshot, watching and ready to interpose if they might. They were a bodyguard around our Lord, even as they are today around His people. *"Are they not all ministering spirits, sent forth to minister for them who shall be heirs of salvation?"* (Heb. 1:14).

The moment that the fight was over, the angels came and ministered to Christ. Why was that? First, I suppose, because as a man He was especially exhausted. We are told that He was hungry, and this shows exhaustion. Besides that, the strain of forty days' temptation must have been immense. Men can bear up under stress, but when it eases, then they fall. Elijah did wonders, smote the priests of Baal, and behaved like a hero. But after it was all over, Elijah failed. As man, our Lord was subject to the sinless infirmities of our flesh. Thus He needed the angels to come and minister to Him, even as the angel did in the garden after the agony and bloody sweat.

It was also because, being man, He was to partake of the ministry that God had allotted to man. God has appointed angels to watch over His own people. Inasmuch as Jesus is our Brother, and as God's children are partakers of the ministry of angels, He Himself also shared in the same. Thus, He showed how He took our weaknesses upon Himself, and therefore needed and received that help that the Father has promised to all of His children.

Also, was it not because He was so beloved of the angels, and they were so loyal to Him? They must have wondered when they saw Him born on earth and living here in poverty. When they saw Him tempted of the Enemy, they must have loathed the Adversary. How could Satan be permitted to come so near their pure and holy Master?

I think that Milton could have best pictured this scene. He would have described every seraphim there as longing to let his sword of flame find a scabbard in the heart of the foul Fiend that dared to come so near to the Prince of purity. But they could not

interfere. However, as soon as they were permitted, they joyfully came and ministered to Him.

And does it not also go to show that His was a nature very sensitive to the angelic touch? You and I are hard-hearted and coarse.

> Myriads of spirits throng the air:
> They are about us now.

Women are to cover their heads in worship *"because of the angels"* (1 Cor. 11:10). There are many acts of decorum in holy worship that are to be kept up *"because of the angels."* The angels are innumerable and are sent to minister to us, but we are not aware of them—often we do not perceive them. But Jesus was all tenderness and sensitivity. He knew that the angels were there, so it was easy for them to come and minister to Him. What they did in ministering to Him, we cannot tell. I should certainly think that they sustained His bodily nature, for he was hungry, and they readily brought food to Him. But they also sustained His mental and His spiritual nature with words of comfort. The sight of them reminded Him of His Father's house, reminded Him of the glory that He had laid aside. The sight of them proved that the Father did not forget Him, because He had sent the household troops of heaven to help and support His Son. The sight of them must have made Him anticipate the day of which the poet sang:

> They brought His chariot from above,
> To bear Him to His throne,
> Clapp'd their triumphant wings, and cried,
> "The glorious work is done."

Now, beloved, if we are tempted, will we have any angels to help us? Well, we will have the equivalent of angels, certainly. Oftentimes, after a temptation, God sends His human messengers. Many of you can tell how, when you have heard the Word after a bad time of temptation, the gospel message has been wonderfully sweet to you. You have sat in your pew and said, "God sent that sermon on purpose for me." Or if you have not had a sermon, you have read the Bible, and the words have seemed to burn and glow on the page, warming your soul by their heat.

Has it not been so with you often? Are not all the holy things more sweet after trial than they were before? Have you not found

them so? I give my willing witness that never does Christ seem so precious, never do the promises seem so rich and rare, never does evangelical doctrine cling so closely to my heart, and my heart to it, as after a time of painful trial when I have been laid aside from holy service and racked with anguish. Oh, then the angels come and minister to us in the form of men who preach the Word or in the form of the living page of God's written Word!

I have noticed, too, that God sometimes cheers His tempted people with clear sunshine after rain by some very gracious providence. Something happens that they could not have looked for, so pleasant, so altogether helpful, that they have had to burst into singing, though just before they had been sighing. The cage door was set wide open, and God's bird had such a flight. It sang so sweetly as it mounted up to heaven's gate that the soul seemed transformed into a holy lark in its ascending music. Have you not found the Lord very gracious to you after some severe trial or some strong temptation? I believe that this is or will be the testimony of many experienced Christians.

As there come these choice providences, so, I do not doubt, there come actual angels ministering to us, though we are unaware of their presence. They can suggest holy thoughts to bring us comfort. But above the angels, far superior to angelic help, is the Holy Spirit, the Comforter. How sweetly can He bind up every wound and make it even sing as it heals! He makes the bones that God had broken to rejoice (Ps. 51:8) and fills us with a deeper experience of delight than we have ever known before.

Well now, I suppose that some of you are in this condition. Satan has left you, and angels are ministering to you. If so, you are very happy. Bless God for it. There is a great calm. Thank God for the calm after the storm. I hope, my brother, that you are the stronger for what you have endured, and that the conflict has matured you and prepared you for something better.

Now, what did our Lord do after the Devil had left Him, and the angels had come to minister to Him? Did He go home and stop there, and begin to sing of His delightful experiences? No, we find Him preaching directly afterward, full of the Spirit of God. He went everywhere proclaiming the kingdom. He was found in the synagogue or on the hillside. Just in proportion as the Spirit of God had enabled Him to overcome the Enemy, we find Him going forth to spend that strength in the service of His Father.

Oh, tempted one, have you been granted a respite? Spend that respite for Him who gave it to you. Is it calm now after a storm? Go now, and sow your fields with the good seed. Have you wiped your eyes, and are your salty tears gone? Go, sing a psalm to your Beloved. Go down to His vineyard, take the foxes, prune the vines, and dig around them. Do necessary work for Him who has done so much for you.

Listen. You have been set free. There are many under bondage to Satan—not free as you are—fighting against him, but still his willing slaves. Oh, come, my brother, God has set you free, so go after them! Go after the fallen woman and the drunken man. Go, seek, and find the most debauched, the most depraved. Especially look after any of your own household who have played the prodigal.

> Oh, come, let us go and find them!
> In the paths of death they roam:
> At the close of the day
> 'Twill be sweet to say,
> "I have brought some lost one home."

And it will be right to say it, if the Lord has dealt so well with you.

LIMITATIONS ON REST

Now, I have to close by reminding you of the third point, which is a searching truth, namely, the limitation of our rest.

Satan left Christ *"for a season,"* or, "until an opportune time." Did the Devil assail our Lord again? I am sure that he personally did; but he did so in many ways by others also.

I notice that, before long, he tried to entangle Him in His speech. That is a very easy thing to do with us. Somebody can take up something that I have said, twist it from its context, and make it sound and seem totally different from what was meant by it. You know how the Herodians, the Sadducees, and the Pharisees did this with our Lord. They tried to entrap Jesus with His words. In all that, Satan led them on. Satan also actively opposed Christ's ministry, and Christ opposed Satan. But Jesus won the day, for He saw Satan fall like lightning from heaven.

A still more artful plan was that by which the Devil's servants, the demons that were cast out of possessed people, called Jesus the Son of God. He rebuked them because He did not want

any testimony from them. No doubt the Devil thought it a very cunning thing to praise the Savior, because then the Savior's friends would begin to be suspicious of Him, if He was praised by the Devil. This was a deep trick, but the Master made him hold his tongue. You remember how He commanded on one occasion, *"Hold thy peace, and come out of him"* (Mark 1:25). It was something like this, "Down dog! Come out!" Christ was never very polite with Satan. A few words and very strong ones are all that are necessary for this Arch-prince of wickedness.

Satan tempted our Lord through Peter. That is a plan that he has often tried with us, sending a friend of ours to do his dirty work. Peter took his Lord and rebuked Him when He spoke about being spit upon and put to death. Then the Lord said, *"Get thee behind me, Satan"* (Mark 8:33). He could see the Devil using Peter's tenderness to try to divert Him from His self-sacrifice. Oh, how often has Satan tempted us that way, entangling us in our speech, opposing us in our work, praising us out of wicked motives to try to deceive us, and then sending some friend to try to divert us from holy self-denial!

There were also occasions when our hearts sink in our Lord. Thus we read in John 12:27, *"Now is my soul troubled."* He seems to have been very heavy in heart at that time. But the deepest sinking of soul was when, in the garden, He cried, *"My soul is exceeding sorrowful, even unto death"* (Matt. 26:38). Satan had a hand in that sore trial, for the Lord had said, *"The prince of this world cometh"* (John 14:30). He said to those who came to arrest Him, *"This is your hour, and the power of darkness"* (Luke 22:53). It was a dreadful season. Our Lord's ministry began and ended with a fierce onslaught from Satan. He left Him after the temptation, but only *"for a season."*

Well now, dear friends, if we have peace and quietness right now and are not tempted, do not let us become self-secure. The Devil will come to us again at a fit opportunity. And when will that be? There are a great many opportunities with you and with me. One is when we have nothing to do. You know Dr. Watt's lines:

> Satan finds some mischief still,
> For idle hands to do.

He will come and attack us when we are alone—I mean, when we are sad and lonely, sitting still and moping by ourselves.

But Satan also finds a very fit occasion when we are in company, especially when it is very mixed company, a company of people who are perhaps superior to ourselves in education and in station, but who do not fear God. We may easily be overawed and led astray by them. Satan will come then.

I have known him frequently to find an occasion against the children of God when we are sick and ill, the old coward! He knows that we would not mind him when we are in good health; but sometimes when we are down in the dumps through sickness and pain, it is then that he begins to tempt us to despair.

So will he do with us when we are very poor. When a man has had a great loss in business, Satan comes down and insinuates, "Is this how God treats His children? God's people are no better off than other people."

Then, if we are prospering in the world, he turns it the other way and says, "*'Doth Job fear God for nought?'* (Job 1:9). You get ahead by your religion." You cannot please the Devil anyhow, and you should not want to please him. He can make a temptation for you out of anything.

I am going to say something that will surprise you. One time of great temptation is when we are very spiritual. As for myself, I have never been in such supreme danger as when I have led some holy meeting with sacred fervor and have felt carried away with delight in God. You know that it is easy to be atop the Mount of Transfiguration, and then to meet Satan at the foot, as our Lord did when He came down from that hill.

Another time of temptation is when we have already done wrong. "Now he begins to slip," says Satan. "I saw him trip; now I will get him down completely." Oh, for speedy repentance and an earnest flight to Christ, whenever there has been a grave fault, and also before the grave fault comes so that we may be preserved from falling!

Satan finds a good occasion for tempting us when we have not sinned. After we have been tempted, and we have won the day and stood fast, then he comes and says, "Now, that was well done on your part. You are a splendid saint." You may depend on it that he who thinks of himself as a splendid saint is next door to a shameful sinner. Satan soon gets the advantage over him.

If you are successful in business or successful in holy work, then Satan will tempt you. If you are not successful and have had a bad time, then Satan will tempt you. When you have a heavy load to

carry, he will tempt you. When that load is taken off, then he will tempt you worse than ever. He will tempt you when you have obtained some blessing that you have been thinking was such a great boon. For example, in the wilderness, when they cried for meat and insisted that they must have it, God gave them their hearts' desire, but sent leanness into their souls. Just as you have secured the thing that you are seeking, then comes a temptation. To all of which I say, "Watch." Christ said, *"What I say unto you I say unto all, Watch"* (Mark 13:37). In another place He said, *"Watch and pray, that ye enter not into temptation"* (Matt. 26:41). And by the conflict and the victory of your Master, go into the conflict bravely, expecting to conquer by faith in Him, even as He overcame.

But what should I say to those who are the slaves and the friends of Satan? The Lord have mercy on you! If you desire to escape, there is only one way. There is the cross, and Christ hangs upon it. Look to Jesus; He can set you free. He came on purpose to proclaim liberty to the captives. Look and live. Look now, and live now. I implore you, do it for His dear sake. Amen.

SPURGEON'S EXPOSITION OF LUKE 4:1–16

And Jesus being full of the Holy Ghost returned from Jordan, and was led by the Spirit into the wilderness. (Luke 4:1)

"Full of the Holy Ghost," and then led *"into the wilderness"* to be tempted. You would not expect that. Yet it is a sadder thing to be led into a wilderness when you are not filled with the Spirit, and a sadder thing to be tempted when the Spirit of God is not resting upon you. The temptation of our Lord was not one to which He exposed Himself; He *"was led by the Spirit into the wilderness."* The Spirit of God may lead us where we will have to endure trial. If He does so, we are safe and will come out conquerors even as our Master did.

...being forty days tempted of the devil... (Luke 4:2)

Six weeks of temptation. We read the story of the temptation, perhaps, in six minutes, but it lasted for nearly six weeks, for *"forty days."*

*And in those days he did eat nothing: and when they were
ended, he afterward hungered.* (Luke 4:2)

It does not appear, therefore, that Jesus was hungry while He
was fasting. He was miraculously sustained during that period. After
fasting, one looks for deeper spiritual feeling and more holy joy. But
the most prominent fact here is that *"he afterward hungered."* Do
not think that you have lost the benefit of your devout exercises
when you do not at once feel it. Perhaps the very best thing that can
happen to you after much prayer is a holy hunger. I do not mean a
natural hunger, as it was with our Lord, but a blessed hungering af-
ter divine things. *"Blessed are they which do hunger and thirst after
righteousness: for they shall be filled"* (Matt. 5:6).

*And the devil said unto him, If thou be the Son of God, com-
mand this stone that it be made bread.* (Luke 4:3)

Satan met the hungry Man and suited the temptation to His
present pangs, to His special weakness at that moment: *"If thou be
the Son of God, command this stone that it be made bread."* The
Devil suspected, and I think he knew, that Jesus was the Son of God,
but he began his temptation with an *"if."* He hissed into the Savior's
ear, *"If thou be the Son of God."*

If you, believer, can be led to doubt your sonship and to fear that
you are not a son of God, Satan will have begun to win the battle. So
he began to storm the royal fort of faith: *"If thou be the Son of God."*
Our Lord is the Son of God, but He was then suffering as our Substi-
tute. In that condition, He was a lone and humble man. What if I call
Him "a common soldier in the ranks"? Satan invited Him to work a
miracle of an improper kind on His own behalf, but Jesus worked no
miracle for Himself.

Now, it may be that the Devil is trying some of you right now.
You are very poor, or business is going very awkwardly, and Satan
suggests that you should help yourself in an improper manner. He
tells you that you can get out of your trouble very easily by some ac-
tion that, although it may not be strictly right, may not be so very
wrong after all. He said to Jesus, *"If thou be the Son of God, com-
mand this stone that it be made bread."*

And Jesus answered him, saying, It is written. (Luke 4:4)

That is Christ's sword. See how swiftly He drew it out of its sheath. What a sharp two-edged sword is this to be used against Satan! You also, believer, have this powerful weapon in your hand. Let no man take it from you. Believe in the inspiration of Scripture. Just now there is a fierce attack on the book of Deuteronomy. It is a very curious thing that all the texts Christ used during the temptation were taken out of Deuteronomy, as if that was to be the very armory out of which He would select this true Jerusalem blade, with which He would overcome the Tempter. *"It is written." "It is written."*

Man shall not live by bread alone, but by every word of God.
(Luke 4:4)

"God can sustain me without my turning the stone into bread. God can bring me through my trouble without my saying or doing anything wrong. I am not dependent on the outward and visible." If you can feel like that, if you can appropriate the promise of God and quote it to Satan saying, *"It is written,"* using it as Christ did, you will emerge a conqueror in the time of temptation even as He did.

And the devil... (Luke 4:5)

He tried Him again. Wave upon wave tried to wash the Son of man off His feet.

...taking him up into an high mountain, showed unto him all the kingdoms of the world in a moment of time. *(Luke 4:5)*

Skeptics have asked how that could be done. Well, they had better ask the one who did it. He knows more about them, and they know more about him, than I do. He did it, I am sure, for here it is written that he *"showed unto him all the kingdoms of the world in a moment of time."*

And the devil said unto him, All this power will I give thee, and the glory of them: for that is delivered unto me; and to whomsoever I will I give it. *(Luke 4:6)*

Does he not talk proudly in the presence of his Lord and Master? What an audacious dog he must have been to howl in the

presence of Him who could have destroyed him by a look or a word if He had wished to do so!

> *If thou therefore wilt worship me, all shall be thine. And Jesus answered and said unto him, Get thee behind me, Satan.*
> *(Luke 4:7–8)*

The temptation annoyed Him; it was so foreign to His holy nature. It vexed His gracious spirit, so He cried out indignantly to the Tempter: *"Get thee behind me, Satan."*

> *For it is written… (Luke 4:8)*

Here flashed forth the sword again.

> *Thou shalt worship the Lord thy God, and him only shalt thou serve.*　　　　　　　　　　　　*(Luke 4:8)*

Then let us pay no reverence, no worship, to any but God. Consciences and minds are made for God alone. Before Him let us bow. But if all the world were offered to us for a moment's idolatry, let us not fall into the snare of the Tempter.

> *And he brought him to Jerusalem. (Luke 4:9)*

Satan now takes Christ to holy ground. Temptations are generally more severe there.

> *…set him on a pinnacle of the temple… (Luke 4:9)*

The highest point of all—elevated high above the earth.

> *And said unto him, If thou be the Son of God, cast thyself down from hence: for it is written, He shall give his angels charge over thee, to keep thee: and in their hands they shall bear thee up, lest at any time thou dash thy foot against a stone.*
> *(Luke 4:9–11)*

Now Satan tries to quote Scripture, as he can do when it suits his purpose, but he never quotes it correctly. You young believers who go out preaching, mind that you do not imitate the Devil by

quoting part of a text or quoting Scripture incorrectly. He did it, however, with a purpose: not by accident or from forgetfulness, he left out the very necessary words, *"In all thy ways." "He shall give his angels charge over thee, to keep thee in all thy ways"* (Ps. 91:11). Satan left out those last four words, for it was not the way of a child of God to jump down from a pinnacle of the temple headlong into the gulf beneath.

> *And Jesus answering said unto him, It is said, Thou shalt not tempt the Lord thy God.* *(Luke 4:12)*

Do nothing presumptuously. Do nothing that would try to lead the Lord to act otherwise than according to His settled laws, which are always right and good.

> *And when the devil had ended all the temptation, he departed from him for a season. And Jesus returned in the power of the Spirit into Galilee.* *(Luke 4:13–14)*

He had not lost anything by the temptation; *"the power of the Spirit"* was still upon him.

> *And there went out a fame of him through all the region round about. And he taught in their synagogues, being glorified of all.*
> *(Luke 4:14–15)*

He became popular. The people resorted to Him and were glad to hear Him. He who has had secret temptation and private conflict is prepared to bear open success without being elevated by it. Have you stood toe to toe with Satan? You will think little of the applause or of the attacks of your fellowmen.